Almost Nothing

The 20th-Century Art and Life of Józef Czapski

ERIC KARPELES

nyrb **New York Review Books** New York

This is a New York Review Book
published by The New York Review of Books
435 Hudson Street, New York, NY 10014
www.nyrb.com

Copyright © 2018 by Eric Karpeles
All rights reserved.

LIBRARY OF CONGRESS CATALOGING-IN-PUBLICATION DATA
Names: Karpeles, Eric, author.
Title: Almost nothing: the 20th century art and life of Józef Czapski / Eric
 Karpeles.
Description: New York : New York Review Books, 2018.
Identifiers: LCCN 2018024071 (print) | LCCN 2018026405 (ebook) |
 ISBN 9781681372853 (epub) | ISBN 9781681372846 (paperback)
Subjects: LCSH: Czapski, Józef, 1896–1993. | Painters—Poland—Biography. |
 Authors, Polish—20th century—Biography. | BISAC: BIOGRAPHY &
 AUTOBIOGRAPHY / Artists, Architects, Photographers. | ART / European.
Classification: LCC ND955.P63 (ebook) | LCC ND955.P63 C9235 2018 (print) |
 DDC 759.38 [B]—dc23
LC record available at https://lccn.loc.gov/2018024071

ISBN 978-1-68137-284-6
Available as an electronic book; ISBN 978-1-68137-285-3

Printed in the United States of America on acid-free paper
1 2 3 4 5 6 7 8 9 10

For Michael Sell

They who one another keepe
Alive, ne'r parted bee.
—JOHN DONNE, "Song"

Contents

Si fractus illabatur orbis
impavidum ferient ruinae.

If the world should shatter and fall on him,
he would stand fearless amid the ruins.

—HORACE, *Odes*, iii. 3

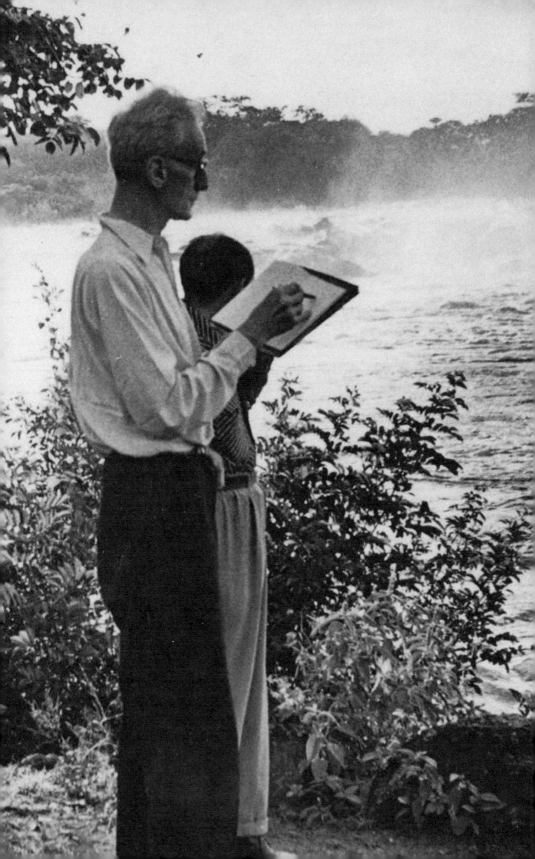

Introduction
Underpainting

MY FIRST EXPOSURE TO the life and work of Józef Czapski came about altogether unexpectedly. One June day I had never heard of him, the next day I was hooked.

Through the generous impulse of an old friend who likes to feed my appetite for critical thinking, I received in the mail one morning, from Paris, a slim French volume on the subject of Marcel Proust. The author's name, Józef Czapski, was not familiar to me. What happened after I opened the package I hardly remember. Like a creature burrowing in its natural habitat, I sank into a chair and started to read right away. I do recall trying to force myself to stop at a certain point, thinking I might sustain the pleasure of reading over the course of a few days rather than exhaust it all in one sitting, but instead I carried on, smiling and nodding, in a state of contentment. Taking in the last words of the final paragraph, I looked up reluctantly, as after the curtain falls on an engrossing performance one hoped would never end. I returned to the room I had not left only to discover a luminous day had long since faded to dusk. The twilight suspended me in its threshold between day and night, much as my consciousness was suspended between Czapski's world and my own.

I was grateful for the book's serendipitous appearance in my life. Attuned to the sublimity of first readings, which can happen only once, I couldn't shake the feeling that the book having turned up was not an accident, and that it had arrived carrying some kind of challenge, not from my friend who sent the book but rather, strangely, from the author, a painter like me. I felt this challenge on a visceral level, and it unsettled me. In an essay dedicated to Czapski, the Polish poet Zbigniew Herbert describes an encounter with an enigmatic work of art, capturing perfectly my own frame of mind:

> I understood immediately, though it is hard to explain rationally, something
> very important had happened; something far more important than an accidental

encounter.... How to describe this inner state? A suddenly awakened intense curiosity, sharp concentration with the senses alarmed, hope for an adventure and consent to be dazzled. I experienced an almost physical sensation as if someone called me, summoned me.

The following day I thought repeatedly, almost continually, of what Czapski had said about Proust and of how he said it. His tone throughout the book is casual, engaging, almost conversational, with no trace of the specialist's dry condescension. Proceeding from a position of rapt wonder rather than analytical distance, he speaks not only of *À la recherche du temps perdu* (*Remembrance of Things Past*) but of his experience reading it. Initially Czapski had not been impressed; after slogging through a description of a society party that went on for several hundred pages, he decided not to continue reading. He was inclined to agree with the caustic assessment of Anatole France: "Life is too short and Proust too long."

I was too little acquainted with the French language to savor the essence of this book, to appreciate its rare form. I was more used to books where something actually happens, where the action develops more nimbly and is told in a rather more up-to-date style. I didn't have sufficient literary culture to deal with these volumes, so mannered and exuberant....

Czapski's confession of not having "sufficient literary culture" to encounter Proust endeared him to me. Having been forced to confront a similar sense of deficiency in myself while engaged in writing a book about Proust's use of paintings in his novel, I found fellowship in Czapski's admission. My excited response to the slender book in my hands was also generated by the knowledge that Czapski never sat down to write a text in any conventional fashion, as I had done. In his introduction, he explains that his book merely represents the transcription of a series of lectures on Proust he had given while being held as an enemy officer during the Second World War, hidden away in a prison camp deep in the malevolent heart of the Soviet Union. He had been struck by the idea that Proust's vision of "time regained" could be offered as a lifeline to his fellow officers, as a beacon of hope for those beleaguered men huddled together in the unrelenting cold, exhausted from overwork, depleted by malnutrition. With no copy of the novel available to him for reference, he had no choice but to reconstitute passages of the text from memory. In doing

so, his very process became a realization, an embodiment of the Proustian endeavor.

I came to understand why the importance and the creativity of Proust's involuntary memory is so often emphasized. I observed how distance—distance from books, newspapers, and millions of intellectual impressions of normal life—stimulates that memory. Far away from anything that could recall Proust's world, my memories of him, at the beginning so tenuous, started growing stronger and then suddenly, with even more power and clarity, completely independent of my will.

Who was this man, at once so vulnerable and so self-assured, a painter in civilian life, attempting to transcend the oppressive constraints of a degrading Soviet prison by speaking to a gathering of his Polish peers—in French—about *Proust*?

A few days later I picked up Czapski's book and read it again. Proceeding more slowly and mindfully this time, I discovered new resonances and a powerful subtext that had eluded me on the first encounter. I became preoccupied with it, distracted and slightly agitated. In such circumstances my default response is to walk. I set off for a favorite trailhead and began to wind my way on a dirt path along a trickling creek, clambering up the side of a steep ridge under cover of Northern California redwood, oak, and laurel, familiar with each rise and fall along the rocky way. After half an hour of steady climbing, I paused on a wooden bridge traversing a ravine as the trail shifts from one slope to the other. The air was fragrant and sweet, birds were chirping. I could hear the murmur of water coursing over rocks below. I looked out at a cluster of gnarled pines I often admire from this vantage point, always slightly reconfigured in appearance depending on the time of day and the ever-shifting dappled light. Several long branches arched and bent outward, their rough but graceful forms often reminding me of studies Paul Cézanne made of the woods above Château Noir, a property just outside of Aix-en-Provence where he loved to paint. I became aware suddenly of a literary association attempting to assert itself in that part of my brain where word and image vie for primacy. I looked down at the fingers of my right hand on the lichen-covered railing of the bridge, then back up at the undulating tree limbs. Unbeckoned, a passage emerged from the second volume of Proust's novel, a scene where the young protagonist, traveling in a horse and carriage along

the edge of a wood, spots a stand of trees as he goes by. Three of the trees invade his consciousness:

> I could see them plainly, but my mind felt that they were concealing something.... And yet all three of them, as the carriage moved on, I could see coming towards me.... Like ghosts they seemed to be appealing to me to take them with me, to bring them back to life.... I watched the trees gradually recede, waving their desperate arms, seeming to say to me: "What you fail to learn from us today, you will never know. If you allow us to drop back into the hollow of this road from which we sought to raise ourselves up to you, a whole part of yourself which we were bringing to you will vanish forever into thin air."... I was as wretched as if I had just lost a friend, had died to myself, had broken faith with the dead, or repudiated a god.

Finding myself within a Cézanne landscape, surrounded by woods and outcroppings of stone under patches of a violet-blue sky, my mind had somehow triggered an involuntary memory from the seminal text of remembering. So much was crowding into my head, I didn't know how to prioritize the flood of stimuli. It was almost too much to process. Proust and Cézanne, each representing a formative cornerstone of my sentimental education, were quite suddenly and unexpectedly beginning to interact. Their spirits had long held sway in separate spheres of my creative imagination; their distinct but equally iconoclastic essences have always proven hard to reconcile.

In Proust's novel, an adult narrator, having swallowed a bite of cookie dipped in lime-flower tea, struggles to identify a vague stirring sparked by a mysterious, alchemical response in his brain. He finds nothing to grab hold of but understands that the truth he is seeking does not reside in the drink "but in myself." Following several failed attempts, he shifts to a neutral state, caught between actively encouraging the memory that wants to present itself and simply allowing it to surface of its own accord. Unexpectedly, through heightened combinations of taste and smell, reasoning intelligence gives way and long-buried visions of childhood begin to open in him like flowers budding under the heat of the sun.

For Cézanne, truth was to be found somewhere solid and grounded, outside of himself, not lurking ineffably at the back of his mind. Day after day, year after year, he placed himself squarely in front of palpable manifestations of the natural world, external realities he studied carefully as symbols of immutable

strength. The weathered flank of a mountain, the tangible weight of pieces of fruit, figures bathing in a river, cardplayers seated at a table—he sought to reconstruct such absolute forms on his canvas with one stroke of his brush after another. Had he lived a few years longer and been able to read *Swann's Way*, he almost certainly would have dismissed Proust's solipsistic gropings as a kind of delusional activity, mercurial and ephemeral.

What was I to make of such a conflict of sensibilities? I spotted a list of titles of other books Czapski had written at the back of his book on Proust. *Cézanne et la peinture consciente* (Cézanne and Conscious Painting) was among them. At the intersection of these two incompatible modernist visionaries, and in allegiance to both, Józef Czapski seemed to be waiting patiently for me somewhere further ahead. *As if someone called me, summoned me.* All I had to do was find him.

Józef Czapski, a figure largely unknown to American readers and artists, lived many lives in his ninety-six years—soldier, public figure, historical witness, memoirist, essayist, painter. Born in 1896, his life spanned nearly the entire twentieth century. His most dominant physical trait was similarly expansive; he stood over six feet six inches tall. Attaining such an unwieldy stature early on, he'd had to master the tall person's delicate navigation of spatial relations in a world built for shorter people. To his young nieces and nephews he liked to boast, "*Je suis le plus grand peintre de Paris!*" playing ironically on a double meaning, *le plus grand* signifying not only the tallest painter but also the greatest. Photographs of him throughout his life show him as thin as a blade, invariably the tallest person in any group. He rose a full head above friends and family, above his commanding officers, above viewers gathered at the openings of his exhibitions. His light, clear eyes were close set, usually seen through a pair of large corrective lenses. A strong, aquiline nose anchored a long face with an imposing brow topped by a crown of smooth, straight reddish hair that tended to tuft up above his large ears. He had a thin-lipped mouth and a very square jaw. His legs, arms, and torso were extravagant in length, his hands big, his fingers beautifully shaped. Like an elongated, striding man by Giacometti, he had a tendency to lean into space. In a letter to Hannah Arendt, Mary McCarthy described seeing her friend Czapski at a Vermeer exhibition in Paris, "an old man, six and a half feet tall, moving contentedly through the crowd like an ostrich, taking pictorial notes in a sketchbook." His voice was high-pitched and squeaky, with the bright colors of a reed instrument. An animated

talker, fluent in four languages, he makes a fascinating subject to observe speaking on film. He liked to talk and he liked to argue a point, to stir up passionate dialogue. He was consumed by an urgent need to communicate.

Born into privilege, a titled aristocrat, he lived like a bohemian, like a monk. He possessed both a childlike spirit of wonder and much solemnity, a by-product of his insistence on truthfulness. Sprite and sage coexisted within him in equal measure, oddly harmonious. A deeply religious and ecumenical Catholic, he had an almost physical aversion to banality and sentimentality. Amid the incessant challenges of Europe's twentieth century, he grappled to define his priorities and maintain them. Given the diversity of roles he assumed, the unity of his character is striking. A singular aura of truthfulness emanates from his mental, physical, and spiritual selves alike. Two questions he habitually asked himself defined separate realities agitating in him: "How can I be a better person?" and "How can I be true to myself?" Serious, earnest, and thoughtful, he became the embodiment of great moral integrity for many people, a good man in bad times.

For all his ardent commitment to taking part in the struggle against totalitarianism, he considered himself first and foremost a painter. Painting gave his life meaning. This great discipline required withdrawal from the world; whenever he could, he sought the solitude of the studio to nurture his vision. When he was unable to make room in his life for a sustained studio practice, he did his best to stay visually alert to the physical world and to record its impact on him. Pencil, pen, and paper were never far from reach. Celebrated for his active engagement in the arena of political ideas, in the theater of war, he is less known, less recognized for his devotion to the demands of a painting life. According to one close friend, Czapski "was more admired for his character than for his painting. Those who bought his work did so primarily out of friendship for the man.... His painting remains practically unknown."

This continues to be the case. His paintings are almost nowhere to be seen in public collections; the majority are held in private collections scattered across Europe. Paintings by Czapski had been purchased and registered in the national collections of Poland and France many decades ago, but these now appear in official files recorded only as inventory numbers for works in storage. Few, if any, canvases are on public display. Random images surface online, eclectic in terms of subject and style, but they are rarely identified by owner or current location. The scarcity of images is disconcerting and their generally poor quality gives little feel for the real thing. Digital files viewed backlit on

screens or reproduced in books and magazines are inadequate substitutes for the original works. Obvious as this may sound, one cannot truly judge the merits of a painting without standing before it. "The presence of the original," Walter Benjamin declared, "is the prerequisite to the concept of authenticity."

A combination of willfulness, zeal, and detective skills were needed to track down and gain access to Czapski's work twenty years after his death. Steven Barclay, the friend who had so knowingly sent me the book of lectures on Proust, had only recently learned of Czapski's existence. He had been helping Mavis Gallant, the Canadian-born, Paris-based short-story writer, to edit her personal diaries for publication. The two of them would sit at her kitchen table in Montparnasse, working their way through volume after volume. Focusing on entries written in the 1960s, Steven began to lose sight of familiar signposts in the intellectual and political landscape of that tumultuous era. Repeated references to Polish émigrés kept appearing. Steven wondered who, for instance, the poet Aleksander Wat and his wife, Ola, were, their names popping up page after page. With dishes piled in the sink and the smell of strong coffee in the air, Mavis regaled Steven with stories from those years, when she had fallen in with a clutch of writers and artists who had decided against living under communist rule in Poland and settled in Paris. "They were very talented," she said of her Polish friends, "as we imagined Europeans used to be." Some of the members of this émigré community would resurface, transposed, as characters in her stories. At one point, Mavis spoke fondly about a painter who had written a book she admired on the subject of Proust: Czapski.

Steven helped me to connect the dots, paving the way for my first direct contact with someone who had known the man. Richard Overstreet, an affable, Berkeley-educated American painter, has lived in Paris since 1960, in a sprawl of elegant old rooms cobbled together by narrow hallways and steep stairs. His apartment and studio on rue de la Vrillière, near Palais Royal, had once been the home of the Argentine-born surrealist painter Leonor Fini and the Polish cultural critic Konstanty Jeleński, one of Czapski's great champions and closest friends. A vivid Jamesian character, Richard continues to live amid the lingering vestiges of these two oversize personalities—and the descendants of their large family of exotic cats. He first encountered Leonor in 1967 when the filmmaker John Huston hired Richard as his assistant director for a movie project set in medieval France. Leonor was designing period costumes for the film. Known professionally for her bold stage designs as well as her paintings, her interest in clothing was not limited to dressing actors. A famous *poseuse*—

photographed in Schiaparelli, in mask and feathers, in the nude—she was a feline beauty who relished the company of cats. Once the Huston film shoot began, a close relationship developed between Richard and Leonor. Gradually, he was drawn into the circle of lovers and admirers who found fulfillment in her unbridled exhibitionism. Jeleński, a central fixture of that ménage, was known as Kot (Polish for cat). Together, Leonor and Kot helped Richard to navigate the byzantine intrigues of the Parisian art world, facilitating the establishment of his painter's bona fides.

Over a glass of wine in a low-ceilinged, art- and book-lined salon, Richard spoke warmly about Czapski, whom he thought of as a remarkable figure now sadly neglected. (This sentiment would be expressed by nearly everyone I spoke with.) Richard told me,

> Sometime in the early 1970s, Kot invited Czapski over. The two of them huddled together in Kot's smoke-filled office on the third floor, where he worked and received behind closed doors. Czapski was extremely courteous, extremely warm, out of a place and time very far from my own. Renowned for his ability to bridge disparate, far-flung worlds, Kot raked the common ground exquisitely in his few words of introduction and made my meeting with Czapski an intimate occasion. Over the years I saw him with Kot on many occasions; he frequently came for lunch. His conversation was always spiced with very racy gossip. He could channel Proust effortlessly, but went zinging along very much in his own register.

On my behalf, Richard telephoned Wojciech Karpiński, a Polish critic who had known Czapski very well, and arranged a meeting. Karpiński owned several Czapski paintings and had written a book about him. A few days later, Richard and I made our way to an address near Place d'Italie. A short, round-faced man in his late sixties with a halo of close-cropped gray hair, Karpiński welcomed us at the door of his apartment and led us down a long book-lined hallway to a living room laden with more books. Richard presented me as someone with an interest in writing about Czapski. Karpiński, who asked me to call him Wojtek, posed a few direct questions, then spoke feelingly about Czapski. He was encouraged to learn that I, as a painter, had been so attracted to what I could find of Czapski's paintings. He also seemed to appreciate the disclosure I felt compelled to make of my limitations for undertaking this endeavor. He smiled and nodded, then probed. We both hid behind our polite conversational French, sizing up each other.

Somewhat abruptly, Richard, who had been rifling through some catalogues, switched subjects and began to speak with Karpiński about a long-standing project involving the estate of Kot Jeleński, who had died in 1987. I withdrew slightly, pushing back in my chair, letting my eyes wander, making a closer survey of the contents of the room. Postcards from museum collections around the world were propped on bookshelves here and there, bearing details of portraits spanning the history of art from Fayum mummies to David Hockney. On one wall, I recognized a large marine landscape by Rainer Fetting. On another wall, framed by an open doorway, lit from above, a luminous oil painting hung, radiating color and warmth. Instinctively I knew that it was a Czapski canvas, the first I had ever seen. As unobtrusively as possible, I rose and made my way over to it.

Taking in a new picture, I tend to follow a set routine. First, I like to assess the whole image from the distance of a few feet. Then I move in very close for an exploration of the surface and an investigation of details. I pull back to arm's length to reconcile what I've found from near and far, and, finally, I like to move away again and view the picture from across the room. This habitual choreography of looking—in, in closer, then back, farther back—includes the same steps I'm usually unaware of making as I paint, seeking the same shifting perspective, an examination of the whole followed by an isolated focus on details. I almost always find something I have not seen before, or some detail to which I have paid insufficient attention. After a while I move in, then back out, in and back out again, as a new visualization of the work in progress slowly coalesces and is freshly imprinted on my mind. I carry this image with me, calling it forth from memory as needed. When away from a painting in progress (often in bed, roused from sleep in the middle of the night), I sense the emergence of a passage presenting itself in my mind's eye, and I can work on it mentally, much as one figures out the next move in an ongoing chess game, until I am back in the studio, brushes in hand.

Here is what I found on Karpiński's wall (plate 1): A painting of a dark-haired young man wearing a short-sleeved white shirt and black pants, seen from behind. He's captured in the process of looking at a long, horizontal abstract painting hung on a yellow wall. Placing himself squarely in front of the picture, he has planted his feet like a dancer in second position, his hands are clasped behind his back and his head is cocked slightly to the left. That's the whole image—the back of a male figure in the act of studying a painting. The contours of the man's form are indistinct; he is composed of three colors,

each used to delineate separate parts of his body. A black splotch indicates the back of his head and thick black brushstrokes define his legs and feet. A pink-orange coral color is used for the exposed flesh at the back of his neck, the back of his forearms, and his hands. At the center of the canvas, the rest of his body—his torso and upper arms—is constructed out of a large unpainted oval shape, representing his white shirt. A few crudely painted thin black lines, like the tines of a rake, suggest clutched fingers at the small of his back, executed with the panache and abandon of late-period Frans Hals.

The painting the young man is lost in contemplation of—the painting within a painting—has an underlying field of pale, muddy yellow and a series of darker boxlike forms stretching horizontally across its middle and upper axes. One cerulean blue square is rendered with a more gestural, viscous application of color than the other sections, which are gray and less articulated, their colors mixed directly on the canvas. A dry thin brush loaded with black pigment has inscribed a scumbled line indicating the perimeter of the painting on display before him. Czapski subverts the abstraction's understated palette by drenching the gallery wall on which the picture hangs in bright canary yellow. This yellow has been brushed on quickly, knowingly, a bravura outburst of radiant color. The background paint drips in several places toward the bottom of the picture, where the gallery wall meets the floor, whose orange-pink color (mixed from the same pigments as those used for the young man's flesh with a touch of white added) is loosely brushed on over the trails of yellow paint. Muffled patches of unpainted canvas show through in several spots, infusing the picture with spasmodic points of light, providing a sort of "pictorial breath," a phrase Czapski uses to describe a quality he admires in painting. These patches are a by-product of ecstatic brushwork, negative spaces giving off light equal in intensity to the colors laid down. The temptation to paint over the unpainted canvas is held in check by the knowledge that once covered, there is no going back, the state of uncoveredness cannot be restored. Czapski is aware that the image would be far less luminous without the contribution of these bald spots.

Only twenty-four inches tall and eighteen inches wide, the small canvas projects a very large presence. Though Czapski was eighty-five when he painted it, the picture, with its saturated cadmium yellow light, pulsates like a young child's crayon drawing of the sun. The cumulative work of less than an hour, it may well have taken Czapski the better part of a day to realize the picture fully, or even as long as a week, pacing himself, gradually putting all the little

touches into place, holding back out of fear of making a wrong move and spoiling the freshness. Or it might all have fallen together in one swift go, a miraculous morning's work. How long it took hardly matters. Every painting, no matter how slowly or rapidly realized, is always an outpouring of the artist's whole painting history up to that moment. This is the answer to the perennial query put to all painters, "How long did it take you to do that?"

Looking at a painting of someone looking at a painting, I began to feel a little self-conscious, but that strangeness was rather quickly overcome by the picture's more dynamic force pulling me out of myself, drawing me back to it. I was reminded of the Homeric and Shakespearean trope of the "story within a story," the "play within a play," by which the fiction of an inner plot is used to reveal the truth of an outer one. A similar phenomenon can be found manifested visually throughout the history of painting. Lost in reverie before the Czapski, I could feel my head fill with an early eighteenth-century image, *Gersaint's Shopsign* by Antoine Watteau, in which the act of looking at a painting of people looking at a painting is raised to a nearly voyeuristic thrill. I was fairly confident that the painting within a painting in the small Czapski canvas was a work by Nicolas de Staël, a French painter of Russian origins whose work I associate with the midcentury Paris art scene. (Later I would confirm that the work is Staël's 1950 *Composition in Gray and Blue*.) Czapski's saturation of pure color, his handling of paint, and the skillful reduction of forms also brought to mind the paintings of Milton Avery. Watteau and Avery evoked in a single canvas? I was intrigued and smitten.

In the process of attempting to validate Czapski as a painter so far, I had been disappointed by his work I had seen in reproduction, able to discern only a rudimentary skill in the handling of paint and what seemed a consistent arbitrariness of resolution. I had been drawn to a certain freshness and boldness of subject matter and composition, but was unable to determine the quality of the paintings' surfaces. In front of this small, bright yellow canvas, those perceived shortcomings evaporated. Before me I had proof of Czapski's mettle as a painter.

When, much later, I came upon a series of his drawings of works by the eighteenth-century sculptor Aleijadinho, I recognized them immediately as studies that could only have been made at a compound of baroque religious shrines in the municipality of Congonhas do Campo, in the Brazilian state of Minas Gerais. Traces of my own drawings of the same monumental group of soapstone sculptures seemed embedded in Czapski's nearly expressionistic

sketches. The arresting combination of crudeness and sanctity in Aleijadinho's figures had made a powerful impression on me; these very qualities would also appeal to me in Czapski's paintings. This unforgettable array of towering sculptures of Old Testament prophets is little known in Paris or New York, their maker routinely overlooked in the chronicles of art history. It was uncanny to discover that Czapski and I had once stood, half a century apart, eyes alert, pencil in hand, in the same spot in the remotest of locations. It is a rare privilege to be exposed to unsung work of such enormous power and presence, to engage with it through eyes unfiltered by preexisting judgments. On an extended visit to South America, Czapski found his way to Congonhas, to Aleijadinho. On my own, I found my way there, too, and then, years later, I would find my way to Czapski; a curious overlap of sensibility and experience threads its way throughout this story of his life and work.

What is it that continues to make such a powerful impression on me in his paintings and drawings? At first I found their success questionable, their overall achievement limited. This book is a testimony to having decided otherwise. During the run of an exhibition of his paintings in Warsaw, Czapski was interviewed by a newspaper reporter who found his subject matter strange: "Lonely people, deserted café tables, faces half-concealed in the metro, minute daily events glimpsed in passing." Seemingly negligible objects "like a bedside table with a single piece of string on it" were cited. Called on to justify such inconsequential presences, Czapski replied, "Each time, it is almost nothing. But that 'almost nothing' signifies everything."

His accomplishment is nearly unclassifiable. An entry in Czapski's journal describes the results of a few days devoted to drawing a variety of flowers. He records his frustration at having only feebly managed to capture something of their vitality.

> As you draw, you feel each line conveyed on the paper as something living, irrevocable, and suddenly the drawing comes to life.... Two drawings of some tulips—done in a single go—seemed to me suddenly to come alive. Why? Because I felt them as I was drawing them, I felt linked to them by my awkward, hesitant, slightly distorted drawing, as if there was no break between the end of my pencil and myself. I was at the end of my pencil.

It is my hope to bring Czapski to life in the way he describes drawing these tulips. He and I meet at the end of my pencil.

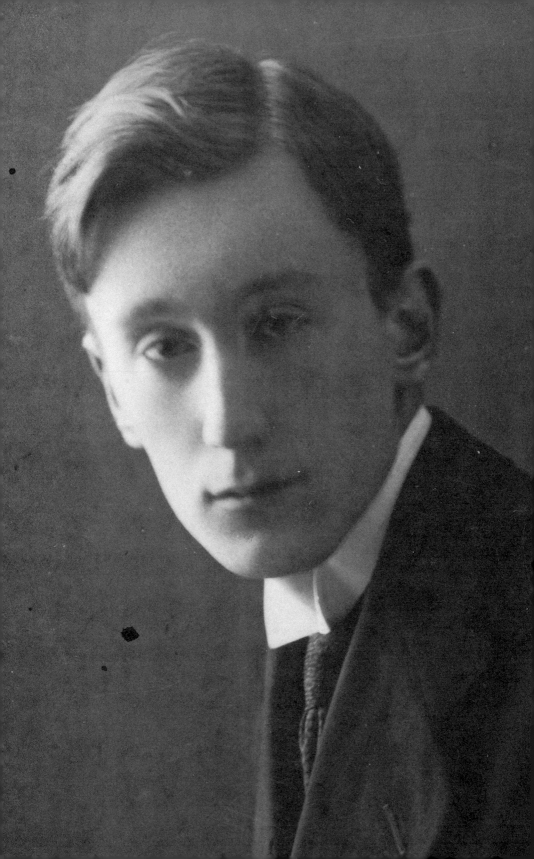

"I *became* a painter"

1896–1939

1

He was born into a life of great privilege. As recorded on a birth certificate dated April 3, 1896, his name in full reads Józef Maria Emeryk Franciszek Ignacy hrabia Hutten-Czapski, "hrabia" indicating the family's hereditary aristocratic title. Playing the part of Count Hutten-Czapski would never appeal to him, and throughout his life he remained leery of those who addressed him in such terms. One friend, the Polish critic Konstanty Jeleński, summarized the cosmopolitan Czapski family history in this way:

> One found among them Austrians who were Czech patriots, German protestants fiercely loyal to Russia. The Polish Czapskis were faithful subjects of the tsar until the day the daughter of a prince of the Roman Empire of the German nation converted them to Polish patriots. His uncles were friends of Mickiewicz and de Tocqueville, and enemies of Bismarck; his aunts were students of Chopin. One cousin was the owner of the castle at Duino, immortalized in the *Elegies* by Rilke; a Stackelberg relative was the chief "protector" of Marie Duplessis, the model for *La Dame aux Camélias*.

The roots of his family tree spread across a wide spectrum of nationalities, cultures, and political beliefs. Baron Alexander von Meyendorff, his uncle, was at home in the intimate circle of Tsar Nicholas II and served as the Russian ambassador to London. His Marxist revolutionary cousin, Georgy V. Chicherin, a close collaborator with Vladimir I. Lenin, became the first Soviet minister of foreign affairs after Leon Trotsky in 1918. Czapski loved to tell the story of his aunt Maria Pusłowska's fury as armed insurgents confiscated everything she kept under lock and key in her bank vault when the Bolsheviks seized power in Saint Petersburg. Forcing her way into her cousin Chicherin's office, she demanded he intervene on her behalf for the return of her jewels. He categorically refused. In a sweeping gesture, she seized piles of classified documents from his desk: "You've stolen my diamonds," she cried triumphantly, "I'm taking your files!" Reclaiming the materials, he showed her out

of his office. "I can only pray to God that you come to your senses," she yelled, before slamming the door behind her. Chicherin, unwilling to grant her the last word, opened the door and shouted after her, "I consider your god to be nonexistent."

Czapski's father, Jerzy Hutten-Czapski, was raised in Saint Petersburg speaking French, Russian, and German. A Polish count, he learned to speak Polish only as a university student. His father, Count Emeryk Hutten-Czapski, Józef's grandfather, claimed he had wanted "to make Greeks or Romans" of his boys. Serving in the Russian civil service, he married a Baltic German countess and became a renowned collector of ancient coins, armor, and textiles.

Czapski's mother, Józefa Czapska, was born Countess Josephine von Thun und Hohenstein. Her eldest brother, Count Franz Anton von Thun und Hohenstein—tall, thin, immaculately dressed—was, for a time, the prime minister of the Austrian government. He made the gift of a chestnut pony to celebrate the arrival of his sister's firstborn son, his nephew Józef. The unruly animal repeatedly unseated the boy, who eventually grew fearful of it. Inadvertently, Count Thun was also the source of anxiety for another sensitive being, a Jewish doctor, whose run-in with the minister yielded a more noteworthy outcome: unexpectedly commanded by Emperor Franz Joseph to appear in Bad Ischl, where the Habsburg court took up residence in the summer months, Count Thun left his office and made his way to the Westbahnhof station in Vienna. Brushing aside the conductor, he boarded the train without a ticket in hand, located a vacant first-class compartment, and shut the door behind him. Another traveler on the platform, observing the prime minister's behavior, began to feel indignant. Having paid a first-class fare, he found that his accommodation, unlike the one Count Thun commandeered, came with no toilet facilities en suite. Rebuffed by this display of entitlement, the traveler—Dr. Sigmund Freud—felt powerless to assert himself. Aboard the train that night he had a disturbing dream that he went on to analyze thoroughly the following morning. Józef Czapski's uncle would appear in the pages of *The Interpretation of Dreams* as a symbol of arrogance and power, a catalyst for Freud's deep feelings of impotence and resentment. Aware that others from this same family had been ministers of culture and advocates for educational reform, the psychoanalyst's chance encounter with Count Thun left in its wake a lingering sense of alienation and an awareness of the irreconcilable natures of political thought and analytic insight. Czapski inherited neither the imperiousness nor the inbred anti-Semitism of his uncle Franz but would

follow directly in the footsteps of his maternal family's dedication to public service.

Czapski was descended from various noble houses—Baltic, Austrian, Russian—with a smattering of Polish ancestry. He was born in Prague, just below the Castle, in a Thun family palace, home today to the Italian embassy. The nursery windows were cast in shadow by the wing of a huge sculpted eagle perched right above the palace's entrance gate. Both sets of his grandparents were wealthy landowners, part of a sophisticated high society traveling freely between Saint Petersburg and Paris, visiting spas in Germany, attending Holy Week festivals in Rome. Their children were raised by Polish, French, and German governesses, tutors, fencing instructors, music teachers. Priests were on the payroll as religious models for the children. Czapski's mother had six brothers and five sisters, all of whom married into other similarly aristocratic households. She had grown up speaking German and French but began to learn Polish when she was twelve, choosing to take up the cause of a beleaguered people she saw as worthy of a greater respect. Marrying Jerzy Hutten-Czapski, she taught her seven children Polish patriotic songs.

Czapski and his siblings—Leopoldyna, Elżbieta, Karolina, Maria, Stanisław, and Róża—were raised at Przyłuki, a large manor house and property near Minsk, in what is now Belarus. They were all under the care of a nanny, Konstancja Jakubowska, a warmhearted woman they called "Babuśka." It was by no means a foregone conclusion that these children—known affectionately as Poldzia, Lila, Karla, Marynia, Józio, Staś, and Róża—would necessarily identify themselves as Poles. It was their Austrian mother's influence that favorably disposed the young Czapskis to the Polish heritage of their father's family. "Who am I? I'm a little Pole," the countess taught each of her children to declaim. Open-mindedness about nationality was not necessarily an indication of a more general liberality on their mother's part. A rigorous and devout Catholic, Countess Hutten-Czapska refused to have non-Catholics in her domestic domain. At Przyłuki, where most of the servants and laborers were Russian Orthodox, her intractability caused serious complications. As her elder son, Józef understood early on that maintaining devout behavior could keep him in her good graces. Craving her love and fearing her reproof, he would always acknowledge her powerful presence in the realm of his religious life.

Her direct influence on his upbringing was short-lived, however. Czapski was only six when his mother died. She developed a severe case of appendicitis during the final weeks of the pregnancy of her eighth child. A daughter, Teresa,

was born prematurely and did not survive. After much deliberation, an emergency operation to address the countess's life-threatening condition came too late to save her. The experience of losing his mother so suddenly marked Józef quite deeply. Though strict and formidable, she had represented safety and unconditional love. Uncomprehending, he did not cry at her funeral, but something of her spirit lodged in his heart, and he carried his affection for her with him ever after.

The children chose to consider themselves Polish patriots as a way of honoring their mother's enthusiasm for her adopted homeland. Their paternal grandmother failed to appreciate this sentiment, seeing herself as far too worldly to rally her loyalties under any single national flag. A Baltic German baroness who had danced with the sons of Tsar Nicholas I at court balls in Saint Petersburg, she had always found her daughter-in-law's dominion at Przyłuki too severely Catholic for her liking. Czapski liked to quote his grandmother saying about herself that she was "too Catholic to be Protestant and too Protestant to be Catholic." Bound together in their own little world, the Czapski children, rather extraordinarily, began to preach a kind of humanitarian socialism on the family estate in an attempt to educate the agricultural peasants. They held meetings for the workers at which progressive tracts were read aloud; weaving and sculpture lessons were offered; magic-lantern shows were presented. These activities annoyed their father and disconcerted their grandmother because, under the young people's tutelage, the field hands no longer felt the need to raise their hats to her as she rode by.

Daily life was self-contained, cut off from the rest of the world, even though railway lines linking Paris, Berlin, and Warsaw ran within a few miles of the estate. Everything the family needed was at hand. Czapski's friend Jerzy Stempowski, whose upbringing was quite similar, recounted his memory of a trip made as a boy with his father to the Russian sector of partitioned Poland, between the Black Sea and the Baltic Sea, an area much like the region where Przyłuki was situated:

> Shaffnagel's store was located on the main street of Berdichev. Here, the local nobility came for its pepper, vanilla, ginger, and an assortment of other colonial products, especially for family holidays and just before Christmas. A mixture of all sorts of vehicles stood in front of the store (each representing a different standard of living). Among them gathered a small group of people speaking vividly to one another. This street and this shop were the primary meeting place

and the source for news for everyone scattered all across the countryside— nobility, landlords, clerks. When I was there, I heard fragments of conversations—about the party at Aunt Teresa's, about the baptism of young Kaprucki, about how someone was trying to buy four horses and what happened because of that. In a quieter voice, news brought by someone from Petersburg and someone from Warsaw was shared. Information about the price of corn was also shared, brought from Odessa by the merchants. The Jewish ghetto in Berdichev was a source of much far-flung information, too, coming from families many people had in New York and Buenos Aires.... Important worries did not trouble any of them, beyond the reality of paying their debts. Their "historical consciousness," as the Germans would call it, was asleep. They were living in peace, far away from the mainstream of current events, which would bring great change.

Beyond the supreme loss of their mother, the Czapski children were happy during these years. Józef's relationship with his baroness grandmother was loving and rewarding, but his beloved Babuśka was the single most important figure in his life. Overseeing their day-to-day upbringing with great kindness and tact, she instilled a sense of discipline in all of them. Mealtime was always a stimulant; with tutors and governesses, they were regularly fifteen or twenty at table. Music played a large part in the life of the family. Józef devoted long hours to piano practice. They would ride for three hours in a carriage to a neighboring property whenever the celebrated pianist and Polish statesman Jan Paderewski visited and gave recitals. Czapski heard the prodigy Jascha Heifetz play when both of them were boys, and maintained friendly relations with pianist Artur Rubinstein throughout most of their long lives. Music elicited some of Czapski's first inklings of exaltation and misery:

> The first real concert of my life. At Houlgate in Normandy, at the Casino. I was already twelve years old. A German singer, a soprano, gave an evening of *Lieder*. Never afterward would I anticipate the prospect of a concert with so much feverish expectation. And I've always retained the memory of a curious torment that kept me from enjoying it; from the first moment I was aware of time passing—already a quarter, half, three-quarters—and soon it was over. The long-awaited happiness had been completely poisoned.

His budding artistic sensibility, preternaturally alert to the relationship between beauty and the passage of time, might be called "proto-Proustian."

Curiously, Proust would begin to write *À la recherche du temps perdu* in the same year as Czapski's first concert.

Following a long-established aristocratic tradition of sending young sons away from home for study, the Czapski brothers were sent to Saint Petersburg to live with a tutor. Although their childhood home was situated in the Russian sector of partitioned Poland, Russian was spoken only with servants, low-ranking officials, and workers in the field. In expectation of future careers in law, Józef and his younger brother, Stanisław, needed to develop a greater familiarity with the Russian language in order to be able to pass the baccalaureate examinations. Leaving behind the family estate, with its leisurely pace of life and privileged status, the boys could not have known that the world of Przyłuki, so substantial and correct, was doomed.

They adapted well in Saint Petersburg given that their material conditions were considerably reduced in comparison to the comforts back home. They were cloistered in their unsophisticated tutor's modest home, working diligently at their studies in a school where their classmates were the sons of concierges and servants, far from the world of "grand dukes and Nijinsky" as some friends later imagined. Józef devoted four or five hours a day after school to practicing the piano, dreaming of a concert career. The icy cold of the north intensified ongoing difficulties with his delicate lungs. Recuperating from periodic bouts of weak and labored breathing, he would plunge into books, giving himself over to their power. His first real immersion in serious reading was sparked by a set of books offered to him on his sickbed, the novels of Jules Verne in Russian translation. His aunt Sofiya Chicherin, the sister of the future Soviet foreign affairs minister Georgy Chicherin, read aloud to him from the stories and novels of Ivan Turgenev and, even more significantly, from the works of Lev Tolstoy, the novelist, moralist and social radical. Under the influence of Tolstoy's writings, young Czapski would come to shape his idea of who he wanted to be in the world. Nothing in his upbringing had prepared him for the power of such writing. He liked to recall that when he first read *The Kreutzer Sonata* he broke into a sweat. Above all, Tolstoy's insistence that one not oppose evil by engaging in violence made a profound impression.

After five long years of subservience to an irksome tutor, Czapski passed his baccalaureate exams and entered the Imperial University. He began to study law. Treated as an adult for the first time in his life, he moved into the elegant town house of his uncle Meyendorff, who, with no children of his

own, loved him tenderly. A paragon of reason and intelligence, Baron Mey-endorff was a powerful role model for Czapski. An advocate for religious tolerance and the rights of minority populations, he sat in the Russian legis-lative assembly, the Duma. Raised in Weimar, an intimate friend of Franz Liszt and Richard Wagner, he filled his Saint Petersburg home with music. With much gratitude, Józef settled into a real home life.

The outbreak of the First World War would soon overturn this comfortable domestic scene. Czapski's first year of university life was wildly disrupted, the measured flow of learning repeatedly undermined by demonstrations. Once Russian armies attacked Prussia in August 1914, Saint Petersburg was renamed Petrograd, a less Germanic-sounding name. (Ten years later the name of the city would be changed again, to Leningrad.) The war dragged on. Sentiment against the tsar intensified. Political parties criticized the regime for its inept handling of the war and workers went on strike. After years of fearing for the future of his young sons, Jerzy Czapski enrolled them in the Russian Empire's most prestigious military academy with the hope of postponing their imme-diate induction into the Russian army and their dispatch to the front. It was hoped too that Józef's fragile health, his chronic bronchitis, and the threat of tuberculosis might stave off conscription. The boys entered the academy known as the Corps des Pages in January 1917.

The February revolution erupted spontaneously. Mounting economic and social demands, compounded by the ongoing strain of war, led to a breakdown of order. Under no particular leadership, industrial workers on strike joined forces with people in breadlines and disaffected soldiers. Chaos resulted. "I sur-vived the February revolution," Czapski later wrote:

> During the white nights, in a city full of tremendous hopes and upheavals, where there was no milk or sugar, the squares were full with crowds of people from all walks of life, all night long, until morning. For hours, quietly, in groups, with passionate intensity, they discussed the existence or nonexistence of God, the honesty or dishonesty of possessing any form of property, the brotherhood of people, the destruction of borders, and a new kind of justice. The president of the Soviet of Workers' and Soldiers' Deputies, newly released from a tsarist prison, published a manifesto urging soldiers on all fronts to lay down their arms and, among the heaps of war corpses, to become brothers. For many months I carried around with me a printed scrap of this manifesto.

In March the tsar abdicated and the academy was quickly transformed into an officer-training school. Graduating in September, Czapski was made a cavalry officer of the First Regiment of Uhlans. Within weeks the October Revolution began with an armed insurrection. Sent out on his first combat duty against the Bolshevik forces, he recoiled. The experience horrified him. Operating under the active influence of Tolstoyan pacifism, he approached his commanding officer and reported that he was incapable of discharging a gun to kill another man. Assuming he would face a court-martial and very likely be shot as a deserter, he claimed he was ready to sacrifice himself on behalf of his anti-militaristic beliefs. The chief of his division listened to the young soldier's outburst, then, remarkably, told him he was sure Czapski's convictions and intentions were pure. "When I was young," he reassured the twenty-one-year-old cadet, "I also wanted to change the world. Go. Try." This surprising acceptance of clearly treasonous behavior must be seen in the light of Czapski's aristocratic title, his bearing, and the power of his family name. In *La Grande Illusion*, Jean Renoir's 1937 film set during the First World War, a German baron, overseer of a camp of French prisoners of war, shoots an enemy plane out of the sky. Learning that the pilot pulled from the wreckage is as highborn as he, the German commandant lavishly entertains the French officer in his rooms as an equal. Pedigree transcends nationality, even in wartime; the two princely figures take far more comfort with each other than they are capable of finding in the company of other men of their own armies. Honor among noblemen no doubt spared young Czapski from more severely punitive measures.

Leaving his regimental company in January 1918, he joined forces with two friends, the Marylski brothers, Antoni and Edward. They combined their respective resources in an attempt to contribute in some small way to the needs of a traumatized populace, guided by the Gospel and the anti-militaristic precepts of Tolstoy. They were assisted by Czapski's sisters Karla and Marynia, who had come to Petrograd to live with their brothers. Czapski set up a makeshift shelter in the center of Petrograd with the blessing of their uncle Georgy Chicherin. Their five ration cards, entitling each bearer to one hunk of bread a week, were pooled for the common good. Czapski put himself in charge of gathering supplies in the early morning hours as peasants brought precious potatoes and milk into the city from the outlying farms. Demand was so great he often returned empty-handed. Before long, milk disappeared entirely from commerce. Soon the bright-eyed youngsters could barely keep their own star-

vation at bay, let alone offer aid to others. Despite their best intentions and a willingness to work hard, their plan collapsed as anarchy took hold in the city five months later. Famine spread. Urban transportation was paralyzed. In May 1918, the group of young idealists returned to their native land, their hopes crushed.

With only some early high-school drawing classes to his credit, Józef began a course of studies at the Academy of Fine Arts in Warsaw. In a flash of conviction and determination, he decided to become a painter. Six months later, at "the eleventh hour of the eleventh day of the eleventh month," the old world collapsed in on itself. Three great empires that had suppressed independent political life in Poland for more than one hundred years—Austria-Hungary, Prussia, and tsarist Russia—ceased to exist. The Second Polish Republic was jubilantly declared. In his excitement, Czapski abandoned his course of studies and, though groomed as an officer, enlisted as a private in the newly reconfigured Polish army, under terms that permitted him noncombatant status. On November 14, 1918, three days after the armistice with Germany ended the First World War, Polish authorities reclaimed possession of their railway system. That same day, twenty-two-year-old Private Józef Czapski was handed a newly minted diplomatic passport and, in consideration of his fluent Russian, assigned a special task by his new commander. His mission was to locate five officers from the Polish First Lancers: Captains Bronisław de Romer and Maciej Starzeński and three of their aides-de-camp, all of whom had disappeared in Russia. Entrusted with a remarkably large sum of cash to purchase their freedom if need be, he boarded a train bound for Petrograd. Czapski's account of his adventures reads like the makings of a picaresque novel:

> At the station at Biała the commander of the train told me that I could travel no farther, Białystok was in the hands of the Germans and no trains were running in that direction. It seemed possible to cross the border only by way of Kiev. After a moment's hesitation I resolved to continue my journey by any means imaginable.
>
> The same day, a vast number of Russian prisoners coming from Germany arrived in Biała. Their gruff Bolshevik bearing and faces ravaged by misery seemed to augur badly. The commander decided to send them as far as Białystok, halfway by train, halfway on foot. I jumped at the chance and attached myself to the convoy, but, seeing the huge number of prisoners, I hopped onto the locomotive. The train departed at midnight under frigid conditions....

As we were nearing our point of debarkation, the locomotive broke down. Immediately, the train was surrounded by German soldiers who made us all descend from the train. Several railway employees whom I had befriended demanded they be able to leave immediately for Białystok. My knowledge of German made a favorable impression, and I was granted the right to board a train that was serving as transport for a squad of German soldiers. I noticed that what had transpired in Berlin made little impression on them; the officers still wore imperial rosettes on their caps and their underlings were submissive. They were animated by a fierce irritation toward Polish troops who had dared to chase Germans and who, according to them, were going to reclaim Białystok. When we arrived at Białystok, we were told that trains were running no farther because of peasant riots in the surrounding area. Finally, the next night, surrounded again by Russian prisoners, billeted in a fourth-class wagon, I left for Vilna, where I arrived at noon the following day.... That same night I continued my voyage via Minsk, Dvinsk, and by Polotsk (Polatsk). In Dvinsk I spoke with some officers of the White Guard. According to them, the Bolshevik terror was at an end, the English were about to arrive, and in a few days the White Guard would march on Petrograd with a great army and thirty million rubles in their possession. I carried on my itinerary, convinced that in a few days Petrograd would be in the hands of the White Guard.

Things unfolded rather differently.

The new Bolshevik government was in the process of shifting its base of power from Petrograd to Moscow as Czapski made his way from office to office investigating the disappearance of the five Polish officers. After weeks, his persistence was rewarded when he secured a meeting with one member of the ruling triumvirate of "the Commune of the North." Elena Stasova, often referred to as "the conscience of the Russian Revolution," was sitting at her desk under portraits of Lenin and Marx, "a well-bred woman of a certain age with a long face, wearing an old sweater and steel-rimmed glasses." Listening to Czapski describe his orders to find the missing officers, she offered her help. A series of meetings ensued over a period of days. Finally, Stasova was able to inform him that the men he sought were all dead, having been executed in a small village near the Finnish border. A Red Army tribunal had pronounced their intentions counterrevolutionary, and they had paid with their lives. Sensitive to the impact of such news on so impressionable an emissary, Stasova was patient with Czapski. He audaciously challenged the legitimacy of her

party and their means. Taking the time to speak to him seriously and thoughtfully, she emphasized her hopes for the future of the Soviet system. "Come back in twenty years," she encouraged him, "and see what progress we will have made."

Czapski would return to Russia. "Twenty years later," he wrote, "I entered Russia in a prison car."

Details in hand confirming the fate of the missing men, he lingered restlessly in Petrograd. His return voyage to Warsaw was repeatedly assured by the authorities, then repeatedly denied. This limbo continued for days. He wandered about the city, observing violent behavior and acts of terror as the Bolshevik system imposed itself. His delayed departure resulted in an unexpected turn of events: Czapski encountered a group of thinkers who would make an indelible mark on his early intellectual development. Waiting for permission to depart the city, he called on a friend who lived in an apartment on Sergievskaya Street. On the door of another apartment in the same building, he spotted the name Dmitry Merezhkovsky. One of Russia's most prominent living writers, Merezhkovsky was the author of *The Romance of Leonardo da Vinci*, an exploration of how Renaissance humanism had taken root and flowered in the soil of barbarism from the Middle Ages. Recognizing the name, Czapski impulsively rang the doorbell. A short man with light-colored eyes and a dark goatee and wearing a fur-trimmed velvet cape opened the door. Czapski would soon learn the cape belonged to Merezhkovsky's wife but he wore it because the apartment was so cold. The young Polish soldier was invited to enter; Czapski would always derive great pleasure from the ease with which Russians welcome new acquaintances. Prompted by an appreciation of Merezhkovsky's writings on the subject of faith, he blurted out that he was a disciple of Tolstoy and was against killing as a means of combating evil. His heart was numbed by what he had seen in the past few years in Russia; his innate pacifism was called into question by the brutality he had witnessed. How was it possible to maintain his beliefs when so many around him were being killed? How could the spirit of the Gospel be reconciled with the violence of war?

Merezhkovsky, calling to his wife to join them, listened thoughtfully to the stranger's distress and calmed him with words that helped to soothe and counsel. "You are a Christian," Czapski would recall him saying, "and killing is obviously a sin, yet you must remember you are not alone but make up a part of history, of world events. You must bear your portion of this sin and fight

for a better world." Merezhkovsky then recounted the parable of the saints Cassian and Nicholas:

> The two men were walking along a muddy highway dressed in white gowns, on their way to heaven. They came upon a peasant who asked for their help, his ox and cart had gotten bogged down. Cassian continued to walk on but Nicholas ran to help the peasant, and, in so doing, soiled his white robe. Arriving in heaven, Saint Peter led them to judgment. The Lord said to Cassian: *Your garments are immaculate; your feast will be celebrated once every four years.* To Nicholas he said: *You have disregarded your white robe in order to help your neighbor; your feast will be celebrated four times a year.*

The story struck home. Czapski understood that his footsteps would follow the path of Saint Nicholas.

Merezhkovsky and his wife, the symbolist poet Zinaida Gippius, opened their home and hosted him for several days and nights. Czapski would later claim that they had effectively "cured" him of Christian extremism and freed him from a state of moral paralysis. Merezhkovsky "created his own world for himself, where much was lacking," chronicler Nina Berberova wrote, "but the indispensable was always present." Gippius, Merezhkovsky, and their intimate friend and fellow writer Dmitry Filosofov were a formidable presence in the world of Russian literature. The three had first bonded as anti-tsarists following the Revolution of 1905, then as anti-Bolsheviks after the October Revolution in 1917. Hoping to negotiate a reconciliation between Roman Catholicism and Russian Orthodoxy, they believed in a "third Russia," a democratic Russia, neither Bolshevik nor tsarist. Their dream—to bring the intelligentsia and the church together in a freely flowing union of intellect and faith—spoke directly to Czapski at a critical juncture in his young life. They armed the young man with an arsenal of reading material: Fyodor Dostoyevsky, Friedrich Nietzsche, and the Russian philosopher Vasily Rozanov topped the pile. Plunging into a period of intense study over the coming months, Czapski found his mind was unburdened, and a long-standing internal stalemate was resolved. The immersion in ethics and passionate thinking helped free him to become the man he wanted to be. The impulse to knock at a door bearing the name of an admired writer led to a rare advancement in the formation of his character and emboldened him to trust such unpremeditated gestures.

Finally granted permission to leave Petrograd on January 22, 1919, he

returned to Warsaw. After reporting his findings to his superiors, he resumed his training at the Academy of Fine Arts in Warsaw. But the clouds of war gathered once more, and his studies were again disrupted. Following the armistice, both Poland and Soviet Russia (the Union of Soviet Socialist Republics had not yet been formed) sought to expand into the void created by the withdrawal of German imperial forces. The Soviets planned an elaborate westward offensive aimed at inciting a communist revolution in crumbling postwar Germany. The Second Polish Republic's newly emerged sovereignty was threatened by Lenin, who viewed Poland as merely the bridge the Red Army needed to cross in order to seize control of all of decadent Western Europe. Early in 1919, hostilities erupted between the Poles and Soviets as Red Army soldiers streamed across the border. By the summer of 1920, the outcome seemed dire for Poland, the troops having made their way nearly to Warsaw. In the middle of August, against all odds, Polish divisions scored a decisive victory, in part because of the insubordination of a leader of the Soviet's Southwestern Front. Set on waging war on his own terms, the officer ignored orders from his superiors to reinforce the exposed flank of his neighboring Western Front. In the interim, the Poles exploited the vulnerability, ripping through the gap between the two armies, forcing the fragmented Soviet formations eastward in retreat. The Polish army pursued the invading hordes and successfully repelled the splintered groups, eliminating one completely, injuring and dispersing three others.

The Red Army's capitulation, the "Bolshevik debacle," left the politburo severely chastened. As a direct result of this humiliating defeat, Lenin's strategy of fomenting international communist revolution amid the ruins of Europe was abandoned. The Soviets were reduced to offering territorial concessions to a "bourgeois Poland" when the Treaty of Riga was signed. This disgrace would leave a lingering appetite for vengeance in the mind of the officer of the Southwestern Front who had led his men to defeat: Joseph Vissarionovich Stalin.

Czapski was an active participant in these events, having left the Academy of Fine Arts to reenlist in the Polish army. In downtown Warsaw, the sculptor August Zamoyski saw his former military cadet, later pacifist friend in the uniform of the First Lancers and called out, "Józio, you change your mind like your gloves!" Czapski desperately wanted to be of service to his country and help in its defense. During mandatory training, he struck up a friendship with one of his instructors, a French adviser to the Polish army. Young Charles de Gaulle had been dispatched to Warsaw to gain firsthand experience of current

39

tactics in making war; he would make strategic use of what he observed on the front lines of this war when leading French fighting forces in the next war. Both men would receive Poland's highest decoration for heroism, the Virtuti Militari. Czapski was singled out for bravery.

Several times my quest for Czapski took me to Poland. On one trip I stumbled on a pencil study of his, a self-portrait of a young man near twenty, made at the time he was a cadet at the Corps des Pages, just before the abdication of Tsar Nicholas II. He shows himself in uniform, standing in profile, lost in thought, looking down. His very square chin is held in toward his chest, his left hand propped on his hip, left thumb tucked under a belt cinched around his waist. A braided sash draped diagonally across his chest accentuates the contour of his thin body under his tunic. The gear is standard late-nineteenth-, early-twentieth-century army issue, including baggy jodhpurs and knee-high boots, a jacket with round brass buttons, epaulets, and a stiff high collar. Except for a light gray smudge to indicate hair, no shading is used; the effect is purely linear. Each line is confident and clear, all the details are rendered simply but distinctly, the pencil's lyrical touch very much in the neoclassicist style Picasso would adopt at the end of the war after his first trip to Italy. The drawing comments wryly on the artist's youth—he presents himself as a serious figure, a man of the world, ruminating, sartorially comme il faut, but a boyish, irre-pressible cowlick erupts at the top of his profiled head, undermining the gravi-tas of his quasi-military pose. About ten inches in height, with no square corners, the sheet is a vertical strip of paper torn from a bound album.

After my first visit to Poland, word began to spread of an American painter inquiring about Czapski's work and life. When I returned six months later, a core group of Czapski aficionados—close-knit, protective, but curious about my curiosity—reached out to me. A chain of introductions was established to numerous blood relatives of his and to the families of his friends, resulting in greater exposure to works that were otherwise hidden from view. In such a way I came across this early pencil self-portrait from 1919 in the home of Czapski's great-nephew Jan Woźniakowski. Jan had thoughtfully extended an invitation to me to come see his collection of his great-uncle's paintings and drawings. Jan's mother, Maria Woźniakowska, is Czapski's niece, the daughter of his youngest sister, Róża. Jan's father, Jacek Woźniakowski, a close friend and supporter of Czapski's work, was admired as one of Poland's foremost art historians.

Jan works at the Museum of the History of Polish Jews and is raising three sons—Hubert, Piotr, and Iwo. They live in a reconstructed rural schoolhouse a few miles beyond Warsaw's city limits. Invited for a Sunday-morning visit, I found Jan on his front porch, at the end of a narrow country lane in a birch wood, wearing gray sweatpants and a long-sleeved "Dog Eat Dog" T-shirt. His hair was closely cropped, his chin sported a few days' growth of salt-and-pepper stubble. In his fifties, tall and fit, he exuded a laconic charm. Entering the house, I was immediately drawn to its warm, bright, open spaces. Jan's two older sons, twenty-one and nineteen, appeared from different parts of the house to be introduced, shaking hands and making eye contact, clearly well brought up young men conforming to house rules about meeting new guests. Lanky and shy and, like their father, clad in sweats and T-shirts, socks and sandals, they chose to hang around for a while and check out the American painter. Jan was trying to herd us all down a wide corridor to the kitchen when I was stopped in my tracks by Czapski's youthful self-portrait (page 217).

We'd just been introduced, but I pulled Jan and the boys in to look closely at a picture they knew so well as perhaps not to see it anymore. A myriad of observations seemed to spill out of me. Huddled beside me, Hubert and Piotr, already young men if only just past adolescence, were virtually the same age as Czapski when he drew the picture. By this time in their great-great-uncle Józio's life, he had already known considerable hardship and undergone enormous upheaval. These fortunate, attractive boys, I thought, could have no idea of what he endured. As these thoughts were forming in my mind, before I had a chance to prepare for what I saw bounding toward me, I was pounced on by a large black Labrador puppy, his tail slashing the air, his front paws pummeling my chest, his tongue reaching for my face. Almost as quickly as he had charged in, the others reacted, lurching to grab his collar, calling, "No, Baba, down Baba, Baba down, down," pulling him off me. We were all laughing, and I was trying to make it clear to them that I really didn't mind in the least, when I caught sight of another force lunging directly toward me. Only a little less tall than the rest of us, Iwo, Jan's third son, was hurling himself down the hallway to join us, an effervescent, explosive mixture of bright and dark energy, a tow-headed force of nature. Born with a condition known as structural chromosomal anomaly, which leaves him cognitively disabled, at eleven years old Iwo is incapable of chewing and unable to communicate verbally. Permanent delay of neuropsychological development is his prognosis.

Clutching Baba, Jan and the older boys held back tentatively, ready to come

to my aid if I appeared to need protection from Iwo's energetic ambush. They gave me time to react and to display a willingness or a disinclination to engage. I hadn't minded Baba, and I certainly didn't mind Iwo. Everyone relaxed as I let Iwo perform a thorough inventory of me, humming to himself. Agreeably sociable in his way, he stood very close to me. His hands waved and danced, he tilted his head this way and then that, he smiled, he frowned, occasionally he squealed. His eyes darted about, he patted me here and there. He hardly stood still long enough for me to take him in, but after a tumultuous overture, he quieted down. Piotr, Hubert, and Jan remained close by, watching Iwo and me, monitoring us. His agitation subsiding, Iwo gradually shifted his active attention from me to Baba. The older boys led their younger brother and the dog in one direction as Jan and I headed toward the kitchen. As we crossed the hallway, I fleetingly spied more framed Czapski drawings and a wonderful oil portrait of a woman.

Jan offered me coffee. As he fiddled with cups and filters and grounds, my eye was drawn to a Czapski watercolor of brightly colored anemones in a tall black vase, hanging in view just beyond him. Finally we sat at a long wooden table, sipping coffee and talking. As a young man, Jan told me, he toyed with the idea of becoming a painter. On a trip to Paris, he sought out his great-uncle for advice and was told in no uncertain terms that he should expect either to devote himself entirely to the pursuit, which meant not having a family of his own, or to accept the idea of being a Sunday painter. "Uncle Józio wasn't trying to discourage me, by any means. But he didn't want me to have any romantic ideas of the life, of what was required." Soon after that conversation, back in Warsaw, Jan wrote a letter to his uncle, laying out his thoughts about painting, thanking him for having taken him seriously. In response, Czapski sent Jan a card on which he had drawn himself as a spindly, elderly man leaning on a cane, under a canopy of storm clouds raining down on him, gesturing up to the idealized young artist (Jan) in full sunshine atop a steep mountain, painting the light. Unafflicted by weather or infirmities of age, the youthful figure on the peak renders the dazzling view in front of him. In the scrawled script of an eighty-five-year-old, Józio wrote to his great-nephew across the bottom of the page: "Old painter to young painter (with thanks for a beautiful letter)." Thirty-odd years later, the card, like a talisman, hangs there on the wall.

Jan weighed his uncle's advice and opted for another path, one that afforded him the luxury of family life. He married and went to America, first doing

graduate studies at Harvard, then finding work as an art restorer at the Metropolitan Museum of Art. He and his wife settled in Brooklyn. They had two sons. When the boys were five and three, the couple decided the time had come to return to Poland. Iwo was born some years later.

After an hour or so, all the boys returned to join us, crowding the kitchen, pitching in to produce a communal breakfast. Impressive quantities of food materialized from cabinets and a well-stocked fridge. Over the course of the meal, with enormous gusto, Iwo consumed a whole loaf of babka cut into cubes, portioned out in his bowl of cereal and drowned in milk. Attended to dotingly by his father and brothers, Iwo waved his hands to catch their attention and pointed at what he wanted. Without missing a beat, Jan continued to speak with me while reaching deep into a cabinet behind him, locating a jar of peanut butter, filling a spoonful and placing it in Iwo's eager mouth. A sweet-natured, warmhearted family, and exceedingly male; a high testosterone level prevailed. A feminine touch was palpably absent. Dominika Roqueplo, Jan's wife, the mother of the boys, died from an aggressive cancer a few years before I met them, following four long years of various treatments, surgeries, and hospitals. During the second year of her struggle, enduring chemotherapy and radiotherapy, she was informed that Hubert, her eldest son, eighteen at the time, had just been diagnosed with acute lymphoblastic leukemia. Hubert's response to treatment was ultimately positive. Dominika's was not.

After eating, Jan and I retired to the spacious living room. A framed photo of Dominika sat on a mantel above the hearth. Sunshine poured through high windows lining one long wall, heavy green curtains hung in gathered columns between windows. Comfortable chairs and sofas were arranged in intimate groupings pushed up against the walls along the perimeter of the large room, leaving a wide expanse of knotty pine flooring, uncovered by rugs, in the center of the room, as if space had been cleared for dancing. It dawned on me only slowly that the space was kept unencumbered for Iwo, not for dancing—fewer obstacles for him to navigate. I also realized belatedly that perhaps I had been too quick to pass judgment on Iwo's brothers. Surely, like their great-great-uncle, they had already endured much at an early age. Their solid, physical presence helped give me a heightened sense of Czapski at their age, poised on the brink of an uncertain future, bound to family and friends, loyal and affectionate. Just as Czapski and his brother, Staś, were sent by their father to study in Petersburg, Hubert and Piotr had been sent far from home by Jan to attend high school in America, part of a student exchange program. The change of

43

place helped give them a chance to reclaim their lives, to stabilize after several intense years dominated by their mother's decline and demise.

I looked around the room. In a bright, animated household where everyone confronted what life offers and reclaims on a daily basis, Czapski's spirit hovered lovingly, his many paintings and drawings displaying astute powers of observation, a keen appetite for people and places, and a relentless search for the sources of suffering and joy.

2

HAVING BEEN IN AND OUT of uniform for several years, Czapski was demobilized, and in 1921 he enrolled again in a course of formal studies, this time at the Academy of Fine Arts in Kraków. Arriving in the medieval city for the first time in his life, he felt isolated and unsettled. He had no knowledge of the city's historical monuments. He understood little about Polish cultural life. He knew no one. Soon, however, a critical shift in his thinking was prompted by another serendipitous occasion:

> I recall exactly a dentist's dark waiting room, where, on a table, under a very ugly art nouveau lamp, among some illustrated magazines, grimy from being handled hundreds of times, I discovered *The Legend of Young Poland*. I opened it to the middle of the first chapter, "History and Myself." I understood immediately, with my whole being, from the first pages of this book, that I was no longer alone, that I was reunited with the whole world, with history; that solitude did not exist, that my most secret thoughts and experiences were not mine alone, that they had a correspondence with the world, they were not the exclusive creation of my mind but were all part of a historic process that formed my consciousness. That I belonged to history, that whether I wanted it or not, not only was I not useless but no one else could do in my place that which I had to do. I had no right to despise the development of my country. I discovered, with a sense of exaltation that I had not found in Russia, another Poland.

Czapski recalled the abrupt impact of these pages as "a sacred slap." *Legenda Młodej Polski* (*The Legend of Young Poland*), by the philosopher Stanisław Brzozowski, helped Czapski to see who he was and who he might become. It gave him strength. Early memories returned of his mother's catechism: "Who am I? I'm a little Pole." Reading Brzozowski, "I became Polish." A counterpoint to his experience in Petrograd with Merezhkovsky and Gippius, his encounter with Brzozowski's text filled him with a sense of belonging and purpose. A

call to arms, *The Legend of Young Poland* rails against the aestheticism and decadence of the neoromantic generation at the turn of the twentieth century. The Polish poet Czesław Miłosz, who wrote a study of Brzozowski, credits the critic with infusing fresh blood into Polish art: "A one-man army.... Brzozowski dealt a decisive blow to the fashionable sobbing over the cruelty of existence." Pure aestheticism would always distress Czapski, who found it a dangerously hermetic state of being, "all delectation." Brzozowski empowered him to search for a pure art that avoided the pitfalls of pure aestheticism.

With renewed enthusiasm, he gave himself over to painting, to a life among new friendships begun at the academy. The fit was not entirely perfect. While he had been performing his duties as a soldier, his younger classmates had already experienced the upheavals of cubism and futurism. Czapski was reading Brzozowski as his colleagues were reading Vladimir Mayakovsky, the Russian futurist and poet who had embraced the cause of Bolshevism in 1917.

> I entered the world of my new friends, an intellectual atmosphere marked by a carefree assurance, a winning optimism, and a sensual joie de vivre totally alien to me. This group did everything possible to forget that, not long ago, the academy had been frequented by long-haired painters in robes. My new friends found me amusing and old-fashioned. My emotional and intellectual responses were different from theirs. I find the joyous affirmation of life a bit forced, it's not my thing. A scene from this era remains in my memory. One day my friends and I escaped from our studio classroom to jump in the Vistula and sunbathe for a few hours on the beach. One of the most gifted among us ("he who works least but makes the most progress," sighed one professor with a mixture of indignation and respect) spread himself out naked on the sand and said, convinced he was announcing something philosophically profound and *modern* to me: "I can't figure out which is more important, painting or getting a tan."

Czapski's earliest known paintings were made at this time, a series of mountain landscapes on small paper boards, painted while on holiday near Zakopane in southern Poland, in the Tatras, the highest mountain range of the Carpathian chain. The tops of tall evergreen and deciduous trees on the edge of a precipitous valley are shown pressed up against the picture plane, while in the distance, under milky-blue cloudy skies, a higher line of purple-blue peaks looms. Depending on the weather and lighting conditions at the time of each

composition, the effect can be majestic or ominous. The studies are direct and solid and convincingly painted, subdued and appealing.

Though Kraków was in an explosive period of creative activity, with many painters committed to constructivism and the avant-garde school of formism, which looked to folk art for inspiration, under the sway of cubism, Czapski resisted the call. Any cause célèbre holding the study of nature in disdain was not for him. He and a small clutch of fellow classmates were not attracted to the call of Russian-influenced nonrepresentational abstraction, yet they longed to move beyond the inflexible alternative of Polish academicism, where religious and historical themes held sway. Issues of content and questions of style began to chafe. One of their professors, Józef Pankiewicz, appreciated and encouraged the group's restlessness. A painter who had spent many summers in Normandy and the South of France working alongside his friend Pierre Bonnard, Pankiewicz instilled in his students a passion for the color-infused innovations of the École de Paris. Inspired by this example, Czapski would become the moving force among a dozen students determined to get to Paris to observe its legendary painting scene firsthand. In a somewhat clandestine manner at first, the group banded together as a self-selecting entity proud of its broad representation of Polish life—among them were sons and daughters from the peasantry and the nobility, Ukrainians and Jews, wealthy Kraków shopowners and members of the provincial bourgeoisie. Coming together as a group under the name Komitet Paryski, or KP, the members of this Paris Committee would only much later come to be known as Kapists.

To underwrite the expenses of their projected Paris field trip, the group organized one dance after another, auctioned drawings and paintings, held raffles, gave readings, and produced amateur theatricals at the Juliusz Słowacki Theatre. They worked hard to raise enough funds to enable them all to stay in Paris for a period of six weeks. The twelve young painters achieved their goal and finally set off in 1924.

Instead of six weeks, they stayed for seven years. Czapski alone among them was fluent in French and, as a result, took responsibility for all transactions concerning the travel, lodging, and feeding of this tribe of friends whose rallying cry was *peinture-peinture* (painting-painting). Cézanne was their god, Bonnard their reigning monarch. The Paris Committee was hungry above all for color, an explosion of color. They wanted color—not line, form, or content—to dominate the pictures they chose to make. Looking to nature for inspiration, to provide a basis for composition, and to suggest the development

47

of color harmonies, they rejected any attempt to simulate colors as perceived by the brain. "Local color," the prosaic means of ascribing blue to the sky and green to grass, was of no interest. This territory had been hard-won by earlier generations, by Eugène Delacroix for instance, whose exoticism overshadowed any interest in ordinary life, followed by the impressionists, who set out to overturn Jean-Auguste-Dominique Ingres's insistence on the supremacy of line over color. These parochial Polish painters traveled to Paris to take up the banner of Vincent van Gogh, the fauvists, and the postimpressionists. Set on *peinture-peinture*, each charted independent territory, confident of pursuing the larger artistic ends that bound them together. Czapski, senior member of the group, continually felt unfocused and watched as his younger friends began to make noticeable progress. He attributed his painterly shortcomings to a lack of talent on his part, but it was really a question of his not understanding what it was he wished to do. Each of his colleagues was carving out a stylistic niche. He, meanwhile, had found a community but not an aesthetic that resonated in him with the sting of truth.

The group rented a communal studio space in the fourteenth arrondissement, on the Impasse du Rouet. (At the same time, a few blocks away, in rue Hippolyte-Maindron, Alberto Giacometti was setting up what would remain his studio for the duration of his long career. He would become a significant figure in Czapski's pantheon of artists.) Czapski would appear faithfully at the Impasse du Rouet every day from the cheap lodgings he had found in Châtillon, just south of the city limits. In Châtillon he shared his rooms with Sergei Nabokov, a shy, pale, blond Russian, a Wagner enthusiast whom Czapski had encountered one day in a café. Prone to stammering, Nabokov supported himself by giving English and Russian lessons. Devoted to music and European literature, he could recite poems beautifully in a variety of languages without a trace of stutter. Also newly arrived in Paris, he had recently received a degree from Cambridge, where playing tennis on the university's clay courts, he and his brother Vladimir had passed some of their only happy times together. Dedicated readers of Aleksandr Pushkin, each Nabokov brother had been working independently on a translation of *Eugene Onegin*, Vladimir into English, Sergei into French. Józio and Sergei also shared a passion for Russian writers, for Anna Akhmatova, Osip Mandelstam, and Boris Pasternak. Both were tall, slender, myopic, and sensitive. For a period of time when each first arrived in Paris, they were intimately bound to each other. Often they would head out with Sergei's first cousin Nicolas, a nascent composer and future

cultural diplomat, also recently relocated in Paris from Berlin. These three highly cultured aristocratic young men were the impoverished sons of large families whose fortunes had been lost. They learned to make creative use of their very limited financial means in Paris, enjoying themselves at cafés, concerts, and parties.

Czapski frequented the Louvre. He expanded his visual education in the presence of its encyclopedic collection, lingering in front of paintings known to him previously only in reproduction or not at all. As was the custom for beginning painters, he got a permit, set up an easel in the galleries, and made copies of pictures for which he felt an affinity, including works by Poussin and Corot. Whenever possible, he attended formal drawing classes at the Académie Colarossi and the Académie Ranson, fine arts schools more in touch with contemporary trends than the highly conservative École des Beaux-Arts.

Aware for a long time that some critical aspect of painting was eluding him, Czapski felt immensely frustrated. On his thirtieth birthday, his two closest friends came to visit his studio. Jan Cybis and Zygmunt Waliszewski were already established young painters who would go on to become renowned artists of their generation in Poland. Before arriving at the Academy of Fine Arts in Kraków, Cybis had studied painting in Breslau (Wrocław) under Otto Mueller, a member of the German expressionist group Die Brücke. Waliszewski had painted since childhood and was a member of a group of futurists. The early works of Cybis and Waliszewski were influenced by the formists. While sharing a bottle of wine, Czapski's friends convinced him to show them his latest still lifes. They sat together drinking, contemplating the pictures. The works Czapski showed his friends

were my last hope in the midst of my doubts, fruit of a period of intense work, and, it seemed to me, evidence of a modicum of progress. They looked at my canvases intently; I waited, flattered by their attention.... After about an hour Waliszewski announced that only a chosen few people were capable of reaching into the heart of painting, all others, despite their hard work and best intentions, would never really paint, that world was forever closed to them. The paintings of mine they considered so carefully—I saw at once—had served as proof of his argument. Cybis held the opinion that one could never tell about someone. The men in whom I placed the greatest trust when it came to painting, my nearest friends—and this was how they judged my chances.

I think at that moment I *became* a painter. I quickly understood that I would

continue my efforts to break through this wall of shadows, and even if I should never succeed, it would be impossible to detach myself from painting.

The group of Polish painters was barely making ends meet financially. They did what was needed to survive, putting their skills to use to generate income. They painted fans and screens and the Spanish scarves that were in vogue; they built and decorated small tables, produced textile designs, turned out illustrations for newspapers and journals. Whatever profits were raised were put to collective use. Though such prosaic work made Czapski miserable, he stopped painting altogether for a while to sketch women's dresses for *Vogue* twelve hours a day to earn some money. More often than not his drawings were rejected.

The group decided to make an appeal to their fellow Poles in Paris and soon found encouragement and support from a few wealthy industrialists and some of the most captivating hostesses in the social and cultural life of the great city. At the top of this list was Maria Godebska-Sert, known as Misia, a consummate doyenne of Parisian society, a symbol of feminine allure. She had been born in Saint Petersburg, where her father, an ambitious Polish sculptor, had set up a studio and won commissions for portrait busts of the imperial family. Misia's Russian Belgian mother died giving birth to her. The newborn was then sent away to Brussels to be raised by her mother's parents. Misia's grandfather, a world-famous concert cellist, nurtured the girl's musical talent. Growing up in the company of Franz Liszt and studying piano with Gabriel Fauré, she developed into a gifted and passionate musician. Misia married Thadée Natanson, a nephew of her stepmother's first husband. Born in Warsaw and raised in Paris, Natanson and his two brothers became founders of *La Revue Blanche*, a lavishly illustrated literary journal in which Marcel Proust, a friend of the young newlyweds, published his early writings. Misia became a muse and patron to the poets Stéphane Mallarmé and Paul Verlaine, and inspired a host of painters, including Renoir, Toulouse-Lautrec, Bonnard, and Vuillard, who all made loving portraits of her. Her dearest friend and confidante was Coco Chanel.

Czapski describes Misia, whom he met through Pankiewicz, as a woman who "could make the sun shine or cause it to rain." She knew everyone. Delegated to lure his friends from the beau monde to help the cause of the young painters, he turned to her for help. She said, "Very well, come here tomorrow, we'll take Picasso to lunch." The next day they all went to the Meurice. It was

decided a fund-raising event was in order and after lunch Picasso agreed to be its patron.

A venue was rented for the occasion, a vast hall used for agricultural trade shows on rue de Grenelle. Invitations were sent out for a "Super Jazz Ball" under the compelling sponsorship of Picasso and Czapski's cousin, Princess Dolly Radziwiłł. (Czapski's great-grandfather's mother was a Radziwiłł.) Preparations began, excitement ran high. In a burst of activity, the young artists set to work painting decorations on an underwater theme. Soon sharks, cephalopods, and seaweed spread across the walls. The hulls of sailing ships were painted on the ceiling; one wall was covered with a panorama of Nice, viewed from below the surface of the sea. Czapski took it upon himself to knock on Bonnard's studio door to request his presence in support of the cause of so many acolytes. Touched by the invitation from a student of his old friend Pankiewicz, the shy painter agreed to attend. On the night of the ball he arrived in a crumpled dinner jacket. Given a tour of the premises, he took pleasure in the exuberantly painted decorations.

The composer Poulenc, Lady Crewe (the English ambassador's wife), the Prince of Denmark, Nina Hamnett, and Elsa Maxwell were all in attendance to help the young artists. Constantin Brancusi lent his support, as did Jean Cocteau. Sergei Diaghilev brought Serge Lifar, at that time the star of the Ballets Russes, who would later sit for a brooding portrait by Czapski. Picasso made a point of being introduced to all the young Poles and shaking their hands, with his Ukrainian wife, the ballerina Olga Khokhlova, at his side. They, in turn, gifted him with a large papier-mâché fish that he carried proudly under his arm. Making his way over to Bonnard to congratulate him on his current exhibition of paintings at Galerie Bernheim, Picasso declared that the work in that show far surpassed anything Bonnard had previously done. Overhearing this exchange, Misia leaned into Czapski and murmured, "Leave it to Picasso. He never pays another painter an unambiguous compliment." All the same, Bonnard was delighted.

Dinner was served at small tables as two pianists played. After the meal, a jazz band let loose and the agricultural hall was transformed into a rowdy dance palace. Bohemian Montparnasse, always happy for a party, turned out in force. Artists' models, wearing only flowers, circulated among the cheerful crowd as everyone danced and drank. When all the bills were finally paid, however, little remained in the way of funds for support of the painters.

Not discouraged, another attempt was made several months later. This

time, an industrialist from Łódź agreed to cover the evening's expenses so that a reassuring profit could be counted on. The festivities were held on a barge moored in the Seine just below Pont Alexandre III. *Le tout* Paris appeared, including many grandees from the Parisian society who were well known to Proust, who had only recently died—the Marquis de Polignac, the Count and Countess de Gramont, the Duke and Duchess d'Alba. Count Harry Kessler came and the Count and Countess de Ganay and the Baron and Baroness Rothschild. In one society columnist's account of guests, the name "Count Joseph Czapski" appeared. The writer neglected to mention that he was not a sponsor but an intended beneficiary. The musical talents of the painters Józef Jarema and Jan Cybis were given full rein, fueled by the thumping jazz piano offered by Stanisław Szpinalski, who later went on to play in the first International Chopin Competition. Everything went according to plan until a torrential rain began to fall and wild winds blew, rocking the vessel. Electric power failed and candles had to be found to light the space. The raucous band played until dawn. The night became the stuff of legend and served to introduce the painters to a wealthy client base, many of whom would buy their paintings in the coming years.

Later in his thirtieth year, Czapski fell ill with typhoid fever. His uncle Meyendorff extended an offer of care and shelter. Having fled Russia between the abdication of the tsar and the Bolshevist takeover, Baron Meyendorff had become a lecturer at the London School of Economics and set up house in Mayfair. Once more he put his home and affections at Czapski's disposal. In pampered surroundings, the ailing young man found himself far from his meager lodgings in Châtillon, where he had been perennially attending to the lives of others. After more than two years of scraping bottom as an artist, he stretched out on a deck chair surrounded by a carefully manicured lawn in the heart of London. He gave in to rest and relaxation. This sun-dappled back garden, the setting for his recovery, was also the enchanted locale of his first dedicated reading of Proust. (The final volume of *À la recherche du temps perdu* would only be published the following year.) This grateful surrender provided Czapski with a far more comprehensive sense of life and what the world of art might have to offer him. Reading the novel caused him to expand his own emotional range; the themes of loss and childhood memory took on increased significance. He gained a wider perspective on the world. This relationship between Czapski and Proust would endure and deepen over another seven decades.

After a month of confinement and recuperation, he got himself to Trafalgar Square, to the National Gallery, and put himself in front of paintings, as he had become accustomed to doing at the Louvre. Weak but determined, he coaxed himself through gallery after gallery in a state of modified torpor, eyeing masterworks by Titian, Rembrandt, Velázquez. One day a small oil on canvas, measuring only fifteen by twelve inches, caught his eye from a distance and captured his full attention. It was as if everything else fell away. The painting, *Monsieur Pivot on Horseback* by Camille Corot, is the study of a man sitting astride a dappled gray horse. The rider, as if in response to having been spoken to, turns his head to look back at the viewer and, shifting position, rests his right hand on the horse's rear flank to better support himself. The horse patiently waits, alert but still. The palette is muted, a silvery greenish brown prevails, detailing the field underfoot and a curtain of dense foliage behind the horse and rider. Two pale, slender trunks of birch anchor the sylvan setting. A touch of yellow on top of the soft, wide-brimmed straw hat the man is wearing is the warmest spot in the picture, and a discreet flash of red near the back of his neck suggests a brightly colored cravat under the jacket collar. "For the first time in my life, I was bowled over by a painting," Czapski reported of the experience,

> Why is it at this precise moment, after years of agonized indecision, study, and the effort to *see* when I could see so little, and precisely at the moment, between illness and reading, when I hadn't touched any colors for several weeks while undergoing a slow reclamation of strength, and in complete ignorance of the way I might paint in the future—why was I freed from this self-inflicted constraint, why was I able to *see* the painting?

Czapski acknowledges a moment "between illness and reading" but does not otherwise make a connection between this experience of unprecedented openness to sensation and his immersion in Proust. From my perspective, there can be no question but that consciously or not, one inspired the other. Like Proust's character Bergotte (who also rose from his sickbed), Czapski dragged himself to the museum. Some element emanating from Corot's canvas, some unforeseen association, lifted a veil, triggered a mechanism in his eyes that enabled him finally to be able to *see* (Czapski's italics), much as Bergotte had been stunned to find the "little patch of yellow wall" in a canvas by Vermeer which he thought he had known so well. Neither Czapski's course of studies

in Kraków nor his long hours in the Louvre had been capable of provoking such a release from "self-inflicted constraint." Standing before the small canvas in London, Czapski understood that what was opening in him was not related to meaning or knowing, as when looking at older Italian, Spanish, and Dutch paintings, but to feeling and seeing. He became receptive in a new and different way, tapping into some previously inaccessible depth within himself. His eyes opened with fresh power.

Czapski's fever and fatigue ran their course and he made his way back to Paris. His health had recovered, but his faith in his work had not. "I began to find myself before an impenetrable wall," he wrote. "Most of the time I just let my brush wander on the canvas with a feeling of being unconnected to what was essential. It's not an exaggeration to say that working in such a dark place was like torture for me. I was unable to coordinate my hand and eye, I couldn't concentrate my attention on what I was looking at, I saw everything as fragments, never as a whole."

Trying to place himself artistically, he painted still lifes and figure studies, street scenes and landscapes. Having not yet identified his own subject or voice, he worked hard in hopes of finding them.

The Polish painters of the Paris Committee were still without a reliable stream of income, yet somehow they managed, by living as meagerly as possible and relying on the generosity of their prosperous friends, to work at plein air painting in the South of France. They followed in the footsteps of Bonnard and Matisse and Cézanne. The careful attention they paid to a theory of color produced works whose overall effect, like those of their professor Pankiewicz, was predominantly decorative. As chief theoretician of the group, Czapski had drafted the group's credo with its insistence on "color above all." But making pictures based on an opposition of chromatic fields continually failed to satisfy his own pictorial impulses. Being true to himself was always of primary importance to Czapski, but in what way that truth might manifest itself visually was as yet far from clear to him.

In need of balm for his agitated state, Czapski looked out beyond the confines of his studio life and developed several important friendships in the larger stream of Parisian life. His family ties opened many doors. He had been introduced to Élie Halévy by Baron Meyendorff while in London. The French historian observed Czapski's artistic and literary passions and immediately thought of his brother, Daniel, back in Paris. Élie and Daniel Halévy were the

sons of the playwright Ludovic Halévy, cowriter of the libretto for Georges Bizet's *Carmen*. They had been raised as Protestants, though their father had converted from Judaism at the time of his marriage to their mother. Growing up a few steps from the Pont Neuf in the heart of Paris, the Halévy boys had been surrounded by an exalted cast of characters that included Bizet, the painters Edgar Degas and Édouard Manet, and the social philosophers Ernest Renan and Hippolyte Taine. Portraits by Jacques-Émile Blanche, another family friend, lined the walls. The stimulating presence of so many accomplished artists produced a humbling effect on the young Daniel, thwarting his ambitions. At heart, he considered himself *un raté*, a failure, a person whose accomplishments didn't add up to much. Such deeply rooted self-doubt was a condition Czapski understood, something to which he was also prone.

Trained as a linguist, Halévy made the first translation of Nietzsche into French. At the turn of the twentieth century he, like Proust, worked in defense of Alfred Dreyfus, the French army captain wrongly accused of treason. Along the way he befriended many politically engaged socialists and developed emphatic liberal leanings. By the 1920s, however, when Élie arranged for his brother and Czapski to meet, Daniel was already a man rethinking his priorities and values, beginning a shift toward a more politically conservative outlook.

Despite an age difference of twenty-four years, the two men had much in common. The exchange between their sympathetic minds would continue right up until Halévy's death at ninety. They shared a basic critical framework entwined with deeply moral precepts. In later years Czapski would have to find a way to reconcile himself with Halévy's retrograde Pétainism after the fall of France, much as Halévy had had to resolve not to let the anti-Semitism of Degas destroy the family's relationship with him. As their friendship progressed, so did the pile of sketches and oil studies Czapski drew and painted of his older friend, made in the house on the Quai de l'Horloge in the presence of Halévy's remarkable collection of drawings by Degas, who had so often sat sketching in the same room. Degas's eyesight had failed him as he aged, as would be true of Halévy, as would be true of Czapski. Living in the eighteenth-century house his mother's clockmaker ancestors built, Halévy straddled the nineteenth and twentieth centuries. A collection of essays he wrote addressed "the acceleration of history." The swift passage of time had a way of impressing itself on residents of the house, and on visitors, too.

Halévy introduced Czapski to his wide circle of friends, arranging over time for him to rub shoulders with influential writers, artists, and thinkers

representing a broad spectrum of political, spiritual, and aesthetic movements. Among those Czapski met and befriended were the painter Blanche, poet Léon-Paul Fargue, novelist Julien Green, critic Jean Guéhenno, cultural theorist André Malraux, Catholic philosopher Jacques Maritain, literary figure François Mauriac, and writer Paul Morand.

It was my last night in Paris after a month of hard work. I decided to decline a dinner invitation from friends in order to be alone, to allow the stimulation of the previous weeks to flow through me unimpeded. I had been all over the city—in people's homes, at meetings in offices, in libraries and galleries and cafés, crisscrossing a dozen arrondissements on a regular basis. The time had come for one last sortie. With a book of Czapski's essays in hand, I set out. It was nearly five o'clock, the end of a beautiful northern European fall afternoon, when the day, suddenly realizing it has stayed too long, quickly prepares to take its leave. When in Paris I like to watch the gloaming somewhere in sight of the Seine, where the city breathes most expansively, where the vast overarching canopy is steeped in the same cobalt blue that inspired the ceilings of Sainte-Chapelle and Notre Dame. Making my way toward the river from Odéon, I turned into rue Guénégaud, where Czapski had exhibited his work decades earlier at both Galerie Jean Briance and Galerie Jacques Desbrières. I crossed the arched span of the Pont Neuf that connects the Left Bank to Île de la Cité and slipped into rue Henri Robert on my right, a very short lane that leads, in a matter of strides, to Place Dauphine, a cobblestoned square where chalky façades of old buildings fan out expansively and the enclosure's far boundary is delineated by the back of the imposing Palais de Justice. It's a place where I like to sit and read, a protected spot at the very heart of the ancient city, a welcome retreat from the bustle beyond the embrace of its high walls. Setting myself down on a wooden bench beneath young chestnut trees in a park lined with crushed stone, I started in on the next essay in my book. I read its first sentence and laughed out loud. In its entirety, the line reads "I crossed the Pont Neuf."

The essay goes on to describe a Polish officer in Napoleon's army, Józef Sułkowski, who was leaving for Egypt from a hotel on Île de la Cité, somewhere, I realized, near where I happened to be sitting. I read for forty minutes or so as the light lingered beautifully in the sky. Then, quite suddenly, the daylight was gone; streetlights were illuminated. I looked up, ready to move, and my eyes landed on something they hadn't previously registered, a new business,

an art gallery whose glowing storefront window projected a warm light into the darkening square. Standing up, feeling the beginnings of hunger and thinking about which direction I might head for a bite to eat, I walked over for a quick look. In the window, an appealing Corot-like landscape was on display all by itself. I opened the door and entered the gallery, a vaulted limestone room lined with many more paintings.

As I moved forward, a few thoughts slowly began to line up in the back of my mind, tremulously, like geese finding their place in chevron flight. I made my way down a long wall of paintings in a state of slight mental distraction, passing from one pleasing pastoral image to the next. After I had studied four or five of the small canvases, a gallery attendant appeared and asked me, in a lilting French, whether I was a painter. I nodded. He said with some pride that he could usually tell by the way someone looked at pictures. He began to speak about the artist on display. Looking past him into the farther recesses of the gallery space I'd entered from the Place Dauphine, I discerned a series of rooms extending all the way out toward the Seine, to what I recognized as the riverfront embankment called the Quai de l'Horloge. Vague thoughts straining for definition continued to come over me, but I couldn't yet fathom what it was my mind was formulating. Then it hit me: I must be standing in the ground-floor space of 39 Quai de l'Horloge, which was once the family home of Daniel Halévy. Dumbfounded, I realized Czapski had been speaking of Halévy and this very building in the essay I was just reading. For decades I've known the historical significance of this address and studied the house from its exterior, its handsome river frontage giving directly onto the Seine, but I had never made the connection that the rear of the river-facing structure gave onto Place Dauphine, where I loved to sit and read. I knew that in the 1880s, several times a week, Edgar Degas made his way to this house for a meal with his old friends Ludovic and Louise Halévy and their teenaged sons, Élie and Daniel. From a memoir I'd read about the misanthropic painter, written by Daniel Halévy as an old man, I knew that at one time this house was full of paintings and drawings by Degas and Cézanne and Gauguin. My mind began to shift again... and it dawned on me that, yes, of course, this same Daniel Halévy had once been the fixation, the object of desire of none other than Marcel Proust, a friend from his lycée who'd made sexual advances and written him outrageous letters. One of Proust's first poems was dedicated to young Daniel: "a subtle, select fire / Quickens that soul and that nubile physique / With a liveliness, exquisite and magical."

I could no longer focus on what the congenial fellow from the gallery was saying to me as we wandered together through the space. Degas, Proust, Halévy were swimming in my head. Somehow, incredibly, I had made my way unknowingly into a building long known to them, a building—of course!—well-known to Czapski, too.

I heard myself being asked what kind of painting I was working on. I turned to the gentleman and said, *"Excusez-moi."* I could only muster the words, *"C'est un peu bizarre."* Cocking his head, he regarded me patiently, as if he had listened to any number of painters describe their process in so many words. I explained to him that I was currently writing a book about a painter and had been researching and amassing information about him, an unknown Polish painter, a painter, in fact, who had a long friendship with a man who was, I believed, a former resident of this building. Visibly taken aback, but smiling quizzically, the fellow exclaimed, *"Czapski, vous voulez dire?"* It was my turn to be taken aback. This was the first time that someone unconnected to my writing project had known the name of the subject of my study, had actually volunteered the name Czapski upon hearing the two words "Polish" and "painter" combined. Seeing my surprise at his response, he smiled broadly. "Perhaps I should introduce myself. My name is Alexis Nabokov. This is my gallery. Daniel Halévy was my mother's grandfather. My parents both knew Czapski well. He is someone I admire immensely, both as a painter and as a man." I was speechless.

Alexis Nabokov is the grandson of Nicolas Nabokov, with whom Czapski and Sergei Nabokov used to make the rounds in the 1920s. Alexis's father, Ivan, is Nicolas's son, who married Claude, Daniel Halévy's granddaughter. Ivan and Claude live upstairs, above the gallery where I was trying to get my bearings. In a manner beyond my understanding, I found myself privileged to enter into a confluence of connections I could never have managed to pull off had I tried. Ten minutes earlier, sitting on a bench as the streetlights were lit, I was luxuriating in the prospect of finding a bite to eat. Instead, by an almost magnetic charge, I'd been pulled into the geographic and sentimental heart of a story I'd been figuring out how to tell, in a location I've walked past countless times without putting two and two together. As if from the pages of his essay, Czapski was preparing the way for me to gain access to this private realm, where, even among an embarrassment of notable visitors, his presence managed to leave a lasting impression.

My desire to effect a link to a vanished world was partly fulfilled by this

chance meeting, which provided me with the opportunity to connect with the descendants of two families very dear to Czapski, the Halévys and the Nabokovs. I felt not unlike Proust's narrator who stood, when introduced to Mademoiselle Saint-Loup at the end of a very long novel, at "one of those star-shaped crossroads in a forest where roads converge that have come, in the forest as in our lives, from the most diverse quarters." Standing beside Alexis Nabokov, and meeting his parents, I was overcome to find myself at such a crossroads, where the past, the present, and the future seemed to collide.

The very personal collection of Degas paintings, drawings, and prints are long gone from the house, but more intangible presences have remained, Czapski among them. "Life," wrote Proust, "is perpetually weaving fresh threads which link one individual and one event to another, and that these threads are crossed and recrossed, doubled and redoubled to thicken the web, so that between any slightest point of our past and all the others a rich network of memories gives us an almost infinite variety of communicating paths to choose from."

Czapski had been in love with Sergei Nabokov. Ivan, who has only a faint recollection of his father's cousin, told me that his mother always claimed Sergei was "the nicest of all the Nabokovs, a sweet, funny man, much nicer, much more dependable and funnier than all the rest of them." But the affair broke off in 1926, just as Czapski contracted typhoid fever. When he left to convalesce at his uncle's in London, heartbreak was prominent on his list of ailments. Czapski's receptivity to Proust stemmed in part from his identification with the narrator's wallowing in hopeless romantic involvements. "I was walking around wounded," he admitted. "Proust was connected with my pain. Without the pain, I may not have understood *À la recherche*."

> I have to confess it was not Proust's precious content that took me in at first, but rather the subject of this volume: the despair, the forsaken lover's anguish at being abandoned by Albertine, the description of all forms of retrospective jealousy, painful memories, feverish investigations, all that psychological insight of a great writer, with its muddle of details and references that struck right at the heart of me.

One of Czapski's very early efforts at writing was a 1928 review of Proust's completed opus, among the first printed in Europe to consider the entire novel. In it, he makes the claim that in all great literature two gardens are featured:

one that is open and public, and another that is secret, hidden, more difficult to access. This early acknowledgment of an essential duality—in matters of the spirit and of the heart, in the shared aesthetics of painting and writing—is integral, paradoxically, to the formation of the consistent whole, to the unity of character within Czapski. In matters of religion, politics, and sexuality, he was unwilling to conform to a singular type, to be bound by defining limitations or conventional expectations.

Arrested by the Gestapo at his home in Berlin in December 1943, Sergei would die in Neuengamme, the Nazi concentration camp where homosexual prisoners were subjected to brutal medical experiments. He bore the prisoner identification number 28631. He may have been betrayed to the authorities for having sheltered an English friend from Cambridge, an RAF pilot shot down over Germany. After the war, Ivan's family, the only Nabokovs in the Paris telephone book, received countless calls of condolence from people who had been helped, or saved, or comforted by Sergei. Resolute in his identity, he had managed to overcome his shyness and was perhaps far more at ease with his sexuality than Czapski, for whom crossing the "narrow footbridge," as he called it, between carnality and spirituality remained a precarious and worrisome adventure. In a rare journal entry alluding to the subject of desire and physical intimacy, Czapski refers to both body and spirit:

Some years ago I was struck by the impression, while reading *Lady Chatterley's Lover*, that for the book's heroine, nature, trees, and grass were to be found on the far side of a glass wall, that all contact with the world had been severed before her amorous liaison. I felt acutely that way myself in the army, in 1920 during the war—the odor at night of the forest, of the villages as we entered them, of leather and horse sweat, of healthy soldiers. I recall the same feeling of being surrounded by a wall of glass that separated me from nature. I was able to come out from behind this glass, from this "interiority," following two paths. First, I began to live physically. I had loved passionately before this too, but without allowing myself anything. In many instances I did not even know what it was I desired. The other path that freed me from this interiority, after years of sustained effort, was painting. I don't mean inspiration, no, but working from nature.... How could I be so sure that this was my path? Going from failure to failure, I couldn't even put the question to myself. My liberation came from following this path, also in accepting my sexual life, which burdened me with thousands of sins, with letting others down, but which freed me from an

absolute solitude I had felt toward the nature that surrounded me—but not toward God. Precisely at this moment of sexual turmoil, with an increased understanding, like a necessity, my path to God remained clear and open.

Never entirely able to merge the two paths, Czapski's commitment to painting was not unrelated to his acceptance of living "physically." It's hard to know, as he wrote these lines, to what degree he may have been thinking of Proust's two divergent paths, or "ways," and their ultimate reconciliation.

As the Kapist group's tenure in Paris extended to a lengthy residence throughout the second half of the 1920s, Czapski was soothed and stabilized by the presence in Paris of his beloved sister Marynia. A PhD candidate from Jagiellonian University in Kraków, one of the world's oldest centers of learning, she was studying the history of literature at the Sorbonne. The intimate relationship between sister and brother was lifelong, symbiotic, and caring. Each was a mixture in almost equal parts of democrat, aristocrat, bohemian, and ecumenical Catholic. Intensely close but never clinging, they were always respectful of the other's autonomy and privacy. Photos hint at a conspiratorial air between them, their body language full of familial intimacy and shared knowledge. Each carried a vivid, breathing memory of their childhood, a world forever lost but still living in them. Inhabiting those cherished spaces together enabled them to stave off feelings of regret or bitterness they might otherwise have cultivated separately in isolation. Each had a circle of friends who knew brother and sister, independently and together. Marynia befriended Sergei Nabokov and worked on translations with him. She welcomed her brother's companions whenever he brought them to meet her.

On a day-to-day basis, Czapski's years in Paris were lived frugally. Content with his lot as far as domestic life was concerned, he experienced no sense of deprivation; quite the opposite, he felt grateful to be able to do exactly what he wanted to be doing, living among friends and colleagues with shared values. His needs were simple; a spartan life was welcome as long as he had paint and canvas, sketchbooks, pencils, and ink. Food and drink would be found, or he could easily go without. His torment stemmed from his scant progress as a painter.

During stays in the South of France, Czapski would head out each day, set up an easel, and attempt to capture the sensations sparked by the lush, light-drenched colors of the Midi. At a small hotel he used as a base of operations,

he met and befriended a Canadian woman who was chaperoning two younger women. One of them was named Catherine Harrison:

> I never thought that a woman could fall in love with me, because I thought of myself as ugly and uninteresting. But Catherine loved me silently, in a most wholesome way. We played games every evening, had fun together, all in an absolutely innocent fashion. A year later I met her again—she was trembling, there was no meaning in her life. She was a very good secretary, she spoke a few languages quite well. Before she went to Sweden for a job, she confessed that she had fallen in love with me back then, and that she still loved me. We started to be together.

As Catherine would discover during the next eight years, Czapski could be a difficult man to love. In partial explanation, he claimed, "at that time the only important thing for me was painting. It was an idée fixe." He was not being disingenuous; during his years in Paris, he seemed to seal himself off from anything that might threaten the primacy of his studio life. This is not to say he did not travel, or meet people, or circulate socially, or fall in love, or enter into erotic entanglements. However, he knew where he wanted his energies to be focused, and he had the discipline to maintain his priorities. He felt there was precious little he might bring to a marriage and recognized that Catherine, a beautiful woman accustomed to a degree of comfort, would be unsuitable for the ascetic life he envisioned for himself. In addition to the problem of his poverty, the prospect of entering into a marriage fell beyond his idea of being true to himself. Marrying Catherine would have secured Czapski's place socially and, paradoxically, afforded him more freedom. But he would not pretend to be someone he was not.

Catherine tried to make the best of the situation, finding solace in the friendship she cultivated with Marynia, who was ever supportive of her brother's strictures. For decades Czapski would maintain very close ties with Catherine, usually with considerable geographic distance between them. Asked about this relationship many years later, Czapski replied, "It hardly matters whether emotional pain is caused by a woman or a man. Such pain produces a strength of suffering so extreme that it allows you to make discoveries bearing no connection to the object of your love. These junctions are very complex."

Czapski rarely traded on his highborn position, but from time to time the aristocratic side of his life would present itself, in stark contrast to the limita-

tions imposed by material privation. Family and friends with considerable fortunes welcomed him as an equal into their glittering world. In 1928 and 1929, he spent most of July, August, and September at a vast estate along the Mediterranean coast owned by one of the great French cultural philanthropists of the era, Countess Lily Pastré and her husband, Count Jean Pastré, whose Paris residence on the boulevard de la Tour-Maubourg was adjacent to the home of Czapski's Radziwiłł cousins. Encouraged to explore the two-hundred-fifty-acre property as he chose, Czapski made himself comfortable strolling the extensive grounds of the elegant château on the French Riviera. He ambled along *les calanques*—the narrow, fjord-like inlets along the coast—put up his easel, set out his paints, and got to work. A marine seascape made in 1928 of Montredon beach, just south of Marseille, shows a pink stucco lean-to with a turquoise shuttered window and terra-cotta tile roof. Perhaps a fisherman's cottage, the structure is built right up against softly rounded cliffs that lead down to the shoreline. A small cove, a patch of beach, a protruding shelf of rock, and, in the bottom right-hand corner, the hull of a beached boat complete the foreground. A distant stretch of low hills across the water encloses the span of sea, a bank of low pink-and-white clouds hovers above the hills, and finally, above the clouds, a band of bright aqua sky. The luminous shadow cast diagonally across the man-made structure provides a contrast of blended values composed of *petites taches*—while the sea and beach and rocky shelf are all built up of individual strokes known as *touches*. The beach scene at Montredon shows us a young painter absorbing a lesson, stumbling to find himself, imposing techniques used by other painters onto his own unformed aesthetic. It's a picture made by an apprentice, pleasing and competent, full of lovely passages, but unpromising as far as representing the emergence of a more personal vision.

The terms *tache* and *touche*, frequently used by Czapski and his fellow Kapists to describe their painting process, are derived, like part of an aesthetic dowry, from the arsenal of techniques developed by the impressionists, whose inheritance, in turn, had come from the experiments of J. M. W. Turner and Eugène Delacroix earlier in the nineteenth century. The application of colors in their pure state directly onto the canvas represented a radical break with the centuries-old tradition of mixing colors on the palette and applying them to the canvas already chromatically resolved. Developments in the science of optics revealed that our eyes, of their own accord, would blend two unadulterated colors seen side by side. With this greater knowledge about how color is perceived, and a growing awareness of the impact of the relationship between

colors, new visual harmonies brought viewers into a more active participation in the experience of seeing. A *tache* involves laying down pure colors side by side, then blending them with the aid of a soft brush directly on the canvas, rather than beforehand on the palette. The result is an area of blended color the viewer's eye comprehends but in whose formation it does not participate. In terms of perception, this represents a more passive intake of sensation, requiring no act of will to interpret. Pissarro was a great pioneer of this method, which would go on to become a dominant technique of impressionist painting. Cézanne, however, learning from Pissarro while painting alongside him, made further advancements based on the idea that color is an inherent part of the expressive quality of forms. He preferred to allow colors, under his exacting control, to harmonize side by side in their pure state directly on the canvas. The process of determining precisely what color is needed and how much paint to load on the brush before applying it to the canvas is called painting by *touche*, which, in contrast to *tache*, engages the painter (and by extension, the viewer) in a far more participatory act of perception. Each color needs to be identified and applied to the canvas like a compositional building block, *touche* by *touche*, layer on layer, in harmonic, almost musical, sequences. Constructing a painting entirely of *touches* laid next to one another is a highly labor-intensive procedure. Many have learned from his example, but few have ever devoted the decades of patience Cézanne did to mastering the technique. It is a risky business; at any moment, something can go wrong, one bad choice and the picture is lost. Unlike the pointillists Georges Seurat and Paul Signac, Pissarro and Cézanne were never interested in the formal science of optics; their response to color was at heart instinctive and emotional rather than cerebral or theoretical. Their understanding and manipulation of color led to a new boldness, a new subjectivity, and a new relationship between viewer and canvas. *Peinture-peinture* is one sect of this religion of color. Czapski and his cohorts were its Polish apostles. Czapski would later embrace a more expressionistic sensibility.

Fortunately, the group did not require slavish devotion to one color theory; each of the dozen men and women staked separate claims. They were actively supportive of one another while enduring the bleakest of living conditions. From the beginning, Jan Cybis held them all to a high standard and bemoaned the fact that they had nothing quite good enough yet to show for sale. He urged them to work, to make stronger pictures. Eventually a sufficient inventory was built up. In 1929, five years after first arriving in Paris, the group was

invited to submit work to a painting competition. Their paintings were singled out for praise by a jury that included Georges Rouault and Raoul Dufy. Hanging these canvases together at August Zamoyski's Paris sculpture studio on avenue du Maine created an unofficial group exhibition. The large space was crowded with artists and critics who had been invited to attend. Gertrude Stein put in an appearance and purchased two paintings by Cybis.

In March 1930, the dozen Poles debuted professionally in an exhibition held at Galerie Zak in Saint-Germain-des-Prés. Léon-Paul Fargue, a poet of the Parisian streets, friend of Proust and Halévy, wrote an introduction to the catalogue at Czapski's request. Focusing his admiration on the communal nature of the Kapist endeavor, Fargue composed lines that strike a tender chord: "Even if I had been unable to see the work they've made, if I had failed to understand their effort, well then, I would simply admire them for who they are. I'm not so foolish, as someone said, to prefer the work to the living being. But I have seen their paintings and I'm confident about their future." A touch patronizing perhaps, but then patronage was just what the group was hoping to attract. Édouard Vuillard came and expressed his appreciation for the work, as did the legendary dealer Ambroise Vollard, who, nearly blind, communed with the paintings by touching their surfaces. Stein reappeared, a feather in any young painter's cap. She bought more canvases, including one by Czapski, who befriended the imposing American writer and secured an invitation to see her ever-growing collection of works by Picasso, Matisse, and Cézanne.

Taking charge of all the arrangements for the group, Czapski also acted as its chief salesman and public relations officer. "Chère Madame," he wrote in a follow-up note to Stein, "I am *so* pleased that you have found that the group is making progress, and that you want to have another painting by Cybis. It was a thrill for him to know that you took an interest in his work, that you have judged his painting with complete understanding.... I will bring the canvas to you in the coming days."

Once the exhibition came down, Czapski made a six-week trip to Spain. In Madrid, he experienced "the shock of my life," one of the high points of his aesthetic education, encountering for the first time the great eye, hand, and deep heart of Francisco Goya.

His cold, masterful portraits of great ladies, dignitaries, kings, and cardinals are painted so smoothly, to the degree that we don't feel the angle of the brush.

They are classical in composition and in the miraculous control of every detail, in the materiality of the object, in the consideration given to local colors, in the carefully advanced gradation of values.

Next to these portraits, in a badly lit side room, were hung paintings by Goya so entirely different that it was difficult to believe they were painted by the same person. War scenes, wild scenes with witches, painted by "lightning," in exaltation, so that we see every movement of the brush, color contrasts so violent they are almost like Soutine, a disdain for local color and the object's materiality, so that some of the canvases give the impression of almost abstract color arrangements.

As painter to the Spanish court, Goya had made the best of working under the severe constraints of a demanding job, safeguarding the promptings of his more fervid imaginings to run free on his own time. This example of isolating styles and choosing between them came as a revelation and a relief to Czapski.

Speaking of myself, I was long tormented by a duality of approach—analytical on the one hand, rational, growing from the Dutch tradition and to a certain extent from the pointillists, and on the other hand, the mad, the unpredictable—the true leap into the abyss. In this I saw a lack of integrated personality, a kind of psychic dividedness that I tried to overcome artificially, without success. With time I noticed the same phenomenon in a painter whose stature was not only equal to that of Matisse but who was one of the very greatest—Goya.

This encounter helped alleviate Czapski's pervasive sense of failure, offering an example of how he might newly attack the impenetrable wall that had blocked his progress. Devoted to the elevation of color as the key determinant in painting, to the bright, sunny saturation of Bonnard, Czapski had despaired of turning his back on life's real suffering, equally in need of a means of expression. Presenting an expansive range of painterly possibilities, Goya appeared before him, affording a greater understanding of the breadth of his métier.

Settling in Arenas de San Pedro, a small village near Ávila, Czapski took rooms overlooking the castle, built in 1400, whose crenellated walls were lined with hundreds of stork nests. Storks were flying everywhere. For the first time in a long while, he was on his own, responsible for no one but himself. The

retreat was powerful and restorative. Each night he succumbed to a nocturnal ritual of active dreaming, unusual for him. Remaining largely solitary for several weeks, he was befriended by a local elder, a curate and dedicated monarchist, who took him on walks, happy for the company. The curate's close childhood friend, a wine merchant whom Czapski found charming, often joined them. A passionate republican, he would taunt his clerical friend, playfully calling him "Rasputin," while the curate, equally stubborn, called him "Lenin" with similar tenderness. Czapski admired their resolve to remain friends despite the ceaseless airing of their political differences.

Before returning to Paris, he sent a postcard from Arenas de San Pedro to Stein and Alice B. Toklas, thanking them for their suggestion: "I think of you two in this town which seems to me the most beautiful of all I have seen in Spain. I've spent six weeks in Madrid, Toledo, Escorial. Thank you for this tip about Ávila. Au revoir mesdames, hope to see you in the fall with my sister, who will be coming back for a few months. We'll come see you often."

The notes and letters between Czapski and Stein exhibit a calculated savvy that helps to expose a side of Czapski's personality generally kept in check, the sophisticated knowingness of "how things are done" in the world at large and the willingness to entertain the idea of how his career might be built. In light of what he determined were more ambitious, serious concerns, he almost always suppressed these impulses as mercenary, exposing the degree of conflict in him while finding his own way. He instinctively knows what Stein wants to hear, how to flatter her sense of expertise in order to sustain her active interest in his work and the work of his friends. A touch of humility before a powerful lady bountiful comes to him naturally, given his lifelong exposure to important figures who preferred to be stroked, not pawed.

Once back from Spain, he found some encouragement. The French state purchased an oil study of a bouquet of flowers he had done the previous year and shown at Galerie Zak. And an exhibition of more than seventy Kapist paintings was in the works for the following year at a gallery in Geneva. When it opened in May 1931, the works were displayed in an elegant and spacious suite of rooms. Czapski, who had overseen all the preparations and accompanied the work to Switzerland, was especially gratified by the scale of the show and the professional standard of illumination. (Later in the year, this exhibition, which was applauded in Switzerland, would be remounted at the Polish Art Club in Warsaw to public disdain.) Making his way back to Paris, Czapski stopped en route to visit Stein and Toklas at their summer house in Belley,

southwest of Geneva. A postcard announcing the time of his arrival included the news that "the Geneva exhibit has closed and we sold forty canvases. The gallery director offered me a job as sales director!"

Czapski's first solo exhibition was mounted in Paris later that year at the Galerie Maratier. Arranged for him by Lily Pastré, it was followed by a second, in 1932, at the Galerie Vignon. The art press made passing comments, praising his "assurance of drawing and technical vigor." He was, finally, launched. As was true for his friends, a solid grounding had been laid. The Polish painters recognized the time had come to leave Paris and return to their homeland, as had always been their intent. The cultural vanguard in Warsaw was beckoning them to return and share what they had learned firsthand. Most of the group reassembled in Warsaw by 1932. Triumphant, determined to usher in the new face of Polish painting, their greatest impact would prove to be as teachers and advocates for the importance of color. Forever after each painter would be identified as having been a member of the Paris Committee, the Kapist group.

3

CZAPSKI RENTED a studio space in Warsaw and settled down to work. It was as if, unpacking his few belongings, he found he had carried along with him the spirit of French painting. An almost evangelical mood was at work among the prodigal painters on their return. Czapski would later claim that they were like "bearers of elementary and absolute truths about painting, truths unknown in Poland." One canvas painted soon after he arrived (plate 2) shows a small terrier-like dog standing in profile on a profusely tree-lined path in a city park, waiting patiently for his master to catch up to him. Painted in the center of Warsaw, the picture curiously calls to mind the small French village Collioure, a town on the Mediterranean coast halfway between Barcelona and Marseille where Henri Matisse and André Derain had begun experimenting with color in an explosive way in the summer of 1905. Czapski's purely chromatic concerns reveal his attention to immediate sensations in the act of seeing, much in the manner of Matisse, rather than any attempt to capture a precise record of external reality or local color. The handling of paint—in the rendering of trees, foliage, and grass, and the path on which the small dog poses—amounts to a fauvist exercise in its use of the complementary colors green and red, yellow and purple, blue and orange. Branches are delineated in dark values, set off against lighter-hued masses of leaves. A few bright white dabs on the dog define its body on the pink-purple path. Across the upper quadrant, brilliant orange and maroon foliage quivers like a wall of flames.

Covered in staccato gestures from a loaded brush, the entire surface is resolved to an equal degree of finish. Beyond what the linear strokes provide, no contours or textures are specified. Near the center of the picture, a thick gray tree trunk is outlined by a red stripe on one side and a blue one on the other, the only solid mass in a vibrating buzz of pure color. Patches of unpainted canvas showing through intensify the luminosity of the brilliant contrasts. Czapski is drunk on a quarter-century-old brew of Matisse's making; the picture radiates a joy of the world and all the colors in it. In this canvas we find

an École de Paris seedling, transplanted in Polish soil, bearing fruit. His painting reaches far past the more conservative boundaries set by his former teacher Józef Pankiewicz.

As had been true for Matisse, this fluorescence of many hues, composed of individual marks of equal importance, served Czapski well during a brief experimental period. Also like Matisse, Czapski would move on and reclaim some of the pictorial conventions he discards here with abandon. His paintings from this early period in Warsaw still tend to conform to a range of stylistic options that come to him from without, tried on like various guises, rather than emanating from somewhere within. Bolstered by the lesson of Goya's divided sensibility, Czapski is still finding his way, learning as he goes.

During his resettlement in Poland, Czapski established an important connection with the writer Ludwik Hering. Attracted to each other on both physical and intellectual planes, the men were in some ways similar, in other ways not, yet they shared an equal aversion to what each had been raised to think of as sinful behavior. Their period of sexual intimacy was brief, but the love and affection engendered proved long-standing. For several years, they lived together in Józefów, a bucolic town only nine miles southeast of Warsaw. History and geography would ultimately separate them and define their relationship; their years apart would far outnumber the few happy years they managed to have together.

With his painting life organized and fruitful, Czapski began to produce essays on a variety of art-related themes in concert with his studio work, encouraged by Hering. From the very beginning, his writing bears the stamp of an individual mind and spirit forging a direct link to something authentically his own, something his painting work had yet to accomplish. During these years, he could more confidently attack the issues of art with words on a page than with a brush on canvas. Two articles about Cézanne, published three years apart, offered a theoretical understanding of how the Provençal master's paintings were made and affirmed how significant their impact was. What Czapski presented critically about Cézanne was neither new nor especially revealing, but the essays filled a significant gap in the awareness of the importance of Cézanne in a place where his singular and indisputable contribution had been widely ignored. Seduced by constructivism, suprematism, and futurism, Polish painters, with their appetite for the avant-garde, had bypassed this father of modernism.

Czapski portrays Cézanne as an exemplary figure, revealing the artist's

heightened consciousness in the act of painting. He describes how the painter moved beyond the impressionists' practice of massing together *taches* of local colors and credits Cézanne with conceiving "a new vision of nature" in which color and drawing are more thoroughly integrated into the process of painting. The essays set out to show how Cézanne saw the world around him; their aim was primarily didactic. The Polish art-viewing public, Czapski noted, was willing to accept the notion of color as increasingly useful to a painter, but only as long as it did not interfere with the correctness of the drawing. Cézanne's drawings were subject to scandalized protest, and he was accused of being unable to draw. The public "doesn't understand that it is precisely the union of color and drawing in which the essence of Cézanne's revolution resides." Czapski peppered his text with quotations from Cézanne's letters and phrases the painter was often heard repeating: "The goal of the artist is to work without caring what others think, to be strong." Such slogans reaffirm Czapski's own intentions and identify him as a willing acolyte and champion of the painter from Aix, even as Cézanne's bold union of color and drawing continues to elude him in his own studio.

Cézanne worked tirelessly to achieve his objectives. Czapski celebrated his tenaciousness, convinced that such hard work must form the backbone of every painter's life. Cézanne attempted to find common ground between his unshakable devotion to the classical tradition and the radical innovations he was formulating at Pissarro's side. Determined "to remake Poussin from nature," Cézanne declared that he wanted to make "something solid and durable of impressionism, like the art of the museums." From one of the high priests of modernism, this seems an almost reactionary pose to strike. Cézanne's admiration for Poussin must be seen as a shared moral perspective, an appreciation that resonated deeply with Czapski's own concerns. It's easy to see how Cézanne's desire to reconcile innovation with classicism appealed to Czapski; unmoved by the harsh linear formalism of the Russian constructivists, he deplored the vision of idealized humanity dictated by Soviet realism. Given an almost spiritual aversion to nonrepresentational abstraction, he constructed a fairly conservative framework of aesthetic considerations for himself.

Czapski's reverence for Cézanne's work may be quasi-mystical, but he never set out to imitate his technique as a painter. He was attracted, rather, by something ineffable, almost metaphysical, at the heart of every one of Cézanne's paintings. Hesitation, apprehension, and doubt haunt Cézanne's works and days. Before each canvas, the same question would arise: "When is a painting

finished?" Cézanne rarely brought works to a state of completion that satisfied him. Shadowed by an intense sense of failure, he walked away from canvases, turned them to the wall, abandoned them, destroyed them. And yet, recognizing the impossibility of his endeavor of trying to capture nature, of rendering only what exists, he persisted. Like the painter Frenhofer in Honoré de Balzac's story "The Unknown Masterpiece," with whom he explicitly identified, Cézanne was resolute in his belief that "it's not the mission of art to copy nature, but to express it." He despaired of ever possessing the spark, the necessary genius to paint what it felt like to see.

Encountering this dark undertow from so exalted a source, Czapski was paradoxically reassured and took heart after his own long experience of uncertainty. "I was in such a state of mental agitation, in such great confusion that for a time I feared my weak reason would not survive.... Now it seems I'm better, that I see more clearly the direction my studies are taking. Will I arrive at the goal, so intensely sought and so long pursued? I am working from nature, and it seems to me I am making slow progress."

This is not a journal entry composed by Czapski in a moment of despondency but a note Cézanne wrote to Émile Bernard only a month before his death in 1906. In another letter, to his dealer Ambroise Vollard, Cézanne compared himself to Moses, and wondered whether he would ever see the promised land, the realization of all his dreams for painting. "Will I ever attain the end for which I have striven so long?" Misery loves company: Czapski was sobered and heartened by Cézanne's unceasing ordeal.

Józef Pankiewicz was about to turn seventy. Somewhat ambivalently, Czapski accepted a commission to write a monograph about him, repaying his debt to this friend of Bonnard who had presented a compelling alternative to the more conventional and conservative forces at work in the academy. Always maintaining that he learned less about painting from Pankiewicz than from his friends Jan Cybis and Zygmunt Waliszewski, Czapski decided nonetheless to honor his professor's influence. He returned to Paris and lived for six months with a fixed objective: making ritual visits to the Louvre with his old teacher as he worked on his text. Invariably, a small flock of enthusiasts would assemble to join them, among them a newly published poet on a yearlong stipend in Paris, Czesław Miłosz, and the pianist Kazimierz Krance and his wife, Felicja. Taking detailed notes and listening hard, Czapski conceived the book as part aesthetic biography, part interview journalism. His opening section would

present Pankiewicz as a young maverick painter intoxicated by French pictures and identify the influences that were at work on him. Czapski's overview of Pankiewicz's career would cover successful early showings at the Paris Salon and the awarding of the French Légion d'honneur.

Czapski assumes an unusual stylistic voice for the 1930s in the second half of the book, as he attempts to bring his subject to life in a section called "Walking and Talking." Each of these later chapters is devoted to a separate visit to the Louvre, with Pankiewicz holding forth on specific works to a small group of enthusiasts who were hanging on his every word. Czapski sets the scene, identifying the gallery and historic period of the work under consideration, inserting lengthy excerpts from Pankiewicz's monologue about the image on view in front of them. Picture surfaces are scrutinized, technique is analyzed, and anecdotal histories of the provenance of the works are offered. Speculation is made about the subjects of various portraits. Anything and everything is entertained in order to make the strongest informed assessment possible. Finally, Czapski gives an account of a visit to Pankiewicz's studio, where teacher and former student look together at reproductions of paintings and discuss the various uses of chiaroscuro in Masaccio, Rembrandt, and Titian. The book ends honoring Bonnard and Pankiewicz's deep friendship, repeating the oft-told tale of the painters together on their own visit to the Louvre:

> They stood together before Rembrandt's *Bathsheba*.
> All of a sudden Bonnard burst into laughter.
> "Why are you laughing?" Pankiewicz demanded.
> "What else can you do?" Bonnard replied. "*What* can one possibly say before such a masterpiece?"

In the Tuileries Garden, with the long façade of the Louvre stretching out behind him, Czapski posed for a photograph. Sporting an elegant suit, tie, and winter coat, his hair slicked back, he looked sheepish but dapper. He appears to be enjoying a rare moment of confidence, making a clear assessment of where he has come from and where he is headed. He had just been to see an exhibition of new paintings by Max Beckmann at a gallery nearby, where the German painter's penchant for "splashing black around like so much bile" made a deep impression. A long-gestating seed of expressionism was planted that would bear fruit years later.

He was ready to return to his studio in Warsaw and move on. *Józef*

Pankiewicz: Życie i dzieło. Wypowiedzi o sztuce (Pankiewicz: Life and Work and a Commentary on Art) was published in 1936.

Once resettled, Czapski began work on a series of portraits. His friend Adolf Rudnicki posed for him, seated or stretched out on the floor, a writer absorbed in reading. A self-portrait from 1937 (page 178) shows Czapski on a wooden chair with a carved scalloped back. His head and upper body fill the right side of a horizontal canvas, his long face turned and gazing over his left shoulder in a three-quarter view. On the left, a matching chair, unoccupied, with a seat of woven rush caning fills the space beside him. His mouth seems poised to open but maybe not, his eyes, behind round tortoiseshell frames, are alert, but the look is uncertain, hesitant, slightly suspicious. He is wearing a herringbone-patterned jacket and a tie. Along the bottom left corner of the picture, his bony hand rests on his knee. A curved lock of hair has tumbled down onto his high forehead—the picture would not be half as compelling without this touch, an almost impetuous affectation in relation to an otherwise carefully studied setting. Painting a portrait is an object lesson in control and stasis; an unruly strand of hair that falls out of place can introduce a welcome element of spontaneity to the process. This is an urban study, complete with an apartment building immediately across the street filling in for background landscape, the water tower atop another building farther away creating a sense of spatial complexity, like a distant peak in a Renaissance portrait. Czapski stares out at us, and behind him we see row upon row of dark windows projecting a suggestion of indifference or even hostile blankness. A slightly creepy presence of unseen neighbors is felt, the flat, blackened panes concealing whatever life might lurk within. Behind the frames of his glasses, Czapski's eyes are also dark and nearly as impenetrable as the windows outside.

Another canvas from 1937 shows an outdoor musical performance. Plays and musical recitals became a favorite motif for Czapski, an avid theater- and concertgoer. These paintings are usually based on studies sketched from a seat in the audience. In the summer, Czapski headed north from Warsaw to the Baltic Sea to attend performances at Waldoper (Opera Leśna), an open-air music festival sometimes known as the Bayreuth of the North, nestled in a heavily wooded hillside in Zoppot (Sopot), on the outskirts of the Free City of Danzig (Gdańsk). The 1937 season included productions of *Parsifal* and *Lohengrin*. Czapski's picture shows an enormous stage set dwarfing two singers standing side by side. The figures are so small their heads and hands are indi-

cated only by a flesh-colored daub, but there is great expressiveness in these touches. The woman's hands are lifted up as she sings, the man's are down in front of him. Both singers focus their attention on the conductor, whose head and torso emerge from the pit in front of them, his raised hands leading an unseen orchestra, his face, like the singers, spotlighted. The performers stand in front of a set depicting a grove of trees beyond which, in the distance, the red crenellation of a castle or fortress wall can be seen. Two huge green monolithic flats flank the singers on both sides. Above and beyond all of this immense theatrical artificiality, the looming silhouettes of real trees lean in, moody against a dark Prussian blue sky. The picture's point of view is from a seat several rows back from the stage. Czapski portrays members of the audience immediately in front of him, in the manner of Degas's and Manet's café concert paintings, where the smaller drama of life around us meets the larger drama unfolding onstage. We see the backs of heads and shoulders twisting this way and that in their seats, lovingly painted in a style and palette quite reminiscent of works Duncan Grant and Vanessa Bell were making at the same time in England. The audience's various attitudes are distracting, as happens during live performances, though it makes me laugh to think of how distracting it would be to have come across someone like Czapski sketching furiously during the opera.

In *Pion* (Vertical), a Warsaw-based arts and cultural affairs journal, a 1938 article titled "Adventures in the Country of Color: The Paintings of Józef Czapski" praised the painter's healthy resistance to any single dogmatic approach to painting. Images of six Czapski paintings from 1937 were reproduced in the text, their titles giving a sense of the range of his imagery: *Concert, Interior, Male Nude, Yellow Shawl, Tram*, and *Amaryllis*. In the magazine's following issue, a review of a group show of young Polish painters makes reference to Monet, Sisley, Pissarro, Cézanne, Matisse, and Bonnard, all in the first paragraph. In the 1930s, in artistic circles everywhere in Poland, the influence of French painting was inescapable. The critic reviewing the exhibit described "the danger of impressionism threatening our young artists," but he singled out Czapski, who "successfully seeks a way out of the impasse on his own terms." Three more of his paintings are reproduced. The first is a view of sailboats bobbing on a sapphire-colored sea, in the fauvist vein. The second is a compelling psychological portrait of a young girl not quite on the verge of womanhood—part child, part temptress—her hair in ribboned braids (page 178). The third Czapski painting is called *In the Mirror* (plate 3). A full-length

75

self-portrait, it's a complex composition whose subject is actually the reflection of an image. Most self-portraits are accomplished by the artist painting his or her reflection, generally without reference to the mirroring surface itself. Czapski, a serial self-portraitist, often contextualizes his own image, slightly shifting the picture's focus from himself to the environment in which we find him. The viewer gets to see the edge of a mirror, or the whole mirror, or the mirror on his armoire reflecting not only the painter but his rumpled bed, etc. In *In the Mirror* we look into the depths of a wide and tall mirror in a public space. Czapski has painted himself dressed in a suit and tie, coming around the curve of a long hotel hallway midstride, one foot up, one foot flat, jauntily making his way toward the viewer along a deep red carpet. One of his arms is extended fully, the other is bent at the elbow and pulled in, clutching a small package to his side. A globe light is suspended high above his head. The pictorial sense of space is deepened and further complicated by a very tall rectangular mirror behind Czapski positioned to reflect the length of corridor he has just come down, a space that would otherwise be outside the viewer's field of vision. We encounter him framed in a mirror, with another mirror behind him, one mirror's reflection caught within the reflection of the other. Czapski's figure, though ambling forward, is caught in the psychic space of multiple reflections, in search of himself.

The picture was not always so layered. In an earlier state, the painting was less complex, simply showing Czapski in the middle distance, sauntering toward us. For whatever reason, this didn't satisfy him, and as an afterthought, he decided to freeze the figure in motion within the confines of a mirror with a rounded top. Altering the picture's original architecture, he erects a low yellow wall across the hallway as if to isolate the figure from the viewer. The painter roughs in the wall as a carpenter would, framing it out with his brush, then covering it over, but only incompletely, as if he left the job unfinished. Czapski now seems to be coming around the bend of the hallway only to find he has been boxed in. Instead of the illusion of the painter walking toward us unimpeded, we have the hastily configured mirror reflecting Czapski walking where we should actually see a reflection of him painting himself, a displacement in the tradition of Velázquez's *Las Meninas*.

Illusion builds upon illusion. The flow of the hall's garish red carpet originally extended from the midpoint of the canvas all the way down to the bottom of the vertical picture plane, but as he reconsidered and constructed his little patch of yellow wall across the hallway, Czapski rendered the carpet in varying

degrees of translucency. We find parts of the underlying carpet still visible; this late-addition mirror is hanging on a nearly see-through wall. Encased in a gilded molding, the large mirror is flanked by two ornamental pilasters whose elaborate decoration is brushed in cadmium yellow with cerulean blue highlights. (This combination of yellow and milky blue is one Czapski is fond of; it appears frequently in his work.) As if to lend weight and substance to a picture plane otherwise threatening to implode spatially, a reddish brown, curved-back club chair has been added to anchor the bottom right corner of the canvas.

Far from being disorienting and confusing to take in, as this description might imply, the painting is in fact quite easy to read, a portrait of the artist as a figure in motion, straightforward and appealing, brightly colored and alive. The quirky passages of overpainting and spatial conundrums quickly fall away. But after studying the painting repeatedly over an extended period of time, I struggled with another way of seeing it. The arch at the top of the rounded mirror has nestled in my consciousness and keeps returning in my mind's eye, the way a melody I can't quite place plays over and over in my head. Where have I seen such a shape before? I find myself endlessly pondering the globe light suspended on a cord from the ceiling. Why does it seem so familiar? Days later, another picture flashes before my eyes, superimposing itself on the Czapski, a distant relative in terms of form and, more tenuously, of content. The painting is Piero della Francesca's *Montefeltro Altarpiece*, a fifteenth-century *sacra conversazione* (a picture in which saints, patrons, and sometimes angels gather informally on either side of a centralized Virgin and baby Christ to honor them). My association is not with the figures in the Piero but rather with the architectural aspect of the arched vault under which all the figures congregate as if under a firmament, and the mysterious "egg" hanging down from it. I seem to have juxtaposed Czapski's modern painting with an early Renaissance protocol. Seen side by side in reproduction, the Piero and the Czapski resist comparison, but the rounded arch dominating the top of both pictures and the flanking pilasters down either side suggest a crude formal analogy. The presence of a large pendant white object in each picture introduces an element of symbolic, if interpretatively ambiguous, importance. The unadorned ostrich egg centered in Piero's altarpiece is floating above the head of the Virgin, dangling on a gold chain from a scallop-shell canopy set within a coffered vault of classical proportion. The globe light in the hotel hallway hovers similarly over Czapski's head; he appears as indifferent to it as the Virgin

does to the egg. The custom of hanging ostrich eggs in sites of worship goes back as far as the time of pagan rituals and was still in force at the end of the fifteenth century; eggs were hanging in the Duomo of Florence throughout Piero's lifetime. The symbolic significance of the egg is open to a variety of poetic interpretations, most incorporating the idea of God as the beginning of life. Colored by an early exposure to the Russian Orthodox faith, Czapski's Catholic belief system was steeped in a personal aesthetic sensibility, and while he made relatively few overtly religious pictures, it would be very wrong to suggest his lifework as a painter was not informed by an active spiritual life. He was a man who maintained a profound attachment to his God. But it is only in my imagination that a connection has been made between Piero and Czapski, thanks to a coincidental overlay of formal elements: the arch and the suspended orb. Czapski would not have painted the mysterious, looming white globe and thought of it as a symbol of a mindfulness to God; symbols had no place in his grab bag of picture-making tools. Sometimes a suspended white object is simply a light fixture in a hotel hallway.

Czapski would later consider the 1930s in Poland—stimulating, productive, pleasurable times—"the happiest of my life." It was a time of great energy and excitement, the cafés and studios ringing with heated debate and creative ferment. The overwhelming feeling of directionlessness that had choked him during the Paris years released its hold. No longer obsessed with being a painter, he *was* a painter. His talents finally began to coalesce, and he produced visually coherent paintings that were rich in complexity. His canvases, less consistently Paris-inflected, were bold and often original, his rendering more and more assured. He had begun to stake out unusual territory for subject matter, finding source material in the realms of theater performance, urban transport, and oddly cropped domestic interiors. He led a painter's life, a routine of hard work in solitude punctuated by periodic engagement with the world beyond his studio. His diligence was paying off. A solid foundation, hard-won, would serve him well.

With characteristic delicacy, Czapski, living in Józefów with Hering, continued to maintain a relationship with Catherine, the striking, beautiful, and unassuming Canadian woman he had been involved with in Paris. She would visit Warsaw and he would introduce her to select friends. "Everyone's crazy about her," he told a friend. "The secretary of the Art Institute begged me to marry her, because she was so perfect and appropriate for me." Catherine had met a man in Sweden who loved her and asked to marry her, who could provide

78

for her and offer the security Czapski could not. But she was determined to marry Czapski and was sure she could make it all work out. At one vulnerable point, after weeks of anguish and strain, the affair broke off. "We almost got married," Czapski confessed. "But I never found the courage. I felt it would be immoral to get married and shut my eyes; for me it was like pretending to be someone else. I never agreed to it." One day as they talked endlessly in circles in front of the Chopin monument in Łazienki Park, Catherine was reduced to tears. She dashed away and soon after left Warsaw, recognizing she had failed to win him. She married her Swedish suitor.

A one-man show of Czapski's work was mounted in Warsaw in March 1938, a retrospective of paintings created since his return to Poland six years earlier. Portraits, self-portraits, male and female nudes, still lifes, landscapes and seascapes, interiors, and urban scenes were included. An elegant pencil drawing by Czapski graced the cover of the exhibition catalogue, a woman's profile, part Matisse, part Pisanello. Later in the year, two Czapski oils went on display in another group show, painted in the months just prior to the exhibition. One was called *On the Veranda*, the other *Dovecote*.

I was able to track down a murky but legible color reproduction of *Dovecote*, showing a cluster of birds poised on a derelict structure. To my surprise, the painting was identified as belonging to a public collection, the Polish Museum of America in Chicago. A Czapski in America? During the museum's posted hours of operation, I telephoned to determine whether or not *Dovecote* was easily accessible for viewing. I was disappointed to hear a recorded message begin to play, enumerating various options, none of which allowed me the possibility of speaking with a person. Impulsively, I pressed the "o" button, hoping an operator might respond.

"Hello, may I help you?" A middle-aged woman's voice suddenly came onto the line, high and sweet; my spirit lifted. I began by saying that I was attempting to verify the existence of a work from the museum's collection, stating Czapski's name and giving a brief description of the painting called *Dovecote*. I heard the woman giggle nervously. She asked me to "hold the line." I could hear her, indistinctly, engaging in conversation with another voice. The words "gallery landing" and "inside, no, I think outside" traveled two thousand miles to make their way into my straining ear. When the woman addressed me again, her voice had regained some confidence. "I hope you will excuse me," she began, very politely. The giggle was gone, but, unexpectedly, a throaty laugh rang out

in its place. "You see, I'm only the president of the museum, my grasp of hard facts is sometimes not what it should be." I expressed surprise at having stumbled upon so high-ranking an officer of the institution. "We're a much more loosely structured organization than most people think," she offered by way of explanation. Then, with perfect executive sangfroid, she added, "To answer your question, yes, the painting is here."

Painted in the summer of 1938, *Dovecote* shows a group of twenty-five or so variously colored birds haphazardly spread across a dilapidated wooden structure built high off the ground. Clumps of grass and the luxuriant foliage of tall trees fill the background, exuberantly painted. The soft hues of sunrise or sunset, a molten wash of pink and gold, drapes itself like a liquid radiance over this depth of green. The birds bask in the changing light. The pigeons or doves are rendered casually but each bird has been carefully seen, their individual markings and feathers noted precisely, as if they were sitting for a group portrait. Only by inference does human life intrude; the crudely constructed dovecote, with its erratic appendages of railings, ladders, and mullions is clearly man-made. The birds congregate with a proprietorial air on its skeletal frame and in its cubicles, looking down from their height, keeping a guarded distance. Some of them look out toward the viewer, others look away. A fleeting moment is caught. Whenever birds are concerned, any sense of sustained stillness is tenuous at best, one can almost always hear an incipient cooing and the tentative flutter of wings preparing for the possibility of flight. The shimmering light in the picture is as ephemeral as the stillness; both are captured and held.

Czapski liked to say about his paternal grandmother, Elżbieta Hutten-Czapska, that although she had traveled around the world, she could never remember the names of any of the people she met, but she could identify with ease every bird on her estate at Stańków in eastern Poland. *Dovecote* might be seen as a tribute to her, a meditation on her impact on the young man and his development as a painter. Czapski must have applied finishing touches to the picture in his studio in Warsaw at the end of the summer of 1938. At that time, Europe was anxiously bracing for the possibility of another major war. In November, when *Dovecote* was put on display in Warsaw, the events of what came to be known as Kristallnacht trumpeted Hitler's intentions for Germany. Along with synagogue windows, illusions of "peace in our time" were shattered. With its languorous radiance, Czapski's painting was inadvertently the study of a world on the verge of self-immolation. Wherever the sketches for *Dovecote*

had been made, that bucolic rural place would no longer remain as it had once been.

Soon after being shown in Warsaw, *Dovecote* was selected by a distinguished fine arts committee to become part of an exhibition of contemporary Polish art slated to be shown in the United States. The canvas would have been wrapped, crated, and sent on a transatlantic journey along with thousands of other art objects and displays. The Polish government invested more than a million dollars to construct an architecturally dramatic pavilion with seventy thousand square feet of exhibition space for the 1939 World's Fair in New York City. *Dovecote* had been chosen to be included as part of a comprehensive spectacle of Polish life.

Some two hundred thousand visitors flooded the fairgrounds in New York City on Sunday, April 30, 1939, the official opening day. (My mother, a sixteen-year-old high-school student, was there selling souvenirs at a concession stand five hours every day after school, twelve hours on weekends, supporting her disabled mother.) Opening day marked the debut of television broadcasting in New York City. President Franklin Delano Roosevelt was at the fairgrounds and delivered a rousing speech for the cameras. The medium of the future had just arrived. The theme of the fair was "Dawn of a New Day."

The fairgrounds spread out across twelve hundred acres of recently reclaimed land called Flushing Meadow. Between April and October 1939, and then again in 1940, more than forty-five million visitors paid to attend. At the British Pavilion, one of the original Magna Carta documents was on display, having left England for the first time since 1215. Vermeer's *Milkmaid*, on loan from the Rijksmuseum in Amsterdam, drew huge crowds. Hollywood film stars Johnny Weissmuller and Esther Williams headlined at the extravagant Billy Rose Aquacade, performing synchronized swimming programs in a vast pool to the accompaniment of a full orchestra, in an amphitheater seating eleven thousand spectators.

In the Polish Pavilion, by the Lagoon of Nations, a display of historical objects and modern paintings filled the ground-floor atrium, Czapski's *Dovecote* among them. The building boasted a tower one-hundred-fifty-feet tall, composed of twelve hundred interwoven golden shields. Soaring high above the low-lying meadow, it was dazzling, if not blinding, in the sun. A monumental bronze equestrian sculpture of the fifteenth-century king Władysław II Jagiełło stood on a thirty-foot-tall pedestal at the junction of the plaza's flatness and the tower's verticality. Heavily armored astride his noble horse,

the king was shown with both arms upraised, bearing swords crossed in defiance. Jagiełło's presence provided the emotional center of an otherwise decorative arrangement of buildings. The statue symbolized the victory of a combined Polish-Lithuanian fighting force triumphing over Teutonic aggressors at the Battle of Grunwald in July 1410. The history of Poland is long, and her collective memory is deep. A single word—POLAND—was carved into the sculpture's massive stone base. A costumed horn player would appear at the top of the tower every evening at seven o'clock to play the legendary *hejnał*, a medieval call to arms warning the people of Kraków of impending attack.

Teutonic aggressors, far from the fairgrounds in New York City, once again invaded Poland on the morning of September 1, 1939. *Dovecote* would never return home.

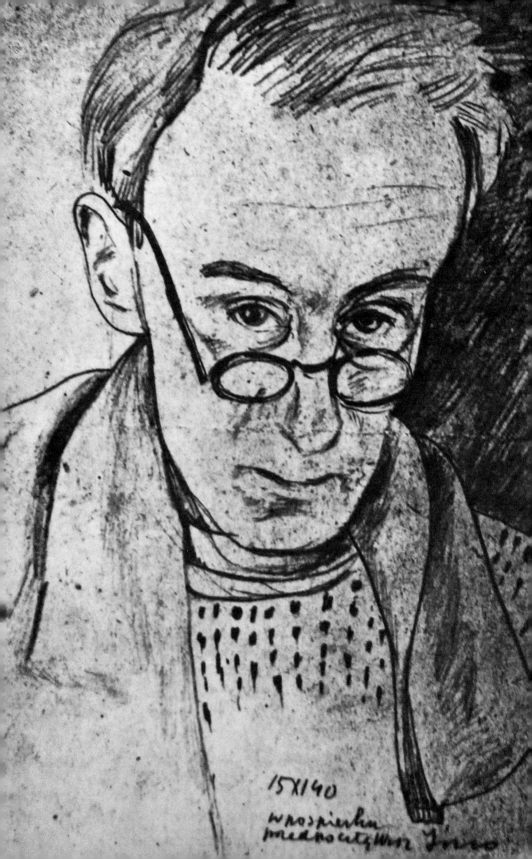

15.XI.40
w rospieku
...

Soldier, Prisoner, Survivor

1939—1945

4

On the morning of September 2, 1939, Józef Czapski gathered his gear, stuffed a small-print volume of the journal of André Gide into the pocket of his greatcoat, and walked to the Józefów train station. He was forty-three years old and had been ordered to report for duty at the barracks of the Eighth Lancers unit just outside of Kraków. He boarded a train heading south.

German forces had already captured one of the towns en route to Kraków, so Czapski was forced to disembark and walk more than fifteen miles to pick up a train on another line. He continued on that train as far as the tracks could take him, then hitched a ride in a truck, set out again on foot, boarded another train, and so on, improvising, getting from one point to another as necessity demanded. A journey of less than two hundred miles, usually requiring only four or five hours of travel, took thirty-six hours to complete. Along the way, he encountered his first casualties of war and watched as many German soldiers were taken prisoner. On the outskirts of Kraków, he saw his first bomb fall, striking a convent. When he finally appeared for duty at the barracks, he learned that he had been named chief of a squadron of reservists. Within a few hours his group was ordered to claim the cavalry's horses and then transported eighty miles to the east, to the town of Debica. By the time his unit arrived, Germans had already seized the stables and commandeered all the horses. As mobilization gripped the nation, men from all walks of Polish life were coming together, unified, passionate. Czapski would later declare that these days of intense fervor were rare, marking an unforgettable historical moment.

As early as March 1939, the German army—the Wehrmacht—had been put on alert for the likelihood of an invasion of Poland. For more than a year, the German minister of foreign affairs, Joachim von Ribbentrop, had been making overtures to the Polish government about forming a common alliance between the two countries to attack the USSR. These propositions were repeatedly rejected out of hand by the government in Warsaw, which was determined to maintain the existing nonaggression treaties with both Berlin and Moscow.

Offering alliance with one hand, Ribbentrop was busy gathering the names of prominent individuals who might pose a threat to Nazi subordination with the other. The list of sixty-one thousand Polish citizens he assembled in his *Sonderfahndungsbuch Polen* (Special Prosecution Book–Poland) represented death sentences. It would be the war's first officially sanctioned template for mass murder.

By August, Hitler's need of a military victory to inaugurate his anticipated conquest of Europe was coming to a head. "Hitler wanted his war that year," Timothy Snyder asserts in *Bloodlands*. "He was far more flexible about the possible allies than about the issue of timing. If the Poles would not join in a war against the Soviet Union, then perhaps the Soviets would join in a war against Poland." Hitler knew he could not fight successfully on two fronts. Toward the end of August, Stalin let it be known that he might consider joining forces. Ribbentrop was sent to clinch the deal. The German foreign minister was greeted warmly in Moscow at an airfield profusely decorated with a mixture of Nazi swastikas and Soviet hammers and sickles. Whisked off to Red Square, Ribbentrop was first introduced to his Bolshevik counterpart, Vyacheslav Mikhaylovich Molotov, then to Stalin himself, a rare privilege for a foreigner. Meetings were held between two implacable totalitarian regimes with the aim of negotiating a position of mutual nonaggression. A marriage of political convenience was resolved upon, whereby all of Europe would be divided neatly into a Nazi sphere and a Soviet sphere. Neither Hitler nor Stalin would abandon his scrutiny of the other's true intents, yet each side put great store in the formation of an elaborate fantasy of co-existence between their conflicting worldviews. Germany agreed to provide the USSR with technology, tanks, and munitions; the Soviets were to supply the Third Reich with oil, iron, grain, and other natural resources. The terms of collusion were formalized on August 23, eight days before the launching of Germany's September Campaign.

Molotov and Ribbentrop quickly agreed on the destruction of Poland. A secret protocol (known as Das geheime Zusatzprotokoll) was appended to the original terms of agreement, clearly stating that Poland, Latvia, Lithuania, Estonia, Romania, and Finland were to be divided between Germany and the USSR. The first item of the protocol authorized German control over twenty-two million Poles and seventy-three thousand square miles of the country, while the USSR was to assert its rights over thirteen million Poles and nearly seventy-eight thousand square miles, including vast tracks of eastern Poland with long histories of tsarist dominion. The second item of the protocol stated:

"The question of whether it is desirable to preserve an independent Polish state, and, if so, what the borders of this state would be, can be definitively clarified only in the course of further political developments." There was little doubt about how the question of desirability would be resolved. The concept of an independent Polish state was anathema to Nazi and Bolshevik visions of the future. The ensuing war was conceived to obliterate any such lingering illusions. For more than fifty years, until the collapse of the Soviet empire, the USSR denied the existence of this secret protocol.

What was set in motion during the early morning hours of September 1, 1939, began with a lie, establishing the tone for all that was to follow. Adolf Hitler addressed the German people: "This night for the first time," he proclaimed, "Polish soldiers fired on our own territory. We have been returning the fire, and from now on bombs will be met with bombs." The evening before, a farce had been staged in which Schutzstaffel (SS) soldiers dressed in Polish army uniforms attacked a German radio station, leaving behind the already dead bodies of German concentration camp prisoners. Distortion and fabrication were used to justify the call for self-defense. The Führer's strategy was often guided by instinct, and at this critical moment it served him well. Believing that neither Britain nor France would respond with any immediacy to an invasion of Poland, he gave the order for a deadly assault to begin.

One and a half million Nazi soldiers concentrated in armored columns began to spill over the Polish frontier across German, East Prussian, and Slovakian borders. Sudden death and destruction was delivered on the ground and from the sky: the blitzkrieg, a devastating "lightning war," focused on eradicating Polish troops, bridges, railroads, and civilians. At 4:30 a.m., Stuka dive bombers led the charge. At 4:45 a.m., a small military depot on the Baltic Sea was fired on by a German battleship. At the same moment, the Polish post office of the Free City of Danzig was besieged by SS units and members of the Danzig police. More than fifty postal employees trapped inside repelled the repeated attacks and put up a strong fight. For some twelve hours they refused to surrender. Following an onslaught of heavy artillery fire from armored cars, the postal workers descended to the lowest floor, underground. The SS commander ordered the basement to be flooded with gasoline, then tossed in a hand grenade. The fire that erupted ended the resistance. As the director of the post office finally exited the building, white flag in hand, he was shot on sight. The remaining men and one woman with a ten-year-old girl emerged. They were all imprisoned, judged by a Wehrmacht court, and executed as

illegal combatants. (The ten-year-old died of her wounds before the sentence was passed.)

The military defense of Poland rested on some nine hundred thousand soldiers in the infantry and air force; cavalry brigades accounted for ten percent of the Polish army. Another million men were called up from the reserves, but given the delays in mobilization, they had difficulty reaching their regiments once the invasion was underway; many reservists were reduced to going to war without weapons. The Polish army relied on 180 armored tanks, its air force on 420 planes. (In comparison, Germany had at its disposition 2,600 tanks and the Luftwaffe commanded more than 2,000 aircraft.) Active paramilitary groups had been long established and fought together alongside the professional troops. Ordinary Polish citizens had armed themselves, too. This act of civilian armed resistance, inflicting casualties on the invaders from the very beginning of the war, confirmed fears held by both the Wehrmacht and the Einsatzgruppen (special task forces). Their shared fear of civilian reprisal opened a path to cooperation between two forces whose territorial rivalry was normally fierce.

Poland certainly knew it could not win a war against Germany on its own. The Poles had put faith in their alliances with France and England, receiving sworn commitments from both governments to come to their aid. In the House of Commons, on March 31, 1939, Neville Chamberlain, the British prime minister, announced that "in the event of any action which clearly threatened Polish independence, and which the Polish Government accordingly considered it vital to resist with their national forces, His Majesty's Government would feel themselves bound at once to lend the Polish Government all support in their power. . . . The French Government have authorised me to make it plain that they stand in the same position in this matter as do His Majesty's Government."

In May 1939, France signed a pact committing French air forces to attack Germany immediately upon report of a German offensive against Poland. France vowed it would engage in troop warfare within fifteen days. Nevertheless, General Alphonse Georges, the commander in chief of the French army, made it quite clear to the French cabinet that there was no possibility of France taking any offensive action against Germany. By July, France's supreme commander of military operations, General Maurice Gamelin, informed the British Chief of Imperial General Staff Lord Gort, of his country's real intentions toward their Polish ally, saying that "we have every interest in the war's begin-

ning in the east and becoming a general conflict only little by little. We shall thus have the necessary time to put on a war footing all Franco-British forces." In August, the British MP Winston Churchill traveled to France and confirmed the French disinclination to honor its pledge to Poland. On his return to London, he declared that the British government was faced with a clear choice between war and shame. For the time being, the British found shame preferable. They would get war on even less favorable terms later on. Honoring their pledge to "feel themselves bound" to Poland, the British sent a mission of low-ranking officers to Warsaw to discuss what assistance might be offered in the event of an attack by Germany. Headquarters in London received a report asserting that the Poles were able soldiers, certainly strong enough to withstand Hitler's troops for several months.

As the confrontation drew nearer, France and Britain remained unwilling to sell arms to Poland. They proved equally unyielding in the matter of granting loans to help finance weapons manufacturing. Harnessing their resources for what finally began to seem to them an inevitability, Britain and France each made the strategic decision to fight only a defensive war, not an offensive one. Neither government saw fit to apprise their Polish allies of this change in status. Deprived of the knowledge of this significant policy shift, Polish leadership continued to count on France's deployment of ninety available divisions after fifteen days of withstanding German attack.

From the very beginning, the Polish plan of defense was conceived as a fighting retreat, with the Polish army holding out until a counteroffensive from France would force the Germans to withdraw firepower on Poland in order to protect their homeland. With 2,500 tanks and 1,400 aircraft along the largely undefended Rhine River, French forces were poised to attack Germany's vulnerable western front. They never did.

The invasion of Poland did not come as a surprise. But in order not to appear to be provoking Germany, general mobilization was repeatedly postponed. A secret call for mobilization circulated on August 24 was withdrawn. On August 27, the Polish commander in chief, Marshal Edward Rydz-Śmigły, issued more secret orders for his army commanders to report to their headquarters. Finally, on the morning of August 30, Rydz-Śmigły declared mobilization of all soldiers and troops. Immediately ambassadors from Britain and France pressured him to repeal the call. Given Poland's dependency on their support, he withdrew the order three hours later. By the following day, August 31, the need to move into action was too intense; over the protests of the Allies,

the mobilization call went out once more. Within twenty-four hours, the country was under attack.

On September 3, the day Czapski began his journey to Kraków, Britain and France each officially declared war on Germany. This prompt show of solidarity caught Hitler off guard. The German populace suffered its own shock. They had been promised an expanded empire but had not expected to live through another world war to achieve it. Having endured two days of ruthless bombardment, Poland celebrated. The announcement produced great expectations. Little came of them. Anglo-French declarations of war were followed by no logistical movement whatsoever. No Allied support was extended to assist the shattered nation. Despite the proclamations of outrage issued by England and France, war against Germany never began. Journalists around the world spoke of the "phony war." In the meantime, the most technologically advanced military force in the world unleashed a war of apocalyptic proportions.

A string of beautiful summer weeks had left the ground hard and dusty underfoot, perfect conditions for the navigation of armored vehicles and marching troops. Long, bright days with clear skies made sighting targets from the air especially effective. On September 7, the Polish government fled Warsaw. Fearing the imminent fall of the capital, the military high command followed three days later. The retreat was ordered by Rydz-Śmigły. This degree of faintheartedness, revealed so soon after the country had been invaded, delivered at best a mixed message to the fighting forces. How could the leadership abandon its headquarters at the moment when so much was at stake? Left to their own devices, under unimaginable odds, the Polish army and air force fought courageously for the life of their young republic. The retreat of leadership had a crippling effect on the ongoing defense of the country. A chain of tactical complications was set off by Rydz-Śmigły's withdrawal, resulting in ruptured lines of communication and, ultimately, the devastating loss of a secure chain of command. Vastly outnumbered, the Polish units were nevertheless successful in achieving the immediate objective of withstanding fourteen days of invasion, at which point they expected to receive Allied support. Residents of the capital city, stripped of the supporting presence of government and army, fought on in the face of dwindling food and water supplies. Warsaw simply refused to surrender. The city sustained three and a half weeks of incessant bombing. Finally, a frustrated Hitler demanded the city be taken. On September 25, more than five hundred tons of bombs fell on the Polish capital. Many thousands of civilians were killed.

The first country to withstand the explosiveness of Hitler's ambition and wrath, Poland was not, as is still sometimes suggested, unprepared for war or operating under outmoded principles of warfare. But in every conceivable calculation of manpower and materiel, the country was dwarfed by its western neighbor. Nonetheless, in the weeks to come, Poland, with very modest means, would inflict greater losses on Germany than Britain and France *combined* when Hitler unleashed his lightning war on them nine months later. Fifty thousand German soldiers were wounded or killed in the September 1939 campaign, nearly seven hundred German planes and a quarter of the tanks committed were destroyed. At no time could Poland have held her own against Germany; there are no "if onlys" about this. But the country might have had more of a fighting chance, and battled longer against Germany, if it had not suffered one more crippling blow: On September 17 another invasion was launched against Poland, this time by its eastern neighbor, the Union of Soviet Socialist Republics.

Czapski would recall these events in his memoir *Wspomnienia Starobielskie* (Memories of Starobielsk). The opening of his book sets the mood: even-toned, perceptive, stoic, wounded by betrayal. He describes the Soviet invasion of Poland just sixteen days after the Germans had overrun the country:

> On September 17, 1939, the Soviet army, without declaring war, burst into Poland at the very moment the country was defending itself as a last recourse against invasion by Hitler.
>
> This aggression from the east happened at the moment we were attempting to organize a final resistance in five districts situated in Poland's southern mountains, near Romania, then allied to us. Inaccessible to tanks, this area provided possibilities for prolonging the battle by means of transforming it into ongoing guerrilla warfare.
>
> This unexpected aggression on the part of a neighboring country with whom we then had no dispute and with whom we had signed a nonaggression pact was a classic coup de grâce, a stab in the back that accelerated the collapse of our last holdout against two totalitarian powers.

Astonishing reports kept pouring into Warsaw that the country's eastern frontier was being violated. Polish intelligence was nonplussed: Russia had no reason to act aggressively toward them. (The treaty between Hitler and Stalin had remained secret.) The shock, severe and incapacitating, led to a

fatal breakdown in the Polish command. "What are the Soviets up to?" was the immediate disbelieving question. At 4:00 a.m. on September 17, hours before slipping out of the country, Marshal Rydz-Śmigły issued a general order commanding Polish forces not to initiate fire against the Soviets, only to return it. This order would not be widely distributed; communications were wholly unreliable. A state of chaos ensued for most of the day, with commanding officers reduced to issuing instructions to their men without higher authority. At first, the rumor spread that the Red Army had come to offer assistance to the beleaguered Poles in their mutual fight against the German fascists. Having waited in vain for British and French support since the Nazi invasion on September 1, the arrival of the Russians momentarily appeared as a godsend. Had the Red Army, nearly one million strong, really come to the aid of Poland? Those troops who did receive the marshal's general order approached the Soviet soldiers in a cordial manner. Mayors of several towns released proclamations encouraging their people to welcome the Bolsheviks as friends.

This illusion of anti-fascist solidarity disintegrated all too quickly for troops on the eastern border. Across a span of nine hundred miles, seven Soviet field armies surged forth like a hammering storm of firepower. Five thousand tanks crushed whatever was in their path. Marching into eastern Poland, Soviet soldiers arrested Polish soldiers and civilians and shot point-blank many who resisted.

The signing of the German-Soviet Nonaggression Pact freed Hitler to move against Poland. He expected a Soviet attack on the country's eastern border to follow in a matter of days. Ironically, the Nazi invasion sparked outrage from non-Soviet communists around the world who were unaware of Stalin's subterfuge with Hitler. Indignant French and Belgian communists railed against the German war machine and encouraged organized resistance, declaring solidarity with their victimized Polish brothers. With swiftness and steel-like resolve, Stalin offered a Machiavellian response to his confreres. Members of the Comintern would have to toe the line behind Soviet Russia. The ideologic theater of war had shifted; old slogans from the days of the popular front would no longer be tolerated. The distinction between fascist and democratic capitalist nations had ceased to matter. As Stalin explained,

> We don't mind if they strike mightily at each other and weaken themselves. It would not be bad if Germany were to destabilize the position of the richest

capitalist countries. Hitler, without understanding it or intending it, is smashing and undermining the capitalist system. Poland is a fascist country that oppresses Ukrainians, Belorussians and other nationalities. Under present conditions, its destruction would mean one less fascist state. What would be wrong if, following the defeat of Poland, we were to expand the Soviet system over new territories and new populations?

The Comintern scrambled to produce updated guidelines, requiring non-Soviet communists to renounce the positions they had taken a few days earlier. The official party line now claimed that "the international proletariat cannot defend fascist Poland, which has rejected the Soviet Union's aid and which oppresses nationalities."

Stalin's delay before attacking Poland was hardly caused by the need to clarify internal communist policy. He was playing a waiting game, watching to see if France and Britain would engage in battle with Germany. If Hitler was forced to defend his western border, such distraction would allow for greater Soviet dominance in Poland. Another factor of restraint was the Soviet Union's ongoing war in the Far East. Stalin was willing to commit troops to the invasion of Poland only after a concentrated Soviet offensive on September 15 resolved the standoff with Japan. At 2:00 a.m. on September 17, Poland's ambassador to the Soviet Union, Wacław Grzybowski, was awakened from his sleep in Moscow. A summons had come for him to appear immediately in the office of Vladimir Potemkin, the Soviet deputy minister of foreign affairs. Reporting at once, the dazed ambassador heard a proclamation of intent read aloud to him. He was stunned to learn that in a matter of hours the Red Army would cross into Poland. "Mr. Ambassador!" the document began,

> The Polish-German War has revealed the internal bankruptcy of the Polish state. In ten days of hostilities, Poland has lost all its industrial regions and cultural centers. Warsaw no longer exists as the capital of Poland. The Polish government has collapsed and shows no sign of life. This means that the Polish state and its government have, in fact, ceased to exist. . . . Left to its own devices and bereft of leadership, Poland has become a fertile field for all kinds of accidents and surprises which could pose a threat to the USSR. . . .
>
> Nor can the Soviet government remain indifferent to the fact that its kindred Ukrainian and Belorussian peoples, living on Polish territory, are abandoned to their fate and left unprotected.

Grzybowski refused to accept the official letter Potemkin tried to force on him, insisting that Polish forces were still actively engaged in combat and that the government, though not in Warsaw, was nonetheless far from moribund. Stalin justified his assault on Poland with a lie, much like Hitler's fabrication that Polish forces had attacked Germany. Copies of this letter were sent to the heads of all the foreign embassies in Moscow. Molotov read the text of the letter on a radio broadcast later in the day. No mention was made of the Soviet alliance with Germany. The smoke screen was entirely effective, claiming that Russia was obliged to stand up and protect their "brother Belorussians and Ukrainians." Order would be restored, Molotov vowed, peace would reign again. The Red Army would keep their "brothers" from "the threat of ruin and massacre by their enemies." (The cowardly flight of the Polish government and high command lent some credibility to the Soviet claim of the existence of a vacuum. However, in a matter of days, the leaders who abandoned Warsaw arrived in Paris. On September 30, a new government, a Polish government-in-exile, was formed under the leadership of General Władysław Sikorski.)

A correspondent from *The Times* of London sent out a dispatch that morning: "The invasion is not regarded in Moscow as an act of war, because according to the Soviets the Polish state has ceased to exist." Being careful to underplay the hostility of their intent, the Russians constructed a pretext that enabled them to march into Poland under the guise of protecting threatened citizens. Expressed in diplomatic rhetoric, this ruse was unjustifiable to Grzybowski. In his account, Czapski points out that Russia never declared war on Poland. In time, this protocol would prove to have grave consequences for Polish people everywhere.

Red Army soldiers invading eastern Poland were subject to a shock of their own. Crossing the frontier on nearly lame horses, many were riding without saddles, and many infantry soldiers had no shoes. Compared to what they knew materially from their lives back home, the fighting Bolsheviks were dumbstruck by what they found in the eastern provinces, Poland's least economically developed region. Led to believe they were fighting to liberate a hardworking population from the harsh yoke of Polish nobility, the Red Army soldiers found themselves among poor country people blessed with a far higher standard of living than they had ever known. Polish peasants had well-fed cows and horses, their orchards were ripe with summer fruit, their larders stuffed with eggs, butter, cheese. Since the advent of collectivization, Russians

no longer knew such riches, everything they raised or grew belonged to the state, not to them.

As Czapski wrote in his memoir: "For eighteen days a country of thirty million inhabitants waged war with the armies of two states of eighty million and one hundred-sixty million. The war ended on October 5 with a three-day battle near Kock, a battle that involved two infantry divisions, a cavalry brigade, and various other detachments. The final battle lasted until our ammunition was completely exhausted."

German and Soviet forces overwhelmed the Polish army, separately and cooperatively. Marshal Kliment Yefremovich Voroshilov, People's Commissar for Defense, ordered his Red Army commanders to assist the Wehrmacht authorities whenever asked. German and Russian armies assaulted the largest units of Polish troops in tandem. One of the main objectives of the Soviet incursion was to dismember the military structure of Poland. Another was to seal the country's eastern and southern borders, to keep the Polish army, especially its officers, from escaping, as the Polish government had just done. Within days, a substantial Russian presence massed along the frontier. Declaring that Poland no longer had legal or political viability, the USSR claimed the Polish lands they occupied as Soviet territory. Since war had never been declared, the status of the Polish army was irrelevant. Polish soldiers were looked upon as common citizens, subject to Soviet penal codes, not military ones. Officers and soldiers alike were thought of as part of a criminal element, enemies of the people, counterrevolutionaries. To claim to be a Polish soldier or officer was a treasonous offense, an act of resistance against Soviet law, and therefore susceptible to the full recourse of justice.

In just twelve days the Soviets occupied all the land to which Stalin had laid claim. Molotov was jubilant. Poland had "ceased to exist." In Moscow, Stalin monitored Hitler's compliance with the territorial division of Poland as set out in the German-Soviet Nonaggression Pact. When he learned that German troops had already begun to lay siege on Lwów (Lviv), far to the east of the agreed-upon lines of demarcation, he was furious. Soviet troops were quickly diverted to the city. The Wehrmacht fell back. Facing a lose-lose situation, the Polish commander at the battle for Lwów, General Władysław Langner, opted to surrender to the Soviets rather than to the Germans. Czapski and his unit, in disarray near Lwów, were surrounded and forced to surrender. The Germans had been their enemy on the field of battle, but they were turned over to Soviet forces as prisoners:

97

I myself was captured at Chmielek, on the outskirts of Lwów, on September 27, along with two reserve squadrons from the Eighth Regiment. With the two reserve squadrons of the Eighth Regiment, without horses, almost without arms, we had roamed for some days, first withdrawing toward the east, then making long detours westward. We were finally surrounded by Soviet tanks and artillery.

The Russian truce negotiators conducted themselves in the same way as those at Lwów. It was evident that they had received the same instructions. They assured us that the soldiers of our regiment would be free (it is verified they did the same elsewhere) and that the officers would be taken to Lwów where they would be released.

I realize only today, in writing this, how totally blind we were to the designs the Soviets had on us. The stab in the back came as a surprise to most of us who were already exhausted from incessant battle conditions, or worse, by ongoing retreat. Our troops had received orders that were contradictory, whose authenticity was questionable—such as those telling us not to engage in battle with the Soviets. We were badly shaken by the news of bombardments and the destruction of Warsaw, and that the capital had been abandoned by the president of the republic, the government, and the commander in chief of the army. My detachment learned of this by radio on the twenty-seventh. The men were hanging by a thread, desperate for something hopeful. Perhaps the Soviets, who hardly stood to gain by a victory for Hitler, would at least facilitate our passage to the border so we could take part in future combat, not in Poland, where for the time being the battle was lost, but in France. Thousands of political agitators tried by every means to maintain this feeble hope.

Officers of my regiment were relieved of their weapons. We arrived at various staging points, going first on foot, then by truck to Lwów, where we were due to pass the night in the half-destroyed barracks of the Fourteenth Cavalry Regiment. Night was falling as we arrived in the city. Long unwashed and unshaven, we had been crammed into trucks. A brief stopover was made in the Market Square, and the truck I had been loaded on was parked next to a stall selling fruit. One of our men wanted to buy some apples and asked how much they cost. While pretending to take the money offered, one of the women vendors was accosted by another, a robust woman who yelled out in indignation at her neighbor. Her eyes gleaming with tears, she then proceeded to grab as many apples as her large brown hands could hold and began tossing them into the back of the truck. This all took place in an instant. Before the Bolshevik

soldier who was guarding us had caught on, we were showered with apples and cigarettes by merchants and passersby.

The truck was then moved to in front of the main post office. Night had fallen. We were heavily guarded by Red Army soldiers who brutally shoved aside anyone who attempted to make their way over to us. But all of a sudden, as if from everywhere, women ran up to the truck, indifferent to the threats of our guards, in defiance of their bayonets, and took from us the letters we were holding out to them that we had scribbled to our families. They gave us cigarettes, even chocolate! What surprised me was this spontaneous spirit, kindled in the street, these manifestations of fraternity and thoughtfulness toward a cluster of profoundly humiliated, disarmed Polish officers squashed together in the back of a Soviet truck.

Susceptible to international scrutiny, the Wehrmacht entered the war with ready-made plans for the containment of prisoners of war. From this practical standpoint, the Red Army was almost entirely unprepared. In a matter of weeks, nearly two hundred thousand Polish prisoners had been taken. Herded from place to place in extremely crowded conditions, they were fed irregularly and poorly, if at all. Forced to sleep on the cold ground, the men were deprived access to latrines. Moved in continually re-forming groups from one deplorable transit camp to the next, they received inconsistent treatment from Red Army jailers whose behavior ranged from bad to brutal. Robbery and provocation was common; on-the-spot executions were not uncommon. The 1929 Geneva Convention standards of behavior for prisoners of war were entirely ignored. Unlike Germany, Russia had never endorsed the Geneva agreement and refused to recognize the Hague Conventions. Only on September 19, two days after Red Army forces had already crossed into Poland, did the politburo decide the fate of its imprisoned Polish soldiers. The NKVD (People's Commissariat for Internal Affairs), rather than the army, would oversee them. In this way, internal security police became directly involved in military operations.

Lavrenty Beria was the commissar of Soviet security forces, the chief minister of the NKVD. A close associate of Stalin and on occasion an intimate friend, he was also a fellow Georgian. He is credited with having replaced his predecessor's depraved fanaticism with a far more rational system of terror and cruelty. Beria established a separate bureau within the NKVD to superintend the administration of prisoner-of-war affairs. The Soviet Council of Ministers then drafted their own pro forma document, "Regulations for the Treatment

of Prisoners of War," which recognized humanitarian concepts and specified decent living conditions. Laden with the duplicitous language that was characteristic of the well-oiled Soviet machine, it was an entirely calculated document, understood within the Soviet power base as a deceit to placate the fears of bourgeois governments.

From the beginning of their captivity, Polish rank-and-file soldiers and their officers received distinctly separate treatment by the NKVD. From the Soviet point of view, Poland's superior officers, drawn from a society of decadent landowning nobles, needed a more punitive set of constraints. The Bolsheviks would teach them about the hard life of the proletariat. At various transfer points and distribution camps prisoners were searched, registered, and separated into specific subgroups. High-ranking officers, state officials, and policemen were ordered to dig latrines and keep them clean. The technique of humiliating officers in the eyes of their subordinates was a standard Soviet ploy, meant to kindle the spark of rebellion in the younger soldiers, to turn them against Poland's feudal class system. The exercise proved largely ineffective and repeatedly backfired. At the sight of their commanders' degradation, Polish soldiers consistently responded with compassion, identifying powerfully with their superiors. The overall morale of the prisoners improved because of this identification, surprising and confusing the Russian guards. In the first weeks of the war, Soviet attempts to overturn the collective will of the Polish troops, to entice the rank and file away from their overlords, to absorb them into an expanding brotherhood of Red Army soldiers ended in failure.

Early September's glorious summer weather gave way to torrential rain. By the first week of October, after having been held a few days and shunted from place to place, Czapski and his group of fellow prisoners were paraded through the mud into the town of Tarnopol (Ternopil), where they encountered flags and signs welcoming the Red Army. As they left the following morning, an old woman, tears streaming down her face, stepped off of a rickety cart and insisted the prisoners take her blanket and overcoat. This futile gesture, clearly prompted in response to a feeling of helplessness and compassion, gave Czapski an emotional foothold, one of many he would recall and use to balance the record of his ordeal of captivity.

In long columns, pushed on by belligerent guards, the straggling soldiers endured a forced march to the Soviet border. Hunger and exhaustion caused many to faint. Shuffling along a thoroughfare that had once served as a route

of holy pilgrimage, they passed statues of saints that had been desecrated by anticlerical forces during the Bolshevik revolution. With increasing frequency they would encounter other seemingly endless columns of men. After mile upon mile of walking beside fields of golden stubble, the men slowed their pace to a crawl as the columns backed up, waiting to cross a single narrow bridge.

5

ENTERING THE SOVIET UNION, slouching toward an unknown future, the Polish prisoners of war crossed the border into enemy territory. The first town they passed through was Volochysk (Woloczyska), a squalid village full of ramshackle houses, its streets paved in shattered cobblestones. No one was around, the place seemed deserted. In the town square, a single flickering red neon bulb illuminating Stalin's profile offered the only evidence of the great Soviet plan for rural electrification. The bleak surroundings were a preview of what was to come, a psychologically charged moment intensified by the dreadful conditions under which they were confined as prisoners:

> Pushed to the straining point, morally and physically, pursued by cruel autumn frost, we two thousand officers were squeezed into two stables already packed with two thousand soldiers. It was our first night on the far side of the Polish border. Reduced to a rabble of men packed into a shed, we were dulled by unhappiness, all morale beaten out of us. We were plunged in darkness and, with the doors closed, the air became unbreathable for those stuck deep inside. If the door was cracked open, the cold was too intense for those near the front. This gave rise to sharp exchanges: "Shut the doors!" "A foul smell never killed anyone." "Open the doors! We can't breathe in here." "Those guys were raised in pigsties." This bickering and quarreling went on back and forth in the pitch-dark, a sign of our state of deep humiliation.

Once a day, each man received a cup of thin soup. After a week of being penned together in the stable, they were put on the move again, led around the periphery of innumerable villages in order to minimize contact with the local townspeople. At an isolated train station, their overland march came to an end. Prisoners were divided into groups and packed in the windowless wagons of a train more than one hundred cars long. The train sat in the station in the dark. The waiting began. Every few hours, the men could hear the arrival

of more prisoners, the shouted orders of guards, and the loading of more cars. They had no means of seeing what was going on outside the confines of their cramped quarters. Late the following day the train departed the station, though once in motion, travel was only ever fitful at best. Periods of lumbering progress alternated with interminable delays. In the Soviet hierarchy of train transportation, prison cars had very low priority; trains moving Red Army soldiers took precedence, followed by freight cars carrying military equipment and supplies. Crammed together in airless boxes with no room to move, the men had no facilities in which to perform their bodily functions. At some stations along the way, the prisoners were fed; the rest of the journey they went hungry. They were given no water.

In Czapski's memoir, his vignettes of men living in confined spaces under physical and emotional strain add a feeling of human warmth, a quality often lacking in such circumstances. Writing about others allowed him to deflect his gaze from his own preoccupations and limitations. Unable to paint, he creates a gallery of written portraits.

Lieutenant Ralski, a naturalist, a professor at the University of Poznan, and a reserve officer of the Eighth Regiment of Uhlans, was among the "travelers" in my car. He and I had spent the entire month of September together in the reserves squadron of our regiment. I did not know Ralski before September. At first sight he looked like a boy, with no military bearing about him. He had, nonetheless, an exceptional solidness of character that made a deeply uplifting impression on his men. Nothing disturbed his composure. As we were being shunted across the snowy steppe of Ukraine, chilled to the bone and starving, unaware of where we were headed, Ralski was able to forget the reality around him and direct his passionate, scholarly observation toward the landscape and any tips of grasses sticking up through the snow. He made a point of telling me that the sight of these grasses interested him to such a degree that he felt a deep joy. Having read about the grasses of the Ukrainian steppe, he was now finally able to see them. On this trip, the idea came to him of publishing a popular guide to the grasses of Poland, and as soon as we were settled in one place, he began to write it. During the September Campaign, when we were forced to scatter from the road because we were being strafed by the Luftwaffe, Ralski would entertain us with inimitable stories of the invasive species whose seeds had been carried to Europe from Canada, grasses that grew with abandon in the ruts where we sought shelter.

103

Arriving in the city of Kharkov (Kharkiv), Czapski's convoy was split into three groups. His name appeared on a transport roster with eight thousand others headed to a prison camp at Starobielsk, in far eastern Soviet Ukraine, several hundred miles north of the Black Sea. From Lwów, where he was captured, to Starobielsk was a distance of nearly one thousand miles.

We arrived at Starobielsk at the beginning of October. Snow was already heavy on the ground. We were surrounded by police dogs and driven over the wet snow through the streets of the town, between rows of earthen huts and tumbledown cottages covered in thatch. A child ran out of one of the houses and sweetly offered us a watermelon.

Behind the low, closed windows, watchful and pitying faces of men and women followed us as we made our way. I remember one of these women, white-haired, with a sad and faded face. Her intelligent, mournful eyes watched us from behind her glasses. I learned subsequently that many members of the Russian intelligentsia who had been deported from their homes in Russia's large cities were to be found in Starobielsk.

Upon arrival, most of us were housed in the buildings of an old convent, on a site that was to be converted into our camp. Others, who were unable to find a place (I was among these) were locked up in a large building in the center of town.

Several hundred of us were guarded there, either in a walled courtyard, in four cramped rooms, or in a shed where strange old carriages were kept, where the floor was strewn with scraps of filthy paper, torn-out pages of books and newspapers from some destroyed library.

All this dirty paper littering the floor proved our salvation. At night the cold kept us awake, so we devised a special system for sleeping. We pressed ourselves up against one another, having only one tattered blanket, on top of which we piled bits of this paper, which protected us from frost. Nevertheless, I was unable to tolerate such a low temperature, so I snuck into one of the four rooms packed with prisoners, where lice devoured us, and where we were so numerous that, sitting or curled up, it was impossible to move. But at least this way I didn't suffer from the cold.

After a week, I was sent over to the actual camp, surrounded by walls that enclosed an area of about fifteen hectares. An indescribable chaos still reigned. The grounds of the convent had once been a famous site of pilgrimage. A large Russian church with broken crosses was being used for storing wheat. During

our stay, a steady stream of trucks and wagons would arrive from all around the neighboring countryside depositing wheat. We were told that it was being stored to send out in the winter—to Germany. Another smaller Orthodox church in the camp was filled with prisoners on wooden bunks stacked way up, like a scaffolding that reached almost to the ceiling. In addition, thousands of officers and soldiers lived in several of the convent's small outbuildings. The men slept on benches, on the ground, in the corridors, everywhere, wherever there was a spot.

Thousands of lice-ridden men, clothed in rags, were locked up in the camp in the course of a snowy and glacial winter. It was impossible to house everyone under a sheltering roof. At the beginning, in Starobielsk, tents were erected, organized in a very primitive fashion. Neither baths, nor medical dispensary, nor delousing facilities existed, and food was always insufficient. By contrast, there were loudspeakers everywhere, as was true throughout Russia, that end-lessly spewed propaganda in a raucous voice. Anti-Polish diatribes were inter-woven with … Chopin. These fragments of études, nocturnes, and sonatas, even broadcast from such a sinister apparatus, dazzled us, and touched us profoundly.

We were terribly cramped at the beginning of our incarceration at Staro-bielsk. The whole mass of men was reduced to despair and overwhelmed by humiliation. To begin with, each of us felt alone and imprisoned in his misery. We were bombarded with distressing news at this point, about the total destruc-tion of Warsaw, where many of us had left family behind. There were reports of hundreds of towns and villages burned to the ground. Every day brought reports of innumerable calamities against Poland, the loudspeakers blaring endlessly, demeaning anything that was Polish.

Our only comfort was the close companionship that was soon established among those of us who had made it through the hardest weeks of September together. But this did not please our prison guards, who went to lengths to separate us from each other, moving us back and forth from one place to another. For several weeks, after I left the shed for the camp, I was bereft of my friends from the Eighth Regiment. Torn away from a milieu with which I was familiar, I was transferred to the camp, bunking at first in one of the vast redbrick buildings, in a room alongside several dozen commanders and cap-tains. Before the war, I had managed to create for myself work conditions that allowed me to pass the majority of my day in total solitude, while the remainder of the day I spent in the company of my loved ones. Camp life, living among

strangers pushed up against one another, proved to be a great ordeal for me. Lack of privacy weighed more heavily on me than the filth, the hunger, or the vermin.

Like many of the hastily configured prisons and labor camps of the Soviet Gulag system, the NKVD prison at Starobielsk was carved out of the neglected remains of a former religious community, untended since the Russian Revolution twenty-two years earlier, a time when the destruction of all religious orders was aggressively enforced. Having served as a fortification in an earlier century, the crumbling walls encircling this monastery no longer provided a sufficient barrier to keep people from coming in. But operational concerns had changed; the role of fortification now was to keep people from getting out. To this end, huge tunnels of coiled barbed wire were laid around the exterior's perimeter and ten observation towers equipped with machine guns and searchlights were erected to watch over the site.

Between the end of September and the middle of November 1939, more than eleven thousand Polish prisoners of war were pressed into this compound of derelict structures that could not possibly contain them all. Most of these men were privates or noncommissioned officers, many were young military cadets. Nearly half the prisoners had been taken as part of the capitulation at Lwów. Upon arrival, all the officers, in a breach of international protocol, were assigned to hard labor. Work details, on rotation, were uniformly rigorous—moving hundred-pound sacks of barley and flour over long distances, unloading freight cars, hauling materials onto trucks, gathering wood in the forest, carrying water in heavy buckets from a well to the kitchen, moving mountains of bricks, lifting mammoth logs onto flatbed railcars—and meant being away from camp all day without food. Workers were marched to their sites under heavy guard, snaking along the rutted back roads to avoid contact with inhabitants of the town. At the beginning of their incarceration, some men found the prospect of performing physical labor a welcome release from the immobility imposed by their overcrowded surroundings, but a few weeks of backbreaking work left most of them exhausted. Unaccustomed to such relentless exertion, many were pushed to the brink of collapse.

In the morning, there was usually porridge, frequently inedible. Sometimes in the evening, potatoes, cabbage soup, or salted fish would be served with a ration of black bread. More often a metal tin of liquid was what passed for a meal, water in which the frozen carcass of a fish had been boiled. A supple-

mentary ration of "dry goods" was given to each prisoner on an irregular basis—a few cubes of sugar, some tea, cigarette papers, and low-grade tobacco. Unlike the abusive withholding of life support experienced by Nazi work-camp inmates, these harsh and primitive conditions of camp life could not be attributed entirely to strictly punitive measures. Seen in the larger perspective of an impoverished standard of living throughout Soviet Russia, privations at Starobielsk were relatively moderate. Despite hardships, which were substantial and intense, the camp was meant to provide a compelling setting in which the NKVD could fulfill its objective of indoctrinating individuals to the communist cause.

At the end of October, an executive decision was handed down from Moscow. Two prison camps—one at Kozelsk in Soviet Russia and another at Starobielsk in Soviet Ukraine—would be reconfigured to accommodate only officers, with the addition of forty-five military clergymen. A third camp, located near Ostashkov, two hundred miles northwest of Moscow, was designated to hold even more officers, as well as members of the Polish military police and military cadets, frontier guards, and those involved in intelligence work. All three of these camps would be operated along the same lines of procedure and principle. Twenty-two thousand Polish officers would be distributed among these three camps—Starobielsk, Kozelsk, and Ostashkov—but Moscow looked upon their inhabitants as a single pool of prisoners.

Once the decision was made to isolate officers from rank-and-file soldiers, camp life at Starobielsk changed considerably. The immediate benefit was relief from severe overcrowding. The camp population dropped from eleven thousand to four thousand prisoners. Significant improvements began to be made under the careful guidance of one of the highest-ranking Polish officers, a fluent Russian speaker, Major Sobiesław Zaleski. An engineer by training, Zaleski was continually negotiating with the Soviet power base, lobbying on behalf of the Polish prisoners for the materials needed to carry out much-needed upgrades. Under his guidance and encouragement, crumbling edifices were repaired and new structures built for housing. A kitchen and shower facilities were erected, laundries established, latrines were improved and expanded. Three new wells were drilled, and the camp's whole electric plant was revamped and monitored for safety. NKVD authorities recognized that having prisoners work as laborers to improve their own living conditions would result in more efficient productivity as well as substantial savings. Accordingly, senior Polish staff was given a fair amount of internal autonomy in such matters.

Under official Soviet supervision, Polish prisoner-doctors were granted oversight of medical care and camp hygiene. A first aid station was organized, as well as a dental clinic and a makeshift hospital with fifteen beds, though virtually no medications were available.

The idea of rebuilding morale through a series of evening lectures was first developed at Starobielsk: "We tried to take up a kind of intellectual work that would help us to overcome our depression and anguish, and to protect our brains from the rust of inactivity. Several among us began to organize military, historical, and literary lectures. This was judged counterrevolutionary by our overseers at the time, and some of the speakers were deported immediately to unknown destinations."

The threat of deportation for transgressions of rules loomed darkly over the men. On the first Sunday following their arrival at Starobielsk, many prisoners had attended a makeshift Catholic mass in their respective barracks. Such a manifestation of religious faith was promptly crushed by the authorities. Camp regulations explicitly limited their personal activities, singling out all forms of prayer, song, meetings, and lectures for prohibition. Reading aloud was forbidden. Sundays and Polish holidays were treated as workdays without exception. Men could not enter any building except for the one where they slept, and they could not congregate in groups outside. No more than two or three men could walk together anywhere on the grounds of the camp. Leaving one's barracks after dark was not allowed, and electric lights, weak as they were, had to be kept on all night. To be caught writing in a diary or taking notes of any kind was grounds for punishment. In spite of these proscriptions, Czapski reports that "the series of lectures was not curtailed but carefully given in secret instead." The men found creative ways of adapting to all the constraints: army chaplains heard confession in undetected corners and gave Communion discreetly. Every night in the barracks, at nine o'clock, a voice called out and all activity ceased for three minutes of communal silence. Evening prayer as a form of resistance was a very old tradition in Poland's long history of oppression.

At the twice-daily roll call, the men were addressed as "former officers of the former Polish army." To speak to the camp leadership in Polish was looked upon as a "refusal to obey orders." Many officers had a working knowledge of the Russian language from their school days, when a third of Poland was partitioned under tsarist rule. Young NKVD interns, known as *politruks*, circulated freely at all hours among the prisoners. Everyone understood that

these recruits were sent out to make reports on what they saw and heard in the barracks and around the camp grounds. Any attempt on the part of the *politruks* to influence the political consciousness of the prisoners was essentially ineffective. NKVD files chronicled this failure, attributing it to the prisoners' unfailing belief that Poland would revive. Attendance was mandatory at scheduled propaganda talks, but the men talked back to the *politruks* who led the discussions. Newspapers approved for circulation were not generally read but torn into strips to use either for rolling cigarettes or as toilet paper. (Paper in the Soviet Union was a highly coveted material, even in its most prevalent form, an extremely low grade of processed pulp that resisted ink and tore when written on with a sharp pencil.) The few glimpses of Russian life the men saw outside the camp reinforced their resistance to Bolshevik agitprop.

A sound system rigged throughout the entire camp broadcast continually from seven in the morning until midnight, day after day. Soviet news bulletins and programs glorifying the Bolshevik soldiers and laborers were aired while Polish culture, the Polish government, the Polish people, and the Polish army were demeaned and vilified. One night at the end of October, the wavelength was switched to Govorit Moskva (Moscow is speaking) and news of the alliance between Hitler and Stalin was made public. "With the fall of Warsaw," the commentator announced, "the Polish campaign is ended. There can be no question of restoring the old Poland."

No place in the camp grounds was beyond reach of the speaker system. Mounted in the farthest recesses of the barracks, the hulking speakers had no knobs and could not be switched off. The relentless noise was not entirely unwelcome, since it did bring news from the outside world and gave the men information to ponder and digest, to argue about. Programs of musical selections were also broadcast, offering unexpected relief, a momentary feeling of escape. In particular, the music of Frédéric Chopin, immediately identified with the indomitability of the Polish spirit, elicited an intense response. Both Nazi and Bolshevik propaganda exploited the music of Chopin, targeting it as a means to different ends. Wanting to deprive the Polish population of any solace Chopin's seductive melodies might produce, the Germans strictly prohibited playing or listening to the music of Chopin throughout the Reich, a law enforced with a special brutality in German-occupied Poland. In contrast, the Soviets felt no such compunction and broadcast performances of his music regularly. From their vantage point, Chopin's music—equal parts balm and distress—left the prisoners agitated, more vulnerable to psychological

manipulation. Or so the authorities thought. Penetrating directly into the hearts and souls of the prisoners, Chopin's music, like prayer, helped generate a dynamic resolve in the face of callous subjugation.

> At the same camp in Starobielsk, as we were wading through the snow with buckets of soup for our comrades, or carrying wooden beams, we would suddenly be hit full-on by a radio wheezing out scraps of Chopin's "Revolutionary Étude," or the Polonaise in A-flat major, and we felt as if this music were being played for us alone, being heard in secret by us alone, as if it had been written just to help us, as if we had rediscovered ourselves through this single rhythm, this single beat that united us all.

The Bolsheviks were methodical record keepers. Upon arrival at the camp, each prisoner was fingerprinted and photographed: one full-face exposure followed by left and right profiles. Every man was required to fill out a printed form targeting specific details about his life, work, and family background. They dreaded the idea of being interrogated, one of the most harrowing aspects of prison life. No one was immune. Prisoners would be summoned by guards in the dark of night and led from their barracks to an interrogation cell. Disturbed from sleep, dragged from bed, forced to dress hurriedly, pushed about by guards with bayonets—all these measures were choreographed to manipulate the prisoner and amplify his sense of defenselessness and fear. Interrogations unfolded over several hours, often lasting until the light of dawn began to appear in the sky. Questions centered chiefly on the prisoner's political outlook, his party affiliations, his attitude toward the USSR. Various methods of examination were used; each interrogator had his own personal style. Some were masters at exerting psychological pressure on frightened subjects, testing their willingness to cooperate as informers. A prisoner might be asked to sit or told to remain standing. The interrogator would smoke—he might offer the prisoner a cigarette, or not, maybe some tea, or not. One interrogator might strike a pose of refined politeness, acknowledging the prisoner's humanity. Another would resort to shouting, using threats, brandishing a revolver and slamming it down dramatically.

NKVD interrogators varied greatly in skill. Though violence was not resorted to in these sessions, they had been trained in the art of inflicting physical torture. Most had no knowledge of Polish, many were barely literate in their own language. Ignorant of the larger world Polish officers called home,

interrogators would usually attempt to confuse a prisoner by asking questions about apparently unrelated subjects on the chance of tricking him into confessing to something he had not expected to have to defend himself against. They often had at their disposal a surprising wealth of information about a prisoner, much of it personal in nature. Men might be summoned before an interrogator several times over a period of months or called every night for two or three weeks. A silent subordinate was almost always present in the room during an interrogation. Notes were methodically taken. A dossier was kept on every prisoner, recording his responses to the interrogator's remarks, as well as all the dates and times of their encounters. Interrogations were considered highly confidential. Prisoners were warned that what was discussed was not to be repeated to anyone, under any circumstance. Each time the process would begin from the beginning. And then repeat. Again. And again.

Each of us was exposed to attempts at blackmail and corruption. Each interrogation was extremely unpredictable as far as style and content was concerned, but generally began with polite questioning on our point of view regarding the military situation, made by high functionaries of the NKVD who had been sent from Moscow, and ending with interrogations that went on over two or three days, often with no breaks, stooping to such gentle exclamations as "Oh, how sad for your young wife that she will never see you again, unless you swear…unless you promise…." As far as I know, no one was beaten or tortured at Starobielsk, unlike at the prisons in Lwów or Kiev and those in Moscow.

As for me, I wasn't especially tormented by these inquiries. In retrospect, they even took a pleasant turn (though not of course at the time), as when I was once cross-examined by three men. I had just stated that I worked as a painter for eight years in Paris. This made them very suspicious:

"What orders were you given by your foreign affairs minister before you left for Paris?" one of the NKVD asked me.

I said I was sure the minister had no idea I was going to Paris.

"Then what did the one who replaced him tell you?"

I told them he must also have been unaware of my departure. I was going as a painter, after all, not as a spy!

"Do you think we don't understand that as a painter you would be able to draw a map of Paris and send it back to the minister in Warsaw?"

I had a hard time convincing my inquisitor that if one wanted a map of Paris all one had to do was to buy one for a few coins on any corner, and that

Polish painters were not spies who secretly make street maps of foreign capitals. Until the very end, I was incapable of getting these men to believe that one could go abroad for reasons other than espionage.

Czapski's rather disarming report of such an encounter sounds casual, almost charming. Never admitting just how seriously vulnerable he was, Czapski's suggestion that the inquiries "even took a pleasant turn" appears flippant. Prisoners were made to squirm. Interrogations were psychologically and phys ically draining. No matter how bad a situation had become for an enemy alien in the Soviet Union, things could always get worse, much worse. The case against the prisoners of war was difficult for the men to contradict; they were Polish patriots dedicated to the Polish cause, which in the eyes of their inter-locutors made them counterrevolutionaries. Czapski does not pretend to speak for others in the camp; he only details his own experience. And yet in this very droll retelling of being sequestered with buffoons, Czapski evokes an Orwellian set piece in which a prisoner could be confronted alternately by gross stupidity and a malignant kind of willfulness.

Another memoir about camp life at Starobielsk provides a corroborating perspective. Published long after the war, it was written by a man Czapski knew well as a friend and fellow prisoner, Bronisław Młynarski, the son of the composer Emil Młynarski, the founding conductor of the Warsaw Philhar-monic Orchestra. A comparison between accounts of life at Starobielsk by Czapski and Młynarski reveals as much about the writers as about the events through which they lived. Czapski, whose book was published before the war ended, endeavored to achieve an objectivity of observation, seeing the world through his painter's eyes. Młynarski, writing decades later, strove to place himself at the center of his own story. Aside from its corroborative testimony, Młynarski's memoir allows us to assess Czapski's objectivity. His report of visiting Czapski in the camp infirmary is more graphic, more worrisome, than any account we have from Czapski himself:

Fever-ridden, he was coughing up tubercular blood. His sunken cheeks were unhealthfully rosy and his long legs extended far beyond the rods of his min-iature bed. His long bony fingers tenderly stroked the plain yellowed muslin sheet and the rough blanket. "I dread leaving this bed, and especially this quiet, this wonderful quiet. To return to that bedlam and hubbub seems worse than anything to me."

Holding his trembling hands I tried to comfort him. His head sank back on his pillow, he let his eyelids fall over his eyes and lay there quietly for a moment. He tried to show by the smile on his parched lips that he was not asleep. I felt fascinated by that head of his, as if I were seeing it for the first time in my life. What a subject for a painter! Only he was the painter, not I. A tremendous skull, elongated, with a high forehead, a bony aquiline nose jutting out of the sunken eye-sockets and the sunken temples. And his greying long red hair blending with a growth of beard several weeks old.

"Don't go yet," he whispered. "Listen: *'Je sens vibrer en moi toutes les passions....'* (I feel all the passions vibrating in me.) That's Baudelaire. *La Musique.* Listen some more...."

He was racked by fever. He added a verse from Apollinaire, then almost inaudibly recreated a scene from Proust, whom he adored.

Suddenly he became stiff and almost rose from his bed. He seemed to be a giant. A terrible coughing seized him and choked him. He smothered it, pressing a blood-stained rag to his blue lips. His spasms continued for a long while. The other patients watched him horror-stricken.

Młynarski takes his leave, driven from his friend's bedside by an officious nurse. Back out in the ice and snow, he recalls Czapski's inspiring voice reciting lines of French poetry. As their magic faded, he was left in low spirits with nowhere to go but back to his freezing barracks. Czapski's own description of that stint in the camp hospital doesn't shy from stating the severity of his condition, but he quickly moves on with a caustic aside about the facilities, ending with an optimistic overview of his prolonged stay:

Soon after I arrived at the camp I fell ill, my lungs gave out. I went into the infirmary with a temperature of 104 degrees, spitting up blood. I had heard—and it was like hearing a fairy tale—that there was a tub there where one could have a bath. Indeed, I was led into a small room where the tub was, but the tub had a hole in it, so a basin had been placed at the bottom of it with some barely warm water. That was all. Nevertheless, they gave me a clean shirt and, after being settled in a small ward with five other chest cases, I had the feeling of finding myself in paradise. We were looked after by Polish doctors, our fellow prisoners, and a young Soviet woman doctor who was attentive, smart, and pleasant. It might seem strange, but I swear I've kept an almost happy memory of that three- or four-week stay in the hospital. After months of uninterrupted nervous

tension, after humiliation day in and day out, living among a crowd of men on the brink of despair, I was able to stretch out and lie without moving, in a clean shirt, in a room where we were five and not one hundred, and all this gave rise in me to a feeling of "happiness." My fever began to fall and I felt renewed. I made a decision then that, at night, as those around me slept, I would write a history of painting, from David to the present day, as a way of keeping up my spirits.

Czapski transforms this tale of grim medical circumstances into a story from which a few drops of happiness are wrung, much in the way lightheartedness infuses his telling of the ordeal of interrogation. As the object of his own scrutiny, Czapski has a tendency to offer upbeat observations in place of more alarming ones. (As a mature painter, his self-portraits will seem similarly predisposed.) His buoyant tone might well be generated by fear of its opposite, the downward spiral of recrimination and despair. Throughout his wartime writings, the suffering of others is invariably given greater significance than any pain he might have been experiencing.

The winter of 1939–1940 was extremely harsh. At Starobielsk, new barracks constructed by three hundred prisoners working fourteen-hour days were finally completed. Each one of the twelve hundred bunks was quickly claimed. The newly built sleeping quarters were unheated and so they were much colder than those squeezed into Shanghai, as the barracks in the old brick church were known. However, they had the advantage of being neither dark, filthy, nor lice-ridden. The new berths provided nearly thirty inches of width per man, as opposed to the more confining twenty inches available in Shanghai. Disregarding camp regulations, the men made the rounds surreptitiously, entering any structure, circulating, stopping in here and there to visit with one another as the housing facilities expanded. In what amounted to a village of prisoners, a closed society of four thousand, men soon began to cross paths with other internees they had not encountered before, distant relatives, friends of friends. Czapski's memoir is full of details of such unexpected meetings. Among hundreds of medical professionals in the camp, he found Dr. Kołodziejski, the prominent Warsaw surgeon who had saved the life of his brother, Stanisław, during the Polish-Soviet War. He rekindled a friendship with Adam Sołtan, a career officer he had known since 1920. The editor and poet Lech Piwowar, a friend from bohemian literary circles in Kraków, presented Czapski with a selection of poems he had written in the camp, each minutely inscribed

on a single flimsy sheet of cigarette rolling paper. Piwowar had been working on a monograph about the life and work of the French poet and playwright Guillaume Apollinaire when war erupted. He was introduced one day to a fellow prisoner named Kostrowicki, who surprised him by declaring that he was related to Apollinaire, who had been born and christened Wilhelm Albert Włodzimierz Apolinary Kostrowicki. The poet's mother had been a Polish noblewoman. The names Czapski records of fellow prisoners previously unknown to him, some of whom he came to know well at Starobielsk, represent a random sampling of the breadth and depth of Polish intellectual life. In the pages of his memoirs, Czapski gives each man a moment to shine, presenting anecdotal material in the way a painter makes choices about what details and attributes to select for inclusion in a portrait.

By November, camp life had become somewhat less disastrous. The passage of time helped the officers adjust to the overcrowding, the nocturnal interrogations, the inadequate food, the freezing cold, and the infestations of vermin. They had found a way of living within a system of restrictions and rules, and knew how to test the boundaries, to work around them. They managed to maintain their loyalties and priorities. At this point, they had been held at Starobielsk for weeks and were adapting to the idea of a prolonged incarceration. In blatant defiance of camp rules, the prisoners made plans to celebrate Poland's Independence Day. As it approached, senior Polish officers sent word down the chain of command that if everyone participated in singing the national anthem, the responsibility, and the expected punishment, would be shared equally. The commissar of the camp, Mikhail Kirshin, fully aware of the significance of the upcoming date, had posters prominently displayed throughout the enclosure declaring that group meetings were strictly forbidden.

Polish Independence Day, November 11, 1939, began in northern Russia with heavy snowfall. At the outdoor field kitchen, two thousand Polish officers stood in line for the first of two morning meal shifts. They were quickly rounded up by guards and sent away, assigned to a work detail. The remaining two thousand prisoners were ordered out of their barracks and told to line up, two men abreast. For several hours they stood outside in the freezing cold as the snow continued to fall, many of the men without overcoats. Eventually they were forced to move, led around the prison grounds under armed guard, then funneled single file through the front gate of the camp. One body at a time, they were shoved into the exceedingly narrow opening formed between the monastery's massive stone walls on one side and the tall, treacherous coil

of barbed wire that circled the entire exterior perimeter of the camp on the other. Unable to avoid scraping against the barbed wire, their worn coats and uniforms ripped and shredded. Guards stationed at measured intervals pushed them on with drawn bayonets. Residents of the town of Starobielsk, who had rarely caught sight of the Poles outside the monastery grounds, gathered to watch the spectacle of men squeezed and prodded along a confined opening, like a medieval rendering of the mouth of hell. As each man returned from his circle around the compound, he was halted, identified, and searched.

Once again, brusque Soviet treatment meant to instill humiliation and subordination produced the opposite effect on the Poles. The men were not chastised by the experience but emboldened. That night, within the confines of the overcrowded church ruin, a joyous celebration erupted. A large cross was erected for the occasion, fashioned from pieces of found wood. Hymns, songs, and the Polish national anthem were sung, and a selection of patriotic texts by writers of different generations was read aloud, glorifying their imperiled homeland and indomitable spirit.

The Polish officers had been perfectly correct in their expectation that punishment for such intransigence would be equally shared. Following this mass disobedience of regulations, Soviet attitudes toward the prisoners of Starobielsk began to shift. The report of thousands of Poles congregating against orders to inspire national pride caused a stir at the highest levels in Moscow, triggering the decision to condemn such flagrant resistance as treasonous behavior. The first punitive measure was handed down late the following night. Lieutenant Stanisław Kwolek, the senior ranking officer residing in Shanghai, was summoned from his bunk, "calm and resolute, but gravely ill," and escorted out of the camp under armed guard. Transferred to an NKVD prison in Kharkov, he was accused of inciting subversive activity. A few weeks later, on December 3, the politburo adopted a proposal to have all the officers "of the former Polish army" officially arrested. The men were already imprisoned; the process of arresting them simply reflected the revised consideration of their status. No longer classified as military men, they were branded as counterrevolutionary criminals and subjected to NKVD procedures of investigation, sentencing, and punishment. To oversee even more intensive interrogations, Moscow sent better-trained security officers whose greater experience enabled them to identify individuals likely to be attracted by deferential treatment and material enticements, those who would be willing to shift allegiance to the Red Army.

In Kharkov, Lieutenant Kwolek was sentenced to hard labor. He would die

a year later, working deep in a Siberian mine. Even so, he lived longer than the vast majority of his Starobielsk colleagues.

Officer-prisoners in all three camps were denied the right to send out mail and could receive none in the first months of their ordeal. The feeling of isolation and disconnection from loved ones back home generated a restless, disruptive energy, creating even more resentment toward the jailers. At the beginning of December, the right to send limited correspondence was granted. Messages, not to exceed twenty-five words, were to be sent on cards to the International Red Cross in Geneva for forwarding to Poland. The men understood that nothing of import should be revealed; censors read all outgoing and incoming mail.

Return mail from Poland began to arrive in volume and was distributed for the first time just before Christmas. The response was electric: a palpable release of tension momentarily surged through the camp. Prior to the arrival of these letters, news of the war had come exclusively from Soviet broadcasts, a forum that gave no credence to the sovereignty of any country called Poland. In the first exchange of letters from home, knowing friends and family wrote carefully worded notes to prisoners that let them know details of the continued fight against Nazi Germany and the establishment of a Polish government-in-exile. Czapski, an inveterate letter writer with a large family and wide network of friends, was showered with mail.

Censors searched carefully not only for any political content or foreign contacts in the incoming mail but, more duplicitously, recorded all the return addresses on mail received by prisoners. This information was highly prized by the NKVD as an overarching plan was being devised to deport the families of every prisoner to detention camps in Siberia and Kazakhstan. These actions formed part of a collective program to remove more than one million people from Soviet-occupied Poland. Wives and children, mothers and fathers, brothers and sisters were all guilty of being related to a prisoner of the state and had to be punished. More than seventy thousand civilians were uprooted and deported from Poland for this crime alone. Forced to leave their homes with only a few belongings, they were rounded up and transported under deplorable conditions to destinations that were unequipped to receive them. About one-third of these deportees died from hunger and cold in the first year. The prisoners at Starobielsk, Kozelsk, and Ostashkov, in rapture at having their first contact from home, had no way of knowing about the suffering their families would endure.

In response to the prison population's steadfast refusal to cease all forms of

Communion and prayer, a decree was handed down from the central Bolshevik command late in December. On Christmas Eve, in a well-choreographed maneuver, every prisoner recognized as an army chaplain was removed from the three camps of officers. These clerics were located in their barracks one by one in the middle of the night, awakened and told to gather their belongings. News spread rapidly through each camp, and many prisoners left their beds to stand outdoors in the cold to pay their respects to their religious teachers. Surrounded by prison guards with fixed bayonets and snarling dogs, Catholic, Protestant, and Jewish clergy continued to offer prayers and blessings as they were loaded onto a truck and driven away. They would never be seen again by the men who had relied heavily on their covert spiritual guidance and care.

As the new year 1940 began, guards started to drop hints that prisoners were going to be released from the camp sometime soon. The Red Army, after having first encountered formidable resistance, was finally gaining ground in their war against Finland. It was suggested that Polish prisoners would be liberated from the camp to make room for the arrival of many thousands of Finnish soldiers. Rumors of all kinds passed from one soldier to the next. By the middle of March, speculation hit a fever pitch. One night *politruks* entered the barracks and awakened the men, asking if there were any among them who could speak Greek or Romanian. The prisoners, trying to assess the meaning of the question, determined that any travel itinerary including Greece surely meant that they would be headed to France and England to join Polish forces fighting there. Travel via Romania could suggest a return to Poland. Spirits rose at the thought of freedom, of finally being able to fight again. As days grew longer, thoughts turned to warmer weather, and with raised expectations of liberation, the men were deftly lulled into a false sense of security and hope. When all the prisoners in each of the three camps were rounded up to be vaccinated against dysentery, typhus, and cholera—a procedure requiring two rounds of inoculations—the certainty of imminent release intensified. Keenly aware of wartime scarcities, the men could only interpret such precautionary medical measures as a serious commitment to their well-being, an indication of the Bolsheviks' investment in their longevity.

A change of status for the prisoners was certainly part of the Soviet plan of the moment, but it did not concern longevity. The men were marked for transport to places where neither Greek nor Romanian would be of much use to them.

On March 5, 1940, Lavrenty Beria, the head of the NKVD, sent a memorandum to Stalin:

No. 794/B
 Top Secret
 People's Commissariat of Internal Affairs
 To Comrade Stalin:
 In the USSR NKVD prisoner-of-war camps and prisons of the western regions of Ukraine and Belorussia, there are at present a large number of former officers of the Polish army, former personnel of the Polish police and secret services, members of Polish nationalist and counterrevolutionary resistance organizations, traitors, and others. They are all sworn and incontrovertible enemies of the Soviet state, full of hatred for the Soviet system of government. The imprisoned officers and police in the camps are attempting to continue their counterrevolutionary activities and to carry out anti-Soviet agitation. Each of them is waiting only for his release in order to join the struggle against the Soviet state as active participants.... In view of the fact that they are all sworn and uncompromising enemies of the Soviet state, the NKVD of the Soviet Union deems the following to be necessary:
 I. The following is to be submitted to the NKVD of the Soviet Union:
 1.) Proceedings against the 14,700 former Polish officers, government officials, landowners, police officers, secret service personnel, military policemen, and prison wardens being held in prisoner-of-war camps,
 2.) As well as proceedings against the 11,000 members of various counterrevolutionary and sabotage organizations, former landowners, factory owners, former Polish officers, government officials, and traitors incarcerated in the prisons of western Ukraine and western Belorussia. Decisions about these latter groups are to be reached in special proceedings with application of the maximum penalty: *execution by shooting*.
 II. The cases are to be processed without summonses, without statements of accusations, without preliminary investigations or bringing charges....
 III. A troika composed of Comrades Merkulov, Kobulov, and Bashtakov (Chief of First Special Division of the NKVD of the Soviet Union) is to be charged with the investigation and decision of the cases.

People's Commissar of Internal Affairs of the USSR,
L. Beria

Four signatures were affixed diagonally across the front page of the memorandum in blue pencil, one above the other, four flourishes sloping down across the typewritten text like the billowing sleeve of an exterminating angel. Stalin signed his name and underlined it emphatically. Below his signature were those of the reigning members of the politburo: Molotov, Kliment Y. Voroshilov, and Anastas I. Mikoyan. The approval of Lasar M. Kaganovich and Mikhail I. Kalinin, the chairman of the Supreme Soviet, were also noted on the front page, their consent having been solicited by telephone. On the last page, Beria signed his own proposal and penciled a note to himself: "Implement." Signing the document a second time, he set the wheels in motion.

Execution by shooting. Whether the inspiration to murder the prisoners came first to Beria or Stalin remains unknown. Very little evidence exists in document form incriminating Stalin personally in any number of murderous directives. He brazenly signed the March 5, 1940, circular calling for the prisoners to be shot, but Beria composed the memorandum and distributed it for approval. The two men would have discussed the situation during the frequent late-night visits Stalin imposed on all of his highest-ranking associates. An understanding would have been reached between them, resulting in the written text. It is important to contextualize this decision; it was not arrived at during the heat of battle or in the throes of chaotic upheaval. A cold, businesslike calculation, the order was given at a time when Stalin was extremely secure in his position. The directive clearly represents his intention to destroy all Polish influence in Belorussia and Ukraine for good. The investigative troika handpicked by Beria—Vsevolod N. Merkulov, Bogdan Z. Kobulov, and Leonid F. Bashtakov—obediently issued death penalties for many thousands of prisoners. No further investigation or due process was deemed necessary.

A remarkably efficient timetable was set to fulfill the terms of Beria's memorandum: eight weeks from start to finish. A month of extensive planning would be needed before executions could begin. The document was signed on March 5, 1940. Transport of Polish officers to their final destinations began on April 5, 1940. By May 5, 1940, nearly all of the Poles identified by Beria had been killed. One by one, each man had been shot with a single bullet in the back of the head. Their bodies, stacked twelve high, were piled into mass graves.

Katyn, a forest in the western Russian district of Smolensk, two hundred sixty miles southwest of Moscow, is only one of several locations where officers were executed and buried, but the name has come down to us symbolizing all

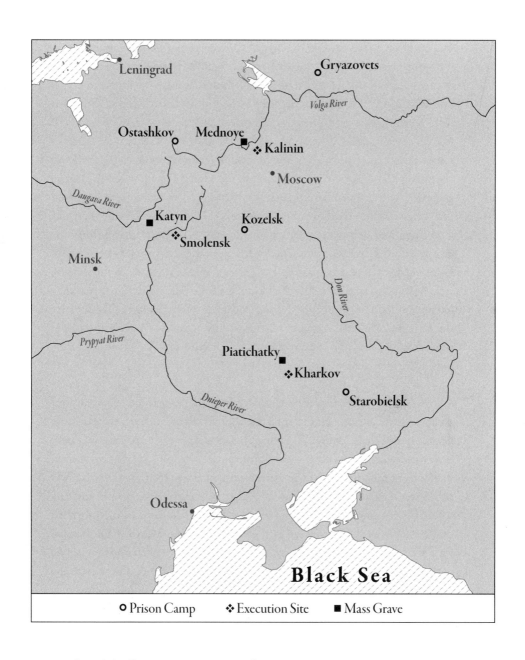

Leningrad

Gryazovets

Volga River

Ostashkov Mednoye Kalinin

Moscow

Daugava River

Katyn Kozelsk

Smolensk

Minsk

Don River

Prypyat River

Piatichatky

Kharkov

Dnieper River Starobielsk

Odessa

Black Sea

○ Prison Camp ❖ Execution Site ■ Mass Grave

Key sites for Polish officers as Soviet prisoners of war, 1939–1941

the executions decreed by Beria. Just as three separate camps had been designated by Moscow to hold those prisoners slated for death, three corresponding execution sites had been selected, and three peripheral burial sites to accommodate the many thousands of corpses. Czapski's Starobielsk colleagues were transported to die at Kharkov; their bodies would be buried outside the neighboring village of Piatichatky. The men from the Ostashkov camp were transported to Kalinin (Tver) to die, then buried in nearby Mednoye. The men from Kozelsk were transported to Smolensk, where most were killed in the NKVD prison, while others, shuttled to the forest of Katyn, were made to kneel at the side of the open pits (where their dead colleagues were piled) and executed on-site. Approximately fifteen thousand men, separated into three groups, were transported to these sites for "dispatch," in Soviet parlance. More than seven thousand additional Polish prisoners held captive in NKVD prisons in Ukraine and Belorussia were killed and buried elsewhere, part of the same directive from Beria. The burial pits at Katyn were only the first to be exposed. Dug deep into the earth's surface, the graves were not immune to the shifting tides of war and peace. At first they were under Soviet jurisdiction, then they fell under German command, then Soviet again. More than five decades after the April and May executions of 1940, post-Soviet-era research and investigation teams confirmed other execution and burial sites. Mass graves continue to be identified nearly eight decades later.

Who knew about the fate of the Polish officers and when did they know it? At first, the execution plans formulated under the watchful eyes of Beria were known by only a select few. The research-and-development process was carefully concealed, held as top-secret information not to be circulated beyond members of the politburo. The expectation on the part of low-level NKVD functionaries was that prisoners from Kozelsk, Starobielsk, and Ostashkov would be transported to Siberia or other northern Russian outposts and then transferred to the Gulag network of forced labor camps. As time approached for the executions to begin, the number of those aware of the prisoners' fate naturally increased. Heads of state security for the three regions where the camps were sited had to be informed and were made to play crucial roles. Once implementation began, ever more participants were incorporated and incriminated—prison camp commanders, transportation specialists, security officials, and an increasing number of NKVD support staff, high- and low-ranking. Young guards and clerks were enlisted to strong-arm handcuffed prisoners

into position to receive their bullet; many of these accomplices went on to become executioners. All of these workers were subordinate to Merkulov, who was assigned responsibility for the program at the three designated execution sites.

In the camps, the authorities encouraged the men to believe that they were going to be sent home, either to German- or Soviet-occupied Poland. Guards and camp authorities knew that the rumors they were circulating were lies, but they remained unaware of the real nature of the operation. Some prisoners were suspicious of news of their release, but most were blinded by excitement. When word was finally sent down to begin depopulating the camps, a sort of euphoria set in. At each of the three camps, beginning April 5, 1940, a lengthy telephone communication came through from Moscow every morning and two Russian NCOs would appear bearing a new list of names identifying between fifty and two hundred fifty men who were told to pack up their belongings for departure that day. Reassured that they were being returned to their places of birth, the men offered prayers of gratitude. Many senior officers were among the first to hear their names called. At Ostashkov, a band played as the first men exited the camp. Under such festive conditions, they left willingly, even exuberantly, each prisoner handed a surprisingly generous food ration for his trip home. At the camp in Kozelsk, the Soviet authorities prepared a farewell reception for several Polish colonels when their names all appeared on the same transport roster. Fellow officers formed a guard of honor, saluting as their senior commanders took leave of the grounds. Among the supplies handed to them were sardines wrapped in foil paper, an unimaginable touch of splendor.

From the start, the mechanical nature of the enterprise of mass killing was in evidence. Unlike the Nazis' reliance on industrial gas chambers, the Soviet massacres exhibited an essentially human connection, a one-on-one encounter between executioner and prisoner, repeated over and over and over. Vasily M. Blokhin, the chief executioner at Lubyanka prison in Moscow, was delegated not only to oversee the implementation of all the shootings but to take on the role of executioner at Kalinin, the murder site for the Ostashkov camp. He had been handpicked by Stalin to engage in this *chernaya rabota*, "dirty work." (Several weeks earlier Stalin had summoned Blokhin to murder the writer Isaac Babel, whose mordant stories of Russian life seem to prefigure his ghastly end.) During the month of executions at Kalinin, daily death lists from Moscow were delivered to Blokhin, a singular distinction; each evening he wired a body

count back to Merkulov in Moscow. Working methodically in a basement cell of the Kalinin NKVD prison, Blokhin pulled the trigger two hundred fifty times a night; "more could not be shot easily in one night." An individual prisoner would be identified within the crowded jail and moved quickly by guards from his holding cell down to a small room where he was searched and had his hands cuffed behind his back. He would be led from this antechamber to the padded execution room where Blokhin, in leather cap, apron, and elbow-length gloves, stood waiting behind the door. Escorted by two of Blokhin's assistants, the prisoner would be brought in and forced onto his knees, placed in position to simplify the procedure of killing. The executioner would fire a single bullet into the base of the skull, another if required. Less than a minute later, two other guards would enter the cell to hose it down and remove the body, taking it out into a courtyard where the handcuffs were removed to be put back into circulation on another victim. Blokhin is believed to have murdered seven thousand men over a period of twenty-eight days.

NKVD personnel—those who planned the executions and those who supervised the prisons, escorted the prisoners, and pulled the triggers at all three sites—were representative of a second generation of practicing Bolsheviks, men who had little of the ideological fervor that motivated the founding Marxist-Leninists. Far from the revolutionaries who brought tsarist Russia tumbling down, these men, first-generation Stalinists, resembled managerial bureaucrats and efficiency experts more than political radicals. Whether plotting prison transport routes, doling out death sentences, or loading corpses onto trucks, their emphasis was on getting the job done quickly and cleanly and being able to report back to superiors who only wanted to see results. In this way, institutionalized murder was subjected to organizational methodology. On occasion, practicality necessarily supplanted ideology. NKVD functionaries knew very well that Soviet-manufactured revolvers, the Nagant pistol, had a tendency to jam, making them unreliable for fast, repeated firings. These were rejected in favor of far more effective German-made pistols, which could be reloaded quickly and produced a less explosive recoil, easing the strain on the executioner's hand and arm. Blokhin arrived in Kalinin toting a large suitcase filled with pistols manufactured by Walther, a German arms maker. He brought German ammunition as well: 7.65mm Geco bullets were used at all three execution sites.

Why were these men marked for execution? Those selected by Stalin and Beria were first and foremost officers, their rank automatically classifying them

as oppressors, as aristocratic elements. (The very word "officer" was hated by the Bolsheviks, who remembered the savagery of the tsar's officers. The Red Army instituted the term "commander" instead.) The Soviet power base perceived them as hardened enemies of their system, beyond the reach of reform, having sworn loyalty to an entity the politburo no longer recognized, a country called Poland. According to ideologic Soviet criteria, these prisoners were bourgeois Poles, the enemy incarnate, members of the intelligentsia. Their elimination would seriously reduce the likelihood of resistance, facilitating the subjugation of an entire nation. NKVD officials maintained that Bolesław Pohorecki, a civilian prisoner being held at Kozelsk, the president of the Polish Supreme Court and unaffiliated with any military organization, was guilty of representing a system dispensing bourgeois notions of justice. Pohorecki was one of more than a thousand lawyers killed by Beria's decree, alongside more than eight hundred doctors of medicine, more than half of whom were Jewish.

Of the four thousand men put onto trains traveling from the camp at Starobielsk, seventy-eight were not sent to Kharkov prison to be killed. Józef Czapski was one of them. Over a period of three weeks, he had watched with increasing dismay as most of his colleagues passed to the far side of the prison gates. Roll calls for transport were very exacting and often repeated to ensure that the men requested by Moscow were present and accounted for. After April 26, 1940, less than one hundred men were left of the four thousand at Starobielsk, and all were confined to a single barrack. Each could only wonder what significance might be inferred from having been left behind so much longer than the others. Transports ceased for a week, then resumed May 2.

My departure was continually put off. Barely a few dozen prisoners remained in the camp. The transports became more and more infrequent. I lingered behind in empty barracks, I spent many hours in the sun on a spot of ground crowded yesterday by thousands of boots, where sudden gusts of wind now raised storms of dust. How I envied my "happy" friends who had already left behind the barbed-wire enclosure and were out again in the wide world. It wasn't until May 12 that I left Starobielsk, one in a group of sixteen men.

The sixteen men suffered the indignity of having to strip naked for their final body search. Passing through the camp gates, they were immediately surrounded by growling dogs and guards with rifles fixed with bayonets. A

125

truck pulled up to convey them to the station. Somewhere in the shuffle between the camp and the station, Czapski's diminutive notebook containing his history of nineteenth-century French painting was lost. His chronology, beginning with David, had gotten as far as Courbet. At the station, they were pushed into cars at the rear of a waiting train, each man identified once more by name and escorted down a long corridor into cell-like compartments whose doors were barred and windows painted over. All of the men not marked for execution were transported from the three camps in this manner. Czapski and his group from Starobielsk traveled six hundred miles to a transit camp close to Moscow. With no reason to imagine that their fellow officers had not been similarly diverted to other camps, or even, as announced, sent back home, they had no way of knowing that they had been singled out for survival. More than twenty thousand of their colleagues were already dead.

Czapski's departure from Starobielsk in the spring of 1940 marks a divide. At forty-four, he had already survived much, but up until this point, he had never been one to look back. Another fifty-three years of life lay ahead of him. During that long span, he would never be far from thoughts of his incarceration and the deaths of so many friends and associates. It seems fair to say that to know Czapski, to hold his complexity, one must venture to confront the darkness and desolation to which he was so powerfully exposed. On the final pages of his lifelong diaries, among his very last written words, the nearly blind man in his nineties repeatedly inscribed in a crude but determined hand the names "Starobielsk" and "Katyn."

6

WE ENCOUNTER CZAPSKI AGAIN at Pavlishchev Bor, a transit camp one hundred thirty miles southwest of Moscow, where around three hundred ninety-five Polish officers were being held, drawn from all three camps. Most were from Kozelsk; the fewest came from Starobielsk. Why were these men spared when so many thousands were marked for death? Conclusive evidence has never emerged. One prevalent theory holds that this cross section of survivors fulfilled the need for a kind of logistical insurance against a time when the Soviets might be held accountable for the murder of *all* the prisoners from the camps. In this scenario, they imagined, they could protest: No! We certainly didn't kill all the generals, or all the anti-communists, or all the young men. Look, here are these officers, still among us.

The compound was surrounded by barbed wire, but living conditions at Pavlishchev Bor were vastly more accommodating than at any of the other camps. The men occupied what had once been a large farm. A forest of ancient oak and fir trees surrounded them. Various outbuildings were refitted as a dining hall, a canteen, and a bathhouse with hot water. On the prisoners' arrival, soap was distributed and fresh underwear provided. Sleeping arrangements were an improvement, with actual beds replacing the narrow, rotting bunks the men had grown accustomed to, and eight to ten prisoners shared a room that might have held fifty or more at their previous camps. The quality of what passed for food at mealtimes was still appalling.

With its large, open areas, the prison enclosure allowed for enhanced access to personal space. The men arrived mid-May, just as spring was gaining a foothold in central Russia. They began to settle in, adapting to new routines and different sets of restrictions. Authoritarian command was not terribly despotic, and some of the men, granted permission to plant seeds, tended a small vegetable garden to which they quickly became very devoted. Czapski began a new journal on May 28, 1940. He made some drawings, tried to re-create his lost text on French painting, and recorded his thoughts about Pushkin, Tolstoy, and Turgenev.

Correspondence with the outside world was again forbidden. The prisoners were once more subjected to exhausting interrogations. To cultivate future informers, a new crop of *politruks* circulated among them endlessly, planting seeds of their own—of discord and disruption—pestering the men with relentless zeal, exacerbating latent grudges held among them. All prisoners nurse a wounded sense of self, and the job of the *politruk* was to inflame that wound. The once cohesive band of Polish prisoners of war began to fracture into smaller subgroups formed on the basis of a single element of identity—nationalist Poles, German-speaking Poles, Jewish Poles, pro-Soviet Poles. Not surprisingly, tensions began to erupt among these divisive factions. Increased hostility further battered a community already under great strain. The poison spread by *politruks* began to take root. Anti-Semitism, deeply bred in the tradition of many Polish officers, surfaced aggressively and flared with increased virulence. In a memoir written after the war, a Jewish surgeon, Dr. Salomon W. Slowes, left this account of polarization among the men:

One day as we queued for soup, a quarrel, fueled by exchanges of profanity, broke out. During the fisticuffs, someone spread the rumor that a young physician named Gurwitz had insulted a former police officer. A short time later, dozens of agitated young men appeared with clubs, knives, and belts that had been concealed from the guards. One of them waved a hatchet in his zeal to avenge the honor of the Polish police. After great effort and a threat to turn to the authorities, Captain Czerny succeeded in persuading the wild rabble to call off their lynch.

Of the four hundred officers in the camp, many displayed a higher level of thought than that of their comrades, demonstrating notably liberal opinions toward their Jewish neighbors. One extraordinary personality of this kind, radiating innocence and warmth, was Captain Józef Czapski—a man of about forty, a cavalry officer, and member of a veteran aristocratic family. He was tall and thin as a rake, and his pinched face was punctuated by deep-set blue eyes that expressed suffering and empathy with others in their hardships. During one of our talks, he reached into his pack and pulled out a photograph of himself with his five sisters, all tall and slim like him. Together, with their stature and innocence, they looked like six holy candles.

Rancor, as well as depression, descended on the men. News of the Nazi occupation of Norway added to their woe.

Just as their vegetable garden began to show signs of growth, the men were told to prepare for departure. After a residency of only a few weeks, their time at Pavlishchev Bor ended abruptly on June 13, 1940. Czapski had already filled all the available space in his journal. It would be August before he could start another, by which time he would be four hundred miles away. Before leaving camp, the men were once again subjected to a body search. Loaded onto trucks, they were driven to a train station where yet another long line of prison cars awaited them. They traveled over a period of five days, confined to a windowless carriage. On the third day, the train pulled into a station and was shunted back and forth from one set of tracks to another. Watching through a crack in a boarded window, Czapski was able to identify a church tower he recognized from photographs. They were in Moscow, the Moskva River was flowing nearby. To everyone's surprise, they were given drinking water and newspapers. The men learned then that two days earlier the Nazis had taken occupation of an undefended Paris. France had fallen.

The train pushed on. Two days later, at a platform just beyond the small station of the town of Gryazovets, the men were ordered off the train. They marched under armed guard for five miles. June 18 was a warm day, sunny and still; summer was gradually reaching northern Russia. The camp to which the men were led was situated on the grounds of yet another former religious community in disrepair. It would be their home for fifteen months. Though far less comfortable than Pavlishchev Bor, living conditions at Gryazovets were still an improvement over those at their former camps. A creek and a pond offered the possibility of bathing outdoors under large stands of poplar, birch, and acacia, as well as a place to wash underwear and shirts. The remains of another seventeenth-century Russian Orthodox church dynamited by the Bolsheviks stood within the walled compound, retaining sufficient vestiges of sacred space to be of comfort to the believers among them. They would use the ruins discreetly for prayer.

Once again they had to sleep in stacked, rotted wooden bunks infested with lice. Having been under Soviet authority for nine months, the men began to succumb to issues of general malnutrition, resulting in skin rashes, diarrhea, and eye infections. The daily soup served to them was of such low nutritional value it really only served to stave off starvation. Twice a week each man received a meager ration of black bread and sugar, their sole source of vitamins and protein. Only in October was outgoing and incoming mail sanctioned by the camp leadership. After a hiatus of five months, each prisoner was again

entitled to send one letter a month. As knowledge of his whereabouts spread among his six siblings, Czapski received more than seventy letters with news from family and friends who were spread far and wide.

It is hard to overestimate the importance of reading and the refuge that literature provided for many of the men. At Starobielsk, very few books had been available. Volumes that had been among a soldier's belongings as he went off to war were passed from hand to grateful hand. "I remember reading Balzac's *A Woman of Thirty*," Czapski recalled. "This poor book had been broken up into pages which one could borrow for barely a few hours, five or six of us reading it at one time, each of us pressing the other to turn the page. All I retain from having read this book, which no doubt was missing some pages, is a memory of breathlessness."

At Gryazovets, the authorities had a far more tolerant attitude toward reading. A small but serious library of books was made available. "I don't think I ever read with such attention," Czapski wrote. "Books helped to awaken my 'involuntary memory.' Though I have a dreadful memory for so many things, I could suddenly call to mind texts, fragments of other books I hadn't had my hands on for years. I could once again see *all sorts of paintings*. For me, personally, the rediscovery of these memories verged on the miraculous."

He began to feel some fresh energy flutter within him and the possibility of a return to creative visualization. It is as if his fingers were twitching for materials with which to draw and paint. Paper was especially hard to come by, but he began to draw on whatever scraps he could find—blank spaces on the margins of newspapers, stained blotting paper, the linings of cigarette packages. With any available stub of pencil he set at it, forcing himself to keep at it, now that "it" had come back. Other painters and paintings may have come to mind as he drew the surrounding landscape, but it was with his own eyes that he again looked out and saw the world. He made time

for daily drawing, with a bad pencil, on wretched cottony paper. That was my salvation. I even managed to get little caps of children's paint, and for a few weeks in a row, I made "portraits" of my friends in small patches of watercolors, or painted still lifes. . . . And that period convinced me for good that the driest drawing—without a trace of "music," the drawing most miserably slavish to nature, deepened every day, sharpened, brought to the limit of one's capacity—is for me, and I stubbornly think, for every painter, a vital source.

Despite the almost carefree reference to "little caps of children's paint," this declaration of his daily drawing ritual as "my salvation" is entirely serious. A succinct statement of faith, the words are not to be taken lightly, despite Czapski's deep-seated suspicion of religious vocabulary used in critical discourse about art. It's not an exaggeration to suggest that drawing and painting *did* keep his spirit from tipping over into despair, and that through his commitment to such work he was able to salvage what he could of himself.

A selection of surviving drawings of camp life and of his fellow prisoners offers an intimate view of Gryazovets. There are casual sketches—figures asleep on their bunks, studies of hands and feet—and more complex drawings, penetrating portraits. Czapski would quite often include written notations of specific colors scribbled over a pen or pencil drawing, reminders for later use when converting a sketch from paper to canvas, evidence of the healthy persistence of a long-held habit. Colors are spelled out and placed the way the names of towns are pinpointed on a map: "yellow" here, "cerulean" below, "dark green" there. One study of a balding man with large, expressive eyes has been overlain with veils of watercolor that obscure but don't hide the names of colors scrawled underneath. On his forehead and on the back of his hand, oddly shaped patches of color have broken out like a case of hives, one pink, one blue. The subject is Adam Moszyński, a bank director from Lwów, who with the help of his fellow inmates at Gryazovets began to coordinate the assembly of the first lists of names of the thousands of officers the Soviets had detained.

Another portrait, a highly finished pencil composition (page 179), covers the bottom half of a page. A bespectacled man lying on his back is engrossed in reading a book he holds above his head. The book's front cover is clasped in his left hand, its back cover clutched by his right hand reaching over across and above his head. Czapski, as if on an upper bunk looking down on his subject, portrays him with wonderfully kind, sad, turtle-like eyes. The gesture of his right arm securing the book is almost baroque in composition, the curve of his fingers echoing the curve of a lock of hair draped on his high forehead. A short tie, such as a Puritan minister might have worn, is almost rakishly knotted around his neck, adding a bit of unexpected sartorial flair. The upper half of the page is given over to a very academic exercise, a beautiful drawing of one of the reader's hands, fingers curled down and inward, quite detailed in line and shade. The subject is Witold Kaczkowski, whose own published

account of imprisonment reveals that he, Czapski, Bronisław Młynarski, Adam Moszyński, and three others bunked together in the same room at Gryazovets.

A signature made in rather primitive capital letters at the bottom of another portrait (page 179), reads: J. CZAPSKI, GRYAZOVETS, IX 1940. The picture, full of emotional complexity and subtlety, is a brown study, a dispassionate rendering of a man fallen into a state of deep absorption. A middle-aged officer with a toothbrush mustache and dark-rimmed glasses is shown in three-quarter view, looking straight ahead, a muted, preoccupied presence in a military jacket. The long, spatulate fingers of his right hand are spread across the pages of a book propped open on the table before him. The fingers of his left hand are in tender contact with his temple, his left elbow resting on the table beside the book. He has slumped into this pose, as a sitter is prone to do after having tried not to move for a period of time, his upper body propped up by his elbow. Perhaps the book has been provided for diversion, but it hasn't succeeded in this purpose—the subject of the portrait is too absorbed in internal musings to focus any attention on it. He may well be lingering on some phrase or image drawn from its pages, but the way in which he is both staring out and looking inward suggests a more complex moment of pause, a tenuous conjunction of presence and absence. With very little, looking only at what is in front of him, Czapski captures the suggestion of an ineffable emotional state, immediately recognizable and unfathomable. Unlike most portraits, this one seems to obliterate any connection between painter and sitter, and, by extension, the viewer. Self-absorbed, found and lost in complicated reverie, the subject resists our intrusive attention. Czapski has honored this resistance by not engaging the sitter. Instead, with exacting clarity, he describes his subject's interiority as seen from the outside. The work is really a portrait of a state of mind as much as the portrait of a specific man.

Though it is unknown to them, the men in these portraits have, for whatever reason, escaped the tragic end of their comrades. On each of their faces, strained imaginings about the future are visible, consuming and deeply troubling. Czapski is equally unflinching in his own self-portraits made at the camp. In November 1940 he draws himself, chin pulled in, staring out at us tentatively over the rim of his glasses, as if we have interrupted him reading or drawing. A scarf casually draped around his neck links two patches of background on either side of his head, one blank, the other darkly filled in. He is wearing a heavy woolen sweater with an overall pattern of small, tight, squiggled

splotches. His lips are inexpressive, his shoulders slope down. His look is non-committal. A charcoal sketch (page 179), made two months later, in January 1941, is so vivid in its depiction of placidity as to be unsettling. His eyes withhold so much, gazing out just over the viewer's shoulder, a slight but intentional displacement. His left eyebrow is raised in a somewhat arch manner, his thin lips are pursed, the overall quality of expression is one of impassivity. A few days' growth of stubble flecks his cheeks, upper lip, chin, and jawline. He has clearly been through a lot and appears quietly attuned to the expectation that he will go through even more. His look is haggard, tired. In this study, the viewer feels his ennui, the long, empty stretch of days facing a prisoner. It is January in northern Russia; he must be very cold, and he wears a sort of duffle coat pulled up around him, its hood draped behind his head. None of his neck is exposed. The coat is not quite buttoned up to the top, though, and a very small patch of its lining, a checkered pattern, is revealed, a rare touch of decorative notation, almost frivolous given the context. He wears a knit hat low across his brow; on one side of his head the hat is tucked behind the ear, on the other side the hat is pulled down to cover the ear. The fully exposed ear is alert, on the job, listening for whatever might happen next, suggesting the importance of maintaining an ongoing surveillance of one's surroundings. Czapski compresses the drawing of his long, thin face to fit and fill the page in the manner of small Flemish devotional portraits by Jan van Eyck and Rogier van der Weyden. With sardonic flair, he has drawn a simple, wobbly frame around the perimeter of the page to enclose his mug-shot-like sketch. A third image done two months later, in March, pulls the lens back as it were, revealing incrementally more of the surrounding prison environment, placing Czapski in a world. We see a shelf with two or three slender volumes behind his head and the back of his chair with a blanket or towel draped over it. He is wearing the same sweater with its dotted pattern, its cowl collar shown in some more detail since the scarf is gone. Again he is looking directly over his dark-rimmed glasses into a mirror, as if asking, "What, you again?"

In his comment about reading at Gryazovets, Czapski claimed that he "could once again see *all sorts of paintings*." He conjures up images of French paintings for the historical essay he is working on, but visions of his own pictures figure among those returning to him. In the pages of his journal, he begins to create a Lilliputian archive of his prewar paintings. Each image he recalls is carefully depicted in watercolor in miniature, reduced to its essence. None much larger than one and a half or two inches across, these condensed images are extremely

detailed. In several instances a pencil sketch, pale as a ghost, lingers beside a highly saturated watercolor study, as if he had first drawn the remembered canvas, then used this preliminary sketch as a guide while setting down a colored version from his "little caps of children's paints." One study shows a man in a dinner jacket sitting at a table playing solitaire, behind him a large blue lamp with a yellow tulip-shaped shade. Another is a vertically oriented landscape of a barge on a bend in a river encircled by tall, lushly foliated trees, crowned by two white birds flying overhead. Each bird is barely an eighth of an inch in length on the page. A plump symphony conductor in tails, arms lifted waist-high, fills the center space of another image. He is standing onstage on a raised platform, surrounded by an entire orchestra. Two violinists with their backs to the viewer sit across from a cellist and other violinists facing outward, all in white tie, concentrating on playing. The audience, receding in the background behind the orchestra, and the vast space opening above it, are carefully delineated. In a rendering not much bigger than a postage stamp, Czapski evokes the excitement in a concert hall midperformance. Two other studies are dominated by a dramatic sunset over a body of water, with golden reflections and banks of colorful clouds gathered on the horizon. In one, a nude male figure lying in high grass on a riverbank is watching the day's end; in the other, a figure is seated by a lake, contemplating the sunset in the company of a canine companion. When Czapski painted all these miniature reproductions, most of the original works were still packed away in storage, piled up at the studio he left behind in Warsaw. By meticulously re-creating these works as tiny icons in the pages of his journals, he seems to be trying to double the chances of their survival. In most cases, his studies from Gryazovets are the only surviving records of these prewar paintings.

The urge to create in the face of loss brings us back full circle to the world of Proust, where this book began. A series of evening lectures, like those held surreptitiously at Starobielsk, were offered at Gryazovets with the consent of the camp commandant, Major Nikolai V. Khodas. Contingent upon the censor's prior approval of any material to be presented, lectures were given on a variety of subjects ranging from mountain climbing to architecture to the history of England, topics meant to lift, distract, and expand the prisoners' minds, not to fortify a nationalist agenda.

Without a single page of Proust's *À la recherche du temps perdu* available to him for reference, Czapski reclaimed the novel and his experience of reading

it purely from memory. His presentations were conceived as a pedagogic exercise meant to inform and divert an audience of fellow officers, a very well-educated group. Among these prisoners the words *temps perdu*—lost time, time lost—resonated with heightened significance. Aleksander Wat (incarcerated at Moscow's notorious Lubyanka prison during the same months Czapski was at Gryazovets) would claim, "the essence of Stalinism is the poisoning of the inner man." Czapski refused to drink from that well, and his talks offered an antidote for those who had. His determination was an act of resistance, different but equally intentional to the "act of bravery" that resulted in his being awarded the Virtuti Militari in the Polish-Soviet War. Despite vigilant supervision by Soviet prison guards, Czapski strove to raise the battered spirits of his audience.

The improbable subject of his talks had the power to neutralize the relentless impact of Bolshevik agitprop, albeit momentarily, to provide a refuge from the repeated interrogations to which the men were forced to submit. His talks were given in French, helping to focus the men's minds and keep their thoughts far from the grim surroundings where they were being held. No mention of the world at war is made anywhere in the body of his talks; the censors would not have permitted it. Reflecting a generous spirit of European culture, the talks rise above any rancor toward Germany or Russia, whose literary luminaries—Goethe, Tolstoy, Dostoyevsky—inform so much of Czapski's worldview. Three years later, when he was no longer a prisoner, he would write an introduction to his talks for their first appearance in print. He describes the setting:

> I recall with gratitude that around forty of my companions gathered for my French lectures. They came into that chamber at twilight, dressed in *fufaika* (quilted cotton jackets worn by Soviet prisoners) and wet shoes. I can still see them packed together underneath portraits of Marx, Lenin, and Stalin, worn out after having worked outdoors in temperatures dropping as low as minus 45 degrees, listening intently to lectures on themes very far removed from the situation where we currently found ourselves. I thought then with emotion about Proust, in his overheated, cork-lined room. He would certainly have been surprised, and maybe even moved, to learn that some Polish prisoners, following a whole day spent in the snow and the freezing cold, would be listening with keen interest, twenty years after he died, to the story of the Duchesse de Guermantes, the death of Bergotte, and anything else I could bring myself to recall from this world of precious psychological revelation and literary beauty.

Projecting Proustian tableaux from the magic lantern of his mind, he deftly shepherded his listeners toward the novelist's promise of time regained, *le temps retrouvé*, the novel's triumphant counterpoint to lost time, *le temps perdu*. Since religious practice of any kind was banned by the authorities, Czapski offers Proust's belief in art as a covert form of spiritual experience, of redemption and resurrection. Under a veil of Proustian discourse, speaking about the suffering of the novel's characters, he navigates a fine line between fiction and abject reality.

With a nod to Proust's enormous complexity, Czapski presented a simplified overview of the novel for an audience whose familiarity with the writer was limited. He offers his own initial resistance to the sheer scope of Proust's book: "I started by reading the description of a high-society party in one of his volumes (*Le Côté de Guermantes?*); the description dragged on for several hundred pages." He refers to the work of other French writers from the time he first arrived in Paris, and claims he lacked "sufficient literary culture" to make his own assessments. He warms up his audience and slowly draws them in, making comparisons between the literature of France and Russia, discussing the difficulties of translation, in particular the Polish translation. He raises the crucial question of whether the Marcel who is the narrator of the novel is the same person as Marcel its creator. Gradually he introduces the major themes of the book, largely as they unfold in *Swann's Way*: childhood and familial relationships, love, jealousy, sensuality, the hierarchical relations between the classes; art and creative upheaval, music, painting, poetry; Henri Bergson, involuntary memory, and, of course, death and time. (Curiously, in all his writings on Proust, Czapski never once names the character Elstir, the painter who plays a major role in the novel.) Speaking about Proust allowed him to address aspects of his own being that might otherwise have remained unexpressed—in his consideration of Proust he provided himself with a forum in which to talk about illness, about aging, about sexual desire.

To prepare for the talks, he mapped out a cosmology of the Proustian universe. In the pages of several cheaply bound exercise books with the word тетрадь (notebook) imprinted on their covers, Czapski got to work. During the first months of 1941 he inscribed "Gryazovets: French Notes" and dated each notebook sequentially. In the bottom right-hand corner of the covers he wrote, "Czapski/Warsaw/Bielanska 14," his last prewar street address, adamantly clinging to his remembered domicile like a Polish buoy in the midst of a Russian gale.

In response to the extensive reach of Proust's novel, Czapski fabricated elaborately layered conceptual diagrams, half written, half drawn. He flung his cultural nets far and wide, cramming as much information as he could onto each page. He called upon deep reserves of aesthetic knowledge and critical thinking in a variety of languages. He was set on giving his talks in French, but the majority of his study notes are in Polish. His schematic drawings in pencil, colored pencil, watercolor, and ink are laden with the names of Proust-related writers, painters, philosophers, and musicians, with artistic movements, historical figures and fictional characters, biblical references and literary icons all grouped in specific subsets of his own contrivance. Clusters of names and lists of ideas were placed strategically on each page, interconnections between them hinted at by colorful arrows, highlighting, and underlining. One sheet has a tiny drawing of a haystack, another a large single grain of wheat encircled by a yellow watercolor line indicating the outline of the sun, with little yellow rays emanating from it. "The death of Proust," "a pearl," and "indifferent death" are encapsulated within. Above, in black ink, another radiant sun surrounds the word "art." Names of critics, artists, musicians, and impresarios mingle with historical art terms (realism, naturalism, romanticism), abstract categories (love, life, compositional methods), and decorative arts (stained glass, still life, Gothic sculpture). Szekspir (Shakespeare) and Byron appear, as does "*le* Jockey Club." The composition of each page is fluid, striving for clarity, though it is easy to imagine Czapski becoming overstimulated by his plan of attack. He returns again and again to the diagrams to add just one more piece of the puzzle, to make one more connection.

The pages do not represent any kind of scripted text. The sheets pulse with an internal rhythm of their own; the energy of the whole is more centrifugal than linear. To decipher their meanings one must abandon any conventional notions of reading a narrative. Clusters of words and lists of names plotted amid isolated concepts are strewn across the page, the data is not entered in a left-to-right, line-by-line formulation. Encrypted like a Rosetta stone for Proust, the diagrams were conceived as aide-mémoire, to trigger sparks of fresh associations during Czapski's quasi-extemporaneous presentations to the assembled group. Preparing for his talks brought him much pleasure: "From those gloomy depths, the hours spent with memories of Proust, Delacroix, Degas seemed to me among the happiest of hours."

Beyond the process of gathering data, these sheets also reveal Czapski's attempt to recall his life as a painter, showcasing his interdisciplinary fluidity,

his ability to reach, apparently seamlessly, for either pen *or* brush. The densely concentrated masses of names and ideas are organized not only with an intellectual rigor but with a visual one as well. Sketching his fellow prisoners had whetted his appetite for painting, and though in the diagrams he limits himself to graphic flourishes and pictograms, the satisfaction that comes from embellishing the pages with color is palpable. Seen as conceptual works on paper as well as notations for reference, the diagrams are aesthetically compelling drawings on their own terms. They exhibit a kind of mutant strain of ekphrasis—not the use of words to describe a visual work of art but the deconstruction of a work of art into words and colors.

Czapski's talks chart Proust's course from the time he was a young man with a penchant for high society to his eventual retreat into solitude as a middle-aged man. Proust worked against the clock to complete his magnum opus. Czapski presents the writer in his creative environment "as if in a coffin, curtains drawn, at death's door, still trying to enrich and deepen his work, line by line." His final lecture involves a retelling of the story of the death of the character Bergotte, followed by an account of Proust's own demise. Czapski chose to confront the issue of mortality directly with his fellow prisoners, all of whom lived with a constant awareness of the real possibility of death at the hands of their captors. Emboldened by his belief in the timelessness of art, Czapski, like Proust and his narrator, is rendered "indifferent to death." He recounts how Proust, fully aware of his precarious state of health, was mindful that "the enormous and feverish effort required to keep on with his work would precipitate his end. But he had made up his mind, he would not take care of himself, death had become truly a matter of indifference to him. Death came and took him as he deserved to be taken, hard at work."

Czapski pushed himself on, thinking of Proust focused on his work until the very end. (Should death come to him in the Soviet hinterland, he hoped to be similarly engaged.) Separated from the world by barbed wire, brick walls, and sentry towers mounted with machine guns, Czapski was held against his will. From the confines of the prison at Gryazovets, he projected himself into Proust's apartment in Paris and recognized the writer's spartan bedroom as a prison of another kind. Proust's ascetic imprisonment was self-imposed, determined by his seriously compromised health. But Czapski could see that the walls of Proust's bedroom, hermetically lined in cork, served as more than just a barrier protecting the asthmatic writer from exposure to the dust and odors and noise that aggravated his condition. The novelist was also shutting out a

world seemingly bent on destruction, in the throes of calamitous world war. Kindling the quiet required to continue writing without further distraction, he converted his affluent milieu into a cell block and appointed his house-keeper, Céleste, the warden of his jail. Czapski relished Proust's making the most of his dire circumstances, transforming an oppressive situation beyond his control into an expansive arena devoted to creation. It was a clarifying moment for Czapski, a Proustian moment.

Czapski's highly personalized account of Proust and his novel was formulated in a Russian backwater, in complete isolation from any cultural matrix. It stands up, nevertheless, as a sophisticated personal analysis, unusual not only from the point of view of where and how it was generated (to say the least) but also when it was composed. *Le Temps retrouvé*, the concluding volume of *La recherche*, had been published in 1927, five years after Proust's death. The novel in its entirety was greeted with an initial burst of enthusiastic praise (including Czapski's essay, published in Kraków in 1928), but by the mid-1930s and through most of the 1940s the prevailing critical response was largely one of either indifference or hostility. Proust's literary standing was in decline, repeatedly battered by reactionary, dismissive judgments. As Czapski sat assembling his diagrams and shaping his talks, Proust's reputation in France was at its lowest point. A few years later, Jean-Paul Sartre would do his best to keep it there, dismissing Proust's work as effete and self-involved. In the opening pages of his postwar literary journal, *Les Temps modernes*, Sartre would declare, "we no longer believe in Proust's intellectualist psychology, we take it to be nefarious." The Russian Marxist literary critic Anatoly Lunacharsky had effusively praised Proust's genius, applauding his "scathing descriptions of decadent capitalism." Sartre brazenly rejected Lunacharsky's analysis, spurning *La recherche* by lambasting it as a "bourgeois" literary creation. Sartre's insistence on *littérature engagée*, calling for a literature of political commitment, was seriously tainted by ideological sanctimoniousness. Many years would have to pass before a new generation of French readers and writers was willing to acknowledge the sheer accomplishment of Proust's magnum opus.

Czapski's lectures were presented early in 1941. Soon after having delivered the whole series of Proust talks to the assembled crowd, Czapski gave them again in private to two of his prisoner friends, Joachim Kohn and Władysław Cichy, who in enthusiastic response suggested making a transcript of his spoken words for posterity. Each man recorded what he heard, so two versions exist.

When the work was published years later, Czapski dedicated the talks to them. "In our canteen, in the great monastery's refectory stinking of dirty dishes and cabbage, I dictated part of these lectures under the watchful eye of a *politruk* who suspected us of writing something politically treasonous." At an unspecified later date, each of these handwritten manuscripts was turned into a separate typescript copy. (The manuscripts did not survive the war. Both typescripts are in a museum in Kraków. Czapski's original notebook with his diagrams was last documented and photographed in 1987 and has been missing ever since.)

Proust maintained that the act of reading, and all it stirs up in the reader, was of equal importance to the sanctity of the text in one's hand, if not of greater importance. Czapski proclaimed that for him, "Proust is now enmeshed with Gryazovets." His lectures are a testament to the survival of both memories, of both worlds woven together, the fictional Faubourg Saint-Germain and the actual Soviet prison camp. In his universe, the experiential breadth and depth of the one defers in appreciation to the other. Czapski was committed to the remembrance of what he'd had to endure. Proust's text, the quintessential book of remembering, provided a template. Allowing passages drawn from past readings to surface in his memory and illuminate the present, Czapski reenacted the very endeavor of the Proustian *recherche*.

It was a warm Sunday in June 1941. A year had passed since his arrival at Gryazovets. Czapski was walking around the grounds of the camp, taking in the sun.

> To this day I can still hear ringing in my ears the wild cry of exuberant enthusiasm thrown out by a scruffy colonel bending his whole upper body from the window: "Hitler attacked Russia!" For us that meant once again fever, life, and every hope. . . . Yesterday we had been vile bourgeois from a feudal Poland wiped out of existence—now we were the sons of noble and invincible Poland, allies of the Soviet Union and the great Stalin. "Did you suffer terribly in Russia?" I never know what to say to that; the mere fact that I was alive, that I could achieve or fight for something, for somebody, that was happiness then. The word "Katyn" was entirely unknown to us.

So begins the next phase of Czapski's war.

For months, military intelligence had been accumulating evidence that

revealed Germany's preparation for an attack on the USSR. Soviet agents doing undercover work in Bletchley Park relayed transcripts to their superiors in which details of a forthcoming German invasion of Russia had been communicated to the Japanese government. They identified the code name as Operation Barbarossa. American intelligence had evidence of German diplomats burning documents before taking leave of their embassy in Moscow. Unconvinced and unwilling to be provoked, Stalin expected Germany to attack at some point but held fast to his belief that Hitler would continue to focus his military might against Great Britain for the time being. He instigated no moves to protect Soviet territory. Why would Hitler risk waging war on two fronts, leaving Germany vulnerable, as had been the disastrous case in the previous war?

Beria, his first deputy Merkulov, and others of the general staff never trusted the alliance with Germany. As early as October 1940, they were devising alternative strategies for what they understood to be an inevitability. One such plan touched upon the surviving Polish officers. There was talk of forming a Polish Red Army division to do battle against the Germans. During the same week this scheme was put into development, Beria and Merkulov were also approving bonuses for the NKVD executioners who had destroyed the leadership of the very Red Army division they were proposing to create. On October 26, Beria issued a proclamation in which a month's salary was granted to fifty commanders as a reward for their part in "clearing out the prisons of the three special camps." A few days later he wrote a memo to Stalin identifying twenty-four "former Polish officers" from the camp at Gryazovets who "believe a military clash between the USSR and Germany is inevitable in the future, and express the wish to participate in a Soviet-German war on the side of the Soviet Union." Lieutenant Colonel Zygmunt Berling was high on Beria's list of interested candidates for a prime leadership role. He was described by one of his fellow officers as "capable, effective and without scruples, a man of excessive personal ambition." From among the group identified by Beria, seven senior officers, including Berling, were sent by passenger train from Gryazovets to Moscow to meet with NKVD officials under Merkulov's supervision. One officer was quickly removed from the group and sent off to solitary confinement. Rigorously interviewed and prodded, the remaining men were wined and dined in a manner that must have come as a shock to their malnourished systems. Their accommodations in a suburb of Moscow were sufficiently luxurious for the name Villa of Bliss to be attached to it. Evidently won over by

the treatment, this handful of men confirmed their willingness to take on the role of commanders of a new Polish army under Soviet control. Asked who among their countrymen might lead a proposed Polish armored division, the six began proposing the names of scores of their fellow officers from the camps at Starobielsk and Kozelsk. After dinner, over a glass of cognac, Beria told Berling that nothing would come of this, that these men were no longer available to lead. Merkulov added, in reference to them, "We made a big mistake." This comment was the first inkling that blood had been shed.

Stalin alone continued to believe Hitler would not attack. Every head of state and military commander in Europe saw what was coming. Operation Barbarossa, the single most expansive invasion ever launched in the history of warfare, finally erupted on June 22, 1941. In one thrust, four million Wehrmacht soldiers massed along a two-thousand-mile front and moved forward in three separate phalanxes, each violating the boundaries set by the pact that divided Poland into separate German and Soviet spheres. Within hours of the invasion, more than eighty percent of Soviet air force planes on the ground were destroyed by the Luftwaffe. Tens of thousands of Red Army soldiers were quickly killed or captured. Minsk fell, then Kiev. Once again eastern Polish cities were bombarded, suffering devastation from yet another round of German blitzkrieg.

German forces advanced on all fronts, their divisions penetrating four hundred fifty miles into Russian territory, securing ground rapidly. The Red Army sustained enormous losses. Soviet war resources were severely strained. German troops pushed east into Soviet Ukraine, Soviet Belorussia, and the Baltic States, heading for Moscow. After unusually fierce resistance, the city of Smolensk finally fell into German hands, a key moment in the unfolding of the story of Katyn. Soviet defenses were toppled. Hitler believed the Red Army would lay down arms after a few months of fighting, long before winter set in. One primary objective was to capture the farms in Ukraine.

The very evening Hitler attacked the Soviet Union, Prime Minister Winston Churchill broadcast a radio speech welcoming the Soviet Union to the fight against Nazi Germany, pledging assistance, declaring "Russia's danger is our danger." In so doing, he lost the upper hand he may have gained by waiting for the USSR to appeal for help. Churchill's unexpected eagerness to extend support confirmed Stalin's belief that the West would have no choice but to come to the aid of the Soviet Union in fighting a common enemy. Recovering

from his apparent torpor, Stalin recognized the need to convince the British of his willingness to cooperate.

Three weeks after the launch of Operation Barbarossa, in an unprecedented turn of events, a Soviet delegation was sent to London to meet with the Polish government-in-exile. To mollify the British, Stalin agreed to discuss the reestablishment of diplomatic relations with Poland, a country whose existence the politburo was loathe to acknowledge. The meetings convened on July 5. Extremely tense negotiations began. Ivan Maisky, the Soviet ambassador to the United Kingdom, and General Władysław Sikorski, the commander in chief of the Polish armed forces *and* the prime minister of the Polish government-in-exile, were joined by the British foreign secretary Anthony Eden. All parties shared the expectation of creating a united front against Hitler, but each arrived with an agenda of its own.

From the outset, the Polish delegates were clear about their position. They wanted assurance that the Soviets would renounce the territorial claims set down in the German-Soviet Nonaggression Pact. They demanded the immediate release of all two hundred thousand Polish military and political prisoners being held in the Soviet Union. (The Soviets themselves had provided this figure.) They expected diplomatic relations to resume between the two countries and for a Polish embassy to open again in Moscow with the authority to oversee the welfare of Polish citizens in the USSR, including prisoners of war and every individual who had been forcibly deported. No accord would be signed by the Polish government-in-exile until these issues were satisfactorily resolved.

The British were determined to lay claim to Russia's natural resources for the battle against Germany. At the beginning of the talks, Churchill invited General Sikorski for a private meeting and politely asked his Polish counterpart to exercise statesmanship during the negotiations. (No such request was made of the Soviet ambassador.) Eden continually pressured the Polish delegation to make compromises and resolve differences as quickly as possible, insisting that their concerns about autonomy and territorial integrity were an unwelcome distraction from the combined effort to destroy Hitler. Sikorski was repeatedly made to feel that he represented the country with the least bargaining power. As the head of both the armed forces and the government, he was already actively formulating a program for a federation of Central European states, looking ahead to a postwar world in which he expected Poland to play a substantial role.

Maisky was a mouthpiece for Stalin, juggling numbers to suit the occasion, rejecting the earlier figures, claiming that only twenty thousand Polish prisoners of war remained in Soviet detention. The other one hundred eighty thousand prisoners, he claimed, had already been released and transported outside the country's borders. He refused to budge on the question of one million men and women deported from Soviet-controlled Poland to Siberia since September 1939, insisting that they were no longer Polish but were now Soviet citizens and subject to Soviet law. The concept of Polish citizenship did not exist for Maisky. As for frontiers, the Soviet ambassador suggested this was too complicated an issue to rush through and agreed to postpone deliberations until such time as diplomatic relations were reestablished, but stated categorically that the Soviet Union would never renounce its right to eastern Poland. Meeting like with like, he announced that until the Soviet territorial gains made in September 1939 were accepted, there would be no further release of Polish prisoners. Maisky would honor none of the Polish demands. Three weeks of deadlock followed. The meetings, mired in mutual distrust, ground to a halt.

The British government all but demanded Poland back down from its position on prewar territorial borders. Eden put enormous pressure on Sikorski to sign a truce with a protocol attached at the end: "An amnesty is granted to all Polish citizens on Soviet territory at present deprived of their freedom as prisoners of war or on other adequate grounds." The wording of this text enraged the Polish delegation. Amnesty? For what crime? The Polish citizens in question were guilty only of being Polish citizens, forcibly ripped from their homes and deported. The truce on offer made no mention of the question of borders. Władysław Raczkiewicz, the president of the Polish Republic, warned Sikorski not to yield and forbade him to sign Eden's proposed treaty. Raczkiewicz and Foreign Minister August Zaleski, both members of the delegation at the table, had been born and raised in a Poland under Russian rule. They maintained a hard-earned suspicion of Soviet tactics. A feeling of stalemate hung over the proceedings. British and Soviet delegates eventually wrested control over the stalled deliberations, virtually excluding Polish representation. This dynamic would be repeated often in the coming years.

Spearheaded by Eden, the Polish-Soviet pact known as the Sikorski-Maisky agreement was signed on July 30. Zaleski immediately resigned from the Polish cabinet, followed by the ministers of justice and military affairs. Two weeks later, the Supreme Council of the Soviet Union issued an "amnesty" according

to which prisoners would be released, given identifying certificates, fifteen rubles a day, and train tickets to their chosen destination. Two days later, a military agreement was reached confirming the establishment of a Polish army in the Soviet Union. Though details were vague, the ranks were meant to be filled by Polish soldiers who had been rounded up by Soviet troops in 1939. The size of the army would be determined by availability of equipment and supplies and the number of soldiers who enlisted. A preliminary estimate of thirty thousand men was expected to create two or three divisions. Maisky, alone among all the negotiators at the table, was aware that the thousands of officers expected to lead these divisions had been killed and buried more than a year earlier, their bodies stacked twelve deep in the cold ground.

The terms of the Sikorski-Maisky agreement placed certain constraints on the Soviets. Famously suspicious of foreigners, they would have to allow representatives of the London-based Polish government and military to move unhindered through their country. They had to accept that their plan to raise a Polish army and send it immediately to the front as cannon fodder would not be realized. General Sikorski would not allow his men to engage in battle until they were fully prepared to withstand enemy action. Considering the physical condition of Polish soldiers exiting from prison camps, this was a critical concession. In order to sustain the goodwill of Britain, the Soviets made many promises they knew they could not keep, and others they knew they would not keep.

Sikorski appointed General Władysław Anders to head the new divisions of the Polish army. A fiercely independent spirit, Anders was a leader who generated intense loyalty from those he commanded. Growing up in the Russian-controlled sector of Poland, he was a keen student of the Russian character and spoke the language fluently. In the September 1939 campaign, while leading his cavalry brigade in battle against both Germans and Russians, he had been shot in the leg. He was recovering from his wound in a prison hospital in Lwów as his fellow officers were being shipped off to Starobielsk or Kozelsk. The Soviets considered him a catch of sufficient interest to warrant having him hauled up to Moscow. Before his wounds had time to heal, he was transferred to the Lubyanka prison for further interrogation. At Lubyanka he was beaten and tortured. He spent seven of his twenty months in prison in solitary confinement.

On August 4, five days after the Sikorski-Maisky agreement was signed, Beria and Merkulov made an appearance together at Lubyanka to release

Anders from a place he might reasonably have expected never to leave alive. Anders recalled the moment in his memoir:

> As soon as I got out into the corridor I knew that something unusual was up. I found the assistant prison commander there and a few of the senior guards awaiting me. They took me up a short flight of steps and then into a lift. This time nobody pinioned my arms behind me. The prison commander himself joined the party and walked beside me. Nobody tripped me up or threw me down steps. Quite the contrary, everyone was the soul of courtesy.

Forty-nine years old, the wounded general walked slowly. He had no shoes. His prison uniform bore the imprint of the NKVD. He was introduced to Merkulov and Beria inside a lavish office within the prison complex and told he was a free man. Beria informed him that he had been appointed commander of a new Polish army. After asking for a cigarette, Anders requested he be put in immediate contact with all of his leadership still held by the Soviets. The two heads of Soviet state security assured him that he would be provided with whatever he wanted, and insisted the time had come for Poles and Russians "to bury the hatchet." Anders was handed carefully into a waiting NKVD limousine and immediately whisked to meetings where plans for the new Polish divisions were being developed. Three weeks passed before he was granted permission to meet with his men. Finally, on the August 25, an ancient Soviet aircraft carried Anders north of Moscow to Vologda, where he was helped onto a hand-propelled trolley car that shuttled him to Gryazovets.

It was an exhilarating spectacle, an electric moment. The new commander and his men assessed one another. Hobbled and gaunt, Anders looked out upon rows of soldiers in formation, most of them dressed in rags, without weapons, many without shoes. The exhausted prisoners over whom he was given leadership greeted him warmly, effusively. Czapski was among those officers who welcomed Anders as he arrived at the camp with an escort of NKVD officers:

> On a sunny, misty, already autumnal day smelling of wet earth, he inspected our ranks, dressed as we were in threadbare uniforms that with some trouble we had brought to a passable state. He walked on a cane with a slight limp (we knew he had been seriously wounded in September 1939 and then dragged from prison to prison in Lwów, Kiev and Moscow), his complexion was sallow,

and his gaze was extremely focused and attentive. In the simplest words, which we found very moving, he called us all back to active service and ended his speech by saying: "We must forget our past injuries ... and fight with all our strength against the common enemy, Hitler, alongside our allies, alongside the Red Army." His words rang out like a verdict with no appeal.

The emphasis on unconditional cooperation with the Soviets was difficult for many to digest, yet the ranks of Polish fighters were roused with a determination to return to battle.

General Anders issued an official proclamation stating that all Polish citizens about to be released from captivity according to the terms of the Sikorski-Maisky agreement were encouraged to come forward to join the new Polish divisions. The announcement had enormous consequences. Even in light of the vast upheavals produced by two years of war across Europe, neither Soviet nor Polish authorities were prepared in the coming months for the movement of so large a mass of humanity motivated by this call to arms. Everywhere deported Poles managed to hear of the appeal, they responded. Word of the "amnesty" and the new Polish divisions spread. Men, women, and children from the frigid north used whatever means of transport they could to get to the recruiting center, many walking hundreds of miles to board boats or trains that would carry them farther south. Most of these individuals were already sick, suffering from malnutrition and scurvy. With no assistance from the Soviets, they tried to find their way, usually with no directions, tickets for transport, or means of survival. Train travel was absurdly congested, the cars filled beyond capacity with Russian civilians fleeing, one step ahead of the advancing Germans. Soldiers and military equipment headed in the other direction. The addition of many thousands of Poles heading south put an incredible strain on an already severely taxed system. Railway platforms all over Russia were packed with bodies waiting to move. Overcome by disease, many perished before a train arrived to take them away from the nightmare they had been living through.

In early September, Anders learned that the headquarters of his new army would be at Buzuluk, a small country town with unpaved streets seven hundred fifty miles east of Moscow, between the Volga River and the southern Ural Mountains. Base of operations for the new Fifth and Sixth Polish Infantry Divisions would be nearby in Tatishchev and Totskoye.

7

ON THE AFTERNOON of September 7, a week after parading before General Anders, Józef Czapski and his fellow officers were finally released from the Gryazovets camp. Nearly two years of imprisonment was behind them. In military formation, the men returned to the same platform where they had arrived as prisoners under heavy guard. As they exited, each former inmate was furnished with a small amount of currency.

> We set off in fours. On the way to the station, a journey of over four miles, it started to drizzle. The fine rain soon fell harder, as our muddy walk took us across miserable terrain, through poor villages consisting of black cabins made of immense logs.... We were walking at a soldierly pace, singing Polish military songs at the top of our voices, in an excellent mood despite the rain. We reached the station. We were ordered to go around the station buildings. We crossed a small, flooded meadow to the platform, where we were lined up in a column according to the numbers of the railcars to which we had been assigned, and ordered to wait. By now it was pouring with rain, and our mood was less enthusiastic. Our commanders had believed the Bolsheviks, who had told them the railcars were already on their way from Vologda, but they had not arrived, and they wouldn't arrive until dawn. Our commanders didn't show up, and so, with cold rain bucketing down on us, we stood and waited in fours until two or three in the morning.... At five, soaked to the skin, we transferred to the passenger cars, which had finally arrived.
>
> And so after two years we regained our liberty.

Czapski and his comrades made another journey of nearly one thousand miles, this time from Gryazovets to Tatishchev and Totskoye. For the first time in two years they were free to converse with whomever they came upon during the constant station stops en route. They mingled with masses of other undernourished, exuberant Poles, mostly deportees who were headed to join Anders and the new army, in search of the protection it offered. Everyone had

a story to tell during the long stretches of travel across an empty, arid landscape. Over the course of ceaseless stop-and-go activity, a sobering awareness dawned on Czapski and his colleagues: The barriers that had been used to imprison them as officers for two years had also served to protect them. The outside world they had known previously had so degenerated during their incarceration that many of the newly freed men could not fathom what they were hearing. Over and over again reports of savage behavior and death by starvation and murder were recounted. For the first time, the extent of the deportation of Polish families from Soviet-occupied Poland to Kazakhstan and Siberia was made clear to them. The men listened to story after story, skeptical at first about the scale of the events, yet the accounts were all so similar and so rich in detail that ultimately their truth seemed undeniable. Czapski's diary from this trip, crammed full of notes made from his encounters and conversations with people of all walks of life, would form the basis of the opening chapters of a book he would later write about his experiences in the Soviet Union during the war.

As the scope of the Polish disaster began to form in his mind, Czapski was also conscious of the pitiful state of the Soviet citizens he saw along the way. Speaking with them about their circumstances, he was surprised by the harshness they recounted of life under the Bolshevik regime. Every citizen, he learned, was legally bound to give anything and everything he owned to the state, including food and milk. For two years, he and his fellow prisoners had been endlessly subjected to a propaganda myth of Soviet bounty and pride. Now that he was seeing life outside the camps with his own eyes, he better understood the reason why camp authorities went to the trouble of maintaining an enforced distance between prisoners and townspeople. Grievances poured out of the people with whom he spoke. They were full of despair, fury, and a sense of hopelessness. Czapski heard much that would stay with him until he died.

After seven days of travel, the men arrived at Totskoye, almost four hundred miles north of the Caspian Sea. Camp consisted of nothing more than a few flimsy tents pitched on the bare steppe. For the time being, in the last weeks of summer, it seemed idyllic.

A crisis was developing. Day after day between five hundred and two thousand individuals would disembark from trains in search of the new army's support and shelter. Tens of thousands of Polish civilian refugees were flocking to the sites where the army was in formation, willing to subsist on next to

nothing for the comfort and security of living freely in the company of their countrymen. Very quickly the sheer volume of people arriving daily became far too large to handle. Organized as a fighting force, the new Polish army was also seen as a shelter, a guarantee of protection from the fickle, vicious grasp of Soviet law. To broaden the reach of this safety net, General Anders established a Women's Auxiliary Service. He began to see the scope of the escalating situation and realized that his mission was actually twofold: to create a fighting army *and* to save the lives of as many nonmilitary Polish citizens in the USSR as possible. Stalin was kept updated on this surplus tide of humanity and was eager for any bodies to ship to the front; nearly every Russian male between the ages of fifteen and seventy had already been conscripted.

Sikorski and Anders pressed the Soviets to allow them to form more divisions, but such appeals were met with resistance. The Red Army was struggling to feed its own troops. By the time General Ivan Panfilov of the Soviet general staff got around to approving a Polish army consisting of two infantry divisions totaling thirty-six thousand men, more than forty-four thousand had already enlisted. Panfilov was unwilling to provide food rations beyond his original figure. He had Red Army guards posted at the railway stations of Buzuluk and Totskoye to forbid any more Polish deportees from disembarking, yet many thousands more were en route. And thousands of others, in remote prisons, camps, and collective farms spread across Soviet Russia, had not yet even heard of an amnesty or the formation of a new army. Word would eventually reach them too, and set them in motion.

From the start the Polish army's training program was hampered by lack of equipment. The Sixth Division, Czapski reported, had to make do with one hundred rifles for ten thousand men. The new army had no uniforms; the men wore what they had arrived in, which in most cases was what they had been wearing when they were captured by the Soviets in September 1939. Many would-be soldiers had their feet wrapped in rags tied with string. Ancient full-dress uniforms from the First World War were unearthed and put into use. The Polish government in London approached Anthony Eden about moving the Polish army's base farther south, nearer to British-occupied Iran, to facilitate a transfer of supplies marked for the Polish troops.

A noncombatant soldier, Czapski was quickly put in charge of the bureau offering assistance to the new arrivals. Most of the men making their way into his office had not yet been posted or were unfit for military service for reasons of health, injury, or age. Many had stood for hours in a long line to seek the

meager services his office had to offer. His role was to inform them of the current situation regarding recruitment and to bring them up-to-date on the status of the army. Czapski explained that the Polish army and government had never ceased to exist, despite what they had heard and read in the past two years. He led discussions in which the alliance with Stalin was stressed as a force for good, echoing the words Anders had pointedly driven home. Most of the men were desperate for contact with their families, the majority of whom had been deported by the Soviets and transported to unknown destinations. With the idea of creating a centralized resource of information for the new Polish embassy in Moscow, Czapski began drawing up lists of names and addresses to help reconnect families separated by imprisonment and deportation. Part of every exchange with any individual entering his office involved a series of questions concerning the officer-prisoners from Starobielsk, Kozelsk, and Ostashkov. Of the endless sea of men who passed through his office, not one would ever confirm having seen a single one of these officers.

Nor had a single one of them turned up to join the new army. Unable to account for their having vanished so completely, Czapski became determined to locate them. In a passage from *Inhuman Land*, a memoir about his search for the missing men, he wrote: "That these men would turn up became, for me, something like an obsession. I had so clear a recollection of that year at Starobielsk, during which time many of them, in the promiscuity of our lives as prisoners, had become my best friends. The very idea of their disappearance seemed impossible to me. . . . The memory of these men haunted me, because I had been one of them."*

In passages detailing his increased feelings of anxiety, fear, and hopelessness about the missing men, the appearance of the word "promiscuity"—"dans la promiscuité de notre vie de prisonniers"*—caught me off guard. Promiscuity suggests a disorderly grouping of diverse elements in close proximity, a quality of indiscriminate mixing. Wondering about the Polish word for "promiscuity," I put aside the French edition I was reading and turned to the Polish text of Czapski's memoir. The lines I quote above were nowhere to be found, they simply do not appear in the original Polish version. I flipped to the title page of the French edition only to discover that the book, which had become so familiar to me, had not been translated literally but "adapted from the Polish" by Czapski and his friend Maria-Adela Bohomolec. Czapski seems to have both expanded and cut his text in places for this version in French. Some references to Polish writers and political figures were abbreviated or excised by him, and he allowed himself a more Gallic flourish here and there. I was startled by this description of the state of communion existing between Czapski and his friends in prison. In a book called *Inhuman Land*, the word *"promiscuité"* almost subversively introduces a glimmer of the "human," a tactile feeling of bodily warmth, of

As he compiled his dossier on the missing officers, Czapski recognized that the stories surfacing about them were only secondhand at best. One he heard repeatedly concerned seven thousand Polish soldiers thought to be drowned when two barges ferrying them across the White Sea were intentionally sunk by the Soviets. Another involved sixteen hundred Poles who froze to death on a train to a Siberian labor camp. Reports of officers spotted in the far northern Arctic region known as Franz Josef Land were plentiful; other reports made mention of officers believed to be working in mines and building airfields in Kamchatka. It was nearly impossible to separate hard fact from rumor.

Where were the officers? Another Russian winter was bearing down on them. Czapski decided to intensify his search by moving to a more powerful base of operations. He left Totskoye, headed to the Polish army staff headquarters in Buzuluk, and filed a report with Colonel Leopold Okulicki, who was acting as a deputy commander while General Anders was away at meetings with Sikorski. The chief of staff of a bustling office, Okulicki was an impressive figure. He had been tortured in a Soviet prison and all of his teeth had been kicked out. His immediate response to Czapski's initiative was enthusiastic and he requested that a more detailed accounting be made on the spot. Dictating to a typist, Czapski poured out all he knew about his companions from Starobielsk, speaking for several hours as page after page of testimony piled up. Exactly which men were missing? Among them were many of Poland's most accomplished soldiers, leaders, and thinkers. General Sikorski was desperate for news of his former aide-de-camp, Major Jan Fuhrman. General Anders was anxious for the return of his old chief of staff, Major Adam Sołtan, whom Czapski had known and admired at Starobielsk. Everyone at headquarters carried a hope that some individual missing from their life would materialize in the next group arriving by train. A thorough list of names of the missing officers would be highly desirable, and at Buzuluk, the authorities finally began a concerted effort to compile one. Prompted by Czapski, the

men confined in overcrowded quarters. Unintentionally, "*la promiscuité de notre vie de prisonniers*" reads as a quintessentially Proustian phrase, with subtly suggestive associations of soldiers penned in together. In seven French words, Czapski unites two ostensibly disparate realms of experience—sensuousness and deprivation, freedom and tyranny, France and Russia. What does the absence or presence of this word imply about the differences between the nature of Polish and French utterances and feelings, and Czapski's relation to each? Expressing himself freely in several languages, he was capable of tailoring various aspects of his sensibility in whichever tongue he chose to write or speak.

first alphabetical list of missing officers was cobbled together by the end of October 1941, consisting of about four thousand names. Adam Moszyński, whose portrait Czapski had drawn at Gryazovets, presented his own independently assembled list for cross-reference. A single consolidated roster slowly took shape as an open file. Names were continually added. Eventually, the expanded document that began with Czapski's litany of remembered names would make its way into Stalin's hands. General Anders ordered Czapski to oversee the coordination of the search and provided him with a portfolio of letters introducing Czapski as his representative.

The Polish general staff forwarded Czapski's report to the newly reopened Polish embassy and its staff, and directed him to Stanisław Kot, the recently appointed Polish ambassador to the Soviet Union in Kuibyshev (Samara), ninety miles west of Buzuluk. Frustrated that talks with Stalin and Andrey Vyshinsky, the deputy minister of foreign affairs, had gone nowhere, Kot had long felt the need for a comprehensive list of names to assist in his dealings with Soviet authorities. He requested a formal briefing from Czapski. At Kuibyshev, Czapski found an encouraging confluence of purpose and determination.

> The embassy had a special atmosphere, created by the combination of people who had come from Britain and a whole series of others who had only recently removed their louse-infested padded jackets, and more who had literally arrived the day before from camps and prisons. This pre-revolutionary detached villa was densely populated with people who in Poland would have had a hard time sitting at one and the same table because they belonged to different social milieux and rival political groupings that were at loggerheads with one another. Now they were all eagerly buckling down to work for the common cause.

Polish authorities were stymied by the Soviets' claim that they had no idea of who these thousands of men were, not to mention where they were. General Sikorski was growing weary of the noncommittal response to his persistent inquiries. The Soviets issued only vague replies, shuffling requests for information back and forth among various bureaus and apparatchiks. It was well known that detailed records were kept for every soldier-prisoner in a dossier that included fingerprints, photographs, and family information. Having heard once too often that all Poles in captivity in the USSR had been released, Sikorski arranged for a face-to-face meeting with Stalin in Moscow, then summoned General Anders to Tehran to work out a strategy. The two men

conferred as Sikorski supervised distribution of British and American supplies for the Polish divisions in Russia.

On December 3, 1941, Sikorski, Anders, and Kot were received at the Kremlin. This was a very dark time for the Soviets: The blitzkrieg continued to rage unabated. German forces were assaulting Red Army defenses within twenty miles of Red Square. Over the course of a few hours, Stalin, Molotov, and Panfilov addressed the pressing issues of Polish-Soviet cooperation in respectful terms. Serious consideration was given to the state of the Polish deportees. Stalin, at first adamant about Poland's responsibility for providing for its own people, eventually conceded that these hordes of people were only in the USSR because of having been forcibly removed from their homes by the Soviets. Agreeing to the establishment of a system to manage the well-being of the deportees, he committed an impressive sum to be dedicated to improving their welfare. He took umbrage at the suggestion that the terms of amnesty were not being fulfilled. Sikorski then proposed moving the entire Polish army to occupied Iran, where British resources could more readily outfit and feed the troops. Stalin balked at the idea of such an exodus and suggested disparagingly that the soldiers of the Polish army were unwilling to fight. General Anders immediately parried the accusation, insisting his men were deeply invested in participating in the war effort but the lack of equipment and food was beginning to break their spirits. Stalin countered that Polish divisions sent to Iran would fall under British jurisdiction and could be prevented from returning to fight in Russia. Ambassador Kot reassured him on this front: "Polish soldiers fight better the closer they are to Poland."

Inevitably, the conversation led to a discussion of the missing officers. Anders presented his case: The NKVD had eyes everywhere and saw everything. It was unimaginable that the movements of so many men could go unmonitored in the Soviet Union. How could thousands of released prisoners move about undetected, let alone make their way thousands of miles, without their presence being made known? Every prison, every labor camp kept records on every single prisoner. How was it that the burden of proof for establishing the identities of these men fell on Poland?

Stalin offered a comment: "We have traces of their stay in Kolyma." This was unexpected news. "Or, it may be that they are in camps in territories taken by the Germans and have been dispersed from there," he suggested, as if it had just occurred to him. The earnestness with which these declarations were delivered served to placate the visiting dignitaries. As it was meant to. Stalin

knew very well that the men were not missing but dead. Immediately before his arrival in the room, a secret NKVD report had been read aloud to him, an up-to-date account of all surviving Polish prisoners of war, informing him of how many Poles had been captured in 1939, how many were conscripted into the Red Army, how many had been exchanged with Germany, how many were released to Ukraine and Belorussia, and how many were "sent to the disposition of the NKVD in April–May 1940"—that is, to their deaths.

The Polish leaders had no expectation of this degree of duplicity. They were being manipulated by a master and were powerless in the face of his malevolence. The meeting was followed by a sumptuous state dinner, characteristically stretching into the early hours of morning. As the sun was rising, Sikorski and Stalin affixed their signatures to a "declaration of friendship."

Four days later, the Japanese bombed Pearl Harbor and the United States entered the war. Polish spirits everywhere rose. Suddenly Hitler's triumph no longer seemed so assured. British and American supplies slowly began to make their way into the hands of the ever-expanding pool of soldiers in Tatishchev, Totskoye, and Buzuluk. Training started in earnest. At the end of December, Stalin approved the expansion of the Polish army into six divisions with a combined force of ninety-six thousand soldiers, promising food rations for all. One Soviet ration was nutritionally equivalent to only forty percent of the average British ration, and Polish soldiers routinely shared their rations with their destitute countrymen and women who surrounded the army encampments. And still the Polish army was far better fed than political prisoners or deportees, or the vast majority of Soviet citizens.

Approval was finally forthcoming for General Anders to move his troops south. Once settled closer to the source of incoming supplies, the army's transition into a series of fully operative military training camps would be accelerated. In January and February 1942, the entire Polish military operation in Russia and its attendant community of deportees began its long trek into Uzbekistan, Kyrgyzstan, and Kazakhstan. Staff headquarters was relocated from Buzuluk to the small city of Yangiyul, near Tashkent.

Czapski, fiercely focused, turned his sights on a closer destination: "It was crucial to take instant advantage of Polish-Soviet military cooperation to save those who were missing or dying, or else it would be too late. Thanks to the indiscretion of a certain Bolshevik, I found out that the Gulag head office had

been transferred from Moscow to Chkalov, formerly Orenburg. I decided to go there in the new year, 1942."

Czapski's fluency in spoken Russian enabled him to communicate with anyone he met on the street in Chkalov, but not many Russians would have been inclined to engage in conversation with so conspicuous a figure in a foreign uniform. Soviet citizens, forced to harbor suspicions about their own countrymen, had little exposure to foreigners. Most would be reluctant, if not altogether terrified, to answer Czapski's startling request for directions to the headquarters of Gulag operations. Undaunted, he made his way from building to building, from person to person, only to be told time and again that no such place existed. On his way out of one office, he casually asked a building superintendent. Without hesitation, the man gave him directions. Czapski easily found the innocuous-looking building and approached the front desk. He presented his letter from Anders, typed on an elegant sheet of heavyweight stationery embossed with the Polish white eagle. Paper of this quality was unknown in Russia and the extravagant flourish proved effective; doors were opened. Czapski was soon ushered into the presence of General Viktor Nasedkin, the chief administrator of the entire Soviet Gulag system. Mounted behind Nasedkin's desk was a large map of the vast Soviet empire strewn with pins. Czapski drank it in as much as his brief meeting permitted, becoming one of the very few people, Soviet or non-Soviet, to see tangible proof of the extent of the complex network of penal labor camps spread across a continent, the notorious Gulag archipelago.

Nasedkin was polite, if noncommittal. Czapski pleaded his case but was soon dismissed. He remained undeterred, next presenting himself at the office of the regional commander of the NKVD, Colonel Bzyrov. Once again he produced the impressive letter from Anders and once again it had its effect. Bzyrov put his unexpected visitor at ease, speaking cordially, but he quickly let Czapski know he could be of no service. Claiming his own rank was not sufficiently elevated to be versed in such national matters as the whereabouts of foreign prisoners, Bzyrov gave Czapski an informative lecture on NKVD hierarchy, identifying individuals and the specific powers they held.

Frustrated, and with nothing further to report, Czapski returned to Buzuluk. A few days later, General Anders was rebuked by a high functionary of the NKVD for having allowed Czapski to travel to Chkalov without first obtaining the requisite Soviet authority. Such behavior was unacceptable, Anders was told, and could not be repeated. Unbowed, Anders sent Czapski

on another mission in the opposite direction, to Kuibyshev, the makeshift wartime Soviet capital, for a series of meetings with the very top level of the Soviet chain of command. Czapski was to be presented as the chargé d'affaires of Anders—his personal emissary—to General Leonid F. Reichman and General Georgy K. Zhukov, the highest-ranking NKVD officials overseeing the interests of the Polish army in the Soviet Union.

Ambassador Kot welcomed Czapski at the embassy in Kuibyshev and offered what assistance he could. The following day, Czapski presented himself at NKVD headquarters with his official papers. He was immediately rebuffed, informed that neither Reichman nor Zhukov was in residence, both men having traveled back to Moscow. Despairing, Czapski returned to the embassy. With considerable tact, Kot tried to dispel any illusions Czapski might still be harboring about the survival of his colleagues. The Soviets, he said, would tell him nothing, and any attempt to procure reliable information would result in disappointment. Not a single word had been heard from even one of the thousands of missing officers in more than a year and a half. With great reluctance, Polish military and diplomatic men like Kot were coming around to admitting the worst.

Czapski was as yet unwilling to arrive at such a conclusion. He set his sights on Moscow. Borrowing several volumes from the ambassador's impressive library of French books, Czapski set out from Kuibyshev in pursuit of Reichman and Zhukov. The scheduled train was not at the station. Czapski waited three days for it, passing his daytime hours at the embassy, his nighttime hours in the station waiting room. It was more than 40 degrees below zero in the center of town.

As for those nights at the station—the way into it was through a large square cluttered with trucks. Then you had to go round a wooden fence and slither along a steep, ice-coated path that led to the large waiting room. Here you had to squeeze past long lines of people waiting for tickets not for hours, but for days (there were always a couple of smaller lines of more or less privileged people, depending on their function or the kind of travel documents they had), then you had to walk, or rather hop across the large room. The entire floor was littered with hundreds of people, in an extremely emaciated state, waiting goodness knows how many days for transport. In the greenish, foggy, sticky light of weak bulbs, in air full of damp from steaming bodies and wet, tattered clothing, the main thing on view were the unnaturally vast, full-length portraits

of Lenin, Stalin, and other leaders. On the floor lay the thin stumps of legs, miserable, puffy faces, and heaps of ragged human figures in padded jackets over naked bodies. The entire waiting room was filled with the roar of a superb radio. A brilliant orchestra, broadcast from Moscow, was playing Strauss waltzes with truly Viennese panache. Meanwhile screaming and quarreling kept erupting in the waiting room, the howling of a woman who may have been robbed, or who may have been a lunatic. After forcing my way through, hopping across the sleepers, treading on them and inadvertently waking them, I would finally reach our partition.

On one of these nights I saw some trucks driving across the station square loaded, as if with timber, with the corpses of people who had frozen to death in the trains, being driven away for burial somewhere. Following their release from labor camps at the time of the German attack on Moscow, these people had been traveling for weeks, with hardly any clothing, quite often in *open* railcars, on trains that stood for days at a time on snow-covered tracks in cruel frosts.

Finally his train appeared and soon after departed for its eight-hundred-mile trip to Moscow. Just as the train began to put on speed, Czapski was recognized by an English officer headed to the rear of the train, who invited Czapski to join him in the car reserved for the British military delegation. Without fuss or fanfare, a well-heated first-class sleeping compartment was put at his disposal, complete with mahogany fittings, carpets, seats upholstered in blue velvet, and a private washroom with a large mirror. Coffee, tea, bread, and sausages were brought to him at regular intervals. Over the course of three days, Czapski's surroundings provided an unexpected, even unfathomable immersion in luxury; running hot water, a gleaming toilet for his personal use, ironed sheets, pillows and a warm blanket, privacy, vistas from the picture windows, elaborate meals at set times. It had been a very long time since he had experienced such comforts. He was able to sustain basic conversations with most of the Royal Air Force officers, but with several of them he communicated more expressively in French. Czapski admired the men and their impeccable manners, and marveled at their deportment, their neatly ironed uniforms, their habit of shaving every day. "The British behaved in the most natural way imaginable," he observed, wryly, "which in itself was extremely unnatural in Russia." At one point on the journey, the train came to a halt at a remote station. A luncheon had been arranged for the British delegation,

among whom Czapski was now considered an honorary member. The station restaurant had been emptied, the platforms swept clean of any trace of the beleaguered public. Shunted aside, local residents were kept at a distance. Czapski sensed that the immaculately dressed British officers did not even see the swarms of starving people who had been pushed away to allow them unfettered access to the restaurant. A bountiful hot meal awaited them, served by attractive young women in white silk blouses.

> Sitting at table, being served by the confused young ladies, and thinking of the crowd packed into the next room, just like the one that had filled the Kuibyshev waiting room, I felt I had too much inside knowledge of the backdrop to this feast to be able to consume it with equally British phlegm. As Germany was busy invading Russia, with the crowd of people jammed into every corner staring at us as if in total disbelief, the perspiring young ladies with their blushes and their wavy locks were a sort of "Potemkin village," provincial theater carefully rehearsed for the British.

At the station in Moscow, a fleet of cars awaited the delegation to whisk them to their embassy. Czapski was graciously offered a lift to the National, one of two hotels reserved for foreigners.

When, following the armistice, Czapski had been sent to Petrograd to locate five missing officers at the end of 1918, relations between Poland and Russia had been severely strained. The administrative structure of the new Soviet state was in flux and the seat of power was in the process of being transferred to Moscow. Step by step, it had taken Czapski several weeks to arrange access to someone in charge. Elena Stasova had made herself available and ultimately provided him with the information for which he had come.

At the beginning of 1942, Poland and the Soviet Union were officially in a state of public reconciliation, the Sikorski-Maisky agreement was in effect, and Stalin had just approved the formation of a new Polish army to engage in battle against Hitler. Fifteen thousand men who had vanished were needed to serve at the core of its leadership. Given the state of mutual cooperation, Czapski believed that his current assignment would surely be far less difficult to resolve than it had been in November 1918. The soldiers of the Red Army were now their brothers-in-arms. All parties stood to benefit by finding these missing officers. On his first night, tucked into bed at the National Hotel, he

felt a surge of hopeful expectation: "I refused to believe that Russia was carrying out mass murders twenty-five years after the revolution. I was sure that in the present circumstances I was bound to have easier access to Beria, head of the NKVD, than I had had to Stasova in 1918."

He would not have easier access. Despite the ascendancy of General Anders and the span of his influence, Czapski was essentially snubbed from the first day he made the rounds. Like Kafka's character K. trying to gain access to the Castle, Czapski found himself up against an impenetrable wall of authority. Forced to submit his letters of introduction for consideration rather than presenting them in person as he had been ordered by Anders to do, he endured the tedious ordeal of waiting, spending each day at NKVD headquarters attached to the Lubyanka prison. Ushered from one waiting room to another, he was reminded of his search in 1918:

> My view of the prevailing reality was completely clouded by my out-of-date recollections of the Bolsheviks of the initial period; thanks to the fact that they included plenty of original, highly remarkable individuals, and not just blindly obedient pawns, through various chinks in the armor it was possible to reach them, and then find a common language on various topics. Once you had made human contact by this route, you could try to get an answer on other matters too. I had forgotten that nowadays the situation had entirely changed. In 1918 there was none of the present Soviet legislation, thanks to which there was no freedom of movement, not even inside the country—a place where high-up functionaries actually supervised each other, where foreigners, including communists, were under constant vigilant control, and where crossing the border illegally was a crime for which hundreds of my acquaintances sneaking in from Nazi-occupied Poland had been punished with three-to-eight-year prison sentences. I had overestimated the fact that these days I was an ally, and that General Anders and the vast majority of Polish soldiers were determined to fight loyally alongside the Soviet army.

Invited to make use of the British Military Mission in Moscow during his visit, Czapski often retreated there to write his official reports. Occasionally he would be invited to dine in the mess hall by the senior officer, Lieutenant General Noel Mason-MacFarlane. Tall and thin, with a drooping white mustache, the elegant old soldier had nothing officious about him. He and Czapski appreciated each other and spoke in French to their mutual delight.

Mason-MacFarlane offered stories of his experience at Dunkirk. Other members of the staff proved equally attentive, full of disinterested sympathy. Czapski was enchanted by their ability to transform wherever they assembled into a small corner of England. In the dark-wood-paneled dining hall, the men would suddenly become quiet, rise to their feet, and lift their glasses. The presiding officer would propose the toast, "Gentlemen—the King!" In the cold heart of ice-covered, fear-ridden Bolshevik Moscow, such warm sentiment for home and country made a deep impression on Czapski.

He would find a quiet corner to do his work. His report dated "Moscow, February 2, 1942" concluded with reference to the missing men:

> In expanding our army in the south of the USSR, following the resolution adopted by Stalin and General Sikorski, we are increasingly aware of the lack of these people, without whom we are missing our best military experts, our best commanders. It goes without saying that the disappearance of these men is impeding our efforts to build our army's trust in the Soviet Union, which is crucial to the favorable development of mutual relations between the two Allied armies in the fight against the common enemy.

At General Mason-MacFarlane's request, Czapski submitted a copy of his report to the British Military Mission and accepted the general's generous offer to have the document forwarded to the Polish government-in-exile headquarters in London via the British diplomatic pouch. Czapski returned to his hotel.

> At every step I saw the expression of a brutal, unbending will; I saw thousands of human faces that were closed or hostile, and I felt the terrible disproportion in physical strength between us and this empire, which in recent years had killed off more Poles than in the whole of history to date. I still didn't believe our men had been murdered, I was deluding myself that they were in Kolyma or Franz Josef Land, but now I had no idea what steps to take to discover their location.

After reading Czapski's pages, Mason-MacFarlane wrote his own assessment of the report and, marking it "Most Secret," included it in the diplomatic bag bound for the Foreign Office in London. "There is not the slightest doubt that the NKVD must know what has happened to these Poles as the most detailed

nominal rolls and information are kept up at every concentration camp and prison.... I am in close touch with Czapski but propose to keep us entirely out of this business, which is a purely Polish-Russian affair. The NKVD is clearly going back on the categorical assurances given by Stalin to Sikorski."

With time on his hands, Czapski sought out anyone who might help, anyone who would listen. Ilya Ehrenburg, a Russian writer he had known in Paris before the war, a fellow denizen of the cafés of Montparnasse, was in Moscow covering the war. Czapski was impressed with Ehrenburg's daily dispatches about the encroaching German forces; the writing was touched with the slightest suggestion of humanity, a quality otherwise entirely absent in the Soviet press and propaganda. Ehrenburg had recently made a trip to Buzuluk with Deputy Foreign Minister Vyshinsky and had been happy to run into Czapski. A champion of French culture within Soviet circles, Ehrenburg welcomed the chance to speak at length about French writers and painters. He admitted to owning a reproduction of a Bonnard painting, insisting it was certainly the only one in Soviet Russia. Czapski was curious about unsanctioned contemporary Soviet art, and Ehrenburg bemoaned the fact that real painting was no longer happening in Russia, that artists with genuine talent were forced to earn their living as costume or set designers. The two men found common ground and appreciated each other's company.

So now I had a right to expect him to help me. But in a bright, luxurious room on the sixteenth floor of the Hotel Moscow, I instantly realized that if he really did want to help me, if he were to show me sympathy merely by the look on his face, or to give me real advice through just a short phrase, he would not be what he was in Russia, he wouldn't be living in the Hotel Moscow, but would have long since been rotting away in the Siberian tundra, in Kolyma or Komi, or the steppes of Karaganda. I can still see him, sitting in a low armchair, quite far away from me, answering me in a loud voice, counting on the fact that here too the room could be bugged. He said he didn't know or barely knew any of the dignitaries on whom this matter depended; he was surprised that I had been chosen for a mission of this kind, as I was *tolko kapitan*—just a captain— and said that a single telegram from General Anders could be more effective than all my efforts in Moscow, because Anders at least was a general.

In the middle of the night, a telephone call awakened Czapski from sleep in his hotel room. The unfamiliar voice on the other end of the line informed

him of his appointment for a meeting with General Reichman at the Lubyanka prison complex the following day. Czapski, trying to curb his overactive mind, presented himself as instructed and was put through the routine of being scrutinized by one subordinate after another. Eventually he was led into the antechamber of the small suite of rooms occupied by Reichman. Much to his surprise, he found himself escorted to a chair immediately next to the one where Major Nikolai V. Khodas was seated. Khodas had been the camp commandant at Gryazovets. Czapski's jailer was equally shaken by the unexpected sight of his former prisoner. Czapski bore no ill will toward the man who had devoted a good deal of effort trying to convince Polish officers of the advantages of joining the Red Army. Khodas's rule had been relatively benign, and it was he who had given approval for the prisoners to hold their lecture series, an activity strictly forbidden by the authorities at Starobielsk. Clearly unsettled by the very sight of Czapski, Khodas must have wondered if he had been summoned by Reichman to provide information about his former prisoner. The coincidence was remarkable. Khodas was shown in to Reichman's office.

After a while, Czapski was summoned. Khodas was nowhere to be seen. As was the custom, an NKVD officer remained standing silently in the room throughout the interview. One of Beria's trusted underlings, Reichman was formal and aloof, impassive, his gestures and words calculated to register the minimum effect possible. Czapski presented his report, the latest findings concerning the fifteen thousand prisoners of war incarcerated at Starobielsk, Kozelsk, and Ostashkov. With no discernible response, Reichman read through the document as Czapski waited. The opening section of his report suggested that if these men were already dead, General Anders was entitled to know when and under what circumstances they died in Soviet custody. A detailed accounting of names and camps followed, which Reichman read with pencil in hand, line by line, slowly moving from the top to the bottom of every page, showing no reaction. When finished, he claimed that the business was no concern of his, something about which he knew nothing. However, out of consideration for General Anders, he would make a thorough investigation and be in further communication. Czapski asked about the possibility of meeting with General Zhukov or Merkulov. Reichman told him they were not currently in Moscow. The interview was over, and he was dismissed.

In the hallway leading to the exit of the Lubyanka complex, Czapski crossed paths once again with Major Khodas, also on his way out. Czapski invited him to dine at his hotel; Khodas declined emphatically and quickly distanced

himself from the towering Polish officer. Having been given the opportunity to directly observe both the overlords of Soviet repression and the victims of their policies in close proximity, Czapski was a rare witness.

Days passed. No word came from Reichman. There were few distractions available to fill the long, empty hours. Moscow was functioning in siege mentality. The city's incomparable collections and art treasures were all packed away in underground bunkers. The State Museum of New Western Art, with Sergei Shchukin's and Ivan Morozov's spectacular Matisses, was closed. The ballet had decamped to Kuibyshev. The façades of majestic buildings were draped in protective covers, all in expectation of a Nazi onslaught. Wherever Czapski went, his Polish officer's uniform and high leather boots drew comment. Mistaking him for a German officer, Muscovites frequently alerted the police. He was repeatedly stopped for his papers. Taking meals with other foreigners at his hotel, he continued to seek out connections in diplomatic circles in the hope of digging up some shred of news about his missing companions. Going from bookshop to bookshop, he thumbed through pile after pile of beautiful books, remarkably precious volumes available at distress prices. Thirty rubles were needed to buy a pound of butter in Moscow; for ten, Czapski bought an elegantly bound, immaculate 1868 edition of Baudelaire's *Les Fleurs du mal*.

More than a week passed in such a desultory manner. Eight days, ten days went by. His permit to remain in Moscow was about to expire. Well after midnight of the twelfth day, Czapski was again roused from sleep by the sound of the telephone ringing in his hotel room. The caller this time was Reichman himself, cordial and chatty, not at all the laconic presence Czapski had encountered at his office. Expressing sincere regrets, he said he was calling to let Czapski know that he would be departing from Moscow on official business in a matter of hours. How unfortunate that they would not be able to meet again! As for the investigation, he had learned that all matters concerning Polish prisoners of war needed to be addressed to NKVD headquarters, now in Kuibyshev. Zhukov and Merkulov were still not in Moscow; sadly there was no one in a senior position to whom Czapski might address any further inquiries. He sincerely regretted that there was nothing more he could do to help. His advice for Czapski was to go to Kuibyshev and speak with Comrade Vyshinsky.

Once fully awake, Czapski understood the situation perfectly. Reichman, so as not to risk offending Anders, choreographed Czapski's time in Moscow, holding him at a distance until polite excuses could be made. Reichman was

perfectly well aware that Anders, Sikorski, and Kot were all in contact with the implacable Vyshinsky. He was merely putting Czapski in his place.

The cut-off phone call nullified not just the purpose of my journey to Moscow, but also the months and months I had spent preparing for it. I had gained no news at all, I still had no idea if my comrades were alive, or where they might be. There were no more doors for me to knock on in Moscow in the hopes of having them opened to me. As for Reichman, I was sure he was refusing to say anything simply because he knew something that he was not prepared to tell me. The story of his sudden departure and the nocturnal call that woke me up gave him nothing but pluses, and me nothing but minuses. I hadn't even been given the time to prepare an answer, so all I could do was accept the verdict and leave, not just empty-handed, but also with a sense of having been given to understand "don't poke your nose into matters we're not going to tell you about anyway."

Czapski's mission was over.

In 1991, the Russian journalist Vladimir Abarinov published one of the first volumes to reveal new information about the execution of Polish officers based on papers he found in the recently opened Soviet Archives. In *The Murderers of Katyn*, Abarinov offers a fitful text that pairs primary documents with speculation, literary detective work with historical hearsay. He also quotes at length from *Inhuman Land*, Czapski's account of his search for fellow officers. This marked the first time any such history appeared openly in print in the Soviet Union. In the course of researching his book, Abarinov managed to track down Leonid F. Reichman, eighty-one at the time. Asked to comment on Czapski's version of their meeting in February 1942, Reichman denied ever having met with anyone named Józef Czapski. The idea of such a meeting in his office was preposterous because, according to him, no one ever entered the inner sanctum of NKVD headquarters who was not a Soviet citizen. A low-ranking Polish officer would never have been admitted, regardless of having presented an embossed letter from General Anders. Reichman had nothing more to say, Abarinov had the answer to his question, and the interview was over.

Jewish by birth, Reichman remained loyal to the Soviet state. The Soviet state did not reciprocate in kind. Though he was a lieutenant general of the

NKVD, Reichman was accused by his own colleagues of being a Zionist spy during an anti-Semitic purge in the 1950s. Sentenced to a long term of hard labor, he served only one year before being released after an amnesty. He died shortly before Abarinov's book was published.

8

IRRITATED AND FRUSTRATED, Czapski headed to the station for his return trip, a journey from the bitter cold of Moscow to the bitter cold of Kuibyshev. The creature comforts of his journey to Moscow in the British delegation's car were but a memory. Characteristically, he decided to devote the time ahead to writing, but this time he chose to write about a subject entirely alien to his surroundings: painting.

What, he wondered, would it be like to return to it one day? To prepare a canvas, to unscrew the tops of tubes of paint and squeeze them onto a palette, to reach for a brush, to stand back and then plunge in? As if he could no longer bear being locked out, he forced his way into an imaginary studio space. Heading south from Moscow, determined to shed his feelings of defeat and failure, he scribbled a passionate credo, beginning with an epigraph from Teresa of Ávila: "In order to attain anything it is not enough to walk, one has to fly." The treatise he composed is somewhat scolding in tone, detailing the process a painter must expect to take up when returning to work after a long hiatus, during which time he or she could only have "regressed." As if chastising himself in advance for his failures, Czapski put himself in the very situation he knew he would have to face one day, only not soon enough. "A painter has to start again, not only going back to the point of having broken off, but much further back. If a painter doesn't feel like obeying this truth ... he condemns himself to an immeasurably longer road." The freedom to move ahead, to put the past behind him, was almost unimaginable, its delay unbearable. One essay begun on this journey drew shape from his incessant note-taking over a period of ten days. In the spirit of Saint Teresa, it's called "Leaps and Bounds."

> I don't see how it's possible to achieve anything without a leap. *Leap* is the word that most accurately expresses what one lives while working, at the moment of vision, when one's relation to work teeters precipitously and is suddenly governed by an entirely new law: The artist is instantly derailed from an almost premeditated trajectory of slowly warming and widening exertion

bound by various calculations and hesitations. He is suddenly torn away, not because he wants to be but because he can't resist a force stirring in him.

At this point all the forms elaborated not only by me but by a long tradition cease to be certainties, we find ourselves before the unknown; that which we perceive, how we perceive, and how we try to realize our perception are sometimes in complete contradiction with all of our preliminary experience and working technique.... Manet said that he felt with each new painting that he was throwing himself into an abyss. That is precisely the leap, the dangerous flight I'm writing about. Up to the last minute we don't know if we have wings to carry us or whether we will crash into the abyss.

Sitting on a hard seat on a slow-moving, freezing transport train, bundled in his worn greatcoat, Czapski affectionately invokes the perennially dapper Manet. In air so cold that it stung any little bit of exposed flesh, he recalled with feeling what a painter experiences "at the moment of vision." He writes: "The moment arrives unexpectedly, like Grace." Subduing an agitated mind, Czapski slipped into a prayerful state as a means of protecting his soul from the outer world. In this way, writing for him was like painting. The feverish working of his spirit infuses his journal entries with a near mystical concentration. His writing is the product of an induced rapture, an intense longing for the return to a life where painting would once again rule his day.

Taken together, the essays that ultimately emerge from these notes feverishly jotted on a train amount to a manifesto, a mixture of aesthetic prejudices and vocational guidelines. His purpose is clear, his voice is firm. But his means can only be speculative, hypothetical. It is impossible for him to know what he will paint, or how, or, perhaps most elusively, when. His will has been chastened by his failure to find his friends from Starobielsk, and he seems hell-bent on returning to a manageable world where he is in complete control, where the shortcomings he expects to confront can be traced solely back to himself. He refers repeatedly to the discipline required of eye and hand, and of these two, the greater discipline is that of the eye.

The notion of a painter fooling himself about what is needed to move ahead informs his critical judgment and, though unstated, it is his own fears he addresses. "The quicker a painter learns humility, the quicker he'll know how to recognize the point to which he has regressed and proceed to move on unhurriedly, the quicker he'll know to move beyond his earlier results." Something essential had been missing in his life during the past years, and would

continue to haunt him for years to come. "I only begin to exist when I paint," he declared. "That's when I feel I do exist, that I have the will to live."

Returning to Kuibyshev, Czapski offered Ambassador Kot a selection of French books he had purchased for him in Moscow. Hearing Czapski's report of unproductive encounters with Soviet authorities, the ambassador could only console him. In Czapski's absence, the Polish army had begun its long haul from Tatishchev and Totskoye to its new base of operations in Yangiyul, Uzbekistan, eighteen hundred miles to the southeast.

Czapski finished the final report on his mission at the beginning of March and set out to join the troops. Over the course of a yet another very long journey, frost and snow gradually gave way to mud and rain. The new headquarters in Yangiyul was housed on a large property surrounded by an immense orchard. Billeted nearby, he settled in and jumped back to work, supervising a small staff of women who had been assembled to deal with the increasing volume of material about the missing officers. Many of them were wives who had not heard from their husbands in more than a year and a half. Letters continued to find their way to the office from families in search of loved ones; all inquiries and reports were duly recorded and cross-checked. The number of unresolved open files continued to grow.

Among the swarms of people surrounding the base, a wraithlike figure with large, pale eyes and a freckled complexion appeared at Czapski's door one day. A friend of the musical Młynarski family, Jan Holcman was a virtuoso pianist of rare talent, and he was wasting away.

He had no idea what had happened to his family, who were shut in the Warsaw ghetto; all he knew was that the Philharmonic had burned down. He lived only for music. He never complained about the Soviets, and stressed that he had studied with superb teachers in Moscow and owed them a lot. But he was starving to death, and dreamed of continuing his education, of visiting Paris, America, and Palestine, where he had distant relatives and numerous acquaintances. But how could he get away, how could we help him? Whatever he may have been, he was unsuitable for the army. With the commander's consent we immediately put him in British battle dress and a pair of heavy British army boots. He was assigned at once to our military orchestra, tasked with transcribing scores. He spent a lot of time in our propaganda department, where on an old rinky-dink piano he played whatever we wanted to hear by Bach,

Chopin, Beethoven, Schumann, Szymanowski or Scriabin. We were hungry for music after such a long time listening to nothing but the camp radio. We very soon took advantage of his presence. We set up a grand piano, an old wreck, on a garden stage among the apple trees, under a poor, leaking little roof the shape of a large shell. We dragged every last one of general staff's tables and chairs outside, but so many people assembled, soldiers and officers, that a large number had to stand.

The concert was held in the evening. Holcman played nothing but Chopin: études, preludes, mazurkas and nocturnes, the Scherzo in B minor, the Polonaise in A-flat major, and the ballads. He played superbly and bountifully. This frail boy had resolution, clarity, strength, and that impulse—nervous and passionate, but also precise, rhythmic and confident—which has always seemed to me to be the essential qualification for a performer of Chopin. The purity of his touch was palpable, from the loud to the softest phrasing, and for the rising crescendo, even though the piano was out of tune and some of the keys gave a hollow or trembling tone.

The entire audience sat as if spellbound by the music, and many had tears in their eyes. Perhaps for the first time we had a reason to be grateful to the Soviets—grateful that here we could freely listen to the music of Chopin, now banned by the police in Warsaw.

Something ineffable from the concert stayed with Czapski for the rest of his life. Holcman's photo would always be among the portraits of family and friends he displayed on his studio walls.

The Polish army remained in a state of ongoing flux of formation and reformation. By February 1942, its ranks had expanded to include seventy-five thousand men. The Soviet military authorities demanded one division be selected and sent to the front. Under General Sikorski's orders, General Anders refused to release a single division until the men were ready for battle. In a fit of pique, Stalin withdrew approval for the army of six divisions he had promised Sikorski two months earlier. He reduced the number of sanctioned soldiers and their guaranteed rations drastically, from seventy thousand to twenty-six thousand. Summoned by Stalin, Anders flew to Moscow on March 18, 1942, and was told that he must shrink his army from six divisions to three. (In the aftermath of the attack on Pearl Harbor, promised wheat consignments from America had failed to materialize, leaving the Soviets in dire need, with no grain of their own.) Anders was informed that all the soldiers rendered super-

fluous were to be reassigned to labor camps to work in the mines, on road construction, and in the forest. By agreeing to these terms, Anders understood that in effect he would be sending his men to face death by starvation or exhaustion. Again he held his ground. He managed to extract from Stalin the consent to evacuate the residual soldier population and their civilian dependents to Iran, where the British and Americans could oversee their upkeep, given that the USSR could no longer feed them. Anders struggled to protect his men.

Less than a year old, the Sikorski-Maisky agreement was quickly unraveling. Once again the Polish population in Soviet captivity was harassed and forbidden to travel, stranded in camps and prisons. Despite the reinstatement of a Polish embassy and the appointment of a Polish ambassador, Stalin steadfastly refused to countenance the idea of an independent Polish nation. Clinging to his view of Poland as a "former country," he saw every Polish man, woman, and child held in captivity in Russia since September 1939 as a Soviet citizen, regardless of prior national identification. Poles, Ukrainians, Belorussians, and Jews were only identified in his mind as part of the Soviet multitude. Stalin shut down the programs that he had recently approved for the deported Poles, revealing once more the capricious nature of his largesse and the depths of his despotism. Ever since the signing of the Sikorski-Maisky agreement, supplies earmarked for Polish relief had been flooding into Russia from India, China, Australia, Britain, and the United States. The arrival and dispersal of tons of canned food, mountains of clothing, and thousands of pairs of rubber boots from the capitalist world led to great agitation within the Bolshevik bureaucracy. Such extravagance and generosity—the likes of which the Soviet state could never provide for its own people—blatantly contradicted the message Soviet propaganda promoted relentlessly about the miserable standard of living in democratic societies. Soon after Stalin's latest mercurial change of strategy, this bounty targeted for Polish relief suddenly disappeared. Delegates overseeing the welfare of deportees were accused of espionage, arrested, and imprisoned. Polish orphanages and schools that had been opened and outfitted by the West were closed overnight. Their new charges were expelled and had nowhere to go.

Unwilling to tolerate any notion of shared command, Stalin had been masterminding his own idea of a Polish army, a branch of the Red Army that would serve exclusively under his jurisdiction, in total disregard of General Sikorski, General Anders, and the forces they commanded. Lieutenant Colonel

Zygmunt Berling was chosen by Stalin to oversee this new Polish army. The Kościuszko Division, as Stalin named it, would come to be known derisively as the "Berling army." Meanwhile, travelers were prohibited from making the journey south to join the Polish army. Anders felt the sea change in progress:

> People still kept reaching the army area from the north, but the Soviet authorities put more and more obstacles in their way. Whole convoys were forced to leave their trains and were left stranded in the steppes with no supplies. There was no possibility of buying food in Russia, and anyone deprived of rations simply starved to death. Sometimes it was possible to barter some clothes for food, but after two years in captivity few possessed any clothing suitable for exchange. The temperature dropped to minus 52 degrees centigrade and icy winds swept the snow into drifts. Many of our men froze to death in their tents. At this time the Soviet authorities began to interfere with us more and more. People would leave the camps and not return, vanishing without trace as so often happens in Russia. The NKVD even kidnapped people inside the camps. We discovered detecting devices installed in the buildings housing the army head-quarters. The wires went to the attics, and from there to the Soviet Post Office.

Conditions at Polish army bases went from bad to worse. The reality of Stalin's refusal to arm Polish divisions could no longer be ignored. Anders still had no tanks, his units were still being drilled with brooms instead of rifles, and half of his men were suffering from scurvy, typhus, and dysentery. In light of the incredible number of nonmilitary Polish civilians surrounding the divisions—who were weak, ill, and hungry—Anders feared the making of a humanitarian disaster. Those who continued to arrive, strong enough to persevere against all odds, represented the fittest of those who had fled their prison and labor camps. They brought with them news of many thousands less fit who were left behind.

Five days after his meeting with Stalin, Anders issued orders for the first evacuation of troops from the Soviet empire, bound across the southern Caspian Sea for Iran. Seaworthy vessels of all kinds were commandeered to transport the troops from Turkmenistan. The decision was made to leave the stronger men behind, believing that their chances of survival were better. The majority of recovering soldiers sent to Iran traveled in a weakened state, most of them depleted even further by dysentery. On March 24, 1942, the first contingent of troops that had been moved from Yangiyul to the shore of the

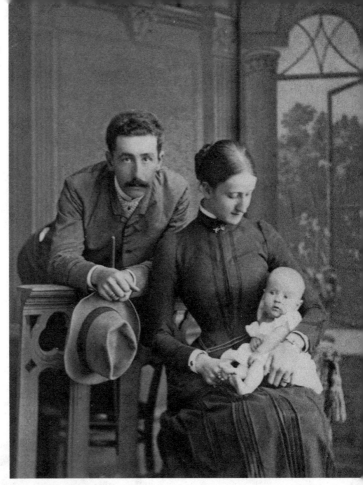

Czapski's parents with their first child, Leopoldyna, born in 1887.

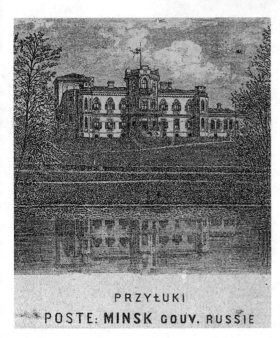

PRZYŁUKI
POSTE: MINSK GOUV. RUSSIE

Przyłuki, Czapski's childhood home.

LEFT: Countess Józefa Czapska with her first son, Józef, born 1896.
BELOW: The Czapski family at home. The children, left to right around their parents: Stanisław, Elżbieta, Maria, Leopoldyna, Róża, Józef, and Karolina.

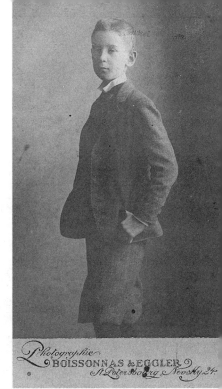

TOP RIGHT: Czapski in Saint Petersburg, around 1910.
BOTTOM RIGHT: Self-portrait in a cadet's uniform.
BELOW: In the uniform of a cadet, around 1917.

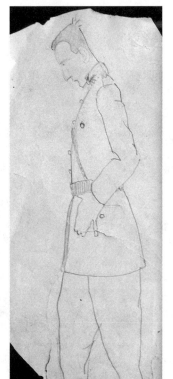

Left to right: Dmitry Filosofov, Dmitry Merezhkovsky, and Zinaida Gippius.

Family gathering: Róża (standing), Leopoldyna, Karolina, Elżbieta (seated in front), with an unidentified little girl. Count Hutten-Czapski is sitting in the middle with Leon Łubieński, Leopoldyna's husband, to his right, and Stanisław to his left. Józef and Maria sit behind them.

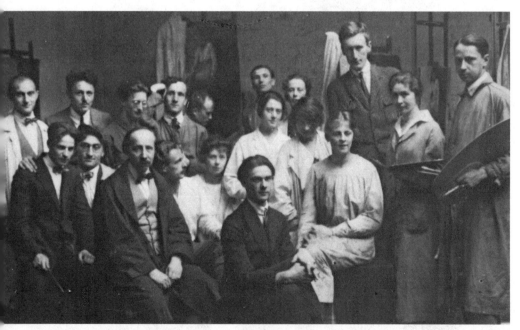

The Academy of Fine Arts, Kraków, around 1920. Czapski is third from right.

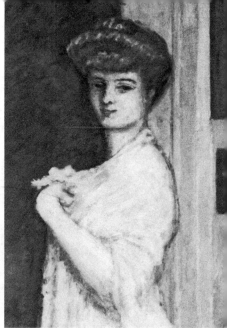

ABOVE: Misia Sert's portrait by Pierre Bonnard.
LEFT AND BELOW: Marynia and Józio.

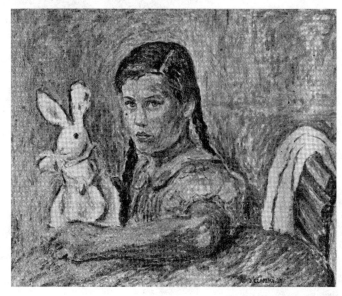

Girl with Toy Rabbit, 1937, oil on canvas, destroyed in the Warsaw Uprising.

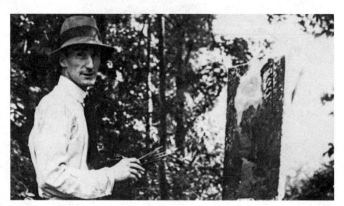

Painting outdoors.

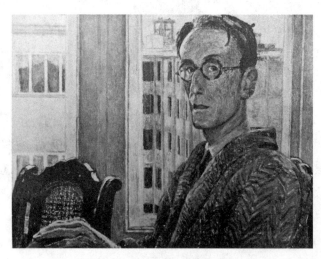

Self-portrait, 1937, oil on canvas, destroyed in the Warsaw Uprising.

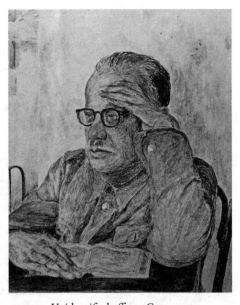

ABOVE: Unidentified officer, Gryazovets.
RIGHT: Self-portrait as a prisoner of war, Gryazovets, 1941.
BELOW: Witold Kaczkowski reading, Gryazovets.

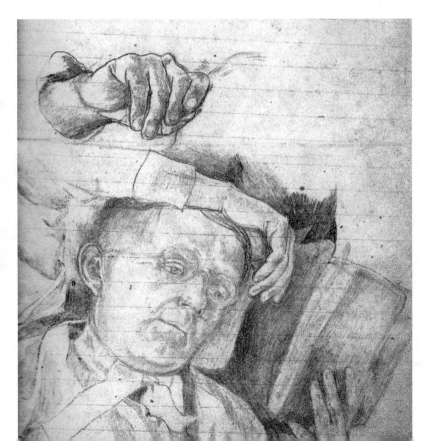

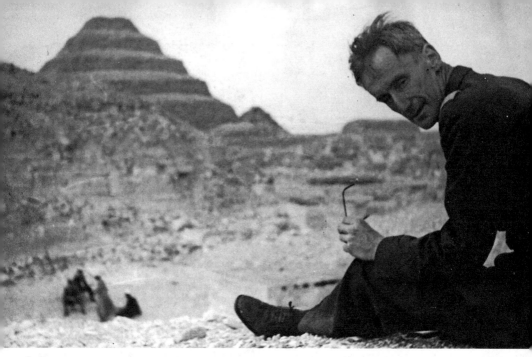

In Egypt, 1943.

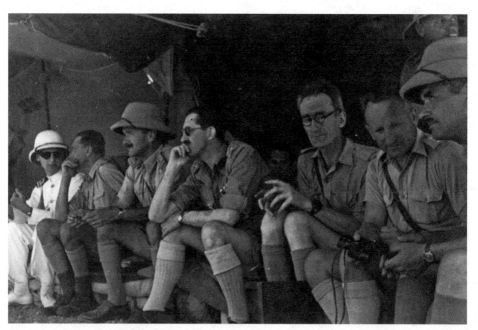

With the Anders Army in the Middle East.

LEFT: With General Władysław Anders, Baghdad, 1943.
BELOW: At Monte Cassino, with General Anders and his adjutant, Eugeniusz Lubomirski, 1944.

Anna Akhmatova, Tashkent, 1942.

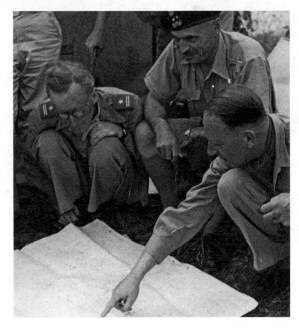

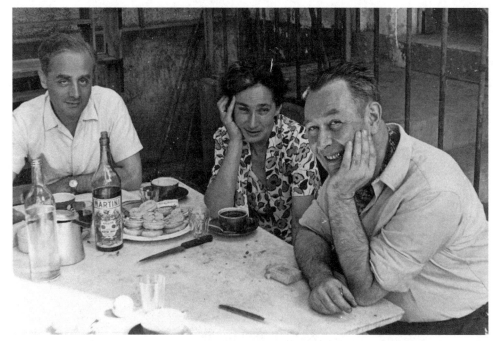

ABOVE: The *Kultura* team, left to right: Jerzy Giedroyc, Zofia and Zygmunt Hertz.
BELOW: The *Kultura* house on avenue de Poissy, Maisons-Laffitte.
BELOW RIGHT: Czapski as *Kultura* ambassador in the United States, spring, 1950.

Congress for Cultural Freedom outdoor event: Czapski is in the third row, notebook in hand.

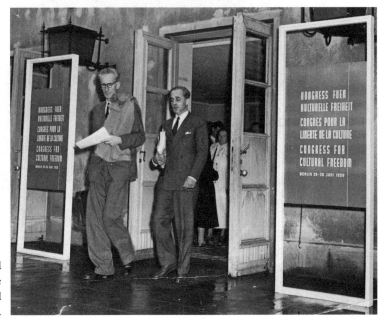

Czapski and Giedroyc at the Congress for Cultural Freedom, June 1950.

CLOCKWISE FROM RIGHT:
Catherine Djurklou, Ludwik Hering, Zbigniew Herbert,
Adam Zagajewski, Czesław Miłosz, Jean Colin.

CLOCKWISE FROM RIGHT:
Konstanty ("Kot") Jeleński, Simone Weil, Jeanne Hersch,
Adam Michnik, Daniel Halévy.

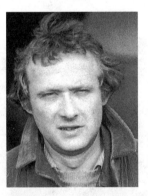

Czapski and Kot Jeleński walking in Sailly.

Zygmunt Mycielski.

Czapski and Zagajewski, Sailly.

ABOVE: In his bedroom/studio with Maria Paczowska, the wife of the photographer Bohdan Paczowski.
FOLLOWING PAGE: Czapski's hands.

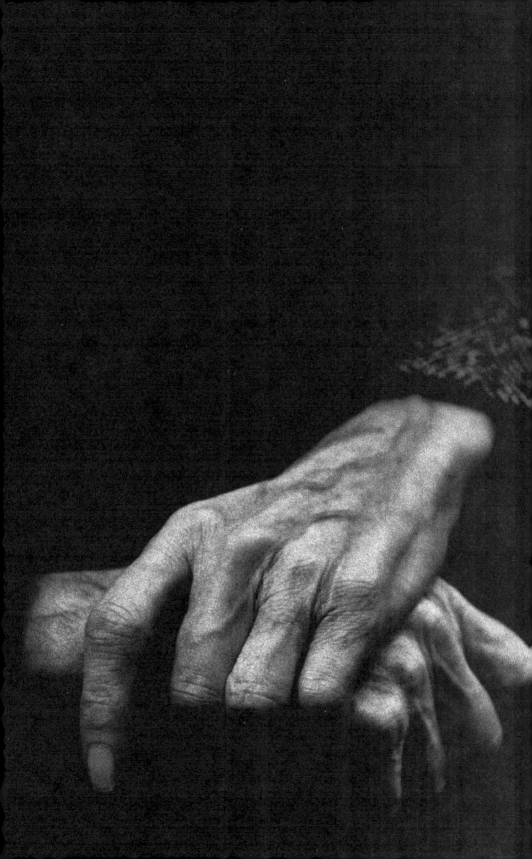

Caspian Sea by shuttle train left the port of Krasnovodsk (Turkmenbashi) headed for the Iranian port city of Pahlavi (Bandar-e Anzali).

Upon the arrival of the very first ship, difficulties arose for Anders from an unexpected quarter. The British authorities in Iran were exasperated by the presence of nonmilitary passengers and were adamant that no more families be allowed on ships specifically charged with the evacuation of military personnel. Lack of food supplies in Iran was their major concern. Ambassador Kot joined in the chorus of disapproval. Anders, desperate to assist any Polish national leaving Russia, had been unable to convince the British or his colleagues of the dire circumstances on the ground in Uzbekistan. "Either I could save the civilian population or leave it to its fate," he wrote in his memoir. "Evacuation might mean some would die in Persia, but if they stayed in Russia they would soon all be dead." Anders made the decision to include as many civilians as possible and accepted all responsibility for their removal.

The final evacuation by sea arrived in Iran on April 5, 1942. More than thirty-three thousand Polish troops and twelve thousand civilians were freed from the shackles of Soviet Russia. The number of Polish cemeteries in the Iranian port cities attests to the precarious conditions of the evacuees. Military and civilian graves were filled with those overwhelmed by exhaustion, malnutrition, starvation, and disease, not those struck down in battle.

As the epic movement of troops to Iran was underway, Anders summoned Czapski to Yangiyul, likely realizing that the man needed a focus for his energies after the failure of his mission to find the missing officers. In early April, he named Czapski as the chief officer of information and propaganda for the Polish army, in recognition of his competence and devotion. Promoted to the rank of major, Czapski was assigned the task of editing all news coming in and going out of the Polish army bases. These took the form of daily bulletins issued from headquarters (one for the general staff, a separate one for the rank and file), and the printing of the *White Eagle*, the army's weekly journal. This large-format newspaper was widely circulated among the soldiers and under Czapski's supervision it would offer an impressive variety of articles concerning not only the war effort but also politics, history, and aesthetics. In its pages one could find poems and maps and surprising photographs that must not have been easy to procure in wartime—an aerial view of Manhattan, for instance, and a reproduction of Cézanne's painting *The Card Players*. Occasionally Czapski was called to task for espousing liberal views, but he was never seriously censured and the paper was read widely and enthusiastically. As the

army's chief cultural officer, all educational, musical, and graphic-arts activities fell under his jurisdiction. Anders also saw to it that the delicate handling of "non-Catholic confessions" (a euphemism for whatever pertained to Jewish Poles in the military) was put in his hands.

The appointment marked the beginning of a demanding job for which Czapski was highly qualified. An important moment had come. "It was only at Yangiyul that I confessed myself beaten. I made myself face the fact that I had ceased to believe in the return of our comrades.... All our work had been in vain.... I thought back to 1939 and the period since then. I could see nothing but death, camps, and the progressive abasement of human life."

His confession prompts him to action: "I've glanced through my journals written in captivity. I will pass them on to the embassy, where they'll be kept safe. I don't return to them, I don't reread them, but nevertheless it's with true regret that I let them go, as if I was ripping out some necessary part of my life."

It was time to move on.

For the next two years Czapski would have the considerable distinction of being in daily contact with the commander in chief of what was first known as the Anders Army, later named the Polish Armed Forces in the East, and finally, the Polish Second Corps. He would often take his breakfast with General Anders at six thirty in the morning. Czapski held his post as each of Anders's successive chiefs of staff joined the team. Such privileged access and contact deepened Czapski's intense admiration for his commanding officer, who was his idea of a model soldier: brilliant, courageous to excess, and very friendly. Their relationship was complex, colored in part by Anders having been in love with one of Czapski's older sisters in 1917. Not from a family of the same social standing, Anders had been unable to present himself as a suitor. Though that privileged life of the Polish aristocracy had collapsed, Anders remained aware of being Czapski's social inferior, even though he was his military superior. Proust-like, Czapski was perfectly clear-eyed in his ability to observe the complicated levels of class distinctions and the impact of rank on social relations, but he was entirely indifferent to it. In the army many deferred to Czapski in light of his family's prominence, saluting him as "*hrabia*" or "*graf*," his inherited title of count, but he placed no value on this and never thought of himself in those terms.

One of Czapski's first assignments in his new role came from Ambassador Kot, who requested he make contact with Aleksey Tolstoy, one of Russia's

most celebrated writers, who was living nearby in Tashkent. Many cultural luminaries, having fled the siege of Leningrad, arranged temporary residence there. Distantly related to the author of *War and Peace*, the historical novelist was a frequent visitor to the Kremlin and a special favorite of Stalin. Tolstoy was also one of the wealthiest men in the USSR and an outspoken supporter of the regime. Maintaining an exalted standard of living while mastering the complex nuances of communist life, he was irreverently known as the Red Count. Czapski was unenthusiastic about Tolstoy as a writer but understood the importance of cultivating a relationship. He wrote directly to Tolstoy, who replied promptly, asking Czapski to call on him.

Their first meeting was cordial and easy. Tolstoy readily agreed to reciprocate and visit the Polish army base, asking if he might bring his wife. When that day arrived, Czapski went to pick up the couple in a magnificent luxury automobile, a Zis personally offered to Anders by Stalin. The Tolstoys toured the encampment by the river, engaging in conversation with the Polish officers, and later that evening, a sumptuous dinner was held with much drinking and dancing. Around midnight, Czapski began to recite some Polish poetry, translating the poems into Russian as he went along. Tolstoy was delighted and much affected by the sonorous quality of the verse. At the evening's end, he extended a further invitation to Czapski, hoping they might meet again and speak more about poetry and translation. A series of encounters between Tolstoy and Czapski began and continued throughout the months of April, May, and June 1942.

At another dinner at the Tolstoys' home, a plan was hatched to publish some Russian translations of Polish poetry written during the war. On this occasion, a lavish affair attended by several notable literary figures, Czapski was introduced to Anna Akhmatova, the legendary Russian poet. Familiar with poems she published before the revolution, he also knew of the hardship she had endured under the Soviet regime. As a younger woman, Akhmatova had been a celebrated femme fatale, but the woman Czapski met was no longer sure of herself, marked by a personal, intimate knowledge of Stalinist brutality. When many other artists fled abroad to safety during the revolutions of 1917, she remained behind, determined not to abandon her beloved Petersburg. Akhmatova and her poetry were both admired and reviled. Her widely praised poems from the days of tsarist Russia were looked upon as bourgeois and decadent by Bolshevik critics. After the revolution, her work was banned, and her poems could no longer be published. In 1921, Akhmatova's husband, the

poet Nikolai Gumilev, was executed by the Cheka, the Soviet secret police, as an enemy of the people. Their son, Lev, was arrested, released, rearrested, tried, and ultimately condemned to fourteen years in forced labor camps and prisons. The vilification Akhmatova endured emboldened her convictions, magnifying, and occasionally distorting, her aesthetic perceptions. With enormous discipline, she harnessed her creative will and transformed the wretchedness of her life into a heroic embodiment of suffering. A figure of stoic endurance, she worked on her "Poem Without a Hero" for twenty-two years.

In 1940, during a very brief period of ideological thaw, she was allowed to publish a volume of selected poems titled *From Six Books*, which also included dozens of new poems. A few months after it appeared, the authorities withdrew the book from circulation. In 1941, after the first months of the siege of Leningrad, Akhmatova was evacuated, first to Moscow, then to Tashkent. Her safety was being overseen by order of the Union of Soviet Writers, the very group that condemned her poetry. Given a cramped room under an iron roof in the Hostel for Writers, she was grateful to be safe from German bombs and far from the threat of starvation. She was very aware of her privileged position, and its tenuous status.

Czapski was quite surprised to find an unrepentant artist, the widow of a denounced poet and mother of a condemned criminal, sitting quietly in the private home of one of the Soviet Union's cultural elite. The evening would prove to have lasting significance for him, and he wrote about it at length, turning over details as one does in hopes of sustaining meaningful impressions. "At about ten in the evening we gathered in the large drawing room around a table with wine, superb *kishmish* (raisins), and other sweetmeats. The heat of the day had passed. It was fresh and breezy," he began. "Akhmatova was sitting under a lamp, wearing a modest dress made of very poor material, somewhere between a sack and a pale habit; her slightly graying hair was smoothly combed and tied back with a colored scarf. She must once have been very beautiful, with regular features, a classic oval face, and large gray eyes. She drank wine and spoke little, in a slightly strange tone, as if half joking, even about the saddest things."

Tolstoy asked Czapski to honor them with more Polish poems, first providing a Russian translation. As he declaimed poems by Stanisław Baliński and Antoni Słonimski, he was keenly aware of Akhmatova, sitting silently, her eyes brimming. "I realized what a hunger there is among Russians for genuine poetry," he observed.

The atmosphere and the ardor of the Russians' reaction exceeded my boldest expectations. I can still see the tears in the large eyes of the silent Akhmatova.... In the past, I had very often tried to attract foreigners to Polish poetry, especially French people, with a minimal result; never before had I sensed such receptivity among my audience, never had I managed to evoke such a lively, genuine frisson as among this surviving handful of Russian intellectuals.... Profound, disinterested communication between Poles and Russians is possible, it occurred to me—how easy it was to penetrate each other's cultures, to infect each other with poetry, the sound of a poem, or to transmit the tiniest little tremor in each other's language.

Concluding his own recitation, he gently persuaded Akhmatova to share some of her poems. "In a strange sort of chant," he recalled, she recited several long passages from "Poem Without a Hero," a sprawling, ongoing work in progress about Petersburg/Petrograd/Leningrad.

Akhmatova's poem began with memories of youth: difficult metaphors, commedia dell'arte, peacocks, violets, lovers, and a maple tree with yellow leaves in the window of the former Sheremetyev Palace, and ended with Leningrad cold and hungry under bombardment, besieged Leningrad. I never forgot the lines about the hungry little boy who during the bombing, in early spring or late fall, brought her some *travinki* (blades of grass) that had grown between the cobblestones.

Discreetly, Tolstoy let Czapski know that several of Akhmatova's early poems had been admired by Stalin. It was he who personally insured her physical safety. For a time, not only was her presence tolerated but she received preferential treatment, gaining entrée to the kind of rarefied gathering where they were currently meeting. In the person of Akhmatova, with her elegant, strong body and her alert, sharp mind, Czapski found evidence of the nearly schizophrenic atmosphere imposed on a closed society of Russian artists.

Akhmatova would make use of her protection during the war years to produce many lyric poems about her exile in Central Asia. Never condemning the regime that condemned her, she bore witness to the misery it rained down on its people, transmuting her anguish into poetry. Joseph Brodsky, whom Akhmatova befriended when he was just a young poet, wrote about her ability to inhabit experience: "Betrayed, tormented by either jealousy or guilt, the

wounded heroine of these poems speaks more frequently in self-reproach than in anger, forgives more eloquently than accuses, prays rather than screams.... She didn't reject the Revolution, she internalized it ... she simply recognized grief." Akhmatova confessed to Czapski about the humiliation she continued to endure in her desperate search for information about the fate of her son: "I've kissed the boots of all the important Bolsheviks in order to find out if he is alive, but I know nothing."

Akhmatova loved her country, her family, her circle of friends, her language. For decades, she continued to write poems without committing any words to paper. ("Paper was dangerous," Brodsky reminds us.) Composing poems in her head, she would speak the lines to trusted friends, relying on each of them to memorize a passage or two. Separate fragments of one poem would be held in the minds of several people, safeguarded for future transcription. Czapski was impressed and enchanted by her creative resolution of such a desperate situation, entwining the mingled dominions of art and memory. As a painter deprived of his own means of expression, he empathized with Akhmatova's struggle to bring her poems into tangible form.

Recognizing a kindred soul, Akhmatova warmed to Czapski's presence and welcomed his recital of Polish poems. He was the first non-Russian she had seen socially in more than twenty years. Discerning the Slavic nobleman in Czapski's character, she romantically carved a space for him in the scarred chambers of her big heart. Shown a photograph of Czapski for the first time many years later, Brodsky would exclaim, "Now I see why Anna Andreevna fell in love with him; he had a White Guard charm."

Carefully, Czapski and Akhmatova negotiated the common ground between them, sharing poems, reveling in each other's sympathetic company, at all times under observation by NKVD agents. She spoke to him about her years in Paris, about her friendship with the Italian painter and sculptor Amedeo Modigliani, many of whose drawings and letters to her had been destroyed the previous year in a fire during the siege of Leningrad. Czapski was captivated by her mysterious appeal.

> I was eager to get to know her better, to see her on her own, and go further into her world, but I didn't dare. Once already an innocent visit that I had made to a woman, without my official escort, had had very tragic consequences. I have retained a memory of Akhmatova as someone "special," with whom contact was difficult because of a certain affectation, or perhaps she just had a

more singular manner. I felt as if I were communing with a wounded person, trying to mask her wounds, defending herself with that affectation. The evening at Tolstoy's went on until three or four in the morning. We spent a long time saying goodbye outside the writer's house, under the crowns of the spreading trees. . . . We parted, promising to meet many times more. At dawn I reached the apartment at the edge of the city, where thanks to a helpful intermediary from Poland I had found a bed for the night.

He barely closed his eyes in what was left of the night, too buoyant, stimulated, excited. Refusing to let go of the mood, he conceived a plan to prolong it. He would host another gathering the following evening, putting to good use the small booty of tea and some sugar he had been saving, and some canned meats. Quickly procuring permission from Anders to occupy the rooms reserved for the commander in chief at the main hotel in town, Czapski sent out invitations for another poetry soirée to the enthusiasts from Tolstoy's the night before, many of whom had expressed a hope of listening to more Polish poems and promised to bring their literary friends. A guest list and a reading list took firm shape in his head. "But at the last moment my plan failed to materialize. Akhmatova sent a message to say she was unwell, Yakhontov, one of the best known Soviet declaimers of poetry (who lived in the same hotel), suddenly had somewhere else to go. I received the same sort of refusals from the other invited guests, who only the night before had so warmly agreed to come and see me. I suspected 'diplomatic' illnesses—an official ban."

Thwarted by Soviet protocol, which forbade and often punished such independent initiatives, he recognized the folly of his fantasy. But then an unexpected twist offered him solace and hope.

Evening came, and I was alone in the room, when suddenly a young woman came in. She introduced herself as a friend of Tolstoy, and said she had been informed that I was going to read some poetry. Clearly the instruction cancelling the gathering behind my back had not reached her. Tall and slender, with fair hair as light as down, she had subtle, pedigree features, and a strikingly natural manner. Seeing that she had been the only one to come, she wanted to leave at once, but I made her stay.

Czapski fails to acknowledge it in this account (having made reference earlier to "tragic consequences" from an unsanctioned meeting), but the

woman who came to see him was not a friend of Tolstoy but a friend of Akhmatova, sent as a messenger to extend the poet's regrets. He writes about this woman in his memoir *Inhuman Land*, expressing "once again that rare, so very Russian, instant contact with someone whom I had never met before, and will probably never meet again." But Czapski is speaking here not only of the messenger but of Akhmatova herself. The passage quoted earlier, "We parted, promising to meet many times more," was as far as he would go. Most likely the two sympathetic souls did meet again, but secretly. They were sufficiently circumspect to suppress any future reference that might endanger them. For many years they sustained this articulate silence. Substituting the messenger for the poet in his official retelling of the story, Czapski goes on to write of his surprise visitor:

> I read the poetry just for her, translating it into Russian, then reading it in Polish, and again I felt the same acute, wonderful reaction. She didn't say a word, but just kept asking for precision, for the sound of a word, for an exact rendition of the meaning in Russian. And then suddenly she said: "So you have already found ways to express what you have endured...though we... have not yet..." and fell silent. She dropped her gaze, and the corners of her mouth were trembling....We talked for a long time, and it felt as if we had always known each other. We parted late that night.

"The next day," Czapski wrote, "I went back to staff headquarters."

A season of intense heat descended on Central Asia. In Tashkent, Akhmatova was stricken first with typhus, then with scarlet fever. It took her many months to recover. In July, Czapski, back in Yangiyul, was diagnosed with both typhus and malaria. His body was wracked by violent spasms. Eventually he was sent to the crowded infirmary at staff headquarters. Throughout the summer of 1942, malnourishment continued to take its toll, disabling thousands of soldiers and civilians, making them even more vulnerable to infection. More than seventy percent of the Polish troops whom Anders had opted not to evacuate to Iran because of their relative strength were afflicted with one or more contagious diseases. Epidemics raged, killing thousands of the Poles who had managed to reach Uzbekistan and many thousands more, soldiers and civilians, who died on their way to join the shelter of the army. Drugs and medical equipment were entirely unavailable, and given the number of cases, makeshift

hospitals were unable to accommodate the vast majority of ailing patients. Czapski's team of *White Eagle* writers was prohibited by the Soviet censor from reporting on the pandemic or printing any photographs of the ill, the dying, or the dead.

Another evacuation, to include more civilians, mostly children, was organized. Sikorski asked for Churchill's support in requesting approval from Stalin. On July 8, an NKVD officer handed General Anders a telegram informing him that the government of the USSR "did not intend to put any obstacles" in the way of a second planned evacuation. Over the course of three intensely hot weeks following the first departure on August 10, forty-four thousand additional soldiers made the trip across the Caspian Sea in the company of more than twenty-six thousand civilians. Several thousand more children made the journey overland. In all, around one hundred twenty thousand Poles left the Soviet Union in 1942 under the watchful eye of General Anders. "We left behind us in Russia hundreds of thousands, and our hearts were heavy," he wrote. "We who survived, had survived by a miracle." In the history of the Soviet Union, a state-approved exodus of this magnitude was unprecedented and would never be repeated.

Colonel Berling, acting as liaison officer with the Red Army during the process of the evacuation of Polish troops, chose to stay behind in the Soviet Union. Berling's defection was treated as an act of treason. His case was brought to court-martial in absentia. The tribunal's verdict was a sentence of death.

Czapski was released from the hospital in late August, still weak but over the worst. All his colleagues had already moved on but he managed to secure passage on a train leaving Yangiyul headed for Ashkhabad, the capital of Turkmenistan, a city within a few miles of the Soviet frontier. Disembarking from the train, he marveled at the sight of a range of peaks rising across a flat plain, bare and pink in the sparkling sun. On the far side of the mountains was Iran, and freedom. Not slated to be ferried across the Caspian Sea, he was allocated a seat on a caravan of Dodge trucks filled with Polish children being driven across the border to the city of Mashad. A palpable lightening of his spirit shows in the pages of his journal devoted to this long ordeal, and his painter's eye, once more activated, describes the mountainous desert landscape he was traversing in broad swatches of vibrant color. Climbing to six thousand feet, the convoy arrived at the border and waited its turn. The customs officials examined those leaving, one person at a time. Once his books and papers had been thoroughly inspected by a censor, Czapski received clearance for departure.

He walked through an opening and found himself on the other side of barbed-wire barricades that separated the Soviet Union from the rest of the world.

As had been true for Anders, Czapski experienced this moment as a hallowed event. His mind flooded with images—the endless rutted roads of mud when first crossing into Russia three years earlier, the anxious wait as all his colleagues left Starobielsk before him, the formations of men standing in the freezing rain on their departure from Gryazovets. Here he stood, finally beyond the reach of the NKVD and the henchmen of Stalin.

He was out.

9

TRUCKS CARRYING THE TRAVELERS AWAY from the border arrived in Mashad a few hours later. Czapski was separated there from his young traveling companions, who were greeted with compassionate embraces by relief workers. Under the aegis of the Polish Red Cross and the vice-consul of the Polish embassy at Bombay, many of the emaciated children would be flown to safety, to begin new lives in India. Those not well enough to travel farther were put to bed in a nursing facility until they were back on their feet. Five thousand orphans were transported, resettled, and supported financially through the generosity of Maharaja Digvijaysinhji Ranjitsinhji of Nawanagar, a friend of both General Sikorski and the recently deceased Polish statesman and pianist Ignacy Jan Paderewski. As the emaciated children arrived in his fiefdom, the maharaja tenderly consoled them, urging them to think of themselves as orphans no longer. He would be their *bapu*, their father.

Czapski's first written comments outside the Soviet Union reveal his vulnerable state. His heart is moved by a simple human gesture: "What most struck me as soon as we entered Iran was the friendliness of the population, though friendliness is a weak word to express the cordiality which they showed. Children waved their hands at us as we passed." The sight of small hands raised in innocent greeting put in perspective three long years of complex, compromised interactions in the realm of Soviet cruelty. From his gratitude for the waving hands of children Czapski moved on, plunging into a critical investigation of his own state of mind.

> In a hotel bedroom in far-removed Mashad, I knew one thing only—that a very important chapter of my life, the Soviet episode, was closed. From this particular past I wanted to emerge, stripped of anything that might link me with it. I spent the morning in search of a new notebook, simply in order to avoid having to use the one I had had with me in Russia.... My new book has a turquoise cover with a Persian inscription in gold. I flung myself upon it hungrily. Now at last I can write without fear, can write down everything I can remember, everything

that, in spite of my indecipherable handwriting, I had never dared to mention in Russia except indirectly, or only in code. Here, in the midst of golden minarets, of blue and gilded domes, among the tides of Persians, Arabs, and Hindus, I can dive deeper and deeper, for several hours each day, into my Soviet memories. Still weak from the aftereffects of my illness, I lay in bed, scribbling away.

He had a long lifetime of overcoming illnesses. Having nearly died from severe dysentery at two, he contracted scarlet fever at six. His weakened lungs were perennially susceptible to attack, but after each assault he rallied. Recovery had an invigorating effect on Czapski's spirits, and he made creative use of his febrile condition. His return to health from typhoid fever in London in 1926 provided the opportunity for him to immerse himself in Proust; fever and coughing up blood landed him in the infirmary for weeks at Starobielsk in 1940, stimulating the composition of his volume on French painting, which sadly was lost. Two years later, in Uzbekistan, at forty-six, he contracted typhus for the second time. This left him further depleted, but he carried on "scribbling away." One benefit of the incapacitation imposed by illness was solitude, which seemed to trigger the production of potent anti-pathogens in his system. Gustaw Herling, a future friend imprisoned in a forced labor camp near Arkhangel'sk during these same years, would write in his memoir: "The hospital was the only place, in camp and prison alike, where the light was extinguished at night. And it was there, in the darkness, that I realized for the first time that in a man's whole life only solitude can bring him absolute inward peace and restore his individuality."

Czapski was no stranger to hospitals. Each threat on his life found him at peace with the idea of dying. He would rise once more into life, humbled and as determined as ever to embrace it.

Under the direction of General Anders, the Polish army was undergoing intensive training in armored warfare as long-awaited arms and equipment became available. Guns, tanks, and jeeps finally materialized in great numbers. With participation in military exercises, corps morale improved as the prospect of fighting the Germans came nearer. The Poles were slowly but surely gaining strength and purpose. Most of the men were sporting new English uniforms and underwear. The healthiest men were moved from Iran to camps in Iraq, placed under the supervising command of the British Eighth Army, then moved across Jordan into Palestine.

"Like most Poles," Anders wrote upon leaving Russia, "I felt that Poland's destiny then, as on the first day of the war, was linked to Great Britain and the United States." In a similar frame of mind, Czapski began to ponder the idea of a postwar Poland. Summing up, he wondered,

> Why was it then that here, at Mashad, I didn't think of what lay in store for us *after* the collapse of Germany? How was it that I did not foresee that other threat, of Poland once more occupied, this time by the Soviets? Was it that I pinned my faith to the inherent justice of the world, or was it that I was merely indulging in that belief, so dear to us Poles, "that everything will turn out alright"? First and foremost, my state of mind was due to the exaggerated confidence all of us had in the moral influence of the "great democracies." We had a blind faith in the promises made, in the pacts arranged, in the Atlantic Charter. Words, mere words! "Poland is the inspiration of the world," President Roosevelt had said, and we read his words as a commitment, as a promise that when the war was over we should not be treated as a pawn in the game played with Russia.

The Atlantic Charter was not a legal document but a statement of intent drafted by Prime Minister Churchill and President Roosevelt in 1941 at the first of their twelve wartime conferences. The text explicitly stated that the undersigned countries "seek no aggrandizement, territorial or otherwise," and went on to claim that no changes in territory would be made against the wishes of any people. Enormous faith had been placed in a credo that declared British and American respect for "the right of all peoples to choose the form of government under which they live" and their "wish to see sovereign rights and self-government restored to those who have been forcibly deprived of them."

Stalin, however, had other plans. By the end of 1942, the tide of war had begun to turn in favor of the Soviets. When the German Sixth Army surrendered at Stalingrad in February 1943, he knew that he had gained the upper hand in all future war negotiations. Accusing Sikorski's government-in-exile of treason for making territorial demands at the expense of Soviet Ukraine, Belorussia, and Lithuania, and of cowardice for its refusal to send troops to the front, he took matters into his own hands. His formation and future endorsement of a political entity called the Union of Polish Patriots laid the foundation for a future Stalinist Poland. In his eyes, this group was the final arbiter on all Polish affairs. He would no longer communicate with the London Poles. Learning that Sikorski had gone to Washington to speak with Roosevelt

about Polish frontiers, Stalin was enraged. He needn't have worried. The American president, equally schooled in duplicity, nodded approvingly to the Polish prime minister but afterward reported to the British foreign secretary Eden that the United States, Britain, and Russia "would decide at the appropriate time what was a just solution, and Poland would have to accept." Churchill went so far as to inform Roosevelt that "the Atlantic Charter ought not to be construed so as to deny Russia the frontiers she occupied when Germany attacked her." Stalin, for his part, patronized Churchill and Roosevelt. But as Churchill, against his own better judgment, was working to bring the two nations into closer relations, Stalin distanced himself from the British. He had allowed more than a hundred thousand Poles to depart the Soviet Union by way of Iran. No movement on such a scale would ever be tolerated again. In January 1943 he irreversibly imposed Soviet citizenship on every Pole living in Soviet-occupied Poland from September 1939 on. Polish citizenship was a concept the USSR would no longer officially discuss or acknowledge. In the Middle East, the men of the Polish army, enduring a malaria epidemic, received this news as one more staggering blow. Every soldier had family and friends trapped inside the Soviet Union. They now had to expect that they would never see or hear from them again.

On April 13, 1943, relations among the Allied nations—Britain, the United States, Soviet Russia, and Poland—strained even further toward a breaking point. Radio Berlin broadcast news of the discovery of mass graves in a forest in western Russia. The bodies of thousands of Polish officers had been found buried in their uniforms, their identity papers intact, stacked twelve deep. Hundreds of disinterred skeletons showed vestiges of a single bullet wound at the back of the skull. One high-ranking Polish officer from Lublin, General Mieczysław Smorawiński, was identified as being among the dead. Nazi propaganda triumphantly accused the Soviet regime of perpetrating the massacre.

The discovery of the graves, and the manner in which the discovery was made known, had a devastating impact. Rumors about mass graves had been heard by the Germans since the summer of 1942. After some preliminary digging, the Wehrmacht high command ordered the graves uncovered and bodies exhumed at the end of March. The site was first visited on April 10 and 11 by a delegation that included some Polish intellectuals from German-occupied Poland. The delegation's hastily dictated report of its shocking findings was radioed by the Polish underground to the Polish government-in-exile in London. A preliminary German report was broadcast on April 11, but it was the

April 13 broadcast that fueled a worldwide sensation. (Whether or not the exhumation of the bodies and the timing of this announcement was orchestrated by the German minister of propaganda Joseph Goebbels is unclear; he may have calculated that an uproar over the revelation of mass graves at this moment would act as a convenient smoke screen for his liquidation of Jews in the Warsaw Ghetto, scheduled for the eve of Passover later in the week.)

After the Germans published lists of the victims and circulated photographs of exhumed bodies littered about opened graves, "Katyn" became a household word among Poles around the world. In German-occupied Poland, the names of thousands of dead soldiers were read aloud, over and over, on amplified sound systems. "The discovery of Katyn," Czapski wrote, "made every Pole even more deeply conscious of our double-edged mortal danger." Hitler was only one disaster they had to overcome. The barely tenuous bond between the Polish and Soviet governments collapsed upon the announcement of the appearance of thousands of corpses. It was now known that Stalin, repeatedly feigning surprise and innocence at the disappearance of the men, knew them to be dead all along.

Two days after the German broadcast (three years after the massacre), the Soviet Information Bureau responded to the charges. *Pravda* denounced Goebbels as a shameless instigator of lies in his attempt to lay responsibility for a Nazi atrocity at the feet of the Soviets. The bureau maintained that Nazi leaders and Gestapo agents were responsible for the slaughter of the unearthed Polish officers. This communiqué, issued by the bureau in Moscow on April 15, 1943, remained the source of all official Soviet statements regarding Katyn until April 13, 1990:

> In the past two or three days Goebbels's slanderers have been spreading vile fabrications alleging that Soviet authorities effected a mass shooting of Polish officers in the spring of 1940 in the Smolensk area. In launching this monstrous invention, the German-Fascist scoundrels do not hesitate at the most unscrupulous and base lies in their attempt to cover up crimes which, as has now become evident, were perpetrated by themselves. . . . Beyond doubt Goebbels's slanderers are now trying by lies and calumnies to cover up the bloody crimes of the Hitlerite gangsters. . . .

That same day, Churchill invited Prime Minister Sikorski and the acting foreign minister, Edward Raczyński, to lunch at Ten Downing Street. He urged them to set an example and put the upheaval caused by news of mass

graves behind them. Anthony Eden then called Sikorski into the Foreign Office to lecture him about how dangerous a game it was for the Poles to get mixed up with Hitler. Eden encouraged Sikorski to submit a statement on behalf of the Polish government stating that the massacre was perpetrated by the Germans. He claimed the British government staunchly believed this to be the case. He warned the Polish minister of the risks of raising the issue in the press.

On April 17, 1943, the Polish cabinet insisted on an impartial investigation of the Katyn grave sites and requested that the International Red Cross send representatives to the scene. Cunningly, Goebbels arranged for Hitler to submit an identical request to the Red Cross at the very moment the Poles did, creating the appearance of the two nations filing in tandem, inferring a collaboration between Poland and Nazi Germany. This gave Stalin the opportunity to vilify the Polish government for colluding with Hitler against the Soviet Union. The International Red Cross, before considering entry into any territory contested by warring nations, insists that all parties be in express agreement about the organization's involvement. Stalin of course refused to grant approval for the Red Cross to investigate, forcing the organization to reject the Polish appeal for an independent inspection of the grave site.

Publicly, Churchill supported Stalin's refusal to entertain a Red Cross investigation; he censored the Polish press in London and Polish broadcasts on the BBC for espousing anti-Soviet opinions. Privately, he was made to accept the hard facts of Soviet guilt. In a letter to Stalin, Churchill elegantly twisted himself into any number of contorted postures to extend a subtly nuanced, if diplomatically compromised, hand:

> So far this business has been Goebbels' triumph. He is now busy suggesting that the USSR will set up a Polish government on Russian soil and deal only with them. We should not, of course, be able to recognize such a Government, and would continue our relations with Sikorski who is far the most helpful man you or we are likely to find for the purposes of the common cause. I expect this will also be the American view. My own feeling is that the Poles have had a shock and that after whatever interval is thought convenient the relationship established on 30 July 1941 should be restored. No one will hate this more than Hitler and what he hates most is wise for us to do.

Churchill was acutely aware of Stalin's intention to create a puppet government. For the time being, however, he would continue to accept Sikorski and

the London Poles as the legitimate leadership of Poland. In principle, Poland was esteemed by both Churchill and Roosevelt, but the two politicians were perfectly clear-eyed about sacrificing it as the price of a continued alliance with Uncle Joe, their surest, if not only, hope for destroying the German war effort.

With the discovery of mass graves at Katyn, the Poles were placed in an extremely difficult negotiating position. Their heightened alarm about Soviet treachery appeared to ruin the rising spirits of their Western Allies who embraced Stalin like a prodigal brother. Given the war's ghastly death toll, the Allies seemed to ask, what was the loss of twenty thousand Polish military men? Who was General Anders to *demand* an explanation of the Katyn graves from their comrade Stalin?

Germany's revelation of mass graves played directly into Stalin's hands, providing justification for him to sever all relations with the London government. Just after midnight on April 25, 1943, Easter Sunday, the Soviet commissar Molotov summoned the Polish ambassador Tadeusz Romer to his office in Moscow and accused the Polish government of consorting with the enemy. Reading aloud from a prepared text, Molotov announced the cessation of all diplomatic relations between the Polish government-in-exile and the Soviet Union. Three and a half years earlier, in September 1939, Ambassador Grzybowski had met with Deputy Foreign Minister Potemkin under much the same circumstances. Romer likewise refused to accept the offending letter, declaring it was "couched in language no ambassador can receive."

After issuing a formal rebuttal to the Soviet accusations, Romer and his entire staff packed up the embassy and departed Moscow three days later. At the train station, William Standley, the American ambassador in Moscow, took his official leave of Romer, a colleague and friend, "feeling without quite knowing why that with him went some of our hope for a free and peaceful world." Standley wired President Roosevelt his assessment of the situation, acutely predicting an evolving trend: "We may, it seems to me, be faced with a reversal in European history. To protect itself from the influences of Bolshevism, Western Europe in 1918 attempted to set up a *cordon sanitaire*. The Kremlin, in order to protect itself from the influence of the West, might now envisage the formation of a belt of pro-Soviet states." The remains of the Second Polish Republic would become a primary fixture on that belt.

The British Foreign Office attempted to establish an internal position regarding the Katyn murders in order to inform and educate the government.

As it became clear that one British ally had ruthlessly destroyed the leadership of another, a good deal of hand-wringing began in the halls of power. Owen O'Malley, the British ambassador to the Polish government, made himself the most knowledgeable member of the Foreign Office on what would come to be known as the Katyn affair. Despite his own moral qualms and his belief in Soviet culpability, he drafted a statement encouraging the Polish government not to publicly accuse the Russians of anything. "The dead cannot be brought to life," the document concluded, "and we now wish to say nothing more about the Katyn affair."

O'Malley sent a lengthy dispatch to his boss, Anthony Eden, a consideration of the facts of the case as far as they could be determined. In it he weighs what Czapski had described as an Englishman's "disinterested sympathy" against the potential consequences of the affair.

> The men who were taken to Katyn are dead and their death is a serious loss to Poland. Nevertheless, unless the Russians are cleared of the presumption of guilt, the moral repercussions in Poland, in other occupied countries, and in England, of the massacre of Polish officers may well have more enduring results than the massacre itself.... In handling the publicity side of the Katyn affair, we have been constrained by the urgent need for cordial relations with the Soviet Government to appear to appraise the evidence with more hesitation and leniency than we should do in forming a common-sense judgement on events occurring in normal times or in the ordinary course of our private lives; we have been obliged to distort the normal and healthy operation of our intellectual and moral judgements; we have been obliged to give undue prominence to the tactlessness or impulsiveness of the Poles, to restrain the Poles from putting their case clearly before the public, to discourage any attempt by the public and the press to probe the ugly story to the bottom. In general we have been obliged to deflect attention from possibilities for which, in the ordinary affairs of life, we would cry to high heaven for elucidation, and to withhold the full measure of solicitude.... We have in fact perforce used the good name of England, like the murderers used the little conifers, to cover up a massacre.

A Foreign Office veteran and ambassador to the Polish government between 1943 and 1945, O'Malley saw himself "swimming against the tide, and to swim against the tide is not the way to get on in the Foreign Office." In a memoir written once he had taken retirement, O'Malley declared

it was of no more substantial use to argue and negotiate with Stalin and his associates than to argue and negotiate with a lot of gorillas and rattlesnakes. . . . What is perfectly certain is that a majority of Poles in those earlier years thought the Soviets to be exactly as I have described them; and though behaving with commendable restraint, they were puzzled by the ostensible belief of the American and British governments that by making political concessions or sacrifices at the expense of other nations they could put Stalin in a good temper and induce him to do what they wanted. . . . Mr. Churchill thought, or anyhow said that he thought, that Russian friendship to Poland was a purchasable commodity and, if purchased, would be durable. Everybody ought to know by now that Mr. Churchill was wrong on both points, but most Poles had known it all along. The difference of view between the Poles and their allies was natural, for Poland is situated next door to the jungle where the gorillas and rattlesnakes live, and the Poles thought they knew much more about the nature and behavior of these animals than Mr. Churchill and Mr. Roosevelt. Who now can say that the Poles were wrong?

The Germans and the Russians each undertook independent investigations of the bodies exhumed at Katyn and, unsurprisingly, drew contradictory conclusions. The Nazis invested a good deal of time, energy, and money to insure an impartial and thorough examination, which they publicized widely. An international commission composed of an unimpeachable group of scientists and academics was assembled to inspect the site, including a judicial-medical coroner and professors of pathological anatomy, ophthalmology, forensic medicine, and criminology. At the end of April 1943, while this stretch of western Russia remained under German command, hundreds of bodies were taken from the graves and laid out for inspection. Each body was numbered. Any material evidence found on the bodies—identity cards, letters, postcards, photographs, cigarette cases, prayer books, rosaries, vaccination records—was secured in an envelope numbered to correspond to the corpse. A great deal of work was done in a very short period of time. The time and the cause of the death was recorded for each body examined.

The Polish Red Cross was also granted permission by the German authorities to visit the site. Extensive studies were made under the supervision of the organization's secretary-general, Dr. Kazimierz Skarżyński. A detailed report of his findings was sent to London via the Polish underground, providing the government-in-exile with their first untainted factual information since the

announcement of the discovery of the graves. The international commission investigation resulted in a three-hundred-fifty-page medical report signed by all twelve participants. This report and that of the Polish Red Cross each independently confirmed the results of the Nazi's own investigation, declaring the spring of 1940 as the time of the massacre, when the forest of Katyn was in Soviet hands. A special medical-juridical commission stayed on and continued work on the remains until the first week of July 1943.

At the end of July, as Red Army forces advanced toward Smolensk, the Germans were forced to withdraw from the Katyn forest. Once more under Soviet jurisdiction, the bodies and the graves became the focus of a second round of scrutiny. Material evidence was of little consequence in these inspections, however, as the investigation's findings were largely fabricated in an office in Moscow. An eight-member special commission convened in order to establish the "truth" about the executed Polish officers. Nikolay Burdenko, a neurosurgeon and internationally renowned academic doctor who held the distinction of being both Stalin's and Molotov's personal physician, was named chairman. Aleksey Tolstoy, Czapski's gregarious host in Tashkent, was named a participating commissioner in his capacity as an active member of the Soviet Academy of Sciences. Very soon after Katyn was back in Soviet hands, Merkulov was sent to supervise the insertion of documents into the uniforms of the dead men—letters, journals, and newspapers bearing dates later than the spring of 1940. Soviet forensic experts were then sent to the scene and uncovered "proof" of materials dating from 1941, proving that the earlier commissions had gotten the time of death wrong.

Like the Nazis, the Bolsheviks also invited foreign correspondents to inspect the site of the graves. One well-rehearsed charade involved a band of British and American diplomats and journalists inclined to favor the concept of Nazi guilt, among them Averell Harriman, the American ambassador to the Soviet Union. Unable to join the deputation, Harriman sent his twenty-six-year-old daughter Kathleen in his place. The group traveled to Katyn from Moscow at the expense of the Soviet state on a well-heated, luxurious tsarist-era train. They were fed extravagantly. Alcohol flowed freely. From the station at Smolensk, the group was transported in elegant cars to the Katyn forest site. Despite a predisposition to endorse the theory of German treachery, the majority of this handpicked group was ultimately unconvinced by what they saw and heard from the Soviets. The extensive forensic conclusions submitted to them

were intentionally pitched far beyond the level of their limited technical comprehension. Still, Kathleen Harriman's comments about the Nazis being responsible for the crime, echoing her father, made their way through American intelligence channels, congealing into hard evidence.

Roosevelt consciously distanced himself from any data pointing to Soviet culpability in the affair. He received a copy of Owen O'Malley's Foreign Office file from Churchill, but no response was ever forthcoming from the White House, despite two separate personal requests for comment from Churchill. A. J. Drexel Biddle Jr., the American ambassador to Poland, submitted his own report, which also provided extensive evidence of Soviet responsibility. Confronting Roosevelt, he claimed that if Poland's sovereignty and territorial integrity were no longer going to be defended by the United States, he could no longer continue as ambassador. Biddle resigned, and his dossier on Katyn was never acknowledged. Report after report failed to make an impact on Roosevelt. He was especially irritated by the vehemence of George Earle III, a former governor of Pennsylvania and an influential New Deal democrat. From his post as special emissary to the Balkan States, Earle had been carefully monitoring the response to the Katyn affair, amassing information and photographs. He intuited a deeper motivation on the part of the Soviets, seeing that their violent acts were meant to silence dissent and exert unchallenged political control over Poland in the postwar period. Roosevelt rejected Earle's conclusions, insisting the massacre was clearly of German design. Seeing that the president was not inclined to accept the facts, Earle took a stand, threatening to go to the press with what he saw as plainly the truth about Soviet responsibility. Roosevelt silenced Earle, writing to him "I specifically forbid you to publish any information." He was relieved of his naval posting in Europe and transferred to Samoa, as far as possible from Washington. FDR was well aware of who had plotted and realized the killings at Katyn, but he went to considerable lengths to prevent his administration from informing the American public.

Roosevelt was also convinced of his own prowess in forging a personal bond with Stalin, one world leader to another. He wrote to Churchill: "I know you will not mind my being brutally frank when I tell you that I think I can personally handle Stalin better than either you or the Foreign Office or my State Department." He placed great store in his ability to psychologically manipulate his Russian counterpart and was dismissive of the British prime minister's

more nuanced approach. Intent on exploiting Soviet tactical capability and resources, Roosevelt envisioned an ongoing entente between the USSR and the United States, a heightened military cooperation that one day would spill over into the political realm under the banner of the United Nations. Stalin and Roosevelt came to Yalta with curiously overlapping prejudices—both favored a weakened Europe, a broken Germany, and a Soviet hegemony over Eastern Europe. Roosevelt scripted his scenario to placate Stalin, to make him grateful, to render him malleable so he would ultimately bend to American will. In this elaborate fantasy of superpower harmony, Poland was merely an irritant.

The Burdenko committee's final document was signed by all eight members of the Extraordinary State Commission. According to these Soviet fact finders, thousands of Polish prisoners had been housed in three prison work camps adjacent to Smolensk before the Germans took them out and shot them in December 1941. Rich in exacting details about the movements of Polish officers during a period of eighteen months after the spring of 1940, the report came as a shocking blow to the Poles. These men, whose identities and whereabouts Stalin repeatedly insisted he had no knowledge of ("it may be that they are in camps in territories taken by the Germans"), were suddenly meticulously accounted for. The Soviets denied their part in the massacre, shrewdly enfolding a test of ideologic loyalty into this denial. For fifty years, innocence of any wrongdoing remained the strict party line—end of discussion. The USSR blatantly lied to the world and to its own people about its role in the executions. Only when the totalitarian superstructure collapsed fifty years later was the lie publicly revealed and acknowledged. In October 1992, a copy of the March 5, 1940, document signed by Stalin, Beria, and the politburo, condemning a total of 21,857 Poles to "execution by shooting," was handed to the Polish president Lech Wałęsa. Also, for the first time, the Russian government acknowledged the existence and authenticity of the secret protocol attached to the German-Soviet Nonaggression Pact of August 1939 that had sanctioned the destruction of Poland and its removal from the map of Europe.

Czapski never understood why he was not murdered with his comrades. He remains an integral figure in any history of these events as a result of his personal knowledge of so many of the victims, his proximity to an execution site, his subsequent investigations and writings on the subject, and his insistence against all odds that the perpetrators be identified and held responsible. In a political atmosphere thick with dissimulation, he steadfastly contested

the Soviet denial as historical evidence about the killings slowly accumulated, with all its graphic detail.

Absorbing the revelations about the deaths of his fellow officers, Czapski struggled to keep his focus as much as possible on the living men around him. Having braved three winters with freezing temperatures consistently dropping to minus 40 degrees, the men of the Polish army now faced conditions of extreme heat in the Iraqi desert. Moving west, the troops were led from one scalding location to the next, assigned to row after row of simple open tents or primitive huts. Outbreaks of malaria accompanied them. Deprived of contact with home for so long, the men liberated from Russia devoured whatever news was available about the current state of affairs in Poland. It was not good, either from the German- or the Soviet-occupied sectors. Poland in 1943 was a subdued nation of mass arrests, public executions, and extensive deportations. In April, the Warsaw Ghetto's remaining Jewish population revolted against their German oppressors. During weeks of resistance, thousands were killed or committed suicide, thousands more were burned to death as Nazi police ignited one ghetto building after the next, block after block. The Warsaw Ghetto Uprising was the largest organized Jewish action of defiance and retaliation of the entire Second World War. Thirteen thousand Jews died and tens of thousands more were rounded up and transported to their deaths at Treblinka, where more than a quarter of a million others had preceded them from the ghetto to the gas chambers. On May 16, 1943, the Great Synagogue of Warsaw was dynamited by SS units to celebrate the completion of their liquidation of the ghetto. From his post in exile, Prime Minister Sikorski issued a brief and doleful statement: "Before all humanity, which has for too long been silent, I condemn these crimes."

Czapski's work frequently took him on missions to various diplomatic postings around the Middle East. In Cairo, at the end of June, he met with General Sikorski, who was inspecting troops and raising morale at various locations. The two men had met before the war, once in the 1920s and again in the 1930s.

Now I was seeing him for the third time. How much he had aged; his fair hair had gone very gray, and I found him far more likable; furrowed with wrinkles, his face looked much less stiff. I had close contact with him on two more occasions, once at Kirkuk, in Iraq, during a difficult face-to-face, hour-long, conversation, and once again just before his departure for Gibraltar, at our

diplomatic post in Cairo. These two meetings gave me an incomparably more human impression of him; his personal sensitivity and vanity seemed to have been extinguished, or offset, by the difficulties of the moment. The man whose face was always tense was paying the price, paying with a huge and incessant effort, and with the greatest possible sense of responsibility. At that point he really did feel himself to be the leader of Poland, and he was.

In the early evening hours of July 3, Sikorski flew from Cairo to Gibraltar, traveling with his daughter, Zofia Leśniowska, the chief of the Women's Auxiliary Service whose husband was a prisoner of war in Germany. The peninsula's British governor, Lieutenant General Noel Mason-MacFarlane, was waiting on the airstrip to welcome his arriving friend. The man who had made Czapski feel so welcome at the British Military Mission in Moscow two years earlier, Mason-MacFarlane had been transferred from his posting in the Soviet Union to the British protectorate. He held Sikorski in great esteem; his sympathy for the Polish cause warmed considerably as his feelings for the Russians cooled. Also on hand to meet the plane was Mason-MacFarlane's young Polish liaison officer on Gibraltar, Lieutenant Ludwik Łubieński. Once Sikorski touched ground and was transported to his suite of rooms at the governor's compound, the general summoned Łubieński and asked for a progress report regarding the release of Polish soldiers from Spanish internment camps. Gratified to receive so favorable an account, Sikorski announced that the time had come for Łubieński to receive new orders. He proposed that the young officer fly with him to headquarters in London the following evening.

These plans would be altered. Hours before dawn on the morning of July 4, an underground courier from Warsaw appeared at the governor's mansion with secret papers for Sikorski. The messenger, in urgent need of continuing on to London, would be assigned the seat the general had just offered to Łubieński. Late in the evening, after attending a Fourth of July holiday celebration at the American consulate, Mason-MacFarlane and Łubieński returned to the airstrip with Sikorski, his daughter, and the courier to bid them farewell. Łubieński held the ladder of the RAF Liberator bomber as his commander in chief climbed into the plane, the last passenger to board. Stepping back on the tarmac, he took his place beside Mason-MacFarlane. As the plane taxied down the runway, Sikorski's two friendly colleagues first saluted, then waved goodbye. They were still watching when, sixteen seconds after takeoff, the plane sputtered, stalled, and nosedived into the Mediterranean, exploding on

contact. Sikorski's chief of staff, his British liaison officer, and perhaps a dozen other passengers had also been on board. Everyone but the pilot was killed.

Seven hundred yards beyond the Gibraltar runway, the single most powerful figure in the Polish struggle for survival and freedom lay dead in the wreckage. Despite considerable internal opposition, Sikorski had held firm command over the Polish armed forces and government for years. A devastating vacuum was immediately created at the loss of a single man's oversight of both military and political affairs. The exiled Polish state would be immeasurably weakened by the return of these powers into two separate entities, two competing power bases previously held in check and focus by one individual. No single person of similar stature or skill was available to replace him, certainly no one was as widely admired. On hearing the news, the English diplomat and journalist Harold Nicolson noted in his diary, "Sikorski's loss is a major blow. He was the only man who could control the fierce resentment of the Poles against Russia, and force them to bury their internecine strife. He was one of those rare people whom one can describe as irreplaceable."

In a heartbeat, the implementation of Stalin's plan for a Moscow-based provisional government in Warsaw found a major obstacle removed. Whether the general's death was accidental or premeditated, Stalin clearly benefited from Sikorski's absence. Seventy-five years later, the possibility of sabotage continues to prompt speculation, much as it did within minutes of the crash as the news spread. In London, Edward Raczyński, the Polish minister of foreign affairs, was awakened in the middle of the night to learn of the disaster. "I even imagined for a moment that his plane had been shot down," he wrote in his diary. Seven months earlier, Sikorski had been on a flight from Montreal to New York that was forced to make an emergency landing after the plane's fuel supply cut off just as it left the ground. The aircraft's undercarriage ripped open as it crashed on the runway. Sikorski, telegraphing Raczyński at the time, wondered about the possibility of subversive intent. Very soon after the incident, he drafted a document in which he laid out his wishes for the future of the Polish government, to be unsealed only in the event of his untimely death.

Given the huge scale of the European war, the presence of certain individuals on the Rock of Gibraltar on the day of Sikorski's death, July 4, 1943, is certainly curious. Ivan Maisky, the Soviet ambassador to Britain with whom Sikorski had entered into talks almost exactly two years earlier, arrived at Gibraltar on the morning of the crash and remained for a grand total of four hours, en route to Moscow to receive orders concerning the end of Soviet diplomatic relations

with the Polish government in London. The British minister of war, James Grigg, arrived in the afternoon. Most tellingly, Kim Philby, the head of British counterintelligence missions on the Iberian peninsula, was also present on the headland, actively doubling as a spy for the Soviets. Philby, an instructor for British Special Operations, specialized in sabotage behind enemy lines. He was well aware that Sikorski was traveling with sensitive material about the Katyn Massacre, documents the Soviets would benefit from seeing disappear. With full knowledge of the Polish commander's schedule during his thirty-hour stay on Gibraltar, Philby could easily have gained access to the general's B-24 aircraft. Theories abound about a plot to murder Sikorski, casting suspicion on the British, the Soviets, and various disaffected Poles. Philby's presence gives rise to any number of conspiracy theories. To this day, no passenger roster has been found for the flight, so the exact number of casualties has never been conclusively confirmed. No cargo manifest exists. The body of Sikorski's daughter was never recovered. Many British and Spanish documents about the investigation continue to remain classified. In the immediate aftermath of the crash, the German propaganda machine, ever opportunistic and anti-Soviet, dubbed Sikorski "the last victim of Katyn."

Lieutenant Ludwik Łubieński, who might easily have been on that plane, was the first person to identify the body of Sikorski when it was finally pulled from the sea. Making last-minute changes to accommodate the courier, Sikorski had unknowingly condemned one man to death while sparing the life of another. Łubieński was Józef Czapski's beloved nephew "Lulu," the youngest son of his eldest sister. Like his uncle Józio, Łubieński inexplicably escaped a tragic end to which others in his very close company had fallen victim.

The Polish Armed Forces in the Middle East officially became the Polish Second Corps in July 1943. At camps in Iraq and Palestine, they were undergoing final preparations for their long-awaited entry into combat against the Germans in Italy. Czapski, meanwhile, continued to develop and supervise courses of study for Polish boys and girls who had traveled out of the Soviet Union along with the army, most of whom were orphaned during the war. In the hopes of qualifying the students for their baccalaureate exams, his educational programs maintained rigorously high standards. Once the troops were called for combat duty, these youngsters would remain behind, flourishing in schools with curricula Czapski had established for them. As the chief of cultural activities, he oversaw the presentation of concerts and plays for the troops, as

well as exhibitions of paintings and sculpture in a number of different Middle Eastern countries during the army's nomadic encampments. A catalogue for one exhibition, featuring many reproductions of works on display and an essay-length introduction printed in Polish, Arabic, and English, is an indication of the army's vastly improved resources.

One day at lunch, Józef Jarema, a member of the Second Corps and an old friend and fellow Kapist from Kraków, cornered Czapski in order to lecture him about the necessity of making room in his life for painting. Jarema was able to provide him with paints, brushes, and canvas. A picture called *Baghdad Landscape*, Czapski's first oil in years, was the result. In his diary, he notes: "My hand is uncertain, small accidents occurred, but I worked with a passion that totally absorbed me. The tranquility afterwards...very strange. I haven't felt that calm in months." A bustling urban scene, the painting shows wooden balconies viewed from an elevated perspective, protruding over the street from a line of buildings three stories high, looking down on an avenue crowded with pedestrians and horse-drawn carriages. The viewer's eye is drawn to a high horizon in diminishing perspective, where a minaret dominates the scene. Little attempt is made to "Orientalize" the subject; the mosque could be mistaken for a church tower in a European city. In conjunction with the opening of the exhibition, Czapski gave a lecture, in French, on the subject of "French Painting from David to Picasso," composed from fragments of his lost notebook. Many in the audience had read his article on Proust published a few weeks earlier in the Cairo newspaper *La Marseillaise*.

Upon arrival in Palestine, a large group of Jewish soldiers of the Second Corps made the decision to leave the army and assist in the building of a future Jewish state under the leadership of Polish-born David Ben-Gurion. Many, disgusted by the general tolerance for anti-Semitism they'd been forced to endure, left their units without formal approval, but it fell under Czapski's authority to issue official military releases, leaves of absence "without expiration" that would remove the threat of these men being held, tried, and shot as deserters. Menachem Begin, who would one day become the prime minister of Israel and receive a Nobel Peace Prize, was among the soldiers of the Anders Army. His mother, father, and brother had been murdered by the Nazis. Many other Polish Jewish soldiers, committed to the fight against Hitler, decided to continue serving under General Anders.

After months of speculation, Stalin, Churchill, and Roosevelt finally agreed to meet at the end of November 1943, the first time the three leaders would

convene face-to-face. Stalin announced that Tehran was the only venue he would entertain for a summit meeting. These terms were accepted, leaving Roosevelt, whose health was deteriorating, to undertake a journey of more than six thousand miles. Imposing his choice of a location on the other two heads of state gave Stalin a preliminary edge, one he exploited to maximum effect over the course of the four-day gathering. Once in Tehran, Churchill immediately found himself sidelined. His request for a private meeting with FDR before the three leaders were to come together at the first plenary was denied. Roosevelt, confident of his ability to thaw Stalin, froze out Churchill. In one session, Stalin impulsively expressed his desire to execute fifty thousand German officers when the war was over. Churchill voiced his outrage, appalled by the idea. Perversely, Roosevelt suggested that Stalin settle for forty-nine thousand. Churchill stormed out of the room. Eventually Stalin went out to find Churchill and attempted to calm him, claiming his remark was only "a joke in the Russian style." Churchill and Roosevelt no longer had anything to say to each other.

At the conference table, Stalin's strategy was to confine British and American forces to Western Europe. Understanding that an Allied presence in Central Europe could make future Soviet dominion in the region more difficult to establish, he refused to entertain the idea of an offensive that would open another Allied path to Germany through the Balkans. Roosevelt deferred to Stalin's position. He told Averell Harriman that he "didn't care whether the countries bordering Russia became communized or not." FDR found common ground with Stalin in their mutual desire to humiliate France and Germany, and, by association, Britain as well. His ambition was to reduce the nations of Europe to a state of powerlessness, easily dominated by the United States and the Soviet Union.

When the final plenary came, Stalin laid his cards on the table, demanding Soviet dominion over eastern Poland. Roosevelt agreed to shift the boundary of Poland to the west, to incorporate parts of Germany. (He requested that his approval be kept secret, however, until after the following year's presidential election, not wanting to risk losing the support of Polish Americans.) Stalin's stated intent to rule over Lithuania, Latvia, and Estonia was checked only nominally by Roosevelt, who contended that citizens of each republic should be given the opportunity to vote in a referendum on the question of joining the USSR. No such offer was extended to the citizens of Poland. A year earlier, Churchill had rejected Stalin's outright claims on Poland, insisting that the

territory had been "acquired by acts of aggression in shameful collusion with Hitler." By the time of the Tehran Conference, he no longer had any traction at the bargaining table.

In the current balance of power, Poland was lost, its fate sealed. No official announcement about the future of Poland was forthcoming, but as General Anders records in his memoir, a sense emerged that the conference "had resulted in an understanding being reached at someone else's expense."

10

THE POLISH SECOND CORPS was finally in fighting form. Having traveled more than three thousand miles—by boat, on foot, by truck and train, from Russia, across Kazakhstan to Uzbekistan, from Uzbekistan to Turkmenistan, across the Caspian Sea to Iran, to Iraq, to Jordan and into Palestine, from Palestine to Egypt—they were ready to join the British forces in North Africa. The Polish soldiers, like the Greeks in Xenophon's historical account of war in 401 BC, traveled great distances from a remote landlocked interior toward the sea. The Greeks cried out joyfully "*Thálatta, thálatta*! The sea, the sea!" when they saw its surface glittering in the distance from a mountaintop in Trebizond. The Poles, too, were exultant as they encountered the Mediterranean at Port Said in Egypt in December 1943. They were on their way to mainland Europe, to the Italian peninsula. This time Czapski was among them.

Once on the European continent, meeting up with other Allied forces, Czapski found Soviet anti-Polish propaganda widespread and insidious. He had the sense of becoming increasingly insignificant, if not invisible, to his international colleagues. Articles in the U.S. Army newspaper *Stars and Stripes* and the British *Eighth Army News* were full of anti-Polish invective, including repeated references to Polish officers "allegedly murdered by the Soviet government." The more enthusiastic the Western Allies became about Uncle Joe, the more indifferent they became to Poland's quandary. Adopting Soviet vilification of the Poles as their own attitude, they, too, accused the Poles of being fascists and pro-German because they deigned to question Stalin's motives. General Anders, who landed in Italy on February 6, 1944, declared to the commander of the British Eighth Army, Lieutenant General Oliver Leese, that "it was not right that on the eve of their going into battle, the soldiers of the Polish Second Corps should have to read slanders against themselves in the newspaper of the army to which they now belonged." Communicating in French with his British superior, Anders received a reply, by telegram, some days later: "I have thought over in detail the point of view you expressed with regard to the actual Polish problems. In my capacity as Army Commander

I have to point out to you how superfluous it is for a Corps Commander to express in public any opinions concerning the political situation, in particular at the present moment."

There was no one else Anders could turn to. The Polish Second Corps had no choice but to operate under the jurisdiction of the British and the Americans. Under his level-headed leadership, the Polish army was encouraged to focus on the destruction of the German enemy, leaving aside for the time being any anxiety about their homeland's future existence.

In the middle of March 1944, the British Eighth Army was put in charge of the theater of war in southern Italy. Lieutenant General Leese approached General Anders with an offer: Would he consider engaging his units as part of a broad offensive to secure the road to Rome? The Germans needed to be pried from their virtually impregnable seat beneath a ruined monastery atop Monte Cassino. Leese made it clear to Anders that this particular field of battle was enormously perilous, that many lives would have to be sacrificed in an all-out attempt to dislodge three of Germany's best divisions from their strategic fortress of rubble. Without control of the heights of Monte Cassino, the entire Allied advance was being held in check. Since January, no force had been able to reclaim the monastery and the surrounding hills. Anders was being given the opportunity to let his men prove themselves. Leese informed him that he was under no obligation to accept the mission; his unit could be transferred to a less dangerous assignment for its first engagement in battle. Anders was given ten minutes to make up his mind, but quickly he chose to accept what was being offered. Distinguishing themselves in battle would both prove their mettle as warriors and disprove the persistent Soviet insinuation that Polish soldiers were unwilling to fight. "Capture Monte Cassino and push toward Piedimonte." Anders accepted his orders and went into army command mode.

The monumental ancient sanctuary of Monte Cassino, a center of monastic art and culture built on the site of a Roman town, had been bombed from the air by the Americans in a symbolic and futile show of force. (Germans had never occupied the citadel. Only civilians seeking shelter in the Benedictine abbey were killed.) In late April, Polish divisions composed of two partial brigades moved into position for the assault. No reserves providing reinforcement were available. Very slowly, night after night, stores of arms and ammunition were moved up the mountainside. The first distance was covered by truck, the next leg by smaller vehicles, the next by mule. For the final push, supplies were carried up by hand, piece by piece. Miles of cable were buried

to form a grid of communications. Just before midnight on May 11, 1944, the division finally opened fire along their front line. The enemy counterattack was immediate and severe. Scores of company and battalion commanders were killed straightaway. Fighting was intense and relentless, and often hand-to-hand. Over and over, positions were captured but could not be held, were regained and then lost again. The German forces redoubled their zeal in response to a new surge of firepower. In addition to gunfire, they broadcast inflammatory propaganda over a public address system along the front lines, asking the Polish soldiers in the midst of battle what they were fighting for. Didn't the Polish soldiers know their "allies" had already ceded Poland to the Soviets? Who was their real enemy?

The first offensive failed to break through. The mountainside was too precipitous. German positions were entrenched amid the debris of the ruined monastery at the top, a shape so formless that the Polish soldiers below didn't know where to aim their guns. Exposed to shelling, they lay in shallow crevices, surrounded by the bodies of soldiers killed in earlier assaults. From a base camp not far from the scene of battle, Czapski reported that "every last scrap of terrain passed back and forth several times, the casualties were enormous." It took eight men under fire three hours to lower a single wounded soldier down the hill. Another assault was attempted two days later with the same brigades. By the late afternoon of May 17, some progress had been made toward a ravine that acted as a firebreak. At that very moment, the British Thirteenth Corps attacked, forcing the Germans to divide their artillery firepower. Taking advantage of the situation, several seventeen-year-olds from a Polish Uhlans regiment charged up, lending a sense of invincibility to the attack, fearlessly climbing into no-man's-land, up and down the steep slope, sustaining crossfire, tossing grenades as they went. One position after another was captured, one bunker at a time. Later that night, under dark skies, the Germans abandoned their perch and retreated to the north. In the early morning hours of the following day, a lancer, finding the ruins of the monastery clear of enemy presence, grabbed his bugle and blew out the Kraków *hejnał*, the medieval military signal known to all Poles, sending a clear signal of Poland's determination and survival. A Polish flag was raised on Monte Cassino.

More than eight hundred Poles had been killed. Two out of three battalion commanders were dead, and twenty-eight hundred men were wounded. Dead colleagues were acknowledged, the needs of those in pain were addressed, and the troops pushed on. One week later, on May 25, Piedmont was similarly

cleared of Germans and secured. The Anders Army had faced and stood down the Wehrmacht, the finest fighting force in the world. The road to Rome was finally open. At the effusive recommendation of Lieutenant General Leese, General Anders was recognized for his key role in this courageous operation and decorated by the king of England.

From the time of his release from the USSR, Czapski would turn to his journal for relief from the stresses of military life, filling it with sketches. Once he arrived in Italy, his drawings record the army's northward march: Brindisi, Taranto, the Bay of Naples, the Italian hill towns, all the way to Bellagio. Rendered in ink, brushed over with delicate washes of watercolor, the drawings show winding roads, crenellated towers, orchards, grazing cows, cypress, and pines. There are scenes set in the interiors of barracks, men playing cards around a table, groups dining in mess halls, studies of soldiers on duty and off, in full battle regalia and stripped down for bathing. One view of rolling hills drawn in swirling lines gives way to a distant mountaintop identified with an arrow pointing at its peak: "Cassino."

His written diary provides an intimate expression of his inner life. On any given day, he would record what he was thinking, what he was reading or remembering. His pressing concerns did not necessarily include whatever happened to be transpiring around him (battle mayhem, death, drudgery, responsibilities). In Loreto, near Ancona, he wandered in a reverie through the Sacristy of San Giovanni making drawings of vivid frescoes by the Renaissance painter Luca Signorelli. His wartime entries often read as if he is not quite living in the same temporal construct or spatial surround as his fellow soldiers; in his mind, past and present exist together seamlessly, little distinction is made between what was written or painted or experienced four hundred years earlier and what he was presently encountering. Art, he writes, "is the experience of life; it's contemplation. It's a vision of life, and essentially, a rupture with time." He is as likely to be thinking of a sixteenth-century Brueghel he has just seen, a poem by Mickiewicz, or lines from a Dostoyevsky novel he is reading as the immediate progress of the theater of war around him. In carefully observed detail he evoked the suspended timelessness one encounters in Italian cities and villages, giving himself over to its seductive charm. Putting down his impressions of the landscape and the figures peopling it, he was strengthened, his sense of purpose affirmed.

He welcomed other voices in his diary. A small square block of text glued to

a page in one of his Italian campaign journals from 1944 is a passage from André Gide's "Encounter at Sorrento," in which the French writer laments the demands of keeping a journal and his struggle to negotiate between inner and outer life in its pages: "I reproach myself for what I have hardly made mention of in my journal, which leaves scant trace of many important events in my life; in such a manner this journal betrays me endlessly, because I do not tend it assiduously, I speak to it only during the desert periods when I need it, when I cling to it, to escape from either boredom, or sadness, and sometimes even despair."

Czapski emphatically underlines the printed words "*ce journal me trahit sans cesse*"—"this journal betrays me endlessly." He lifts a phrase from Gide's passage, "*dans les périodes désertiques*," writing it out in longhand next to the block of published text and adds "*de ma vie*": "during the desert periods of my life." Having cut these lines from the pages of a magazine to add them to his diary, Czapski is responding enthusiastically to the expression of something he knows to be true, grateful for the sound of his own words echoing back to him from another source.

June 4, 1944, two days before the Allied invasion of Normandy, the American Fifth Army entered Rome, the first European capital to be liberated by the Allies. American and French troops moved on shortly afterward to participate in another invasion, Operation Dragoon, planned for the South of France in August. The Polish forces stayed behind in Italy. Their next mission was to secure a base somewhere along the Adriatic coast. Ships bearing much-needed supplies were in search of a safe harbor as a point of entry. On July 18, after almost a month of heavy fighting, the Polish Second Corps succeeded in capturing the port city of Ancona. Three thousand German soldiers were taken prisoner. An extensive sweep for mines had to be performed on land and underwater before any military ships could be allowed to enter the port and unload cargo. Adolf Bocheński, a man Czapski first met in Iraq and came to consider among the most lucid and profound thinkers he ever knew, became a master at analyzing the Nazis' sadistic strategies for the placement of mines. He had fought at the Battles of Narvik and had been wounded during the siege at Tobruk. An expert and indefatigable defuser of mines, he had led so many patrols on his hands and knees that he claimed to walk better on all fours than on two legs. (During their time in the desert, he would navigate by the stars, which he thought of as old friends.) He held the idea of danger in contempt. On his first outing in Ancona, his wounded right arm in a sling,

Bocheński defused twenty-two mines. He died trying to defuse his twenty-third of the day. In tribute, the *White Eagle* published what would turn out to be Bocheński's eerily prophetic essay about future relations between Poland and the Soviet Union, in which he clearly described his vision of the forthcoming Soviet occupation, unfolding covertly and mercilessly in stages.

Following the battle for Ancona, the Polish units were given their first opportunity to rest and regroup. The American journalist Martha Gellhorn, on assignment in Italy in June and July 1944, crossed paths with the armored division of the Polish Second Corps, the Carpathian Lancers, near Ancona in late July. She had been traveling across Europe reporting on battles and soldiers in twelve countries, frequently camping out among fighting units in the field. Her impressions and analysis formed the basis of an article she submitted to *Collier's Weekly*:

> All the Poles talk about Russia all the time. The soldiers gather several times a day around the car which houses the radio and listen to the news; they listen to all the news in Polish, wherever it comes from. They follow the Russian advance across Poland with agonized interest. It seemed to me that up here, on the Polish sector of the Italian front, people knew either what was happening ten kilometers away or what was happening in Poland, and nothing else… what went on in Poland could be seen in every man's face, in every man's eyes.…
>
> It is a long road home to Poland, to the great Carpathian mountains, and every mile of the road has been bought most bravely. But now they do not know what they are going home to. They fight an enemy in front of them and fight him superbly. And with their whole hearts they fear an ally, who is already in their homeland. For they do not believe that Russia will relinquish their country after the war; they fear they are to be sacrificed in this peace, as Czechoslovakia was in 1938. It must be remembered that almost every one of these men, irrespective of rank, class, or economic condition, has spent time in either a German or Russian prison during this war. It must be remembered that for five years they have had no news from their families, many of whom are still prisoners in Russia or Germany. It must be remembered that these Poles have only twenty-one years of national freedom behind them, and a long aching memory of foreign rule.

Ever since the defeat of Hitler's Sixth Army at Stalingrad in February 1943, the American press was in a honeymoon phase with the Soviet premier and

the Red Army. *Time* magazine named Stalin Man of the Year in 1943. (In its reporting, *Life* magazine suggested that the NKVD was "a national police similar to the FBI.") Gellhorn's impassioned report was never published by the magazine that commissioned it; the editorial board perceived it as too critical of the Soviet Union.

In 1939, when the war began, Britain and France did not honor their pledges to come to Poland's aid, and in 1944, as the war was winding down, Britain and the United States reneged on their commitments. Disregarding the tenets of self-determination boldly proclaimed in their own Atlantic Charter, the American and British governments went about fixing the future borders of Poland, colluding against Poland at negotiations in which the Poles were not invited to participate. By the late summer of 1944, it seemed foreordained that Poland would merely slide from Nazi occupation to Soviet occupation.

On the ground in Poland, the Home Army—the Armia Krajowa, or AK, the largest underground resistance organization in any European country—had long been fighting German and Soviet occupation, but the forces were beginning to splinter into factions of conflicting political, military, and tactical priorities. After years of successfully perpetrating acts of sabotage against German transport, the AK had proven largely ineffectual against the Soviets. Nearly all of eastern Poland was falling under communist control. Bolshevik rule was being laid down mile after mile, day after day, as Red Army divisions were approaching Warsaw. The Germans continued to retreat.

News of a failed plot to assassinate Hitler spread across Europe on July 20. Unfounded hopes were raised among the Allied nations that perhaps the Nazi war machine was finally running to ground. Two days later, Stalin issued a manifesto declaring the Lublin Committee, his handpicked body, "the only legitimate government in Poland." He renounced any tie to the London government-in-exile. The Red Army severed all contact with the Polish underground. This change of status was never communicated to the Home Army, who continued to expect to fight a common enemy alongside Soviet troops. Suddenly, underground AK fighters engaged in resistance against the Nazis were finding themselves confronted by Red Army soldiers, weapons drawn, giving them the choice between swearing allegiance to the USSR or being taken into custody as criminals and facing the consequences.

Soviet tanks were spotted on the east bank of the Vistula River on July 31.

The AK commander Tadeusz Bór-Komorowski issued the long-awaited order for the Home Army to mobilize. Word spread through the city. Varsovians unearthed weapons—rifles, grenades, pistols, knives—from every secret corner in which they had been stowed since 1939. The intent was to sustain a fight against the retreating Germans for five days, at which point Soviet reinforcements were expected to provide backup. As if at the last possible moment, the Warsaw Uprising was launched August 1, 1944. Fighting exploded in many neighborhoods at five o'clock. A grid of separate battlefields, the entire city was locked in a grip of violent offensive and defensive tactics. Exchanges between the SS and the citizens of Warsaw were savage and relentless. Reprisals were brutal.

The situation quickly degenerated into a perfect storm of helplessness. The first day of the uprising brought a mixture of minor successes and overwhelming failures, but perhaps the most significant response came from Hitler, who, learning of Polish resistance, ordered Heinrich Himmler to wipe Warsaw off the face of the earth. His orders were to kill all inhabitants: men, women, and children. No prisoners were to be taken. A carnival-like atmosphere of killing quickly spread as the Nazis brought in special teams of SS commandos known to indulge in ruthless behavior.

The AK command appealed to the leadership of the Allied forces, but their calls for help fell on deaf ears. A litany of reasons for not providing assistance were repeatedly voiced: Allied air bases in Europe were too far away from Warsaw to make supply drops, the risk was too great, there were insufficient aircraft. It became rapidly clear that, despite armed units of considerable size clustering in the eastern districts of Warsaw and beyond, the Red Army had no intention of providing backup to fight the Germans. For the next five months, Soviet tanks and soldiers remained stationary within close proximity of the uprising, offering no assistance to the beleaguered Poles. Stalin, once Hitler's ally but now his enemy, refused permission for British or American relief planes to refuel at any of the six Soviet-controlled airfields in range. Warsaw and its citizens withstood wave after wave of German bombardment; the Soviets engaged no antiaircraft artillery, leaving the skies wide open for Luftwaffe reconnaissance and bombing raids. From the Soviet viewpoint, the more AK soldiers and members of the Polish intelligentsia the Germans killed, the better. Stalin insisted there was no uprising, maintaining his position that no underground army or government currently existed in Poland. If there was

an uprising, he claimed, then it had been started by criminals and he would not lend support.

During these same weeks, General de Gaulle's underground resistance movement received abundant Allied support in the push for Paris. The French capital was liberated on August 25, 1944. No Allied assistance was made available to the Polish underground resistance movement engaged in fighting the same enemy. At the same time that Paris was drenched in champagne and overwhelmed in celebration, tens of thousands of civilians were murdered in Wola, a western sector of Warsaw. Bombs fell around the clock. One neighborhood or another was always on fire. The killing and ruination continued, unabated. Resistance within the city intensified. No help came from beyond the city limits.

Czapski had access to directly observed details of the insurrection from his sister Maria, who remained in Warsaw throughout the war. As mayhem was unleashed across the city, she wrote to him regularly, conjuring up images of familiar neighborhoods, describing the intense confrontations erupting on an almost hourly basis as the city's residents fought for their lives. At a loss to account for the West's silence in the face of such savagery, Czapski wrote a fifteen-page pamphlet, an "Open Letter" addressed to two prominent French writers and statesmen he had known since the 1920s, Jacques Maritain and François Mauriac. The letter protested the lack of response from the guardians of European Christian faith in light of the victimization of the Poles. Czapski praised Mauriac for having voiced outrage over the slaughter of Spanish Basques by General Franco's forces and Maritain for his ceaseless defense of persecuted Jews. Both men had publicly condemned fascism and totalitarianism, and each was a figure of decency and integrity. (Maritain would become the French ambassador to the Vatican, Mauriac would go on to win the Nobel Prize in Literature.) Czapski held these two pillars of tolerance and nonconformism in high esteem, but he could not understand their refusal to engage: "Why aren't you coming to the aid of a people who are perishing? With your silence, you participate in the destruction, perhaps irreversible, of the intellectual and moral prestige of France." Given the extremity of the violence against the people of Warsaw, Czapski detected in their silence a kind of denial, in which the West carried on pretending not to hear the cries from Poland.

After numerous edits by British censors, Czapski's letter to Mauriac and Maritain was published in the *White Eagle*. With the approval of General Anders, Czapski posted the letter farther afield, hoping to prompt these exem-

plars of humanitarian compassion into engagement and dialogue about the fate of Poland. The published letter made its way to New York, where it was circulated widely and endorsed by many prominent Polish thinkers, who wrote a companion letter in support of his and saw to it that both letters were distributed along proper channels across the United States. "This letter, in which he puts a damper on his feelings of friendship and veneration," Gustaw Herling observed, "is the voice of a man too attached to the French traditions of intellectual independence for him to be quiet. It is a call to the true France, France at the time of the Dreyfus Trial." Neither Maritain nor Mauriac ever replied.

The tragedy unfolding in Warsaw began to receive international coverage only when the world press recovered from its hangover following the glorious parties in the streets of Paris. Slowly, Stalin's willful refusal to assist the Poles fighting their Nazi occupiers stirred up murmurs of outrage. For months the Poles, portrayed in the press as impediments to Allied cohesion, suddenly came to be seen as victims of Allied intransigence, as Soviet forces amassed in the outlying districts of Warsaw remained inactive, standing by while the Germans demolished and depopulated the Polish capital.

The uprising was fully crushed and smothered eight weeks after it started. Two hundred thousand civilians died during the insurrection, twenty thousand AK soldiers, and fifteen thousand Wehrmacht soldiers. Five hundred thousand residents of Warsaw were expelled from the city and on October 5 many thousands more were processed for relocation through a Nazi transit camp for displaced civilians in the small neighboring city of Pruszków. One hundred thousand men and women were sent to forced labor camps, sixty thousand more were transported to Auschwitz or Ravensbrück, the remainder taken some distance from Warsaw and released. German authorities sent workers in to strip any structures that were still standing of valuables—furniture, paintings, carpets, clothing—followed by special burning and destruction crews to fulfill Hitler and Himmler's orders to leave nothing standing. Block by block they worked, commanded to leave "not one stone upon another." Between eighty and ninety percent of the city's buildings and infrastructure was reduced to rubble.

In mid-January 1945, the Red Army occupied what was left of Warsaw. Weeks later, in the Crimean city of Yalta, another Big Three conference convened to address the future world order. From the start, Churchill found his bargaining

power even more severely reduced. The dwindling state of Britain's imperial treasury distanced him from two leaders overseeing comparatively limitless resources. Churchill's strength of moral character held no currency for Roosevelt, who kept him at arm's length. The American president's main objective was to secure Soviet military power in the fight against Japan once the war in Europe came to a close. He took pleasure in the dismemberment of Old Europe, Britain included. Stalin came to Yalta fully apprised of the agendas of the Western leaders even before the conference began, privy to detailed secret information provided by double agents Donald Maclean in Washington and Guy Burgess in London. In negotiations, Stalin seemed to hold all the cards.

The future of Poland dominated the six plenary sessions. The answer to the question of which government would become internationally recognized—the government-in-exile in London or the Moscow-selected Lublin Committee—was no longer in doubt. Churchill and Roosevelt made only half-hearted rhetorical gestures toward assuring "democratic" elections and the right of self-determination for the Poles. Stalin insisted on a "Russian peace" for Poland, a peace maintained by a government of his choosing, policed by Soviet forces that would report to Moscow.

In September 1939, Poland became the first country to stand up to the German war machine. When, in January 1942, Polish representatives arrived in Washington to sign a "Declaration of United Nations," they joined twenty-five other Allied countries in their acceptance of a formalization of the Atlantic Charter, each forswearing the opportunity to make a separate peace. As the end of the war in Europe seemed within reach in the spring of 1945, fifty-one countries were invited to send representatives to San Francisco to formalize a charter for an international peacekeeping organization to be known as the United Nations. Poland, alone among the original signatories of the United Nations Declaration, received no invitation. On April 25, 1945, the United Nations conference began without representation from Poland. Two months later, one hundred fifty-three delegates signed the United Nations Charter. Not one Polish name appears among them.

On July 5, 1945, President Truman announced recognition of Stalin's puppet government as the legitimate government of Poland. The Lublin Committee had transformed into the Provisional Government of National Unity. The following day, Jan Ciechanowski, the Polish ambassador to the United States,

resigned along with the entire embassy staff. Ciechanowski titled his memoir of the war years *Defeat in Victory*.

Poland was officially subjugated to the terms of Soviet geopolitical reality. Within months, Stalin's face would appear on a stamp of the newly formed "People's Poland," commemorating "Polish-Soviet Friendship month."

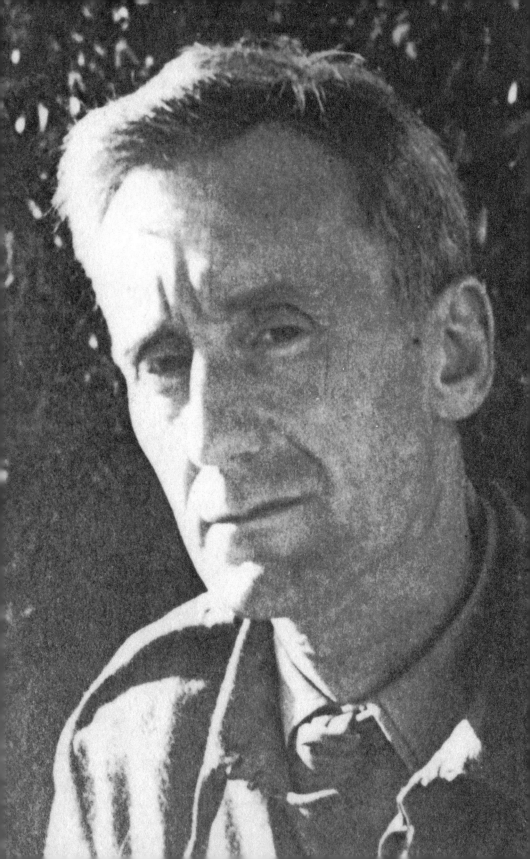

Diplomat, Advocate, *Kultura*

1945–1951

11

POLAND WAS IN A TRAUMATIZED state. Having lost a full fifth of its prewar population—more than five hundred thousand fighting men and women, and five million civilians—the country had nearly one million war orphans and more than five hundred thousand invalids to care for. The nation, ostensibly on the "winning side," was deprived of territory; large swaths of the country and two great cultural centers—Lwów and Wilno [Vilnius]—no longer belonged to Poland. Along the eastern border, 69,000 square miles were lost to the Soviet Union. On the western border, 40,000 square miles—including the city of Gdańsk and the western territories—were added to Poland from Germany. Conflicting ideas of what Poland was and would become shattered everyone's concept of peacetime. "I've never met a single Pole capable of analyzing this national tragedy dispassionately," Czapski exclaimed. Who possessed the authority to determine the shape of Poland's current identity as a homeland, as a people?

Historians mark May 8, 1945, the day of Nazi Germany's surrender, as the official end of hostilities and the beginning of a new Europe. Hostilities, however, continued for the Poles. After six years of plotting and fighting against the depredations of the Third Reich, enduring unspeakable conditions, Polish citizens and Home Army soldiers were being rounded up and arrested by their Soviet occupiers and accused of collaborating with the Nazis. They were tortured and deported; many were executed. The Provisional Government of National Unity, newly installed in Warsaw, stripped General Anders and seventy-five other high-ranking officers of their rank and nationality, accusing them in absentia of crimes against the Polish nation. At the end of the war, approximately one hundred twelve thousand soldiers of the Polish Second Corps were stationed beyond the borders of Poland. A substantial portion of this fighting force came to the corps after having been released by "amnesty" from the netherworld of the Gulag. They had been arrested by the Soviets in 1939 and shipped to forced labor camps. From among those soldiers who had left the Soviet Union with General Anders, only three hundred ten requested

repatriation to a communist-controlled Poland. These men ran the very real risk of facing persecution, imprisonment, even execution on their return. Once in Poland they were regarded with suspicion and considered unlikely to swear allegiance to the government installed by Moscow in their absence.

Anthony Eden's successor as the British foreign secretary, Ernest Bevin, a former trade union leader, made it perfectly clear he wanted the demobilized Polish forces in Britain repatriated as soon as possible. To absorb so considerable a mass of able-bodied men into the British workforce would mean far fewer jobs for native-born soldiers returning home. But where were the Polish soldiers to go? Where was "home"? General Anders refused to concede to Bevin's demand to repatriate his men until free elections were guaranteed in Poland. Both men knew there was little likelihood of that happening.

The idea of warriors denied a home, never mind a homecoming, troubled the conscience of Winston Churchill. In April 1945 he toyed with the highly secret idea of an initiative called Operation Unthinkable, a military contingency plan for war against the Soviet Union. The operation's primary objectives were gaining control over Eastern Europe and enforcing a "square deal" for Poland. The strategy was to strike Red Army forces in Germany on July 1, a surprise attack focused on troops concentrated around Dresden, in order "to impose upon Russia the will of the United States and the British Empire." The plan, acknowledged publicly for the first time only in 1998, never went beyond the developmental phase. At the war's end, the Soviets maintained a four-to-one superiority in numbers of soldiers on the ground in Europe, and a two-to-one superiority in numbers of tanks. Backing down, Churchill nevertheless continued to regret the situation facing the Poles.

A month before Nazi Germany surrendered and victory in Europe was declared, General Anders dispatched Czapski from Rome with orders to rally support for Poland among intellectuals in London and Paris. Anders charged him with the establishment of a Paris bureau for the Polish Second Corps.

> In 1945, after an absence of ten years, I arrived in a Paris still sad and empty, as if shrunken. Montparnasse was completely deserted; cars in the streets, American ones in general, were rare, while on the boulevards endless droves of American and English soldiers dawdled. Despite the liberation, despite the huge V projected onto a mauve sky from the Arc de Triomphe, what a contrast with the Paris of days gone by! Suddenly, I considered the idea that Paris was already

dead, that what I was seeing was no longer Paris but the ruins of Paris, that I was about to watch as at any moment a heavy green wave was going to inundate the city, swallow it up. . . . The whole landscape, so delicate, with its shadows and bluish-pink lights, seemed unreal, and once again this strange impression pierced me; this landscape so impregnated with French and Polish memories didn't exist in reality, it could disappear entirely from one moment to the next, it was only a mirage.

His arrival in Paris coincided with his forty-ninth birthday, what would come to be the halfway point of his life. Forty-nine years were behind him, forty-eight years loomed ahead. With the single exception of a cityscape painted in Baghdad, he had not worked as a painter for a very long time. Warsaw, his home when war erupted in September 1939, was in ruins. Compared to the wreckage of virtually every building in the city, the burning of priceless libraries and collections of art, and the willful destruction of treasures dating back to the Middle Ages, the loss of a single artist's output was no more than a trifle. But it was Czapski's trifle. Six years of war had obliterated not only the discipline of a painter's studio life but the paintings themselves, their tangible residue buried somewhere under mountains of ash and stone. At this juncture, he was forced to examine the grounds upon which he could still consider calling himself a painter. Entering his fiftieth year, he wrote that he "would have to begin again at zero."

Yet duty called. Czapski knew what was expected of him by others and what he expected of himself, and at what cost. He had to stifle the urge to return to a studio life. His creative impulses had to be put on hold, contained once again.

During this period before the war ended, as Czapski was regularly traveling between European capitals, his quiet but damning memoir, *Wspomnienia Starobielskie* (Memories of Starobielsk), was released, first in Polish as an army publication in Rome, followed soon after in a French translation, *Souvenirs de Starobielsk*, printed in Paris. His eyewitness report of life as a Soviet prisoner of war, teeming with word portraits of fellow officers and prisoners he would never see again, was clear-eyed and factual, brutal only because of the nature of the events described so evenhandedly. In the book's introduction, Gustaw Herling, also a survivor of the Gulag, noted that the experiences recounted by Czapski were "lived by a Pole, meditated on by a European, written by a painter." The book, he added, "has the feel of a ship's log, soaked by the waves, thrown from the boat as it was sinking." A fairly resounding silence greeted

the unheralded modest volume, which emerged nearly concurrently with the revelation of the scope and horror of Nazi atrocities. Meanwhile, the Soviet Union was busy rewriting recent history, actively eradicating all reference to Stalin's early alliance with Hitler. Czapski's frank book was an antidote to that self-serving fantasy. In an article he wrote at the time for the Parisian periodical *Gavroche*, titled "The Truth About Katyn," Czapski asked, "Why is the massacre of several thousands of Polish prisoners of war at Katyn *still* a 'mysterious' affair for many French people? Why are serious and usually well-informed people *still* asking me whether 'Russians or Germans committed this crime'?"

On the whole, the French left was unwilling to entertain the possibility of an annihilating Marxist-Leninist tyranny as described by witnesses like Czapski. To do so would be to obliterate their consuming faith in the idea of progress, to challenge their belief in the possibility of material change for the proletariat. In the first national elections after the war, the French Communist Party (PCF) produced by far the largest block of leftist votes. The French right, diminished and badly tainted by its association with Marshal Pétain and Vichy, was reduced to a state of powerlessness. The looming presence of the Soviet bloc was now closer than ever; East Germany was only two hundred fifty miles from the French border. Moscow was no longer so far away. Public discourse about life in postwar France would be dominated to a remarkable degree by political perspectives from the Kremlin, a stunning reversal for a culture famous for exporting ideas, not importing them.

Paradoxically, France at midcentury was the land of the most exceptional concentration of philosophical inquiry in all of Europe. Raymond Aron, Albert Camus, Jean-Paul Sartre, Simone de Beauvoir, Louis Althusser, Simone Weil, and Maurice Merleau-Ponty all produced their most challenging work in these years, representing a wealth of brilliant but polarized positions. In the words of the Italian critic Nicola Chiaromonte, these thinkers became a "symbol of defeated France, which because of them had imposed itself victoriously in its chosen domain—intelligence." In an atmosphere of irrational narrow-mindedness, an embarrassment of intellectual riches flourished.

"For a period of about twelve years following the liberation of France in 1944," Tony Judt wrote, "a generation of French intellectuals, writers, and artists was swept into the vortex of communism." They did not necessarily join the Communist Party in significant numbers, but many embraced the communist ethos as a guiding principle for positive social change. The French

left, radicalized by its involvement in the resistance, adopted a fiercely ideo-logical stance. An atmosphere of bullying began to prevail in the volatile intel-lectual environment of postwar Paris, codified and legislated by militant individuals and organizations. Stalin's tactics of intimidation and violence were appropriated; the sacrifice of an individual life for the "collective good" was seen as necessary and praiseworthy. As the leading non-Soviet apologists for Stalinism, the French left seemingly cast aside notions of right and wrong as a standard for moral behavior. According to the seductive Marxist concept, everything and anything could be justified by participation in the "inexorable movement toward human liberation." By and large, the left embraced the Soviet party line without holding it up to analytic scrutiny, forgoing a process otherwise considered de rigueur by their exacting forebears. How else can one understand their retrospective acceptance of the Moscow show trials of 1936–1938? The PCF obediently aped the Bolshevik system of classification; non-conforming behavior was branded counterrevolutionary, ergo, fascist.

"The allure of Stalin and the fear of Stalin were prevailing sentiments," Czap-ski wrote about Paris at the time. People whispered stories to one another about the abduction of political émigrés. A wait-and-see passivity took hold. "Sitting one morning in Koestler's hotel room in Paris I was speaking about Stalin. Suddenly we both noticed that a sheet of white paper had been slipped into Koestler's room under the door bearing the message: 'Be careful, you're speak-ing too loudly, there are members of the Soviet delegation in the hotel.' Koestler exploded: 'So here too, one must talk about Stalin only in whispers!'"

Sartre, the reigning prince of Parisian intellectuals, broke rank with his literary and philosophical peers Camus and Merleau-Ponty over questions of fealty to Moscow. Unlike his colleagues, Sartre condoned communist violence as a man-ifestation of "proletarian humanism," something to be admired, not scorned, a necessary means to an end. His political orthodoxy was succinctly expressed in his claim that "an anti-communist is a rat." He publicly denounced Camus for valuing the individual above the state. He deleted from the pages of *Les Temps modernes* his coeditor Merleau-Ponty's criticism of a text Sartre had endorsed. Camus distanced himself from Sartre; Merleau-Ponty resigned his post.

Formidable voices were raised in opposition to Stalin from various corners of the European left. Raymond Aron, Arthur Koestler, George Orwell, Ignazio Silone, and Manès Sperber were generally marginalized by their French peers, their arguments dismissed, their resistance to Soviet dogma viewed as treach-erous, even delusional. (No less a figure than Nietzsche was condemned by

Sartre as a "prophet of fascism.") This group would provide the core leadership of the European anti-communist left. Aron's book *The Opium of the Intellectuals*, highly critical of the fanaticism of theoretical Marxists, cemented the group's stance in relation to leftist dogmatism. Speaking of this stellar assembly of minds who held intellectual dishonesty in disdain, Czesław Miłosz claimed, "A heartrending characteristic common to all was the desire to speak or shout the truth despite the closed ears of Western opinion; there was an element of sacrifice in the very desire to bear witness."

Europe had gone through another dark age. As it withdrew from the shadows, emotional confrontations erupted everywhere. Revenge was sought against those known to have collaborated with the enemy; fingers were pointed, vendettas cried out for settling. The work of reconciliation was spasmodic, a long, slow, rocky process. While on a visit to Rome to report to General Anders, Czapski paid a call to Jacques Maritain. The agnostic-turned-Catholic philosopher in whom he had placed much faith had recently been appointed as the French ambassador to the Holy See. Maritain attempted to provide an explanation for not having responded either publicly or privately to the open letter Czapski had published the previous year.

"I would have had to be very severe about Poland, to say some very painful things. The Poles have suffered too much to remind them today of such truths."

"If there ever is a time to tell the truth, it's in a time of misfortune," I replied. "Poles today are more than ever capable of hearing. Tell me what it is you want to say, no matter how hard it may be to hear."

"I can't forgive Poland for its anti-Semitism and its attitude toward Russia, its contempt, treating the Russians as subhumans while posing as the last bastion of Christendom."

I have to admit that his reply hurt me very deeply. Maritain knew perfectly well my position on anti-Semitism. I didn't hide from him that what he said struck me as surprising. Wasn't it the Russians who invented the word *pogrom*? In her years of independence, Poland welcomed hundreds of thousands of Jews fleeing from Russia. The Germans murdered millions of Jews. But only the Poles are to be held accountable for their anti-Semitism? His reproach about Poland's disdainful attitude toward Russia was an old cliché bandied about as an argument right up to the destruction of Warsaw, accomplished by the Germans under the eyes of the Soviet army which did not so much as move a muscle, content instead to sunbathe a few miles away.

Throughout his tenure as ambassador, Maritain lobbied to have the pope make a proclamation denouncing anti-Semitism. He was not successful.

As for Mauriac, Czapski wrote:

I later visited him in Paris and touched upon his lack of response to my letter. He replied by shrugging his shoulders but, as I thought, his face betrayed a measure of embarrassment. But this was a time when de Gaulle was politicking with the Soviets, which he needed to do in his playoff with the USA and Great Britain. Silence would have to prevail over the Warsaw Uprising. Ah, these Poles, always doing something out of turn!

Grappling with these issues, Czapski was nevertheless able to keep himself from becoming overwhelmed by them. He retained a remarkable equilibrium, calling on his impressive capacity for empathy. Making his way across the Middle East with the Anders Army, Czapski had continually sought further knowledge about the various political and social groups he and the troops were encountering. Scanning the shelves in an antiquarian bookshop in Tehran, looking for information about the Shiites and Sunnis, he had come across a French volume published in 1865, *Les religions et les philosophies dans l'Asie centrale* (Religions and Philosophies of Central Asia), by Joseph Arthur de Gobineau. Throughout the war and long after, Czapski kept this book within reach; it would become dog-eared and delicate, talismanic. What spoke directly to Czapski from these pages was Gobineau's description of how Central Asians, enduring a succession of clashing dynasties, senseless massacres, and the destruction of cities, were inclined to slide into an incapacitating torpor. A pervasive mood of apathy and weariness prevailed, an indifference to life, the belief that nothing is worthy of attachment, nothing real. Gobineau's term *"atonie"* described this state of profound listlessness that Czapski considered to be a serious threat to himself and those around him. He recognized its seductive appeal—the slow descent into lethargy and impotence, keeping the world at bay after having lived through too much. It was a cautionary tale for him, though he remained disciplined, alert, and fairly indomitable; *atonie* was never a condition to which he was in danger of yielding. "It wasn't in Tehran but only in Paris where I arrived from Italy after the war in 1945," Czapski wrote, "that it became clear to me how exactly Gobineau's reflections corre-sponded to my own state of affairs." In order to define his priorities for the immediate future, he posed to himself two interconnected questions: "How

can I be a better person?" and "How can I remain true to myself?" They were questions he would repeatedly ask himself throughout his life.

A deputy representing both the exiled Polish government and army in London and Paris, he was a sane man in a maelstrom of chaos and turmoil. More than anyone else in Anders's chain of command, Czapski was capable of exerting influence on behalf of non-communist Poland in the French capital. His reach was broad and encompassing. He knew important figures of the intellectual left, and made his way easily in and around its many labyrinthine sub-groups. He had a direct link to the political center, notably through his connection to Charles de Gaulle and André Malraux. And he had unimpeded access to the conservative leadership of the political right through his acceptance in Polish aristocratic circles and among members of the upper echelons of the powerful Catholic hierarchy. Never invested in the idea of personal power, Czapski was canny enough to know how to capitalize on his image as a figure of moral integrity and of culture in order to effect political liaisons. He was seen as his own man, trustworthy and honorable.

Advocating for a Polish presence in Paris, Czapski was fulfilling a role oddly similar to the one he had performed two decades earlier on a far smaller scale among a dozen painters. And it was an old friend from those days to whom he turned for help on one of his first missions. Misia Godebska-Sert had remained in Paris throughout the war, her unimpeachable reputation lending her a glow of invincibility. At the moment when the French government was about to withdraw its recognition of the London-based Polish government-in-exile, it was essential that sensitive documents be removed from government and army offices in Paris, as they were vulnerable to break-ins by lurking Soviet operatives. Czapski and Sert worked quickly and efficiently to gather the classified files. Sert's willingness to hide the papers in her apartment on rue de Rivoli relieved Czapski of his immediate concern for their safety. The materials were eventually transferred to the newly organized base of Polish operations he would go on to create at Hôtel Lambert.

Hôtel Lambert is a luxurious seventeenth-century urban mansion designed and built by the architect Louis Le Vau along the banks of the Seine at the eastern tip of Île Saint-Louis, a singularly well-preserved example of Parisian domestic architecture and decorative painting. Purchased in 1843 by Prince Adam Czartoryski, Hôtel Lambert would come to represent the body of exiled nineteenth-century Polish liberals who gathered there after the failure of the November 1830 uprising against the Russian Empire. Through the prince's

generosity, Hôtel Lambert provided refuge for those involved in the promotion and preservation of Polish language and culture at a time when these were being aggressively suppressed by the Russian, Prussian, and Austro-Hungarian empires. The Hôtel Lambert became synonymous with the cause of Polish independence in the heart of Europe. Honoré de Balzac, Eugène Delacroix, Franz Liszt, Hector Berlioz, and George Sand were regular guests, invited by their mutual friend Frédéric Chopin, a frequent Hôtel Lambert resident who composed sparkling polonaises for the annual ball.

With its sumptuous suites of elegantly proportioned rooms, Hôtel Lambert continued to be a touchstone for Polish émigrés after more than a century of ownership by the Czartoryski family. Czapski was invited to make his home there for many months in the spring and summer of 1945 as he relocated from Rome to Paris; his old friend Count Stefan Zamoyski, a former aide-de-camp to General Sikorski, was married to Princess Elżbieta Czartoryska, whose family still maintained the gracious property. Photographs from his prolonged stay show Czapski standing outdoors on the terrace of the *jardin suspendu* in early spring, in front of masses of barely budded-out branches overlooking the Seine. Newly out of uniform, he wears a rather stylish two-toned jacket and has a hollow-eyed expression. His sister Marynia is once more at his side in other snapshots showing them posed among small groups of friends in the garden. Their faces exhibit both signs of relief at the war's end and a subdued anxiety about the uncertainty ahead.

Czapski reached out in all directions for support in the struggle for a non-communist Poland. He arranged a meeting at the home of André Gide, who, as early as 1936, had published *Return from the USSR*, a cri de coeur over the devastating impact of totalitarianism. Gide listened attentively to Czapski's appeal, then rose in search of a book. He returned carrying a volume of his diary, sections of which had been published, including the excerpt Czapski had pasted into the pages of his own journal. Standing before Czapski, Gide began to read aloud a passage about the immense suffering of Poland. As Czapski would later describe the scene, the author intoned his own lines as if they had been written by Racine. Deeply moved by his own humanity, Gide considered such a compassionate citation in the pages of his personal diary an invaluable contribution to the Polish cause. These words inscribed in his journal, he made clear, were what he was willing to offer.

Czapski was introduced to George Orwell, then stationed in Paris and writing for *The Observer* and the *Manchester Evening News*. *Animal Farm*, his

fantasia on totalitarian behavior, was still in proofs, its publication long delayed. The manuscript had been rejected by Orwell's radical socialist publisher Victor Gollancz on the grounds of its being an attack on the Soviet regime, a crucial ally in the war effort. T. S. Eliot rejected it on behalf of Faber and Faber, and after first promising to accept it, Jonathan Cape later changed his mind. (Secker and Warburg finally took the book on and saw it into print.) During conversation over lunch one day, Czapski made an offhand comment about Stalin's personal bravery, about his having remained in Moscow during the German advance (unlike the Polish commander in chief Edward Rydz-Śmigły who abandoned Warsaw shockingly early). This unexpected perspective on the Soviet despot prompted Orwell to alter a single word in his iconic text in order to reflect a more nuanced consideration of his vainglorious Stalin-like character, the pig Napoleon. Describing the barnyard animals who "flung themselves on their faces" in response to an explosion, Orwell decided he wanted "all the animals including Napoleon" to be changed to "all the animals except Napoleon."

Orwell would later receive a letter from Koestler, asking if he had read the French edition of Czapski's *Memories of Starobielsk*, hoping that through their combined efforts they could arrange to have it translated into English and published in Britain and America. "Dear Arthur," Orwell wrote in reply, "It's funny you should send me Czapsky's [*sic*] pamphlet, which I have been trying for some time to get someone to translate and publish. There is no doubt that he is not only authentic but a rather exceptional person." As for his own copy of *Souvenirs de Starobielsk*, Orwell declared "it's a rather treasured item of my collection." An abridged version of *Memories of Starobielsk* was translated from the French edition and printed in New York as early as November 1944 by an organization called the National Committee of Americans of Polish Descent. Czapski's abbreviated text appeared as an appendix to a pamphlet called "Death at Katyn," a rather controversial document for the time. About the author of *Memories of Starobielsk*, the pamphlet offered only this: "We do not make public here the identity of the officer. It is however known in Washington, to the War Department and the Department of State.")

Czapski threw himself into the realm of public affairs. He became a critical fixture in a tight émigré circle in Paris that shared a distaste for all self-conscious displays of nationalism, especially the kind of Polish nationalism that tended to gloss over the dark side of the country's past. The orientation of this circle

of Poles was highly inclusive, embracing their country's ancient minorities and religious factions and supporting the idea of independence for Poland's neighbors Belorussia, Lithuania, and Ukraine. Never anti-Russian, they were only anti-communist. Given Poland's ambiguous future, their commitment to a vision of what we would today call multiculturalism was far ahead of its time, standing in clear opposition to a pervasive "patriotic" sensibility that espoused a far more restrictive idea of what it meant to be Polish.

These like-minded spirits were either old friends or had discovered one another in the ranks of the Anders Army while in the Middle East. From the time Jerzy Giedroyc first transferred into Czapski's press bureau from the Carpathian Rifle Brigade, the two men began a conversation that continued all the way to Rome and far into the future. Czapski would claim it was never really a dialogue, as Giedroyc usually did most of the talking. Giedroyc had begun his prewar career as a secretary to various influential ministers, then gone on to edit a series of small, smart journals that were quickly noticed. One weekly magazine called *Polityka* became successful, and as its editor, he came into contact with many of the brightest and most vocal young writers and thinkers of the interwar period in Warsaw. He knew himself to be cut from a different cloth than the writers, though, and wished only to ensure that they would have a forum to showcase their work. From the beginning at *Polityka*, the qualities he would become known for as an editor were apparent: open-mindedness, loyalty, clarity of thought and vision, decisiveness. He had a fierce and focused political temperament, and like Czapski's, one devoid of personal ambition. Giedroyc was that rare political animal who possessed none of the necessary qualities of a politician. He found communication on a one-to-one basis exceedingly difficult, yet he was sufficiently confident and aware of his strengths to commit his entire professional life to championing the work of other writers. His would be a singular and brilliant career.

Czapski named Giedroyc as overseer of the military books and periodicals section of his news and culture unit. While in Iraq, their circle expanded to include Juliusz Mieroszewski, Gustaw Herling, and a married couple, Zofia and Zygmunt Hertz. Once the group arrived in Rome in 1945, in the aftermath of the battles of Monte Cassino and Ancona, they decided the time had come to transform their conversations about the future into deeds. As the war machine began to wind down, Giedroyc was sufficiently persuasive to convince the army high command of the need for a Polish-language publishing venture. The Polish Literary Institute, the Instytut Literacki, came into being.

Giedroyc foresaw that when the fighting in Europe finally ended, Poles would receive no substantial help from the West. He intuitively sensed that great numbers of Poles were once again going to become political exiles. They would need a tangible presence to keep their opposition to Soviet domination alive and to remain continually visible to other Europeans, as their forebears had done in the nineteenth century. Giedroyc always insisted on keeping one ear attuned to the muffled voices from Poland, voices that no longer enjoyed freedom of speech. He liked to quote Marshal Piłsudski: "You can't break down a wall banging your head on it, but in the absence of other means, why not try?"

The Polish Literary Institute was officially sanctioned in Rome, General Anders appointing Giedroyc as its director. A Soldier's Fund had been created by military authorities of the Polish Second Corps to help its men enter civilian life abroad, and a small loan from this fund enabled Zygmunt Hertz to salvage a huge printing press the British army in Rome had just slated for destruction. The Polish Literary Institute, registered under Italian jurisdiction as a publishing house named Casa Editrice Lettere, put out twenty-six books in its first year of operations. Alongside the new titles, the fledgling publishing venture also issued a reprint of Adam Mickiewicz's 1832 messianic volume *The Books of the Polish Nation and of the Polish Pilgrims*, with a new introduction by Herling. The small print run of the book sold out quickly. The editors were pleasantly surprised by the troops' hunger for reading material. Mickiewicz's concept of "a pilgrimage toward freedom" came to serve as the foundation for Giedroyc's preparations for the long term of exile ahead.

General Anders placed his hopes on military action to bring about a reversal of the dictates of Yalta. The members of the Literary Institute believed a political about-face was highly unlikely. They invested no faith in the redemptive powers of the West. Out of this conflict of expectations, the institute's independent strength and clarity of vision arose. When, in June 1946, the great postwar London Victory Celebration committee failed to invite Polish forces who fought under the British high command to march in a massive military parade to be led through the city led by the Supreme Allied Commanders, it reaffirmed the institute's position. Forces from Belgium, Greece, Czechoslovakia, France, the Netherlands, the United States, and even Brazil were invited to participate, but to avoid the risk of alienating Uncle Joe, Poland was not. Churchill and senior members of the RAF protested and considerable public

criticism was voiced. A conciliatory gesture was made, but it was too little, too complicated, too late. Polish forces were unrepresented.

The institute's most significant undertaking was the creation and nurturing of *Kultura*, one of the most influential intellectual journals of the twentieth century. With a run of six hundred thirty-seven issues over a span of fifty-three years, *Kultura* begins and ends with Jerzy Giedroyc. Given the overtly political nature of so much of *Kultura*'s contents, wouldn't a name like *Polityka* have been a more appropriate title for the journal? But in the weeks and months following the armistice, as plans for the journal emerged, a title like *Polityka* would have been too overt, too provocative. Czapski would insist that "every attentive reader of *Kultura* was aware from the beginning that what we wanted to be was a review of politics. How much easier our position would have been if we had adopted an exclusively literary and cultural agenda, as we were so often advised to do." In time, *Kultura* would become synonymous with Poland itself, as once again an exile community was enlisted to act in loco parentis for Polish institutions denied the right to exist by an oppressive occupying power.

With a striking mustard-colored cover, *Kultura*'s debut issue appeared in Rome in June 1947 under the joint editorship of Giedroyc and Herling. Richly varied in subject matter, it presented an international roster of writers; Paul Valéry, Federico García Lorca, and Arthur Koestler were all represented. An essay by Czapski about Pierre Bonnard, who had just died, was included. From his very first article in a journal with which he would be involved for decades to come, Czapski's tone rang true, full of verve, anxious to offer opinions and declare passions. His essay speaks to the reader in a voice not unlike the one he uses in his private journal—intimate, serious, critical, always laced with doubt—but another voice, more knowing and confident, also sounds. Czapski's texts encourage the illusion that his commentary is spontaneously combusting in his mind. He liked to say that, for him, writing was like breathing. Nevertheless, a good deal of hard work went into the shaping of prose to make it flow, to appear effortless. He has a way of repeating key words for emphasis, of extending phrases rather than dividing thoughts into separate sentences, of pushing the limits of grammatical construction. All this serves to invoke a quality of serendipity, of thoughts conveyed just as they form, in order to make the reader feel he or she is actually accompanying Czapski as he discovers what it is he wants to say. The essays are soliloquies on a subject, written in a

colloquial voice, expressing a personal bias or taking a stand. He may have learned a great deal about writing from reading Proust, but he never succumbed to the novelist's prolix style.

The act of writing an essay on Bonnard put Czapski back in his painting studio, if only in his mind. The unmistakable whiff of paint fumes and turpentine leaps off the printed page. It had been years since he was engaged in the day-to-day life of painting and his longing for brushes and colors and canvas remained intense. The loss of tactile pleasure in handling paint was a blow he bore as well as he could, and writing about paintings and the act of painting was part of his process of bearing up. Czapski spoke about Bonnard from the position of a disciple paying his respects.

> The first impression is one of ravishment before the combination of colors, only later does reflection come. This touch of blue, is it a dress? Or a mountain? That form behind the red-and-white checked napkin, is it a woman's hand, or a cat? It takes quite a while before everything in the picture becomes clear, vigilant, wise, as far as color and form are concerned. "Give me some mud and I'll make a Venus out of it," Delacroix exclaimed. What dark browns, what tones of yellow, violet, and red Bonnard used to make his Venus of the bath! For Bonnard, color was as coherent and infallible as mathematics. He overturned the established range of colors knowingly, losing all sense of subject matter, to discover again and again new combinations. No other painter in the world created such a range of violets.

Rapture is not all Czapski has to offer. He contextualizes Bonnard for his readers, making a case for the French painter's significant impact on contemporary Polish painting, citing his long association with Pankiewicz. Unsentimental, Czapski makes short work of his former professor's accomplishments in respect to the master:

> Bonnard and Pankiewicz met in 1908. The two painters became friends; in 1909 they rented a villa together in Saint-Tropez, not far from Signac's house. They worked there side by side all summer. From then until war erupted in 1914, they were frequently together, either along the Mediterranean coast or in Normandy. Despite all my respect for Pankiewicz, I don't mean in any way to put forth his name as comparable to Bonnard. But I also don't find any other

contemporary painter Bonnard's equal, except perhaps for Matisse and per-
haps—despite everything—Picasso.

Czapski had little interest in the work Pankiewicz produced after World
War I, when he renounced modernism. Bonnard was pushing ahead into
uncharted territory, heightening the abstract elements of his pictures and
turning up the volume with more and more surprising juxtapositions of color.
He created "a higher mathematics of color," furthering "the consciousness of
the counterpoint of color." Drawing a comparison between Bonnard and the
cubists, Czapski wrote, "Bonnard impoverished neither form nor color, he
enriched them, creating a difficult synthesis of what he inherited from impres-
sionism and from abstract painting." This "difficult synthesis" was precisely
Bonnard's influence on Czapski's body of work, combining a reverence for
nature, a primacy of color, and a refusal to let local color hold sway.

In admiration of Bonnard's boldness and ambivalence about "subject mat-
ter," Czapski quotes a comment the French painter repeatedly made: "Abstract
painting will save painting." Bonnard was the rare painter whose engagement
with abstraction Czapski could endorse wholeheartedly. We may not at first
know if we are looking at "a woman's hand, or a cat," but whatever luminous
palette Bonnard chooses to indulge in, we come to recognize a form taken
directly from life, from nature—the figure of his model, the orchards and fields
seen through a window, the sea, domestic animals, a kitchen or dining table
laden with bowls of fruit and flowers, himself in his bathroom mirror. Czapski's
use of the word "abstract" is always worth noting, producing as it does complex,
predominantly conflicted feelings in him, feelings often inflamed by his aware-
ness of abstract elements in paintings he admires. When abstraction implies
nonrepresentation, he is generally not interested. In another essay he quotes
Picasso saying "there is no such thing as abstract art, one has always to begin
with something."

A very small Bonnard nude, not much more than a sketch, was always near to
Pankiewicz until his death in his Parisian atelier. The flesh was painted in tones
of lemon and Naples yellow, with delicate gray shadows and touches of green
in the background. The flecks of color, which have nothing to do with local
color, give the viewer what was essential in Bonnard: an unexpected harmony
of colors, revelatory and always his own.

Czapski immerses himself in the ephemeral beauty of Bonnard's oeuvre. His relief is palpably felt in lines such as these. And yet a mournful undercurrent tugs at his ecstatic eulogy, an expression of grief unrelated to the death of Bonnard and his buoyant joie de vivre. The essay on Bonnard, titled "Le paradis perdu," mourns not only the passing of a great painter but also the loss of the world in which Czapski had been free to become himself. Between the world wars, Bonnard created most of his luminous body of work. These were also the exciting years of Poland's Second Republic, when artists like Czapski were finally free to pursue their own visions. The poet Jan Lechoń expressed his gratitude for such freedom, weary of the responsibility of writing patriotic lines, exclaiming, "in the spring let me see spring, not Poland." There *had* been a period of freedom, when spring was simply spring.

The Second Republic was no more. Witold Gombrowicz, a passionate, self-involved writer for whom Czapski held a begrudging admiration, detailed the forces at play for Polish artists at this time:

The new "proletarian" Poland has confined Poles once again to a narrow and primitive style, to a paralyzing mythic formulation. On one side, the Pole living in Poland is reduced to dimensions prescribed by the prevailing doctrine; on the other, the Pole living in exile remains chained to his old ideas of nationality, which subjugate and limit him to the point at which there is no question of a free development of his energies and of his culture. Is it surprising then, that after such experiences, I look around me in search of a radical change and new means for confronting my existence? To effect, if possible, a certain liberty of movement! To effect a possibility for creation! To assume a position in which one can get underway! To overcome the paralysis of our existence! And not to submit to Poland, this Poland whose burden we bear!

Czapski was constitutionally incapable of not shouldering the burden. He continued to submit. So a brightly colored nude by Bonnard represented a paradise lost on many levels. "In the time of a free Poland we fought for painting's independence, not thinking of the imminence of new defeats and ruins, of deportations. Faraway problems—totalitarianism, dictatorship—hardly penetrated our universe. We have all paid for this detachment with a brutal awakening. None of us has been spared, we have emerged naked from a burned world."

A new postwar generation of artists was making its way. He would encounter

groups of them in Paris and London, fellow émigrés searching for stability and the freedom to work. Poland in extremis was not their preferred subject. "Le paradis perdu" was not simply a Miltonian garland laid on the grave of Bonnard but a reference to an era senselessly destroyed, irredeemably lost.

Around the same time the first issue of *Kultura* appeared, a short story called "Major Hubert in the Anders Army" was published. Written by Adolf Rudnicki, a fighter in the Warsaw Uprising and a friend of Czapski's from before the war, it tells the story of a noble officer who, despite his intelligence and open-mindedness, stubbornly refuses to see how he is being manipulated by the enemy. Its protagonist was clearly based on Czapski. No one who knew the two men could be in doubt about the real identity of the story's principal character. "Major Hubert" was Rudnicki's attempt to lash out at what he perceived as Czapski's entirely wrongheaded assessment of the massacre in the Katyn forest in 1940. He believed his old friend had been misled and was going about fomenting political unrest by accusing the Soviets of murder. From Rudnicki's point of view, it was obvious that Goebbels had conducted a lavish propaganda campaign around the Katyn killings to divert attention from Nazi guilt, and that Czapski had fallen for it. His story was conceived as a rebuke and a corrective.

Czapski recognized that Rudnicki had been impelled to write "Major Hubert" from a position of psychic pain. The two men had been quite close friends at one time. On many occasions, Rudnicki had modeled for figure studies and sat for portraits in Czapski's Warsaw studio. In "Major Hubert," Rudnicki reversed these roles, portraying his painter friend in turn, but, according to Czapski, the result proved to be "a false portrait." Wounded by the publication of such a public dressing-down, Czapski did not respond, secure in his own knowledge of the events, but he was saddened that his friend had so hostilely projected onto him his own set of illusions. Instead, he held on to the memory of a remarkably generous gesture Rudnicki had once made. Hearing that Czapski had become a prisoner of war soon after Poland was invaded in 1939, Rudnicki impulsively wrapped and sent to him a precious gift, a two-volume edition of the letters of the poet Cyprian Norwid. The books materialized almost miraculously at Starobielsk at one of the rare moments when prisoners were able to receive packages. Czapski treasured the thought and gesture as well as the books.

For a long time he avoided Rudnicki, but eventually the two men would

be reconciled. (Rudnicki, recognizing his mistaken position, never reprinted the story in subsequent collections.) The emotional upset stemming from the publication of "Major Hubert" colored Czapski's first letter to Ludwik Hering after the war. Memories of their happy years together comforted him and sustained him emotionally when little else could. He knew he need not justify himself, but his frustration was such that he did feel the need to have his position fully understood.

"Hubert" makes my writing to you difficult. It's quite silly to say a portrait is not a good likeness, but I am not this bankrupt person. Because I don't feel guilty that people told me things that other people are afraid to say; I don't feel guilty because I won't forget about those who were murdered, and I don't feel guilty because I won't think that Old Poland was a heap of rubbish. If we speak about rubbish, I think there's more today than there was before; I don't feel guilty that since 1945 I've been working very hard, which I sometimes curse, but I also love. I don't feel guilty that I can't live only for painting while we're at the edge of an abyss.

I don't feel myself important because I risked danger while looking for my friends in Russia, while chatting with Ehrenburg, Tolstoy, Gorky's wife, with great Red Army generals, and believe me, with thousands of other people. I don't feel important because while sitting for a year in Iraq I organized education programs, the press, and ran various theaters, when one hundred thousand people were thrown into the fire of the desert, when men's hands were scalded touching the sand. I was always fighting for the same thing, for the fate of the Jews in the army, or the fate of the Ukrainians. I don't feel important because I served those people with love and with passion. I don't feel important because I already have a big file of articles about Norwid, about painting and about life, which could prove to be a good book. I don't feel important because I painted portraits of young men like Jacek, young men I had to save from various military troubles. I don't feel important because I published essays by Herling, who wrote them on his backpack at the front, and a book of anti-totalitarian and liberal articles against xenophobia written by Bocheński. I will never forget my close and cordial contact with Jews in Palestine, where, after all, we were able to create this army, and I kept cordial relations with them despite the fact that three-quarters of the Jewish soldiers deserted, and because of me, relations within the army with these Jews remained good.

I have hundreds of drawings, many of which I've lost along the way, or given

away, I also have hundreds of notes.... It's possible that I won't ever return to painting or writing, but I think I would really know how to do those things now. I'm not doing it not because I don't want to, but because there is around me a steady stream of voices crying out, from people in pain, separated from their native land, looking for some kind of engagement, whom, thanks to my work, I can help. So I'm standing at the crossroads of the most painful Polish issues. I feel more Polish than I have ever felt before, fully conscious of our black sins, our crimes and pettiness, but also full of the sense of the unbelievable beauty that you can also find in being Polish. While writing I don't want to appear in any way false, I just want to let you know. I beg you, keep your strength and be patient. Let us believe that we will meet. Do not betray what in your life and mine was the most important and personal living connection. Don't believe the lies, lies converted to new religions, and don't believe that the world is divided just into black and white.

Czapski knew deep loneliness. Hering was far away. ("Do I need to write that I think of you, that our feelings for each other haven't changed, that I am almost unchanged, only much older?") But he was also a highly social animal, grateful for the company and comfort of others. Marynia was near, always a reassuring presence, as was the son of his eldest sister, Poldzia, his nephew Jerzy Łubieński, the brother of Ludwik Łubieński. Family ties provided support and brought him much pleasure.

12

WITH THE DEMOBILIZATION of the Polish Second Corps, the future of the Literary Institute came into question. As a base from which to connect with Poland, Rome was not ideal. The heart of Polish émigré life was largely divided between London and Paris. Jerzy Giedroyc's decision to transfer operations to Paris meant the loss of Gustaw Herling, who preferred London, but everyone else accepted a move to Paris willingly. Czapski made arrangements for the publisher's office to be temporarily based at Hôtel Lambert. Selling off its printing press in Rome, and its large and valuable reserve of gasoline, the institute secured the financial foothold needed to make the move to Paris.

Almost immediately, antagonisms erupted. The newspaper *L'Humanité*, a mouthpiece of the PCF, spread the alarm about suspicious activity at Hôtel Lambert. Getting wind of an "enemy base" being established "in the very heart of Paris," the Stalinist paper ran a series of vituperative articles identifying Czapski and his men as "bandits" preparing for a "fascist putsch." It was suggested that illegal deliveries of arms were being unloaded under cover of night on Île Saint-Louis. A large photograph was printed in the paper with a bold X marking the spot of Czapski's office window, signifying the center of covert actions under the command of General Anders, that notorious puppet of the "fascist" Polish government-in-exile. "The existence of this Major Czapski has never before been revealed until now," *L'Humanité* proclaimed. "We understand the reason for this silence. This clandestine organization controls all the work and all the men of Anders's Army in France. Its presence in the center of Paris can no longer be tolerated." Czapski's position as an outspoken critic of Soviet policy rendered him persona non grata in many circles of French intellectual life. Thus began a period of exile within exile. Though Major Czapski may have been an interloper unknown to the PCF, their endeavor to expose and demonize him as a dangerous outsider only proved their lack of awareness of his standing as a consummate insider with long-standing connections to the highest circles of Paris life.

In 1945, upon my arrival from Italy, I went to see Malraux. We were meeting again for the first time after a long interruption. From first setting eyes on him, I sensed a feeling that I can't define other than by using the term *fraternité*. He hadn't really known me well previously, but at this moment, he knew something beyond me. Poland really existed in his imagination, he was not one to use the old cliché of "praiseworthy, unhappy Poland" or the other, imported by the communists, "fascist Poland." You could say he had latched on to the nerve and the hidden sense of our history and recent tragedy. At this point in time he told me, regarding *Kultura*, "If you ever have need of me, give me a sign, I'll do all I can." We never abused his offer, but every time we turned to him, he did his best to help us.

The minister for information at the time under General de Gaulle, André Malraux parried the PCF attacks on Czapski with aplomb, dismissing them far and wide as simple Stalinist propaganda. De Gaulle, feeling genuine sympathy for the Polish cause, admired the Poles and recognized the struggles they were being forced to endure. His informed position carried great weight, much to the dismay of England and the United States. The undisputed head of the French Resistance, de Gaulle had been leader of his own government-in-exile, the first major figure in all of France to reject Nazi rule. He had undergone a trial similar to the one the Poles were currently enduring. His open support for the goals of the Polish Literary Institute was an invaluable endorsement. He deputized Malraux to write to the editorial board of *Kultura* on his behalf.

Dear Friends,

Our own experience of foreign occupation, which remains in our memory, inspires in us feelings of fraternity and moves us to readily identify *Kultura* as the journal of an occupied country.

You are right in saying that the battle you have undertaken as a group of people is a solitary one, as solitary as any one individual who says NO to a victorious tyranny; this relative solitude represents the price that your justified pride pays for your moral, political, and material independence.

Without any doubt, it is time for the West to understand that you and they are indelibly linked, for all resistance is a matter of perseverance, and readiness for war demands strength of spirit.

As the titular head of the Provisional Government of the French Republic, de Gaulle sanctioned and monitored the institute's activities, offering assurances that it could publish whatever material it saw fit. He admired Czapski and identified him as someone who was allowed personal access to him at any hour. Thanks to Czapski's gift for effecting bonds of personal trust with people in power, Giedroyc was provided with complete freedom to edit and manage *Kultura* as the review he envisioned.

In October 1947 Czapski packed up his office at Hôtel Lambert and moved the institute's base of operations to the village of Maisons-Laffitte, just beyond the Paris city limits. Their new headquarters was a nineteenth-century building that had been ransacked by the Germans during the war and left virtually in ruins. Structurally and cosmetically, 1 avenue Corneille was in grim condition, but with the arrival of the group from Rome, everyone pitched in and made the best of it. Settling into a communal environment, the team lived, worked, and took meals together. Czesław Miłosz, who would come to know it well, described the scene:

> That first *Kultura* house, a rented *pavillon*, immensely ugly and inconvenient, on the avenue Corneille; the cold of winter in the outskirts of Paris, with scant heat from the potbellied *chaudières*, loaded with coal; and that district of chestnut-tree-lined avenues that went on for kilometers, piles of dry leaves....
>
> Those who have held in their hands the *Kultura* annuals and the books published by the Literary Institute, and those who will hold them in their hands in the future, ought to think for a moment about the kitchen pots, the preparation of breakfast, dinner, and supper by those same three or four individuals who were also responsible for editing, proofreading, and distribution, for washing up, for doing the shopping, fortunately an easy task in France, and should multiply these and similar domestic tasks by the number of days, months, and years. And also think about string, about wrapping paper, about dragging, carrying, handing over the parcels at the post office.

"We were all old soldiers," Czapski explained about himself, Giedroyc, and the Hertzes. The terms of engagement were extremely familiar and seemed to suit them well enough. The new home of *Kultura*—part monastery, part kibbutz, as Giedroyc liked to say—was sandwiched between the banks of the Seine and the forest of Saint-Germain-en-Laye (two significant entities in the history of French painting). The slight geographic remove from the capital

served Giedroyc's purposes. Never comfortable as a social being, he had no interest in the arena of Parisian high life and held little patience for the trappings of material comfort *à la française*. A creature of habit and a bit of a loner, he happily worked long hours in a surround of colleagues who were devoted to him and who efficiently and dispassionately met all his needs.

Once the house became habitable, Czapski acquired a red motor scooter. A very large man on a very small bike, he dashed back and forth into the center of Paris, visiting galleries and museums, attending meetings, haunting bookshops, gathering with friends and visitors in bistros and cafés. As soon as the *Kultura* staff was settled in at Maisons-Laffitte, he sent for Marynia, who was working at the Sorbonne. She moved in and joined the household. Brother and sister would not be separated from each other again.

His feelings for Ludwik Hering, coupled with his hunger for a sexual life, remained intense, sometimes gratifying, often frustrating. "If only you knew," he wrote to Hering, "in these eight years I've felt you physically close to me. How often I can see, feel Józefów.... This memory has put me on fire at so many latitudes, how I can see your every movement!... I am sending you kisses, Ludwik, but I don't know how. I don't know how to express my love for you."

From Hering came a similar confession. "I haven't been free of erotic matters," he began. "Everything else happens to me more often than kisses. When it happens, when it comes to mean something for me, my heart leaps up to my throat and I long so dreadfully for what happened back then. Of course it's stupid to look to you for consolation. I'm unable to find anything that might console you. Or myself. In my helplessness, as I think about the passage of time, about our ages, about our time, that other desire stabs me...."

The absence of persistent erotic temptation allowed them to cherish the memory of each other, to find a kind of redemption in their hearts, in their minds, and in the pages of a massive correspondence. Hundreds of letters were written back and forth over the years, Czapski regularly supplementing his words with drawings of all kinds, instinctively sharing with Hering whatever occupied his visual field of reference. Most of the letters are slightly distorted by the use of a veiled code, proper names and events changed to hide the content from censors who, after 1945, read all mail coming into and going out of Poland. In the first postwar letter from Poland to reach Czapski, Hering wrote to thank him for the tea and cigarettes he received at a time when people

around him were starving and desperate for food. In Warsaw, Hering recounted, he frequently ran into Czapski's old friend Jan Cybis, who

> told me in his deep voice how well he remembered you looking like the pharaoh Ramses, so suddenly I can't help seeing you as Ramses. I can almost imagine you as a living person now, but for a long time I was obsessed by an image Jerzy Łubieński put in my head. He had been reminded of a time during the war when he saw you. You were freezing, he said, waiting in a long queue to get water, holding some kind of jug in your hand, standing there in place of another soldier who was too ill.
>
> I was also obsessed with your face in the window of the train on the morning we parted. I was afraid of what would become of this face, afraid it would be the last time I saw it, afraid you would die with that face. But I'm no longer afraid. My beloved, it's a great happiness to know I am in your dreams, in your imagination. And so now I will also incorporate the future into my dreams....

Hering became Czapski's displaced better half, his most trusted and intimate other.

In the aftermath of the war, during the early years of the Literary Institute's tenure in Paris, Czapski fell headlong under a spell cast by the writings of Simone Weil, whose unpublished body of work was being edited and released posthumously. Weil had died in August 1943 at the age of thirty-four, a self-abnegating, quixotic figure, a graduate of the École Normale Supérieure whose death could be attributed in part to her refusal to eat at a time when so many were starving. (At the age of six, during the First World War, she refused to have any sugar because soldiers at the front had none.) Weil was a fearless thinker for whom independence of mind always came first. Her energies were directed toward helping the poor and the oppressed; she experienced a nearly pathological sensitivity for the suffering of others and found, in her own suffering, a source of absolution. Around the time of her seventeenth birthday she wrote an essay about a valiant gesture Alexander the Great had once made, pouring his store of water out onto the desert sand to show compassion for his thirsty army and the hardships they had to endure. "Sacrifice is the acceptance of pain ... and the will to redeem suffering men through voluntary suffering. Every saint has poured out the water; every saint has rejected all well-being that would separate him from the suffering of men." Her contention

was that Alexander's unpremeditated act was not useful to anyone but potentially useful to everyone, a theme she repeatedly expanded on as a defining concept for the rest of her short life. When she was twenty-four, Weil had a face-to-face encounter with the Marxist revolutionary Leon Trotsky, whom she reproached bitterly for the Soviet state's maintaining a ruthless stranglehold on the hobbled people of Russia. Feeling solidarity with the aims of communist theory, she recognized the party's deep intolerance of any kind of dissent. She would never join the Communist Party, just as she would never consent to be baptized or join the Catholic Church on the basis of *its* intolerance of dissent. Weil worked as a lycée teacher, devoting herself to her young students, helping them to overcome their self-centeredness, attempting to turn their energies toward the arena of public life. Her own radical engagement—supporting the rights of workers, addressing unemployment, participating in demonstrations against municipal authorities—proved threatening to her superiors and resulted in her having to change teaching jobs frequently. Above and beyond the demands of her course load as a teacher, Weil offered classes at workmen's education centers and wrote dozens of articles for militant left-wing papers. Her concentrated efforts toward broadening the education of working adults resulted in her being dubbed "the Jewess Mme Weil, militant of Moscow," "the Red virgin of the tribe of Levi" by a patronizing, anti-Semitic mainstream press.

Raised in a loving Jewish family, Weil held the Old Testament (which she read in Greek) in contempt, but with a comparable single-mindedness she also refused to be seduced by the appeal of the New Testament and the blandishments of her Catholic friends. Though her intention was to achieve a state of selflessness, her process of self-effacement often alienated her peers and not infrequently served to compromise the very people she was determined to help. In a meaningful but often counterproductive way, she thought to alleviate other people's pain by absorbing it herself. For Weil, the supreme symbol of Christianity was not resurrection but crucifixion.

In 1936, Weil went to Spain to join the fight against fascism and Franco. On her return to Paris, she was despondent, scarred by the horrors perpetrated on both sides of that civil war. Like Czapski and his embrace of Tolstoy after a first brush with military reality, Weil adopted a staunch pacifist position during the years France was deeply divided about war with Germany. Once the true impact of Hitler's racial laws was revealed, she abandoned this anti-war agenda. She berated herself, characteristically, appalled at her own naivety.

Severe in all her judgments, she was always most harshly contemptuous of herself.

Among European intellectuals, Weil's life and work triggered responses divided nearly equally between veneration and vilification. Czapski was acutely sensitive to the contradictions inherent in this young woman's relentless search for meaning. Recognizing the extremes in her behavior, Czapski understood how her brilliant logic could occasionally be derailed by her intense passions. He recoiled at her inflexible absolutism but managed to maintain faith in her larger, radiant visions, focusing on her humility, her enormous depth of feeling for the struggles of the downtrodden, her striving toward God. Of more interest to Czapski than her politics, the questions Weil framed about faith and justice, about truth and beauty, were of paramount importance. Czapski's reading of Weil's notebooks and letters as they were first published was one of the great encounters of his intellectual and spiritual life.

> SW tries to show something else, something different. And I, like a sinking man, would like to hold on to this, to not drown. "Every Christian knows that each small thought of love is greater than any act." Do I really believe in it? . . . why is this single sentence of SW so important for me? Because it saves me from the breakdown of myself and gives me hope. Not only that, it gives me consciousness, from where I can look for help.

Weil identified specific contingencies that she set as preconditions for engaging with the divine. Paying attention was necessary, attention being a state of mind to be cultivated and mastered in order to make oneself available for the possibility of grace, for the presence of God. "Absolutely unmixed attention is prayer," she insisted. Attention required an active condition of waiting, of expectation. At the very moment we achieve emptiness, the presence of the divine floods into us. We are simultaneously drained and filled.

Weil was distrustful of the imagination, holding it in disdain, seeing it as antithetical to attention. "The imagination is continually at work filling up all the fissures through which grace might pass." She felt that the imagination's fostering of personal identity threatened to obstruct the threshold to God. To be attentive to reality in all of its mystery, she claimed, we must be far from our own individual desires and anxieties. "We only attain to real prayer after we have worn down our will." This did not sit well with Czapski, for whom imagination and will were both necessary. Will, he believed, had saved him,

kept him from descending into *atonie*. Czapski knew that Weil, too, had been driven by will and that these dictates were cautionary checks on herself as much as on her readers.

Weil believed that our longing for the beauty of the natural world must be inspired by God, and art must therefore be a true reflection of that aspect of the world. In this way she, like John Ruskin, equated aesthetics with morality. This insistence on parameters of limitation was another red flag for Czapski, who rejected Weil's line of thinking for the way it straitjacketed art. In his lectures on Proust, Czapski pointed out that not a single reference is made to God in a novel of several thousand pages. Proust created and occupied a profoundly moving spiritual realm on its own terms without reliance upon a divine being. Art was the divinity Proust worshipped, art was sufficient unto itself. Czapski worshipped at the same altar.

Weil believed the perfection of an individual spiritual life was predicated upon a consent to be *nothing*. The role of imagination, by contrast, is to generate *something*. "The imagination, filler up of the void, is essentially a liar." She described the imagination as a *combleuse du vide*, a usurper of the emptiness, through which God might otherwise approach us. "There is the real presence of God in everything which imagination does not veil." Czapski, for whom imagination was the very breath of life, struggled with Weil's vehemence. How could he possibly accept any thought of discarding imagination or, by extension, abandoning art? All the same, he was able to find in Weil's emphasis on attention the very condition he sought when drawing, the prayer-like activity he engaged in on a daily basis with a degree of faith equal to any other he held dear. Imagination, made manifest in drawing, had helped him to survive.

He found Weil's deliberate asceticism a problem, aggravating him at a time when he was not painting but only still dreaming of his return to it. Could art really be vanity, a delusion, an obstacle to God's grace? Certainly Weil's great mentor, Blaise Pascal, thought so, and she conscientiously followed his footsteps on the path to knowledge and faith. She had undergone a profoundly unsettling religious conversion not unlike Pascal's. Weil found in Pascal "that transcendent realm to which only the truly great minds have access, and wherein truth abides." She looked to Pascal as a role model, as a teacher from whom she could learn, with whom she could argue, in full awareness of her insignificance in relation to his genius. Czapski would come to look to Weil in much the same way.

He saw that Pascal's retreat from the world and his contempt for the senses

were not entirely incompatible with the concerns of Proust, among the most worldly and epicurean of writers:

> It's not in the name of God, nor in the name of religion, that the protagonist of *À la recherche* rejects everything, yet he, too, like Pascal, is struck by a shattering revelation: he also buries himself, half-alive, in his cork-lined room (here I willingly blur the distinction between the hero and Proust himself since in this case they are one) to serve until death what became for him an absolute, his artistic work. The last book of his novel, *Le Temps retrouvé*, is likewise mixed with "tears of joy," is the triumphant hymn of a man who has sold all his worldly possessions to buy a single precious pearl, who has measured all the ephemera, all the heartbreak, all the vanity of the joys of the world, of youth, of fame, of eroticism, and holds them up in comparison with the joy of the artist, this being who, in constructing each sentence, making and then remaking each page, is in search of an absolute he can never entirely attain, and which, besides, is ultimately unattainable.

Forming an alliance between the distinct but overlapping universes of Pascal and Proust, Czapski shaped himself intellectually, and in this mind-set his rapprochement with Weil was finally forged. "The supreme function of reason," Pascal suggested in *Pensées*, "is to show man that some things are beyond reason." In this territory "beyond reason" lay the dominion where Pascal, Weil, Proust, and Czapski found common ground. Czapski's demands upon himself, often repeated—"How can I be better?" and "How can I remain true to myself?"—intersect at this juncture where his thoughts met Weil's. Her words unsettled and agitated him, but he held his ground. Her presence in his spiritual life, often adversarial, was enormously welcome, fortifying, and affirming.

Since his release from the camp at Gryazovets in September 1941, Czapski had been filling pages of his diaries with notes about his wartime detention and his travels around the Soviet Union, carefully erecting an extensive scaffold of historical events, drawing up rosters of individuals and experiences. Sustained for years, these notes gradually evolved into a larger narrative form. The title of his second memoir, *Na nieludzkiej ziemi* (*Inhuman Land*), was drawn from a poem by Stanisław Baliński: "For those who now lie suffering on wooden planks / With eyes wide open in an inhuman land." He wrote to Hering:

Painting is inside me almost nonstop, perhaps I'm deluding myself that I may be able to return to it very quickly, to paint again. But I hunger for something else, too, I have another need, and I will not start to paint again until I satisfy this need. I must write. I do not wish to die before I write this thing. . . . I wake up "condemned." Everything that is written after such a long break is untrue, it seems to me that I am bleeding, that I am disgusting. I think every day, almost constantly, it is in my thoughts and I think of it sometimes with relief, as liberation. I am unable to pass over in silence what I have seen.

Czapski channeled his creative energies into writing his book. Narrating in a dispassionate voice, without recourse to outrage, he let the cruel facts speak for themselves. He underscores the experience of devastation by remaining objective, as acts of brutality, one after another, simply described, become almost unbearable to encounter on the page. Only on rare occasions, when the painter in him meets the writer, does Czapski yield to a lyrical turn and allow himself to compose a shocking tableau. Miłosz commented on the curbs imposed on a writer in the face of barbarism: "It is not my intention to write a commentary for Goya's drawings. The immensity of events calls for restraint, even dryness, and this is only fitting where words do not suffice."

In the months following the institute's move from Hôtel Lambert to Maisons-Laffitte, Czapski put the finishing touches on his manuscript. *Inhuman Land* is a more calculated memoir than *Memories of Starobielsk*, stemming from the moral obligation he felt toward those who had not survived, those unable to speak for themselves. ("Damn you if you don't talk about us," he overheard someone cry out as he left one of the camps.) In the years after the war ended, the category of "those unable to speak" was no longer limited to the dead or those left behind. As Poland was materially and ideologically engulfed by the Soviet Union, the words "inhuman land" took on a broader resonance and a more complex meaning, not unlike the words "*temps perdu*" at Gryazovets. In his introduction to *Inhuman Land*, Czapski wrote, "I've begun to understand more powerfully than ever before the mortal danger that menaces my country today."

When his manuscript was completed, he sent it around to sympathetic readers who might be of help in placing it with a publisher. Malraux's response was welcome, quick in coming, fulsome in its praise. He offered to send the book out. "Malraux sent my manuscript to Calmann-Lévy and ten days later I received word from the man responsible for the collection that my book had

been accepted. The man in charge was Raymond Aron. He simply advised me to edit a chapter or two on purely literary grounds."

The French philosopher, journalist, and political scientist Raymond Aron had fled Paris to join the Free French forces in London. After the war he was named the director of the Calmann-Lévy publishing house, which offered translations of Arthur Koestler's *Darkness at Noon* and *The Diary of Anne Frank* to the French public. A rational humanist and a secular Jew, Aron had watched the rise of fascism as a student in Germany in the early 1930s and was well equipped to understand the dark powers at work in the Soviet Union. Most postwar progressive pieties, such as the unity of the left and the likelihood of a proletarian revolution, were anathema to him. His field of study was the relationship between knowledge and action, and the very limited possibilities for change in a liberal society. As the employee of a publishing firm, not the owner, he experienced these limited possibilities frequently. Czapski continues:

> Within a week's time I was summoned before M. Calmann-Lévy himself: "I don't at all share the opinion of M. Aron. I can't publish your book. You speak too much about the Poles and that's not of interest to the French. There are major cuts that would need to be made. What's most serious is that you're too anti-Stalinist, *that won't do.* You'll have to rework your text: begin it by being for Stalin, and then only toward the end can you express a few criticisms and judgments."

The manuscript of *Inhuman Land* would go from publishing house to house, rejected in no uncertain terms because of the unacceptable mirror it held up to Stalin's Soviet Union. When the second issue of *Kultura*, a double issue, was released in 1947, the first to be printed in Paris, a lengthy excerpt from *Inhuman Land* was included, alongside articles by Malraux and Daniel Halévy.

Czapski was actively engaged in developing a plan for the formation of a University in Exile to serve the displaced youth of Eastern Europe. He became evangelical on the subject. From his point of view, if young people were to be deprived of the opportunity to study, the emergence of a future enlightened leadership was called into doubt and the Soviets' devastating impact on the Polish intelligentsia of his generation would simply carry over into the suppression of the next. As was true of thousands of youths already living in

displaced persons camps, Eastern European students fleeing postwar totalitarian regimes were being denied entry into European universities because they had no proper national identity cards. Without these official documents, the halls of learning were closed to them. Czapski recognized their need to be untethered from the menial jobs they had been reduced to taking on in order to support their families. They needed to be enrolled in structured programs and to maintain the necessary discipline of study to develop their minds. Having created schools for young soldiers and children during his years with the Anders Army in the Middle East, he understood what was required and what was at stake in order to insure the regeneration and perpetuation of an educated populace.

Czapski was assisted in this endeavor by an old friend, Anatol Muhlstein, a former Polish diplomat and writer on international affairs who had left for America when France fell. Muhlstein helped him to flesh out his ideas for a broad-based system that they envisioned as being formed in alliance with an existing degree-granting educational institution in France. True to his belief in the importance of addressing a multiplicity of political and cultural entities, Czapski expected the University in Exile to cater to students who had fled from the Baltic States, Hungary, Romania, Bulgaria, Czechoslovakia, Ukraine, Lithuania, and Poland. He felt strongly that American graduate students should be encouraged to attend in order to foster an atmosphere of exchange and mutual respect. To encourage civility, co-existence, and the cross-pollination of ideas, and in part to alleviate the refugee population's need for accommodations, student housing would have to be built, creating a vital microcosm of European community. Three distinct faculties were conceived as the infrastructure for studies: first, political history, social sciences, and economics; second, Central and Eastern European languages, history, and literature; third, English and American language, history, and literature. Czapski pushed for the creation of an extensive library network, too, a symbol of the very freedom of thought that was smothered by Soviet dogma.

Early in 1948, American foreign policy strategists unveiled the tenets of the Truman Doctrine. The U.S. Congress funded the Marshall Plan in recognition of the need to counteract the influence of the communist ideology that was spreading throughout Europe. In the same months, General de Gaulle's staff planned and convened a conference along the same lines in Saint-Étienne. Czapski, invited to present his University in Exile plan, was greeted with an enthusiastic response. At Saint-Étienne, he forged a preliminary connection

with another conference attendee, James Burnham, an American political theorist and professor of philosophy, a mover and shaker with the potential to transform Czapski's project into reality. (Burnham had been a radical activist in the 1930s, a founder of the American Workers Party, and a friend of Trotsky. When Hitler and Stalin joined forces, Burnham was horrified, rejected the concept of dialectical materialism, and denounced the USSR as just another form of imperialist class society. Abandoning his socialist credo, he became a vocal anti-communist and political conservative.) Burnham was especially enthusiastic about finding such a fully realized vision in Czapski's conceptual proposal. No stranger to the complexity of such undertakings, Burnham had worked for the Office of Strategic Services during the war and stayed on as the organization morphed into the Central Intelligence Agency once the war ended. Burnham believed he could pave the way for funding a University in Exile, and identified Czapski as its chief visionary and principal architect. Aided and informed by Muhlstein's understanding of developments in emerging American policy, Czapski proposed a budget for the university and asked that it be submitted as part of the Marshall Plan's strategy for undertaking a "cultural reconstruction of Europe." Burnham would remain in close contact with Czapski over the following two years, keeping momentum going, making introductions on his behalf to officials at the U.S. State Department.

A colored-pencil drawing from 1948, a narrow, vertical sheet (plate 4), shows a dining scene in a restaurant—a table covered in a yellow-green cloth, elegant glasses filled with white and red wines, a tall carafe of water, and a round plate piled with food. A young man is leaning in from the right, his lips open in speech, his fork carefully overturned on the side of his plate. Speaking across the table to someone unseen, he has one elbow propped on the table, his forearm and hand poised to add expressive emphasis to his words. Czapski uses a very Bonnard-like palette of saturated colors.

The table is no ordinary one. Looking out from several stories up, a guest seated at this table is offered an expansive view of Paris through a large plate-glass window. A blue bridge over the Seine can be seen below. The bridge is the Pont de la Tournelle, which connects the Left Bank with Île Saint-Louis. On the island, the roadway continues as rue des Deux Ponts, a blue street running between two blocks of violet- and blue-colored buildings. An elongated sculptural monument of a brooding female figure towers over the river on the bridge's eastern flank. The statue, created in 1928 by the half-Polish,

half-French sculptor Paul Landowski, is the hooded form of Saint Genevieve, the patron saint of Paris. It was a work well-known to Czapski—its imposing presence and posture reminded him, affectionately, of his sister Marynia. In Czapski's drawing, the statue is rendered in purple and serves as a middle ground, mediating the space between the intimate table and the sprawling cityscape beyond.

This colorful work on paper was made at the same time that Czapski was working on his essay "Tomb or Treasure":

> Another day, coming from the Polish Library on Île Saint-Louis, I crossed the Pont de la Tournelle. High up on a building on the far bank, the windows of the restaurant La Tour d'Argent sparkled. After the liberation of Paris, it had been closed for some time, having been too accommodating to the Germans. Now it's newly opened, one of the most expensive restaurants in Paris; nevertheless, it was at La Tour d'Argent (which must then have been rather more modest) that the friends of Mickiewicz organized a banquet in his honor in 1855, barely two months before he died.

Czapski made his drawing in the same rooms where Mickiewicz was feted. Perhaps he was in such elegant surroundings because of a meal he organized for someone of standing, someone potentially helpful to the cause of *Kultura* or the University in Exile, or he might have been there as a guest at a dinner he could not reasonably decline. Many people would find the prospect of a meal at La Tour d'Argent an enticing proposition, but Czapski was not one of them. Never seriously interested in food, scandalized by the cost, uncomfortable in pretentious settings, he would have come because it was important, but he would not have come unprepared. He brought his sketchbook and colored pencils. The drawing's orientation is from one of the restaurant's fabled tables looking down onto the bridge. In the essay, he describes himself as walking across the bridge toward the Left Bank, glancing up at the exclusive restaurant. He appears in both drawing and essay, as if gazing up at himself from the pavement below and looking down on himself from the seventh-story window.

Through distinct observations of eye and mind, hand and heart, Czapski accounts for his place in the world visually and verbally. Yet harmony does not reign. It is difficult to reconcile this vibrant study, saturated in luscious Bonnardian colors, with the dejected tone of Czapski's essay, in which he dwells

on the ruin of Paris, a city to his mind sadly "contaminated" by its recent history. Tomb or treasure? The title of Czapski's essay is taken from lines by Paul Valéry, emblazoned in gold letters above the entrance to the Palais de Chaillot: "It depends on who passes / Whether I be tomb or treasure / if I speak or am silent. ..." The essay ends with an echo of these lines, declaring that it "depends on us whether this old country will be tomb or treasure." The outcome seemed unclear to him.

Inhuman Land finally appeared in Polish and French editions in 1949. The publishing arm of the Literary Institute, the Biblioteka Kultury, released *Na nieludzkiej ziemi*, while *Terre Inhumaine*, with an introduction by Daniel Halévy, was brought out by the publisher Les Îles d'Or, which was willing to take on a controversial book as long as the author paid the expenses. The first French edition bears a standard copyright notice: "All rights of reproduction and translation are reserved, for all countries, including the USSR." While the thought of Czapski's text being translated into Russian and printed in the Soviet Union was beyond imagining, another kind of censorship was at work in the Fourth Republic of France. Much of the leftist press refused to review the book or to address the issues it raised. In keeping with standard Bolshevik propaganda tactics, the book was simultaneously dismissed on both defensive and offensive fronts. Officially the book just didn't exist, but if such a book *did* exist, it was the work of a fascist and should be boycotted. The French Communist Party took the precaution of systematically purchasing copies from bookstores and destroying them.

From an unexpected quarter, a welcome battle cry was raised. A heartfelt endorsement written by François Mauriac was published in *Le Figaro*. Deploring the Stalinist bullying his esteemed colleague was forced to endure, and angered by attempts made to discredit him, Mauriac exclaimed: "This soldier of the army of Anders who fought alongside the Red Army, don't try to smear him, I know him, I respect him, and I love him, this Polish pilgrim who, going from sadness to sadness, extends his hand, like that statue by Bourdelle on Place de l'Alma, fixed in an eternal gesture, stretched out toward his Poland, endlessly revived and recrucified."

Czapski would certainly have winced at the idea of himself as that pilgrim à la Mickiewicz in Antoine Bourdelle's monument to Polish fortitude, but he graciously tolerated such an effusive tribute with the understanding that it represented an attempt on Mauriac's part to make amends for not having

responded to his open letter at the time of the Warsaw Uprising.

A copy of *Inhuman Land* finally made its way to Hering, smuggled illegally into Warsaw. (Being found in possession of such a book could lead to arrest and prosecution.) Previously Hering had only been able to read certain passages of the text that had been surreptitiously copied out by Czapski in his letters. Hering's response to reading the entire volume was enormously heartfelt. Because mail was read by censors, he had to refrain from referencing specific details in the book:

> I've come to Warsaw for a few days. I spent all day and all night reading the book.... I knew only a few of its chapters and imagined that I had understood what it was all about. I'm devastated by it. I'd like to tell you about my emotions, but I'm afraid that I'm incapable of expressing them.... The power of this book is that the reader sees the facts through a man and his attitude toward facts. The honesty of his gaze is overpowering. The book is lodged inside me so totally that I'm not even too sorry I have to return it. I may find it easier to carry on without seeing you now that I know this book.

To mark the tenth anniversary of the invasion of Poland, Czapski wrote an essay for *Kultura* in 1949 called "In a Whisper," looking back over the past decade and remarking on the current state of remembrance. The tone is bitter, allowing a voice more commonly found in his private diaries than in his public journalism to emerge:

> I sometimes think that man has no right to exist, that we are all alive only thanks to our thoughtlessness, our disloyalty, our unremembering. If we could remember for real and remember constantly, no one would be able to breathe, to stay alive. As we speak and write the most sacred words, even our memories of those who died take on the sleekness, the shine of inert, polished wooden objects, of tools of propaganda. All over this planet we repeat words, words, words—and this gives us permission to think that we're being faithful? On this anniversary perhaps it'll be better to be silent and to think. To see everything that we have lived through, to get to the bottom of things and not stop halfway, to not erect any rosy screens of fiction between ourselves and reality, to not tape up the wounds with optimistic band-aids, which only hasten the rot. To remain silent. But even today this "minute of silence" has already become a kind of empty liturgy at thousands of vacuous commemoration ceremonies.

He had declared to Hering: "I will not start to paint again until I satisfy this need." The compulsion to tell his story in *Inhuman Land* was finally spent, the resulting narrative formally published. His military duties were wrapped up, he had found a voice for journalistic writing. The prospect of allocating an open space for a return to painting grew increasingly real.

He took the plunge. A self-portrait in oil from 1949 was almost an exercise to see if he was really ready, to see what might come out of him at last. He shows his long face, calm but slightly tense. From behind brown glasses, one eye looks straight ahead, the other is slightly occluded by crosshatched reflections in the lens. Wearing a blue shirt and purple tie, he stands before a mirror that reflects his head and upper body, the right half of which is hidden behind the easel and the upper corner of a stretched canvas; this is the back side of the picture we're looking at. His left thumb is clutching a palette flecked with dabs of various colors in the bottom left corner of the picture. A wall papered in a relaxed floral pattern can be seen behind him. Through a double-hung window, a vertical sliver of landscape is rendered, crowned by the tops of trees in the distance and an animated band of blue sky. Two lengths of curtain soften the picture, one hanging by the window, the other, more diaphanous, at the painting's far right border. A series of vertical edging strips seems to suggest the frame of the mirror into which he's gazing. A familiar Matissean trope for Czapski, this transitioning element allows the viewer a spatial divide between the image presented and his or her own place outside of the picture.

To Hering he writes:

I've not held oil paints in my hand since Józefów, other than for the one painting I made in Baghdad, which wasn't bad, a landscape out of a window.... All I want to do now is to disconnect myself from painters, from the Louvre, from the methods, and to use all my passions to gnaw their way into some painting of mine. Maybe a painting of an old Jewish woman in a train or standing at the Otwock station is closer to my heart today than the most scrumptious Parisian ideas. My painting really seems to have no use for Paris. I have one good friend here who continues to blast me harshly for not painting. Even though I tell him, "But the sky is falling, and you want me to sit and paint?" And he says, "Maybe the sky is falling because you and the others have stopped painting."

The tenth anniversary of their separation does not go unacknowledged:

I, too, can remember that last day, in Józefów, with its early morning mist of approaching autumn, when we saw the airplane, but it's your face the way it was at the station in the long hours of waiting that has stayed with me most clearly, when you understood much better than I did what was being torn apart and collapsing. Again, this came not only from your valor and your wisdom but also because you rejected all pretend consolation. Yesterday I found a small old notebook, '40 or '41, in which I had written that I wanted to live for Marynia and for you. I wrote that I worried more about her because she would not manage to rebuild her life, but that you, who are somehow free and courageous, sometimes despite appearances, and our communion was so complete and somehow fulfilled, you would be able to rebuild your life without losing anything of our past together.

A full-length self-portrait in colored pencil (plate 5) shows Czapski drawing his likeness in a sketchbook he is holding, standing before a mirror propped above a mantelpiece in a room lined with decorative paneling. The drawing dates from the months before the oil self-portrait described above. His gaze is centered on what he is drawing, he does not look out at the viewer. Nattily dressed in blue trousers, orange sports coat, dark blue sweater, pink shirt, and red tie, he looks urbane and studious, but his figure forms only part of the larger picture. He stands right of center, shuffled to the side, discreetly trying to be peripheral. By the time he begins the oil portrait some months later, he has moved to a place where he is ready to take full ownership of his image, and puts himself front and center, even if partially hidden behind the canvas. His work materials—palette, paint, brush, canvas, easel—are prominently featured in the picture too, presented as tools of his trade, proud affirmations of vocation. The canvas he is working on is only loosely draped over its wooden support; one corner furls upward and a flap of material extends loosely beyond the confines of the stretcher bars. This canvas flap seems to suggest a hint of tentativeness, of being not entirely convinced he has the capability to fulfill his intentions. After all the years spent waiting, is he ready once again to take the leap, as he insisted in the essay he wrote on one of his myriad train journeys in Soviet Russia? Twelve years and many pencil and ink studies of his face have passed since his last self-portrait in oils. In this first postwar offering, his thick mass of hair is still reddish blond. His sideburns, however, have begun to turn silver.

13

JUST AS HIS HOPES for reestablishing a studio practice began to take shape, Czapski's plans were once again put on hold. At Jerzy Giedroyc's bidding, he agreed to undertake a six-month tour of North America to spread the gospel of *Kultura*. The journal, banned in the Polish People's Republic, had achieved a level of success, owing in part to Czapski's diligent advocacy. (The communist press singled out his participation as "the work of an émigré traitor.") The viability of *Kultura* placed him in a position of increased responsibility. Above and beyond the submission of his own articles and essays, he acted as the active link between the Literary Institute and the French world of letters. Promoting the work of Polish intellectuals to their French counterparts, he facilitated the translation and publication of Polish writers while encouraging editors in Paris to read their books and essays and take them on as clients. His trusted relationships with Raymond Aron at Calmann-Lévy, with Albert Camus at Gallimard, and with François Bondy at the journal *Preuves* (Proofs) contributed to the flourishing of *Kultura* by cultivating a larger audience for Eastern European intellectuals and creating a forum for thinkers and writers of the non-communist left.

Giedroyc, who lived in Maisons-Laffitte for fifty years with only a rudimentary command of French, repeatedly called attention to Czapski's cosmopolitanism in half-mocking, half-envious tones, referring to him as his "minister of foreign affairs." Incapable of public speaking, Giedroyc relied on Czapski to circulate out in the world, raising awareness and money. He devised for Czapski a grueling schedule of fund-raising appearances in key cities with the greatest density of Polish émigrés in Canada and the United States, in hopes of connecting to the minds and wallets of the largest concentration of people sympathetic to the cause of Polish freedom of speech. Such exposure would expand *Kultura*'s reach and spread the word about the University in Exile.

On November 23, 1949, Czapski sailed from Liverpool aboard the *Empress of Canada*. He prepared a variety of talks for his tour—about the Katyn Mas-

sacre, his time in a Soviet prison camp, the religion and literature of Russia, Proust. An ambitious travel itinerary had been mapped out, with talks scheduled in Montreal; Toronto; New York City; Boston; Philadelphia; Washington, D.C.; and Chicago. And in smaller venues, too, in smaller towns: Syracuse, New Bedford, Orchard Park. Everywhere he went, Poles were anxious to welcome Czapski. He was put up in fine hotels as a distinguished visitor or bunked down in a spare bedroom as one of the family. A modest speaker's fee for each of his talks was pooled with small sums solicited for the good of *Kultura*.

Two months prior to Czapski's departure for North America, a new People's Republic of China was declared. Within weeks of his arrival in North America, the Soviet Union withdrew from the United Nations Security Council. The tide of public opinion in the United States was shifting against Stalin. Nevertheless, whenever he was interviewed on American radio, Czapski would still be advised that any direct reference to the events at Katyn and Soviet culpability would be censored. In Boston, he gave two lectures at Harvard University in Polish, followed by two in English, a language he spoke somewhat hesitatingly. In a talk called "The Russian Man; Before and After the Revolution," he framed the subject by citing his own experience. Like Rilke, he also "found so much generosity in the hearts of this cruelly oppressed people."

In the course of a single year I saw tens of thousands of faces of Soviet people. What were the traits that struck me, in this mass of Soviet men and women as differentiating them most decisively from the Russians whom I had met twenty years earlier? First of all came their *Gleichschaltung*, the extraordinary uniformity of their thinking. With only the barest exceptions, I never heard any person express the slightest criticism or doubt of the wisdom of the Soviet authorities. The very style of the political comments, the pitch of enthusiasm for the government, and above all the dithyrambs in honor of the infallible Stalin, were always on the identical level. This monotony of statement, so different from the variety of reactions among the Russian people in former times, was only very rarely broken.

The distinguishing mark of today's generation under the Soviets is their incapacity for disinterested thought. They invariably think in dogmas, the course of their thinking is always politicized and narrowly pragmatic. The basic cause of this intellectual narrowness and leveled state, of the fact that people think only along officially prescribed lines, is fear.

In Washington, Czapski met twice with Czesław Miłosz, the acting cultural attaché at the embassy of the People's Republic of Poland. Miłosz never joined the Communist Party but was employed by the Ministry of Foreign Affairs. He and his wife Janina arrived in America in 1946, grateful to be removed from the constraints of postwar life in Warsaw. The poet initially embraced his post in the Department of Culture and Art with some enthusiasm, taking his job of disseminating Polish culture seriously. His overseers praised his intelligence and organizational skills, but noted that as far as political matters were concerned, he needed to be monitored. Given the minefield of Polish loyalties at home and abroad, this is hardly surprising. Working first at the consulate in New York, Miłosz was soon promoted to second secretary and transferred to the Polish embassy in Washington.

Miłosz and Czapski had often met in Paris and had known each other in literary circles in Warsaw before the war. Miłosz and Maria Czapska worked as colleagues throughout the Nazi occupation of Warsaw, both actively engaged in trying to save the lives of Jews. Deputized by Giedroyc, Czapski went to see Miłosz to assure him that if he was ever in need of a safe house in the West, he would always find a welcome at *Kultura* in Maisons-Laffitte. Given the prevailing hysteria about communist infiltration in the United States, it seemed unlikely that the poet would be granted sanctuary in America should he decide to defect. Miłosz felt increasingly trapped between two worlds, neither of which, in his mind, was manifestly superior to the other. The West seemed to him to have no soul, to be devoid of the values necessary to him in his pursuit of a reconciliation between art and spiritual faith. Life went on as if the war had not happened, "the people in the streets of Manhattan were free from what flowed in me like molten lead." In the East, he was restricted by the dictates of enforced aesthetic platitudes and the prevalence of fear. Following the Fourth General Congress of Polish Writers in early 1949, members were under mounting pressure to comply with the forms of socialist realism. "I simply could not stand that ever-growing totalitarian atmosphere," he wrote, "and that fear of everyone by everyone." Miłosz knew that to break with Poland would result in the immediate censorship of his work at home and the undermining of his credibility as a Polish literary figure. The prospect of living where he could not seek solace in his own cherished language was painful, and he imagined he would be despised by the émigré community for having agreed to work for the People's Republic. Miłosz had no one to console him in America, no one who could appreciate the degree of distress from which he was

suffering. He turned for advice to no less a figure than Albert Einstein, who counseled Miłosz that as a poet, he needed, above all, an audience that could read his native language. An optimist, Einstein felt that the current state of crisis in Poland would be temporary, and that it might be wiser for Miłosz not to make an irrevocable break with his homeland. That meeting in Princeton enhanced the poet's sense of isolation and excited his chronic skepticism. Czapski listened attentively to Miłosz's lament, then made a persuasive case for the benefits of exile. He presented himself as an artist in the West who was able to express himself in whatever manner he chose, who lived his life free from the menace of state interference. He was no stranger to the whims of Soviet brutality.

Behind the scenes, with his American contacts, Czapski worked to stress the potential importance of Miłosz as the first intellectual of his stature to consider fleeing from the Soviet bloc, but the U.S. embassy announced that the poet was "not interesting enough" to secure a visa. In a severe letter to Giedroyc, he detailed what he saw as Miłosz's political indecisiveness and limitations, his having created a buffer zone between the aspirations of Marxism and the savagery of communism. A few months later, Miłosz was called back from Washington to the embassy in Paris. He had no choice but to leave behind his young son and his wife, who was enduring a difficult pregnancy and forbidden to travel.

Like a twentieth-century Tocqueville, Czapski kept a detailed record of where he went in America and whom he met, filling pages with impressions and anecdotes. Readers of *Kultura* were given the chance to travel alongside him as a serial publication of his *Notatki amerykanskie* (Notes from America) appeared in eight monthly installments between June 1950 and January 1951.

> I don't know of another country where the cabdrivers are as talkative and good-humored as they are in the United States. All are eager to enter into conversation, all of them ask me how I like America, and all sing the praises of this country, so much that someone newly arrived from Moscow would think that every cabdriver is a well-paid agent of capitalist propaganda. *How do you like this country?* is the sacred question I hear all the time. . . . Tired of always hearing the same question, I switch roles. *How do you like this country?* I ask my next driver (whose parents are both Jews from Warsaw). He turns around to look at me, the question seems so stupid. He replies, "It's *my* country!"

Czapski's luggage held plenty of paper, pencils, brushes, and watercolor paints. He kept a visual record of his journey, he was always drawing. Page after page of sketches fill his diary, sketches of people he encountered aboard the ship, on buses and trains, in bars and bus stations, in hotel lobbies, in restaurants and at concerts, endless glimpses of men and women active and at rest, at work and at play. North America's vast open spaces and densely crowded cities provided him with a wealth of subjects. He sketched landscapes and cityscapes, oil refineries and new car lots, the interiors of offices, urban dock scenes, and train stations. In the Boston Public Garden he drew the Kościuszko memorial, in Philadelphia, Independence Hall. The New York City skyline appealed to him from the moment it came into view, with seagulls overhead and a flotilla of tugboats leading his ship into berth. Simple, strong black lines construct a mass of skyscrapers on the page, mansard roofs, boxy towers, spires, and a sea of windows. His sketchbooks swell with images reflecting the energy and diversity of New York. Black Americans are especially well-represented; elegant matrons in Sunday finery, jazzmen in porkpie hats, car mechanics leaning over an open engine, derelicts sprawled out on seats in the subway. Fascinated by the stories of black women of all ages and sizes, he struggled to overcome his shyness to ask them to speak with him. Parking himself in the corner of a hotel bar, he would sketch women in furs and great hats perched on barstools, barmen in white jackets and black ties in service to them, rows of glasses of all sizes and shapes and liquor bottles with elaborate pouring tops. He turned his gaze on disheveled people and indigent people, solitary figures reading on buses. His renderings of a fleet of uniformed sailors on a train, mostly tumbled over, sound asleep, exude a faint whiff of eros. Hiding behind his sketchbook, he observed their slumber, his eyes wandering over their fit, sprawling bodies as he drew them. He made drawings of open spaces in Central Park, hemmed in by the surrounding buildings looming vertically just above the tree line. At the Frick Collection, he sketched a *Resurrection* attributed to Andrea del Castagno, at the Metropolitan Museum of Art, a *Woman Bathing in a Shallow Tub* by Degas. Architectural details were always of interest: industrial smokestacks, river crossings, skyscrapers, public sculptures. Perhaps waiting for his own turn at the podium, he drew another man giving a speech, text in hand before a microphone. On many pages, hastily scrawled names and numbers of people he encountered appear squeezed in between text and images: 220 East 42nd Street, 606A 3rd Street, Brooklyn, 3 East 69th Street, 60 Fifth Avenue, 740 Madison Avenue. MOnument 2-0620, RHeinlander

4-7893, TEmple 7-942. The names Philip Rahv, Sol Levitas, Max Ascoli were duly inscribed, scattered among the names of the left-leaning anti-communist journals for which they wrote—*Partisan Review, The New Leader, The Reporter, Foreign Affairs.*

One rainy afternoon he had lunch with Jan Lechoń, another celebrated Polish figure, a poet whose work combined strains of romanticism and classicism. Lechoń made his literary debut at fourteen and at the start of the Second Polish Republic was a founding member of the Skamander school of experimental poetry, a group whose mandarin qualities Czapski never particularly relished. A cultural attaché at the Polish embassy in Paris, Lechoń moved to Brazil after the fall of France, then, after the war, to New York, where he was instrumental in establishing the Polish Institute of Arts and Sciences of America. The Nazi destruction of Kraków's Polish Academy of Learning left a void the Polish Institute intended to fill, albeit in exile. As both a diplomat and a creative artist, Lechoń understood the constraints Czapski was putting on himself, trying to balance a creative life and a public life. He hounded Czapski to rethink his priorities: "Why bother working for *Kultura*? Drop it! I know about how these things work—they've just removed seven feet of my intestines!" (Lechoń offered a rare glimpse into how Czapski's integrity and perceived sanctity may have been found insufferable by others. In mocking terms, but rising to Czapski's defense after the publication of "Major Hubert," he wrote to a friend, "It's a sham for Rudnicki to pretend he didn't know who was responsible for Katyn. But I'm sure Czapski, who has to smell every piece of his shit to see if it stinks, spoke to him sincerely. . . .") Filing for American citizenship at the height of the McCarthy era, Lechoń learned that his application was rejected. He had been denounced to the authorities as a homosexual. He jumped to his death from a window high up in the Hudson Hotel.

Czapski grabbed a cab to take him to Grand Central.

> At 5:14 p.m. I'm due to leave New York for Chicago, where I am to speak about Katyn before the Polish National Association. I leave the apartment on Madison Avenue a little after 4 p.m. Right away a yellow taxi appears. We take off into the flow of traffic and turn down Park Avenue. Ahead of us Grand Central Terminal spans the street.
> Yesterday, the air was cool and sharp, today it's heavy, gray, stifling. The

vehicle floats forward, moving like a boat; its shock absorbers are very impressive. The car radio emits a soft music. Out of the windows I see, on both sides of the street, endless intersections and garlands of green lights that, after a few seconds, change to red. The cars stop, only to begin again smoothly after a moment, then come to a stop again. Not much air. A cushioned ride, soft music, the lingering odor of gasoline, stops, starts, a touch of nausea.

The station. A polite black man reaches for my suitcase and places it on a cart already piled high with elegant luggage and hands me a receipt. In my pocket I've got my ticket for Chicago. For the time being, I've got nothing to do but make my way leisurely to my train, where the porter waits for me with my bag.

Voyages, departures, taxis, porters, tickets, station restaurants and dining cars onboard, everything is perfectly well-organized, everything goes off without a hitch, so well that after a while one begins to move automatically, thinking no more about the mechanics of travel than about the button on the vest you're trying to close.

Entering the terminal's vast central hall, he was jolted from his reverie by the huge crowds of people making their way around him. The music of Bach was being played on an organ somewhere nearby, intensifying his feeling of being in a kind of cathedral. Everyone around him was well dressed and polite. Settling into his roomette on the train, he marveled at its design and comfort, a foldout bed made up with beautiful sheets—and such soft blankets. Black porters came and went with offers of tea or coffee, took his shoes away to be polished. The train pulled out of the station slowly. In the long dimly lit tunnel Czapski speculated about what he had experienced so far.

Obviously I'm only describing the surface. It suffices to read several books written by Americans, or to go to the theater and see Arthur Miller's hugely successful play *Death of a Salesman*, to get a glimpse of a darker reality in America. Nevertheless, what appears on the surface is not insignificant, it reflects the way of life of millions of Americans. I know very well that under these well-cut suits beats the same human heart, that suffering exists here as it does elsewhere, and a sense of failure, of frustrated passions, of despair and death—despite all that's done to conceal it—but the expression on people's faces, the prevailing bounty, the calm rhythm of life, isn't this, right here, what the whole world dreams of?

By the time the train finally emerged from its dark labyrinth into the open air, his complacency was shattered. The slums of Harlem lining the tracks came as a shock, destroying his limited idea of "what the whole world dreams of." As thousands of windows flashed by, he observed a parade of despairing faces and dismal interiors. From his clean, comfortable perch, he has been thrust into the dark underbelly of American bounty. Not a tree to be seen, only derelict buildings and poverty. Here is another America. The scene reminded him of the worst conditions of shtetl life back in Minsk.

A profound sense of desolation descended on him. His mind reeled. In just a few minutes he had gone from marveling at the ease of travel and the elegance of his berth to a state of disbelief that in America so much misery could exist in such close proximity to so much prosperity. Yet, he asked, who is he to be passing judgment? What are he and his fellow Poles doing in this country? How has their own nation been lost? Helpless, scattered, and betrayed as they were, wouldn't it be better for Polish exiles to adopt an open and approachable attitude like the Americans, with their ease of smiling, and put away the burden of the past, keep it hidden from sight? "Or maybe," he wondered,

> on the contrary, should we be shouting that their victory is fragile, that even here disaster might unfurl, that we exiles, despite or thanks to the weight of our past, from which we cannot and do not want to detach ourselves, are more conscious, more vigilant, and that this bitter awareness that is ours more than a few of us would refuse to exchange for all the happiness of America? Our role might be precisely to forget nothing, and to remind the Americans that they are not invulnerable. The alarm bell that has sounded is the Korean War....

Looking out over a grim landscape of the urban poor, he shifted back to a painter's mentality. Utrillo and Toulouse-Lautrec came to mind, soothing his agitation. "Only a gaze that refuses to falsify a difficult truth could extract beauty from these streets." This phrase revealed and encapsulated what would become Czapski's own tireless anti-aesthetic credo. An alliance formed between difficult truths and beauty would imbue his work as a painter, defining a critical aspect of his oeuvre. Such a pairing had been revealed to him once before, to his immense relief, in Madrid, standing before the black paintings of Goya.

Fifteen minutes later his train pulled into Riverdale, a commuter station on the Hudson River, which he knew to be the home of Arturo Toscanini.

Mature trees lined the banks of the wide, shining river. Attractive houses dotted the riverbank. "In a quarter of an hour I find myself transported from Grand Central Terminal to the hush of Switzerland; on the blue Hudson I see some small boats." After such misery, serenity. What a quarter of an hour!

The next day the train arrived in Chicago, the largest center of Polish immigrants in the world. In 1950, more than six hundred thousand Polish Americans called Chicago home. Czapski had come just in time for the community's celebration of the Third of May, Poland's national holiday honoring the signing of the first Polish constitution in 1791. The parade and gathering were much in the spirit of the American Fourth of July. Banners and flags were draped everywhere in Humboldt Park, and men and women promenaded in a variety of native costumes and uniforms. An outpouring of officials and personalities assembled, everyone circulating about, everyone with a smile. Orchestras played and marching bands strutted. Even though the weather was springlike, a glacial wind was blowing off the river.

Speeches were made. Orators needed to be mindful of the linguistic disparity of their audience, many of whom had only a slight grasp of the subtleties of the Polish language, others who had only a handful of English words. In the American electoral style of finding the lowest common denominator, speakers were reduced to mouthing generalities and relying on exaggerated superlatives. The level of Polish discourse was weakened, Czapski noted, diluted by its prolonged contact with the English language. For someone newly arrived from Europe, this simplified speech, full of praise and enthusiasm, unnuanced and crude, registered as a mass of empty clichés.

The purpose of this event is to solicit funds for displaced persons, to raise awareness about their immigration to the United States. Young women in regional costumes from Kraków, in velvet hats richly embroidered in gold and huge crowns of artificial flowers, pass through the crowd carrying a large opened flag into which money is tossed, more bills than coins. Displaced persons are a cause one can understand: compatriots living in Germany awaiting visas, with no possible future there and, for the most part, a horrible past. Many of these people have been able to come to America thanks to one Polish American or another who is able to assure them of work and provide proof of lodging, who is willing to sponsor someone about whom all they know is that they are Polish. These are completely disinterested gestures, representing material as

well as moral engagement. Polish associations organize this immigration efficiently, spreading word of it with not inconsiderable means. The new arrivals come and adapt almost instantly.

Nationalistic fervor at such a pitch generated a good deal of speculation on Czapski's part. (He estimated between ten thousand and twenty thousand people were in attendance at the parade. The following day the newspapers unanimously reported a crowd of more than one hundred thousand.) In name, Poland was being honored, but surely that country only existed in America as a romantic idea. What relation did these largely Americanized people bear to the reality of a distant Soviet-controlled satellite nation in Central Europe? What "tradition" were they keeping alive, and for whom? And what kind of dreamer was he, the Parisian émigré? Were his ideas of Poland somehow more legitimate than theirs? Czapski struggled not to condemn the superficiality he found infecting those who were trying to fit in.

When the festivities ended, he was approached by a man he had been introduced to earlier in the day, who invited him to join a group of friends at their social club nearby. He was happy to go along. Spare and plain but welcoming, the Matejko Room had long wooden tables. Watercolors of Polish scenes by Jan Matejko hung on the walls. (A renowned nineteenth-century historical painter, Matejko and his cumbersome compositions were held in disdain by the *peinture-peinture* crowd from Kraków.) Czapski settled in among some of the older men, studying their faces, listening to their stories. Not one of them was in any dire need, not one was homeless or hungry. But he couldn't help noticing the sadness in their eyes. The adage about old trees taking poorly to transplanting came to him. He was fifty-four; like these men, he had no illusions about seeing Poland again. Like him, these men had been uprooted more than once in their lives, but unlike him, they seemed to have lost a certain physical and moral strength along the way. Some of them had once been officers in the armed services, one had been a lawyer, two others had been journalists. In this final chapter of their lives, in the United States, they were working in factories or as tailors or clerks. "I've seen these faces—from Starobielsk to Paris—of ordinary or exceptional men struggling to keep their heads above water, the vestiges of their generation." Demoralized and depressed by years in Soviet camps, or by moving about as stateless refugees, they had been forcibly displaced from everything that once held meaning in their lives. They had lost

the drive to begin anew yet again. Despite a lingering modicum of goodwill, they no longer had the energy required to pursue more challenging work—they were old and ailing and had managed to learn only a little English. They felt useless. After a day of bright costumes and speeches, cymbals and horns, remembrances and euphoria, the company of these quiet men, nursing their beers and playing checkers, made a sobering impression. In his diary Czapski noted that the day was "a mixture of vaudeville and the sublime."

His visit to the Matejko Room was not without uplift. Czapski was introduced to a thirty-year-old medical student named Arthur, a relatively young man who came regularly to spend time with these older men, aware that his presence was a comfort to them. Tall, brawny, implacable, he looked them in the eye and spoke to them from his heart. He was both friendly and volatile. The youngest of six children, Arthur had been raised by a hardworking mother who was widowed when he was only a few weeks old. Czapski observes,

> Arthur speaks Polish poorly, he can barely read it, he's American-born and fiercely patriotic. Here, among the recent immigrants, he's discovering a new Poland he didn't know and, despite his serious course load of study at the university, has begun to learn Polish. His parents were immigrants; everything he has become, he has earned through hard work. Just about to finish medical school, he had to find work in a factory for four years in order to earn the money for his studies.

Czapski and Arthur shared a few drinks and discussed the parade. Listening to Czapski's lament—the vulgarity of half-dressed majorettes parading through a tribute to those who fell defending Warsaw—Arthur got defensive and angry, dismissive of visitors from the Old World who were always so quick to condemn. "God, you're tiresome, you should hear yourself talk! Even in Shakespeare there's a mixture of tragedy and comedy, humor, even pornography!" He urged Czapski to spend a little time in America before condemning it so much. "You arrive, you don't understand anything, and as soon as you see something you don't like, you criticize!" Czapski, for whom the only unacceptable condition of human relations is one of indifference, immediately warmed to Arthur and his aggressive defense of his country. He found Arthur's honesty and spontaneity a tonic. A citizen of a young and happy nation, Arthur experienced Old World formalities as false. Why then, Czapski wondered, had this young American bothered to come to the Matejko Room, why was

he attracted to this vestige of old Polish culture at all, why didn't he put faraway, impoverished, unhappy Poland behind him? Despite his loyalty to America and his insistence on how things should be done, Arthur remained a link in what Czapski imagined to be an invisible chain.

"All that I know about Poland is that, when a crust of bread would fall on the floor, my mother would pick it up, kiss it, and eat it. One day, when I spurned a piece of bread from the end of a stale loaf, my mother refused to give me my dinner. Later I ate it because I was hungry. All that I know about Poland is that piece of bread."

Arthur was quiet, his light but myopic eyes peered through his glasses at his unfinished shot of whiskey.

I had with me an anthology of Polish poetry. I showed him a poem, the Polish text printed across from its translation. He read it with some difficulty, often glancing over at the text in English:

For that land where people raise a crumb
of bread from the ground out
of respect for the gifts of Heaven
I yearn O Lord
—Cyprian Norwid

Arthur kept still, looking keenly at the page. There, in a strange book, he came across that gesture of the Polish diaspora whose present and sad memory always remained with him. Picking up the crumbs of her hard-earned bread and respecting them as a gift from above, his mother, with this gesture, passed on to her son the distant and foreign world of Polish culture. For the moment, this quatrain, speaking to him of his mother's gesture, revealed to Arthur the rich treasure of Polish poetry, impenetrable for so many people.

It was easy now to show other Norwid poems to Arthur. I watched his reactions joyfully; he laughed, he even understood a particularly abstruse verse. This poet who failed to find a publisher in his own lifetime, whose friends, even some great artists, considered his work "obscure," received from Arthur, the son of a poor woman, an unerring comprehension of its meaning and beauty, of its language and metaphor....

Arthur later wrote to Czapski:

You know that my medical studies leave little time for me to learn Polish, but the few verses I can learn are a consolation for me. Can you understand that poetry is a great luxury for me? In Polish verse there are nuances that don't exist in English! They say Shakespeare is universal, but there are poems even he couldn't have written. I only want to tell you that even these details are precious to me. Polish poetry has become my sole pleasure.

This proof of the power of Polish poetry was very meaningful for Czapski, who worried about the diminishment of his country's cultural patrimony as a side effect of political ruthlessness. As a member of the Soviet bloc, Poland could no longer sustain the freedoms necessary to protect and preserve its own heritage.

It is the victors who write history, who collect the documents, who falsify history. We only know about Gaul from what the Romans wrote after having destroyed it. What will be known about Poland in the years 1939, 1940, 1941 depends on the victors. The history of Poland risks being reduced to a small footnote, skillfully presented. What will the world know about great Polish poetry? About as much as it knows about the poetry of Gaul, no doubt. With the exception of Chopin, what do even the most refined spirits know today about our tradition, about our art? I've just finished reading the third volume, four hundred pages long, of Charles Du Bos's *Journal*. It's concerned mostly with literature. Among its three volumes, one finds the names of hundreds of writers, English, American, Russian, German, and Italian poets, even Persian and Chinese poets, not to mention the French. He speaks enthusiastically, with penetration; this highly sensitive work is like an essential seismograph of poetry of the period between the two world wars. Not a single Polish name appears.

A large volume, *Modern Painting*, just appeared in bookstores, a rich over-view published by Skira. I've never seen its equal. The reproductions are of the highest quality. Naturally the French dominate, alongside the Germans. Munch, the superb Norwegian disciple of Gauguin, is represented. . . . Once again not a single Pole; at every turn I find the same thing. In Atlantic City, I scoured the shelves of a vast bookstore. I found translations of Turgenev, of Thomas Mann, of Sholem Asch, and even a copy of Gide's *Corydon*. Not a single Polish writer.

While in Chicago, he finds refuge and comfort during visits to the Art Institute:

We in Europe have no idea of the quantity of works of art transported here, nor of the intelligence and care with which they are displayed. El Greco, Velázquez— one canvas here is more beautiful than any I found at the Prado—Rembrandt, a van Gogh unknown to me, the most beautiful Cézannes! And a whole room of Picassos, just a fraction of the collection. In all the rooms young people are drawing, taking notes. . . . The museum is *alive*, the visitors are enthusiastic, young and old alike, and the works are masterpieces from all around the world. Chicago claims two hundred thousand Swedish immigrants who came at the time of the great Swedish famine around 1900, at the same time as a huge wave of Polish immigrants. Coming to the Art Institute, Swedes can find their roots on exhibition here, the secular culture of their old country.

In vain I searched for even a small room of Polish art or culture. Chicago is the largest center of Polish immigration in the world, some six hundred thousand Poles are here . . . no one seems to have had the idea to put on display any example of Polish culture. If Arthur had come to the Art Institute in search of Polish art and culture, he would have left the building with the feeling that no such thing exists.

A few days later, Czapski was informed of the existence of a Polish Museum of America. Finally, the very thing he had bemoaned the lack of in Chicago awaited him, the chance to see the fruits of Polish culture on display in America. The shock was intense. Entering rooms of chaotic clutter that caused him dismay, confronted by an accumulation of weak, uninspired representations of Polish art and culture, he spared himself no disenchantment.

I went to visit the Polish Museum of America, run by the Union of Polish Roman Catholics. A comparison between the two museums is staggering— what a difference in terms of refinement. The Polish Museum is a jungle of memorabilia, crammed with things, showing no awareness of museology, with no hierarchy of values—and just a stone's throw from the Art Institute! One treasure, a beautiful sculpture in the Polish folk tradition, sent to New York for the 1939 World's Fair, washed up here after the war and got buried in a corner of a large room among a jumble of display cases, inaccessible to the viewer. One has to make an effort to discover it, but who among non-Polish visitors (if they exist at all) would have the patience to find it? I found paintings of "young" Polish artists, also sent for the 1939 fair, but none of the better painters of that generation—Cybis, Waliszewski, Czyzewski—were represented.

I was struck by the mediocrity of the work, painted in the Paris style. And among these I found my own painting *Dovecote*. My impression? Dead colors, heaviness, distinctly third-class. Such paintings do no service to the cause of Poland.

He has no illusions. He experiences no thrill of recognition, no excitement in the discovery of a work painted thirteen years earlier, long assumed lost. His assessment of *Dovecote* is sober and reasonable; "third class" may be harsh, but in comparison to the wonders at the Art Institute, it is not wrong. His pronouncement—"such paintings do no service to the cause of Poland"—is also not wrong, but it is ironic to read such an unexpectedly conventional response from the theorist who once championed painting's release from a historical imperative, who espoused the cause of pure painting, of *peinture-peinture*. Frustrated by the glaring absence of Polish art at the Art Institute, then distressed by its dismal presence at the Polish Museum, Czapski the independent painter and Czapski the dutiful citizen face off and wrestle, like Jacob and the angel. Like Jacob, Czapski the painter will prevail.

Returning from America, Czapski settled once more into his room at Maisons-Laffitte and resumed work for *Kultura*. Very soon after his return, he and Giedroyc left for Berlin, having been encouraged by James Burnham to represent Poland at the inaugural meeting of the Congress for Cultural Freedom. The organization, composed primarily of social democrats of the anticommunist liberal left, has a controversial history, full of dissenting opinions, but a powerful feeling of accord united the multinational gathering at its opening convocation. Formed in response to Soviet expansionism and concerns about the impact of totalitarian ideology, the congress set out to reclaim for itself the "progressive" ideal currently in the clutches of Stalin and his security police state. The philosophers Bertrand Russell, Karl Jaspers, John Dewey, and Jacques Maritain headed the roster of invited speakers. Arthur Koestler presented his "Manifesto for Free Men," cowritten with Manès Sperber. Before a sea of notable intellectuals from around the world, Czapski gave an impassioned speech about the formation of a University in Exile. "Each atom bomb is more expensive to build than a university: nevertheless, a university consistently led by design and vision might prove far more dangerous for the Soviet regime than a bomb, and would surely be more in line with the precious tradition of free men striving for liberty."

The University in Exile would ensure a future generation of intellectuals who could return to their homelands and spread democratic principles, laying the groundwork for a more open society. Identified as one of the long-term aspirations of the congress, the university idea received a widespread, enthusiastic response. An old friend from Paris in the 1920s, Sergei's cousin, the composer Nicolas Nabokov, would become the secretary-general of the Congress for Cultural Freedom and an advocate for the University in Exile. An International Committee was formed, of which Czapski was one of twenty-three appointed members. From this moment forward, however, Czapski's plan was examined, reconfigured, and finally drained of substance. At first sought after and embraced, he was soon ignored. An educational entity based on his original concept would eventually emerge in France under the name of the Free Europe University in Exile, but the contentious political negotiations for control of its mission never involved Czapski, and he was never acknowledged for his input. He was not invited to the opening ceremonies. From his point of view, the Free Europe University in Exile, overtaken and supervised by the National Committee for a Free Europe, failed to address the needs and realities of exiled youths. It had been conceived as a vehicle of propaganda, and as such was vulnerable to the vicissitudes of American foreign policy. (When, in 1966, *The New York Times* revealed that the CIA had largely funded the Congress for Cultural Freedom, Czapski was better able to comprehend the failure of his University in Exile proposal.)

The Congress for Cultural Freedom's convocation in Berlin was held between June 26 and 30. This final week of June 1950 marked the dead center of the twentieth century. Over the course of these very same days, North Korea launched its invasion of South Korea with the support of the Soviet Union and Communist China.

In November, Czapski appeared as a witness at the trial of David Rousset, a left-wing French journalist and authority on Nazi concentration camps, a survivor of Buchenwald and Neuengamme. Rousset's firsthand exposé of the world of concentration camps, *L'Univers concentrationnaire*, had been well-received when published in 1946. In an attempt to reveal the continuation and preservation of forced labor camps on a massive scale in the Soviet Union, Rousset paid to have a two-page advertisement appear in *Le Figaro littéraire*, in which he declared that long after the war with Nazi Germany had ended, Russia was still mercilessly exploiting its political prisoners. In his text, the

term "Gulag" made its first appearance in print in the French language. Rousset claimed that slave labor was tolerated as a necessary evil, fundamental to the upkeep of the Soviet economy, exposing a truth long hidden from public scrutiny. His letter appealed to former inmates of Nazi camps to join him on a commission to inspect the Soviet camps, to create an International Commission Against Concentrationist Regimes. Composed entirely of survivors, the commission's credibility would be unassailable.

An active member of the French Resistance during the war, Rousset was vigorously attacked by fellow journalist and editor Pierre Daix in the pages of *Les Lettres françaises*, a French communist newspaper. A survivor of Mauthausen, and the future biographer of his friend Picasso, Daix accused Rousset of slandering the Soviet Union and making false claims. In response, Rousset brought libel charges against *Les Lettres françaises*. During the trial, Daix's counsel tried to undermine Czapski's authority as a witness, questioning his expertise on the subject. This provided an opening for Czapski to speak of his personal experience. His declarations about the Katyn killings enraged the defense counsel and unleashed an explosive uproar in the courtroom. After twice issuing warnings, the judge was forced to call a recess. Czapski's testimony forms part of a group of firsthand accounts of life in Soviet camps that collectively decided the case in Rousset's favor in 1951. Extensive coverage of the trial helped to rouse some on the French left from their ideological stupor, leading to a more balanced understanding of the praxis of the communist doctrine in which they had invested so much of their faith. Merleau-Ponty admitted ruefully that "the meaning of the Russian system" had been called into question. Others clung to their adamantly Stalinist bias. After the Rousset trial, Sartre, unrepentant, composed an open letter to Camus: "We may be indignant or horrified at the existence of these camps; we may even be obsessed by them. But why should they embarrass us?"

Having been recalled to Europe, Miłosz was named the first secretary for culture at the extravagant Hôtel de Monaco, home of the Polish embassy in Paris, at a time when Polish relations with the French were severely strained. Constantly on the defensive about being watched and overheard, he was on guard for signs that his transfer and promotion were a cover for a more ignominious end. The Polish ambassador ran a tight ship, keeping his staff under strict observation and as much as possible in isolation from the world beyond the embassy walls. After a few months, the poet was called back to Warsaw,

and soon after his arrival, was asked to surrender his passport. Taunted by his superiors for having been exposed to American values, he was looked upon with suspicion and tested repeatedly for loyalty. The conflict in him grew unbearable, the strain was enormous, yet he still doubted the wisdom of defecting. A personal intervention on the part of those who believed in his role as an artist determined the course of action that enabled him to return to his posting in Paris. He immediately fell ill, then received word that Janina, in America, had given birth to another son after a life-threatening delivery. Permission to travel to her was refused.

On February 1, 1951, Miłosz reached out to Giedroyc by telephone from a post office in the center of Paris and made his way to Maisons-Laffitte. He was clearly under surveillance; the Ministry of Foreign Affairs in Warsaw was immediately alerted that Miłosz was on the move when he was observed getting into a taxi with two suitcases. Denied asylum by the U.S. embassy, he was granted it by the French. Recalling the chain of events, he wrote:

> They invited me to come over, and I went. I was extremely nervous, a complete wreck. I was very unpleasant to them, extremely stubborn and sullen. But the kindhearted Zygmunt Hertz took me under his wing. For a long time he wouldn't let me go into town alone, because of the possibility that I might be kidnapped. At that time, the communists did such things.... I felt terrible, because I was an outsider, and they were all linked by common experiences. I heard endless conversations about what it had been like in Yangiyul, in Iraq. I behaved badly toward them and imagined the worst possible things about them. This satisfied my sense of deep humiliation. At that time, I had much warmer contact with Czapski than with Giedroyc.

Weathering the storm of his defection, Miłosz adjusted spasmodically to life in what he came to call "the sovereign principality of Maisons-Laffitte." A camp bed was set up for him in the library and he was given a desk. For three and a half months, he remained in hiding. At no time could he be left unguarded, even to stroll out in the garden. Finally, in May, Miłosz publicly announced he had broken with the Polish People's Republic. Czapski had predicted correctly: The poet's defection did indeed spark a media frenzy. From the leftist press, he was subjected to abusive barbs portraying him as a traitor, a cowardly deserter, and worse. Pablo Neruda, a fellow poet and cultural attaché of the Chilean embassy in Paris, another future Nobel laureate, a friend

"with whom I used to share a drink," wrote a scathing denunciation of him titled "The Man Who Ran Away." In many quarters of the Polish émigré community Miłosz was looked upon with suspicion and derision. But he was resolute. "I have rejected the new faith because the practice of the lie is one of its principal commandments and socialist realism is nothing more than a different name for a lie." Encouraged by Giedroyc, with some helpful input from Czapski, Miłosz began to write of his conflict with both East and West while still in residence on avenue Corneille. A significant cross-pollination, with far-reaching consequences, took hold when Czapski put his battered copy of Gobineau's *Les religions et les philosophies dans l'Asie centrale* into Miłosz's hands. Discovering the Islamic concept of *ketman*, or concealment, in its pages, Miłosz developed it as a metaphor to help explain to the West how Central Europeans had to learn to traverse the treacherous minefields of totalitarian repression by means of withholding their true feelings and finding a way to live with the contradictions of saying one thing while believing another, much as their Central Asian neighbors had. Writing *The Captive Mind*, the book that would make him famous, Miłosz described the attraction Stalinism held for intellectuals and their respect for the rules required to navigate the subtle demands of the New Faith. "One must keep silent about one's true convictions if possible," Miłosz explained. "As in Islam, the feeling of superiority over those who are unworthy of attaining truth constitutes one of the chief joys of people whose lives do not in general abound in pleasures." He identified socialism's *ketman*-like impact on Central European character, on the mind-set of the individual thinker whose "chief characteristic is his fear of thinking for himself." Miłosz had the habit of taking ideas from others and making good use of them; Czapski had the gift of planting ideas in the right minds.

Czapski would also introduce Miłosz to the writings of Simone Weil. He seemed to have an unerring instinct about who might respond to what. Miłosz's Polish translations of Weil's writings were published as an anthology in the pages of *Kultura* and would have a profound impact on many religious circles throughout Poland. Miłosz continued to seek asylum in the United States to reunite with his family, but having once been a communist diplomat, his appeals fell on deaf ears. After a separation of three years, his wife and young sons came to live with him in France. His relationship with *Kultura* continued, if at times under strained circumstances.

An English translation of the French edition of *Inhuman Land* appeared at this time. Czapski found his reputation as a historical witness growing. In

The Observer, Harold Nicolson praised the author's objectivity, acknowledging the remorse felt by many British citizens who "were blind" to the consequences of the Yalta agreement. "All we can do is to preserve our sense of guilt intact; and not to seek escape from it in forgetful heartlessness." Czapski was invited to return to the United States to lecture on his experiences as a prisoner of the Soviets. In Washington, he gave a talk titled "Soviet Reality in Russia" as part of a series at Georgetown University organized by Jan Karski, the courageous resistance fighter. A Polish officer, Karski had concealed his true rank when taken prisoner in 1939 and escaped from a train bound for a POW camp in Germany. He made his way back to Warsaw and joined the resistance. On an extremely dangerous fact-finding mission, Karski, a Polish Catholic, was smuggled into the Warsaw Ghetto. With the unimpeachable information he gathered there, Karski was sent to confer with the London government-in-exile about the Nazi's intent to destroy the entire ghetto and its inhabitants. He furnished reports to the unbelieving Polish and Allied governments about organized mass exterminations of Polish Jews as early as 1942. (In July 1943, Karski was granted a personal audience with FDR in the Oval Office, followed by a meeting with Supreme Court Justice Felix Frankfurter. In both meetings, detailed accounts of the ongoing progress of the Holocaust were revealed. Frankfurter's response to Karski's information ultimately required some clarification: "I did not say Karski was lying, I said I could not believe him. There is a difference.") Karski, who was completing his PhD at Georgetown, was grateful to have Czapski on his conference roster. Having read his wartime chronicles, Karski took the initiative of writing personal letters of invitation to individuals of consequence in Washington, encouraging them to attend a talk by a distinguished speaker of whom they had probably not heard. The colloquium, sponsored by a group known as the International Relations Inquiry was called "Sovietism as a Philosophy and a Technique."

In the United States, concerns about the fate of soldiers taken prisoner of war by the Soviets surfaced as a topic of congressional discussion once American troops became more deeply embroiled in a war against communist forces in Korea. Seeking a context for such an investigation, a committee of members of the United States Congress was formed to study the conditions that led to the massacre of prisoners under Soviet rule at Katyn. The Madden Committee, named for its chairman, Representative Ray Madden of Indiana, held meetings between October 1951 and November 1952. The committee traveled to London, Frankfurt, and Berlin, convening the first congressional sessions ever held

overseas. Eighty-one witnesses were interviewed, one hundred eighty-three exhibits were produced, and more than one hundred depositions were taken. Czapski ("known in Washington, to the War Department and the Department of State") was called to Frankfurt in April to testify as a primary witness. Under oath he proclaimed that "Russia is the most centralized country in the world when it comes to issuing orders or directives or policy. Full responsibility for this crime does not rest with some NKVD sadist, but with Beria and Stalin." The committee's final report, filling seven large volumes, appeared in December 1952. Unanimously, the committee concluded that the NKVD had been responsible for the murder of thousands of Polish officers. As a congressional committee, they recommended that the Soviets be brought to trial before the World Court. The newly elected Eisenhower administration neglected to move on the committee's recommendation.

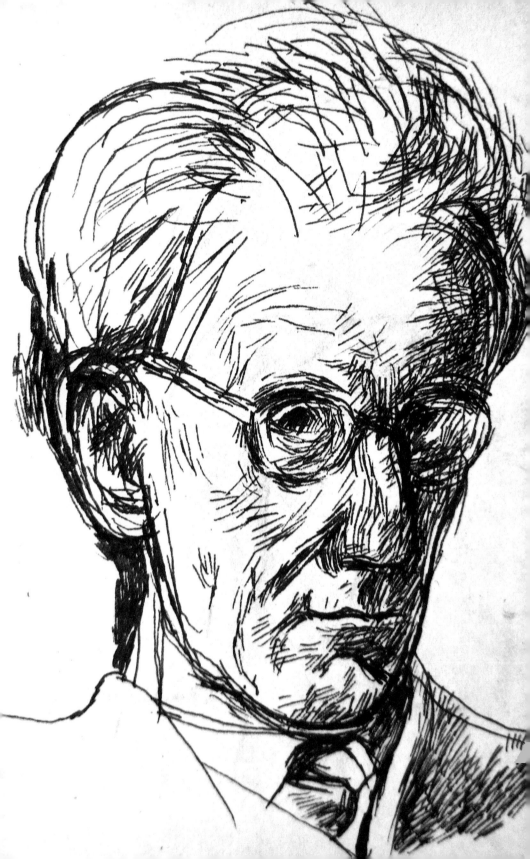

A Return to Painting

1951–1979

14

CZAPSKI WAS FINALLY ABLE to establish a consistent routine in Maisons-Laffitte that would fill his days for the coming decades. So much had needed to be set right in his life before he could allow himself to shift his internal balance of power to painting and sustain that focus. Preparing to stake new ground, he proceeded with curiosity. Would there be an apparent stylistic carryover from before the war or a rupture? A painting from 1950, a spare, almost Romanesque figure of a woman seated in profile at the keyboard of a harmonium, is inconclusive evidence. The dominant palette is somber but saturated. The woman is wearing a dark blue sweater and dark brown skirt. A black lace mantilla, pinned to her reddish brown hair, frames her solid yellow face, shown in profile. Her body is turned toward the instrument that appears to have swallowed her hands. The image is tightly cropped, including just the figure, a glimpse of the edge of the piano, and a background reduced to an overlay of scumbled brushstrokes. Painterly associations point more to the flinty crudeness of Rouault than any brightness of color à la Bonnard. The mood of the picture is doleful, prayerful—the eyes of the pianist are shut, she is focused intently on playing—but at the same time the suggestion of melodies unheard is uplifting. The image is both inert and highly charged, as when one gives oneself over to music.

The painting was bought by Jeanne Hersch, a Swiss philosophy professor of Polish-Jewish origins Czapski had met in 1948 and worked with as a colleague at the magazine *Preuves*. They had both attended the Congress for Cultural Freedom in Berlin. It was the first of many of his canvases she would purchase over the years. Impressed by his intelligence and integrity, Hersch, a former student and translator of Karl Jaspers, found overtones of Rilke in Czapski, sensing in him "a kind of humanity by permeability, a manner of allowing thoughts and feelings, be what may, to penetrate his inmost depths and transform him." Pleased to be of practical assistance, she provided an introduction to the director of Galerie Motte in Geneva, and there, in 1951, Czapski

held his first exhibition of paintings and drawings since 1939. A catalogue, with a tribute by Daniel Halévy, accompanied the exhibition. In his essay, Halévy offered a confession: Czapski's prewar paintings had always been a source of frustration for him. He was repeatedly confounded by the painter's focus on color and form. "How is it that Czapski, so sensitive to human relations, was such a dehumanized artist?" He recalls saying to his friend: "I'll be happy on the day I find a human face drawn by you." When war erupted, Halévy heard all sorts of dire reports about Czapski's fate. Then, one day in 1945, while staying in the countryside, he received a telephone call telling him that Czapski was back in Paris.

> What a lot of stories he had to tell! We talked, he recounted tales, helped all along by a fat sketchbook whose pages he turned rapidly, and on these pages I noticed, among the scribbled lines, o happy surprise!, many drawings of faces. "There they are," I cried, "the faces I've been longing for!" "Yes," he explained, "I spent a lot of time in prison camps and developed a taste for drawing my comrades." Happy conversion! Catastrophe reduced his Montparnassian attitudes to nothing, saving the artist.

The following year Czapski's work was shown in a solo exhibition at Galerie Bénézit in Paris, a venue with which he established a secure business relationship and where he would show his work for many years. His first show of new work brought out many old friends and supporters. Among the well-wishers were André Malraux and Albert Camus. Czapski had arranged for *Kultura* to publish excerpts from Camus's book *The Plague* in Polish translation. Malraux had then written to Camus with the suggestion that, in lieu of being paid for the rights, he allow *Kultura* to retain the fee and "hand it over to Polish writers in exile." Camus readily obliged. The Algerian-born writer came to have a look at Czapski's exhibit just at the moment when his contentious fallout with Jean-Paul Sartre was being made public, dominating the front page of every European newspaper. In a note Czapski wrote to Camus to thank him for having come, he drew parallels between power plays in the political arena and in the art world. Camus, expressing his doubts about ideological campaigns in general, and about any progress the avant-garde might be making in particular to further the cause of art, graciously replied, "I wouldn't worry about not being part of what one calls *the movement*. The movement today isn't moving forward. What continues to advance is exactly what is beyond move-

ments—a gift for observation, composition, and, finally, genuine feeling."

To Ludwik Hering, Czapski offered this report of his critical reception and his state of mind:

> The reactions are odd. One of the best critics here who genuinely admired the drawings said that my paintings are like a "slap in the face" for him, that they have French influences but are not in the least bit French, and then he added that this can be explained by the fact that I'm not French. I thought that this was the best compliment I could get, since if these paintings were French, defined as having the most perfect taste and charm, where would I be? My latest paintings are not cheerful; on the contrary, they are very dark, disturbing to "people with taste." I think that painting is always a challenge and that my canvases contain a lot of darkness, like an inner gash, hundreds of times more than my relations with people do, even with those to whom I'm close.
>
> I'm fifty-seven already, life is leaving me, ending. I've never been able to deny myself anything, I have never totally sacrificed myself, I've always wanted, desired, and for this reason, the instants of Grace were so few and the moments of darkness so many. Painting has been immensely helpful to me, more and more, especially this past year—I think that I know now what I must be aiming for. At times my drawings (this smacks of foolish megalomania) are almost those of a master, and the oils are still very uneven, often bordering on kitsch, but of course they are the most important and dearest to me.
>
> Drawing represents ten whole years of *not* painting. I wish I had today this ease with oils that I already have in some of my quick drawings.

Czapski's drawings are consummate works: immediate, alive, and fully realized. He drew in a state of complete absorption. Bending slightly from the waist, he worked quickly, his sketchbook held out in front of him, only occasionally looking down at the paper, his hand loyally recording whatever path his eye traversed. In the process of transferring this image from sketchbook to canvas, the drawing's spontaneity is too frequently sacrificed, the moment lost. In his drawings, a language in which Czapski was more than fluent, he managed to achieve a certain degree of eloquence. His graphic expressions were effortless, vivid, searching. His progress in achieving mastery in the language of painting, by comparison, was slow going, requiring more concentration, more practice. But he had moments, flashes of balancing control and inspiration.

His drawings manifest a relationship between dark lines and a white page. A single stroke is enough to indicate the surface an object sits on; with the simplest suggestion of a few squiggled lines, a person leaning on his bicycle appears. Spatial relationships immediately become more complex when painting. The spaces that emerge easily when drawing on paper must be more fully accounted for on canvas, embracing more complexity. Attention must be paid to color and value, light and shadow, opacity and transparency. This all conspires to overwhelm the less encumbered simplicity of line. More than is true of most painters, Czapski grappled with this transition from line to color. Making the change from pencil to brush, he frequently stumbled. Cézanne's lesson failed to combust spontaneously in him. He was very slow in developing a facility for the highly temperamental medium of oil paint. Every student of painting learns at his or her own pace. (And with very rare exception, every painter is always, and forever, never more than just a student of painting.) Even in Paris in the 1920s, Czapski watched as each of his younger colleagues found a path, going from strength to strength. Aware of not being proficient in certain preliminary skills, he applied himself and, eventually, developed an eccentric touch, distinctive enough to express his own vision, to be his alone. In the 1930s, he laid the foundation for a body of work with canvases unquestionably bearing the stamp of a sensibility in ferment. The crucial missing decade of the 1940s, when he barely held a paintbrush, set this development back. The great flowering of Czapski's work as a painter begins quite late in his life, at which time, from sheer doggedness, he finally gained confidence in his ability to paint directly, rather than continuing to translate from line to color, from drawing into paint.

Czapski was certainly capable of producing powerful images on canvas, but working in oil colors was a complicated activity for him; he was often too self-conscious of his technique, operating on a less intuitive level than when drawing. Evidence of sustained effort can easily defeat a picture, deflating what Czapski called the image's pictorial breath. *The Beggar*, a painting from the early 1950s (plate 7), feels labored, the brushwork awkward and clumsy, but it is also clearly inspired. A fine representation of Czapski's strength and singularity as a painter, it is not so much that he has finally mastered the unity of line and color as that he brilliantly melds method and mood. An example of a work that is "like an inner gash," *The Beggar* displays the full form of a tall man dressed in a bulky overcoat seated indoors on a bench, emotionally col-

lapsed in on himself. His head is dropped forward so only the crown of it can be seen, a round black hole on the canvas. One hand has dropped out of sight between his legs, the other sits in his lap, palm turned up in supplication. The imploring sign of a slightly raised thumb articulately voices all the communicative effort of which he is capable. His legs propped down before him, spindly and rubbery, seem as if they would barely be capable of supporting his body. His feet point in toward each other. The wooden bench on which he sits is affixed to a tiled wall behind him. The floor, a bold and rhythmic pattern of linoleum squares, tilts precipitously down and out from under his feet. The subject is in a stupor of emptiness; the pulse of the picture is in the decorative elements surrounding the slumped human form. Is he sleeping, or drunk, or suffering terribly? He has imploded, only his hand seems alert. The overall palette is subdued of color, muffled, nearly grisaille; one hint of pink for the entreating thumb and another for a strip of exposed flesh at the back of his lowered head attempt to introduce human warmth or to alleviate the gloom, but the gesture seems feeble, against the odds, in keeping with a mood of quiet despair.

What is it about this image that prompts Czapski to capture it, what drives him to devote himself to the act of recording such a bleak portrait of a sad life? We are not inherently drawn to these subjects of his—a forbidding concierge standing guard, a blind man with his cane, a docile clerk working at a bank counter, an old woman sitting alone on a train—but what makes the pictures compelling is *his* interest. Like a manic character in a Dostoyevsky story, Czapski becomes inflamed at the sight of a person, or a group of people, or a color, or a flower, or a moment suddenly observed that calls out to him to be painted. He makes a quick sketch and then rushes home to imprint the image on canvas while it remains clear and fresh. The painter Stanisław Rodziński recalls waiting one day with Czapski on the platform at the train station in Maisons-Laffitte, heading into Paris to see an exhibition. They both noticed a woman wearing a yellow beret, red sweater, and purple skirt. Czapski whipped out his sketchbook and began to draw her, adding his usual notations for colors. The two painters boarded the train and traveled on, but once inside the galleries it became clear to Rodziński that Czapski was preoccupied and possessed, conflicted about wanting to be with his friend but needing to work while the image of the woman in the yellow beret was still vivid in his mind. Unable to let go of it, Czapski excused himself, fled the museum, and dashed

back to his studio. By the time Rodziński returned to Maisons-Laffitte later in the evening, he found that Czapski had finished several more drawings and made a painting with which he was completely unsatisfied. "I should never have gone with you. I had it, but it just vanished." Painters know from experience that rare moments occur when, brush in hand, you find yourself capable of tapping into something far greater than what you might have thought possible. The process requires a kind of magic, elusive and unbiddable.

> What's most elevated and singular always comes from the present moment. Sketching a white radiator against a white wall, or ordinary apples on an ordinary table, I'm really dazzled by the unlimited richness of forms, of colors, of values, and aware of the meagerness of my means of expression in relation to so much in the world, and in a certain sense I cease to exist. What's most significant for me in this polemic is the observation that what leads me is not a theory but a vision, not a preconceived idea but a blind necessity, that my visions are cyclical, independent of my will, of my thought. I don't at all deny the (immense) role of thought and will, but their time and place is found elsewhere—before and after.

The impact of a vision renders him "dazzled," leaves him stimulated and sensitized. "I can only compare it to an erotic experience." Not setting out to make "art," Czapski strives to capture life and the world as he sees and experiences it through the medium of paint. "Art serves to transmit sensations that are greater than we are, but igniting these sparks doesn't by any means turn the artist into a god. He is only the means of transmission." He often refers to himself, brush in hand, as "playing Don Quixote," obeying voices he hears within. Writing to Miłosz, he describes the manner in which his eye and hand simultaneously receive instruction:

> A muffled shock comes to me, speaking softly and bluntly. A whisper: "Paint that!"
> —"But why that?"
> —"That's not your business to know. You'll know later. Or maybe you won't."

Here it is in a nutshell. The rest is merely technique and discipline, call it preparation, entirely necessary, but only ever just a rehearsal for the moment

when the command, a bolt from the blue—"Paint that"—catapults the painter to another realm of perception and understanding.

As he understood the breakdown of his own body of work, Czapski's oil paintings fell into three distinct categories (to which I propose a fourth, his self-portraits). The first group includes still lifes, which he turned out methodically, with varying degrees of success, as pictures in and of themselves. Selected from a familiar inventory of props—a few vases and pitchers, a worktable, an end table, a chair, a fabric drape, pieces of fruit, some flowers—they are sometimes exuberant, as when a bouquet of blooms fills the canvas, sometimes subdued and reflective in mood, an empty bowl on a dark cloth. His setups can feel conventional and uninspired because his commitment to the genre has more to do with the discipline it enforces—like a musician doing scales or an athlete running laps—than with any conscious search for inherently compelling forms of beauty. "You can paint a still life even on your worst day, when nothing is going right," he liked to say. Painted in the same room in which he slept, his still lifes often project a sensual warmth derived from a suggestion of the unseen artist, whose bathrobe or blanket or coffee cup has been sacrificed for study, fresh from contact with his bed-warm body. Unintentionally intimate in nature, they reveal a private side of Czapski, as if one had stumbled upon him still in his pajamas. His penchant for transforming the commonplace into subjects for study—sinks, radiators, bottles, the spartan furnishings of his room—suggests the depths of a private solitary being. These objects are vital presences with whom he shares his days, they are forever calling out to him—his easel, armoire, mirror, bookshelf, and desk. He considers their ostensibly inanimate nature much in the way Proust's young narrator considered his bedroom: "Perhaps the immobility of the things that surround us is forced upon them by our conviction that they are themselves and not anything else, and by the immobility of our conceptions of them." Periodically Czapski will tire of the formality of this endeavor, of what he thinks of as a "Dutch" approach to picture-making, and put off doing another one; but always, after a brief hiatus, he returns, finding that still-life painting allows "my eye's sensitivity and accurate rendition of color and form" to flourish. When not properly exercised, his eye suffers.

The second classification, the largest of the three, includes paintings taken directly from images beyond the closed world of his studio, most of them translated from sketches he has made while out and about in Paris or on his

travels. The subjects range from figure studies to landscapes to personal scenes of daily life to portraits: glimpses of people in varying states of connection and detachment seated at café tables, waiting for a train, lingering on a street corner; performers onstage at the theater and in concert halls, or members of the audience; cartoonlike automobiles, mechanical equipment, bicycles, power lines, and pylons; deserted streets in rural villages, parks, pedestrian crowds in the city center, workmen in overalls, dogs, old women, bathers at the seaside; solitary figures standing at pinball machines or before paintings, stooped bodies peering into display cases at exhibitions; trees and fields, clouds and sky, mountains, seascapes. These works are made comfortably, assuredly, knowing what it is he is after, in pursuit of an image he has latched on to from his routine life, hoping to relay a feeling of freshness and surprise through the use of unexpected angles and points of view, realized with a flair for unconventional cropping. The compositions are frequently idiosyncratic, but their power stems from the immediacy of the impression received by the painter, from the process of transforming what he has seen into his own re-creation of that experience of seeing. Over and over the process repeats itself.

The third category of paintings is difficult to convey as a unity, its boundaries the hardest to delineate. These works are dominated by images that have percolated deep inside of him, and, Czapski explained, have had to be extracted "from my own memory." Expressionistic, occasionally even grotesque, these works are inspired by the power and freedom that once bowled him over standing before the black paintings of Goya and the agitated canvases of Chaim Soutine. In an appraisal of Goya's influence on modernism, Malraux wrote that the Spanish painter "foreshadows all modern art; nevertheless painting is not in his eyes the *supreme* value; its task is to cry aloud the anguish of man forsaken by God." Men and women seen in this category of works by Czapski often border on destitution or indigence, and include those afflicted with *atonie* as described by Gobineau. Solitary, intense, they are figures on the edge, turned inward. Attuned to certain realities in himself and in the world around him, Czapski was a painter with an empathic character who would find these marginal beings compelling to paint: *The Blind Man*, *The Passenger in Third Class*, *Misery* are the titles given to such works. Somber in mood, if not outright depressing, they present an aspect of visual and ethical truth, one we are often inclined to turn away from once having confronted it, finding ourselves saddened, rendered helpless, repulsed. Czapski, attracted to the splendor of the physical world, also acknowledges these unseen psychic spaces each of us car-

ries. The scope of his subject matter expands to include life's dark underside of pathos and pain. An urgent disquiet, coupled with an unwillingness to look away, yields brooding, superficially unappealing, difficult paintings. And yet the shift toward expressionism is an act of exaltation, a blending of the unseemly with the beautiful, as captured in a favorite poem of Czapski's by Hugo von Hofmannsthal, "Manche freilich" ("Many, it is true"), with its acknowledgment that "the light are bound to the heavy / As the air is bound to the earth."

The weariness of peoples quite forgotten
I cannot banish from my eyelids,
Neither can I keep away from my terrified soul
The silent descent of distant stars.

Many fates weave alongside my own,
All are interconnected by a common existence
And my part is more than simply this life's
Slender flame or narrow lyre.

In these stark, often tender works, Czapski concocts a commingling of internal and external verities, a highly individualized synthesis of lessons learned from Proust and Cézanne.

These divisions are rudimentary but serve to impose a preliminary order over a large body of work. Another approach, involving the application of conventional art historical notions of early, middle, and late periods, is harder to enforce. Many of the hundreds of canvases Czapski painted are signed with the year of execution, though the majority bear only a signature. As is true of his undated letters and journal entries, undated canvases can be difficult to locate in the continuum. His painting technique is unconventional. In each of the categories outlined above, there are clear progressions, slow and steady, as the work moves to a greater command of his aesthetic impulses, as he masters whatever means are necessary to best express the impact of the moment. His touch is inconsistent over the decades, but from his very beginnings as a painter he is capable of pulling off something rare and wonderful. He is not proficient technically nor does technique especially concern him. Passages can feel heavy-handed, crudely painted. This crudeness, an extension of his resistance to overly refined aestheticism, is a reminder that for him, painting is not about creating an artificial beauty. Many works have an amateurish look to them,

with uneven surfaces and varying degrees of finish, but the life force captured in his works is unmistakable, representing something entirely more interesting to him than style, than technique. His strengths lie elsewhere. The cartoonlike nature of many figures borders on the exaggerations of caricature. A series of figures riding in the third-class carriage of a train evokes the spirit of Daumier. He is unapologetic about his rudimentary skills when put to good use.

Painting, for Czapski, "is a form of prayer." Significantly, he declared, "painting is always a defeat. The defeat always carries an obligation to go on further. I can't imagine a peaceful painting that hasn't paid for its happy resolution."

What is vision? A certain synthetic, singular way of looking at the surrounding world. A moment of such vision always comes unexpectedly, like grace. Sometimes without any preparation, without means to give it a proper embodiment, sometimes after many years of work, as a reward—always incommensurate and even incongruous with the effort we put in. Sometimes it arrives inconspicuously and manifests itself slowly and more and more effectively in a work begun without vision, or virtually without vision.

If we read the medieval mystics, we find striking analogies there with the artist's vision, the paths leading to that vision and the paths that lead to states of ecstasy. I don't want by any means to confuse the infinitely more sensual, material experience of the artist with the ecstasies and states of prayer of Saint John and others, but nevertheless the analogies are so striking, the graph of these states is so often identical in its fits and starts, that even the most secular artist should give it some thought.

Finally able to commit himself fully to the daily ordeal, Czapski became the painter he always hoped to be, working tirelessly and building toward a future that promised endless discipline. His painting gains depth and resonance as he learns to identify and obey his own instinct and to trust his ability to capture whatever is essential for him, assembling a fairly eclectic body of work and satisfying a variety of painterly impulses. Over the coming decades he would continue to exhibit widely and regularly.

A beautiful letter arrived from Italy. "Because of our shared love for Proust and Bonnard, I feel very close to you." The letter, full of praise for Czapski's writings about painting in the pages of *Kultura*, was sent by a precocious intellectual who felt he had much to learn from an unusually articulate artistic

sensibility. Konstanty Jeleński was a young, well-read aristocrat who came "from the last generation of Poles of the landed gentry intelligentsia, those who spoke French more often than Polish." Having once seen Czapski in Paris, only briefly, he was prompted to prolong the acquaintance by mail at the encouragement of a mutual friend, Jan Tarnowski, who had been an intimate but disruptive presence in Czapski's early life. Czapski replied enthusiastically. Two years after posting his first letter, Jeleński moved to Paris and quickly put down roots. Quite soon he was known everywhere, and by everyone, simply as Kot, a contraction of his first name and also the Polish word for cat.

A quarter of a century younger than Czapski, Kot was born in 1922. His father, also named Konstanty Jeleński, held a string of diplomatic posts across Europe, in Madrid, Bucharest, Vienna, and Munich, and the family accompanied him as he moved from embassy to embassy. Kot adopted a cosmopolitan spirit early on. Only seventeen when Poland was invaded, he rushed to join the Polish army in France on his eighteenth birthday. When France fell shortly after, he went to England and combined military service with university studies. When the war ended, after having taken part in the Normandy landings, he was a seasoned veteran at twenty-three. Demobilized along with thousands of other Polish soldiers on the Italian peninsula, he found work with various organizations, ultimately as an economist with the United Nations. While in Rome, he lived for some years with an American painter, Bernard Perlin, who had a large working studio and a generous stipend at the American Academy in Rome. Kot blossomed in proximity to working artists and savored the atmosphere of the atelier. One day he was introduced to the Argentine Italian surrealist painter Leonor Fini by a mutual friend. Confident, independent, irascible, Fini projected an allure that worked on Kot like a charm. The impact of their first meeting was galvanizing. Some deep hunger in him was fulfilled trying to satisfy her exhibitionist needs. Kot finessed his way into the protean ménage of admirers and lovers huddled around Fini. Cherchez la femme, he deserted Perlin, left Rome, and followed her to Paris. For the next thirty-five years, Kot remained by her side. "Everything that is good within my nature is strangely tied to Leonor, though maybe also everything difficult. Everything that is not superficial, I owe to her."

Jeleński would distinguish himself as a critic, translator, and essayist across a broad spectrum of European artistic and intellectual circles. He had a brilliant, penetrating, mercurial mind and a tender, loving, affectionate character. Oxford educated, he wrote in five languages about art, French and Polish

poetry and politics. His reviews and commentary were published in *Le Monde*, *Der Monat*, *Tempo Presente*, *Partisan Review*, and *Kultura*. The year he first went out to meet Czapski at Maisons-Laffitte, he began a twenty-year tenure on the editorial board of *Preuves*, the journal of the Congress for Cultural Freedom. Translating Polish poets into French, he became an ambassador of Polish literature. Mary McCarthy, who described him as "elegant, physically and morally," declared him to be the essential link between the cultures of Poland and Eastern Europe and those of Western Europe and the United States.

Kot was many things to many people. He knew himself well. "I want to tell you," he wrote very early on to Czapski, "that *what I'm going to do* or *what I am devoting myself to* is to a certain degree now less important to me than that I simply be me." And who was that?

> I've been, in no special order, a liberal, a son, a humanist, a reader, a scrupulous functionary, a Pole, a friend, a lover, a pederast, etc. "Kot Jeleński" is a somewhat Promethean character, if someone's looking, a whole series of characteristics adding up to a fictitious whole: a physical aspect, a succession of events culled from life, friendships nurtured to prove that one exists, intellectual convictions, a philosophy chosen with a view toward a certain eclecticism, and a "historic" approach to the world and to life.

Always impeccably turned out, Kot was the rare Polish intellectual entirely at home in his own body, who yielded as willingly to his appetite for sex as to his insatiable hunger for knowledge, equal parts Apollo and Dionysus. Over the years, he and Fini retreated from Paris to various remote islands to live in a state of (knowing) innocence, often unclothed, as if in search of life in the garden, before and after the fall. Men and women in Kot's intimate sphere of relations describe how he would physically touch them while speaking with them, establishing meaningful contact, which they experienced as a jolt, an almost electric connection. "He was flesh incarnate," one friend recalled, "with no taint of the devil whatsoever." In a late poem about Fini, Miłosz refers to Jeleński as "truly a gorgeous man" with "boyish looks."

Kot's relaxed attitude toward sensuality was inbred. His mother, a great beauty, was a translator of French and Italian literature into Polish and a colorful fixture of the beau monde between the wars, traversing the map of Europe with her ambassador husband. Kot was always much-loved by Jeleński père,

but sadly for Kot, the harsh reality was that this man with the same name was not his real father. The Italian diplomat and anti-fascist foreign minister Count Carlo Sforza and Kot's mother had an affair from which Kot issued. Sforza, with two children of his own, maintained a lifelong indifference to Kot. In a bizarre twist, Sforza's acknowledged son, Sforzino Sforza, Kot's biological half brother, had also once been a devoted lover of Fini's.

Never one to be forthcoming about his erotic life or to dwell on his "physical aspect," Czapski teased Kot about their unsuitability as friends. With little patience for Fini's histrionics, he recoiled from her avid self-involvement. Their respective approaches to picture-making were entirely incompatible. It is a tribute to the trust in which he held Kot that Czapski was willing on occasion to enter Fini's realm and bow before her, recognizing this as the way to keep the peace, to avoid putting Kot in a position of conflicted loyalties. This trust was reciprocated. Uncharacteristically, Kot lowered his guard to Czapski, used him as a sounding board to express the periodic chaos of his emotional life. "I don't know if you understand me," he wrote to Czapski while away on holiday in Calabria with Leonor:

> Several times lately you've spoken about my "sadness" and said there is some-
> thing in me that "worries" you. But everything, I think, must be measured in
> broader terms. It's possible that life with Leonor makes me sadder than if I lived
> on my own. Alone, I have a facility for adaptation, I delight in easy victories,
> I have the "lightness" of someone untethered from the torpor of heavy eroticism.
> But often, when alone, I have no feeling for life. This feeling is given to me by
> Leonor, and maybe by my tender and fiery love for her, bitter and sad though
> it is. You see, you've so often said that our friendship makes no sense, but
> nevertheless it's to you alone that I can say all this.

The two men became soul mates and intimate friends, like-minded spirits equally voracious in learning, providing each other with a sense of aesthetic and political fraternity. Their correspondence consists mostly of letters written when Kot was away from Paris, sequestered with Fini on Corsica or at their country place in the Loire valley. Packed with references to what they were seeing and writing and reading, these letters project a warm intimacy, revealing the strength of their exceptional bond. Rare specimens, they were two of a kind, embodying an enlightened largesse drawn from the best that privileged birth offers. Intolerant of intolerance, they shared a feeling of revulsion for

the parochial anti-Semitism of their colleagues and an undeniable attraction for their own sex. Each held a deep gratitude and respect for the other's wisdom and love.

Despite his relative youth, Kot would agree to sit in judgment of Czapski's creative output whenever asked. He was generous in his assessments but could be stern. From the fleshpots of Rome he addressed a letter to the ascetic in Maisons-Laffitte, slightly defensive but clear-eyed:

> Your Christianity, like Rozanov's, is connected to a cult of the everyday, with its grayness. There is also already in you a very strong Puritan element that is anti-aristocratic, heightened in your case by a rebellion against your own milieu. I think that both your irritation and your judgment are highly "superficial" because they come from the upper level of your consciousness, from "the atmosphere of modernity." Your own aristocratism, your hunger for beauty and life and truth shines through the quotidian. It exists despite yourself. Like Midas, you turn this into gold.

Czapski came to rely on Kot's appraisals. A source of such profound understanding and trust is an invaluable treasure in the life of an artist.

As Czapski consoled Kot about his tumultuous intrigues with Fini, he was himself involved once more in a complicated relationship with Catherine Harrison, the Canadian woman he had declined to marry in the 1930s. Reestablishing contact from Stockholm after the war, she initiated another amorous connection to him in the 1950s, despite, in the interim, having married a Swedish baron, Gustaf Djurklou, and bore a son. Catherine actively pursued her liaison with Czapski, regularly making her way to Paris to be with him and, when apart, engaging in a passionate correspondence over the next twenty years.

> Joseph, my love, I feel you very close. Almost every night in my dreams I see you very clearly. Last night I saw you at your typewriter through a half-opened door. You smiled at me. Please excuse my writing such nonsense to you. My heart is so full of love and gratitude that I cannot express myself. Dear, beloved Joseph, bless you and thank you for your patience and your warmth and tenderness and goodness.... You see I can't write to you without crying, and I cry because I have never known such happiness as you have given me in the years since I found you again.

Could you be a darling and reserve me a room at Familia [a hotel on rue des Écoles] or any other not too expensive place you choose. I feel I should not take a room in Maisons-Laffitte, which you will understand. I shall assume it is the Familia unless I hear from you to the contrary. Please promise me not to think of meeting me at Invalides [where an Air France shuttle bus from the airport comes into central Paris], I may be very late. I'll telephone you as soon as I wake up on Monday morning. Maisons-Laffitte 1904. You know I sometimes wake up in the night saying the number....

Dearest Joseph, I don't like writing but I know that you read between the lines. Happy New Year to you and Marynia.

I love you.

Your Catherine

Czapski certainly welcomed Catherine back into his life. "We met every year for twenty years. Through all the years of her husband's illness she would come to Paris to be with me." However, he admitted he personally had "an inability to trust in true love." Several canvases—interior scenes with an armoire, chair, and table arranged around an open window giving on to an air shaft with pipes—have been suggested as loving tributes, painted in the afterglow of their trysts in the same hotel room near Gare Saint-Lazare year after year. He kept her well-informed of his painting exhibitions, several of which she traveled from Sweden to see, and he sent her clippings of his published articles and essays. A director of the Swedish Fulbright Program, she worked professionally in the arena of international cultural exchange, but Catherine was not an intellectual. Whatever the extent of their amatory connection was, she brought an unexpected reservoir of female tenderness and affection into Czapski's life.

Working in his studio, he faced the eternal call-and-response of process and inspiration. He considered this analytically, writing down his thoughts each night after having cleaned his brushes:

It's always the same! The first stab seems entirely satisfactory but as I proceed, I move toward a naturalism, which wouldn't be so bad, but then I move in toward a detail and correct it, and in making the correction, I destroy the whole—the painting is ruined. Genius lies in the ability to make the most of conditions as they exist, not in dreaming of ideal conditions that don't.

309

So why do I work? Because in this work, and only in this work, I have the feeling that I'm headed in the right direction, the direction toward making what I do come to life. The question of fame? Do I suffer from having come to nothing, that for a long time art has moved beyond me, I'm not in step, is this for me a humiliation? I'd rather have some money, have a real studio, clients who buy from me as they buy from [Jan] Lebenstein, real collectors, but all the same, truly and sincerely, I'm not in the least touched by all this, I don't think of it, but what's more, my painting doesn't lend itself to all that, it's too uneven.

In concert with his painting and writing, he was eagerly reading a three-part history of art compiled by André Malraux, originally called *La psychologie de l'art* (The Psychology of Art), ultimately issued in one volume as *Les voix du silence* (The Voices of Silence). A lyrical six-hundred-fifty-page prose poem, the book presents itself as a history of the visual arts over millennia, a quasi-encyclopedic thesis attempting to break down, assess, and reassemble our understanding of modernism in light of the past. The central concern of the book is to revive lost worlds of primitive and sacred art and bring them back to light both on their own terms and in relation to art of the ensuing centuries. Ever on the lookout for clues to better evaluate modern abstraction by contextualizing it within the history of art, Czapski was hungry for illumination; he read *Les voix du silence* as both theoretician and practitioner. Malraux presented Sumerian art, Cambodian sculpture, prehistoric Rhodesian cave painting, and Mexican murals alongside the works of Botticelli and Georges Braque. He paired a Piero della Francesca panel with a twelfth-century Buddhist fresco. Czapski questioned this approach, with its blurring of boundaries, in his review of the book for *Kultura*. On the one hand, he claimed, "chaos and discord" ensued. On the other,

profound confrontation, on a scale never before attempted. Malraux seeks relationships and contrasts between these works of art, not based on content but on style, formally. . . . He knows that form, even the most abstract, always expresses something: a religious experience (the source of all the arts, with the exception of modern art) or the revolt against a civilization that has lost the ambition to create a hierarchy of values. Only in the nineteenth century— Malraux dates the break from Manet on—does the artist openly declare his independence; it was not content or a fidelity to nature that created value in a work of art, but the pure play of color and form.

Skeptical of some of the author's claims, Czapski too often finds in the book's fluid ease of expression a tendency to gloss over questions of fact, a quality, he observes, equally true of Malraux as a conversationalist. What puzzles and stymies Czapski is Malraux's nearly wholesale acceptance of abstraction as *the* formative means of expression in his time. Malraux, the mythomaniac, posits one true path alone, and Czapski was not on that path. To cling to representation or figuration as Czapski did was to risk being perceived by the prevailing critical zeitgeist as reactionary or engaged in a completely anachronistic activity. He remained stubbornly devoted to the visible world around him, his resistance to abstraction as a painter deeply grounded in his loyalty to the human values he saw it bent on destroying. "Abstraction seems more and more foreign to me."

I'm waiting for a bus in a gray street. My joie de vivre? I think this is what signifies: The will to live, to work, after having been in solitude. I breathe again with my breath, I see anew, I breathe with my eyes. Earlier in a café: a woman's leg and the edge of her striped skirt. Her leg was wrapped around the foot of a modern armchair. This woman doesn't interest me at all, but I want to, I must, make note of this leg wrapped around the chair. Waiting for the bus: an old house, black, with traces of gray hairline cracks. These two glimpses—of the leg, of the house—which are far removed from any normal regard, why exactly is it that these ask to be noted, and in what way are they so totally different? My discovery of the world is the discovery of forms or compositions that exist in the world, that surround us, and that usually go unremarked upon by us. Who, apart from me, looks at ugly legs, and, at a bus stop, a house neither beautiful nor ugly, only filthy, as if covered in dust? I look at it because I'm charmed by this great delicacy of gray.

In his suprematist manifesto, Kazimir Malevich denounced representation as a bourgeois notion. The Russian avant-garde was antipathetic not only to representation but also to what representation represented—namely, humanity. The proto-cubist breakdown of picture space related to a breakdown of ideals and institutions, a breakdown of life as it had been known. Czapski was suspicious of the avant-garde's flirtation with absolutism and its overtones of fascist ideology. The interconnection of political history and art history touched him vividly.

The Russian language of modernity, inspiring movements like suprematism, was welcomed by the first wave of Bolsheviks as a radical break from hidebound

tradition. In an ideologic about-face, such modes of expression were quickly vilified and avant-garde aims were denounced as counterrevolutionary. During Stalin's reign, ideas of *any* kind were too dangerous to commit to paper or canvas. Fear dominated every creative act. One never painted or wrote or composed what one wanted, the threat of consequences was too great. The humble materials of the visual artist—paper, pencil, paint—in and of themselves became suspect. In place of Soviet modernism, an enforced paradigm of socialist realism was institutionalized to dignify the labor of workers in steel plants and on communal farms. This became the only acceptable lens for portraying the new order. Though resistant to the reductivism of the avant-garde on the one hand, Czapski found social realism to be merely doctrinaire on the other, the painter's role essentially reduced to coloring between the lines drawn by the politburo, a creative process prompted by obeying, not seeing, by submission, not truth. This enforcement of a sanctioned mode of representation was as offensive to him as constructivism or suprematism.

> One of the central themes of Malraux's book is the attempt to wrench the reader out of the charmed circle of realism which has constituted European art from the Renaissance to the nineteenth century. He demonstrates that art arose not from the study of nature or the attempt to copy the thing seen but from man's beliefs and his conception of the world. He even attempts to view the realism of Courbet, for example, as above all a revolt against the "ideal beauty" inherited from David and Ingres, and not as a struggle to achieve fidelity to nature. But Malraux creates a misunderstanding; he minimizes the equally important element of realism, that is, the desire to render what the artist sees. It is clear that art cannot exist without abstraction, but Malraux does not sufficiently stress the fact that art, like Antaeus, must renew its contact with the earth to keep its strength.

In this insistence on "contact with the earth," Czapski's critical prejudice is revealed, he stakes his claim. Meanwhile, postwar European visual culture, predominantly centered on Paris at midcentury, also presented a manifesto of territorial commitments. The French, recovering from the upheaval of war, shedding their memory of Vichy and collaboration, picked up where they had left off, resuming their presumption of cultural supremacy. Basking in an ongoing idolatry of Picasso, Parisians paid little heed to other European artists who, having fled for their lives across the ocean, were generating a new artistic power

base, grafting the emotional experience of expressionism onto the rootstock of abstraction. Paris, capital of the nineteenth century, gave scant credence to what might be happening in America, beyond its role as a commercial resource for the importation of European culture. Czapski, on his visit to New York in 1950, had no sense of arriving in the capital of the twentieth century, the center of a new aesthetic world order. The playing field of cultural authority was shifting from France to the North American continent, fueled by consumerist values and a bullish marketplace whose beneficiaries were willing to invest in art. Frequenting the Museum of Modern Art, Czapski admired its extensive collection of Matisses and Cézannes, but had no knowledge that only a few subway stops away painters were at work addressing the same issues of abstraction and figuration that continued to inflame him. These newly American painters from Europe were establishing a fresh vocabulary, a synthesis of old-school traditions and current concerns, creating what would come to be known, contentiously, as abstract expressionism.

Many of these painters had sensibilities surprisingly compatible with Czapski's own. Claiming he had "a lustful relation to things that exist," Mark Rothko resented being called a colorist. His large output included hundreds of figurative paintings from the 1930s that were remarkably similar in sensibility to those Czapski painted—people waiting for trains on subway platforms, men and women congregated in the street, perched in windows, sitting alone at café tables, musicians performing in concerts. Willem de Kooning, Arshile Gorky, Jackson Pollock, Rothko, et al., certainly renewed their contact with the earth, but no longer felt themselves dependent on it for imagery.

This revolt against the natural world agitated Czapski, who seemed unable to keep from personalizing his distress. He dismissed Malraux's crusade to deify living painters and elevate them to the pantheon: "It would be better perhaps to say to painters that they are NOTHING," than to incite a "grandeur of false gods." The painters of the Parisian school of lyrical abstraction whom Malraux glorified—Georges Mathieu, Pierre Soulages, Jean-Paul Riopelle, Henri Michaux—were seen by Czapski defensively, more in light of their personal habits of swagger and self-aggrandizement than as serious artists.

He revealed the degree to which his own work consumed him to Hering:

A French writer said: "First there is love, then there is work, and then there is nothing." I'm still in the second phase and I know that the third, nothing, may be all there is, but that's very difficult. For now, my entire effort and my joy,

too, comes from my work. But I'm so soft, I've never learned how to carry the burden of solitude, people exhaust me more and more, and I have less and less strength, and I know now that I'm playing for my life's stakes but too late in the day. Paintings, resonant and visual, I still think are important to me; Matisse, Cézanne, Rouault, and Bonnard and, above all, Goya and Soutine.

Failing to find meaning in images that do not relate to the immediate world around him, he continued searching for the ineffable in those that did, in figures, in quotidian scenes, in objects. His perpetual wrangling with naturalism is the attempt to extract an *essence* from every image, and this practice is in itself a means of conceptual abstraction, a distillation of the process. Recognizing this paradox does not help him soft-pedal his zealous advocacy of the visible world.

In response to his critique of *Les voix du silence*, Malraux asked Czapski to consent to be interviewed by him. Malraux asked him, disarmingly, "Why do you paint?" Czapski replied: "Painting for me is an opening to something, nothing more. All the rest is secondary, failing to register what is essential, without which I wouldn't know how to call what I do 'painting.' For the painter, the canvas must very quickly be forgotten, otherwise it obstructs what is to come and any possibility of progress.... It's not the outcome that counts, but the process."

15

IN 1954, the Polish Literary Institute, forced to withdraw from its run-down but familiar headquarters on avenue Corneille, found itself in need of a new home. Identifying a suitable property nearby, the institute turned once again to Count Zamoyski, who generously agreed to provide the substantial cash loan that the purchase transaction required. The transfer of the institute's base of operation and living arrangements for Giedroyc, Czapski, the Hertzes, and other *Kultura* staffers went smoothly. Giedroyc's much younger brother Henryk had joined the administrative team in 1952 and become part of the extended family. As the émigrés took possession of their new home, the Polish People's Republic's surveillance of the anti-communist *Kultura* crowd was beefed up. Any Poles who visited Maisons-Laffitte were interrogated on their return to Poland "by men who already knew what they had discussed over lunch, and what they had eaten for breakfast." Spy cameras routinely recorded Zofia Hertz walking her dog and Czapski coming and going on his motorbike.

To support the purchase of a new headquarters and repay the loan to Count Zamoyski, a direct appeal was circulated among the *Kultura* subscriber base. The journal's loyal, if far-flung, readership had continued to grow. Seven years of consistently provocative material, considered essential reading of its kind, had established a solid reputation. Giedroyc delegated Czapski to expand the subscription base even further by embarking on another fund-raising tour, this time among the émigré communities of South America. In May 1955 he boarded a ship in Marseille for a journey of four months that would take him to Brazil, Uruguay, Venezuela, and Argentina. Before crossing the Atlantic, the ship called into port at Barcelona, Gibraltar, and Dakar. The passenger list, composed mostly of Italians and Argentineans, included an order of nuns who remained sequestered throughout most of the voyage. They were scandalized by the hedonistic behavior of the carefree travelers and found blasphemous the mock "baptism" ceremony held in the ship's swimming pool as the vessel crossed from the Northern to the Southern Hemisphere at the equator. Czapski kept notes and made drawings that would serve as the basis for personal essays

he would contribute to the pages of *Kultura* as he had done on his trip to North America. One essay, "Tumulte et spectres" (Tumult and Specters), is a consideration of the upheaval of travel and the anxiety caused at the prospect of substituting one's familiar world with an unknown one:

> I don't like cruise ships, not even the best ones, with their endless corridors and staircases.... I consoled myself with the thought that there were men (from Saint Paul to Saint Exupéry) who knew how to transform the great distances covered on foot, by boat, on trains and airplanes, into a useful tool for overcoming one's anxiety. Travel is also a way to flee from ghosts, who, unacquainted with modern means of transport, generally arrive late, offering a brief respite from them in one's new surroundings.

Arriving in Rio de Janeiro, Czapski visited Polish émigré communities and gave talks in venues large and small. Treated as a distinguished visitor, he was personally escorted to the major sights and welcomed in backwater villages, always working to cater his presentations to his audience. One excursion took him to Iguazu Falls, in Argentina, near the borders of Paraguay and Brazil, where he produced a series of drawings of the raging waters. A photograph shows him at work, trancelike, his sketchbook held out before him, a stick of graphite poised in his hand, his eyes focused in the middle distance, lost in concentration amid the deafening roar of the falls. Thin as a scarecrow, he stands with his head cocked to one side. On this journey his diaries overflow with drawings of subjects outside of his usual Eurocentric field of vision— sketches of exotic flora, brilliantly colored birds, men in large straw hats, and women carrying laundry on their heads. Making his way through remote villages in the state of Minas Gerais, he encountered the remains of an architectural and artistic style known as the Brazilian baroque, developed in the eighteenth century as a result of the incredible wealth being unearthed in the region. Mine owners, extracting diamonds and gold, oversaw the construction and decoration of elaborate churches built to give thanks. One artist, Antônio Francisco Lisboa (1730–1814), commonly known as Aleijadinho, the "little cripple," had exceptional gifts and devoted his life as an architect and sculptor to the creation of devotional environments celebrating the glory of the Bible and its stories. Lisboa had lost the use of his hands through a degenerative disease but, apocryphally, continued to carve wood and stone with a chisel strapped around his wrist. Between 1780 and 1790 he designed and built a series of six covered pavilions

in an opening cleared at the base of a hill in the jungle town of Congonhas. Each pavilion showcased a different scene from the Passion of Christ with life-size forms composed in striking tableaux. The sixty-six painted wooden figures in various configurations reveal the prevailing religious sentiments of the time—an awareness of pain and an acceptance of suffering. In 1800, already desperately ill, Aleijadinho designed a basilica at the crest of the hill, the Sanctuary of Bom Jesus, and surrounded it with monumental soapstone figures he carved to represent the twelve prophets of the Old Testament. Czapski made studies of these seemingly primitive forms whose exquisitely refined facial expressions and mannered bodies twist and turn on their pedestals high above the jungle. Stepping back from the thrill of capturing the impact of each figure, he also made sketches of other visitors and the ridges encircling the site, contextualizing the remarkable energy the works produced. His drawings of the sculptures from a range of different perspectives are bold and expressive, radiating empathic feeling, an acknowledgment of aesthetic pleasure and joy.

Czapski's younger brother, Stanisław, had been part of the Polish exile community in Buenos Aires since the end of the war. Starting over in Argentina, Staś and his family would periodically return to Europe to visit relatives. The *Kultura* trip provided Czapski with the opportunity to repay these calls and to see his brother in his own domain. The timing of the trip proved fortuitous. Retaining bits of shrapnel in his chest and legs from wounds received during the Polish-Soviet War of 1920, Staś would live for only a few more years. (When he was struck down in battle, Czapski had been fighting with another regiment nearby. Word was sent to him about his brother's state and he raced to find Staś on the ground, half dead, blood pouring from his head. Fabricating a makeshift support, he managed to carry his brother's body to a small clearing away from the fray of battle. Once night fell, he transported him to a nearby town. He found an improvised medical facility, housed in an army ambulance train. Staś was operated on by a surgeon who removed a piece of shrapnel from his pericardium, saving his life. Czapski met this surgeon, Dr. Kołodziejski, the chief physician of a Warsaw hospital, again as a fellow prisoner at Starobielsk. Kołodziejski did not survive the massacre of Polish officers.)

In Buenos Aires, Czapski concentrated his energies on fund-raising events and public lectures. He also spent some time with Witold Gombrowicz, whom he had met in Poland before the war. Gombrowicz's first play had been printed in the prestigious Warsaw journal *Skamander*, edited by a conclave of dazzling literary personalities whose combined brilliance both attracted and repelled

him. Gombrowicz's first books, *Memoirs of a Time of Immaturity* and the anarchic satirical novel *Ferdydurke*, were published later and largely ignored. At that time, Czapski found the man artificial and disagreeable, a poseur.

Gombrowicz was asked to work as a reporter overseas and welcomed the opportunity for a temporary reprieve from what he experienced as Poland's suffocating provincialism. In 1939, he sailed on the maiden voyage of a ship bound for Argentina, expecting to return in a matter of weeks. War put an end to that plan. Like Czapski, Gombrowicz would never return to Poland. With about two hundred dollars and nothing more to his name, he struggled to get by in a foreign land, often living, like Czapski, thanks to the generosity of fellow émigrés. Insomniac and destitute, but ambitious and determined to put some distance between himself and the smugness of European cultural norms, he made the most of his fate, which he found had produced a silver lining: "I do not conceal that when the door was bolted and I was locked in Argentina, it was as if I finally heard my own voice." Devoted to writing, he secured jobs that would not inhibit his ability to work. Befriending members of the exile community, and alienating many more, Gombrowicz lived a bohemian life, juggling odd jobs, writing, playing chess, and cruising the city's underworld for the thrill of random sexual encounters. A minuscule stipend secured from the Polish legation kept him from starving. In Europe, his reputation as a writer slowly but gradually increased. His postwar writings, extravagantly self-referential, were finding a devoted following in the pages of *Kultura*. His autobiographical novel *Trans-Atlantyk*, a parody set in Argentina, narrated in an ancient form of oral storytelling that was common among the rural Polish nobility, was among the first titles to appear under *Kultura*'s book-publishing imprint. In all, he would spend nearly twenty-four years in Argentina.

It might be hard to imagine more clearly opposing positions on literature and art than those held by Czapski and Gombrowicz. Czapski manifested an almost visceral degree of reverence for books, for poets and writers. Gombrowicz, openly hostile, took every opportunity to disabuse his readers of their high esteem for the republic of letters. "The more one knows, the more stupid one is." Gombrowicz set out to provoke others; Czapski, only himself. Czapski kept a diary as a means of sustaining a private, internal dialogue. Gombrowicz wrote his as a way of entertaining himself and because Giedroyc promised to publish it in *Kultura*. Still, Gombrowicz and Czapski shared a similarly principled position on the question of being Polish. Miłosz, writing about Gombrowicz, isolated a theme underlying all of his work: "how to transform one's

'Polishness,' which is felt as a wound, an affliction, into a source of strength."
Gombrowicz was always wary of what he perceived as the "illness of Polishness."
Czapski's Polishness was drawn from a loving attachment to the memory of
his mother, far more a benediction than a wound, but he drew on his Polish
identity as a source of strength in much the same way as Gombrowicz.

Both writers found an advocate for their work in Camus, who wrote to
Gombrowicz in Argentina announcing his intention to help him publish in
France. (Czapski was delighted to find the newly published three-volume
Pléiade edition of *À la recherche du temps perdu* waiting for him at home on
his return to Maisons-Laffitte, a gift from Camus.) Kot Jeleński also champi-
oned both writers, spreading the word about them among editors and pub-
lishers far and wide. He fretted, as they did, over the growing number of
nationalists who were laying claim to all of Polish culture and attempting to
idealize it. Kot wrote an introduction for the French edition of *Ferdydurke* and
arranged to have a fragment of the novel published in *Preuves*. He claimed that
reading the book as a sixteen-year-old had opened his eyes, changed his life.
"After *Ferdydurke*," he wrote, "I lived in a different way. I understood that I had
to take a stand." Czapski and Gombrowicz may have had unsympathetic feelings
for each other, but Kot recognized an essential compatibility in their respective
disciplines. Observing Czapski's slow emergence as an expressionist with a
penchant for the grotesque, Kot thought his new work was moving within
range of Gombrowicz's punishing aesthetic. Eventually, Czapski and Gom-
browicz would arrive at a kind of genuine, if distant, respect for each other.

Before setting sail to return to Europe, Czapski managed to schedule an
exhibit of his drawings and paintings in Rio, an experience that enabled him to
meet many South American and exiled European artists. Once home, he found
the cumulative response to his financial appeal on behalf of *Kultura*, composed
of small and large donations, heartening. In less than two years, the original
loan to purchase the new headquarters in Maisons-Laffitte was repaid. Czapski
had been so effective that a considerable surplus revenue remained, enabling
Giedroyc to establish the *Kultura* Fund, with the express intent of providing
assistance to any Polish exile in need. The move in Maisons-Laffitte, from 1
avenue Corneille to 91 avenue de Poissy, covered a distance of just under a mile.
More than sixty years later, the Polish Literary Institute remains in residence.

The large house behind a tall stand of trees faces the road, its deep window
boxes planted with red and white geraniums, the colors of the Polish flag.

Czapski's small upstairs room at the back of the house looks out over a walled garden and a line of mature chestnut trees. When I visited, warm, bright daylight hovered just outside the windows but did not quite reach into the corners of the room. The off-white walls shimmered in a spectrum of cooler greenish hues produced by sunlight bouncing off waxy chestnut leaves outside. A milk-glass light fixture hung from the ceiling. A large rectangular wooden table with corkscrew legs, a vestige from his room at Hôtel Lambert, filled the center of the room. Underfoot, narrow-width planks of dark oak flooring were scuffed and timeworn.

In these two hundred fifty square feet, Czapski lived for four decades. The space served not only as a bedroom (with a communal bathroom down the hall) but also as a painting studio, writing room, library, and reception lounge for his many visitors. His large easel dominated one wall, his narrow bed was pushed up against another, the room cluttered with piles of sketchbooks, stacks of canvases, and all the paraphernalia a painter required—brushes, tubes of paint, rags, jars of mixing medium, sticks of charcoal, palettes, palette knives. Photographs of loved ones and postcard reproductions of admired artworks were tacked on whatever wall space was available. Shelves lined the walls with row upon row of thumbed-through volumes. The cell-like enclosure, barely adequate habitation for one person, also served to shelter a multitude of spirits taking up residence in Czapski's animated mind. For nearly thirty years Marynia lived in an even smaller room on the floor above.

I pulled up a chair and sat down where I knew his bed used to be, my head full of images of Czapski and bits and pieces of anecdotal history relayed to me by those who knew him well. Settling quietly at the very place where Czapski faced what he hoped to realize in paint, day in, day out, year after year, I was at the geographic "still point" of his creative life. Here he mixed his colors and made his marks, pondered, painted, swelled with certainty and crumpled in doubt, prayed, swore, cleaned his brushes and retreated, sometimes in despair, sometimes in exaltation, only to begin again the following day. Here he wrote essays of affecting eloquence about the act of painting and about the books of poetry, fiction, and philosophy he always turned to for understanding. Here, his large head propped against a pillow on a low wall, he filled the pages of a diary held upright on his bony knees, a lifelong, obsessive activity, and here he scribbled a mountain of correspondence to friends near and far. Here, too, he received a steady flow of visitors over the years, showing them his latest canvases, reading aloud select passages from his journal and

books. One friend wrote about finding Czapski on his sofa, his legs drawn up, behaving "like the retired head of a state intelligence agency, no longer running things, but still maintaining his many contacts, who, through force of habit, continued to report on their activities to their former boss. Józef grilled his guests about what they'd heard, read, seen. He was voraciously inquisitive. He was curiosity personified, the perfect embodiment of curiosity. When he heard some story that interested him, he responded with his whole body."

He was most himself when alone within the walls of this humble room, positing, grappling, making, marveling.

Something of his living presence still lingers. By the time I first entered this quiet, luminous bower, Czapski had been dead for more than twenty years, during which period no other person had occupied the space that was so long associated with him. Czapski's room is now materially empty but mystically full, part storage space, part makeshift shrine. His worldly goods have been removed, but in acknowledgment of his long tenancy, two still lifes are kept on display, providing a welcome infusion of color.

In February 1956, just short of three years after the death of Joseph Stalin, the Twentieth Congress of the Communist Party was held in Moscow. In a highly surprising "Secret Speech," Nikita Khrushchev set out to topple Stalin from his lofty historical pedestal, condemning "his intolerance, his brutality, and his abuse of power." The momentary destabilization of authority brought on by the dismantling of a supreme autocrat's reputation produced seismic ripples powerful enough to reach as far as the nether limits of the vast Soviet Union. In Poland, the hard-line Stalinists found their hold on power immediately weakened. For a brief period of time, a political thaw led to greater autonomy as the government inched cautiously toward a more localized and nationalized idea of socialism, one less subservient to Moscow. The Polish October marked the end of Stalinist reign in Poland at about the same time as the more tumultuous Hungarian Revolution was posing the first serious threat to Soviet control in the satellite republics.

Previously forbidden avenues of communication were opened a little. For many years, from a distance Czapski followed developments in the work of an old friend who lived in Warsaw, the composer and music critic Zygmunt Mycielski. When Czapski had been painting in Paris in the 1920s, Mycielski was there studying piano and composition with Nadia Boulanger. Creative, articulate, ethical, he lived the life Czapski might have been subjected to had

he returned to Poland after the war. Unfazed by deprivations, Mycielski composed six symphonies, orchestral works, and many song cycles with texts from poems by Cyprian Norwid, Zbigniew Herbert, and Jarosław Iwaszkiewicz. He also wrote engrossing music criticism from the vantage point of a practitioner, much as Czapski wrote about painting. Politically, Mycielski focused on doing what he felt was the right thing in light of implacable opposition. He worked conscientiously to counter the regime's stance of cultural isolation, advocating for permission to invite international musicians into the country at a time when its own musicians were denied the right to leave. The effects of the 1956 thaw finally allowed Mycielski to welcome to Poland a host of Italian, West German, and French musicians, including Boulanger, for a series of professional gatherings and performances. He helped to organize an international festival of concerts of contemporary music that would come to be known as the Warsaw Autumn.

Czapski, too, benefited from relaxed prohibitions. Instigated by a loyal following anxious for the opportunity to see new works, an exhibition of his paintings and drawings was curated and mounted in the Polish People's Republic. He, of course, could not appear alongside his works on display—even in a period of detente the risk of arrest as an enemy of state was too great—but his canvases were much acclaimed in Poznan and Kraków. Given the chance to spend a lot of time with paintings he had known only from descriptions and sketches in Czapski's letters, Ludwik Hering wrote a glowing report. "Your work, possibly like no other painter's," he concluded, "honestly reveals the creative process." To his friends Krystyna Zachwatowicz and the filmmaker Andrzej Wajda, Czapski wrote, "News that my paintings were being exhibited in Poland and that people were moved by them, even moved to tears, made me realize suddenly that this was what I had always wanted." In his journal, one quote from the diary of the Swiss poet and critic Henri Frédéric Amiel recurs repeatedly: "Who among us has not his promised land, his day of ecstasy and his end in exile?" Czapski claimed the opportunity to have his work on view in Poland was tantamount to *his* promised land. He described a painter's struggles in the introduction he wrote for an exhibition catalogue, but he might equally have been speaking in code to his Polish friends about the burden of exile: "At some moment in life, one becomes aware of the fact that one's pictorial vision is determined by an attitude to the surrounding world that is not limited to painting, that this vision of the artist, as it happens, is—and must be—solitary,

that no one can help him find the expression he has been looking for his whole life. At that very moment, he has the feeling of really beginning to paint."

After the exhibition came down, Hering and Czapski spoke to each other directly, over the telephone, for the first time in seventeen years. Private telephones, once quite common in Poland, were exceedingly rare after the war. In central Warsaw, Hering stood in the bustling post office, among crowds of people in charged states of expectancy, waiting for the call to come in from Paris. For many months, he had been unable to muster the emotional wherewithal to mail his letters to Czapski, letters he wrote but found wanting and put aside. A mutual friend had recently carried a small canvas by Czapski from Paris to Warsaw and put it directly into Hering's hands. The painting, of a large woman huddled in a flimsy shelter selling lottery tickets, was a study of brute determination in the face of meager prospects. Czapski, who claimed it was "not one of my best," acknowledged that no one picture could ever be really satisfactory.

The two men continued to derive enormous strength and purpose from each other, sometimes, given the distance and divide between them, to an almost unbearable degree. Prolonged physical separation from a loved one can lead to the fabrication of an idealized person who, under the circumstances, cannot be compared to its flesh-and-blood source. Hering and Czapski were acutely attuned to both the appeal and the danger of romanticizing each other. Offering his kind of solace, Czapski wrote:

It's hard to find two people who are more across from each other, instead of next to each other. To you, so many things in me were not only foreign but also hostile (not in me but in my beliefs or hopes, which you contrasted with your belief in the hopelessness and criminal tragedy of the world, and how all your and my convictions were more superficial than that which brought us close). Today, you and your revolt against life revisit me again and again, and I can feel it so strongly inside me, but I think without losing any of my hopefulness, just like then. Everything, everything, everything I can remember from our years together is dear to me now, if not dearer. Do you remember that shopwindow in Napoleon Square? And maybe it was precisely that we met for real, as if we were naked, with only that which made us each himself the most. This is what always gave us this incredible sense of our friendship's uniqueness and freedom. I have always had the feeling that you can see me as I really

am. I write these few words today because I need to, and so that you will always, always, always know that you are with me.

They lived in separate realities. Making the most of a seemingly hopeless situation, each man tended the idea of the other like an eternal flame. When, finally, they could hear each other's voice after so many years, there was really nothing to say, or no way to put into words what was most meaningful. How could one speak of what was between them? What words were available to them to describe the depth of feeling and the gratitude? Was the bond reinforced after their few minutes on the line, or diminished? What one takes away from such a conversation is far more valuable than what one has been able to bring to it. Inchoately voiced yearning and hopelessness traveled along so many miles and miles of underground telephone cables, back and forth, back and forth.

Longing to engage his affections in some present application, Czapski cultivated attachments nearer to hand. He increasingly took pleasure in a friendship with a young acolyte, Jean Colin. Jerzy Łubieński, Czapski's nephew, had introduced his uncle Józio to this young painter in whom he had recognized a good deal of his uncle's sensibilities. The son of a general practitioner, Colin had abruptly left the study of medicine after two years in order to devote himself entirely to painting. When Łubieński first brought Colin to meet his uncle, the young man was twenty-one, the elder fifty-two. Czapski immediately responded to Colin's self-effacing presence and seriousness of purpose, grateful to find in him evidence of a dedication to the visible world. In possession of a sharp eye and a fierce intelligence, Colin quietly applied himself to the task at hand with a mild demeanor and humble spirit. His small paintings, mostly landscapes, interiors, and still lifes, combined a blend of nineteenth-century French and seventeenth-century Dutch aesthetics.

Czapski would help Colin find professional and financial support, encouraging friends to consider making purchases from the young painter's studio. Czapski wrote to Hering that Colin, as much as anyone in France, really understood the stakes involved, the relation between painting and religious faith, between painting and life. Their subjects and styles were not particularly compatible, but their commitment to work was equally intense and consuming. The young painter was beholden to his old friend. Colin wrote in his journal,

Often, seeing the paintings of Joseph I like best, those that show people he encounters during the course of a day, I tell myself that I feel closer to him than he could possibly imagine, and that if I paint houses and objects, it's because I'm afraid of not being able to paint faces or the silhouettes of people, out of a kind of terror, because people are always moving or passing by, and I can only capture them after a long period of study. Joseph, he throws himself in the fray each time; quickly he either demolishes the figure or he gets the upper hand with it, with a force that belongs only to him, from what he's just seen.

One spring day, riding along the street on his Vespa, Colin crashed, his bike veering onto the sidewalk. Having momentarily lost control of his hands and feet, he suddenly realized he was unable to brake. Thrown over his front tire as it hit the curb, he was hurled onto the pavement. He was not badly hurt, but the incident was unnerving. A medical report from tests taken soon after the accident revealed the presence of an encroaching degenerative motor neuron disease, amyotrophic lateral sclerosis (ALS). Over the next three years, paralysis gradually spread throughout Colin's body. Czapski made himself available, offering support and encouragement when needed. Understanding the gravity of the situation and the importance of the gesture, he discreetly made arrangements for a joint exhibition of their work at a gallery in Amiens. The show revealed their shared temperament, if not a common sensibility. Czapski's expressive images were briskly laid down while Colin's took form slowly, sustained over time, imprinted on canvas like a long exposure. A self-portrait by Colin, a ponderous picture, shows him standing in his studio before an easel and canvas, surrounded by various framed paintings hanging on the wall and several works in progress turned away from view. A nearly life-size sculptural crucifix looms on the wall behind him. The painter placed his own lank figure in front of this imposing, suspended body. The hands of Christ are spread wide, nailed in place; Colin's hands are drawn in, clutching his palette and brushes. The eyes of the crucified Christ are closed, his head bowed, dropped to one side; Colin's eyes are open, looking directly at us. To the right, a skull sits on a low table, partly obscured by the open studio door; its empty eye sockets seen in three-quarter view. The open door sits ajar, framing a darkness beyond. It is an indication of Colin's seriousness of purpose that he assembles these symbols of human activity and mortality, religious feeling and vestiges of art, and places himself squarely, if tremulously, in the center.

The age difference between the painters may have suggested a relationship

of teacher and pupil, but Czapski rejected such hierarchical notions and considered their exhibit one of equals. The following year he helped make arrangements for a solo show of Colin's work in Paris. The young man had a small and loyal following of collectors (among them, Katharine, Duchess of Kent), cultivated after earlier successful exhibitions in London and Paris. Always a very methodical painter, Colin continued to work hard as long as his hands allowed. He produced more than twenty new works during his last two years as a painter.

Coming to Amiens from Paris one day, Czapski brought along his young niece, who was visiting from Kraków, hoping to introduce some youthful cheer into a household muffled by sadness. Elżbieta Plater-Zyberk and Colin had met before, but since their last meeting she had blossomed from a girl into a poised and lovely young woman. Immediately attracted to her, Colin experienced a complicated reaction. He didn't want her to know about his feelings, to embarrass her or to impose on her in any way. The idea of her forming an affectionate relationship with a dying man who imagined he loved her was unthinkable. As it happened, she found herself attracted, too, and was not put off by the idea of caring for him. An attachment formed.

While this unlikely, unusual courtship was unfolding, Czapski decided to paint Colin. He made several drawings of the young man in his bed, then began to work on an oil portrait in which Colin, seated upright, peers out soberly at the viewer, deeply self-contained but alert and present. The brushwork, lively and vivid, hints at an active life force not manifestly observable in the slightly imploded body of the subject. Patches of canvas left unpainted aerate an otherwise potentially stifling atmosphere. The picture is most alive in the suggestion of Colin's expressive, sad eyes. The downturn of his mouth echoes the arch of his eyebrows, his large round ears jut out on either side of his head; pointed collar tabs protrude from his V-neck sweater vest. Colin's hands, neither idle nor especially serviceable, fill opposing bottom corners of the picture, the fingers of each hand poignantly placed, one hand fondling the pages of a book. An appetite for communication is discernible in his deep-set eyes. He appears to be speaking nonverbally to the painter as he is being carefully observed by him. It is an arresting portrait, portentous in mood, articulate against all odds, redolent of inner effort and anguish.

At the end of December 1958, Elżbieta Plater-Zyberk and Jean Colin were married in Amiens, in the living room of his parents' home. Six months later, at the age of thirty-one, Colin succumbed, telling his brother, "you know, it's

not so hard to die." Czapski would help spread awareness of Colin's paintings, writing about the work and memorializing the quiet strength of the young painter.

For the invitation to his own upcoming exhibit at Galerie Bénézit, Czapski selected an apt quotation, a statement of where he stood aesthetically:

> Some people claim that poetry demands subjects that are neither poor nor dry.…
>
> A poetry that, in order to be poetry, requires attractive things and seeks out what is graceful, is not within my power.
>
> —Cyprian Norwid, 1869

In addition to the portrait of Colin, Czapski produced several others in 1958. Each one of these could be said to be painted in a different "style," but each finds its own voice, heightening the intimate connection between painter and subject. Czapski felt free to make the most of whatever approach best suited his subjective experience. Technically fluid, unencumbered by any theory of seeing, Czapski mined the character of his sitters like a novelist, finding the appropriate touches to fix the person in paint, to describe his milieu, and to expose his relation to the world. These works mark a phase of confident transition. In less than a decade he has mastered his medium, having made great strides since his first postwar self-portrait in 1949. Preliminary sketches exist for all of these 1958 portraits, but the drawings no longer serve as a mechanical template for a painting. He has begun to feel a confidence, a fluidity in his handling of paint, a conviction that previously eluded him. After an endless output of effort, he has managed to put into effect the lesson of Cézanne he longed to achieve. He is, indeed, now drawing with color.

Daniel Halévy, aged eighty-six, is shown in all his aging glory, sporting a dense, grizzled beard, sedentary perhaps but extremely attentive. Covered in colorful wet-on-wet Soutine-like squiggles, blotches, and viscous dabs of paint, his portrait hums with activity. Everything is positioned close up, the painting's mottled surface expresses a sense of immediacy. Halévy, cultural patrician, is front and center. Unlike the feeling of distance and trepidation in the Colin portrait, this figure is happy you have come to see him, beckoning eagerly, awaiting the chance to meet you. His open face is rendered in the same yellow ocher Czapski uses to paint the wallpaper of the room, the same animated

golden highlights that show up on the frame of a small painting behind Halévy also dot his cheeks and brow. The seventeenth-century residence on the Quai de l'Horloge has been Halévy's home for his entire life; he is so thoroughly ensconced in its domestic environment that he now appears in Czapski's friendly portrait as a permanent fixture of the house, so integral a part that he is beginning to blend into its walls. Halévy's head sits just below center, his steady eyes gaze out straight ahead from the picture's lower quadrant, unusual placement for eyes in a portrait, but somehow appropriate for the reduced stature of an elder statesman. The curve of his shoulders accentuates his some-what rigid posture, his head droops forward slightly, his heavy body anchors the composition. Seated in a curved low-back chair, he is surrounded by many framed paintings, a tea service, lamps, various objets, and a large mirror that reflects a huge bookcase and more paintings on the opposite wall. A tall blue vase is on a mantelpiece directly behind him holding a spray of branches cov-ered with upward thrusting green leaves that seem to erupt from the old man's head like a mythological symbol for vitality and renewal. A shimmering quality of surface detail activates the portrait, which seems at once a celebration of Halévy and an homage to Degas, his spirit still palpably present in the room where, now in his place, Czapski sits painting.

An ailing young man and a vigorous elderly man: The weight of their respec-tive mortalities lends a certain poignancy to each of these two portraits. In stark contrast, Zbigniew Herbert, a Polish poet brimming with robust health in the prime of life, offers a very different subject for study. Making his way across England, Italy, and France on a hard-won Ministry of Culture grant from the Polish People's Republic, Herbert had earned the freedom to travel, albeit on a pauper's budget and often under surveillance. Welcomed in Paris by the émigré community, he befriended, among others, his hero, Miłosz, and his future publisher, Jerzy Giedroyc. At the Galerie Bénézit on boulevard Haussmann, Herbert saw an exhibition of paintings by Czapski, known to him previously only from his essays on art (officially banned in Poland) and his underground reputation as a painter. A series of photographs of their encounter at the gallery shows Czapski, elegantly turned out in a smart summer suit, beaming and ushering Herbert around the show to the young man's delight. The difference in their physical statures is almost comical. Herbert has the wiry, compact body of a jockey, Czapski, the girth and span of a beanpole.

Herbert had led a tumultuous life. Born in Lwów in 1924, he was a fifteen-

year-old high-school student when war began. He came of age intellectually in the secret school system organized by the underground at a time when Polish-language schools were forbidden, first by the Soviets then by the Nazis. The fear and terror of those years in Lwów—the murder of one hundred twenty thousand Jews and the execution of eminent university professors and their families (among them Tadeusz Boy-Żeleński, Czapski's friend and the translator of Proust into Polish)—left their mark on Herbert and imposed a mournful counterpoint to all he would later come to write celebrating the solace of art. His family fled to Kraków in 1944, just before the Red Army reoccupied Lwów and began to implement their planned expulsion of its Polish population. Working in a bank to help support his family, he attended lectures at Jagiellonian University when he could and took drawing classes at the Academy of Fine Arts, where Czapski had studied. One year his earnings came solely from the sale of his own blood. Holding various jobs—in a radio station, as a teacher, as a museum guard—he managed to obtain degrees in economics and law, all the while making deeper inroads into various schools of European philosophy. Herbert had a poem printed here and there, mostly in Catholic newspapers, but because he refused to toe the line and write according to the imposed dictates of socialist realism, he prepared his first book of poems knowing it could not be published in his own country. Yet the same thaw that enabled Czapski's work to be shown in Poznan and Kraków finally enabled Herbert to find a Polish publisher. His first books, admired by critics and readers alike, appeared in 1956 and 1957.

A discerning and thoughtful poet and essayist with an exacting eye and enormous erudition, Herbert had a knack for adding compact ornamental pencil drawings as embellishment to his letters and texts. His work addresses the upheaval of European history in stark, plain language, though even his darkest poems offer humor, compassion, and an ironic wince. A modernist in the sense that he wrote free verse without the dictates of rhyme or meter (and usually without punctuation), he was equally a classicist, adrift in Greek myths and parables. His writings highlight the contradictions inherent in the human drama of life; his deep capacity for empathy rejects the cold, unfeeling purity of aestheticism.

Czapski and Herbert developed a cordial rapport. Their first written correspondence was an exchange of postcards where Herbert signed his note with mock pomposity and an academic flourish, "Maître Z. Herbert." Czapski replied "Dear Master," and wrote across the message on his return card, in red

pastel, "I love your poems!" As with Colin, Czapski was more than a quarter
of a century older; his vigor and artistic integrity proved sufficiently appealing
to a youthful spirit in search of a model for how to be an artist in the world.
Herbert would write a poem called "In a Studio":

when the Lord built the world
he furrowed his brow
calculated calculated calculated
that is why the world is perfect
and uninhabitable

instead
the world of the painter
is good
and full of mistakes

Some months after their introduction, Czapski wrote a note to Herbert
inviting him to visit Maisons-Laffitte, expressing interest in painting the poet's
portrait. In Czapski's preparatory drawings for his portraits of Jean Colin and
Daniel Halévy, the subjects are not seen head-on, yet in the oil portraits, they
look out directly at the painter and viewer. By contrast, the numerous prelim-
inary studies Czapski made of Herbert show him peering intently at the painter,
but the oil portrait shows him with his eyes cast downward. In the drawings,
Czapski defines the precise shape of Herbert's head with a few broken lines,
outlining the jaw as a U-shaped scaffold within which the more nuanced marks
of the facial features are placed. The poet's face is extremely boyish, his lips
small and tight, his ears large, but his eyes in these remarkable drawings are
undoubtedly those of a mature man, pulling you in as they beam out a mixture
of intelligence, feeling, and wariness. Herbert's hair, sculptural in mass, sits
piled atop his head like a crown or a turban in a Jan van Eyck portrait. In the
oil (plate 8), he is presented in a nearly idealized state, as a contemplative and
a lover of books. In the vertical canvas, tall and narrow in format, his downward
bent head is centered. He is shown seated, and we see the upper half of his
body only, the fingers of both hands actively attached to a miniature volume
laid out on the desk before him, a pen lying just within reach. Flipping dis-
tractedly through the book's pages, perhaps thinking before reaching for the
pen, he might be poised to write something, or he may simply be reading.

These two activities are only tenuously separated for writers. The poet's complex gaze, shown so powerfully in the drawn studies, is here averted, turned down and away from the viewer but intensely concentrated as he grapples with whatever image is forming in his mind. His brow is slightly furrowed. Czapski's portrait suggests distraction and focus, the mental activity of a writer preparing to write, a moment rarely captured in paint. The face of the watch on Herbert's left wrist is turned out and away; present time is acknowledged but banished while at work. Herbert, a great believer in the continuity of human life and experience throughout history, walked out into the light of day after visiting the prehistoric caves at Lascaux and wrote: "Though I have stared into what some call the abyss of history, I did not feel I was returning from another world." (This sentiment harmonizes perfectly with Czapski's absorption in the Signorelli frescoes at Loreto days after the battle for Ancona had been won.) The palette of Czapski's portrait of Herbert is somewhat muted, with soft grays and umbers, but the poet's cowl-necked blue sweater is richly painted in layered passages of saturated cobalt and midnight blue. Herbert's luxurious head of hair is painted with panache.

A fourth work rounds out this group of portraits from 1958 (plate 9). *Self-portrait with Lightbulb* presents the gaunt head and broad shoulders of the artist looking out circumspectly at the viewer, not quite open faced but present, pensive. Wearing a pair of eyeglasses whose right temple is conspicuously missing, he is unflustered, suggesting that such is the state of things: "My glasses are broken? Yes, well, okay, it's not a big deal." His eyes are sober, probing, his right eye slightly distorted by the lens, his left, clearly seen, is acutely focused and serious. Czapski's mouth is set hard in his square jaw, clean-shaven and blue, with dark lines indicating creases at the bottom of his slender cheeks. His brow is high and splotched, crowned by a widow's peak. A mane of silvery hair frames the top of a tall, bony skull. A no-nonsense, bare-boned contact is established immediately with the viewer, squelching any thought of the self-portrait as an affair of vanity.

The picture Czapski is painting is indicated by the narrow vertical edge of canvas, a strip of linen wrapped and nailed to a wooden stretcher bar, hung centered on the far right side, as if sitting quite high on an unseen easel. Behind him, way up above his head in an undelineated space between wall and ceiling, the small circular canopy of a light fixture is floating in the air with a single lightbulb suspended from an attached cord. Everything is presented in a rather matter-of-fact way. Confining the image of himself to the lower right-hand

corner of the picture, Czapski has filled the remaining space above and behind him with a surfeit of painterly gesture. Loose, wet, unblended squiggles of khaki gray, silver, and violet animate the space across the breadth and height of the canvas, exuding more energy than any of the static forms of wood, glass, or flesh. Like a pale water lily on a Monet pond at sunset, the bare bulb is swimming in a lake of luminous effects, but whether the bulb is actually the source of any of the light filling the pictorial space is hard to determine. It is also unclear whether Czapski or the space around him is meant as the subject of the painting. There seems to be an acknowledgment of shared territory, of fullness and emptiness, being and nothingness, existing together at once, side by side, neither one state nor the other prevailing. The animated, almost ecstatic atmosphere of the picture—absence rendered palpable with great effervescence—raises existential questions after the fashion of Samuel Beckett and Alberto Giacometti, both figures exerting a powerful influence on Czapski and the cultural life of Paris at the time.

Though not intended to be seen as a group that bears relation to one another, this subset of four paintings represents the range and power of the artist in a fixed year. These works, independently conceived and resolved stylistically, provide an example of Czapski's burgeoning assurance a decade after his return to painting. In an aesthetic context, they reveal his pictorial concerns in light of what he calls the "ineluctable push" to abstraction encountered nearly everywhere else. These works pave the way for another picture in which Czapski shifts the parameters of portraiture, his creative counteroffer to the intellectual challenge of nonrepresentational painting.

The setting could not be more prosaic. A bathroom. On the ledge of a wide twin-basined white porcelain sink with silver faucets and handles, a striped blue-and-white washcloth, a blue shaving kit, and a glass holding a single toothbrush are laid out. Mounted high on the wall above the sinks are twin fixtures, bricks of neon light. One is illuminated, the other not. Under the lights, centered above the sinks, is a long, horizontal, unframed mirror. In its reflection we see the artist standing at work, one hand supporting a sketchbook in which the other hand is drawing. This is a droll sort of self-portrait, however. We see the artist, facing front, but we're only shown what is visible to the artist in the mirror, the painter's thin body from just above his knees to just below his shoulders. (Anyone six feet or taller will immediately recognize the situation.) No face appears at all, no eyes to peer out at us, no expression to read. *Neon and Sink* (plate 10) is a headless self-portrait.

Considering all the studies of his face done on paper and canvas over the years, their scope and variety, this literally self-effacing self-portrait occupies a special position. Conceived as his friend Colin was slipping from life, the painting has an unsettling effect. What are we to make of this bizarre, disconcerting image, the trunk and legs of a body dressed in a blue smock and white pants? In *Self-portrait with Lightbulb*, Czapski painted himself into a corner, minimizing the impact of his presence. In *Neon and Sink* he is pushing the boundary even more, taking one step closer to eliminating himself entirely. Like Matisse's *French Window at Collioure*, an abandoned painting from 1914 in which the painter came as close as he ever would to creating a purely abstract image, *Neon and Sink* is Czapski's most radical attempt to see how far he may go. As ever, the source for the painting is a drawing, made directly *sur le motif*, from what he has seen in a bathroom mirror, but the finished painting is a fully articulated manifesto addressed to contemporary critics of figurative art. He seems to want to withdraw himself bodily from the battle between representation and nonrepresentation. The tenderly arranged still life of glass and toothbrush affirms his commitment to and affection for what surrounds him, but what could be more abstract than a self-portrait without a face? One friend of Czapski's couldn't stomach it. Gabriel Marcel, the Christian existentialist whose philosophic subject was the dehumanization of the individual in contemporary society, was profoundly disturbed by the image. "How," he asked, "could you paint such a thing?" The comment delighted Czapski, who recorded it in his diary. *Neon and Sink* acknowledges that the unseen can rightfully become the subject of a representational painting. Others may seek to express themselves without reference to the world around them. Czapski cannot.

16

FLYING INTO WARSAW on my first visit to Poland in search of Czapski's paintings, I spotted the Vistula River from several thousand feet in the air. How was it that I could identify with such certainty a topography I'd never seen before? Having studied so many political maps of Poland's shifting boundaries over a period of years, I was seeing an almost familiar landscape materialize. As my eyes scanned the curved tapestry of earth framed by my window, my mind, like a piece of old-fashioned theatrical equipment, began to sputter and project a stream of black-and-white images in my head. A scene from *Kanał*, Andrzej Wajda's film about the last days of the Warsaw Uprising, flashed before my eyes. Two resistance fighters, slogging through the filth of the city's underground sewer system, stumble upon a sun-drenched opening on the Vistula. Looking out onto the shining river, they realize they have not, after all, reached the end of their escape route but merely arrived at the scene of their final reckoning. They are trapped between the Nazis, in active pursuit of them, and the Red Army soldiers on the far shore, who will not lift a finger to save them. In 1944, Poland no longer figured on any map of Europe; the river simply marked the boundary between two evils: German control and Russian control. These cinematic frames slowly dissolved from my eyes as the plane began its descent for landing. The outdated geopolitical reality in my head gave way to the Polish capital's approaching presence. I could make out the buildings and parks and arteries of twenty-first-century Warsaw. The wheels touched down on the runway of Frédéric Chopin Airport.

That evening, in a quiet restaurant, I read the French translation of some Polish essays given to me by a young art historian assigned the task of shepherding me about during my stay. Dark-eyed, loquacious, slightly formal in bearing, Mikołaj Nowak-Rogoziński sized me up quickly at our first meeting earlier in the day. Discovering a common affection for certain painters and writers, as well as a shared passion for the indexes of books, I asked him for something to read as a complement to Czapski's essays. Late in the afternoon he deposited a book at my hotel. *Essais pour Cassandre* (Essays for Cas-

sandra), a collection from 1961, was written by Jerzy Stempowski, a writer Czapski had known well before the war as part of the Russian Literary Club in Warsaw. A student of philosophy, literature, history, and medicine, Stempowski shared much with Czapski in terms of sensibility and background. His subject was political exile, its freedoms and its miseries. He dedicated his essays to the daughter of the mythological Trojan king Priam, the princess-prophet Cassandra, who saw the approach of catastrophe but was powerless to prevent it.

Waiting for my meal, I flipped through the book and selected an essay called "La bibliothèque des contrabandiers" (The Smugglers' Library). I was drawn in by its opening sentence, a question Stempowski asks himself: "Among the books read during the war, which one touched me the most?" In September 1939, Stempowski fled Poland and fell ill shortly after. During a long recuperation, he received a random assortment of books as a gift. "I would like to write about the chaotic destinies of books during the war," he wrote, "and their unforeseen meetings with the reader." *Chaotic destinies.* The two words side by side on the page seem to ring out a leitmotif of Polish history.

Stempowski eventually decided the books that touched him most were a volume of Virgil and a collection of Latin poets of the Renaissance. Two lines of Latin verse about the river Tiber and the ruins of ancient Rome, written by the sixteenth-century Sicilian humanist Janus Vitalis, prompted this response from him:

In the time of the Renaissance, the Tiber ran among ruins, some of them still visible today, some of them buried under neighborhoods erected later. Each in their turn fell into ruin—buildings from the time of the Roman republic and empire, from the Byzantine revival, from different periods of the Middle Ages. The poet, looking at all these remains, observes that only the river, which runs among them all, remains immutable.

Disce hinc quid possit fortuna: immota labascunt
Et quae perpetuo sunt agitata manent

"Look," he says, "at the power of destiny; that which is immobile turns to dust, that which is perpetually in motion, remains." When I read this couplet in the winter of 1940, I thought of Warsaw, where perhaps only the Vistula has remained unchanged.

These lines put me in a kind of rapture. The leap in time from the classical world to the Renaissance, from the Middle Ages to the Second World War, and in geography from the Tiber of Rome to the Vistula of Warsaw, all resonated with the disconcerted feeling I had experienced hours earlier looking down on the unchanging ribbon of river from the air. The Renaissance poet constructed an aesthetic response to his observation of man's vulnerability in relation to nature's ever-flowing energy. A keen, learned reader with a sensitive ear, Stempowski could hear burbling sounds emerging from both river and poem, "the whisper of the pentameter imitating the murmur of the Tiber between its muddy banks." He admired the Italian poet's ability to draw poetry from the timeless world decaying around him. At a time when representation of the natural world ceased to find validity in the field of painting, Stempowski's friend Czapski would persist like Janus Vitalis, insisting that his observations of the visible world still mattered.

The following morning I made my way to the National Museum in Warsaw with an appointment secured in advance. Special permission is required to view their collection of paintings held in storage. Visitors to the reserves must be accompanied by museum personnel at all times. At the staff entrance where I was instructed to appear, I filled in security clearance forms and was introduced to a young intern named Tomasz who would escort me into sections of the building not accessible to the general public. Tomasz led me up a few flights of stairs, down a series of linoleum-floored hallways lined with historical paintings, then into a small elevator that took us to a lower level. At the end of a long corridor, we turned a corner and went up more stairs and entered another elevator, from which we emerged in an imposing room, part of the museum's public exhibition space. Crossing this gallery, which overlooked an interior courtyard's expanse of travertine floor, we came to a locked door. Scanning his badge and punching a code into a keypad, Tomasz stood patiently. The door clicked opened. We went in and then down more flights of stairs, at the bottom of which he buzzed at another locked door. He turned to me and smiled, raising his eyebrows triumphantly, indicating that we had at last arrived at our destination, the reserves room, where the museum's holdings of unexhibited paintings are kept. A face peered through the small grimy window in the door. Tomasz nodded to it, and the last barrier fell. The door swung open.

I passed into an extremely long room, expanding in both directions from the fortified entrance, its ceiling quite low. The space was dim and crowded,

not especially clean. A dozen or more stalls were lined perpendicular to the very long narrow corridor where I stood, each housing rows of floor-to-ceiling rolling screens. Tomasz led me down the hallway to a small office tucked away at the back and introduced me to a department official wearing a white smock and a chunky necklace of beautiful stones, her hair swept up in an immaculate French knot. We spoke in French. Her voice was soft and tentative, and she formed her sentences beautifully, though this seemed to require some effort on her part. She asked me to sign some additional waivers and forms, and then handed me an inventory of the museum's holdings of Czapski's work, a document several pages long summarizing all of the information currently on file. Upon completion of these formalities, Tomasz gestured for me to follow him. Leading me back out into the reserves room, down into a murky recess roughly twenty feet deep and seven feet wide, filled on either side with row after row of rolling panel screens, he pulled a section of movable wall out into the recess. I was on one side of the screen, he on the other. The sliding wall of rigidly reinforced heavy-gauge fencing that faced me was about nine feet long, eight feet tall, lined on both sides with framed paintings of different sizes suspended from the screen by hooks on wire. Without sufficient room for the rack to pull out to its full length in the narrow passage, some pictures could only be viewed by peering in at an oblique angle. Many works were in a sad state of disrepair, suffering from varying degrees of neglect. With a combination of expressive gestures and a handful of English words, Tomasz explained that a few of the Czapski paintings were too fragile to be removed from the storage rack, so I would have to look at them on the screen to which they must remain attached. He pointed to a canvas at the bottom of the screen, partly covered in shadow cast by a larger painting above, and took his leave of me. The screen stood between me and the corridor, sealing me off from the exit. To look at the painting full on, I needed to squat. My spatial options were severely limited. My habitual choreography of looking was out of the question. Long fluorescent tubes overhead provided ineffective lighting for a canvas on this lower level; every time I leaned in to get a closer look, my head cast one more shadow across the picture.

Still, I was looking at a painting by Czapski, and that's what I'd come for. About thirty by forty inches, this painting from 1955 (plate 6) is of a man standing inside a brightly lit butcher shop, seen from the point of view of someone on the street looking in. Directly behind him, the bloody carcasses of seven animals are suspended from a metal bar overhead. The solitary figure

337

stands at the back of the space looking out toward the street. The building's exterior is painted in pasty, muddied colors, but the interior is animated by rich, warm colors of flesh and viscous blood. Outside the shop, on the left side of the canvas, a doorway, with its street door propped open, reveals a small dark vestibule leading to a steep flight of stairs lighted from above. In the middle of the canvas, rather improbably, a large red velvet drape hangs, attached to the front of the butcher shop. The crimson material, a counterpoint to the bloody slabs of meat, is suspended from ceiling to floor and gathered two-thirds of the way up. It hangs between the open storefront and the open stairwell, an odd, theatrical element introduced into an already bizarre juxtaposition of domestic and commercial life. The man in the shop is dressed head to toe in a dark monochrome. His featureless face is a deep pink orb encircled in black. Various cuts of meat are packed into wooden crates directly underneath the hanging carcasses. The sides of meat are Czapski's homage to an iconic image painted by Rembrandt, *The Flayed Ox*, and are also celebrated in several paintings by Chaim Soutine. (Three years older than Czapski, Soutine, the tenth of eleven children, was born and raised in a shtetl just outside Minsk, not far from Przyłuki, where Czapski spent his childhood.) A silver bicycle, propped against the front entry and pointed in, draws the viewer's eyes into the space. Czapski was inveterately fond of wheeled transport of all kinds.

Tomasz returns and leads me to another canvas (plate 12). A silver-and-blue-haired woman is seen sitting up in bed, underneath a blanket, one hand behind her head propped on the headboard, the other gesticulating as she speaks. She has two visitors, a man and a woman seated in chairs on either side of her at the foot of the bed, the woman to the left, the man to the right. Their bodies are only partially included; most of what we see of them is their laps. Each is represented by only one hand, but their single hands are quite expressive. The man, dressed in a gray suit, has his hand resting on his thigh, patient and turned inward. The woman's is outstretched, clutching a needle and the end of a row of knitting, suggesting she has come prepared, knowing she will need to keep busy while sitting still. The bizarre cropping of the bodies of the bedside visitors is off-putting at first, but humorous. What does the painter mean by showing only a slice of each of these companions on the perimeter of his field of vision, not extending it far enough to include their faces? It is my first introduction to a compositional device favored by Czapski, the severed image, the odd framing of elements in the picture plane. (I had

not yet seen *Neon and Sink*.) The painter is declaring "Here is what I see, and how I choose to configure it," squeezing into the frame whatever strikes him visually. At the same time, he is making a choice as to what constitutes the edge, what warrants inclusion. The painting, almost like a comic-book version of Vuillard, is very animated, the colors are saturated and bold, with a good deal of jarring textile patterns. The garment worn by the bedridden woman has an arrangement of red diamonds on a green background that clashes with the yellow-and-green tartan print on the dress of the knitter, whose red needle loaded with purple wool is held out in front of her. The wall covering behind the bed's bulky headboard is composed of blue, green, and yellow quasi-floral motifs rendered exuberantly in varying degrees of focus against a field of red that changes tone and value from left to right. The subject, even flat on her back in bed, is clearly a dynamic personality at odds with her confinement, strong enough to overpower two friends in attendance. The hands of each visitor, little portraits in themselves, reveal a certain passive resistance in the company of such a dominant figure. The picture's odd composition and colorful vibrancy reinforce the bedridden subject's forceful character and the compressed energy in the room. I would later learn that the painting is of Maria Dąbrowska, a noted Polish writer, a powerhouse with a reputation for being difficult, who had come to Maisons-Laffitte on a visit and, collapsing with the flu, was put to bed. The male figure by her side is Jerzy Stempowski, whose book of essays I had just begun to read. Stempowski's father, Stanisław, had been Dąbrowska's lover for many years. The knitting woman is Anna Kowalska, who during the occupation also became Dąbrowska's lover. Knowing more about the characters and the complex layers of relatedness among them, I see the picture as a wry commentary on the domestic life of the Polish intelligentsia. Czapski was no flatterer. Dąbrowska hated the picture, painted in 1964, the last year of her life.

The National Museum owns twenty-two paintings by Czapski. Over the course of many days, I spent time with each of them under variable conditions of lighting and access. At one far end of the airless storage facility, an area had been cleared and an easel and chair temporarily set up to create a more spacious viewing area for those canvases that could be removed from the storage racks. These were brought to me one after another by a sturdy woman in a beige smock. The arrival and removal of each painting in sequence was accompanied by the reverberating click of her high heels, now louder, now softer, as she made her way up and down the long, narrow, wooden floor, coming and going. A

339

residual gloom of Stalinist Poland hung over this vaguely sinister environment, where paintings seem like inmates serving time, scrupulously accounted for but rarely seen for what they are. As someone from the outside world, I had to jump through hoops to get inside. My sense is that these works have precious few visitors.

Of the museum's twenty-two Czapski paintings, eight date from before the Second World War, an unusually rich trove of a rare surviving breed, since almost all of Czapski's prewar paintings, drawings, and journals were destroyed during the Warsaw Uprising in 1944. Of these eight, five were deposited on loan at the museum by Czapski's old friend Jan Tarnowski, who acquired them directly from the painter's studio in Warsaw during the late 1930s. (For more than one hundred years, Tarnowski's family owned Rembrandt's painting now known as *The Polish Rider* at the Frick Collection in New York. It has long been debated whether the painting is actually of a Russian cossack, and whether it's merely the provenance of the painting that is Polish, not the dashing equestrian figure.) Tarnowski donated Czapski's paintings just before fleeing Warsaw in 1939, never to return to Poland. His collection of Czapski works included a still life of red lilies, a few rural landscapes, and several conventional portraits, one of a man in a fez, another of a woman in a beret.

One of Czapski's most ravishingly colored images, listed on my museum checklist as *Man at Exhibition* from 1959 (plate 11), has been deemed worthy of public exhibition and granted reprieve from the reserves. It hangs upstairs in a gallery given over to twentieth-century Polish art. A lanky gray-bearded man (think George Bernard Shaw) is seated precariously on a spindly chair in a museum or gallery space, both of his arms pressing against the contour of his upper body, his hands dangling by his thighs. He displays a very proprietary air, gazing out of the picture, assessing the viewer. Is he a museum guard? Sizing up people would be part of his job. His legs are jauntily crossed at the knee, and he is wearing what looks like a brown unitard and startling chartreuse socks. At first glance, he has an almost goofy cartoonlike presence, yet he is nevertheless a very self-possessed figure, serious (if you ignore the socks) and thoughtful. He sits in front of a cadmium red wall that glows and pulsates with color. The simple word "red" implies a unity of color, but this wall is composed of dabs of scarlet, alizarin crimson, vermillion, cerise, magenta, and a spectrum of pinks. The paint has been applied in an extremely loose and gestural manner, in places as luscious as smeared lipstick. The picture exudes painterly pleasure. A halo of carmine encircles the guard's head, investing him

with overtones of sanctity; he exhibits the aura of a saint in a Russian icon. Two framed canvases are hung on the red wall behind him, one of them surrounded by an ornately gilded frame. On the curved wall of another gallery room farther off, two smaller paintings can be seen through an opening in the red wall. The four framed paintings that figure in Czapski's painting are not readily identifiable. The red wall overpowers them, anyway—it is a tour de force of painting unto itself that reminds me of works painted in New York in the same year by the likes of Philip Guston or Grace Hartigan. The attentive guard appears as an anchor, a watchman defending the domain of figurative representation from any possibility of the picture dissolving into pure lyrical abstraction.

This luminous canvas was painted at the time of abstraction's apotheosis, when it was deemed that the pursuit of any other visual vocabulary was an outmoded, even reactionary activity. Czapski, with *Neon and Sink* and *Man at Exhibition*, remained true to himself, obeying an inner certainty, even at the risk of appearing out of step with the aesthetic spirit of the times. Reluctantly he found common ground with the surrealists, whose work he disliked but with whom he agreed at least that art had "to signify something." Non-representational abstract paintings were anathema to him. He was certainly seduced by the vital role abstraction plays as a tool in paintings—from the Italian primitives to Goya to Anselm Kiefer—but until the end, he held on to the idea of limiting his subject matter to what manifested itself miraculously before his eyes. He preferred to follow the humble path of nature rather than confine himself to the exalted realm of ideas, embodying a comment made by J. M. W. Turner: "My job is to draw what I see, not what I know is there." In Proust's novel, the narrator, paying a call on the painter Elstir in his studio, recognizes the discipline this requires: "The effort made by Elstir to strip himself of every intellectual notion when face to face with reality was all the more admirable in that this man who made himself deliberately ignorant before sitting down to paint, who forgot everything he knew in his honesty of purpose ... had in fact an exceptionally cultivated mind."

Proust may as well have been writing about Czapski.

Czapski's journals from his teenage years to just before the Second World War were all destroyed, but he managed to fill another two hundred seventy-nine volumes after the war. All but five of these are housed in the heart of medieval Kraków, in one of Europe's oldest ancestral libraries, the Princes Czartoryski

Library, not far from the fourteenth-century Basilica of Saint Mary and Market Square. (Two volumes remain in private hands and the current location of three others that survived the war is unknown.) The Academy of Fine Arts, where Czapski once studied, is close by. Near the end of his life, Czapski received a generous offer from the Beinecke Rare Book and Manuscript Library at Yale University, spearheaded by Czesław Miłosz, to purchase and conserve the complete set of his fragile volumes and incorporate it into their legendary Eastern European collection. He declined to sell them, unable to commit them in perpetuity to a place where he felt no viable connection. Another offer, to reproduce facsimile versions of all the volumes, was also politely refused. He did not want them buried in a hermetic environment far from his world and he did not want them widely distributed hand to hand in his own backyard. He left the extensive collection of journals to his niece Elżbieta, who eventually placed them in safekeeping at the Czartoryski.

Mikołaj, ever efficient and amiable, joined me in Kraków. I found him waiting for me in front of the library, on the narrow, cobblestone street of Saint Mark, ready to walk me through the institutional formalities and see me settled in. Encountering a protocol similar to the one used for registering at the museum in Warsaw, I came up against residual communist-era attitudes again. For the scornful older woman behind the official visitor's desk, my foreignness was almost intolerable. Once I was proven a legitimate visitor, she seemed disappointed not to be able to refuse me entry.

On the fourth floor I received my reader's card. A work space had been assigned to me. After filling out request forms listing specific inventory numbers, a library cart bearing the first distribution of Czapski's journals was parked beside my table. The journals are kept in upright cardboard storage boxes, holding from eight to ten volumes, with each individual volume nestled in its own protective paper slipcase. My first consignment comprised four boxes, thirty-six volumes in all. The first box has very early journals of different sizes, all bound in what were once shiny black covers. Their spines are so worn they now have the look of weathered bamboo. The physical reality of the journals is impressive, even daunting. I tried to determine what these few books might represent proportionally of the two hundred seventy-nine volumes written over the course of fifty years. I calculated roughly that each year Czapski must have filled five or six of these books, on average one hundred fifty pages long. Every eight to ten weeks he would find himself reaching for a new book of blank pages. The formats and binding materials of the books changed over

the decades. Most of the wartime volumes have only a rudimentary cardboard cover. Later, given more options, he chose cloth-covered books, first in black, then in gray. The books he used were bound mostly with unlined pages, though some had lined pages and a few had graph paper. Throughout the 1970s and '80s he settled on a preferred style, horizontal in orientation, a handsome oatmeal-colored linen volume that he often bought at Esquisse, an art supply store on rue des Beaux-Arts in Paris, where, during the same years, I often bought my canvas, sketch pads, charcoal sticks, and stretcher bars.

Czapski wrote and drew in black ink, blue ink, and pencil, supplemented by various colored pens, or whatever was at hand. Like most diaries, long stretches of pages are filled with line after line of handwritten text, but more commonly he wrote in no systematic fashion, covering pages in what seem to be outbursts of words in no determinant form. Words like raindrops splatter across the page, continually taking on new shape as long as the deluge continues. As he wrote, he had to contend with the presence of his drawings. He would accommodate these by writing around them, or he might invade their territory and write directly over them. Conversely, when he drew, he had to find space on a page already littered with words, or push ahead and stake a claim on the first available blank sheet. The impulse to write and the impulse to draw were triggered at different moments by different proddings; drawings on a given page do not generally correspond to the text surrounding it; the drawings are self-contained works, not illustrations accompanying a narrative. This response to visual and verbal stimuli is indicative of the firing of twin engines in his animated brain.

Former thoughts expressed in the heat of the moment were always vulnerable to reassessment by present thoughts. Above and beyond this already excessive display of word and image, a set of posterior notations appears, sometimes added only a few hours or days later, but often weeks, months, or years after the original comments had been committed to paper. He is talking back to himself. Crammed into whatever little blank space is left or quite often overlaying the text, the resulting additions create an effusion of literary pentimenti. The pages are crowded with numerous voices, each one his. "My journal," he wrote, "*c'est moi.*" He thought of his entries as "the mutterings of a shepherd to his sheep. My journals are my sheep."

Seen en masse, the journal is perhaps Czapski's most revealing self-portrait, though even a prolonged scrutiny fails to produce the whole picture. Its vastness is almost beyond comprehension, but size is not the only obstacle. The

handwriting on any given page can vary from legible clarity to indecipherable scrawl, often shifting radically in a matter of lines. He slips in and out of different languages in the course of a single sentence or paragraph. Any suggestion of ordered sentences and paragraphs would create the wrong impression; there is nothing systematic about the manner in which entries, frequently fractured, break down into columns of text or are diverted around a sketch, squeezed somewhere on the page. Some entries are voluminous, lasting for pages, others are explosive outbursts scribbled in haste, compressed between earlier entries, sometimes upside down, wherever a bit of space allows. Here is a telephone number and an address, there a shopping list of oil colors to purchase for the studio. A smattering of colored thumbnail facsimiles of old paintings erupts after periodic lapses of time, laid out like a pattern of mosaic tiles; he continually uses tiny telegraphic sketches to keep track of the progress on his most recent work. There are speculative drawings that might eventually be brought to bloom, transplanted onto canvas. The portrait of a stranger spotted on the metro on one sheet is met by another perspective of the same head on the facing page. A letter from a friend is pasted in, a review of an exhibition, a family photograph, a clipping from a newspaper article, a postcard reproduction of a painting by Giorgio Morandi or Albrecht Dürer. For many years, Polish scholars and specialists have been at work slowly decoding the mystery of the many thousands of pages of journal entries. Fragments have been published, sampling the depths of a highly intricate interior life, revealing a mind fueled by curiosity and consoled by vivid reasoning.

Drawings flood these volumes, acting as an alternative to the insufficiency of words. These pages represent the borderland between writing and painting. Images come from near and far. In the war years, he drew his fellow prisoners and exotic vistas of the Middle East—mosques and camels, pyramids and ancient ruins. Drawings of barracks life, cardplayers, swimmers and sailboats, palm trees and flamingos help solidify his hold on the transient wanderings of the Polish armed forces in the East. Once he was settled in Paris, street scenes proliferate and architectural details of buildings and bridges. People waiting for a train, a sleeping dog, a vase of flowers, a young man with his bicycle, a couple seated at a bar, a woman gossiping at a café table, a barber shaving a customer—a sketch most likely made as Czapski waited his turn. He never went out actively in search of an image or subject but would wait for one to make itself visible to him, frequently with the force of revelation. When an image struck, he was seized by the impulse to capture whatever had

triggered his vision. A drawing was quickly made, successful or not, but its imprint would linger in his mind as if developing, ripening, waiting for the moment it could be transferred into paint. That very first impression was the significant sensation against which everything was measured.

Like his conversation, his journal was peppered with quotations. He refers to these as his "golden nails," small, shining, precious tacks holding his rambling pages together, anchoring the peripatetic cast of his mind. The citations serve as signposts along the way, "soldering and creating my style and my voice." Memorable utterances offered by his various masters are duly inscribed in the pages of the book of his own life. Proust, of course, and Cézanne. Dostoyevsky, Simone Weil, Hugo von Hofmannsthal, Stanisław Brzozowski, Vasily Rozanov, Norwid, Camus, Beckett, Rilke: "My personal library without which I don't know how I would live." Czapski gathered about him the poetry he drew from these writers and painters. From their colors and words, their ideas and images, he derived warmth and comfort, even strength of purpose, in his effort to face the world every day.

The following excerpts are taken from the pages of his diary, many of them written in the early 1960s. They provide a smattering of comments and reflections, a brief exposure to his many voices and moods. Czapski regularly shifts between first- and second-person point of view, even when referring to himself (italics for emphasis are his):

Waking up. The hardest thing is having to face the void. It has to be done to keep from seizing up. One mustn't look back, like Lot's wife, and this *I cannot manage to do.* Last Friday, several hours of reward out of all proportion; everything seemed easy then and *is* easy. But the force of one's character is consistently making difficulties, it's not just about the act, but the wandering thoughts, the "what if I did this? . . ." which ruptures any continuity of line or effort.

Six thirty in the morning. Demons. Kafka says (in the *Diaries?*) that after a day of work they disappear, but as the night passes, they revive, they're back, they surround you in silence, waiting for you to wake up.

Once more a prayer arises, a submission to the divine will: *accept* life.

All of this is barely felt, they're like sub-feelings, sub-panics that recur, most of the time the same; at present in an unexpected way, after a long period of interior serenity, intellectual inactivity, thought returns to life as I paint, that is to say, when, during the largest part of the day, I can be *alone.* But painting

is not an end in itself, it's the path leading to a face-to-face—with what? With whom? I'm suffocating in my little room, there's no way to move, how could I paint?

Routine and counter-routine. When is it routine and when is it a combination of known technique, provoking an increase of attention and precision? After many years this combination seems personal to me, unique and infallible, then, slowly, the idea dawns on me that I could do otherwise, that maybe I should do otherwise, but then suddenly I'm threatened by what seems gratuitous. Over the years, my proven technique could instantaneously detect what was fake. Do I return to the old methods or persist in experimenting? As always for me, the approach is hesitant, lots of backward steps, and this too I must accept without renouncing the tentativeness, which is as old as my adoptive and painstaking rhythm of work.

Once again today I worked with a sharp awareness of powerlessness, of "well, more or less."

A priest. Visit. He's not interested in art or literature; religious problems, human affairs. My first impression: an interior life, a great simplicity and a great frankness. A man still young, lean, bald, with glasses. Through him I felt once more the lack of gravity, the nonessential character of art. Of what importance whether one likes Bernanos or Proust, Picasso or Braque? He looked at three of my paintings. A woman at the back of a dark loge at the Conservatoire next to a coral-colored column; a black man in an empty white-tiled metro passageway; a colorful café scene, at the back a couple embracing, on the other side a solitary figure, bald, with a raspberry-colored face. "These paintings?" said the priest, "Exactly the problems I'm swimming in."

I didn't understand. I thought that, not interested in abstraction, he concerns himself with figurative art. I asked him whether that was what he meant, and he replied, "No. *The solitude.*" I suddenly felt he's a poor man assailed by loneliness.

At table, Marynia told an amusing story and ended by saying, "Yes, but you, Father, you love God!"

Silence.

"I'm not even so sure."

What could my paintings offer this priest? For him, they could perhaps only be a resource that fail to nourish him, offering him no help.

He went out into the cold and rainy night, with his baldness, his youth, his loneliness.

Dusk already. Work once again, fresh and sure. Sure, in what way? In the way I control myself, objectify, expand the range of my sense of color which, when I don't work, is impoverished. The routine? Could you call this routine, this secular technique that opens a universe of happy, pictorial experiences before me? This slow pace couldn't be called vision, it's more like an apprenticeship of looking.

Yesterday at the hairdresser's to have my hair cut. The woman at the reception desk, the mistress of the business owner it seems, her face powdered in white, red mouth, her lips enlarged by lipstick, light blue eyelids. Empty eyes, absolutely empty. *Are you still making beautiful pictures?* My throat rattles. *Yes, yes, I know what beautiful things you make.* This empty face, this empty small talk, these clichés overcome me more than Callas with her singing last night. Dark bottle-green train cars with posters in all the windows (little blue turquoise curtains with white checks). Then at the café, at midnight, the fat cashier enthroned beneath her haystack of platinum blonde hair by her cash register under sparkling dark windowpanes, I felt a sensation far more intense than seeing the stage set of *Norma*, antediluvian, cheap. What stayed with me from that evening? The memory of the hall [the Paris Opera], always marvelous: the gold, the red, the light, the hundreds of faces in such a surround and in this light, high above my head, the fresh power of Chagall's colors, those that I like so little in his paintings, here they really sing.

After work. The whole secret of a painting, is that at a given moment, "under pain of death," it must attain its own proper logic, and that's when it changes its relationship to the canvas, to the *truth* of the painting. What just before was completely unacceptable ("let's see, it's not like that in nature or in the sketch") becomes not only necessary but the only true thing! Sometimes this moment, a fraction of a second, comes very late, sometimes it lasts from the beginning or never arrives at all, and it's as if the painting was never born. Delacroix said the most difficult thing is to know at what moment to stop working on a painting.

Spent some two hours at work, not more, and feel a really extreme exhaustion. If I had two such hours every day, things wouldn't be so bad.

Still coughing. A weakness, but I get back to work. Sickness, even without being threatening, is the best medicine for exhaustion. Often one has the time to get things done, then before falling sick one feels like there is no time to get things done, that work isn't moving ahead, the engagements, the delays build up and one no longer has the energy to cope. A slight temperature, a hint of the flu, and all of a sudden you shut down everything, you cancel engagements (with no drama), you push back the delays, you drop one thing after another, and soon your nerves calm down, and you sense that once again you're capable of real work, slow and concentrated.

(A memory, the year 1927. Typhoid fever and the long weeks of convalescence: that illness brought my painting to a dead end. A despairing, nervous exhaustion, but I began to see as never before. It was only then that the link between sensation, eye, and hand established itself in me.)

I finished reading Gombrowicz's *Cosmos*.

Interiority. A man who has lost his connection to the world....Why is Gombrowicz immoral, why am I scandalized, something that almost never happens to me in reading? On top of this, he's arch-Polish, and often surprisingly Catholic! In what? In his unconscious sense of values, in *his awareness of sin* and of evil. Is this a literature written in a state of mortal sin? Gombrowicz, who is so strange to me, more than that, hostile, is for me a much more serious and vaster concern than literature. I can't get to the bottom of it.

Lichtenstein's paintings are a conscious effort aimed at completely suppressing pictorial qualities, not in order to create new ones but to give in to the American lifestyle. It's no longer about being imbued by the surrounding world, but conformism to the extreme in relation to life.

My conversation today with Roy Lichtenstein. A modest young man, he has a nice face and a pleasant wife. Not a shadow of affectation. He speaks barely a few words of French yet the contact was immediate and we started right in jabbering about painting. But the director of the Sonnabend Gallery, small and tiresome, began to sell me on Lichtenstein, using the same hackneyed clichés that I read everywhere. I broke off the interview and left.

What was most important yesterday was the new *Connaissance* [the art journal *Connaissance des Arts*] I bought with its color reproductions of Nicolas de Staël. Maybe it's just yet another illusion of old age, but this day where, under a beating rain—torrents of water—I splashed about in flooded streets, hurled

myself into overcrowded buses, it did not seem to me to be a day of treason toward painting, just the opposite, of opening and joy, useful, precisely fruitful for painting. All of a sudden a hundred plans!

A large canvas today, *Woman in the Metro*, enormous fatigue, I think it's the first canvas painted with real passion in several months. A feeling put to the test yesterday, in the metro, that I'm in the midst of painting today, it's the kind of painting about which I dream; the magazine I bought with the pictures by de Staël gave me the boost I needed, just as when at the last second one gives a push to the parachutist when it's time for him to jump. It's not possibly, once again, just a moment, a surge? It's clear that here, it's not the will at work, but necessity. What can the will provide? Don't get in the way. Don't muddle these feelings.

My feverish application when painting may have been necessary over the years, it's the only means I have of keeping from dissipation. I'm like that American woman Gertrude Stein told me about: her whole life she flew about from place to place, vagabonding across Europe, traveling everywhere with her big bed, supposedly Louis XIV, bought in Aix or Avignon. According to Stein she was carrying on just like her ancestors, who conquered the West, who cut down the forests, then pulled from their covered wagon their rocking chair and built a house around it. They laid the tracks for the railroad and then took off once again. In another new place, they pulled out the chair and built another house. So this American woman sent her a postcard from Sorrento: "I'm here in the place I love most in the whole world, *I'm going to stay three days*." (My visions, my paintings are very often "for three days," though I have no American ancestors.)

Gare Saint-Lazare (I'm reserving tickets), a young man in a white shirt, with Armenian eyes and black headphones against his ear, at the base of a dirty column painted yellow and a red (geranium) oilcloth spread out on the ground—above his head a steel sign inscribed with the words *Booking Office*. It has been quite a long time since I've had the experience of a painting appearing "already painted" like a lightning flash—the background lemon yellow, orange, rich, dirty greens, the white of the shirt and these heavy blacks.

Over the years, one's sensitivity evolves—from a pugnacious and attentive quality to a quality one holds against oneself (a bitterness of the eye like a

bitterness in the mouth). An absolute sense of attention joined to a knowing sensitivity, that's what counts over the years, it's this that finally makes the leap possible. And it's only now that I see this clearly! When, after several strokes of the brush on a large canvas I have to lie down, I lay on my bed, out of breath. I'm consoled when I come across an old article by Jean Guitton, pasted into one of my notebooks, an article where he recounts that Darwin could never work more than two hours a day, and that also, after having dictated to his son for ten minutes, he might say, "Okay, that's enough." But at heart, it's what I've always known, for many years. When, from a window of the house on rue Staszica, painting a view of Warsaw under snow, I interrupted my work. I got into bed and waited. "But you're not working, you're sleeping, you're always in bed!" Jas would say when he came by to see me. "When I'm working on a portrait and a bout of tiredness comes over me, when I can no longer see anything, I keep on working, I pretend to see, because I'm ashamed in front of the model!" In such a way Jas compromised his sight, wasted his talent.

My faults, at the present moment? Not only being scattered to the right and to the left but also too often working too assiduously, too voluntarily, with a lack of confidence in "the advent of the Holy Spirit," with impatience, with an incapacity to wait, with a hasty nervousness and a lack of vigilance. I must remember what is in my power to get close to in these elevated states that come by themselves, from outside. Thus battle in myself all the residue, and maybe above all the fear of emptiness, the fear of that state which has all the signs of laziness, but which is, on the contrary, an extreme effort of patience, endurance, and vigilance, the vigilance of a hunter on the lookout. To know to wait an hour between each stroke of the brush, but to wait as the hunter waits for the bird whom he wants to bring down, waiting with no extraneous movement.

The debate with Artek [fellow Kapist Artur Nacht-Samborski], undoubtedly the most intelligent of my painter friends, presses me on. The most important thing to remark on in this argument is that what guides me is not a theory but a vision; not a preconceived idea but an overriding necessity; and that along with this, my visions are cyclical, immediately independent, the opposite of my will, of my thought. In no way do I deny the (immense) role of thought and will, but their time and their place is to be elsewhere—before and after. The attempts to escape this cycle, tried hundreds of times, result hundreds of times in a failure of deception, as when a medium, short on magical powers, resorts to turning the table with his feet.

After work. Oh, if only there were more days like this!

A café. A fat woman in front of me wearing a cobalt dress tinged with violet, badly washed hair curled into little ringlets. Powerful, tanned arms. A man in glasses with a face like a lamp and small eyes by a table on a sofa of Venetian pink. Across from him my head in a mirror with hair like Ben-Gurion's. A tired face with harsh creases leading down from the nose, cheekbones, sharp hobnails for eyes, the kind of complexion that's always almost magenta. *Ce corps qui est à moi et qui n'est pas moi.* [This body that belongs to me and that is not me.] The top part of the mirror grows more and more pinkish-brown. Splendid; the top of my face grows even rosier with ruddiness from the shutters shielding the café from the sun.

It's always the same thing. At a given moment I suddenly feel the need to choose between a line or a mark closer to photographic exactitude and a line or a mark more loyal to the very feeling that I want to describe. At the same time, I'm surprised to notice that my perception of the landscape was not confirmed decisively at the moment I first saw it, sometimes with an indifferent enough eye, but rather from the moment when I took up my pencil and made the drawing, in the heat of the moment, instantly. Despite all the faults ascribed to haste, this drawing remains for me the unique reflection of my feeling, the point of departure for my painting. So it's not nature then that binds me to the landscape but the immediate feeling that it arouses in me.

By arranging painters and writers like boxers and tennis players—this one is good, that one bad, this one even worse—we harm them. Every artist, if he is authentic, is unique, and only when he is experienced in this way can his value truly be seen. The same is true of suffering. Organizing pain into some sort of hierarchy based on an objective valuation of reasons that cause the pain—this, too, is false because every pain is unique and incomparable. Jerzy Stempowski told me about an episode when he was a young man. He was in the South of France and in a period of deep depression. He didn't leave the house for many days, but once, in the middle of the night, he left to go to a café along the coast for a coffee. There he got ... coffee that was served cold. It was too much for him. He stood up and walked out to the beach and decided to drown himself. It was pathetic; the sea was too shallow. He kept wading out but the water every-where was only knee-deep. After a few hours, he turned back ... back to life.

Memory of childhood: One of my sisters, at eight years old, had fallen in love with an old gentleman, a friend of our parents. As soon as she heard he was coming to the house, she painted her nails with crayons in a full range of colors in order to charm him. One time, when the fellow had just left, our mother asked her what had caused such frantic and strange behavior in her.

"But maman, he's so beautiful, his nose is so *red* and has such *black* spots."

Vision is a shock, where willful choice between this or that is powerless—a miracle of beauty which one alone can see; unique, fleeting, imperceptible or even held up to ridicule by others.

Every painter is like my little sister.

Two inseparable realities—the life lived and the life examined—served to shape Czapski's understanding of what it was to be in the world. He engaged with his diary in an extremely active manner. Each day began with a near-ritualistic immersion in the emotional, intellectual, and spiritual offering found in its pages. On waking, he would pull down a random volume from the two rows of shelves above his bed and plunge into whatever presented itself. Revisiting old ground invariably prompted the breaking of new ground. The monumental diary he continued to create could be said, with equal conviction, to have created him. In a large number of the self-portraits Czapski drew and painted, these rows of books appear as a palpable manifestation of his inner life encircling the physical body standing in front of them. These works should be viewed as double self-portraits.

To know Czapski is to know his diaries. His diaries, however, cannot yet be said to be known.

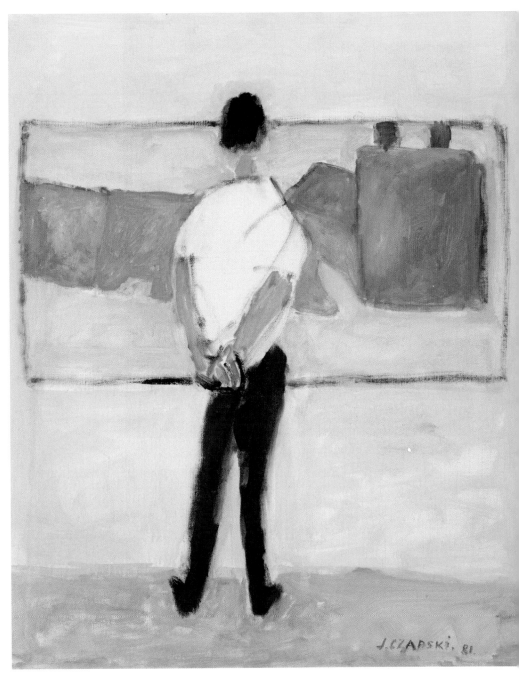

Plate 1: *Young Man Before de Staël*, 1981, oil on canvas.

Plate 2: *In the Park*, 1933, oil on canvas.

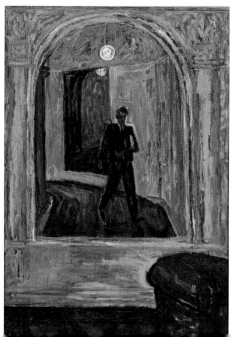

Plate 3: *In the Mirror*, 1937, oil on canvas.

Plate 5: *Self-portrait*,
1948, colored pencil on paper.

Plate 4: *À La Tour d'Argent*,
1948, colored pencil on paper.

Plate 6: *The Butcher Shop*, 1955, oil on canvas.

Plate 7: *The Beggar*, 1953, oil on canvas.

Plate 8: *Zbigniew Herbert*, 1958, oil on canvas.

Plate 9: *Self-portrait with Lightbulb*, 1958, oil on canvas.

Plate 10: *Neon and Sink*, 1959, oil on canvas.

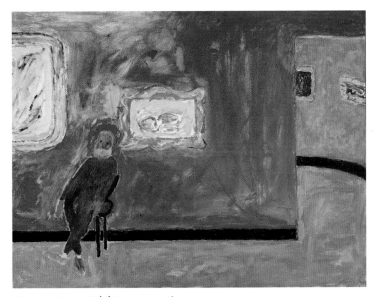

Plate 11: *Man at Exhibition*, 1959, oil on canvas.

Plate 12: *Visiting the Patient (Maria Dąbrowska)*, 1964, oil on canvas.

Plate 14: *Baggage Trolleys in the Station*, 1965, oil on canvas.

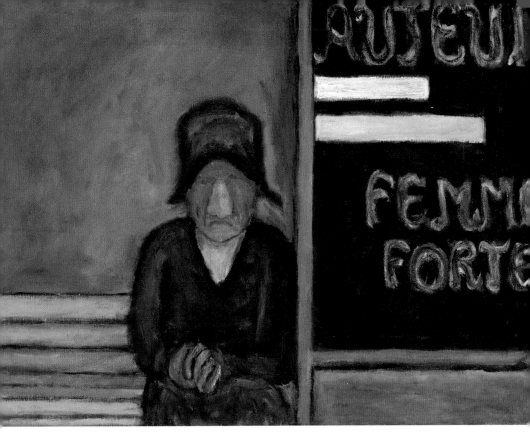

Plate 15: *Femme Forte*, 1965, oil on canvas.

Plate 16: *The Young Philosopher (Eric Werner)*,
1971, oil on canvas.

Plate 17: *Self-portrait*, 1974, oil on canvas.

Plate 18: *Exhibition*, 1977, oil on canvas.

Plate 19: *Thomas and Claudia Thun*, 1982, oil on canvas.

Plate 20: *Poland (Białołęka)*, 1982, oil on canvas.

Plate 21: *Yellow Cloud*, 1982, oil on canvas.

Plate 22: *At the Eye Doctor*, 1982, oil on canvas.

Plate 23: *Sunrise*, 1984, oil on canvas.

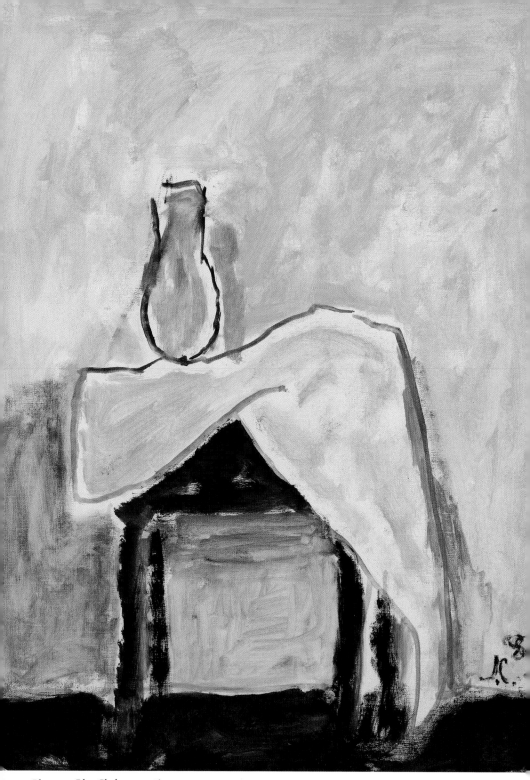

Plate 24: *Blue Cloth*, 1985, oil on canvas.

TOP: Plate 25: *A page from a 1966 diary of Józef Czapski.*
BOTTOM: Plate 26: *A page from a 1970 diary of Józef Czapski.*

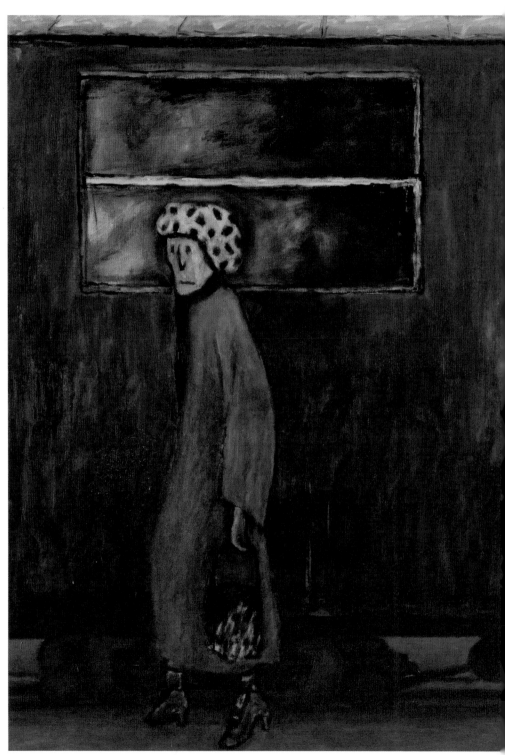

Plate 27: *Woman in Front of a Train*, 1971, oil on canvas.

17

A COLLECTION of Józef Czapski's essays on painting and painters, written over a period of three decades, was published by the Polish Literary Institute under the name *Oko* [The Eye]. "This book," he writes in his introduction, "is primarily a reflection on painting, conducted palette in hand," honoring Cézanne's cautionary quip, "There is some danger to thinking about painting without palette in hand." Czapski continued:

> I've always regretted not having three hands, because my thoughts on painting while I'm at work are not only for me extremely important but they define the very moment. As soon as I step away from the canvas, this feeling of absolute discovery dissipates and I have the impression of being able to think about it only with my brain and not with all of my being; each speculation enters into the realm of possibility, it is no longer a *necessity*.

The book collects essays from his prewar days in Paris and Warsaw, pieces written during the war while he was still at large in Soviet Russia, and others composed once he'd returned to a painter's life in Paris. Acknowledging that his feelings about various painters, paintings, and artistic schools had changed over time, Czapski emerged from the chrysalis of *peinture-peinture* into a more expansive critical viewpoint. The defensive, theoretical positions recounted in his earliest texts fade in comparison with the confident power of his postwar essays on such figures as André Derain, Raoul Dufy, and Chaim Soutine. These articles present a more exacting knowledge of the process in which he is engaged. In a biographical note, his friend Kot Jeleński celebrated the freshness of Czapski's outlook and his working methodology. Kot wrote,

> The "eye" of the title is his painter's eye. Fascinated by the most mundane appearances, he manages to seize on them. His method is similar to a roving photographer, camera strapped over his shoulder. He is not on the lookout for an image; on the contrary, such an image grabs hold of him, brusquely infusing

his passive regard with an immediacy of vision. The trigger mechanism's objectivity is converted into a scribbled sketch in one of the rough linen-covered notebooks from which he is never separated. The immediacy thus fixed, he develops it in the dark chamber of his memory before transposing it onto canvas.

In these essays we find a plea for the supremacy of eye over mind when it comes to pictures. Every painting, Czapski insists, must always be looked at as if for the first time. His tone is at once defiant and defensive, protective of the great treasures mute canvases contain.

While Czapski's quest for the mystical potential of painting was ongoing, his impulse to paint "from my own memory, from vision" found little common ground with the burgeoning Parisian taste for lyrical abstraction and informalism, trends that disturbed him in their glibness and patent opportunism. At the beginning of an essay called "L'abstraction: le pour et le contre" (Abstraction: For and Against) from February 1960, Czapski claims his territory: "This text speaks of painters and abstract trends which, in one way or another, have left a trace on the consciousness of a nonabstract painter." Written by a man born in the nineteenth century, the essay is impassioned and readable, but it fails to achieve critical distance. Aware of having boxed himself in, he assesses his limitations and strives to find his own ground: "We have all become more aware of the active presence of a mark of color or geometric forms on a canvas and are more sensitive to their combinations, whether they represent something or nothing. This is equally true for artists whose art has nothing to do with pure abstraction." Railing against artists like Yves Klein, Georges Mathieu, and the Italian Alberto Burri, Czapski comes as close to vindictiveness as at any time in his decades of writing. He finds Mathieu's monumentally scaled canvases pretentious, their self-aggrandizing references to Zen calligraphy and the improvisations of jazz superficial. He dismisses the painter's gestural flourishes, finding them as meaningless as the automatic writing of the surrealists. The thought of Mathieu driving around Paris in his Rolls-Royce comes as an almost personal affront. Czapski first encountered Burri's crude textile and debris constructions at the Biennale in Rio in 1955, and then again in Paris, where he discovered they were being sold for hundreds of thousands of francs. Acerbically, Czapski describes an installation that Burri has made for an Italian millionaire, assembled with rags gathered from the garbage. Enormous canvases by Klein, uniformly covered in his signature ultramarine blue, were lav-

ished with praise by critics agog at the thought of how many thousands of sponges had been required. "Distinguishable one from the next only by their size," Czapski notes, "identical otherwise in color and workmanship; ultramarine blue surfaces, no surprises." André Malraux, the reigning minister for cultural affairs, praised these same works, made by "painters liberated from the world, perhaps masters of the world."

Sotto voce, Czapski derided Malraux for his habitual reliance on cliché, for descending to such a level of pomposity and critical opportunism. By contrast, he praised the work of the art critic Jean Grenier, citing "his rare attention and total independence." A former philosophy professor, Grenier had taught and influenced a young Albert Camus in Algiers. Once in Paris, he contributed regularly to *Combat*, the anti-communist newspaper Camus edited until 1947; Grenier's later writing on aesthetics appeared in the pages of *Preuves* and *Nouvelle Revue Française*. Czapski admired Grenier as a critic but he did not always agree with him in substance. In an essay called "*Un courant irrépressible*" (An Irrepressible Current), Czapski zoomed in on an aside Grenier let fall, where he states that nothing is more interesting to him than to watch a figurative painter in the process of becoming nonfigurative. According to Grenier, the conventions of subject matter—landscape, people, narrative, perspective—had overstayed their welcome and no longer spoke to the spirit of the times. "An irrepressible current," Grenier insisted, "pulls modern painting along in this direction. What can we do?" As if gasping for breath, Czapski asked if these significant aspects of painting could really be reduced to mere conventions. Were they not more essential to the painter than that? "Such an attitude is convenient for a critic," he decided, "but it fails to suffice for a painter." The influence of the world of fashion and its corrosive impact on the perception of painting surfaced as a subject in Czapski's criticism. "Fashion is a secondary phenomenon, the consequence of success, in the sense that the authorities decree that this painting or that hat is beautiful and is the quintessence of taste, is of the moment. These suggestions never last," Czapski declared. He began to refer to Picasso as "the Dior of painting."

To fortify his position, Czapski reported a movement counter to the one that fascinated Grenier—that of a nonfigurative painter in the process of becoming a figurative one. Nicolas de Staël's rising star fascinated and delighted Czapski. Russian-born, Staël became a French citizen in 1948 after having led a nomadic life in Morocco, Algeria, and Italy. He descended from wealthy Swedish barons dating back to the ninth century and grew up within the

citadel of the Peter and Paul Fortress in Saint Petersburg, where his Russian father held the office of vice-governor. Once the Bolsheviks seized power, the family fled to Poland, where both his mother and father would die three years later, when Staël was only eight, a biographical note not lost on Czapski. Staël's earliest works as a painter were studies of saints and angels in the style of Russian icons. For a time he worked in a surrealist mode, then began to lean toward an increasingly abstract format, his images predominantly geometric but always highly atmospheric. Under the influence of Georges Braque, who became a friend and mentor, he developed a subdued palette. Indifferent to any idea of commercial outcome, Staël worked like a demon, always skirting the edge of dire poverty. In 1952 alone, he created two hundred forty-two paintings. His work gradually began to build a broad audience, and, surprisingly, a one-man show at the Knoedler Gallery in New York was a succès d'estime as well as a complete financial triumph. Later that year, Staël signed an exclusive contract with Paul Rosenberg, the French art dealer in New York who represented Matisse, Braque, and Picasso.

Monetary success made little impression on him. Czapski writes, "Rich, he acted with the same degree of casualness as he had done when poor." But Staël's aesthetic focus began to shift as he became increasingly seduced by the idea of subject matter. His moody geometric compositions gave way to forms recognizable for what they were—sailboats, pianos, birds, bottles, humans. He began to paint landscapes and still lifes. Two of his very large paintings, *The Orchestra* and *Football Players*, would become iconic images of the contemporary Parisian art scene. Against Grenier's claim that most contemporary painters consider a rupture from nature a necessary step, Czapski offered Staël's reverse transformation. "A return to nature," Czapski claimed, "is far more difficult than a rupture from it." He admired Staël's solitary, passionate devotion to painting, his journeying artistically "at full gallop." Czapski thought of Staël as a prodigal figure returning to the fold; he could hardly suppress his pleasure in the triumph of Staël's last few years. "It was as if he discovered the world anew." Largely indifferent to the abuse heaped on him for turning his back on abstraction, Staël, no stranger to isolation, continued to prefer going it alone. In March 1955, he threw himself from his studio window in Antibes. He was dead at forty-one. A maverick and a loner, Staël had character traits that appealed to Czapski as much as his paintings did.

A major event for Czapski was the appearance of *Still Life Painting: From Antiquity to the Present Time*, a richly illustrated volume written by one of the

Louvre's chief curators, Charles Sterling. A Warsaw-born Jew, Sterling refused to accept the false papers the Louvre procured to keep him in Paris during the occupation; he fled to New York and found work at the Metropolitan Museum of Art, cataloguing their collection of French paintings. Sterling was the embodiment of visual intelligence and aesthetic sensitivity. He only mastered the French language at the age of twenty, but he wrote in French with enormous conviction and power. Unlike Malraux, his intent was not so much to persuade as to reveal. Sterling considered the long history of still-life painting with a scholar's bent but through a fresh set of eyes. Still lifes were generally relegated to the lower echelons of artistic accomplishment, dismissed disdainfully as mere rhopography, the depiction of trivial, everyday objects. (Michelangelo reproached Flemish painters for making pictures of "useless things.")

Sterling singled out Cézanne for praise as the painter who irrevocably established the notion of a painting's purely pictorial concerns. Boldly stripping all remnants of literature, narrative, and history from his consideration of what was directly in front of him, Cézanne raised the common still-life genre to the heights of "elevated subjects." He proceeded to rebuild the world, solid stroke by stroke. Under Cézanne's disciplined scrutiny, the poor still-life genre, banished to the sidelines in the early nineteenth century, actively revived.

After so much talk of abstraction, Czapski was pleased for the chance to elaborate on paintings of things. His enthusiastic review of Sterling's book listed various schools of still-life painting from Pompeiian frescoes to Roman mosaics, from Giotto to van Eyck, from Velázquez to Chardin, reserving a special mention for the Spaniards, for Cotán and Zurbarán, Goya and Picasso. In the decades to come, Czapski would become increasingly devoted to still lifes, turning out swift, sure, luminous compositions of "inanimate and immobile objects."

In another essay in *Oko*, Czapski describes having been to an exhibition of masterworks from the museums of Vienna on loan to the Petit Palais. Leaving the building, he was overcome by the beauty of the canvases he had just seen, but, he wrote, he realized that at no time was he focused on the narrative imagery of the pictures—rather, he had simply taken in their marvelous colors and shapes. He didn't advocate such a narrow perspective and censured himself for being as bad as someone who looks at a picture exclusively for its content, "ignoring the plastic elements."

When Kot Jeleński reviewed Czapski's collection of essays, he rejected the truth of this claim outright:

I don't believe Czapski. I can't believe that looking at the Brueghels from Vienna he didn't once think of "man and nature," "the weather," or "the nonsense of everyday life." I think Czapski's mind was on something else. He may not have been interested in the apparent subject of the picture, in the anecdote; but for Brueghel, conscious or not, *The Fall of Icarus* or *Netherlandish Proverbs* are but a pretext for expressing his view of the world, the poetic essence of his work. Let's say right away that this poetics is indissolubly bound to its "plastic elements," it is more a question of form than of content . . . but when one looks at a painting, one cannot "ignore the plastic elements."

Czapski's tendency to imbue art with moral overtones does not escape Kot's notice. "Can one arrive at a fullness in art," Czapski had written, "without following the narrow path of absolute humility?" Kot suggests that such vocabulary "subjugates art to a moral attitude approaching Christianity." In an essay on Cézanne, Czapski had written about the necessary connection "between the abstract perfection of a composition in a square of canvas and a concrete vision of the material world." To justify his observation, Czapski goes on to quote a passage from Cézanne's letter to Joachim Gasquet: "If, by the mystery of my colors, I make others shiver, won't they feel a sense of the universal?" Kot suggests this connection is an example of Czapski's mind moving toward a kind of redemption. "As I see it," Kot suggested, "Czapski's love for Cézanne doesn't result from his admiration for 'a perfect composition in a square of canvas,' but from his identification with a pantheistic poetics of nature, an attempt to capture a universal rhythm. This expression appears on each page of *Oko*."

Kot focused significant attention on Czapski's dual role as painter and writer. In the pages of *Oko*, he found aesthetic and intellectual richness, history and psychology, concerns "indistinguishable from the deeper sensibility that touches every aspect of life." He experienced the collection as both a document of Polish artistic culture and "the autobiography of a pictorial sensibility." Illuminating the singular, complex relationship between Czapski's written autobiographical essays and his painted self-portraits, Kot also writes insightfully about the symbiosis of faith and art in Czapski the man. "Art for him is the *function* of an objective metaphysics." The essence of the religious experience, Kot declares, "belongs to the domain of the sacred, alongside certain forms of artistic experience, eroticism, narcotics, and war." In such lines, Kot reveals his own epicurean concerns, distancing himself from his friend's far

more ascetic nature. Bathed in the warm glow of Kot's overarching sensuality, Czapski appears at his most mystical. Both men, however, recognized that any simple equation of artistic and religious experience must be seen in the context of their increasingly secular age. "If art must suffice," Czapski suggests, "if it must be the new religion of an agnostic culture, if it is only a *questioning* thrust in the dark, which cannot expect a response since there is no one there to respond, if Bach, Rembrandt, or Norwid are also only a *questioning* without also being a response—then art is only like everything else in life, or as Kirilov puts it in *Demons*, life is only a 'diabolical vaudeville.'"

Dostoyevsky was never very far from Czapski's mind. The fictional character he refers to from *Demons*, Alexei Nilych Kirilov, expects only suffering and pain; of all the actual people Czapski knows, the individual who might best exemplify the idea of life as a diabolical vaudeville is Anna Akhmatova. Against all odds, the Russian poet had managed to survive the years of Stalin's terror and sadism. In the aftermath of Stalin's death, the European Community of Writers awarded Akhmatova their Etna-Taormina Prize and the poet was granted permission to travel to Sicily to receive it, albeit under heavy KGB surveillance. It was her first excursion outside of Soviet Russia since the start of the Bolshevik revolution. The following year, Oxford University awarded Akhmatova an honorary degree, and again she was offered a passport, and again traveled under close scrutiny. In England, she was greeted rapturously, with enormous outpourings of respect and affection. Akhmatova, in quite frail condition, was decorated at a ceremony whose ringing bells reminded her of a church holiday in Russia. From the stage of the Sheldonian Theatre, the university rector descended a flight of steep steps to confer the degree upon Akhmatova, rather than having her risk a fall mounting them as protocol demanded. The breaking of tradition provided an additional source of pleasure.

Emboldened, she made the decision to defy the regulations stipulated on her own travel schedule and discreetly slipped away to Paris for a few days on her return trip home. Her handlers were frantic. But, as a result, after twenty-three years, Czapski and Akhmatova again found themselves together. The situation was once more a constrained one, in an artificial social environment. Unpromising from the point of view of meaningful connection, the brief encounter was nevertheless significant and memorable for each of them.

20 June 1965

An unexpected phone call: Anna Akhmatova is passing through Paris and would like to see me. I leave straightaway for her hotel near the Étoile. (I made these notes in pencil as I left the hotel, I'll now add some more details I held on to but didn't note then.) In a spacious hotel room, Anna Andreevna is seated in a large armchair, fat, imposing, calm, a bit deaf. Not the tragic poet, the still-beautiful woman met at Tashkent, but an old woman, as if pacified, who looks at her past and the work of her life from above and at a distance. A great artist enshrined in world glory, surrounded by devoted young women and ancient émigré friends. Very grande dame. She makes me think of eighteenth-century idealized portraits of the Russian tsarinas.

Last year Anna Andreevna went to Taormina to receive an international prize, the "Etna-Taormina." Her first trip abroad since, I believe, 1914! She spoke of the prize with considerable irony. On her return, she wanted to come by way of Paris, but Surkov [secretary of the Union of Soviet Writers] told her, "You'll return the same way you came." On this trip, too, she was sent to England by way of Ostend so as to avoid Paris.

Once in London, she finally succeeded in getting the Russian ambassador to give her authorization to come to Paris, on the condition that she stay only two days, no more. Yesterday, not being able to book a ticket to Moscow, she put her departure off for another day; severe reproaches to the ambassador for his insubordination. At the station here, not a single official came to meet her, only her husband's old cousin, whom I knew in the thirties. It's thanks to him that she was able to locate me.

Left alone with her for a few moments, I asked her for news of her son. (She had spoken to me of him when we were together in Tashkent in 1942, of his arrest even before the war and his deportation to an unknown destination.) She told me he spent fourteen years altogether in the camps, was released, then arrested again. He took part in the "taking of Berlin," and at present was at liberty, a professor, writing a dissertation on the Huns. He was in excellent physical shape, "but he lost his head a bit in the camps. Since his return, he started to hate me and never wants to see me again. I've not seen him in three years. Oh well," she added, "and so it happens that the one closest to you becomes a stranger."

Then I asked her about Brodsky. She knows him and holds him in high esteem. He was released from the camp at Arkhangelsk for three days. "The highest medical authorities we sent him diagnosed his case as extremely serious,

schizophrenic, etc. He returned to the camp with these medical reports, but the doctor there decided he was fine. I couldn't figure out what it was all about, they weren't arresting anybody, then, all of a sudden, Brodsky!" In general she spoke calmly, with economy, not using superlatives, and this gave weight to each of her words. She had heard about *Kultura*. She also knew that I had written something about her, she had come across a mention of it in a bibliography somewhere, but, obviously, she had never been able to read my text.

In front of her cousin and me, she recited a poem she had written in London, in a singsong voice. The text was written on a scrap of paper taken from her book of London addresses. Then she destroyed the paper, tearing it into little bits. "I know it by heart," she said. She thought of destroying the address book, too. Her cousin expressed surprise that she couldn't even take her own notes with her. Akhmatova turned to me and said, "You see, he left Russia forty years ago and he's already forgotten! Spoken like a Frenchman!"

Emerging without warning from the ether she liked to describe, Akhmatova materialized in Paris, a fleshy but fragile emissary from an unburied past, a potent symbol of an ambiguous, truncated present. She was bundled off back to Moscow and then Leningrad, her traveling handlers chastised by their superiors for indulging her.

Months later, displacing the cold grip of the past, a herald from the future appeared in Czapski's life, a younger and stronger figure who would help direct and ensure his way ahead. In the neighborhood of Gare Saint-Lazare, in a bistro near the offices of the Congress for Cultural Freedom, Czapski was sitting by himself, finishing his meal, absorbed in a book. Zygmunt Hertz, catching sight of him from across the room, approached and asked Czapski to join him at his table to meet a young visitor from Poland. The slight irritation of having been disturbed vanished at the prospect of contact with a fresh mind, a new perspective. Wojtek Karpiński had never met Czapski, but by the time of their first face-to-face encounter he was already long familiar with the painter's writing on art and literature from the pages of *Kultura* and *Oko*. As a high-school student in Warsaw, he had read *Inhuman Land* and *Memories of Starobielsk*, copies of which were held under restricted use at the National Library; access to these volumes was granted only with special approval. Karpiński was already familiar with Czapski's reedy, high voice, having heard him interviewed on Radio Free Europe, and was aware that Czapski was celebrated as a significant historical personage, rather than highly regarded

as an artist among the Polish intelligentsia. Everyone agreed that he was a completely charming man, intelligent, articulate, passionate, but wasn't he really just a writer who dabbled in paint?

Karpiński was twenty-two on that day when he and Hertz set out for lunch. Czapski was pushing seventy. At this first meeting, Karpiński observed that Czapski failed to make categorical distinctions between his visual and verbal worlds. He had only one objective: to make sense of the world around him as a means of enriching his inner life, be it with pen or paintbrush in hand. "Whoever meets Czapski," Karpiński would later write, "is struck by the multiplicity of his incarnations and by the unity of his spiritual and physical silhouette." He could see that Czapski liked to talk and liked to be challenged, was genuinely tolerant, and, unlike many senior statesman, had an appetite for opposing points of view. In the din of a crowded Parisian watering hole at lunchtime, the two men started in straightaway. First came books, then the conversation turned to painting.

The following morning, having camped out on the floor of a friend's *chambre de bonne*, Karpiński found a letter from Czapski slipped under the door. He wondered how the post office had ever deciphered the nearly illegible address. It took several attempts before he was able to crack the code and begin to make sense of several long pages of scrawl, a continuation and expansion of their lunchtime talk. Once back home in Warsaw, Karpiński wrote often to Czapski, addressing his envelopes to the French friends in Paris who would put the letter directly into Czapski's hands, thereby avoiding the risk of exposing them both to investigation by the Polish secret police. In the privacy of their separate, quiet lives, a connection began that would join the men for decades, the prolonged extension of a thread of conversation that had begun unexpectedly in a loud public space.

Completely poised, hands folded in her lap, a seated woman in a white dress and white shoes, perched on one side of a long brown couch, is seen from above. Czapski's painting *Stairwell* (plate 13) is composed from the point of view of someone leaning over a banister and peering down past a flight of curving steps to the figure below. Her lap marks the picture's slightly off-center visual bull's-eye. As with his own truncated figure in *Neon and Sink*, Czapski presents the woman without a head; we see her compacted figure only from the shoulders down, the rest of her is cut off, obstructed from view by a structural element of the stairwell. The architectural dynamism of the overall picture

is fueled by the upward-winding trajectory of stairs. The canvas has a Piranesi-like spatial complexity, circular and flowing but fragmented and quirky. Spiral-infused decorative ironwork of the kind often found in Parisian apartment buildings supports a curved polished-wood railing that winds up the stairs and around the space, encircling the headless feminine form. Horizontal rectangles representing the treads and risers of the stairs and a diagonal grid pattern of stone tiles on the landing anchor the image. The substantial weight of building materials plays against a whirling sensation induced by the perspective of leaning down into the stairwell's vortex.

Preliminary sketches for *Stairwell* show Czapski's enchantment with the image and over many pages in his journal he repeats the motif of the seated woman seen from above. In the drawings, she clutches a handbag, but this detail is sacrificed in the oil, where her hands appear joined, somewhat blurred. The painting is charming and benign, compelling, yet from a metaphysical point of view, a headless woman is certainly a provocation, a perverse offering. A stairwell, as one passes through it or pauses in it to sit for a spell, is a transitional space. Czapski has latched on to this momentary vision, his picture seizes on what is fleeting in a context of what appears immutable materially. At some point the woman in white will depart and a palpable emptiness of stone, metal, wood, and tile will reassert itself.

Czapski insisted that artists are not godlike figures but vehicles of transmission, serving to record sensations of the visual world we inhabit. *Stairwell* is just such a transmission, a work of masterful execution, its aura charged yet also dispassionate, impersonal. The following year he painted another female figure with her hands in her lap. *Femme Forte* (Strong Woman) is a canvas (plate 15) that falls among Czapski's Goya-esque pictures, alongside others like *The Beggar*, *The Blind Man*, and *The Concierge*. A horizontal format is bisected vertically. In the left half, an elderly woman is seen sitting on a low train-station bench made of yellow wooden boards. She wears some sort of bonnet whose gable-like brim is steeply pointed above her brow, causing a shadow to darken her face. Her eyes, swimming in the shadow, are indistinct and only her fleshy nose protrudes into the light. Her hands are tightly clasped in her lap, her fingers firmly entwined. Her shape is compact, the body held tightly and gathered into itself. The V-shaped neckline of a black outer garment reveals a triangle of white material underneath, a pronounced patch of brightness. The uninflected gray wall behind her is a study in flatness, the painter making something of the nothingness of empty space. Almost centered in the

picture, the huddled figure sits up against the vertical barrier that separates the picture's two halves. A signboard fills the right side. The word "Auteui" has been scrawled on the top, and underneath, on two lines, the words "Femme Forte." Czapski employs his customary casual rendering of commercial lettering. Such signage in his work, when legible, offers little meaning but seems to represent the visual impact advertising makes on urban lives. The vast billboards found in the Paris and London metro stations serve as a setting for his contemporary figures as tellingly as Whistler's Venetian alleys or Watteau's sylvan backdrops. At the same time, such elements also manage to evoke certain tropes, like Campbell soup cans, in pop art.

His choice of Auteuil as a posted destination (the final letter is not included in his picture) suggests the possibility of another level of meaning for Czapski because it is the birthplace of Proust. (I confess to an associational flight of fancy here: Triggered by the combination of a vague reference to Proust and the words "strong woman," I can't help but think of this humble figure as Proust's character Françoise, the officious but compliant family servant the narrator abuses and ennobles in the pages of the novel. Seeing her in a hand-me-down dress she has transformed "with simple but unerring taste," the narrator recognizes Françoise as a person full of competence and modesty.) In an advertisement, the words "Femme Forte" would more likely be accompanied by the image of a fit and youthful female figure. Instead, what we see just beyond the sign's border is an old woman whose strength is related not to muscle tone but to fortitude. *Femme Forte* is uncharacteristically ironic, illustrating the kind of juxtaposition one often sees as one goes about one's business and registers with a nod. The conceptual disparity—between what the words evoke and who the woman he has painted appears to be—is wide and somewhat comical on first viewing, but through Czapski's quiet assembling of seemingly contradictory elements, the observer finds an aptness of association. Looking straight ahead, the woman appears isolated, turned inward, contained, unremarkable, aware of her mortality. Fading into the gray atmosphere, she is in the process of becoming invisible. Yet Czapski, recognizing an indomitability in her, rescues her from invisibility, honors her, empowers her with his acknowledgment of her survival against the odds. She may be battered, but she truly appears as a woman of strength.

His engagement with this image is profound enough for him to create more paintings from the same originating impulse. *Femme Forte* paintings exist in three separate versions. Two were painted in 1965, a third, four years later.

Slight variations occur from one to the next. One woman has a closed umbrella beside her. In a third rendering, the woman's hands are more relaxed and she holds in them the handle of a closed umbrella that stands upright between her legs. Like van Gogh and his numerous *répétitions*, Czapski joins the tradition of painters who return to a favorite image to reimagine it over and over.

What are Czapski's paintings about? (Kot teased him for being disingenuous on the subject.) When asked directly, he would respond by saying his paintings were not about anything, but surely the contemplative aura emanating from the *Femme Forte* series is not solely a mixture of colors and compositional effects, the sum total of "plastic elements." Czapski repeatedly declares that his paintings are triggered by a visual impulse, not by design or calculation, but the headless figures in *Neon and Sink* and *Stairwell* show him pushing his understanding of what a picture needs and what is superfluous, well beyond the first thrill of vision. He siphons inspiration from everyday life, from accidental sightings and quirky juxtapositions, from the bone and fiber of the visible world, from whatever he sees with his eyes open. Yet even during his floundering Kapist years, his painterly concerns were rarely if ever exclusively formal, nearly always retaining a deeper, if unvoiced investment in content, in meaning. His embrace of various genres represents this breath of involvement. What he hoped to avoid at all costs was the lifelessness of aestheticism. Many pictures record what was immediately in front of him, others aspire to say something visceral about the pain of life, about suffering. Many embody traits of both categories, mixed to varying degrees by the same hand.

In his review of Elizabeth Bishop's first volume of poetry, the literary critic Randall Jarrell wrote: "All her poems have written underneath, *I have seen it.*" This can be said with equal conviction about Czapski's paintings, in all their manifestations. *Baggage Trolleys in the Station* from 1965 (plate 14) is a perfect example. Seven large, abandoned metal baggage carts stand clustered on a station platform. Behind them, a train car emptied of passengers sits idly on the tracks. In this unremarkable grouping, Czapski finds an image worthy of being painted, a cluttered stage set before the actors make their entrance. Where are all the travelers and their bags, where are the conductors and porters? The last stragglers have left the train, it is too early for new passengers to board. The scene is devoid of people—the main protagonists, for whom all this machinery, equipment, and architecture exists, are nowhere to be found. A dark, muted palette lays in the subdued colors of travel venues—the somber

gray of the platform, the rusty reddish-brown of the wagon's undercarriage, the industrial green of the sides of the train. Set against this institutional monochrome, six trolleys striped in gaudy yellow and one in bright orange offer visual relief. How does the vibrant orange sing with such feeling, why does it induce such a glow of pleasure? Czapski's imagination is fully engaged, and such canvases represent the trust he places in his own sensibility, the confidence he has gained by sticking to visions of the world as they appear. It has been a very long apprenticeship for him, but by the mid-1960s he has begun to produce pictures of singular power consistently, and his belief in himself has started to pay off. The painter has found a way to lay claim to the realness of things, uncovering the inner life of the most unexpected objects and places. A veil of silence cannot be said to overlay this scene—one can imagine announcements for arrivals and departures, the noise of engines, and the buzz of travelers out of sight—but Czapski has isolated a tableau of Chirico-like quietude within a vast urban train station. The paint almost hums with found stillness.

Giorgio Morandi, another Italian painter invoking stillness, made a strong impression on Czapski. His still-life canvases are generally small in scale and composed of quasi-formal groupings of jars and bottles. The pale tonalities and exacting composition of a spare oil study by Czapski, showing a long-necked white pitcher on a bureau desktop, are informed by the work of this Bolognese master. The vessel is shown in profile, its handle fused at the top and halfway down its height, just where the form begins to swell out slightly. A decorative border design fashioned in clay, like a line of W's strung together, circles the form. Glazed all white, the object provides an opportunity for the painter to find a wealth of nuanced tonal variations representing that elusive noncolor. The wall behind the pitcher is a watery field of muted pale yellows, simply but expressively brushed in. Overall, the canvas is hazy and vaporous, but it has a tactile strength in the bold, gray shadow the handle casts behind it, the shadow appearing more substantial than the rendering of the form itself. The pitcher sits on a flat wooden surface whose grain is composed of mottled patches of browns and grays. Underneath the desktop, off to the right, the single spherical knob of a desk drawer acts like a compositional ballast. The shadow under the drawer pull is painted a very dark umber, as is an opening like a keyhole for the drawer on the far left, as is a strip of darkness running along the bottom of the picture indicating the space underneath the desk. The image is very pure, very reduced: Except for the weight of the pitcher, the

canvas is ephemeral, abstract in feel and touch, like a color-field. Painted in 1965, the year after Morandi's death, the picture might be seen as a tribute, celebrating all the virtues of clarity and poetry associated with him.

More effusive and baroque in style, *Nasturtiums*, from the same year, high-lights the breadth of Czapski's expressive range. A decorative panel, brimming with deep coral, salmon, and red orange blossoms against a blue-gray back-ground, the work has the same pulsing energy as the curling tendrils of an invasive nasturtium plant. An unmeditative, joyful picture, it exudes a vibrant force of color. A spate of colored-pencil studies of these nasturtiums brightens the pages of his journal, with groups of flowers exploding en masse and indi-vidual blooms observed in loving detail. This is that rare occasion, however, when a Czapski drawing fails to make the same degree of impact as the finished oil on canvas it inspired. The painting's sumptuous, viscous swirls of oil color are more tactile, more resplendent, more evocative of nature's rhythm of growth and intense vivacity than the graphic rendition on paper.

In person and in print, Kot Jeleński was a powerful advocate for Czapski. At the same time he was a crusader for the difficult writings of Witold Gombro-wicz. Sensitive to the subtle ways in which their respective paths of resistance to the suffocating traditions of Polish culture overlapped, Kot attempted to bring these two singular artists into closer orbit, to provide an opening for further dialogue between them. He encouraged Gombrowicz to invite Czapski to write an article about his work. Kot hoped to edit and publish the exchange as part of a series of critical monographs on writers in the *Cahiers de L'Herne*. Gombrowicz was willing to address such a request to Czapski and received, in turn, a complex series of replies over many months. The formality of address between them is in part a pose, imbued with a touch of irony. The men knew each other but kept a respectful distance:

Maisons-Laffitte 11 April 1968

Dear sir,
Your entirely unexpected letter brought me much pleasure. *I do not see* how I would be able to write about you for *L'Herne*, even putting purely practical questions aside: an exhibition in London in May, stupefying drudgery. There is a fundamental reason: Still and always I do not get to the bottom of Gom-browicz *in* me and *for* me. There are many different layers in you, there are things I hate in you, the feeling that you methodically destroy that which for me gives

367

existence its unique sense. Moralist, you preach the freedom of every reflex (provided it be individual, personal, and, at the same time, you preach our absolute independence), and so, long live murderers and sadists, each with the right to his "piece of meat in the soup"—a piece of the young boy that you killed off in *Pornography*. I wouldn't mistake you for a brother of J. J. Rousseau.

I lack the tool to speak with you, not only because I'm not a philosopher and that I never approach this territory other than as a dilettante come to peck. When I think of you, more important things are called into question for me, *you know* which. How to express my essential reproach, the conviction that you are knowingly *deaf* as far as certain problems are concerned?

The scene in the church (*Pornography*), several subjects in the *Diary*, sometimes make it seem you are suddenly *very close*, as if we are posing *the same* questions, but this has nothing to do with the tightrope-walking Gombrowicz, the poseur, the Dalí of Polish literature, the excellent writer and tarantula. For me, there are always several Gombrowiczes, nevertheless I know they are the same.

What's left? A villa in the South of France, worldwide fashionable success, mercy! And still more the babbling of fans and chattering of enemies: These latter are fearful (because you've become a celebrity) and have kept themselves quiet. I know how much what I write here will seem confused to you, it would be so simple to apply clichés that repel me as much as you, and this is why I would not like to write in *L'Herne* without having the feeling that I am fully responsible for what I say.

Again, thank you for your letter.
Cordially,
Józef Czapski

Maisons-Laffitte 23 April 1968

Dear Sir,
You're preaching to a convert, I am very tempted to write on you, but *truly*, I can't promise anything.
Most cordially,
Józef Czapski

It's Berl who said: "I don't write to *say* but to *know*." There is that in me. Without writing, I do not know what I really think of something. The temptation I have to write about you is the desire to explain you to myself and to understand.

Maisons-Laffitte 6 February 1969

Dear Sir,

Among other things, my senile impotence consists in writing letters that I don't finish and don't send, they accumulate disproportionately and, all muddled, seeming illegible to me, they go into the trash can. Now I've decided to send this, *whatever I write and whatever form it takes.*

I'd like to speak about you in a "disinterested" manner, and to you alone, to explain to you a bit about why it is so difficult for me to write an article on you and what motives are filling my head. *First,* I could with equal conviction try to demolish you or praise you to the skies. My attitude toward you not only becomes more and more complicated, becomes more contradictory each day, but keeps changing without end. I'm discovering how slight and superficial all my readings were....

Gombrowicz as I saw him in 1933 or 1935 (?). Only many years later was I able to understand that this "artificialness" was a solitary search for a proper form, that it was for you a tearing away of the ties of foreign forms already dead in you, or nearly. You were saving yourself and saving your nascent thought through caricature, the ferocious deformation of your entourage. (Norwid said: If you awaken a man by dropping a rose petal on his face, even so you would be brutal!) Not only caricature but every view, personal and shrill, is tested for deformation and lies; being a painter I know something about this.

My first meeting with you, at my place, rue Filtrowa [in Warsaw], thirty-five years ago, one that weighed on my whole attitude toward you. Returning from Paris following an absence of seven years, I discovered the latest Polish literature: Andrzejewski, Miciński, Rudnicki, and Gombrowicz. With the first three, sympathy on first contact, more than that, friendship. I hoped for the same spontaneously amicable encounter with you. I only had known as yet, I think, your brilliant, fantastic stories, this was before *Ferdydurke.* You came—and you struck me as unbearably artificial, moreover prematurely old, you told me art did not interest you at all... I failed to extract from you a single sound in a natural voice. A poseur? I had no interest in seeing you again....

You write that you already see your form in others, in letters and texts, you wonder if you still have the energy to create a new form. I find you can now speak of yourself in the third person (like de Gaulle!). The myth of Gombrowicz, the reflection of his reflection eats at Gombrowicz. ("Poor Gombrowicz," my sister rightly said reading an article, "only apes imitate him!") Today I should

369

like to see him nude in turn, because he of the myth is perhaps no more than the skin of the serpent that the serpent has left behind. Today, after months of illness, exhausted by asthma, no longer trampled underfoot by imbeciles but glorified, Witold who is no longer amused by either shrimp, or champagne, or the Nobel Prize, *Witold before the void* is seeing another "landscape."

The other Gombrowicz, he of his writings, appears to me as a man who seems to be closing windows, stuffing all the cracks where a "slight aura" might rush in. He's a positivist Gombrowicz, refusing the possibility of another dimension, flat, Gombrowicz in hell, cut off from experiences that could, in the fraction of a second, transform his vision of existence and give him a new will to live. But he is, in a certain manner, at the opposite pole of the Gombrowicz of "me, me, me."

Here I must stop, otherwise this letter will get tossed in the trash, but you will have understood some of the paths my reflections on you have followed. Your role in Polish literature, your influence on the character of Polish literature, seems to me irreversible.

Very cordially.

J. C.

Gombrowicz was touched and grateful for this outpouring of quasi-hostile, passionate, conflicting feelings, the intensity and depth of consideration moving him to reply with equal candor, in order to accommodate the request of their mutual friend, Kot. He returned Czapski's letters to him, with a proposal:

March 1969

Dear Sir,

I've lost much time looking for your letters, gone astray in some abyss of my innumerable files. But here they are, have a quick look at them and tell me if you agree to publish all three of them in *L'Herne*. For my part, I think this would be even better than an article, more animated. I would prefer to change nothing. There are very interesting things, for example, when you say that a single visit from me determined your whole attitude toward me, or else the definition, very apt, of my "pose" as a protective wall behind which I was able to choose my form. And all of this written in the heat of the moment. In any event, I would be grateful for the return of these letters, precious as they are

for me. I hope your cares are gone, as for me I limp along and can no longer write long letters.

Most amicably,

W. Gombrowicz

As per the novelist's wishes, Kot included this exchange of letters, unchanged, in his volume *Cahier Gombrowicz*. Czapski, irritated by the idea of an artist hiding behind a mask, was repulsed by Gombrowicz's narcissistic affect and his degree of self-involvement. All the same, he would find much to contemplate and even admire in the legacy of this contentious spirit who unwittingly helped to reshape the idea of being Polish in the world.

"My entire life I have fought not to be a 'Polish writer,' but myself," Gombrowicz declared. Four months after his last letter to Czapski, he was dead.

The Fullness of Time

1979–1993

18

As Czapski entered his seventies, the children of his many nieces and nephews and cousins began to appear in his life. Another generation, coming of age under communist rule, having grown up in the muted, reflected glory of their great-uncle, made their way to Maisons-Laffitte to meet the legend and pay their respects. Once more Uncle Józio played at being "*le plus grand peintre de Paris.*"

Striding into the lobby of an unadorned building from a busy street in Warsaw one afternoon, I had to pause to let my eyes adjust to the dark before climbing several long flights of green travertine steps in a narrow, steep stairwell. I had come to visit the family of Janusz Przewłocki, the son of Czapski's sister Karla. When Czapski returned to Poland in the early 1930s after his first tenure in Paris, he and Marynia often set out to the east of Warsaw for Mordy, where Karla lived on the family estate of her husband, Henryk Przewłocki. Czapski would take advantage of being in the countryside and would set up his easel and work en plein air. In a portrait he made of Janusz as a tow-haired six-year-old clutching his toy, a wooden horse on wheels, evidence of the loving bond between Józio and his nephew was clear. It would be deep and lifelong. Janusz died in 2007, but his wife and son graciously invited me to pay a call on them. Catching my breath in the darkness at the top of the stairs, I rang their bell. The door opened and the tiny hallway landing was immediately transformed into a celestial chamber of beaming sunlight. Slightly blinded, I fumbled to find my footing, and stepped through the open door. Finding myself in a high-ceilinged foyer, I realized I was sandwiched between two exceedingly tall and thin figures whose shadowed silhouettes against the blaze of light I could not at first distinguish. After a moment I felt my right hand being grasped in welcome. Janusz's widow, Elżbieta Przewłocka, née Czartoryska, was willowy and quite frail, but she had been determined to be at the door to greet me. Even taller and equally slender, her son Grzegorz smiled distractedly at me, focusing his slightly agitated attention on the immediate needs of his elderly mother. As a group we shuffled together into the apartment and regained our bearings.

Introductions were made in a generous, bright room lined with deep book-cases. Late-afternoon sunshine, nearly liquid, poured in from a bank of windows. Soviet-era Warsaw apartments, built as the city was being resurrected out of the post-uprising rubble of the late 1940s, were solidly constructed, if austere in design. Softening the severity, ancient etchings, faded photographs, framed drawings, and paintings competed for attention on the walls, and a variety of inviting sofas and upholstered chairs representing a broad spectrum of furniture styles were smartly arranged on soft carpets over a beautiful parquet floor. An imposing, highly polished wooden chair with intricately patterned inlays sat proudly in one corner of the large room, isolated like a throne. As he saw me take it in, Grzegorz muttered, "A gift to the Stackelberg family from Catherine the Great," and directed me to a more comfortable seat. (One of Czapski's great-great-grandfathers, Count Otto Stackelberg, had been the empress's ambassador to Paris, Madrid, and Stockholm.)

As a teenager and young man, Grzegorz, in the company of his father, would often visit his great-uncle Józio. Janusz Przewłocki acted as a facilitator of sorts for Czapski as the effects of age began to take a toll. He was one of very few people who could decipher the scrawl of Czapski's handwriting in his letters and diaries. As a proven judge of art, a position of privilege his discriminating uncle bestowed on him, Janusz would be called on to view new paintings and pass comment on them. On occasion, near the end of Uncle Józio's life, he would be handed a loaded brush and instructed, under the gaze of the artist, to add the initials "JC" to the corner of a canvas, when Czapski's hand was no longer steady enough to execute such a precise detail. Czapski's hand was sufficiently nimble to make drawings of Grzegorz as a teenager, however. In one study, immediately evocative of the fashions of the early 1970s, the youth is shown sporting a flowing mane of hair and wearing a bold flower-patterned shirt with a flounced front. The artist made a gift of the drawing to Grzegorz, inscribing it, affectionately, "Portrait of Byron, by an unknown painter." Another sketch, in ink, shows the young man in profile, curly-haired, his eyes flashing. Its inscription reads "Portrait of Grzegorz, style of Delacroix."

As these drawings were presented to me and put in my hands for closer viewing, they stirred up much emotion in Grzegorz. The connection between the artist and his model, despite the long passage of time, was still palpably alive and deeply felt. Some inchoate sentiment passed between us as one precious work after another was offered to me, each preceded by a poignant intake of breath. As I responded to both the images and their guardian, I could feel

the degree to which Grzegorz continues to honor and draw inspiration from his father and great-uncle. And it soon became clear to me that the long climb from the street had brought me not only into the cordial home of Czapski's descendants but into one of his main treasuries. Czapski drawings and painted sketches hung on every wall and poured forth from cabinets and drawers, from closets and chests. Framed and unframed works on paper were handed over for my consideration, some in a state of pristine conservation, others on crumpled, crumbling pages. Some images were yellowed with age and fading; on other sheets the sketches seemed freshly inked, hardly dry. A whole series of drawings of Czapska sisters—Poldzia and Karla and Róża and Marynia—were placed gingerly before me. Pensive, unflinching portraits made over the decades began to pile up, sketches mostly caught on the fly. Relaxed and unposed, the women appear completely comfortable under the gaze of their brother's hungry eyes, their heads and bodies supple, gaunt, at rest. Surrounded by these faces I felt myself in the presence of any number of interpersonal connections that form an intimate family history.

Drawing after tender drawing of dogs followed, then still lifes, then landscapes, and an outpouring of more heads, among whom I recognized Zbigniew Herbert, André Malraux, and Daniel Halévy. Next, astonishingly, came drawings of sleeping prisoners of war made on pale lined paper from Czapski's time in Gryazovets. These gave way to more wartime work, made when he had been released from the Soviet camp and was traipsing across the Middle East, delicate watercolors of handsome soldiers in mufti, boats along the Tigris River, street scenes in Baghdad. And, to my amazement, drawings from even earlier times, from Czapski's years in Saint Petersburg during the revolution, a delicate pencil portrait of his compassionate Tolstoyan companion Antoni Marylski in profile, dashed off on the back side of a sheet of personalized stationery. The presentation of works, one item after the next—drawings, paintings, sketchbooks, memorabilia—continued for more than two hours.

Later, over tea, Madame Przewłocka spoke about her husband's role in Czapski's life, how he became a repository of stories and personal history, of anecdotes and wishes. During the later years, as Uncle Józio became inseparable from his diaries, Janusz, under his supervision, took to making barely visible pencil annotations for posterity, writing directly on the pages to identify people whose names surfaced in written entries and whose faces appeared in drawings. Przewłocki was a keen historian, with a penchant for professional and amateur archival photographs; he knew the intrinsic value of Józio's

extensive documentation of the twentieth century. His collection of Czapski family photographs is an astonishing resource. After Marynia died in 1981, Madame Przewłocka went to Maisons-Laffitte and moved into the upstairs room Marynia had occupied for such a long period of time to keep an eye on her husband's aging uncle. One night before turning in for bed, she came down to check on him and found him sprawled out on the floor under his worktable. He had fallen and was unable to get up. He had clearly been there a long time; neither she nor anyone in the house had heard him fall. Flustered and anxious, she helped him to stand. Seeing he was not badly hurt, she quieted her nerves and asked him how he had passed the long hours before she found him: "What did you do all that time?" Smiling, he hugged her and tried to calm her agitation. "Oh, no need to worry about me," he replied, "I just lay there, perfectly happy, thinking about Proust."

At a gathering after a poetry reading in Teatr Polski, one of Warsaw's elegant theatrical venues, I received an invitation to visit the home of another Czapski descendant. Having heard about my interest, Franz von Thun und Hohenstein kindly asked if I was free to come for Sunday breakfast with his family the following day. Franz's sparkling eyes lit up when he smiled, which softened the outward aura of Austrian correctness that had made him seem somewhat unapproachable. A dignified and warmhearted soul, he is uniquely poised to represent Czapski, being a relative both by blood and by marriage. The namesake of the former Count Thun, the Viennese minister and brother of Czapski's mother, Franz is married to Róża, the granddaughter of Czapski's youngest sister. Two daughters issued from the marriage of Czapski's sister Róża to Ignacy Plater-Zyberk; the elder, Elżbieta, married Jean Colin and, after his death, Benedykt Łubieński. The younger daughter, Maria, known as Maya, married Jacek Woźniakowski, an art historian who knew Czapski independently, as a friend and a critic of art. Maya and Jacek Woźniakowski had four children— Henryk, Róża, Anna, and Jan. Róża Woźniakowska married her distant cousin Franz Thun. Their four children—Marynia, Sophie, Christoph, and Jadwiga— carry the genetic legacy of both the Czapski and Thun families. I tried to master this complicated genealogy as I made my way back to my hotel.

Franz welcomed me at the door of his home the next morning and apologized for the absence of his wife who, as a member of the European Union Parliament, had been called to Riga at the last minute for a meeting with the Latvian president. Entering the spacious, slightly hushed household of Franz

and Róża Thun, I found a large table set with bowls of fruit, platters of cheese, jars of preserves, all laid out for a late breakfast. Franz offered me coffee and explained that he thought we might eat a bit later, after I had the chance to spend some time alone with his mother-in-law, who rarely came downstairs. He escorted me up a wide, airy stairwell lined with photographs, drawings, and paintings. The lights were dimmed, and it seemed clear that some members of the household were still asleep. Leading me into a room whose door was propped open, he introduced me to Maya, a lovely, bright-eyed, impeccably dressed woman whose silver hair was swept back in a small bun. Wearing two tight strands of pearls about her neck and a thick silver bracelet on her wrist, she smiled warmly and asked me to forgive her for not having come downstairs to greet me. We spoke in French. Franz excused himself to go back downstairs to continue assembling platters of food, clearly well-trained to fill in as host whenever his wife was called away on affairs of state. Maya, who'd had a career as a biologist and was still active in political causes, was a mine of family lore, but seemed a bit guarded at first about divulging too much about Uncle Józio. Gradually becoming aware of how much I already knew, she dropped all sign of restraint and wanted only to ensure I was correctly informed. Referring repeatedly to anecdotes she had learned from her late husband, Jacek Woźnia-kowski, she wanted me to know how much it pained her to think of how underappreciated Czapski was as a painter. The walls of her bedroom were full of framed drawings from the pages of his sketchbooks, portraits of her and her sister Elżbieta, of her aunt Marynia, of her mother as an older woman, and of her daughter Róża as a teenager. "For Czapski," her husband had written, "art was a form of associating with people, with the world."

Maya became quite open and responsive as we talked. She declared she felt well enough to come downstairs after all. Arm in arm, we descended slowly. She led me to a mustard-colored dining room hung with a colorful quilted tapestry, where the generous table had been set. In one corner of the room I spied a late nineteenth-century portrait that, on closer look, I recognized as a portrait of Czapski's mother, Maya's grandmother, seated indoors at a window beside an exotic potted palm, an open book in her hand, probably her Bible. Even seated she appeared fabulously tall, poised on the edge of her chair in a full-length white silk dress, her reddish hair tightly braided and coiled atop her head. Her face was long and narrow. The portrait immediately brought to mind a passage from Czapski's diaries: "Moments of happiness? A light-colored carpet with dark patterns, I'm playing on it with blocks. Mama's sitting nearby

in an armchair and there is full sunshine and a fragrance of hyacinths from flowerpots that the gardener brought in. The shine of Mama's gold-red hair in the light. A feeling of absolute and eternal safety and happiness."

Looking at the portrait of Józefa Czapska, I was struck by how much all the Czapski children clearly resembled their mother, who was, of course, a Thun by birth. Stepping back from the painting, I realized I was standing in a house where strains from both Thun and Czapski families have melded once again and everyone looked related.

Once seated, Franz, tall and firmly built like most of the clan, took the opportunity to share with me some of his memories of times spent with Czapski. Working as an international projects adviser, he had traveled abroad a great deal. Called on to make frequent trips to Africa, Franz would arrange his travel so as to be able to go through Paris, where he could easily make the trip out to Maisons-Laffitte and have some time with Uncle Józio. In exacting detail he recalled his delight as the two of them would drive out on summer evenings through the French countryside in a Fiat 660, a tiny car with a retractable top. As they drove, their heads extended high above the windshield. "How we carried on! Józio was always so full of emotions and feelings, that he could be laughing heartily one moment, then tears would be welling up in his eyes the next." Before Franz could continue, we were interrupted by the appearance of his youngest daughter, Jadwiga, her hair still wet from a shower, bending over to kiss her grandmother and her father and reaching out to shake my hand. Assuming the role of hostess in the absence of her mother, she refilled pitchers and plates, inquired about what we might need, fixed herself some food and drink, and sat down to join us. Her opening question was directed at me, expressing curiosity about my interest in her great-great-uncle whose paintings and drawings had been constant fixtures in her life. With obvious pleasure, Franz yielded the conversation to his vivacious daughter. Educated at an international school in Warsaw and widely traveled, Jadwiga speaks flawless American-accented English.

At about 12:30, having been in the house for more than two hours, listening to Czapski stories from across three generations of one family, I was surprised by the appearance of yet another Thun, Christoph, or Babu, as he is known. Obviously pulling himself together after a late night, he stretched out a hand, nodding and grunting a greeting. Only very recently returned from his first trip to the United States, Christoph had been playing drums in a Warsaw-based garage band at the South by Southwest music festival in Austin, Texas. He

seemed somewhat surprised to find an American at the breakfast table between his father and sister, speaking with his grandmother in French about his great-great-uncle. For my part, I could not get over the sight of him. Seeing Chris materialize from across the room was like watching a flesh-and-blood twenty-two-year-old Józef Czapski come sauntering toward me, hand extended, ready to make my acquaintance. The resemblance was unnerving, even a bit freaky.

An hour or so later, it was time for me to return to my hotel, from which I had set out early in the morning on foot, walking across half of Warsaw. Babu, plied with food, buzzing from caffeine, was ready to start his day. Did I need a ride? He'd be happy to give me a lift. I said my goodbyes and thank-yous to the family as he and I piled into his large, beat-up white van. We hit a wall of slow-moving traffic heading into the center of town but continued to talk, discussing the indie music scene, Polish cinema, Texas barbecue, and such. As we approached my hotel, he pulled the van over and came to a stop. Ready to hop out, I was surprised when he turned off the ignition. Chewing his lip a bit, his eyes darting about, he asked sheepishly if I would mind if he were to ask me something personal about his well-known ancestor. "I've heard about him my whole life," he announced with some trepidation. "He's like a hovering spirit. But conversation about him within the family always goes only so far and then stops. I've heard some kind of rumbling noises from friends of the family, stories about him beyond the saintly legend, but no one *in* the family wants to talk about it. You seem to know so much about him." Long pause. "Was he gay?"

It was a relief to hear the question put so directly. It may be the twenty-first century, but I was in Poland, a country where eighty percent of the population identifies as Catholic, where many long-held taboos remain firmly intact. And so I sensed a lot was at stake. I knew that my reply to this sophisticated but credulous Józef Czapski look-alike should not be flippant. Maintaining my credibility and standing within the family of Czapski descendants was no small consideration; I needed their permission in order to publish my research. I couldn't risk ruffling feathers by making pronouncements about a renowned member of their tribe I'd never met. It was clear to me, however, that to prevaricate under these circumstances would be wrong. If Czapski had no illusions about himself, Babu, having asked a question point-blank, had the right to an honest answer. I took a deep breath. "He slept with both women and men," I said, "but I believe his sexual preference was primarily homoerotic. So, essentially, about what you're asking, the answer is yes."

He took it in, pursing his lips. "Huh," he said, shrugging his shoulders, nodding his head slowly. "Cool." He turned the ignition back on, reached over and shook my hand in farewell.

Making our way toward the center of the Old Town of Kraków from the stretch of river near Wawel Castle, walking down the middle of a wide cobblestone street in the pedestrian zone, Mikołaj Nowak-Rogoziński and I were deep in conversation about Czapski when I saw him look up and past me and break into a smile. He excused himself and walked over to a nicely dressed, rosy-cheeked woman with strawberry blond hair peering into a shopwindow. I watched as he made what seemed like a stiff and abbreviated bow toward her; he then shook her hand. After speaking with her for a moment, he turned and pointed at me, and brought her over to make an introduction. Róża Thun was quite cheerful and clearly aware of who I was, citing various family reports. "My mother doesn't often make the effort to go downstairs anymore. She really enjoyed her time with you." We stood talking for about ten minutes, a fixed point in a shifting tide of shoppers and tourists. Several times people came up to speak with her, or to shake her hand, or to bow, slightly, in recognition. A born parliamentarian, whose irrepressible warmth of character shines through her bright eyes, she deftly negotiates the formalities required in her role as public servant. The phone in her purse rang. Apologizing, she said she would have to take the call and turned away, putting her head down and slipping into a sterner tone of voice than the one she had been using with us. Mikołaj and I walked on. He had mentioned to her that we were due to travel to Warsaw the following day; later in the afternoon Róża texted Mikołaj to find out if we could travel together to Warsaw.

At the station, we found a compartment to ourselves and talked steadily over the course of the three-hour journey. I let her know that I once had the opportunity of studying her great-uncle's portrait of her and hoped she might have some recollection of the experience of sitting for him as a fifteen-year-old. His portrait of her as a teenage girl is compelling, a young woman looking out unabashedly at the viewer, slightly defensive but confident. She is seated at a table in a dark blue sleeveless top, her blond hair fashionably pixieish, her hand gingerly placed on an art book spread open on the flat surface in front of her. She has pushed herself back in her chair as if to say, "I'm game to do this, but for how much longer?" The paintings in the book do not seem to concern her.

Róża rolled her eyes. "I was a kid, it was a little strange and uncomfortable for me, but he did his best with me.

"I went to meet him in Paris in 1969, when I was first given permission to travel out of communist Poland. I was going to study French for a few weeks and my parents said to be sure to go and see Uncle Józio and Aunt Marynia, but don't take up their time, they're very busy people. And they were. There were always visitors and people in the house at Maisons-Laffitte. I think about it now from a different perspective, having had children of my own. They had no children; what did they know about what a teenager might like to do? But Uncle Józio took me to the Louvre. He didn't take me to see the *Mona Lisa* or some other famous work, no, he led me to the room with small northern European still lifes, pictures with butterflies and tulips and pieces of fruit that any young girl would like. We stood looking at them and he asked me questions about what I saw and what I liked. And then, after half an hour or so, he leaned in to me and, in a quiet conspiratorial voice, asked which one I wanted to try and steal and take back home with us. He told me he knew which one he was going to take. I have to admit at first I was scandalized, not knowing he wasn't serious. I mean, I had just come out of Poland where you didn't make such jokes.

"He was an artist and loved beautiful pictures and surrounded himself with art books and his own drawings and paintings. He was clearly very engaged in the visual beauty of the world. He and Marynia were really *very* poor, but that was never an issue. You know how it can be with people who have very little in the world to call their own? When it comes to sitting down to a meal, you would never know because they make each meal a ritual and a sacrament. The table is cleared, places set, everyone gets a glass if only for water, and a plate and utensils if only for some small morsel of bread or such. This was *never* the case with Józio and Marynia. They didn't care at all about food, they just made some room at their worktable, sat down, and paid no attention to what they might eat and got up as soon as they finished to get back to their business. They had no interest in any ritual around eating or drinking. Or in clothes for that matter, or in their surroundings. Józio made beautiful paintings but he was blind to beauty in how he lived. They didn't care, they were indifferent, they didn't see. In this sense, they were truly bohemian."

Catherine Djurklou's son, Nils, was another young person who figured in Czapski's life. Nils's bluster and hearty spirit featured frequently in his mother's

letters to Czapski. A snapshot was pasted in the pages of Czapski's diary of the dashing young man in a sweater and tie, pipe in hand, showing him sitting under one of Czapski's paintings, framed and hanging in the Djurklous' living room in Stockholm. Over a period of twenty-five years, Catherine regularly wrote to Czapski about her son with maternal pride and concern, from the time of his birth, through primary school and university, to his later vicissitudes in love and his stabs at various professional careers. In the archive at the Princes Czartoryski Library, I read letter after letter she wrote to Czapski, their correspondence ending only when Catherine died in 1977. I was in a quandary of sorts. I hoped to be able to see some of the paintings Catherine received as gifts from Czapski over the years and described in her letters, but I was unsure of how to present myself to a man whose mother had been romantically tied to someone other than his father for decades. How much did Nils know about Czapski, about the nature of the relationship between his mother and Czapski? (Even having read her letters, how much could I say I really knew?) I wrote to Nils, and our first exchange of emails was encouraging and enthusiastic. Of course he remembered Czapski, his name had been a very familiar one since childhood. He recalled that during one of his visits to Paris as a boy, his mother had taken him for a visit to Maisons-Laffitte. The paintings he inherited from his mother were now hanging at his home in Helsingborg, Sweden. I was certainly most welcome to come and see them any time.

Czapski kept more than one hundred of Catherine's letters, letters overflowing with heartfelt attachment and gratitude, discreetly perfumed with unspoken longing. Had she kept his letters to her? This possibility prompted my decision to visit Nils in Sweden. Catherine had been dead for almost forty years; had Czapski's letters surfaced, had Nils read them, what did they reveal? His letters to Catherine certainly existed at one time, but without access to this primary source material, the ability to determine the nuances of their intimate involvement would remained limited. Regardless of how consistently she declared her love and referred to the pleasure of receiving his loving letters, there was little to prove that he was equally enamored.

En route to Sweden, I stopped in Copenhagen and spent hours with the many Giacometti sculptures and paintings on display at the Louisiana Museum of Modern Art. An exhibition called *Cézanne and Giacometti, Paths of Doubt* had been mounted at the museum a few years back, and in the course of thinking about Czapski and his paintings, thoughts of that exhibit returned frequently to me. Cézanne and Giacometti's similar traits of diffidence and

self-effacement, their separate but equal "paths of doubt," provide a framework that helped me to approach an artist like Czapski, whose own highly disciplined solitary journey, as he struggled for fulfillment of his vision, was realized with only a tenuous sense of accomplishment. About Cézanne, Giacometti wrote "that because of him, today our entire vision of reality has been called into question." For himself, he claimed, "I do not create in order to produce beautiful paintings or sculpture. Art is merely a way of seeing." To the extent that he had said this in so many words, Czapski embodied the same aspiration, the same understanding. To see Czapski whole, one must appreciate the way he positioned himself aesthetically, philosophically, how he was able to celebrate the truth of others as a way of trying to form his own truth. The artistic and poetic voices of Cézanne, Bonnard, Proust, Goya, Tolstoy, Norwid, Giacometti, Morandi, and Weil all shaped him. He took solace in their certitude and drew courage from their doubt.

Just north of the museum at Louisiana, I caught a ferry across the Øresund Strait, a channel separating the North Sea from the Baltic Sea, a slender divide between Denmark and Sweden. The ferry departed from Helsingør, also known as Elsinore, its windswept terminal tucked under the fifteenth-century Kronborg Castle, the site of the tragedy of Shakespeare's *Hamlet*. Crossing over to Helsingborg, in Sweden, to meet Nils Djurklou, I surrendered to thoughts about the Danish prince and his decidedly complicated feelings about his mother's amorous proclivities. Contemplating Catherine and her love letters to Czapski, wondering what Nils may or may not have known of this extramarital affair, I settled into a funk. "And thus the native hue of resolution is sicklied o'er with the pale cast of thought."

From the pier, I followed a short few blocks uphill to the apartment of Nils and his wife, Lilie, both of whom were well into their seventies. They greeted me warmly. Nils, a quiet but spirited presence, stood proudly beside Lilie, who was animated and gracious, an ageless Scandinavian beauty. Our preliminary exchange of letters and emails seemed to have made us friends in advance. Beckoning me in, they offered a glass of excellent champagne and we made a toast, with a nod to Czapski, in acknowledgment of our convergence. (Once again, I felt myself having been pulled somewhere almost beyond my own reckoning.) Entering their comfortable and light-drenched living room, I saw that pride of place had been given to three Czapski canvases. A rather conventional, uninspired still life of a glass of red wine and green apple sat low on a wall just above a sofa. Another, at the back of the room in an alcove, was a

scene of two men, one young, the other slightly hunched with age, standing across from each other at either end of a bistro bar. A third, a haunting study of a woman's face, hovered just above the high-backed chair where Nils sat, flute glass in hand. The woman peers out from the painting directly at the viewer, but her expression is inscrutable. The overwhelming impression was one of sadness and isolation, her stillness holding front and center, while behind her the din and bustle of animated café life carried on. The painting was badly in need of cleaning—its melancholic mood is enhanced by a buildup of grime through the years. Eventually I was able to determine that it was not a portrait of Catherine, as I had wondered at first.

Before sitting down to lunch, Nils and Lilie walked me around the flat. A fashion photographer's wedding portrait of them as a very glamorous bride and handsome groom was presented to me. Framed photographs of Catherine were scattered here and there. A middle-class Canadian girl with the dazzling good looks of Deborah Kerr, Catherine became a stylish and elegant Swedish baroness (rather than a Polish countess). Pictures of Nils and his mother from different decades were presented to me from various photo albums; in one from the early 1960s, mother and son were caught twisting together on a crowded dance floor. Hanging on the wall in Nils and Lilie's bedroom, I spotted a drawing Catherine had bought from Jean Colin, a study of roofs and chimneys in red and black chalk with traces of watercolor. Several drawings of Catherine by Czapski were also on view, two profile sketches were especially strong.

Over lunch around the kitchen table, they told me more about themselves, about Catherine and Gustave and what they knew about Czapski. Much of what they reported about themselves was already familiar to me, having read Catherine's extensive accounts of their first meetings, of their courtship, of their budding family life and the usual struggles involved in raising small children. Nils had written to me that he had been brought by his mother to Maisons-Laffitte as a boy. As we were sitting over coffee, I asked whether he and Czapski ever met again. He lit up. "I have a little surprise for you." He got up and quickly returned with a small laptop computer. Lilie began to clear the table, keeping close enough to contribute her side of the story as needed. "In 1966," Nils began, "Lilie and I decided to get married. She had just been hired by a Swedish designer to model his new line in Paris. I was temporarily between jobs, which gave me the freedom to follow her. I went to Paris, too, and watched Lilie and nine other Swedish girls work the fashion shows." Nils pressed a key

on his computer and some silent, scratchy black-and-white footage began to roll on his screen. I could make out various landmarks of Paris right away, the camera following a bevy of slender beauties in shockingly short dresses on parade—in the Luxembourg Gardens, at Trocadéro, window-shopping on the Champs-Élysées. Periodically the camera would zoom in on Lilie, ravishing, mindless of her beauty, showing off the clothes she wore and posing in good fun. As the camera panned the crowd of hangers-on, the camera lingered on Nils once or twice, undeniably proud and smitten. The sweet film, impossibly innocent, ended after a few minutes. Before pressing another key, Nils leaned over and said, "Keep your eyes peeled." More footage, Paris again, a new location. An outdoor café, a sunny afternoon, tables set up under an awning on one of the *grands boulevards* crowded with diners. The camera circled around to the front of the establishment, trying to stay out of the way of a line of aproned waiters coming out the door toting cluttered trays. Suddenly, Lilie emerged, exquisitely done up, beaming at the camera. Another figure close behind her came into view. Straightening up from having had to duck his head to get through the door, Czapski was then recognizable. He, too, smiled broadly, and almost as soon as he appeared, dapper and avuncular, the film clip abruptly ended. The coverage was brief but vivid. Nils explained that he had taken it at the luncheon Czapski had arranged for them, in honor of their marriage. Knowing no one in Paris, they never forgot this kindness.

Though they could see I was clearly delighted by the surprise appearance of Czapski in the film, I sensed they felt sorry for having so little of substance to pass on. I tried to remain upbeat, but a bit of my disappointment must have leaked out. I was in possession of all they had to offer. There would be no stash of letters to read, no ringing confirmation of Czapski's shared feelings of love. Making one last attempt, I carefully probed a little deeper, asking Nils directly about the nature of the friendship between his mother and Czapski. He readily volunteered that he knew it was extremely close, and he admitted that his father certainly had not cared for the man, nor the fact that his wife was always dashing off to Paris to see him. "Of course," Nils added somewhat cavalierly, "Czapski was homosexual."

Nils's father died in 1972 from a prolonged illness that had kept him bed-ridden for many years. When Catherine died five years later, Nils wrote to Czapski to inform him of the details of her death. In his letter he mentioned that while at the hospital, he had seen his mother's dog-eared copy of *A Family of Central Europe*, Marynia's history of the Czapski family, on her bedside

table: "We often spoke about your sister and you, who I sincerely believe Mother loved, after her family, more than anybody else in the world." Nils had a request: Would Czapski grant Lilie and him permission to reproduce one of the sketches he had made of Catherine on the front of a note card the family was going to send out to acknowledge people's kindness at the time of her death? Then he added, "I would also appreciate if you would write to me about how you met and knew my mother, something not well known to me, which interests me very much." Czapski wrote back agreeing to their request, even asking them to forward several of the cards to him, so he could write to other friends and family about her death. His letter to Nils, dated December 30, 1977, was effusive about Catherine, about her warmth, about how easily she charmed people, about how much she would be missed. No reference was made, however, to Nils's interest in learning more about how Czapski and Catherine had met and how they knew each other.

19

A LETTER ARRIVED at Maisons-Laffitte addressed to Czapski from an unknown person, asking if he knew of a poem dedicated to him by Anna Akhmatova, who had died of heart failure less than a year after her brief stay in Paris. According to the correspondent, Akhmatova had worked on the poem over many years and finished it in late 1959. In her usual fashion, she committed it to memory and relied on trusted friends to learn passages of it as well. But she refused to tell anyone who inspired the poem. The letter writer wanted to know what Czapski knew about the poem, which was subsequently printed in two different versions. She detailed the history of her research:

> I had my first conversation on the subject of this poem with an old friend of Akhmatova, and it was she who showed me the discrepancy between the two versions, saying that Akhmatova didn't dare leave the word "Warsaw" in the first version when it was published in Moscow in 1961, but that today it was possible. This person asked me if I knew about whom the poet was speaking. I replied in the negative. "I do know," she said, "but I won't tell you; all I'll say is that the word 'Warsaw' will provide you with the answer."
>
> Several days later, Mme X. (also a close friend of Akhmatova) said to me: "I don't understand why no one wants to tell you what's going on in this poem. There was a Polish painter who was in Tashkent during the war and Anna Andreevna met him."
>
> As for me, I'm certain the only Pole that she saw then was you.

Czapski knew nothing about the poem. He was unaware of its existence. In an essay written sometime later to honor Akhmatova, he quotes from the letter he received from an unknown Russian woman and offers his perspective on the history of Akhmatova's poem.

> I don't doubt that Akhmatova's poem is a transposition of memory, seventeen years later, of that night when I accompanied her from the house of Alexis

Tolstoy, the night when I read from an open book the poems of Norwid, of Baliński, and of Słonimski. I still remember the tears in her eyes when I clumsily translated "Christmas in Warsaw." After the reading, Akhmatova promised to translate that verse. Then she recited her own "Poem of Leningrad." I recall the path we took as we walked together later in the night. The moon shone. After the heat of the day, the air was breathable. We were both drunk on poetry. Without ceremony, Anna Andreevna dismissed someone who wanted to join us, after just a few strides. It was only then that she divulged to me the mortal anguish and fear she held for her son. Suddenly, this woman who had such an affected manner, keeping her distance from us all in the house of Stalin's dignitary, Alexis Tolstoy, came very close to me, became human, a different woman, tragic to the depths of her soul. She said to me then: "I don't know why, we hardly know each other, all the same, you are nearer to me than all the people who surround me." Speaking with me, she said, she breathed a different air, free from the fear that, in Russia, at that time, strangled everyone, literally everyone.

He began to wonder whether or not, during their last meeting in Paris, Akhmatova had been waiting for him to make mention of a poem he did not know had been written, a poem that commemorated their first evening together, and what that evening had meant for her, and how she had cherished its memory. When a copy of "From the Cycle: 'Tashkent Pages'" was finally sent to him, he pasted the poem's Cyrillic text into his journal. Then, writing about the poem, he identified Akhmatova's old friend who had told the letter writer that she knew who the mysterious stranger from Warsaw was: "According to Nadezhda Mandelstam, this poem is dedicated to me. In its first version to appear in print, even the word 'Warsaw' was suppressed out of fear of the censor." The poem, dated December 1959, would later be published with the potentially revealing reference to Warsaw intact:

From the Cycle: "Tashkent Pages"

That night we drove each other crazy,
The ominous darkness shone only for us,
The canals murmured to themselves
And the blossoms smelled of Asia.

And we passed through the alien town,
Through midnight heat and smoke song—
Alone under the Serpent constellation,
Not daring to look at each other.

It could have been Istanbul or even Baghdad,
But alas! Neither Warsaw nor Leningrad,
And this bitter difference
Was stifling, like the air of orphanhood.

And I imagined that centuries marched by,
And an invisible hand beat a tambourine,
And sounds, like secret signs,
Circled before us in the darkness.

I was with you in the mysterious gloom,
Walking as if in no-man's land,
But suddenly the crescent moon
Skimmed like a diamond boat over our meeting-separation . . .

And if that night should return to you
In the course of your hidden fate,
Know that someone dreamt
About that sacred moment.

In their respective solitudes, kindling the spirit of centuries streaming by, Akhmatova situates Czapski and herself in the timeless limbo that the art historian Aby Warburg calls *das Nachleben der Antike*, the afterlife of antiquity. The constellation Serpens hangs above them in the night sky, the only constellation with two noncontiguous parts, each signifying half of a snake, the head to the west, the tail to the east. Between these separated halves, an independent constellation represents the ancient healer Asclepius holding the snake in his hands. This celestial division echoes two separate earthbound bodies, together but apart, walking in "the ominous darkness" on earth, "not daring to look at each other," distinct in their individual woes but able to derive comfort from shared lines of poetry and their improbable discovery of each

other. The line "Walking as if in no-man's land" curiously evokes the Polish title of Czapski's memoir of those years, *Inhuman Land*. Taken from a poem by Stanisław Baliński, which Czapski may have read aloud to her that first night they met at Tashkent, his memoir's title is *Na nieludzkiej ziemi*. In Russian, Akhmatova's "no-man's land" is *po nitchenoi ziemlie*.

"Know that someone dreamt / About that sacred moment." Russian literature scholar Victor Erlich (whose socialist activist father, Henryk, an executive committee member of the Second International, was killed while in the custody of the NKVD) remarks that "few of Akhmatova's contemporaries were as endowed with so exquisite a sense of the sacred as Józef Czapski." "How grateful I am for this poem," Czapski confessed, "and that she had wanted to see me again in Paris, and how much I regret it was not possible to listen to her, to speak with her as we had done at Tashkent. I couldn't have foreseen that our brief encounter, practically in the middle of a crowd of people, would be the last, that I would never see her again, nor ever say to her what certain poems of hers and that encounter at Tashkent were for me."

Beginning in 1970, Czapski began to spend his summer months in the village of Sailly, some thirty-five miles northwest of Paris, where he lodged at a very modest country hotel owned and run by Antonina Niemojowska, a bighearted woman known as Tuta, the niece of one of his brothers-in-law. The Hôtel Au Sel Fin had become a holiday destination for Polish émigrés, a conventional establishment in the French style complete with flocked fleur-de-lis wallpaper and boldly patterned floral fabrics, oilcloth table coverings, lamps made from old wine bottles, big armoires, and lumpy beds. Meals came from the kitchen of the hotel's bistro, whose bar was a center of socializing in the small town. Czapski would transform his room into a painting studio where he worked happily throughout the long summer days of vivid sunlight. The hotel served as a base from which he would walk out into the fields and low rolling hills of Île-de-France, a countryside dotted with small farms and woods that would inspire an outpouring of landscape paintings, his palette stimulated by the lingering light and saturated depth of colors. Within the hotel, a flight of steep stairs mounting from street level to the rooms above became the subject of an almost magic-realist painting, the study of a radiant, upward-turning celestial ladder lit by a heavenly orb overheard, leading into the unknown.

Alternately attentive or abrupt, Tuta lived in a constant state of financial upheaval, yet under her mercurial caregiving Au Sel Fin would become like a

second home for Marynia and Józio as they aged. He would invite friends to visit and then shepherd them on long walks, usually several miles in length and a few hours in duration. "When I came back to Paris I was so tired," Wojtek Karpiński recalled, "but within hours of my return he called me and wanted to continue our conversation." Kot Jeleński found himself at the mercy of Czapski's capricious agenda, far from civilization: "You never truly understood my attitude to Cézanne," the old painter cried, returning to a thread of conversation more than twenty years old, holding his friend hostage. Karpiński: "It would be almost ridiculous in some other mouth, but with Czapski, and Kot, no. It was very touching."

Having maintained a close connection with Galerie Motte in Geneva, the site of his first postwar exhibit, Czapski found that an audience for his work had begun to grow in Switzerland. The gallery announced its plan to mount a Czapski retrospective in 1971 and an exhibition of new paintings the following year. The retrospective brought together more than seventy works on canvas and paper. The earliest canvas dated from 1950, the most recent was barely dry. Eight of the works on display at the opening were finished right before their installation. A cherished friend, the Serbian writer and editor Vladimir Dimitrijević, founder of the publishing house L'Âge d'Homme, bought one of these late arrivals, Czapski's arresting canvas *Woman in Front of a Train* (plate 27), a haunting and haunted figure, a standing sister of the older seated *Femme Forte* paintings. Goya-esque in its psychological power and spare elegance, with strong overtones of Matisse in the handling of the paint, the canvas raises the question of what other painter might conjure up shades of Goya and Matisse, blending their styles into a single striking image, a perfect example of Czapski's particular protean sensibility.

Ambivalent about putting himself forward commercially, Czapski had never tried to court patronage for himself, but members of several wealthy families with whom he was connected regularly purchased works at annual showings in Paris and London. Many of these pictures were loaned for the retrospective exhibition in Geneva by collectors who had played a part in helping to support the painter over the previous decades, including Jeanne Hersch, Cécile Muhlstein, Lady Frances Phipps, and Marquis Gilles de Boisgelin. Cécile Muhlstein was herself a painter, the daughter of Czapski's old friend Anatol Muhlstein, who had died in 1957, and Diane de Rothschild. (Cécile's daughter, Paulina, told me: "I met Czapski once, coming out of the movies on the Champs-Élysées with my mother, I was around eight years old. It was like meeting a friendly

giant. It made so powerful an impression on me that I could take you and show you the very spot where I met him, I never forgot it.") One of the paintings Cécile Muhlstein loaned to the Swiss exhibition, *Lady and Dog* from 1960, is of a plump woman in what appears to be a fur coat striding along a wintry stretch of beach in Brittany, trailed by her small, exuberant dog. On the back of the canvas Czapski painted the word "Dinard," the name of the Breton town. The subject is Lily Pastré, the lady bountiful whose grand estate on the Côte d'Azur Czapski had visited before the war and used as a painting retreat. A psychologically complex portrait of Cécile Muhlstein's first cousin Beatrice de Rothschild exudes a keen air of discomfort on the part of the sitter, suggesting the work may have been a commission, a working arrangement Czapski generally disliked but may have agreed to at a time when he was especially in need of funds. The attractive young woman, her eyes hard, her arms crossed in a defiant pose, seems equally reluctant to participate. Her combination of petulance and boredom results in a keenly observed study, arresting, vaguely off-putting. It is wonderfully painted and extremely affecting, a meeting of two fiercely independent sensibilities.

Marquis Gilles de Boisgelin was descended from French nobility, the owner of a large family estate in Brittany. Having served in the army in the Second World War, he was wounded as an active member of the resistance and decorated for valor. As a diplomat at the French embassy in Washington just after the war, he met his future wife, Jolanta Wańkowicz, whose father was working in the Polish embassy. After the couple married and returned to France in 1952, Jolanta introduced Gilles to Czapski, an old family friend. (Like Przyłuki, the Wańkowicz family estate near Minsk had been lost after the Treaty of Riga in 1921.) Boisgelin, handsome and proud, commissioned a portrait of himself, to Czapski's chagrin, but the resulting picture satisfied the marquis enough for him to begin buying other paintings from Czapski. He accumulated a collection of twenty-two oils, roughly one canvas a year between 1954 and 1977, and even more drawings. True to many artist-patron relationships, this one would sail fitfully between smooth and rough waters.

Muhlstein and Boisgelin were people of means with Polish roots or family connections who felt the impulse to encourage Czapski in his endeavor as an artist primarily out of their respect for the man. (From materials provided by the Boisgelin Collection: "The couple decided to collect Czapski paintings not only for their beauty but also to support the fight for Poland's independence, in particular through *Kultura*, based in Maisons-Laffitte.") As a direct

result of the Geneva retrospective, however, a young French woman, strongly drawn to the inherent power of the work, was motivated to write about what she saw. The volume she would write on Czapski, *Czapski: La main et l'espace* (Czapski: Hand and Space), would serve to expand the base of his audience and broaden support for his paintings. Murielle Gagnebin-Werner was the wife of Eric Werner, whose dissertation in philosophy at the University of Geneva had been overseen by Jeanne Hersch. The young couple had heard Hersch extol the virtues of her Polish painter friend, and when she turned sixty in 1970, Hersch invited thirty friends to a little village in Austria on the Swiss border to help her celebrate, including Czapski and the Werners. For Gagnebin-Werner, their meeting was stimulating and of considerable consequence. The idea of working on something about Czapski crystallized in her mind and, months later, when his retrospective opened in Geneva, she was able to stand in rooms full of his paintings and make an assessment. She decided to write a book about him. Immersing herself in the project, she made many trips to Paris, even on occasion staying as a guest at the *Kultura* house in Maisons-Laffitte. Gagnebin-Werner considered Czapski through the lens of philosophical speculation, and he responded by holding forth on Pascal and Dostoyevsky, Henry James and Thomas Hardy, Tolstoy and Rozanov. All of this discourse would later be put to use in her analysis of his pictures. Czapski made himself available to her and spent some time with the young couple. Her letters to him quickly proceed from respectful, formal inquiries to familiar, personable missives. In his fashion, he flooded her with mail. Czapski traveled back and forth frequently between Paris and Geneva during the weeks of his retrospective, and on occasion he would stay with the Werners, sometimes overnight, sometimes for a few days.

On one Geneva visit, he turned up unannounced at a class Eric Werner was holding at the university and made some sketches of him teaching. Werner was well aware of the presence of the seventy-five-year-old gentleman sitting at the back of a room filled with college students. The ink and colored-pencil sketches Czapski made became studies for an oil painting. The finished portrait of Eric Werner, from 1971, titled by Murielle *The Young Philosopher (Eric Werner)* (plate 16), is long and narrow in format, almost four feet high, two feet wide. Werner's head and shoulders are shown centered at the very bottom of the tall vertical canvas. Wearing a rusty orange jacket, lavender shirt, and red-brown tie, he is shown seated at a banquette with a very big mirror behind him. His hands are clasped and his forearms, as one sees in many Netherlandish

portraits, rest right along the picture's lower edge. Crowned by a lush mass of reddish-gold hair, Werner's head is large, exaggeratedly so, presented almost as a cartoonist's idea of an intellectual, his cranium swollen to accommodate all the brain activity within. The subject's facial features are somewhat dwarfed by a massive forehead; his mood is somber, reflective. His eyes, masterfully rendered, are slightly shifty and evasive, staring down and to his left, full of suppressed feeling and doubt. Werner's eyes do not look out at the world but seem turned inward. He may be teaching students in a classroom, but he is not engaged with them. His immediate presence is tenuous at best.

In the mirror behind Werner looms a reflection of his shoulders and the back of his big head. Two large cerebral masses in a single portrait suggests the powerful aura, and burden, this one man was projecting. Above the Siamese-twinned heads, the empty reflected space is broken into three bands of white bordered by pale blue stripes. An elaborately patterned decorative gold frame runs along the right side of the mirror providing the dominant upward thrust of the picture, extending from behind Werner all the way to the top of the canvas. *The Young Philosopher (Eric Werner)* calls to mind elements from several Czapski self-portraits. The enormous gold-framed mirror serving as a reservoir of space and reflection recalls the image of Czapski sauntering down the hotel hallway in the prewar *In the Mirror*, and the compositional device of anchoring a vertical picture with an intensely self-absorbed head at its very bottom echoes *Self-portrait with Lightbulb*.

Werner's feelings about this portrait were highly ambivalent. Aware that Czapski had come into his classroom and made some sketches, he never suspected that the painter was using them to make an oil portrait.

> Czapski never mentioned he was working on a painting, I know he never showed it to me. My parents acquired it in 1973. It was at their place I saw it for the first time. I took an instant dislike to it. It bore no resemblance to the image I had of myself. Really, I had no idea of myself looking like that. My parents may have liked it at first (otherwise why did they buy it?) but they quickly tired of it. They wound up foisting it on me—after all I was the subject. But what was I going to do with it?

A few years later, moving from Geneva to Lausanne, Werner had the painting carefully wrapped and stored it provisionally behind a metal ladder in a closet in his new home. The temporary placement stretched on for more than twenty

years. When, after unwrapping the canvas from its protective shroud, Werner finally laid eyes on the picture again, he was surprised to discover a true likeness he had been previously blind to, a likeness shrewdly observed by Czapski. In retrospect, Werner came to realize that his initial inability to recognize himself in Czapski's portrait did not suggest some failure on the part of the artist to capture his essence but the fact that his own essence was not yet clearly known to him. Czapski had seen this and expressed it.

At the time the portrait was painted, Werner's dissertation on Camus and Sartre had just been published and criticized for presenting the two philosophers only as abstract entities, not as people living in real time, in history. Czapski had been able to diagnose this deficiency in Werner, seeing how the young man's intellect was overpowering any real connection to life. Only decades later was Werner able to appreciate what Czapski had seen. He thought that the painter, acting much like an analyst, had known more about "the young philosopher" than the young philosopher had been capable of knowing himself. Werner wrote about Czapski: "He saw that my soul's various parts were not developing in the same rhythm, they lacked harmony. Feelings, passions, life were not as clearly defined in me as my mind. I had put life to one side. Czapski exposed the imbalance."

After having applied unsuccessfully for many years, Ludwik Hering was finally granted a passport that enabled him to travel outside of Poland. In the Polish People's Republic, passports belonged to the state, never to the individual, and once issued were kept on file in a government security dossier. In 1972, Hering's request for his passport was accepted. Czapski had been encouraging him to come to Paris and had assembled financial support for his travel expenses, without which Hering could never have made the journey. Their reunion, after more than thirty years, was momentous, joyful, but not completely easy. Hering was depressed, having been beaten down by a life of endless confrontations and restrictions, and he had not been able to rouse himself to continue writing. Czapski was a perennial source of encouragement, trying his best to get Hering to break through his resistance:

You've always been solitary and defiant, you have always despised all ideologies, including mine. . . . But write, I beg of you. . . . Let the hell we all saw, the human vileness, the human suffering, which you can empathize with like no one else, live on for someone, let a spark, a trace of it remain in your art. You may reject

everything, you may hate the Poles and Poland and Our Lord, but you must give your unique testimony to what is true. Do not allow skepticism to devour you and do not abandon me. Because I feel truly myself only in you.

A gulf of faith separated them, and always had. Hering, born into a Protestant family, had little tolerance for the idea of God. His inflexibility on this subject always dismayed Czapski. But this considerable philosophic difference failed to sunder their bond, their need for each other. The visit was a qualified success, full of intense feeling and moments of happiness. On his return to Warsaw, Hering was detained by the security police and interrogated about his time abroad. The *Kultura* house in Maisons-Laffitte was under continuous surveillance by undercover Polish agents, and he had been spotted coming and going. He was expected to divulge everything he had seen and heard inside.

In 1973 Vladimir Dimitrijević brought his Swiss friends Richard and Barbara Aeschlimann to meet Czapski. The couple was from Chexbres, a small Swiss village on the northern banks of crescent-shaped Lake Geneva with spectacular southern views across Haute-Savoie to the Mont Blanc massif. Richard Aeschlimann was a painter and graphic artist who warmed to Czapski's way of being in the world. The following year they all met again in Paris for the opening of Czapski's exhibition at Galerie Lambert, on Île Saint-Louis, steps away from his old base camp at Hôtel Lambert. The exhibit had been timed to coincide with the publication of Gagnebin-Werner's book on Czapski, and a celebratory crowd convened. The Aeschlimanns were quite overcome by the pictures, responding viscerally to many of them. They quickly bought one of the most recent pictures, a view of the train yards at Gare Saint-Lazare called *Entry to Paris*. When the gallery closed its doors after the vernissage, a festive group took over a large table at a nearby restaurant, among them Czapski, Dimitrijević, Hersch, Kot Jeleński, the Werners, and the Aeschlimanns. The event was a joyful occasion for Czapski. He could not have predicted the fellowship that would develop between himself and the Aeschlimanns; he was unaware that an important phase of his professional career would soon begin.

At seventy-eight, Czapski might appear to have been entering a valedictory phase, following a show in Paris, a retrospective in Geneva, and a critical assessment of his lifework in print. He had, however, little interest in looking back and summing up. A self-portrait from the year of his show at Galerie Lambert shows a tall, silver-haired painter considering his face from behind square-

framed glasses (plate 17). He paints himself at work, showing the back of his canvas on an easel tilted in diagonally toward him. His facial expression is neutral, he is busy studying himself, that's all that is presented. He looks solid and somewhat rigid but the viewer gets caught up in the exchange of active looking back and forth between mirror and canvas. Just above the level of his shoulders, two parallel bookshelves mounted high on the wall provide horizontal grounding in a predominantly vertical picture. The lower of the two shelves holds a spread of identically bound black books leaning to the left, the volumes of his diary, never far from reach, while on the upper shelf other books of significance for him lean to the right. Czapski situates his head in a halo of books. Wearing an old red bathrobe belted tightly about the waist, pencil in his breast pocket, he reveals himself to us as if having just risen from bed, returning to work in whatever garment he's wearing. As is true in some late Rembrandt self-portraits, Czapski's casual dishevelment is only partly affected. He has no thought of slowing down, he is geared up, ready to plunge in again, to keep going.

> After a day of hard work and sustained focus (with hours standing, in movement, approaching and moving away from the canvas), I feel a far less powerful fatigue than after a day sacrificed to conversation.
>
> Despite all my critical self-abuse, I have to acknowledge that I am making discoveries and am moving forward with my method of working: more endurance, less haste in the application of colors, although, with age, time counts for more and more. (Proust! Proust! His painter heading up to the mountaintop to capture a valley as seen from on high, but by the time he has arrived the sun has already set, it's too late.) Each of my discoveries is a completely simple truth, discovered a hundred times before, but in the only way: to make a mark, to meet the masters one has forgotten, without repeating what they've done and without copying them. One must discover everything under the brush, with all one's being. Something might all of a sudden make sense forty years after you've heard it spoken of, but which had not yet clicked, intellectually or even emotionally, in *your* work, not at the end of *your* paintbrush.
>
> My truths, discovered long ago by others, are today associated for me with Matisse's working method, which has had so profound an impact on me in the past; his method strikes me as the freshest, joining as it does the most intelligent and conscious rapport toward nature while at the same time addressing the problems of abstraction in painting.

When the exhibit at Galerie Lambert came down, Dimitrijević asked Aeschlimann if he would transport a van full of Czapski paintings from Paris to Lausanne, to enable a gallery owner there to choose works for another show. Making the delivery, Aeschlimann found the gentleman in charge refined and charming, very old-school French. From a low sofa in an empty room, the dealer considered what to select from a group of fifty-six oils and thirty-six watercolors. Aeschlimann mounted them one after another on a white wall. Czapski was present in the empty gallery as well, and remained in the room as decisions were made about what might be acceptable and what was not. With the barest of feeling revealed, choices were arrived at with a simple yes or no, some made with alacrity, others only after some quiet thought. Works were separated into two groups, admissible and inadmissible. "No, not that," the dealer would say, shaking his head. "Yes, all right, that's in." Czapski, listening carefully, took it all in stride. Driven by ideas of commercial salability, the dealer consistently rejected works Aeschlimann found challenging and powerful. The experience agitated and saddened him. For Czapski to have to endure watching his work being judged in such a calculated manner was shocking for Aeschlimann, his twenty-nine-year-old skin far thinner than the seventy-eight-year-old painter's.

Aeschlimann was certainly willing to concede, nevertheless, that the dealer's selection made a beautiful show. Lausanne was covered in posters for the exhibition, which had been designed, printed, and posted at Dimitrijević's expense. Much to Czapski's delight, a full house turned up for the opening, giving him the opportunity to speak about his work with complete strangers as well as old friends. Attentive and forthcoming, he relished the attention and the accolades. Yet for all the dealer's discriminating choices, the exhibition yielded the sale of only a single watercolor sketch. This commercial failure mobilized Aeschlimann, stirring him into action. He and Barbara approached Czapski about the possibility of their undertaking an exhibition of his work in Chexbres, given that the paintings were already in Switzerland and available for another showing. Czapski was agreeable. The couple went into action, renting a space and preparing it as a gallery. Thus Galerie Plexus came into being, whose primary focus would be the work of Józef Czapski.

With little in the way of experience, but much in the way of commitment and energy, the Aeschlimanns pulled off an opening exhibition for the new gallery in 1976 at which twenty-seven works by Czapski were sold. This exhibit

would be the first of many successful showings initiated by the Aeschlimanns, in Chexbres, in Geneva, in Vevey, and in three different cities in Poland. Every exhibit in Chexbres produced an unexpected new source of interest. One year a gentleman flew in from Argentina and bought several canvases, another year two German ladies purchased a group of paintings. Americans and Canadians came and took works home, as did some minor British royals. The pleasure for Czapski was not so much represented by the commerce, though he was grateful for the income, but by the exposure and the connection with people who responded to his work. The Aeschlimanns undertook the considerable task of overseeing the welfare of an aging artist's life, placing their resources at the service of a painter who lived day to day without savings or security. Czapski continued to exhibit his work at galleries in Paris and London, but over the course of the next fifteen years he would also show his work regularly in Chexbres. During this period Galerie Plexus generated more sales of Czapski's work than any of the other venues, continually helping to keep the painter in art supplies and to make ends meet. The Aeschlimanns, fulfilling dual roles—dealer and patron, seller and buyer—would eventually acquire their own personal collection of more than two hundred works, the largest repository of Czapski paintings anywhere.

In Richard Aeschlimann, Czapski found a disciple who saw it as his calling to nurture and support. A warm, responsive presence, gently urging the painter on, Aeschlimann repeatedly acted on Czapski's behalf, scheduling exhibits, lining up contacts, cultivating clients and critics. In Czapski, Aeschlimann found a role model from whom he had much to learn about art and life. In the way that Kot Jeleński served Czapski as an intellectual advocate and champion, Aeschlimann served as a business manager and artist-enthusiast. Steadfast and efficient, he felt privileged and honored to take up the roles of dealer and collector.

Eighty at the time of his first exhibit in Chexbres, set in his ways, Czapski continued to rest secure in the belief that somehow or other God would provide. As ever, he was indifferent to money and averse to the idea of savings. He and Marynia lived as frugally as they always had, content with their lot, devoting scant attention to what came in financially or what became of it. He was made uncomfortable by the monetary assessment of any item of supreme value—as if such assets could be translated into coins of the realm! His ambition and sense of worth lay elsewhere. The escalating flamboyance and excess of the

"art world" distressed him. When Aeschlimann was enthusiastically approached by a prominent German gallery with an offer to coordinate exhibitions of Czapski paintings in several German cities, it was a moment of reckoning. Internationally renowned, representing art stars like Joseph Beuys, the gallery balked at the price list Aeschlimann submitted for works by Czapski. From the German dealer's point of view, the prices proposed by Galerie Plexus were far too low for anyone to take the work seriously. Young painters the gallery took on entered at much higher price points. The gallery director insisted Aeschlimann's prices be increased at least tenfold. In consultation with Aeschlimann, Czapski rejected the offer. He wanted nothing to do with it, not wanting to be trapped, he said, like Leonor Fini, selling "only to bankers and speculators" whose motivation for buying was the profit margin derived from investment and resale, whose primary concern was money, not painting. The artificial inflation of the value of a work of art was not a game he saw himself playing. He'd rather be *un raté* than a success under those terms. The refusal says a good deal about Czapski, about what it meant for him to be true to himself, and shows how clearly he understood and accepted the Don Quixote role he played in a world of his own making. Aeschlimann, too, proved himself to be a rare dealer who knew, even in the face of the loss of potentially lucrative business, how best to "represent" an artist by supporting his psychological truth, recognizing its critical relation to his creative spirit.

To celebrate Czapski's eightieth birthday, Kot provided two tokens in honor of their long friendship. First, at the prompting of Karpiński, he wrote an essay about Czapski's enduring devotion to the Louvre, a tribute to mark both a new decade for Czapski and the fortieth anniversary of the publication of his influential book on Pankiewicz. As they had frequently done, Kot and Czapski walked together through gallery after gallery of the Louvre, taking in the great collection, this time intentionally re-creating various routes Czapski had followed with Pankiewicz decades earlier. As always, the museum provided a sensational backdrop. Sublime masterworks of the history of art, indifferent to the passage of time, continued to emit their particular, immutable truths. Yet all around them, much had changed. It struck Kot that when he had first visited the Louvre there were fewer visitors, that the majority of them were older and they were far more homogenous in terms of social class. Czapski begged to differ, insisting there had always been plenty of young people and individuals representing all walks of life. But the overwhelming presence of

the "masses" in the hallowed chambers gave ample proof of a revolution of mores and cultural norms.

Kot's other birthday offering was an invitation to accompany him on a trip to Venice, where Czapski had not been since just before having written the Pankiewicz book. They made the journey and hit the ground running. They loved dashing about, walking everywhere to look at frescoes and paintings, churches and canals. Czapski made several studies looking across the Grand Canal to the dome of San Giorgio Maggiore, sketches that were put to use in later paintings. His favorite perch was outside Caffè Florian in Piazza San Marco. In the city of Titian and Giorgione, Veronese and Carpaccio, Czapski was content to sit drawing pigeons and the throngs of tourists, resharpening his focus on immediate visual sensations. He had imbibed a surfeit of painterly theatrics on such elaborate display and welcomed the opportunity to return to the world before his very eyes.

Back at work in Maisons-Laffitte, a natural decline in his physical strength and mobility slowly set in, but this was happily countered by a sustained outburst of creative energy. He was able to adapt easily enough to ailments and pains, decreased flexibility and reflexes, but the threat of diminishing eyesight began to weigh on him. No longer trusting his ability to maneuver through the manic stop-and-go of Parisian traffic, the time had come to put his treasured scooter out of commission. And, with gradually growing awareness, he observed unmistakable signs of decline in Marynia, two years his senior. He worried about her breathing as she slowly mounted the stairs to her attic room. Much less sharp than usual in her verbal exchanges, she was sometimes confused. A slow slide into dementia began. He wrote to Hering about her condition:

The closest people become strangers when they suddenly lose their memory! A sense of how things are related, and suddenly the wide world narrows down to an indifference toward nearly everything, and only some repeated clichés are left, and when this dialogue—which may sometimes have been inept, but it was there—a dialogue and a mutual need have ceased to exist, when she asks you about the simplest things seven times, ten times, one hundred times, and when all of a sudden there is an instant of recognition and she despairs, "Don't tell me! I can't remember ANYTHING! I'm a complete fool!" Marynia is eighty-four, after all, and so it's time to end. If a person has lived and accepted the world with all its terror and suffering, he must accept himself, too, his fate and the fates of those who are dearest.

He was characteristically embarrassed to speak of his own little aches and spasms, but among trusted friends he voiced his concerns repeatedly about growing old and the impact this was having on his painting. From Kot, on vacation in Corsica with Leonor, he heard: "What you write about your difficulties with painting certainly has nothing to do with age, you've always had periods when you'd rather write than paint. Of course keep writing, especially in your journal, but your job right now is *painting*, not writing."

Such words worked like a tonic on him. He found that he was increasingly less intimidated by the idea of painting and more vigorous in his attack. He had never aspired to create a consistency of image, had never developed a formula as some painters do. Continuing to respond to visual triggers in the wider world, he would harness himself to what was immediately available when he did not go out, painting interiors, still lifes, portraits of visitors. His studio became more cluttered, he needed to adapt to his reduced visual circumstances. He began to keep his tubes of paint inside individual manila envelopes with the name of the color written in large script on the outside for ease of identification. Books piled up, manuscripts, letters, galleys, magazines. Postcards of portrait heads and photographs of loved ones tacked on the walls of the room created a dynamic of looking, faces peering out at him as he glanced back at them.

Meanwhile, he continued to haunt the galleries and museums, hungry for pictures and interaction. The subtle exchange between people and paintings appealed to him more and more as a subject for his own work. Sensitive to the moods and body language of other museumgoers, he watched as they approached a picture, took it in or passed it by, settled on one canvas as opposed to another, looked at it carefully, determined to see what it was the painter was after. A large and provocative retrospective marking the centenary of the death of Gustave Courbet opened at the Grand Palais in 1977. Sketches Czapski made at the museum during the run of this exhibit prompted him to make a small oil on canvas called *Exhibition* (plate 18). I had been enormously drawn to online reproductions I saw of the painting and decided to make a pilgrimage to see the picture in Bydgoszcz, a small provincial city between Warsaw and the Baltic Sea. I was willing to travel quite far for the chance to be in the presence of *Exhibition*, to see something uniquely itself, existing nowhere else. Goethe, after all, had gone to Rome in 1787 in search of works by Poussin and Claude, and in *Italian Journey* observed, in the rococo extravagance of the

Palazzo Colonna, "I shall never rest until I know that all my ideas are derived, not from hearsay or tradition, but from my real living contact with the things themselves." Real living contact. That was precisely what I was after.

It did not come very easily. Likely, it's not meant to. I was longing to reach the open road but was stuck in a car in horrendous early morning traffic, trying to leave Warsaw's city center. After an hour, I began to wonder how I had come to undertake such an adventure, and, really, why. Fortunately I had brought Mikołaj Nowak-Rogoziński along with me, to rely again on his good services as a translator and negotiator, but despite his calming presence, my patience was being severely tried. We moved along at a snail's pace. Surely, I tried consoling myself, Goethe's trip to Rome must have had its own complications.

Eventually the gridlock loosened up. We drove for about three and a half hours from the outskirts of the capital city, following a series of roads that became increasingly smaller and narrower until we were weaving along a single lane through dense stands of birch and pine. Every quarter mile or so, from the open trunks of cars parked on the slender, sandy shoulder of the road, people were selling wild mushrooms freshly foraged in the woods. Bydgoszcz emerged on the far side of this forest, its Modern Art Gallery housed in a renovated agricultural building, an enormous barnlike structure with huge exposed timbers. Mikołaj had made arrangements in advance to insure I would be able to see *Exhibition*. When we arrived and checked in, a museum official, a pleasant woman wearing an elegant scarf, escorted us to the gallery where the canvas was installed. Together we climbed a few flights of stairs in a light-drenched modern glass stairwell affixed to the exterior of the old building. Entering the main exhibition space on the top floor, we had to adjust our eyes to the dimness inside. Despite various pinpoints of light directed from elaborate fixtures high above, the interior, with a dark floor of wooden planks, remained quite murky. Many of the freestanding display panels laid out in the center of the space were painted black. The collection of twentieth-century Polish paintings was hung rather haphazardly. Shadows fell across nearly every picture surface. Not a single canvas or sculpture was fully visible. I felt as if I had walked into an abandoned convention center.

The curator led us to where *Exhibition* was on display. A small painting, it was hung far too high for easy viewing, and its whole right side was heavily cloaked in shadow. Czapski's painting shared a wall with paintings by two of his old friends and fellow Kapists, Jan Cybis and Tadeusz Potworowski. I tried to find a way to look at the painting, to connect with it, but I was stymied and

so began instead by asking questions. I asked the woman about the painting's acquisition and its provenance. She was caught off guard by a non-Polish-speaking American's interest in Czapski. She began to cross-examine Mikołaj in turn. Uncertain about how to answer my specific questions, she begged our pardon and left us in search of the museum's historical record for the painting. In her absence I grumbled to Mikołaj about the appalling installation values. He did a reasonable job of pretending to listen sympathetically, no doubt having become accustomed to my impossible attitude about paintings being badly hung and lit. The official returned and read to us from the file. *Exhibition*, painted in 1977, was purchased in 1980 by the Polish state government. It was bought in Kraków at Desa, the state-owned antiquities shop, with acquisition funds targeted for the Modern Art Gallery collection at Bydgoszcz. How the painting got from Paris to Poland in the first place and why the Polish People's Republic decided to acquire a work by a painter whose reputation it was otherwise determined to keep tainted were questions whose answers were not in the museum's file. How did it come to auction within three years of its being painted? It remains mystifying how in 1980—at a time when the communist Polish economy had nearly entirely collapsed, when wages were pitiful and food prices astronomical—approval for such a transaction was granted. Mysteries abound.

I asked the woman about the title given to the work. In Bydgoszcz, the wall label read *Wystawa* (*Exhibition*). In various publications and online I had seen it referred to as *Museum* and *At the Museum*. Czapski was largely indifferent to the names of his pictures, but, I told her, he often scribbled some telling reference on the back of his canvases. By now Mikołaj could see where I was going with this. He had seen me frustrated before at not being able to properly study a painting's surface. Plainly reading the signals I was giving off, he went into action, graciously but persuasively asking the official if she would kindly remove the canvas from the wall so we might look at the support stretchers behind to see whether Czapski had written some note or other. Resistant at first, but clearly curious and impressed at our familiarity with the territory, she glanced conspiratorially around the cavernous room we had entirely to ourselves. She hesitated but agreed to accommodate the request. Reaching up, grabbing hold of the modestly framed work and tipping its bottom out, she lifted the painting off its hooks and turned it around to face us. There, in Czapski's hand, the words *szkic do obrazu* (sketch for a painting) were shakily inscribed on an upper expanse of unprimed tacked canvas. Phase one of the

subterfuge worked—the canvas was off its mount. Without too much con-
niving, I was able to advance to the next stage, to convince the curator to stand
the painting on the gallery floor and prop it against the wall where, curiously
but quite obviously, the quality of light was far more consistent and unob-
structed than higher up on the wall.

Freed from shadows, the painting revived. I stretched out on the floor and
sat across from it for a long time. The others left me as I communed. I entered
the picture. I found a tall woman in a long orange dress strolling past a very
large canvas, taking it in, her feet moving in one direction, her head turned in
another. Clutching a purse, her arms crossed in front of her, she is shown only
from the back, her slightly tilted head a helmet of yellow shoulder-length hair.
The painting she pauses in front of nearly fills the whole wall on which it is
hung and envelops her entirely; parts of the painting are obscured to us by her
form. In the painting, two female figures are shown centered at the bottom
of the canvas and, in relation to her, appear life-size. One figure is seated, the
other, on her hands and knees, is washing the feet of the seated woman. The
blond museumgoer focuses on this gesture, though her thoughts, distracted
by what she sees, have not yet communicated with her feet, which still appear
to be moving forward. In the farther reaches of Czapski's picture, another
woman, in a green dress and black shoes, gazes across the gallery at another
canvas. She, too, is dwarfed by large canvases, but appears even smaller because
she is, proportionately, so diminished in size compared to the woman in orange.
One woman is shown as a giant, the other as a midget. Czapski enhances this
feeling of displacement by situating them in a room of monumental canvases.
The figures are witnesses, viewing other paintings he has painted into his own
painting. To paint paint is a conjuring act at an even further remove from
painting human forms. The upper reaches of Czapski's small canvas present
high corners of Courbet's massive paintings, where tremulous light and forms
dissolve. It is easy, and delightful, to get lost in this miasma of frame within
frame, surface within surface, space within space.

A figure painted by Czapski looking at figures painted by someone else
creates a hierarchy of seeing in which any viewer of *Exhibition* participates.
To feel the picture's power and find its beauty, the viewer has to accept that
what is being seen is an illusion and yield to its seductive allure, the magic
shared when one accepts what paint can be made to do. The illusion of captured
reality is reinforced, celebrating the interaction between painting and viewer,
closing the gap between them. The viewer, like the viewers in Czapski's picture,

is brought within the very mystery of painting. To see the painting, and the world, in this way bestows additional resonance and meaning to the act of seeing. Czapski's achievement in such pictures is to demystify the experience of making art and, in so doing, to hallow it.

As I had experienced with other Czapski paintings in the reserves at the National Museum in Warsaw and in Kraków, I felt the picture come to life under my scrutiny, unfolding its glory. I thought of Mark Rothko's comment that "a picture lives by companionship." This canvas certainly held my companionable interest. My eyes were full and excited, drinking up every inch of its painted surface. I felt close to Czapski, imagining him as he lay down the colors, dabbing here and there, holding his brush steady to drop in a highlight. I was slightly intoxicated by the thrill of seeming to be with him as he painted, making choices, covering his tracks in some passages, leaving evidence of his hand at work in others. I gazed at the upper corners of the canvas, marveling at his touch. The subtle interplay of the colors in the upper regions of the rendered painting, and the various colors selected for the museum walls, ranging between dark grays, browns, and yellow ochers, helped animate a conceptual relationship between his picture and Courbet's. An alchemy of sorts enabled him to create the specific tactile feeling for each. The history of art is flush with such skill, hardly uncommon, where flesh and foliage and fabric are each rendered in dazzling displays of brushwork. What I find so compelling about these picture-in-a-picture paintings by Czapski is their self-referential insistence, taking pleasure in showing viewers paused in consideration of paintings made much like the one he was in the process of making. Art and the experience of it, life lived in the presence of art—Czapski relishes the chance to meld art and life in the same image, acknowledging makers and viewers and the act of looking. In his diary he records the impact of the exhibition on him as "titanic." "I will start to work on the canvas derived from my impressions in the Grand Palais (Courbet). It seems important for me, as a form that liberates the breath."

I reluctantly wrapped up my investigation of the small canvas, the "study for a painting." I knew it highly unlikely I would ever see *Exhibition* again. I'm usually aware of the visual imprinting that occurs as I take my leave of a picture I've gotten lost in. What I carry away can only ever remain simply a ghost image. I had flown across the world and driven for hours to sit here communing with this singular work, because that's what it really takes to see a painting. I lament that the picture continues to linger in half shadow on a gray wall in Bydgoszcz.

20

"THE HOUSE OF *KULTURA* on avenue Poissy," Miłosz wrote in an essay about Zygmunt Hertz, one of its residents, "was like an island that had emerged from the swirling seas, between one cataclysm and the next." By the time Julia Juryś went to work in the offices of *Kultura* in 1979, the house at Maisons-Laffitte, with its large library and polished interiors, was neatly split into separate camps, a psychological battleground with much bad feeling already existing between two clearly opposed groups. Czapski and Jerzy Giedroyc would always maintain respect for each other, but a state of estrangement had cast a pall over the entire operation and its aging tenants. The success of their unified intellectual endeavor was irrefutable, but it came at a considerable price personally for each member of the household. A tacit line of demarcation was drawn, upstairs versus downstairs. Giedroyc and the offices of *Kultura* reigned below, while Czapski and Marynia minded their respective work spaces above. In the confidence of certain select friends, Czapski would refer to Giedroyc as "the rhinoceros," a pointed jab softened by an affectionate association with Eugène Ionesco. When asked about living in Maisons-Laffitte under such conditions, Zygmunt Hertz liked to say, "for a concentration camp, it's very nice." Hertz, whose presence Miłosz claimed "transformed and humanized the house of *Kultura*," died the year Julia arrived, and the loss of his warmth and amiability was much mourned. His wife, Zofia Hertz, efficient, exacting, and essential, continued to play a key role in the logistical maintenance of the publication, but she did not possess her husband's sweet nature. She no longer valued Czapski as a productive member of the team and treated him accordingly. Guests arriving from Poland, acknowledging the rift, learned the drill: after paying court to Giedroyc, they would say their goodbyes and leave through the front door, only to walk around the house to the back door, mount the stairs, and visit with the Czapskis.

Julia, a freckled, vivid redhead who speaks Russian, German, Polish, Swedish, French, English, and some Yiddish, came to do editorial work and to translate. In her first week on the job, seated at her desk, she felt a presence

behind her one day. It was Czapski, inviting her to come upstairs. They found they could talk to each other easily, seriously, and gleefully, and this bound them in a relationship that helped compensate for some of the bitter feelings lurking all around. Julia was moved by the effervescence of Czapski's mind, the sparkle and bite of his wit, and she recognized all that he carried, how he dealt with the strain. "He had an overwhelming personality, and it often overwhelmed him." Plainspoken, thoughtful, and opinionated, Julia was a breath of fresh air to Czapski.

I first met Julia in Paris in 2013. She surveyed the lay of the land for me: "Giedroyc was an entirely political animal, Józio was not at all. By the time I turned up, they had sustained a partnership for more than thirty years. Finally able to focus on painting, Czapski greatly reduced his dealings with *Kultura*, except for the occasional essay or review he would submit. He had a long history there, but it was over. Over the years, Giedroyc's intellectual scope became more and more limited. He put up roadblocks everywhere that he would never cross, and he got lost as one door after another locked behind him. Józio, by comparison, was becoming more and more open, he kept going on looking, he was always opening new doors. Giedroyc was completely a Pole, and ultimately this made him something of a provincial, especially next to Czapski, who was a true *weltmensch*, a man of the world, who knew and understood everything, who had no limits. There were very few people who were up to his level, intellectually and spiritually."

Julia would have lunch with Czapski almost every weekday, joining him in his room on her break. After lunch, she would read to him from Polish and French newspapers. "The goal," she said, "was never to get to the end of an article." They would discuss everything at length, one thought leading to the next. "He was enormously alert to ideas and extremely sensitive to nuance." He liked to quarrel, and enjoyed a good argument. He always had a great hunger to learn from others. "He was allergic to banalities," Julia said. "And he liked to suffer, he had a need to suffer, he fed off of his sense of suffering. He was a master at turning his sense of failure into creative energy." His eyesight was variable, but undoubtedly deteriorating.

In a journal entry, Czapski remarked that "the work of a painter must be loneliness." In a letter to Richard Aeschlimann he wrote:

> The expression of solitude in my work is often commented on. Maybe it's true, but I never pose this kind of question. When I paint, I never imagine I'm doing

it for some reason, or for some person. I'm alone and I paint what I have to paint. This disinterested side seems to be the basis of art. I subjugate myself to daily life, to the discoveries I make seeing a table, a basket, a face in a window or a café. That's where I find the point of departure I call disinterested discovery, the joy of it! Maybe that's the solitude people find, this world apart.

Marynia's gradual descent into a state of deeper agitation and withdrawal weighed heavily on him, and an emotional burden of helplessness and sadness took its toll. He steeled himself against grief, working hard to keep active and occupied.

A welcome counterpoint to his sorrow arose, providing distraction and relief. A huge retrospective of the work of Nicolas de Staël opened at the Grand Palais in May 1981. Enraptured, Czapski attended frequently, always with drawing materials in hand. His diaries are full of sketches of visitors to the exhibition taking in the work of the Russian-born abstract painter. He tried once more to comprehend Staël's suicide at the age of forty-one.

He was known as a pure abstract painter. Already covered in glory, he began suddenly to discover, as if for the first time, with a new eye, objects, nature, long perspectives, northern seas, Sicily, Agrigente, Honfleur, women, and flowers. . . . I suddenly felt, in de Staël, a pure source of inspiration, clear and crystalline. It wasn't a fleeting impression but a certainty, before which all the manifestations of virtuosity as well as all the gossip vanished, all those doubtful myths about art created on demand, an art, which, spanning every century, must serve as a new religion (Malraux). All that vanished before de Staël, brilliant and always true to himself, whether abstract or figurative. Was it fate that chose his death for him, or did he choose this fate, like the death of van Gogh?

Roused by an intense feeling of fellowship, Czapski was stimulated by the bright canvases of Staël, which he had known primarily through reproductions. He launched into a series of paintings derived from visions captured at the Grand Palais. He made dozens of drawings and watercolors and painted five oils, each showing one or more museumgoers interacting with a specific canvas. The painting I first saw at Wojtek Karpiński's home of a young man looking at a Staël, originally owned by Kot Jeleński, is from this series. Another shows the backs of three young people as they take in Staël's painting of a flock of

411

gulls in flight. At the exhibition, this canvas was displayed across from a nearly twenty-foot-long canvas called *The Orchestra*, of which Czapski includes only one end, where, against a vibrant red background, a colossal golden double bass is rendered like a huge pear. This 1981 painting by Czapski of two Staël canvases from 1955 was purchased by the French state but has not been seen in decades. Next to a glued-down photograph of this work in his journal, Czapski penciled the words "Hôtel Matignon," the residence of the prime minister of France. A third is in Miami, a fourth in Warsaw. The current whereabouts of the fifth in the Staël series, something of a companion to Karpiński's, with a female viewer before a horizontal, geometric abstract, is unknown.

In the middle of the Staël exhibition's four-month run, Czapski's beloved sister died, at age eighty-seven. "My dear," he wrote to Hering,

Marynia died the day before yesterday after months and months of semi-amnesia, increasing unconsciousness, which was total in the last weeks—after three days of breathing heavily like a fish thrown out on the sand, she died as if she had fallen asleep. She could no longer recognize any of us. The funeral is the day after tomorrow.

So many years of living together. I have to rebuild my life without her, it won't be easy, because even though I still have energy, for some time now it has seemed *tattered*, I can see obvious signs in myself of this increased forgetting, which is interspersed with clear experiences, visions. I still am able and want to work. Before I die, I would still like to have a time of painting in the high heat of work and to do something with the volumes of my diaries.

He was eighty-five. He would certainly make the most of his time, producing a prolific late flowering as a painter. It was as if, at long last, he appreciated what he could do and went about doing it, achieving a certain mastery of his materials, his vision, and his touch. All of his worrisome contradictions seemed to lose their hold over him, and he found a way to fuse them into a cohesive consolidation of opposing impulses he could exploit for his own needs. His final decade of painting yields a most remarkable body of work, highly original and compelling. As the years went by his eyesight worsened, but he could see enough to work and made the most of the little he could see. For almost ten years he laments his condition, entry after entry in his diary expressing the belief that his painting days are over. His late correspondence despairs of how he is going blind and will paint no more. Yet he continues to paint.

Yes, yes—you have before you the real tragedy of your life—when the end of your life is quite close YOU SEE what you haven't done, what you could yet do, but only now, because in order to do that you must reach a level of maturity in your work, and at the same time you know you can do no more than the pharaoh who knows he is going to die in twenty-four hours from a snake-bite.... I have the feeling of seeing only now what I might do with the hundreds, the thousands of fleeting experiences spread throughout my notebooks.

It is the familiar rise and fall of conviction and remorse, day after day, year in, year out, a habitual stocktaking of success and failure. Who determines the success, and against what standard? After an exchange of letters about the impact of the Staël exhibition on him, Czapski, having naturally undervalued his own work in comparison, received welcome words of encouragement from Kot:

Don't be cross with me for liking your paintings more than the Staëls: Your viewpoint is more interesting to me than his. Your curiosity is completely disinterested and you transmit this curiosity to the viewer who readily shares with you a moment of admiration. It has always struck me that this sharing is the role of painting. In the case of Staël, I suspect he wanted to paint a mas-terpiece rather than a "moment of vision" like you.

Extended stays at Tuta's hotel in Sailly meant an agreeable removal from Maisons-Laffitte and provided a change of scene that allowed for long country walks, stimulating his appetite for the landscape. An invitation to visit another country abode arrived from one of his favorite relatives; Thomas von Thun und Hohenstein had taken up residence in a splendid villa in the midst of rolling farmland in Bavaria. Czapski was introduced there to Thomas's fiancée, Claudia, and the threesome set out each day on walks around the baronial estate of Haindling. Once back in Maisons-Laffitte, Czapski made a painting (plate 19) based on a series of sketches of the young couple lingering in a field, and subsequently offered the canvas as a wedding gift when they were married. Claudia is shown wearing bright red-orange pants and Thomas bright yellow ones. Harvested fields are covered in golden stubble and a yellow-green hillside topped by a darker green crown of woods hovers in the distance. The figures stand clearly apart, separate but strong, each almost impersonally rendered as far as defining features are concerned, but the physical chemistry between the

bodies is palpable. It's a rather sexy painting from an eighty-six-year-old man who understood the attraction the two young people had for each other. The canvas is inscribed on the back, in German, in Czapski's shaky hand, "A gift from Uncle Józio, almost blind!!!"

Yellow Cloud (plate 21), a vertical landscape from the same year, uses a similar palette to a establish a very different mood. A large yellow-orange cloud formed like the land mass of Scandinavia hangs down in the sky, where it nearly collides with an upsurging crest of hill. Along the top of the ridge, a stand of woods is covered in dark shadow cast by the pendulous form above it. The overarching sky is divided between blue sunshine on one side and a layer of pale gray cloud cover on the other, the big yellow cloud hovering in between, a celestial presence, luminous. The mown banks of the hillside, also vivid yellow-orange in color, are edged on either side by green fields, like a decorative border on a piece of fabric. Czapski's brushstrokes are loose and gestural, and the applied paint has plenty of body. Cloud and field sing a yellow-orange *exsultate, jubilate* to each other.

Though glowing and bright, *Yellow Cloud* is not entirely bucolic. The sculptural form of the cloud, big and baroque, is at once vaporous and substantial, ethereal but with a touch of menace. Is it accruing mass or dissolving into mist? Field and cloud may sing joyfully to one another, but a hint of dissonance can also be detected in the quiet massing of a veil of gray mist near the top of the canvas. Globules of black paint representing distant treetops add a sobering note of darkness. Various elements are resolved simply, but the painting's overall impact is quite complex. From an art historical frame of reference, any pastoral landscape can be read as a mingling of pagan and Christian traditions, harking back to the idea of an original garden and the conflict played out in Eden between mankind's innocence and subsequent knowledge of the world. This opposition between what is shown and what is felt, between the purity of nature and the artifice of civilization, between exaltation and contemplation creates a suppressed tension that unifies Czapski's late unpeopled landscape works. Writing about these paintings, the poet Adam Zagajewski considers that they "reach the point where anxiety and dread can no longer be separated from serenity, even happiness." These works represent a breakthrough for Czapski, when his stubborn hold on the visible world finally begins to yield to more numinous aesthetic speculation. The speed of execution with which these canvases were painted suggests that the painter did not allow himself time to get in his own way, and for a period of years this slapdash freedom

becomes his method for realizing sensations recalled from the rural country-side. The dissolving yellow cloud can be seen as a harbinger of his willingness to relax into a less skeptical rapport with abstraction.

The touch of Czapski's brush is central to the pleasure these paintings elicit, what the brush defines, what it accentuates, and what it implies. His brush-strokes are fearless, whipping across a canvas like the wind blowing over a field. Diminished eyesight freed him from a certain tyranny of form; it is as though he is letting his brush do the seeing—he loads it up with color and lets it play across the canvas, showing him what he is seeing as it goes along. In the choice of color and subject, several of these works—sunsets, rainbows—encroach on pastoral cliché, but each is composed with verve and feeling, capturing the fresh air, the pure atmosphere of wide-open country. The paintings seem to inhale vision and exhale color.

The expressive power released in Czapski's late pictures can be found in his work all along, in a latent state, an unsurprising observation for any reader of Proust. A canvas from 1957, for instance, a narrow vertical image with a very low horizon line, shows a bend in a road Czapski knew very well, avenue de Poissy, leading from the village of Maisons-Laffitte toward the outlying district where the headquarters of *Kultura* stood. On the left, iron railings of private gardens line the street, receding to a vanishing point. Masses of tall, dark green trees on either side of the roadway soften the transition between land and sky, interrupted here and there by man-made structures (garages, fences, telephone poles). Above the foliage, dominating the canvas, the heavens surge upward. Animated blue-gray clouds, like a child's drawing of ghosts rising from a haunted house, dance in a gold-tinged sky. The viewer is placed in secure relation to the earth underfoot and the celestial canopy above. This sense of grounding celebrates Czapski's attachment to the visible world around him, but raises the ever-troubling specter of what he calls "naturalism," the painter's proclivity to pay too close attention to what's right before him. Smaller details eclipse the larger picture. The idea of transcendence, hinted at in the swirl of colors in the sky, is still subordinate to what has often been called the "theater of everyday life" in Czapski's work, here taking the form of the sidewalk, road signs, telephone poles, a bus. In the 1950s his agenda was still dominated by the social and political work that needed to be done. Pure aesthetic consum-mation was distant, a hopeful objective, beyond his reach at that time. This image of a bend in the road can be read as the expression of an internal con-flict—between his personal responsibility to work as a painter and his ethical

sense of obligation to others; between the sacred and the profane; between the forces of art and of life. By the late 1970s, he had reconfigured his priorities and could indulge his longing to consider what he called the inexpressible. His horizons broaden to include the ever-expanding lines of ground and sky stretching away from him as far as he could see. He has moved beyond the constricted, fixed point of a bend in the road, no longer so completely tethered to the signposts along the way. Having followed the road to its farthest destination, he has become one with the world he so cherishes, he has become entirely absorbed into it.

One after another his late landscapes lead him toward the state of pure painting that had previously eluded him by his own obstructive inclinations. Slowly, doggedly, he orchestrates his own acts of assumption. "Yet nature is made better by no mean / But nature makes that mean," Polixenes proclaims in *The Winter's Tale*, Shakespeare's late pastoral lyric: "The art itself is nature." Czapski finds himself painting the shimmering landscape, merely one more of nature's forces, triumphant. Like Monet's late Japanese bridge and water lily paintings, these late works by Czapski are fueled by combustion, several explosive elements reacting at once—a fear of encroaching blindness, a greater willingness to push himself, and a courageous determination to take leave of the world with brush in hand. Proust died in bed with recently scribbled notes on his bedside table; Cézanne collapsed on a muddy roadside after a deluge, easel and canvas near to hand. These were his models for the end.

No longer hidebound to a narrow "path of humility" in relation to the visible world, Czapski allows himself to pursue another way as a painter, moving into new territory. The resulting work feels unshackled, as if coming from a place of spontaneous release. Paradoxically, his body of late bucolic landscapes is unified by his deliverance from the subjugation of nature. Many factors figure into the onset of this development, perhaps chief among them the limitations age can bring in its inevitable, if inconsistent reduction of mobility and vision. Out of such organic deterioration a certain coalescing of Czapski's priorities emerged, a sense of renewed possibility and freedom. As he had done for eight decades, he faced what was before him and made the most of it. He liked to quote the Japanese master Katsushika Hokusai, who, on his deathbed at eighty-nine, said, "If heaven allows me another five years of life, I could become a good painter." In this crepuscular phase of Czapski's life, nothing held precedence over painting. People were there to assist him as he adapted to living with diminished powers; he dictated letters when he could no longer

write in a legible hand, and friends came to read aloud to him from the pages of books he could no longer see. But only he could paint for himself, only his hand could control the brush in response to visual instincts, only he could mix the colors as needed.

Painting and religious belief consumed him. Each required faith, each tested him over and over. The domains remained clearly delineated, but mingling so actively in such close proximity within him, it was inevitable that one should necessarily inform the other. Having condemned Malraux for his overuse of religious vocabulary, creating muddle and confusion among art, aesthetics, and religion, he was wary of conflating these twin lifelines. Czapski's belief in nature, embedded deeply in him, ultimately was inseparable from his belief in God. To turn away from one was to turn away from the other. Abstraction in Czapski's painting life and mysticism in his religious life represent seductive conceptual presences he was forever drawn to with his deep schoolboy capacity for wonder. The appeal of both abstraction and mysticism intensified as he aged, and over time, his inclination to resist the temptations they offered wore down. The aesthetic and spiritual barriers he had constructed in self-defense were gradually dismantled. In so self-aware a man, the physical act of aging helped to placate his fear of leaving the world; he understood what lay ahead, what was inevitable. With the urgency mortality engenders, Czapski reengaged with Teresa of Ávila's insistence on the leap of faith, accepting her credo "one has to fly." He drew even closer to Simone Weil, whom he cherished and feared. In his comment "painting is a prayer," he attempts to balance the equa-tion of faith and art in himself, hoping to avoid the muddle of Malraux. He never proselytized. With flickering vision, he made as effective use of this juxtaposition of spirit and sight as he could, striving to find more in the less he could see. In his journal, he quoted Paul Valéry: "God made everything from nothing, but the nothing shows through." Czapski's late works aspire to this condition.

In the same year as *Yellow Cloud* and the study of the Thun newlyweds, both strikingly colorful, Czapski painted two canvases—one a study of four women, the other of five men. Muted and gray, nearly monochromatic, these pictures were conceived with an intentionally reduced palette, drained of the play of cool and warm tones, of vibrant color. Appropriately enough, one of the paint-ings is called *At the Eye Doctor* (plate 22), in which Czapski (making hay out of a seemingly endless round of doctor visits) presents a high-ceilinged waiting

room with a large window and a tall bouquet of flowers perched on a pedestal. Four women sit in a row waiting their turn, fairly relaxed in composure given the circumstances. It is a droll sort of picture, easily overlooked, a prosaic nonevent rendered in a variety of thicknesses of black and gray paint with patches of unpainted canvas left showing through. The picture's inky darkness is manipulated to maximum effect, as a master Polish cinematographer might have done, allowing for a broad spectrum of atmospheric and emotional possibilities. His close observation of a room full of strangers interacting socially in a context of suppressed medical anxiety is overlaid with the painter's sardonic commentary about losing his sight. He does not skirt the fact that he can only make out the others in the room through a blurry haze. Each of the four figures is reduced to a nearly generic female shape, but each is distinct, rendered with a great economy of means. Each has her hands folded politely in her lap and both feet planted on the floor. An array of eight exposed white shins from under a parade of varying skirt lengths and shoe styles is Czapski at his whimsical best, à la Daumier and Rouault. A tall bouquet of flowers is a little black-and-white tribute to painterly indulgence, if you can imagine Munch's *Scream* reconceived as a floral arrangement. The minimal crossbars of the window frame recall Kazimir Malevich's suprematist period: "With the most primitive means the artist creates something that the most ingenious and efficient technology will never be able to produce." Crude, tonally spare, compositionally cluttered, the picture's overall effect is nonetheless pleasing. Despite his myopia, Czapski captures a banal moment with a singular touch of poetry.

The other canvas tells an entirely different story. Like exiled Poles everywhere, Czapski avidly monitored the fluctuating political situation in the Polish People's Republic. A mood of social unrest was spreading across the country. Now and again signs of rebellion surfaced. The regime, confident and cynical, would send out security forces to make an example of protestors. In response to reports of savage police beatings, a group led by Antoni Macierewicz and Jacek Kuroń formed the Workers' Defense Committee (KOR), intending to publicize the state's barbarism and raise funds to assist in the legal defense of assaulted and arrested individuals. The government sent police to harass the group, which, in addition to sponsoring lectures on freedom, also ran a publishing venture that used mimeograph machines to print the works of banned writers and distribute them underground. Some members were jailed, some attacked, their homes searched and ransacked. With the founding

of KOR in 1976, intellectual activists like Kuroń and Adam Michnik reached across a historic divide to find common ground with activists from the working class. Meanwhile, the Communist Party blundered on, borrowing even more heavily from abroad as a stopgap measure. Its inept management of the economy eventually spurred another escalation in food prices. Again, small-scale protests erupted, organized by workers. Then, unexpectedly, strikes began to spread like wildfire to every industrial center in the country. KOR collaborated in these activities. In the port city of Gdańsk, in the late summer of 1980, shipbuilders at the Lenin shipyard formed a trade union called Solidarność— Solidarity—and a nationwide strike movement was born bearing that name. The coalition between the workers, embodied in an electrician from Gdańsk named Lech Wałęsa, and the intelligentsia, led by Kuroń, was unusual and profound. This unlikely confederation was aided and abetted by the vocal support of the new pope, John Paul II (Karol Wojtyła), a former archbishop and the cardinal of Kraków and a symbol of moral resolve. Standing together, they posed a considerable threat to the status quo. An estimated ten million workers, at least half of Poland's entire workforce, would sign on to become members of the first independent trade union in a communist country. The Communist Party secretary Edward Gierek's monopoly on ruling power began to erode. The pope, addressing adoring crowds around the world, spoke eloquently about the struggle of the Polish people, of "their disappointment and humiliation, their suffering and loss of freedom." Later, a new party secretary, General Wojciech Jaruzelski, was appointed in an attempt to put an end to the country's uncontrolled outbursts of resentment against communist rule. Jaruzelski declared martial law in 1981, banning Solidarity and jailing its leadership. For nineteen months martial law was enforced, and freedoms were drastically reduced.

Among the thousands of opposition activists who were jailed, Kuroń and a few other leaders were singled out and kept under guard in a special camp in Białołęka, a suburban district of Warsaw. A covert photograph of five prisoners walking in a desultory fashion on a routine exercise break, Kuroń among them, was smuggled out of Poland and widely distributed in the world press. With this image in hand, Czapski painted a dynamic oil study of power suppressed. He, who had left Kraków in 1924 to sever all relations with such pictures, painted in 1982 the single example from the genre of "historical painting" to be found in his oeuvre. Limiting his palette to only black and white

paint mixed to gray, he honored the picture's original source material, a black-and-white photograph, but also hinted at the Western European idea of life in the Soviet satellite nations, a dismal existence drained of all color. The mood he captured in *Poland (Białołęka)* (plate 20) was bleak, dystopian, murky. Five male figures stroll down a prison walkway approaching the viewer head-on in different states of studied repose. Despite their relaxed demeanor, caught mid-stride, the tension is tangible. The space the men occupy is fortified on all sides, walls more than twice their height line their path, pushing in from either side, and a sinister webbing draped high above their heads obscures the sky. Dressed in casual street clothes, each man is portrayed individually, each has a distinct body language, but like the four women in the eye doctor's waiting room, their faces are nondescript, featureless. In a brooding, malevolent environment, the men appear wary and highly vulnerable.

In a nod to the historical moment, Czapski's shaky hand painted the name of each man on the horizontal crossbar of the stretcher at the back of the forty by thirty-two inch canvas. The men were referred to as "The Magnificent Five," a reference to a popular film about gunslingers in the American west, *The Magnificent Seven*, in turn based on Akira Kurosawa's film *Seven Samurai*. Czapski's image creates a sense of heightened suspense, as if the unarmed men might be walking into a line of fire. The painter's willingness to resist using colors from his arsenal of paints calls to mind Goya's monochromatic *Disasters of War*. For many years *Poland (Białołęka)* hung in the hallway leading to his room at Maisons-Laffitte.

Adam Michnik, the founder and editor of *Gazeta Wyborcza*, Poland's newspaper of record, is a figure of epic proportions. Physically a bear of a man (a chain-smoking bear), he has led a richly storied life. He credits Czapski with providing an example for him and claims to have drawn great strength from him, and to continue to do so. "He was one of the greatest people in my life," he declared, peering into my eyes to make sure that I was registering the significance of the remark, and then, just before inhaling deeply on a cigarette, repeating, "one of the greatest." The trail of smoke he exhaled in the space between us seemed to reassert his conviction. "Unlike me, he was never a political animal, but always a man of culture and morality." Shrugging his shoulders, regretting that what he was about to say might prove disappointing to me but that there was no way around it, he continued, "As far as I'm concerned, his genius is in his writing, not in his painting."

Born to Jewish communist parents in 1946, Michnik began his career as a dissident at a very early age. That he was to become a champion of the Polish Catholic Church's involvement with Solidarity indicates his remarkable sphere of influence. A voracious reader like Czapski, Michnik was always profoundly moved and informed by what he read. At fifteen, still somewhat angelic in appearance, he was expelled from school for giving speeches on educational reform. From the start, he was a quick thinker on his feet, exposing party rhetoric for what it was. He believed passionately in what he had to say and was almost obsessively enraged about the treatment of workers living under the banner of a purportedly worker-centric ideology. Given to shouting, he carried on shouting, ignoring the cost to himself, which, living under totalitarian despotism, was not an insignificant consideration. "I am from the school of the rebellious," he intoned, wagging his finger at me, "the same school as Czapski."

As a history student at Warsaw University, Michnik stood up in support of Kuroń, "the godfather of the Polish opposition," and Karol Modzelewski. These two graduate students had written an open letter to the Communist Party, flawlessly expressed in Marxist rhetoric. This letter landed them both in jail. Repression at all levels of university life followed. Arrested for the first time, Michnik was released after serving two months. Arrested again in March 1968 during a phase of state-sponsored anti-Semitic harassment, he then served his second, much longer term behind bars: three years. Once that sentence was served, Michnik's life alternated between activism, writing, and prison terms. Working for a time in a factory that manufactured lamps, he eventually moved to Poznan and enrolled at the university in a master's program in history.

Like Kuroń, Michnik worked to encourage cooperation between Poland's beleaguered workers and the intellectual opposition, with the objective of forming a solid political alliance. In response, the authorities persecuted both the intellectuals and the workers. At one point, between arrests, Michnik was seen by KOR as potentially more valuable outside of Poland, spreading international awareness of the cause. An arrangement was made to have him invited to Paris. Jean-Paul Sartre extended the invitation. The Polish People's Republic, preferring to deny Sartre nothing, approved a passport for Michnik. After landing at Orly, Michnik quickly made his way to Maisons-Laffitte.

"I first arrived at the door of *Kultura* in the very dark of night. Someone let me in, led me to a bed, and left me. In the morning I heard this high-pitched

voice calling out, 'Is Adam Michnik here somewhere? Has he arrived?' 'Yes,' I answered, 'I'm over here,' and he came up to me and hugged me. I was dumbfounded. 'No, no formality, Józio, call me Józio!' He could have been my grandfather. We began to trade stories right away. A plan had been afoot for me to go for lunch that day with Jeleński and Zygmunt Hertz. Right away he piped up, 'I'll join you!' At the restaurant someone asked me if I thought Poland could ever again be independent. Kot laughed at this, and said, 'I believe it will happen and the place is going to be so sovereign, we'll have to emigrate all over again!'

"Czapski was a divine presence," he continued, "a terribly brave man with naivety and goodness emanating from him. I loved the pro-Russian side of his nature. He reminded me of Myshkin in *The Idiot.*"

Years later, back in Poland, back in prison, Michnik wrote an essay in which he paid tribute to Czapski's accomplishment as a writer and a moralist. Having tried to read *Seeing*, a collection of Czapski's essays on art, Michnik admitted he could not find a way to be "in dialogue" with the writings on Cézanne and Bonnard, Soutine and Degas, Picasso and Cybis. Yet, as he confessed in his essay "Reading," he found in Czapski's formidable stand against the great ideologues of modern art parallels with his own situation battling the great ideologues of communism. On the subject of Czapski's philosophical impact on him, Michnik is reverential but clear-eyed, eloquent:

> We seem to know exactly what it is we don't want, but no one knows how to express what it is we do want. The language needed to describe our longings doesn't exist, it is one of the peculiar characteristics of our time. No known language can encapsulate our experience. We're in search of a language that touches directly on the inexpressible. Stanisław Brzozowski had such a language eighty years ago. Józef Czapski has such a language now.

Czapski's book of essays continued to absorb Michnik as he awaited trial in his cell, accompanying him into the courtroom during his hearing, sitting beside him as judgment was passed. "From this book," he wrote, "I was looking for a means of escape, and protection from the violence and lies that filled the courtroom." He was sentenced again to three years in prison.

> Just as I was being sentenced, I was thinking, what would Józio do in my place, what would he be thinking? It was scandalous how I was tried—they wouldn't

let me speak in my own defense during the proceedings. So just after they read out my sentence, I stood up with Czapski's book in my hand and, looking into the eyes of the prosecutor and the judge, I said, "After all I've heard and seen here today, I can do only one thing to remain faithful to myself and to my conscience: I forgive those who tortured me and those who slandered me."

Tell me Józio: was I right in what I did?

Michnik had been thinking of the way Czapski had negotiated his response to Adolf Rudnicki after the publication of "Major Hubert." "At first, Czapski refused to see his old friend, but eventually he found forgiveness in his heart. I always remember that. It helps me when I'm faced with what feels like people's small-mindedness."

21

CZAPSKI'S STYLE IS SINGULAR. One measure of the impact of his eye on our own is how his work encourages us to look more closely at the world. Sitting under trees in the back garden of a café in Kraków, the poet Adam Zagajewski and I played a game while waiting for our drinks to arrive: Spot the people Czapski would have chosen to draw. Identify which women seated at the tables, or which men at the bar, which solitary presences wouldn't have escaped his eye, whom he couldn't have resisted sketching. "That's a Czapski," one of us would say, nodding or pointing in a given direction, the other swiveling his head to see and confirm.

Later that week, I went to hear Zagajewski give a reading of his poems and watched as the hall filled with people, a whole sketchbook full of potential Czapski drawings. Zagajewski himself, a born raconteur, is an onstage performer like so many of the actors and musicians drawn by Czapski from his seat in the audience. The intently listening crowd, with their tilted heads, folded hands, crossed legs, scarves, hairdos, and hats, became a feast of easily imagined Czapski sketches. Each person was visible through the lens of Czapski's voracious spirit and hungry vision, each a Czapski painting or drawing in the rough. Czesław Miłosz once observed, "Czapski's paintings bring us back to the secret of human individuality. They are so easily identifiable from a distance; one knows instantly that they're Czapski's. Works of art as essence." In a letter to Miłosz, Czapski wrote, "We do not know anything about the value of that which we give, it is *unutterably contained in what has been uttered.*" He was quoting Ludwig Wittgenstein, and gave the reference in full: "If only you do not try to utter what is unutterable then *nothing* gets lost. But the unutterable will be—unutterably—*contained* in what has been uttered." These lines resurface repeatedly in his diary, another touchstone of purpose and understanding. "I feed upon quotations," he told Miłosz, "I find in them *an answer* such as I wouldn't be able to find myself, so now I live on quotations and they rescue me."

Zagajewski first met Czapski in 1983, the year he moved to Paris. He noticed

how the eighty-seven-year-old "refused old age, just as he had once rejected his aristocratic origins. He behaved as sovereignly and freely toward old age as he did, for example, to his Polishness." Zagajewski, thirty-eight, found the elderly gentleman quite hale and hearty, open to everything and everyone, intelligent, moral, funny. He would travel out to Maisons-Laffitte and read to Czapski, who, with time, was especially interested in having his own pieces read aloud to him. Zagajewski made his selection from a roster of nearly two hundred articles that appeared in the pages of *Kultura* under Czapski's name. One day he found Czapski stretched out on his bed, a sheet drawn up over his face. Assessing the situation, Zagajewski found a text and began to read, and immediately Czapski sat up, conquering the apathy that had overcome him. He could recall the words he had written, sometimes decades earlier, and would finish the sentences along with Zagajewski. When Czapski was feeling particularly limber, or restless, they would go on outings. One night, Zagajewski arranged to take Czapski to the theater to see a new play about Simone Weil.

> The actress playing Weil bore a strong physical resemblance to her. And she seemed to have entered her role so deeply that she appeared to be possessed by the same mystico-hysterical agitation that had killed Weil herself. They even had to stop the performance at one point since the actress had become so deeply absorbed in the mystic's own suffering and ecstasy that she couldn't go on.... Józef likewise shook, trembled, and took in every word spoken by either the stage Weil or the actor playing the narrator of the biographical tale. He responded to every word, since he knew them all, knew every twist and turn. He reacted almost the way a child does in the theater. He'd whisper the words along with the actors, even jump up from his seat as if he wanted to leap onstage and save Simone Weil from the disasters awaiting her.... Then Weil's death in Great Britain began to draw ever closer; the narrator was about to pronounce de Gaulle's verdict on Weil (*Elle est folle*, she's crazy!), but Józef broke in, leaped from his seat, to the actors' and spectators' astonishment, and cried with deep feeling: *Elle est folle!*

Zagajewski was putting together a collection of poems. The publisher thought the book, *Going to Lwów*, would benefit from illustrations, and immediately Adam thought of Czapski. "He was pleased with this and gave me access to his diaries to look for pages that would fit." The volume's cover would

be graced by a drawing of voluptuous leaves hanging from the chestnut trees in the garden of Maisons-Laffitte. Broad leaves filling the upper page dangle with a sensual vitality, vibrating like a crowded night sky brought down to the treetops. Various drawings are scattered throughout the book: boys gathered around bicycles; studies of flowers in vases; a seated figure in despair, his head in his hands; two views of a man in a Gandhi cap writing; and a page with two views of a small desktop, one version with three books stacked in a corner, the other with nothing on the surface but a bit of crumpled-up paper, looking almost like a small skull. One poem in the collection, called "Van Gogh's Face," is dedicated to Czapski.

> …your clear-cut face, the face
> of a just man, anxiety
> dressed in skin…
> more alive than living ones and more
> collected.

Something peering out from a van Gogh self-portrait he encounters hanging from a Paris kiosk reminds Zagajewski of Czapski's face, something rapt, filled with intensity. It is a shrewd, ennobling, and heartfelt association.

Czapski took comfort in a reinvigorated connection with his old friend Zygmunt Mycielski, the composer and music critic who lived in Warsaw. On occasion Mycielski would manage to visit Czapski at Maisons-Laffitte. Both men had been raised in privileged circumstances among aristocratic families, both devoted their lives to creative expression, both were attracted to other men. For many years the editor in chief of *Ruch Muzyczny* (Musical Movement), one of the oldest journals in Poland dedicated to classical music, Mycielski was forced out of his position of editorial eminence after expressing outspoken support for Czech musicians following the Soviet invasion of their country in 1968. An enthusiastic correspondence blossomed between the two old men looking back on their long lives. Inevitably, a frequent subject in their long letters was the death of friends.

Among these losses, the most painful was the death of Ludwik Hering, who, ill with cancer, committed suicide in December 1984. Already aware of the nature of his medical condition, he had gone to Paris for one more brief visit with Czapski, devoting much of his time to consultations with doctors. Seeking familiar ground, the two men plunged into their open-ended discus-

sion of Dostoyevsky, picking up where they had left off. The polemics of the great Russian novelist provided a neutral groundwork where they could address issues between themselves from within the context of his fictional characters. According to Czapski, these talks "connected us and separated us." The struggle between positive idealism and corrosive atheism in *Demons* offered Hering a foundation on which he could unload his despair. With a passion like Alyosha's in *The Brothers Karamazov*, Czapski found himself trying to burst Hering's implacable nihilism, hopelessly trying to inspire in him a sense of redemption and faith.

Like Alyosha, Czapski felt that he had failed to save the one person closest to him. Hering had been the one, apart from Marynia, who understood him, who encouraged him, who loved him. They had shared only three or four years together in Warsaw before the war; Hering's secure place in Czapski's life had been otherwise restricted to the form of an internally held presence. What could it mean that he was no longer alive, that his physical life was over? He had survived all along as an incorporeal being.

He had organized it all. He left a note that he didn't want anyone to know that he had killed himself. But in truth, he hung himself in an old wardrobe. He wanted his death to be as silent as possible, to spare Ludka [his niece], his one love. He had organized it all, the funeral at the Calvinist cemetery and the stipulation that the priest should do no more than recite the "Our Father." He was angry with God because of the suffering of mankind, angry with a God he did not believe in.... He is gone and nothing, nothing can now tie me to this dead person. The threads are all broken, broken forever and no trace remains of the feeling that our ties were important. But while he lived, these ties were the most important ones for me, right until the last moment of his life.

In a rare acknowledgment of his own vulnerability, Czapski went through the motions of striking this entry about Hering's suicide from his diary, slashing a long line down through it, noting in the margin below, "I crossed out what I wrote above not because it was wrong but because it was too private."

Like his headless figure in *Neon and Sink*, Czapski remained unsure of how much of his true self he was willing to lay bare. "Silence," he wrote, "seems to me the only path for a diary to take, one kept for years by a man who wishes not to disappear after his death but who demands that this silence, which is

a kind of impoverishment, be respected." This is not a protest against the failure of words to proclaim his most complex feelings but about a nerve being exposed. "Because of Ludwik's death, I am again prone to senile impulses: Everything from my past seems to be swept away from my life." Here, once more, Proust's literary landscape of loss is evoked. Czapski is recalling the moment in the novel when the narrator learns of the death of his elusive lover, Albertine, and flounders, trying to fill the void with activity and people, aware of the futility of such desperate measures. Marcel attributes his thrashing about to a need to please "*notre sénilité bavarde, mélancolique et coquette,*" our chatty, melancholic, and flirtatious senility. Czapski shifts his perspective from his own moment of weakness to this phrase. He is better prepared to live with a vicarious expression of grief. Like a leitmotif, the words "*notre sénilité bavarde, mélancolique et coquette*" resurface for more than a year in the pages of his *journal intime*, which is really at once not so terribly intimate and yet also very much so.

Despite raising the question of his continuing viability as a painter to anyone who would listen, Czapski nevertheless refrained from abandoning the act of painting. It would come upon him and overtake him, regardless of his insistence that he was finished and done for. He seemed to have no control over its emergence, but he never resisted the call once it came. To Aeschlimann he wrote: "As far as my painting goes, I'm in a complete fog. Every other day I decide I have to give it up, then I begin to paint again. I seem to have lost my ability to make decisions." Painting was no longer a question of discipline but of submission. When the urge came over him, his brushes and palette and easel, always near to hand, would return to life.

Late in 1984, he received a vague invitation to participate in the Nouvelle Biennale de Paris slated for the following year with an international roster of artists. The tenor of the invitation was noncommittal, he would learn subsequently, because the individuals in charge of determining which artists would be included had no idea who he was. An Eastern European curator put Czapski's name forward as an accomplished painter currently at work in Paris, but his existence was entirely unknown to all the French members of the selection committee. He was initially approached about the possibility of exhibiting three canvases. In due course, a host of Biennale representatives appeared at his studio and, clearly surprised at what they found, expanded the invitation, requesting he provide ten. A flurry of activity ensued, Czapski calling on a

host of friends to help steer him through the process of logistical requirements and deadlines. Kot Jeleński took up the role of ringmaster. Wojtek Karpiński agreed to compile a biographical note and to write the catalogue entry.

To Mycielski he wrote:

> I came down with the flu, too, and then it became tuberculosis of one lung. While lying in bed, I've been able to think about my future. I can no longer see—at all—I can't read. I've been trying to paint—lots of old women in black and white acrylic—this is the last of my work whose existence seems real to me. The fate of my canvases is already fixed, I'm sending everything to Aeschlimann in Chexbres, everything. I trust him more than anyone. He's preparing another exhibition of my paintings next March.... Thinking about my painting, I can't really figure out if it's worth anything. Perhaps my best canvases, those I care about most, are the landscapes from Sailly. Those great open spaces with new skies every sunrise. They are the nearest, in the sense of painterly quality, I think, to the still lifes of Morandi, who for me in the last years is the best exponent of working directly from nature. Don't be offended, but he became my Bach; what I experienced thanks to Bach was a form of silence which I felt only in his music. Everything else was a kind of noise for me. In Morandi it is exactly this silence I find, and when I'm feeling at odds, it's enough for me to open to a page of reproductions of his paintings for me to experience something similar to Bach in this most humble, simple art.

The Thirteenth Paris Biennale opened in March 1985 at the Grande Halle de la Villette with a roster of nearly one hundred artists. Most were young art world celebrities whose studio inventories were calculated to withstand the growing demand for contemporary art, among them stars like Julian Schnabel, David Hockney, and Georg Baselitz. The prodigious sales of their works fueled an aggressive market cunningly modeled on a Wall Street paradigm. Czapski was by far the elder statesman; the large percentage of those whose work was on display were half a century younger than his eighty-nine years. The experience of being granted entrée to a world formerly closed to him elicited a series of complex responses, beginning with pleasure. Many of the young painters being shown had staked an aesthetic claim in reaction to the prevailing preeminence of abstract art. Like him, they had sought means of engaging with the world they could see around them. Would they find him a painter of interest? He was aware of the significance of having been validated by the

gatekeepers of the scene, those whose intent was to manage what they decided was important Art, their influence extending from painters' studios to the back rooms of dealers to the public venues they controlled.

Assembling a group of pictures he was happy with took some doing, but after receiving a variety of responses from trusted friends, he settled on ten canvases. Most of the works he decided to include were part of the personal collection of paintings the Aeschlimanns had been building. They received the news of his inclusion in this star-studded showcase with a customary grace and a genuine concern about the long-range impact of such exposure on him. Readily agreeing to lend him whatever works they owned, they made plans to come to Paris. Dispassionate about what lay ahead, they may have felt some small sense of vindication for having made a solid investment in an underappreciated artist and his paintings. Still, their response was tentative, and they resisted the urge to embrace a triumphal mood on Czapski's behalf. They were better acquainted than he with the core values at the heart of such an enterprise. This caution proved well-founded.

Czapski wrote to them,

Dear friends,
I'm not going to say much because I expect you'll be coming to see for yourself the spectacle of the Biennale, which from my point of view is a complete fiasco—even the room of that celebrated and marvelous painter Józef Czapski. My work is hanging next to another painter, who is showing one huge painting of a man pissing (literally) on a corpse, and another, even bigger, of Menachem Begin sitting in Hitler's lap and nursing at his breast. On the day of the opening, a live cow, painted red and green, was let loose to wander among the galleries.

The frenzy of the contemporary art world, with its addiction to hyperbole and predisposition for shallowness, reflects a culture in which aesthetic importance is determined by monetary values rather than the other way around. The Biennale marked an important moment in Czapski's professional career. Observing the circus atmosphere, he recognized the desperate longing for money and fame on the part of nearly everyone involved. He was not indifferent to these claims and did not recoil from them as if he were above the fray. What most distressed him was the enthusiasm with which Art was put to such shallow, meretricious ends, in an atmosphere in which high culture was clearly held in disdain, with the dealers and collectors laughing all the way

to the bank. Still, he had decided to participate. Helplessly, he had to accept that he had chosen to take part in the intentional desecration of what he held as nearly sacred ground.

Brushing up against all the bombast and tinsel, he better understood that his self-imposed distance had been, all along, an act of self-preservation. He derived some pride from having made his long, lonely journey on his own terms, for having lived according to his own truth, for having believed in himself. He processed his reaction to the spectacle/debacle, shaping it into one of his last essays for *Kultura*, "The Death of Cézanne," published a month after the exhibition came down. He noted that "among the works at the Biennale, I found not a single trace of any allusion to the era of Cézanne to which I feel so bound."

The cult of Cézanne, which I and my nearest friends embraced along with a multitude of other painters we didn't know, began to pale, to disappear without my really having taken notice. I realize it today, but I should have understood that it was happening more than twenty years ago. Young painters today speak of Cézanne with respect, his paintings are found in all the great museums of the world, dozens of volumes are written about him, but no one any longer turns to him for discovery. It's not unlike my relationship with Delacroix; I've always admired his sketches and his preparatory drawings, but his major canvases, which have played such an important role in the history of art, leave me cold.

This recent Biennale convinced me of something I haven't sufficiently paid attention to: Times have changed, and what had been burning questions for me seem much less urgent today. A modern painter learns as much from Malevich and Mondrian as from the masters who worked from nature. Suddenly it dawns on me that for a very long time now I have belonged to a post-Cézannian era.

Lingering on his early influences, he composed another essay for *Kultura* on his belated appreciation of Monet, without whom "Cézanne is unimaginable." Following a pilgrimage to Giverny to see the restored gardens of the plantsman painter, he found that he distinctly preferred the paintings of the garden to the garden itself. Sympathetically, Czapski dwells on the pitiful condition of Monet's eyesight following failed cataract surgery that left him with less than one-fortieth of his vision in only one eye. And yet Monet went on painting valiantly. The trope is increasingly poignant and meaningful for Czapski. At the same moment he wrote these lines about Cézanne and Monet,

about painting, he wrote to Mycielski about no longer being able to write. And yet he continued to write, submitting several more essays to *Kultura*:

> As for writing, without my sight to nurture me, I can't write anymore about painting. I think I've already said everything I could and now I have nothing more to say. I don't want to force myself at all, but if I try at some point to paint or write it would only be because of my strong internal spiritual needs. While admitting that I repeat myself, and he's right, Jacek Woźniakowski suggests that I should still write. But it's time for my life to come to an end. I really think I've done what I could do. Unfortunately it's not me who makes this decision about how long I will continue to live. I'm writing you such a long confession because I want you to know how it is, and to let you know that every part of me already feels that life should already be finished.

On the front of one of his diaries covered in oatmeal-colored linen, he took great care to legibly letter a phrase from the historian Jules Michelet: "*Le long supplice de la vieillesse*" (The long torment of old age). Michelet wrote the nineteen-volume *History of France* and lived in the center of Paris in absolute retreat from the world during and after the Commune. At the end of his life, losing first his faith in God, then in man, he claimed he was caught between nothingness and the arbitrariness of a capricious divinity. He died in 1874 at the age of seventy-five. Czapski was eighty-nine when he inscribed the doleful phrase on his journal cover, as if acknowledging its truth. But unlike Michelet, he did not retreat. True, each day he remained in his bathrobe a little longer. His skin began to loosen its grip on his face, his skull became increasingly prominent, patches of stubble remained on his cheek or neck after he had finished shaving. He could look haggard, though his eyes, behind large thick lenses, were generally bright. Of course some days were better than others. He continued to welcome visitors, feeding off of their energy in order to supplement his own. Julia Juryś, Adam Zagajewski, Wojtek Karpiński, and other friends and family members appeared on a regular basis to attend to his needs, to pass some pleasurable hours in his inimitable company. Karpiński recalled:

> On another occasion, he was once again depressed. I tried to distract him. What I read held little interest. I then began to recount some fragments from Paul Valéry's *Degas, Dance, Drawing*, a book he [Czapski] declared every painter should have in his pocket. He responded more and more animatedly, up to

the point where Degas, who had ambitions as a poet, complained to Mallarmé that he was struggling with a sonnet, for which he had so many ideas. Józef, quite alert now, got ahead of me and beat me to the punch line, beginning in Polish and ending in French, citing the response a startled Mallarmé made to Degas: "But Degas, it's not with ideas that you make verses, it's with words." Then he joyously repeated the advice that Ingres had given to the young Degas: "Make lines, lots of lines!"

Another time I spoke with him about the magnificent exhibition of his work that I went to see at the National Museum in Poznan. I brought along photographs I had taken of the installation in the galleries of the museum. He could not see them. He took them up one by one in his hands, listening with pleasure as I spoke about the success of the exhibit, but it was as if he were in a fog. He said once more that he had always doubted himself as a painter, but he was passionate about his work. He spoke in broken sentences. After a moment he said quietly, "I expressed my breath."

Wojtek ("my most important connection to intellectual life") read aloud for a few hours when he could, and together they made their way through *Le Temps retrouvé*, Proust's final volume. Baron de Charlus, perhaps Proust's most imaginatively complex creation, often pops up in the pages of Czapski's late diaries, his presence revived by Wojtek's reading. In discussions with Tadeusz Boy-Żeleński, Proust's Polish translator, Czapski had always been struck by how he perceived the decline and humiliation of Charlus as a source of farce rather than pity. No doubt Czapski now identified even more keenly with Proust's poignant portrait of the pathology of old age, his own mind still alert but his body far less responsive. Charlus endured a progressive degeneration and was but a pale shadow of his once virile self; his young man's appetites were imprisoned in the body of an old man. The last of his race, the sole survivor of his times, the baron lived so long that he could recite, like a catechism of lament, all the names of those dear ones who died before him. When Róża, Czapski's youngest sibling, the subject of innumerable portraits by him, died at eighty-five, he was bereft and felt he had become, like Charlus, the survivor of his generation. However, his worn spirit rallied over and over again, his humor never seeming to flag. Visitors were continually amazed by his ability to make the most of resources that were dwindling with age. Reflecting his lifelong lack of vanity, he described himself with cunning wit, highlighting the burlesque qualities of his current Charlus-like situation to Mycielski:

433

Do you know this story? A woman who had a parrot would often go to visit friends in the evening. One day, her nephew came from Africa with a monkey and asked her to keep the animal for some time. That night the lady came home from her friends and found, instead of her parrot, some poor creature on the floor, all bloodied and featherless, and this animal, hardly moving, kept repeating, "*Quelle charmante soirée! Quelle charmante soirée!*" And you know, I am that parrot. Good people keep coming to visit me and I always seem to be saying, "*Quelle charmante soirée!*"

He received as a gift from a friend a monograph of the American painter Milton Avery, written by the curator Barbara Haskell, published a few years earlier. A keen sense of relatedness immediately drew Czapski to the bold images he had never before seen or known of. He was enraptured by the paintings. Like Czapski, Avery had weathered the battering storm of modernism by following his own path. In the 1930s and '40s his simplification of forms was too radical for the New York generation absorbing the social-realist legacy of the Ashcan school. By the 1950s, his disinclination to abandon the natural world for abstraction marginalized him critically. Through it all he filled his canvases with saturated hues having little to do with local color, emerging from the shadow of Matisse and the Fauves with his own potent combinations. Born eleven years before Czapski, Avery had been dead for twenty years by the time Haskell's book made its way to Maisons-Laffitte. Almost ninety, Czapski was intensely receptive. The direct and significant impact Avery's pictures made on him came as an uplift to his painter's spirit, long mystified by what he had failed to find in work held in such high esteem by others.

A greenish-black sea under a thin band of blue sky, under it a beach with two figures in black silhouette. Could one with any more freshness and childlike simplicity transmit a marine landscape in a nearly abstract manner? It seems to me that Avery has figured out how to square the circle. The bloody struggle between abstract and figurative painters that I've seen and lived through seem resolved by this American painter whose existence had been unknown to me until now, and who died in 1965, ten years after de Staël.

The balance of intimacy and monumentality, of drawing and color, or what he could determine of it from the photographic images, spoke directly to

Czapski. His late discovery of Avery's work led to a reconciliation, a resolution of his relationship with abstraction that had long eluded him.

Along the path I've traveled, from Bonnard to Matisse and de Staël, the painting of Milton Avery seems to me like a continuation, leading to a liberating synthesis, joining Cézanne's advice about creating in front of nature to a nearly pure abstraction.... This synthesis, which I have always leaned toward, liberating me—with what slowness—from naturalism, attains here a marvelous harmony of forms, particularly in the landscapes. I feel that if I were to paint again, I would be nourished and fortified by this artist who has brought to painting something I've always dreamed of.... I'd like to find in myself the source for so great a joy that has, literally, rejuvenated me.

He could, and did, paint again. Grateful to let go of so much resistance, inspired by Avery's example, Czapski, the self-proclaimed ex-painter, entered an even further late-blooming phase. A narrow window of time opened, about four years, after receiving the Avery book and the emergence of his last canvases, several dozen of them.

He produced a rhapsodic suite of still lifes, elemental, pulsing with life. Forms are assigned their place on the canvas, outlined as if to anchor the object—a chair, a table with a single vase (plate 24) or a pair of bowls—and then a controlled explosion of color and gestural strokes erupts, it's as if he is making palpable what he can barely see, taking command of the space with a combination of exquisite restraint and suffused power. He is creating pictures as a way of finding himself, and finding himself, he seems to absent himself from the equation of painter and painting, stepping back from the canvas, from the world, almost as a rehearsal for the end, leaving in his place something vibrant and alive. These spare, confident pictures radiate absence amid a terribly tactile presence. Writing about the late works of Beethoven, the philosopher and composer Theodor Adorno speaks about the trembling rapport between objectivity and subjectivity. The canvases Czapski painted in his nineties supremely manifest these opposing forces: "The power of subjectivity in the late works of art is the irascible gesture with which it takes leave of the works themselves. It breaks their bonds, not in order to express itself, but in order, expressionless, to cast off the appearance of art."

Another late work, *Galerie Plexus*, is one more portrait of the artist with

no head. This time, thirty years later, the little of Czapski to be seen is merely a stretch of leg from mid-thigh to his knees, plus the tips of his two large shoes, which push into view from the bottom of the canvas. The setting is a gallery space, a room we see through the eyes of the seated painter looking out and down. Straight ahead is a yellow wall on which three paintings are hung, one vertical in format flanked by two that are horizontal. To the right another canvas hangs on a darker wall, while to the left we see barely a strip of a third wall and the indication of one more canvas. Each picture on display is reduced to a crude rectangle with a yellow line around it indicating a frame. Each of the paintings is singular, but only to the degree that the dry-brushed black strokes Czapski fills it with are not like any of the others. Are the pictures landscapes, still lifes, portraits? Probably not portraits is about as much of a distinction as one can venture. A small, brown, three-legged side table stands to the left of Czapski's bony knees and a small yellowish rug projects like an afterthought into the room from under his feet. Czapski's knees, shown as if he were looking straight down on them, are rendered like two upright rounded archways refusing to lay flat, with a black-toed shoe sitting just to the right of each thigh. In this severe reduction of a human presence in the picture plane—a nearly perverse cropping of bodies runs through his entire oeuvre—he seems almost to be illustrating the words of the Russian critic Wladimir Weidlé, whose *Les Abeilles d'Aristée* (The Bees of Aristaeus) he emphatically underlined and annotated. In an essay called "Abstraction et Construction," Weidlé writes, "In what is unequivocally called abstract art, it is not the lack of figuration in itself that is regrettable, it is the absence of the human spirit." This absence of the human is what keeps Czapski from embracing nonrepresentational abstract art. "One finds man in a peach of Chardin, in a tree of Corot, and also in a Greek column or the ornament on a page of the *Book of Kells*." This is abstraction Czapski can embrace. In *Galerie Plexus*, man protrudes into the image like a thumb in the viewfinder of a camera, his presence irrepressible, not to be denied.

Inspired by Avery's example of liberating synthesis, Czapski painted what can never be mistaken for an abstract picture. He created a similarly "marvelous harmony of forms" that draws from both abstraction and the visible world. *Galerie Plexus* appears to be a picture of a seated figure in a room full of paintings. As in a Morandi still life, all the narrative elements are present but the picture is hardly about any of them. The canvas radiates negative capability like Titian's late, great *Flaying of Marsyas*, where the handling of the paint

enhances the image's emotional strength and its communicative power. Beneath a superficial narrative—gallery, paintings, figure—Czapski's surfaces are rough and scumbled. Rendered almost whimsically, the picture also gives off an opposing whiff of looming disaster—suggestions of blindness, amputation, mortality. The satyr Marsyas is cruelly punished by Apollo for his presumption, and so is the painter of *Galerie Plexus* shown fettered at the bottom of the canvas and made to see his folly. The divine triumph of art over any mere mortal artist is made perfectly clear.

In an essay called "What Abstract Art Means to Me," Willem de Kooning conjectured that art used to be about what one put in a picture. Then the question arose not of what one could paint but rather of what one could *not* paint. Czapski, always judicious and restrained about what he put into a picture, nevertheless remained very susceptible to the idea of what might be left out. But from the turn of the twentieth century, when subject matter became an option you might choose *not* to have, he drew a line, never relinquishing his hold on it. In many pictures he left out a great deal (for instance, his head in *Neon and Sink*), but subject matter, which, according to de Kooning "is the forever mute part you can talk about forever" remained a necessary feature of his paintings. In one of Czapski's final essays devoted to painting, "Thoughts Without Conclusion," he positions Avery as a very late arrival among the masters whose example sparked his own continually developing creative sensibility. Discovering such a kindred spirit at so advanced a stage, he carried on painting "without conclusion."

In 1986, Czapski's face appeared on a stamp issued by the clandestine postal service created by Solidarity, one in a series paying tribute to the key members, the heart and soul, of *Kultura*. Samizdat editions of his texts, bearing covers embellished with various self-portraits, circulated widely in the Polish People's Republic, printed on the kind of poor-quality paper he had known as a prisoner in Russia. Another exhibition of his work held at the Museum of the Warsaw Archdiocese was very well attended but not reviewed in the official press, where he remained persona non grata. His renown spread beyond Poland, generated largely by his remarkable longevity as a painter; his name and face appeared frequently in print, the subject of interviews, articles, and critical assessments.

In May, Czapski eagerly attended a reading given by Zbigniew Herbert, who, having lived through years of martial law in Poland, moved to Paris in

1986. Czapski wrote to the poet to express his feelings of admiration and appreciation for the evening's stimulation:

> A number of times I met Daniel Halévy's brother-in-law [Jean-Louis Vaudoyer], who knew Proust well. When Proust was already quite ill and absolutely had to see this exhibition or that for his work, this painting or another, he would take Proust in his car. This is likely how it was in 1920 or 1919 when there was an exhibition of Dutch paintings in Paris. Vermeer's *Avec le pan jaune* [*View of Delft*] was not there, but there were Dutch paintings and Proust was lightly taken with a spell of faintness. There was a scene in one of Proust's last volumes, the death of Bergotte, in the gallery in front of Vermeer's painting where, looking at that picture, he reproaches himself for having written with insufficient attentiveness, insufficient depth. All of this came from that visit to the Dutch exhibition that my friend told me about. But this is not what I am getting at here. Rather, it is that usually, when he took Proust to an exhibition, as this friend told me, Proust looked at the paintings as if with complete indifference, to his friend's surprise. Yet later, returning home, naturally exhausted from his outing, Proust lay down in bed and only then would he relive the exhibition, with rapture to the point of becoming feverish. You will understand that I am not making some kind of comparison, but that I have noted a similar division of experience and vision, or experience and hearing, in myself for many years. I experienced something similar tonight after your reading.

Czapski's dependence on his diary, his longtime companion, intensified as his mobility was increasingly challenged. Forming letters with a wobbly hand, his handwriting appears as if made by a child clutching a pencil and learning how to shape letters. The words in a sentence don't sit on a line, they seem to levitate. Sometimes a single word is a cradle of letters strung between its first letter and its last. Page after page of erratically shaped words resemble sheets covered in automatic writing. Czapski admitted that part of his lifelong discipline of making daily entries stemmed from his having found the activity so comforting. He always wrote in a prone position, diary in hand, resting his body as he wrote, a lazy way to keep his mind occupied while his physical self unwound. At ninety, however, a great deal of effort was required. Looking over the pages of his later volumes is not quite like watching a man gasping for breath but rather like seeing determination embodied in writing. The long

agony of old age is revealed in the degradation of his handwriting, never known for its clarity to begin with, yet each hard-won letter formed words full of feeling and meaning. He writes the phrase "*notre sénilité bavarde, mélancolique et coquette*" repeatedly. In the midst of a page of mostly Polish text the words "To be or not to be," in English, stand alone. And yet, unlike Hamlet, Czapski is hardly obsessed with questions of mortality. From a dictated letter to Mycielski:

> In the past days I had a very good moment with my paintings. I sold two and I've already prepared paintings for an exhibition on the twenty-fourth of April in Chexbres. This collection is different from anything I've ever done. Extremely simplified still lifes; for years I wanted to paint like this. To throw away everything that isn't needed. I don't know what people will think, but for me that doesn't matter. I don't care. But what's unusual is that I thought I would immediately die after finishing these still lifes, because I've gotten to the point of maximum simplicity. But here's another surprise—I'm still alive.

One further surprise was soon divulged, and this one was a great shock. Kot Jeleński was dead. He had contracted HIV as the AIDS epidemic was leaving its deadly imprint on the French capital. He had fallen sick and died very quickly. Leonor Fini was nearly deranged with grief. When Czapski heard the news about Kot and the reports of Leonor's lamentations, an image swam into his mind: He was standing at his father's grave. He remembered hearing the prayer being read, "the resurrection of the body and life everlasting, amen," and then recoiling as his aunt began to wail, "Do you believe that, that he is alive and happy where he is? No, it's not possible, people made that up because they can't stand it."

> I hear Aunt Paulina's cry of doubt so strongly today, her brutal rejection of consolatory faith. For Kot, faith didn't exist—I think. He was so completely in life; here, in life, he was spread about, involved with hundreds of people in their lives, everywhere, anywhere he could be of help. This was a rare quality in a friend, he was so human in every impulse and like a BROTHER. But how can I write about what is unutterable, unspeakable?

Giving voice to his feelings, he wrote an obituary whose title, "Hojność blyskawiczna," immediately summed up Jeleński's open personality and spirit:

"Instant Generosity." Czapski marveled at how Kot had been able to give of himself entirely at each encounter, no matter how brief. The other person was always more important. With a gift for introducing seriousness into every exchange, he was never insincere or superficial. In addition to his commanding intelligence, Kot was also intensely intuitive, knowing when his help might be most needed, and whenever Czapski needed him, Kot was there. It was a unique friendship. Losing Kot, Czapski lost his most important judge, his most trustworthy critic.

Aware of the degree of closeness between Kot and Czapski, Czesław Miłosz went to see him at Maisons-Laffitte. He wrote later to Jeanne Hersch: "I don't understand how he can paint so much and so well, even though he is almost blind, or at least that's what he says. Especially the paintings of the last couple of years; those are what he wanted to show me. In particular one still life with a rag in shades of grey and white. I am surprised by his ongoing youth as a painter."

In Poland, the economy, crippled by outstanding foreign loans, continued to fall. Even after martial law was revoked, social unrest continued. A heady atmosphere of resistance to authority prevailed. By 1988, the idea of involving the leadership of the workers' movement in talks about the economic future emerged, out of desperation, as an option. Lech Wałęsa was head of an illegal organization, but it was useless for the floundering regime to continue to deny his potential as a bargaining agent. Reluctant at first, he eventually agreed to sit down with the minister of the interior to discuss finding a way to end the protests and the paralysis. For months, informal talks were held, during which time neither gestures of reform nor threats of dire consequences produced results. By February 1989, General Jaruzelski was forced into the position of recognizing Solidarity as a partner in the negotiations, and in April the legalization of the first independent trade union in a communist country was ratified. Soon after, *very* soon after from all points of view, general elections were held, the first legitimate elections since the end of the Second World War. In the Parliamentary Assembly election, the Communist Party and pro-communist groups were guaranteed sixty-five percent of the seats. The remaining thirty-five percent were all won by the anti-communist opposition. After the elections, the pro-communist groups largely abandoned the Communist Party. In the national Senate election, all seats were openly contested. Ninety-nine out of one hundred seats went to the opposition coalition; one was won by an inde-

pendent candidate. The party no longer held a single Senate seat. Postwar Poland elected its first non-communist prime minister since 1939.

The Polish Communist Party was dissolved shortly after. One of the highest priorities of the new government of the Third Polish Republic was to pressure the Soviet Union to make a public declaration of culpability in the death of nearly twenty-two thousand Polish servicemen in 1940, after fifty years of sanctioned lies. On April 13, 1990, the forty-seventh anniversary of the German announcement of the discovery of mass graves in the Katyn forest, Mikhail Gorbachev, the general secretary of the Communist Party of the Soviet Union, handed General Jaruzelski two boxes containing the NKVD dispatch lists for prisoners from Kozelsk, Ostashkov, and Starobielsk. The Soviet news agency TASS issued a communiqué: "The archival materials that have been discovered, taken together, permit the conclusion that Beria and Merkulov and their subordinates bear direct responsibility for the evil deeds in Katyn Forest. The Soviet side, expressing deep regret in connection with the Katyn tragedy, declares that it represents one of the heinous crimes of Stalinism."

Neither an explicit admission of Soviet guilt nor a disavowal of the duplicitous Burdenko Report, the public statement signaled the end of the intent to cover up. Gorbachev had opened the door. When Soviet Communism finally collapsed, and the USSR ceased to exist after a failed coup in August 1991, Boris Yeltsin, the president of the new Russian Federation, took more assertive action by opening the Soviet archives to historians. On October 14, 1992, photocopies of forty-two documents concerning the massacres at Katyn and elsewhere, including the March 5, 1940, politburo directive signed by Stalin and Beria, were turned over to the Polish president Lech Wałęsa and immediately published in full in Polish translation.

Czapski, and the whole worldwide community of Polish exiles, followed these events every step of the way. The iron curtain had fallen and the Berlin Wall was toppled. But the significance of the acknowledgment of Soviet guilt was for Czapski an especially gratifying resolution after fifty years of symbolically carrying the torch for the truth to be known. Natalia Lebedeva, one of three Russian historians determined to make public what had been uncovered in the Soviet archives, wrote directly to Czapski. She wished to alert him to the fact that according to a paper trail she had followed, he had personally escaped execution with his fellow officers because of a request made through the German embassy in Moscow on behalf of Count Fernand du Chastel, the Vichy ambassador in Rome. Czapski had never understood why his life had

441

been spared and this information shed no light on the subject for him; he did not recognize the names of any of the diplomats concerned. He wrote back to Lebedeva, in Russian: "How strange it is: I am very old, I hardly write and hardly think, but I am stunned! I have lived long enough to read your letter and your published research articles....This has stayed secret for so many years!... It is so strange to me, because I have no knowledge of any connection to the German embassy."

People speak of Czapski's life as being touched by a special providence, a seductive but specious theory to which he gave no credence, having long resisted such unfathomable notions concerning Simone Weil. He had escaped death, he had survived. He still did not know why, but now he was relieved of the burden, of the responsibility, of holding the truth of how the others had died.

After so many years of suppression, the sudden advent of Katyn as a subject of public discourse in Poland came as a profound release. The filmmaker Andrzej Wajda, whose father had been a prisoner at Kozelsk and a victim of Katyn, was determined to make a film about the massacre. Having known Czapski over the years, Wajda shot footage of one very long interview at Maisons-Laffitte in which Czapski spoke at length about a variety of subjects touching on his life, on Katyn, and on art. Wajda and his wife Krystyna Zachwatowicz, a powerful advocate for Czapski's place in the larger Polish cultural context, accompanied the painter to an exhibition of works by Francis Bacon one day. They found the images haunting, compelling. "It wasn't the case of spectators dominating the paintings as usually happens," Czapski commented, "but the paintings on the wall that held sway over the viewers."

With Andrzej Wolski, a filmmaker friend, Wajda discussed a pet project he was nursing for another film:

> The subject is very interesting: an old painter who sees poorly—who can really see *almost nothing*—painting. And he paints better and with more vigor than he has done ever before. I would begin initially with a long shot—Czapski, almost blind, in the act of painting. In the same sequence, a wide shot of the tubes of oil paint propped on scraps of paper upon which the names of the colors have been written in large letters so he can make out what's what. He's not painting from memory.... Such a film could be quite successful, but it mustn't feed on illusions. I learned from Czapski that the problems of painting can only be resolved by painting.... At the end of the day, I would have no hopes for discovering the secret of his painting.

For Wajda, Czapski's input on a film about Katyn was a blessing. He cherished what Czapski's observant eye and attention to detail had noted, and he made use of Czapski's precious wartime diaries, full of descriptions and drawings of life as a prisoner. Wajda would ultimately pay posthumous tribute to his friend by inserting an oblique reference to him in the screenplay. In the film *Katyn*, the highest-ranking officer among the prisoners of the camp addresses his men as they all crowd together in a dim, narrow space piled high with tiered bunks. Reminding his military cohorts of their duties, he adds: "I wish to say a few words to those, who, though not professional soldiers, share our lot here and are in the majority. I see scientists, teachers, engineers, lawyers. I see a painter, too. You must endure, because there won't be a free Poland without you."

At ninety-four, Czapski was the subject of a large retrospective at the Musée Jenisch in Vevey, Switzerland. More than one hundred canvases were included, works spanning a period from the 1950s to the weeks just before the June 1990 opening. It was the largest assembly of his pictures ever on public display. Museum officials at first assumed that the painter would not appear, his physical condition too frail to endure so much travel. But Czapski, not one to be left behind, mobilized his energy and, with the help of many, appeared at the vernissage and beamed at the crowds of people. Sitting by himself for a moment in a wheelchair, he was exhausted but happy. According to Wojtek Karpiński, he looked like the subject of a Czapski painting:

He was above all grateful. Toward those who organized the exhibition. Toward those who brought him to Switzerland. Toward those who came to the opening and surrounded him in a close circle. And also—he didn't formulate this in words, but it contented him to think it, as you could see in his eyes—he was grateful for the paintings, for this passion that brightened his whole life. Through how many gray and somber hours did it represent for him salvation and life. *Du holde Kunst* [You, noble Art]—in this song Schubert pays homage to art, thanking it with exalted passion for its help. Czapski didn't invoke Schubert at the museum in Vevey. Besides, he used another vocabulary, he rarely employed such words as "art" or "artist," he spoke instead of "my work," of "carrying on with work," of " the speed of work," he spoke of the "métier of painting," of the "labor," or even the "job" of painting, but in somber moments of truth he would evoke "vision," "éclat," "inspiration," "flight," the need "to find my breath," he wanted "to express his breath." In the Swiss museum he found his breath.

He kept on. He maintained his diary as long as he could, his hand holding a brush or pen, "as if there was no break between the end of my pencil and myself." In this way his journal still operated as a playing field between painting and writing. As ever, he would migrate between disciplines. He continued to draw in his diary, making beautifully reduced and elegant still lifes in black ink—a single line delineating a bottle, another signifying a drape, another the tabletop, *tout court*. And landscapes: in one drawing a single line represents the crest of the Alps, another the far shore of Lake Geneva, and a third the near shore, with a thin veil of watercolor filling in for mountain and sky and water. Unlike the strenuous exertion required of him to shape letters and words, the drawn images appear effortless, fluid, spare, his hand perfectly in control of his pen, like the stammerer who, reciting poetry, intones beautifully. (Like Sergei Nabokov.) Words written in huge letters spill across other pages. His very late entries are reduced to solitary names and places: Soutine, Bonnard, Matisse, Goya, Morandi. Norwid, Weil, Zagajewski, Proust. Starobielsk, Kozelsk, Ostashkov, Katyn. He is clutching at these as if to hold his mind in place, exposing the building blocks of his memory, stripped of all that is superfluous. Over and over again he writes KATYN, he writes and rewrites the name of the place where so many died. He cannot relinquish his role of witness, he has held it too long, too well. Among his final entries, the words "*Trzeba się gotować do milczenia*" are scrawled: You have to prepare for silence.

When his eyes could no longer see enough to make out even the simplest of forms, he was reduced to making marks, to drawing just lines, but these lines are so articulate, full of tremendous feeling. They're lines that can whisper, or hum, or shout. Open boxlike forms fill a long sequence of pages, one to a page, composed of a single line that encloses a space whose shape echoes the edges of the sheet it's drawn on. He is drawing space, at once containing something and allowing something to release. Drawing to feel the paper under his pen, it is as if, in both senses, Czapski was drawing breath. The effect is incredibly stirring to behold, so little encompassing so much: the almost nothing signifying everything.

On the cover of one late volume of his journals he fashions the words "*On meurt seul*": We die alone.

Wednesday. Awoke before six. Earlier, in the middle of the night, I awoke, certain it was daytime. Why did fragments from [painter and poet] Stanisław

Wyspiański suddenly come to mind? As he was dying he could no longer hold a paintbrush. That's when he said, "Now I know how to paint." His death seems to me unspeakably awful, the death of a man who felt his unrealized genius within him and knew he could no longer express himself. Today I think of death completely otherwise, as a salvation, as a liberation, as an "enough," neither mystical nor poetical.

By the end of his life, Czapski's days were considerably circumscribed. As Julia Juryś told me, he was "waiting patiently to die." Przyłuki, his childhood home, filled his thoughts, he walked in his mind from room to room, the vestiges of the grand house and its decorations momentarily more vivid to him than the rooms downstairs at Maisons-Laffitte. Dutiful friends appeared to sit with him and read aloud, various generations of nieces and nephews attended to him. When the Romanian philosopher Emil Cioran, a longtime intellectual colleague and fellow exile in Paris, heard about Czapski's declining health, he commented, "It's as if you told me that Jesus was still living. Czapski has been old for the past hundred years!" He wrote directly to Czapski: "Here we are both of us, old. I'm sure, however, that you have not lost your trust in man, no more than I have lost my distrust. But beyond this small disagreement, friendship, unchanging, remains." In her diary, Mavis Gallant described several late encounters with him, noting the gradual decline of his memory. "*How did I meet you? Are you a friend of the Wats?* Then it was, *Are you a friend of . . .* just anyone. Then I faded entirely, name and face." When he could no longer hold a pen, the pages of his diary sat unmarked, mute for the first time.

His very last days were unremarkable. Julia came and checked on him each morning as soon as she arrived for work, and would return to see him through-out the day. Sitting together quietly, they no longer spoke. He was very nearly completely blind. On the morning he died, they listened together to the music of Chopin from a battered audiocassette.

"At one point, when the music was almost over, Józio said exactly two words, and only two words: '*Holde Kunst.*' Nothing else. Just '*Holde Kunst.*' Two words. His last words. With his perfect German pronunciation.

"A few more minutes and the tape was over. Józio's breath was getting shorter and shorter. At this point, I was standing next to him, holding his left hand very strong. His was a strong mountain grip. Not tender but strong.

"At one point, he stopped breathing. The room was silent and calm. Outside,

people went on working as usual. I don't know if anybody was aware Józio had been dying this morning.

"I sat down in his old chair for a long while before going upstairs to Pani Janina [the housekeeper] and then downstairs to Giedroyc, to tell them Józio had died."

German was the affectionate language he and his mother had spoken together when he was a small boy. His last words are from Franz Schubert's song "An die Musik" (To Music). The song opens:

Du holde Kunst, in wieviel grauen Stunden . . .

You, noble Art, in how many gray hours,
When life's mad tumult wraps around me,
Have you kindled my heart to warm love,
Have you transported me into a better world . . .

Józef Czapski died in his room on January 12, 1993. He was ninety-six.

Elżbieta Colin Łubieńska, his sister Róża's daughter, and Janusz Przewłocki, his sister Karla's son, arrived at Maisons-Laffitte and made arrangements for a funeral to be supervised by the community of Pallottine priests dear to Czapski. A coffin had to be specially ordered since his body was too long to fit in any of the ones commercially available nearby. For a time, his body was laid out in its white silk-lined coffin, placed in the corner of his small room by the window where his bed had been, open underneath a long span of groaning shelves whose books continued to stand vigil in his honor, useful and reassuring to the very end. A death mask was made as well as a mold of one of his huge, bony hands. On the day of his interment, several strapping men were brought in to remove Czapski's body from the room he had occupied for so long at the back of the house. Slowly, they navigated a circuitous path along a series of narrow hallways upstairs, carefully making their way down the turning center stairwell lined with Czapski's portraits of his fellow *Kultura* contributors, and out the front door, where a gathering of family and friends stood respectfully on the lawn, sheltered by the crossed branches of towering cedar trees. His body was placed in the back of a flower-filled hearse and driven to the church in the neighboring village where quite a large crowd of friends and admirers was already gathered.

The January day was mild and blustery, the prevailing mood was neither dark nor particularly emotional. A letter of praise from President Wałęsa was read at the church by a representative from the Polish embassy. Following a funeral mass officiated by priests, the casket was taken to the adjoining cemetery for burial in a grave beside Marynia. As prayers and blessings were intoned, cemetery attendants attempted to lower the oversize coffin into an open trench that had been prepared to receive it, but the hole dug by the gravediggers was not long enough. The grave needed to be enlarged; the mourners waited, shuffling and murmuring as the short winter day's light began quickly to fade. The priest and the large group of mourners in attendance reassembled and crowded around the site. Once again the coffin was lifted; once again it would not fit. Altogether this process of digging and moving the coffin was repeated three times. On the fourth attempt, in near darkness, the long remains of Józef Czapski were finally lowered into the grave and covered with earth.

Acknowledgments

More than one presiding spirit hovered over the writing of this book. Like Józef Czapski, my father, Frank Karpeles, was a prisoner of war in the Second World War. The B-17 Flying Fortress he was navigating was shot down after having dropped tons of explosives on German aviation factories during an Allied assault. In the neatly penciled diary he kept as a prisoner he wrote, "This is a period of my life I will never forget or ever wish to remember." At no time later would he speak about these experiences, no doubt hoping to spare his family. What he suppressed may have been kept from surfacing directly, but the choked-back emotion was palpable and irradiated his aura. Despite his intentions, I bear the indelible residue of his suffering; the "black milk of daybreak" flows in my veins, too.

The first time I laid eyes on my father's prison diary was after he died suddenly, at fifty-eight. Like Andrzej Szpilman reading *The Pianist*, his father's account of surviving the Warsaw Ghetto Uprising, I also felt my father's book "revealed to me a part of my own identity." The history of my father's withholding is germane to the understanding of my intense and immediate feeling for Czapski as a subject. Reading his vivid and compassionate record, I was left with a clearer and deeper sense of what my father might have endured. Like my father, Czapski would never forget, but unlike my father, he wished very much to remember. His courageous acts of witness helped bring me closer to an awareness of what my long-grieved-for father had been subjected to and served to bridge a chasm between us.

The process of writing a life can be profoundly isolating at first, but over time it develops into a more sociable, collaborative activity. Many people have been helpful, sharing insights with me, teaching me, encouraging me to bring Czapski to a wider audience, supporting my efforts.

From the start, Wojciech Karpiński offered rare fellowship. Step after

449

Virgilian step, he made things happen, knocking down obstacles as quickly as I could raise them. The gifts he has bestowed on me, indulgently—his knowledge, his aptitude for critical thinking, and his friendship—are really beyond measure. Thanks to him, Julia Juryś and Mikołaj Nowak-Rogoziński agreed to shepherd me over the broad terrain of Czapski's life, which they know so well. As I made my way across an unfamiliar landscape, they lingered patiently nearby, affording me the luxury of making my own discoveries. Passionate and scrupulous guides, all three are more deserving of recognition than the word "acknowledgment" alone can suggest. Mikołaj's devotion has been particularly exhaustive and deeply appreciated.

At the Princes Czartoryski Library of the National Museum in Kraków, Janusz Nowak provided guidance and elucidation. His persistence in deciphering Czapski's densely scribbled volumes has been nothing short of heroic. At the Polish Literary Institute in Maisons-Laffitte, I sat in rooms and wandered around grounds richly imbued with Czapski's presence; Wojciech Sikora and Anna Bernhardt made me feel welcome there. Irena Grudzińska, the late Julia Hartwig, Stanisław Rodziński, Irena and Aleksander Smolar, and Krystyna Zachwatowicz and the late Andrzej Wajda all took time to speak with me about the specific impact Czapski's friendship made on their lives. The brothers Kłoczowski—Piotr in Warsaw, Paweł in Kraków—added degrees of nuance and complexity to my understanding of Czapski the man. Barbara Torunczyk encouraged me in my quest for Czapski and published my introduction in *Zeszyty Literackie*. Over the years, Katarzyna Herbert has made me welcome in her home, and on one memorable afternoon, on the far side of Warsaw, as rain pummeled the windows, I spent several hours with her ailing sister, the late Teresa Dzieduszycka, the woman responsible for much of the translation of Czapski's written work into French. One night, their niece Maria Dzieduszycka, always vivacious, escorted me to a tango party at a cousin's palatial flat in Kraków. Far from the music and the dancing, I stumbled upon some yellowed drawings hanging on a wall: Czapski's views of the New York skyline in 1950. The filmmaker Andrzej Wolski shared his extensive video footage of interviews with Czapski. In Sweden, Lilie and the late Nils Djurklou greeted me warmly. Anka Muhlstein, the daughter of Czapski's friend Anatole, spoke with me in New York. In Paris, Alison Harris, Odile Hellier, Agnès Montenay, Richard Overstreet, and Vitek Tracz buoyed me in my endeavors.

Owners of Czapski paintings opened their doors to me. At Galerie Plexus

in Chexbres, Richard and Barbara Aeschlimann, dealers and collectors with vision and determination, generously accommodated me at every turn. In Paris, Vera Michalski, Paulina Nourissier-Muhlstein, Maria Nowak, and Erik Veaux allowed me to linger with pictures they owned and discussed the meaning of Czapski and his work in their lives. Michael Popiel de Boisgelin heartily granted me access to his collection in Kurozwęki, and Jean-Marc Payot warmly described the integrity of his old friend and shared his works with me. Marko Dimitrijević, the son of Czapski's friend Vladimir, hosted me at his home in Miami, as did Ewa Kitowski, the daughter of Czapski's housekeeper Janina Gąskiewicz, in San Francisco.

When I began to write about Czapski I was largely in the dark about the specifics of Polish history, despite being an avid reader of accounts of upheaval in twentieth-century Europe. Like most Americans I've queried, I was unaware of our country's postwar betrayal of Poland, its ally. The historians Tony Judt and Timothy Snyder shifted the lens of my understanding, deepening my awareness of the very nature of what we call history. Writers Anne Applebaum, Stanisław Barańczak, Anna Bikont, Timothy Garton-Ash, and Jan Gross and Irena Grudzińska-Gross fed my appetite for more knowledge and perspective. When this book reached manuscript stage, Jerzy Borzecki read it with attention to historical detail and offered strategic commentary. Any mistakes of record concerning these complex events and the players involved are my own.

Members of Czapski's large family, both maternal and paternal descendants, shared memories of Uncle Józio. In Kraków, Weronika Orkisz spoke with me in her home, then considerately left me on my own to contemplate paintings made by her great-uncle and by Jean Colin. Her permission to make use of Czapski material is an invaluable gift. In Warsaw, I visited Grzegorz Przewłocki and his mother, the late Elżbieta Przewłocka. Jan Woźniakowski welcomed me to his home and introduced me to his three sons. Róża and Franz Thun were generous with their time, as was Maria Woźniakowska, Czapski's niece and Róża's mother. Henryk Woźniakowski made suggestions about source materials. In Germany, I was invited to call on siblings Amelie, Johannes, and Thomas Thun in their respective homes, to meet their spouses and look at their pictures. I corresponded with Czapski's great-nieces Rula Lenska and Gaba Łubienska-Steele.

An unexpected turn of events resulted in Markus Hoffmann becoming my literary agent; it has been a pleasure to work with him on this and other projects. At New York Review Books, Edwin Frank, with his pitch-perfect literary

sensibility, seemed intuitively to understand the significance of Czapski. Susan Barba offered thoughtful and constructive editorial help. Nick During, Linda Hollick, Katy Homans, and Sara Kramer ably assisted. I'd like to express my appreciation for the considered scrutiny of Joel Coen, Walter Donohue, Dan Frank, Penny Wolfson, and Marek Zagańczyk, careful readers of my text at different stages of development. Additional thanks are due to the late Anna Cienciala, Robert Gottlieb, Joan Henry, Sean LaRiche and Mary White. As I first considered writing about Czapski, Alissa Valles was instrumental in making me believe I stood on sufficiently solid ground to consider undertaking the task. At Claremont-McKenna College, Robert Faggen, the director of the Czesław Miłosz Institute, endorsed my research and named me a fellow. I was fortunate to receive funds from the Swiss-based Fondation Jan Michalski pour l'écriture et la littérature at a critical moment. Those who pitched in to underwrite expenses for various research trips helped to make a significant difference in my travels: Roy and Rose Borrone, Susie Tomkins Buell and Mark Buell, Sophia Collier and Chula Reynolds, Christina Desser and Kirk Marckwald, Jeffrey Fraenkel and Alan Mark, Beverly and Rose Gasner, Harriet Heyman and Michael Moritz, Marty and the late Pamela Krasney, Joseph Lurio, Mimi Mindel, Tim Nelson, and Richard Snyder and Paul Wiseman.

A group of writers I'm privileged to know set a very high professional standard for clarity and integrity, which I have tried to live up to: Douglas Crase, Mark Danner, Alex Finlayson, Jeffrey Harrison, Robert Hass, Brenda Hillman, Michael Ondaatje, Michael Pollan, Francesco Rognoni, Orville Schell, David Sheff, Linda Spalding, and Terry Tempest Williams. Several days spent traipsing about Warsaw and its environs with William and the late Paula Merwin remain vividly etched in my mind. To sustain momentum in order to complete a book project like this over many years, I benefited from the loving care of many individuals near at hand. My heartfelt thanks to Sue Conley and Nan Haynes, Logan Goodman and David Strathairn, Elizabeth Grace, Melinda Griffith and Aenor Sawyer, Peggy Knickerbocker and Robert Fisher, Michael Lerner and Sharyle Patton, Frances McDormand and Joel Coen, Davia Nelson, Joshua Robison and Michael T. Thomas, Jenepher Stowell, Janet Visick, Julie Westcott and David Lahar, and Hanford Woods. Steven Barclay's enthusiasm for this project and his ongoing advocacy have been remarkably consequential on many levels. He is a rare friend.

And, from beginning to end, Mike Sell, without whom…

Notes

Citations for the books mentioned in these endnotes, if not given in full here, can be found in the bibliography that follows.

A Note on Translations

Passages from French texts, including passages from French translations of Polish texts, have been translated by the author, with the sole exception of those from *À la recherche du temps perdu*, which are from the C. K. Scott Moncrieff and Terence Kilmartin translation.

Passages from Czapski's *Na nieludzkiej ziemi* (*Inhuman Land*) were translated by Antonia Lloyd-Jones unless specified as quoted from the French version, *Terre Inhumaine*, which were translated by the author. Lloyd-Jones's translations are from an early, unedited manuscript of the volume forthcoming from NYRB; changes in wording and punctuation are possible. Chapter numbers are provided here for reference.

Czapski's diary entries in Polish and other Polish texts not available in French were translated for the author by Mikołaj Nowak-Rogoziński. Letters written by Józef Czapski, Ludwik Hering, and Zygmunt Mycielski were translated by Maja Łatyńska and Mikołaj Nowak-Rogoziński.

UNDERPAINTING: AN INTRODUCTION

11 *I understood immediately* . . . Zbigniew Herbert, "Still Life with Bridle," in *The Collected Prose: 1948–1998*, 235.

12 *I was too little acquainted* . . . Józef Czapski, *Lost Time: Lectures on Proust in a Soviet Prison Camp*, 12.

13 *I came to understand* . . . Józef Czapski, "Proust w Griazowcu," in *Czytając*, 96.

14 *I could see them* . . . Marcel Proust, *Swann's Way*, in *Remembrance of Things Past*, vol. 1, 771–73.

14 *but in myself* . . . Ibid., 48.

15 *an old man* . . . Mary McCarthy, *Between Friends: The Correspondence of Hannah Arendt and Mary McCarthy*, 199.

16 *was more admired* . . . Wojciech Karpiński, *Portrait de Czapski*, 25.

17 *They were very talented*…Christine Evian and Christine Bertail, *Mavis Gallant on Her Work*, 110.

18 *Kot invited Czapski*…Richard Overstreet, email to the author.

22 *Lonely people*…Michael Gibson, "Odyssey in an Inhuman Land," *International Herald Tribune*, June 1, 1986.

22 *As you draw*…Józef Czapski, diary entry, May 1, 1973, in *L'art et la vie*, 231.

CHAPTER 1

27 *One found among them*…Konstanty Jeleński, "Dział wód," in *Chwile oderwane*, 94.

27 *You've stolen my diamonds*…Piotr Kłoczowski, *Józef Czapski: Świat w moich oczach*, 22.

28 *to make Greeks or Romans*…Maria Czapska, *Une famille d'Europe centrale*, 102.

30 *Shaffnagel's store*…Jerzy Stempowski, "Esej Berdyczowski," in *Od Berdyczowa do Rzymu*, 14.

31 *The first real concert*…Józef Czapski, diary entry, March 29, 1963, in *L'art et la vie*, 196–97.

33 *I survived the February revolution*…Józef Czapski, "Autour de Stanisław Brzozowski," in *Tumulte et spectres*, 256.

34 *When I was young*…Kłoczowski, *Józef Czapski: Świat w moich oczach*, 31.

35 *At the station*…Józef Czapski, *Recit du Voyage par le comte Joseph Czapski dans le but de rechercher le capitaine Bronisław de Romer*, 2.

37 *Come back in twenty*…Wojciech Karpiński, *Portrait de Czapski*, 9.

37 *Twenty years later*…Józef Czapski, unpublished lecture, Harvard University, March 24, 1950.

38 *The two men*…Maria Czapska, *A travers la tourmente*, 91.

39 *Józio, you change your mind*…Ibid., 115.

CHAPTER 2

45 *I recall exactly*…Czapski, "Autour de Stanisław Brzozowski," 257.

46 *A one-man army*…Czesław Miłosz, *The History of Polish Literature*, 379.

46 *I entered the world*…Czapski, "Autour de Stanisław Brzozowski," 258–59.

49 *were my last hope*…Józef Czapski, "Mon Londres," in *L'art et la vie*, 27–28.

51 *Leave it to Picasso*…Józef Czapski, "Le paradis perdu," in *L'Oeil: Essais sur la peinture*, 55.

53 *For the first time*…Czapski, "Mon Londres," 29.

54 *I began to find*…Ibid., 27.

57 *a subtle, select fire* . . . Marcel Proust, "Sonnet Thinking of Daniel Halévy While Noticing Those Who Are Absent," in *The Collected Poems*, 9.

59 *one of those star-shaped* . . . Marcel Proust, *Time Regained*, in *Remembrance of Things Past*, vol. 3, 1084.

59 *Life is perpetually* . . . Ibid., 1086.

59 *I was walking around* . . . Piotr Kłoczowski, *Józef Czapski: Świat w moich oczach*, 88.

59 *I have to confess* . . . Józef Czapski, *Lost Time: Lectures on Proust in a Soviet Prison Camp*, 12.

60 *Some years ago* . . . Józef Czapski, diary entry, June 2, 1965, in *L'art et la vie*, 206.

62 *I never thought* . . . Kłoczowski, *Józef Czapski: Świat w moich oczach*, 104.

62 *at that time* . . . Ibid., 101.

62 *It hardly matters* . . . Ibid., 88.

65 *Even if I had been* . . . Léon-Paul Fargue, introduction in catalogue, Galerie Zak, 1930.

65 *Chère Madame* . . . Józef Czapski, letter to Gertrude Stein, April 18, 1930, Beinecke Rare Book and Manuscript Library, Yale University.

65 *the shock of my life* . . . Józef Czapski, "Le bond et le vol," in *L'art et la vie*, 47.

67 *I think of you two* . . . Józef Czapski, postcard to Gertrude Stein, June 4, 1930, Beinecke Rare Book and Manuscript Library.

68 *the Geneva exhibit* . . . Józef Czapski, postcard to Gertrude Stein, May 29, 1931, ibid.

68 *assurance of drawing* . . . Z. S. Klingsland, "Młody Paryz," in Muzeum Narodowe w Krakówie, *Gry Barwne: Komitet Paryski*, 45.

CHAPTER 3

69 *bearers of elementary* . . . Józef Czapski, "Tło polskie i paryskie," in *Patrząc*, 41.

71 *doesn't understand that* . . . Józef Czapski, "Rewolucja Cézanne'a," ibid., 57.

72 *I was in such a state* . . . Maurice Merleau-Ponty, "Cézanne's Doubt," in *The Merleau-Ponty Reader*, 69.

72 *Will I ever attain* . . . Paul Cézanne, letter to Émile Bernard, September 21, 1906, in "Cézanne's Letters to Emile Bernard" in *The Courtauld Cézannes* (London: Courtauld Gallery, 2008), 164.

73 *They stood together* . . . Józef Czapski, "Matisse et le troglodyte," in *L'art et la vie*, 134.

73 *splashing black around* . . . Józef Czapski, letter to Zbigniew Herbert, November 27, 1977, in *Czapski-Herbert Korespondencja*, 79.

75 *the danger of impressionism* . . . Konrad Winkler, "Malarstwo, Grafika, Metaloplastyka," *Pion*, no. 16 (1938): 237.

78 *the happiest of my life* . . . Czapski, "Tło polskie i paryskie," 16.

78 *Everyone's crazy* . . . Piotr Kłoczowski, *Józef Czapski: Świat w moich oczach*, 104.

CHAPTER 4

88 *Hitler wanted his war* ... Timothy Snyder, *Bloodlands: Europe Between Hitler and Stalin*, 115.

89 *The question of whether* ... Anna M. Cienciala et al., eds., *Katyn: A Crime Without Punishment*, 41.

89 *This night for the* ... William Shirer, *The Rise and Fall of the Third Reich: A History of Nazi Germany*, 599.

90 *In the event of any action* ... House of Commons Debate, 31 March 1939, vol. 345, cc. 2415–20.

90 *We have every interest* ... Halik Kochanski, *The Eagle Unbowed: Poland and the Poles in the Second World War*, 49.

93 *On September 17, 1939* ... Józef Czapski, *Souvenirs de Starobielsk*, 37.

94 *We don't mind* ... Victor Zaslavsky, *Class Cleansing: The Massacre at Katyn*, 8.

95 *the international proletariat* ... Ibid., 9.

95 *Mr. Ambassador!* ... Cienciala et al., eds., *Katyn: A Crime Without Punishment*, 44.

96 *The invasion is not regarded* ... U.S. House, Committee on House Administration, *The Katyn Forest Massacre: Hearings Before the Select Committee*, 1639.

97 *For eighteen days* ... Czapski, *Souvenirs de Starobielsk*, 37.

98 *I myself was captured* ... Ibid., 44.

CHAPTER 5

102 *Pushed to the straining point* ... Józef Czapski, *Souvenirs de Starobielsk*, 50.

103 *Lieutenant Ralski* ... Ibid., 53.

104 *We arrived at Starobielsk* ... Ibid., 55.

108 *We tried to take up* ... Józef Czapski, *Lost Time: Lectures on Proust in a Soviet Prison Camp*, 5.

110 *At the same camp* ... Józef Czapski, *Inhuman Land*, Part 1, chapter 18.

111 *Each of us was exposed* ... Czapski, *Souvenirs de Starobielsk*, 100.

112 *Fever-ridden* ... Bronisław Młynarski, *The 79th Survivor*, 127.

113 *Soon after I arrived* ... Czapski, *Souvenirs de Starobielsk*, 89.

119 *No. 794/B* ... Anna M. Cienciala et al., eds., *Katyn: A Crime Without Punishment*, 118.

124 *more could not be shot* ... Ibid., 124.

125 *My departure was continually* ... Czapski, *Souvenirs de Starobielsk*, 109.

CHAPTER 6

128 *One day as we queued* ... Salomon W. Slowes, *The Road to Katyn*, 96.

130 *I remember reading* ... Józef Czapski, *Souvenirs de Starobielsk*, 99.

130 *I don't think I ever* ... Józef Czapski, "L'URSS 1939–1942," in *L'art et la vie*, 35.

130 *for daily drawing* . . . Ibid., 33.

135 *the essence of Stalinism* . . . Aleksander Wat, *My Century*, 92.

135 *I recall with gratitude* . . . Józef Czapski, "Proust w Griazowcu," in *Czytając*, 97.

136 *I started by reading* . . . Józef Czapski, *Lost Time: Lectures on Proust in a Soviet Prison Camp*, 12.

137 *From those gloomy depths* . . . Ibid., 8.

138 *as if in a coffin* . . . Ibid., xxxi.

138 *the enormous and feverish* . . . Ibid., 67.

139 *we no longer believe* . . . Jean-Paul Sartre, "Introducing *Les Temps modernes*," in *"What Is Literature?" and Other Essays*, 259.

140 *In our canteen* . . . Czapski, "Proust w Griazowcu," 97.

140 *Proust is now enmeshed* . . . Ibid., 96.

140 *To this day* . . . Czapski, "L'URSS 1939–1942," 35.

141 *clearing out the prisons* . . . Anna M. Cienciala et al., eds., *Katyn: A Crime Without Punishment*, 37.

141 *believe a military clash* . . . Ibid., 276.

141 *capable, effective* . . . George Sanford, *Katyn and the Soviet Massacre of 1940*, 118.

142 *We made a big mistake* . . . Cienciala et al., eds., *Katyn: A Crime Without Punishment*, 208.

146 *As soon as I got out* . . . Władysław Anders, *An Army in Exile*, 43.

146 *On a sunny, misty* . . . Józef Czapski, *Inhuman Land*, Part 1, chapter 1.

CHAPTER 7

148 *We set off in fours* . . . Józef Czapski, *Inhuman Land*, Part 1, chapter 1.

151 *That these men would* . . . Józef Czapski, *Terre Inhumaine*, 29.

153 *The embassy had* . . . Czapski, *Inhuman Land*, Part 1, chapter 10.

154 *Polish soldiers fight better* . . . Anna M. Cienciala et al., eds., *Katyn: A Crime Without Punishment*, 294.

154 *We have traces* . . . Joseph Mackiewicz, *The Katyn Wood Murders*, 83.

155 *sent to the disposition* . . . Cienciala et al., eds., *Katyn: A Crime Without Punishment*, 286.

155 *It was crucial* . . . Czapski, *Inhuman Land*, Part 1, chapter 9.

157 *As for those nights* . . . Ibid., Part 1, chapter 10.

158 *The British behaved* . . . Ibid.

159 *Sitting at table* . . . Ibid.

160 *I refused to believe* . . . Ibid., Part 1, chapter 11.

160 *My view of the prevailing* . . . Ibid.

161 *In expanding our army* . . . Ibid.

161 *At every step* . . . Ibid.

161 *There is not the slightest*...Eugenia Maresch, *Katyn, 1940*, 19.

162 *So now I had a right*...Czapski, *Inhuman Land*, Part 1, chapter 11.

165 *The cut-off phone call*...Ibid.

CHAPTER 8

167 *A painter has to start*...Józef Czapski, "Les interruptions du travail," in *L'art et la vie*, 43.

167 *I don't see how*...Józef Czapski, "Le bond et le vol," in *L'art et la vie*, 45.

168 *The moment arrives*...Józef Czapski, "La vision et la contemplation," ibid., 49.

168 *The quicker a painter learns humility*...Józef Czapski, "Les interruptions du travail," ibid., 43.

169 *I only begin to exist*...Józef Czapski, letter to Ludwik Hering, January 25–31, 1957 in Józef Czapski and Ludwik Hering, *Listy 1939–1982*, vol. 1, 250–255.

169 *He had no idea*...Józef Czapski, *Inhuman Land*, Part 1, chapter 18.

172 *People still kept reaching*...Władysław Anders, *An Army in Exile*, 95.

189 *Either I could save*...Ibid., 102.

190 *It was only at Yangiyul*...Józef Czapski, *Terre Inhumaine*, 124.

190 *I've glanced through*...Józef Czapski, unpublished diary entry, March 24, 1942.

192 *At about ten*...Czapski, *Inhuman Land*, Part 1, chapter 17.

192 *Akhmatova was sitting*...Ibid.

192 *I realized what a hunger*...Ibid.

193 *In a strange sort of chant*...Ibid.

193 *Betrayed, tormented*...Joseph Brodsky, "The Keening Muse," in *Less Than One: Selected Essays*, 40.

194 *I've kissed the boots*...Józef Czapski, diary entry, 1967, in *L'art et la vie*, 215.

194 *Now I see why*...Adam Zagajewski, "Toil and Flame," in *A Defense of Ardor*, 91.

194 *I was eager*...Czapski, *Inhuman Land*, Part 1, chapter 17.

195 *But at the last moment*...Ibid.

195 *Evening came*...Ibid.

196 *once again that rare*...Ibid.

196 *I read the poetry*...Ibid.

197 *We left behind us*...Anders, *An Army in Exile*, 116.

CHAPTER 9

199 *What most struck me*...Józef Czapski, *Inhuman Land*, Part 1, chapter 26.

199 *In a hotel bedroom*...Ibid., Part 1, chapter 27.

200 *The hospital was the only place*...Gustaw Herling, *A World Apart*, 103.

201 *Like most Poles*...Władysław Anders, *An Army in Exile*, 141.

201 *Why was it then*...Czapski, *Inhuman Land*, Part 1, chapter 27.

203 *The discovery of Katyn*...Ibid., Part 2, chapter 1.

203 *In the past two or three days*...Anna M. Cienciala et al., eds., *Katyn: A Crime Without Punishment*, 306.

204 *So far this business*...Allen Paul, *Katyn: Stalin's Massacre and the Triumph of Truth*, 229.

205 *We may, it seems to me*...Ibid., 228.

206 *The dead cannot*...Eugenia Maresch, *Katyn, 1940*, 147.

206 *The men who were taken*...Owen O'Malley, *Katyn: Despatches of Sir Owen O'Malley to the British Government*, Polish Cultural Foundation.

207 *it was of no more substantial*...Owen O'Malley, *The Phantom Caravan*, 228.

209 *I know you will not mind*...Susan Butler, ed., *My Dear Mr. Stalin: The Complete Correspondence of Franklin D. Roosevelt and Joseph V. Stalin*, 63.

211 *Now I was seeing him*...Czapski, *Inhuman Land*, Part 1, chapter 6.

213 *Sikorski's loss is a major blow*...Harold Nicolson, *Diaries and Letters 1939–1945*, 303.

213 *I even imagined*...Edward Raczyński, *In Allied London: The Wartime Diaries of the Polish Ambassador*, 149.

215 *My hand is uncertain*...Józef Czapski, unpublished diary entry, December 20, 1942.

CHAPTER 10

218 *I have thought over*...Władysław Anders, *An Army in Exile*, 155.

220 *every last scrap*...Józef Czapski, *Inhuman Land*, Part 2, chapter 3.

221 *is the experience*...Józef Czapski, unpublished diary entry, 1944.

222 *I reproach myself*...André Gide, "Rencontre à Sorrente," magazine excerpt in Józef Czapski's journal, September 24, 1944.

223 *All the Poles talk*...Martha Gellhorn, unpublished 1944 article for *Collier's Weekly*.

227 *This letter, in which*...Gustaw Herling, introduction, in Józef Czapski, *Souvenirs de Starobielsk*, 26.

CHAPTER 11

233 *I've never met*...Józef Czapski, *Inhuman Land*, Part 2, chapter 4.

234 *In 1945, after an absence*...Józef Czapski, "Tombes ou trésors," in *Tumulte et spectres*, 32.

235 *lived by a Pole*...Gustaw Herling, introduction, in Józef Czapski, *Souvenirs de Starobielsk*, 27.

236 *symbol of defeated France*...Nicola Chiaromonte, *The Worm of Consciousness and Other Essays*, 53.

236 *For a period*...Tony Judt, *Past Imperfect: French Intellectuals, 1944–1956*, 1.

237 *The allure of Stalin*...Józef Czapski, "Malraux," in *Tumulte et spectres*, 324.

237 *Sitting one morning* . . . Ibid.

237 *an anti-communist is a rat* . . . Annie Cohen-Solal, *Sartre: A Life*, 328.

238 *A heartrending characteristic* . . . Czesław Miłosz, *Miłosz's ABC's*, 270–71.

238 *I would have had to be* . . . Józef Czapski, "Maritain, avait-il raison?" in *Tumulte et spectres*, 68.

239 *I later visited him* . . . Czapski, "Malraux," 323.

239 *It wasn't in Tehran* . . . Józef Czapski, "Sur Fond Parisien," in *L'art et la vie*, 53.

242 *flung themselves* . . . George Orwell, letter to Roger Senhouse, March 17, 1945, in Peter Davison, *George Orwell: A Life in Letters*, 246.

242 *Dear Arthur* . . . George Orwell, letter to Arthur Koestler, ibid., 291.

245 *every attentive reader* . . . Józef Czapski, "Dwadzieścia pięć lat," *Kultura*, no. 12/303 (1972): 7–8.

246 *The first impression* . . . Józef Czapski, "Le paradis perdu," in *L'Oeil: Essais sur la peinture*, 60.

246 *Bonnard and Pankiewicz met* . . . Ibid., 57.

247 *a higher mathematics* . . . Czapski, "Mon Londres," in *L'art et la vie*, 31.

247 *Bonnard impoverished* . . . Ibid., 63.

247 *Abstract painting will* . . . Ibid., 60.

247 *there is no such thing* . . . Józef Czapski, "L'abstraction: le pour et le contre," *L'Oeil: Essais sur la peinture*, 83.

247 *A very small Bonnard* . . . Czapski, "Le paradis perdu," 59.

248 *in the spring* . . . Jan Lechoń, "Herostrates," in *Karmazynowy poemat* (Warsaw: J. Mortkowicza, 1920), 5.

248 *The new "proletarian" Poland* . . . Witold Gombrowicz, *Walka o sławę*, vol. I (Kraków: Wydawnictwo Literackie, 1996), 48–49.

248 *In the time of a free Poland* . . . Czapski, "Le paradis perdu," 67.

250 *"Hubert" makes my writing* . . . Józef Czapski, letter to Ludwik Hering, February 21, 1946 in Józef Czapski and Ludwik Hering, *Listy 1939–1982*, vol. 1, 35–39.

CHAPTER 12

252 *The existence of this Major Czapski* . . . *L'Humanité*, April 1947.

253 *In 1945, upon my arrival* . . . Józef Czapski, "Malraux," in *Tumulte et spectres*, 324.

253 *Dear Friends* . . . Ibid., 325.

254 *A rented pavillon* . . . Czesław Miłosz, "Zygmunt Hertz," *To Begin Where I Am: Selected Essays*, 172, 175.

255 *If only you knew* . . . Józef Czapski, letter to Ludwik Hering, October 10, 1947, in Józef Czapski and Ludwik Hering, *Listy 1939–1982*, vol. 1, 62.

255 *I haven't been free* . . . Ludwik Hering, letter to Józef Czapski, August 23, 1948, in Józef Czapski and Ludwik Hering, *Listy 1939–1982*, vol. 1, 105.

256 *told me in his deep voice* ... Hering, letter to Czapski, November 25, 1947, in Józef Czapski and Ludwik Hering, *Listy 1939–1982,* vol. 1, 69.

256 *Sacrifice is the acceptance* ... Simone Pétrement, *Simone Weil: A Life,* 37.

258 *SW tries to show* ... Józef Czapski, diary entry, January 13, 1970, in *Wyrwane strony* (Warsaw: Zeszyty Literackie, 2010), 189.

258 *Absolutely unmixed attention* ... Simone Weil, *Gravity and Grace,* 106.

258 *The imagination is continually* ... Ibid., 16, xxxiii.

259 *The imagination, filler up* ... Ibid., 16, 58.

259 *that transcendent realm* ... Simone Weil, *Waiting for God,* 64.

260 *It's not in the name* ... Czapski, *Lost Time: Lectures on Proust in a Soviet Prison Camp,* 57.

261 *Painting is inside me* ... Czapski, letter to Hering, October 8, 1947, in Józef Czapski and Ludwik Hering, *Listy 1939–1982,* vol. 1, 59–67.

261 *It is not my intention* ... Czesław Miłosz, *Native Realm: A Search for Self-Definition,* 203.

261 *Damn you....* Czapski, letter to Hering, October 10, 1947, in Józef Czapski and Ludwik Hering, *Listy 1939–1982,* vol. 1, 66.

261 *Malraux sent my manuscript* ... Czapski, "Malraux," 323.

262 *Within a week's time* ... Ibid.

265 *Another day* ... Józef Czapski, "Tombes ou trésors," in *Tumulte et spectres,* 29.

266 *This soldier of the army* ... François Mauriac, review of *Terre Inhumaine, Le Figaro,* April 4, 1949.

267 *I've come to Warsaw* ... Hering, letter to Czapski, September 13, 1949, in Józef Czapski and Ludwik Hering, *Listy 1939–1982,* vol. 1, 143.

267 *I sometimes think that man* ... Józef Czapski, "In a Whisper," *Kultura* (June 1949).

268 *I've not held oil paints* ... Czapski, letter to Hering, July 18, 1949, in Józef Czapski and Ludwik Hering, *Listy 1939–1982,* vol. 1, 126.

269 *I, too, can remember* ... Czapski, letter to Hering, September 14, 1949, in Józef Czapski and Ludwik Hering, *Listy 1939–1982,* vol. 1, 138.

CHAPTER 13

271 *In the course of a single year* ... Józef Czapski, "The Russian Man; Before and After the Revolution," unpublished lecture, Harvard University, March 24, 1950.

272 *the people in the streets* ... Czesław Miłosz, *Native Realm: A Search for Self-Definition,* 265.

272 *I simply could not stand* ... Andrzej Franaszek, *Miłosz: A Biography,* 284.

273 *I don't know of another* ... Józef Czapski, "Presque le paradis," in *Tumulte et spectres,* 73.

275 *Why bother working* ... Józef Czapski, "L'Autre Rive *et souvenirs personnels,*" ibid., 232.

275 *It's a sham for Rudnicki* . . . Jan Lechoń, diary entry, June 26, 1950, in *Dziennik*, vol. 1, 332.

275 *At 5:14 p.m.* Józef Czapski, "Les sonnettes," in *Tumulte et spectres*, 123.

276 *Obviously I'm only describing* . . . Ibid., 126.

277 *Or maybe* . . . Ibid., 127.

277 *Only a gaze* . . . Ibid., 130.

278 *In a quarter of an hour* . . . Ibid., 131.

278 *The purpose of this event* . . . Józef Czapski, "La petite glace noire," in *Tumulte et spectres*, 86.

279 *I've seen these faces* . . . Ibid., 90.

280 *Arthur speaks Polish* . . . Józef Czapski, "It is our custom," in *Tumulte et spectres*, 135.

280 *God, you're tiresome* . . . Ibid.

281 *All that I know about Poland* . . . Ibid., 139.

282 *You know that my medical studies* . . . Ibid., 143.

282 *It is the victors* . . . Józef Czapski, "La chaîne invisible," in *Tumulte et spectres*, 99.

283 *We in Europe* . . . Czapski, "It is our custom," 136.

283 *I went to visit* . . . Ibid., 138.

284 *Each atom bomb* . . . Józcf Czapski, from "Biada urzędnikom," in *Kultura*, 1950, no. 7–8, 10.

286 *We may be indignant* . . . Tony Judt, *Past Imperfect: French Intellectuals, 1944–1956*, 115.

287 *They invited me* . . . Adam Michnik, *Letters from Freedom*, 205.

288 *I have rejected* . . . Sacvan Bercovitch, gen. ed., *The Cambridge History of American Literature*, vol. 8: *Poetry and Criticism 1940–1995* (Cambridge, UK: Cambridge University Press, 1996), 243.

288 *One must keep silent* . . . Czesław Miłosz, *The Captive Mind*, 57, 60.

289 *All we can do* . . . Harold Nicolson, "Eyes Wide Open," *The Observer*, August 5, 1951.

290 *Russia is the most centralized* . . . Józef Czapski testimony, in U.S. House, Committee on House Administration, *The Katyn Forest Massacre: Hearings Before the Select Committee.*

CHAPTER 14

295 *a kind of humanity* . . . Jeanne Hersch, "L'éclairer l'obscur," Musée Jenisch catalogue, 14.

296 *How is it that Czapski* . . . Daniel Halévy, introduction, Galerie Motte exhibition catalogue.

296 *What a lot of stories* . . . Ibid.

296 *hand it over to Polish writers* . . . Albert Camus and André Malraux, *Correspondance (1941–1959)*, 64.

296 *I wouldn't worry* ... Albert Camus, unpublished letter to Józef Czapski, 1951.

297 *The reactions are odd* ... Józef Czapski, letter to Ludwik Hering, December 4, 1952, in Józef Czapski and Ludwik Hering, *Listy 1939–1982*, vol. 1, 176.

300 *I should never have gone* ... Józef Czapski, unpublished letter to Stanisław Rodziński, 1979.

300 *What's most elevated* ... Józef Czapski, diary entry, January 30, 1963, in *L'art et la vie*, 92.

300 *I can only compare* ... Czapski, diary entry, February 13, 1973, ibid., 227.

300 *A muffled shock* ... Józef Czapski, letter to Czesław Miłosz, August 1, 1963, in Karpiński, *Portrait de Czapski*, 188.

301 *Perhaps the immobility* ... Marcel Proust, *Swann's Way*, in *Remembrance of Things Past*, vol. 1, 6.

301 *my eye's sensitivity* ... Józef Czapski, "La rapidité et la qualité du travail," in *L'art et la vie*, 39.

302 *foreshadows all modern art* ... André Malraux, *Les voix du silence*, 97.

303 *the light are bound* ... Hugo von Hofmannsthal, "Manche freilich," translated by Scott Horton, *Harper's Magazine* (November 10, 2007).

304 *is a form of prayer* ... Czapski, diary entry, May 8, 1979, in *L'art et la vie*, 235.

304 *What is vision?.* ... Czapski, "La vision et la contemplation," ibid., 49.

304 *Because of our shared love* ... Kot Jeleński, letter to Czapski, *Listy z Korsyki*, 5.

305 *Everything that is good* ... Jeleński, letter to Czapski, *Listy z Korsyki*, 16, summer 1953.

306 *I want to tell you* ... Jeleński, letter to Czapski, *Listy z Korsyki*, 11, August 26, 1952.

306 *truly a gorgeous man* ... Czesław Miłosz, "Leonor Fini," translated by Anthony Miłosz, *Brick*, no. 87 (Summer 2011).

307 *I don't know if you understand* ... Jeleński, letter to Czapski, *Listy z Korsyki*, 16, summer 1953.

308 *Your Christianity* ... Jeleński, letter to Czapski, *Listy z Korsyki*, 9–10, July 22, 1952.

308 *Joseph, my love* ... Catherine Djurklou, unpublished letter to Józef Czapski, undated.

309 *Could you be a darling* ... Djurklou, unpublished letter to Czapski, January 30, 1958.

309 *Dearest Joseph, I don't like* ... Djurklou, unpublished letter to Czapski, undated.

309 *We met every year* ... Piotr Kłoczowski, *Józef Czapski: Świat w moich oczach*, 109.

309 *It's always the same!* ... Czapski, diary entry, October 24, 1961, in *L'art et la vie*, 187.

310 *profound confrontation* ... Józef Czapski, "Malraux et *Les voix du silence*," in *L'Oeil: Essais sur la peinture*, 66.

311 *Abstraction seems more* ... Czapski, diary entry, June 13, 1965, in *L'art et la vie*, 209.

312 *One of the central themes* ... Czapski, "Malraux et *Les voix du silence*," 72.

313 *a lustful relation*...Mark Rothko, "Address to Pratt Institute, 1958," in *Writings on Art*, 125.

313 *It would be better perhaps*...Czapski, "Malraux et *Les voix du silence*," 74.

313 *A French writer said*...Czapski, letter to Hering, May 1953, in Józef Czapski and Ludwik Hering, *Listy 1939–1982*, vol. 1, 184.

314 *Painting for me*...Józef Czapski, letter to André Malraux, in Murielle Werner-Gagnebin, *La main et l'espace*, 122.

CHAPTER 15

316 *I don't like cruise ships*...Józef Czapski, "Tumulte et spectres," in *Tumulte et spectres*, 159.

318 *I do not conceal*...Witold Gombrowicz, *Diary*, 627.

318 *The more one knows*...Ibid., diary entry, October 30, 1966.

318 *how to transform*...Czesław Miłosz, *The History of Polish Literature*, 434.

319 *After* Ferdydurke...Rita Gombrowicz, *Gombrowicz en Europe*, (Paris: Denoël, 1988), 19.

321 *like the retired head*...Adam Zagajewski, "Toil and Flame," in *A Defense of Ardor*, 69.

322 *Your work*...Ludwik Hering, letter to Józef Czapski, July 17, 1957, in Józef Czapski and Ludwik Hering, *Listy 1939–1982*, vol. 1, 276.

322 *News that my paintings*...Józef Czapski, letter to Krystyna Zachwatowicz and Andrzej Wajda, March 2, 1987, *Zeszyty Literackie*, no. 132, Winter 2015.

322 *Who among us*...Henri-Frédéric Amiel, diary entry, April 26, 1852, in *Journal Intime*.

322 *At some moment*...Józef Czapski, introduction to exhibition catalogue, National Museum in Poznań, June–July 1957.

323 *It's hard to find*...Czapski, letter to Hering, October 11, 1953, in Józef Czapski and Ludwik Hering, *Listy 1939–1982*, vol. 1, 187–188.

325 *Often, seeing the paintings*...Jean Colin, May 10, 1956, in *Journal*, 99.

326 *you know, it's not so hard*...Vincent Guillier, *Jean Colin d'Amiens ou le jeune homme et la mort*, 70.

330 *when the Lord built*...Zbigniew Herbert, "In the Studio," in *The Collected Poems: 1956–1998*, 160.

331 *Though I have stared*...Zbigniew Herbert, "Lascaux," ibid., 13.

CHAPTER 16

335 *Among the books*...Jerzy Stempowski, "La bibliothèque des contrabandiers," in *Essais pour Cassandre*, 133.

335 *In the time of the Renaissance* ... Ibid., 147.

336 *the whisper of the pentameter* ... Ibid.

341 *The effort made by Elstir* ... Marcel Proust, *Within a Budding Grove*, in *Remembrance of Things Past*, vol. 1, 898.

345 *My personal library* ... Józef Czapski, diary entry, June 23, 1965, in *L'art et la vie*, 220.

CHAPTER 17

353 *The "eye" of the title* ... Kot Jeleński, introduction, Galerie Lambert exhibition catalogue, Paris, 1974.

354 *This text speaks* ... Józef Czapski, "L'abstraction: le pour et le contre," in *L'Oeil: Essais sur la peinture*, 81n1, 81, 88.

355 *An irrepressible current* ... Józef Czapski, "Un courant irrépressible," in *L'art et la vie*, 115, 116.

356 *Rich, he acted* ... Ibid., 120.

358 *I don't believe Czapski* ... Konstanty A. Jeleński, "Czyste malarstwo czy poetyka," in *Chwile oderwane*, 190–191.

358 *Can one arrive* ... Józef Czapski, "L'URSS 1939–1942," in *L'art et la vie*, 34.

358 *subjugates art* ... Jeleński, "Czyste malarstwo czy poetyka," 192.

358 *between the abstract perfection* ... Józef Czapski, "Rewolucja Cézanne'a," in *Patrząc*, 57.

358 *If, by the mystery* ... Michael Doran, *Conversations with Cézanne*, 123.

358 *As I see it* ... Jeleński, "Czyste malarstwo czy poetyka," 191–192.

358 *indistinguishable from* ... Ibid.

359 *If art must suffice* ... Józef Czapski, "Malraux et *Les voix du silence*," in *L'Oeil: Essais sur la peinture*, 77.

360 *An unexpected phone call* ... Józef Czapski, diary entry, June 20, 1965, in *L'art et la vie*, 211.

362 *Whoever meets Czapski* ... Wojciech Karpiński, *Ces livres de grand chemin*, 71.

365 *All her poems have* ... Randall Jarrell, "Poets," in *Poetry and the Age* (London: Faber and Faber, 1996), 206.

367 *Dear sir, Your entirely unexpected* ... Konstanty A. Jeleński, *Cahier Gombrowicz*, 355–358.

371 *My entire life* ... Witold Gombrowicz, *Diary*, 737.

CHAPTER 18

379 *For Czapski* ... Jacek Woźniakowski, "Józef Czapski," in *Pisma Wybrane*, vol. VI, 217.

379 *Moments of happiness?*...Józef Czapski, diary entry, March 29, 1963, in *Wyrwane strony* (Warsaw: Les Éditions Noir sur Blanc, 1993), 49.

385 *that because of him*...Felix A. Baumann and Poul Erik Tojner, *Cézanne and Giacometti: Paths of Doubt*, 157.

388 *We often spoke about*...Nils Djurklou, unpublished letter to Józef Czapski, January 22, 1978.

CHAPTER 19

389 *I had my first conversation*...Józef Czapski, diary entry, 1967, in *L'art et la vie*, 214.

389 *I don't doubt*...Ibid.

390 *According to Nadezhda Mandelstam*...Ibid., 215n1.

390 *From the Cycle*...Anna Akhmatova, *The Complete Poems of Anna Akhmatova*, vol. II, 293.

392 *few of Akhmatova's contemporaries*...Victor Erlich, *Child of a Turbulent Century*, 185.

392 *How grateful I*...Czapski, diary entry, 1967, in *L'art et la vie*, 215.

393 *When I came back to Paris*...Wojciech Karpiński, email to author.

396 *Czapski never mentioned*...Eric Werner, *Portrait d'Eric*, 32.

397 *You've always been solitary*...Józef Czapski, letter to Ludwik Hering, February 21, 1946, in Józef Czapski and Ludwik Hering, *Listy 1939–1982,* vol. 1, 38.

399 *After a day of hard work*...Józef Czapski, diary entry, June 24, 1965, in *Wyrwane strony* (Warsaw: Les Éditions Noir sur Blanc, 1993), 100.

403 *The closest people*...Czapski, letter to Hering, September 21, 1978, in Józef Czapski and Ludwik Hering, *Listy 1939–1982,* vol. 2, 270.

404 *What you write*...Kot Jeleński, letter to Józef Czapski, June 27, 1975, in *Listy z Korsyki*, 47.

408 *I will start to work*...Józef Czapski, unpublished diary entry, 1977.

CHAPTER 20

409 *The house of* Kultura...Czesław Miłosz, "Zygmunt Hertz," *To Begin Where I Am: Selected Essays*, 179.

410 *the work of a painter*...Józef Czapski, unpublished diary fragment, May 13, 1942.

410 *The expression of solitude*...Józef Czapski, unpublished letter to Richard Aeschlimann, undated.

411 *He was known*...Józef Czapski, "De Staël," in *L'art et la vie*, 159.

412 *Marynia died the day*...Józef Czapski, letter to Ludwik Hering, June 15, 1981, in Józef Czapski and Ludwik Hering, *Listy 1939–1982,* vol. 2, 281–282.

413 *Yes, yes—you have*...Józef Czapski, unpublished diary fragment, May 27, 1977.

413 *Don't be cross with me* ... Kot Jeleński, letter to Józef Czapski, September 16, 1981, in *Listy z Korsyki*, 55–56.

414 *reach the point where* ... Adam Zagajewski, "Toil and Flame," in *A Defense of Ardor*, 94.

417 *God made everything* ... Paul Valéry, *Mauvaises pensées et autres*, in *Œuvres*, vol. II, 907.

418 *With the most primitive* ... Kazimir Malevich, "Suprematism," in *Manifesto: A Century of Isms*, edited by Mary Ann Caws (Lincoln: University of Nebraska Press), 408.

422 *We seem to know* ... Adam Michnik, "Czytając," in *Polskie pytania*, 42–43.

422 *Just as I was being* ... Ibid, 75–76.

CHAPTER 21

424 *Czapski's paintings bring* ... Czesław Miłosz, *A Year of the Hunter*, 255.

424 *We do not know anything* ... Józef Czapski, letter to Czesław Miłosz, in Czesław Miłosz, *Unattainable Earth*, 118.

424 *If only you do not try* ... Ludwig Wittgenstein, letter to Paul Englemann, April 9, 1917, in *Letters from Ludwig Wittgenstein with a Memoir* (Oxford: Blackwell, 1968), 6–7.

424 *I feed upon quotations* ... Miłosz, *Unattainable Earth*, 117–18.

425 *refused old age* ... Adam Zagajewski, "Toil and Flame," in *A Defense of Ardor*, 68.

425 *The actress playing Weil* ... Ibid., 86.

425 *He was pleased with this* ... Adam Zagajewski, email to the author.

426 *your clear-cut face* ... Adam Zagajewski, "Van Gogh's Face," *Without End: New and Selected Poems*, 99.

427 *connected us and separated us* ... Józef Czapski, unpublished diary fragment, December 1984.

427 *He had organized it all* ... Ibid., December 1984–January 1985.

427 *I crossed out* ... Ibid., October 9, 1985.

428 *notre sénilité bavarde* ... Marcel Proust, *Albertine disparue*, in *À la recherche du temps perdu*, vol. IV, 174.

428 *As far as my painting* ... Józef Czapski, unpublished letter to Richard Aeschlimann, undated.

429 *I came down with the flu* ... Józef Czapski, letter to Zygmunt Mycielski, February 6, 1985, in "Kamerton," 2013, no. 57, 34–35.

430 *Dear friends* ... Czapski, unpublished letter to Aeschlimann, undated.

431 *among the works* ... Józef Czapski, "The Death of Cézanne," *Kultura* (1985).

431 *Cézanne is unimaginable* ... Józef Czapski, "Monet des années après," in *L'art et la vie*, 173.

432 *As for writing*...Czapski, letter to Zygmunt Mycielski, February 6, 1985, in "Kamerton," 2013, no. 57, 36.

432 *On another occasion*...Wojciech Karpiński, *Portrait de Czapski*, 81.

434 *Do you know this story?*...Czapski, letter to Zygmunt Mycielski, September 27, 1985, in "Kamerton," 2013, no. 57, 42.

434 *A greenish-black sea*...Józef Czapski, "Pensées sans conclusion," in *L'art et la vie*, 177.

435 *The power of subjectivity*...Edward W. Said, *On Late Style: Music and Literature Against the Grain* (New York: Vintage, 2007), 9.

436 *In what is unequivocally called*...Wladimir Weidlé, "Abstraction et Construction," in *Les Abeilles d'Aristée*, 192.

436 *One finds man in a peach*...Ibid., 193.

437 *is the forever mute part*...Willem de Kooning, "What Abstract Art Means to Me," in Willem de Kooning and Harold Rosenberg, *De Kooning* (New York: Harry N. Abrams, Inc., 1974), 143.

438 *A number of times*...Józef Czapski, letter to Zbigniew Herbert, June 2, 1986, in Józef Czapski and Zbigniew Herbert, *Korespondencja*, 97–98.

439 *In the past days I had*...Czapski, letter to Zygmunt Mycielski, February 20, 1987, in "Kamerton," 2013, no. 57, 82.

439 *Do you believe that*...Józef Czapski, unpublished diary fragment, May 5, 1987.

440 *I don't understand*...Czesław Miłosz, *A Year of the Hunter*, 253.

441 *The archival materials*...TASS communiqué in Anna M. Cienciala et al., eds., *Katyn: A Crime Without Punishment*, 345.

442 *How strange it is*...Józef Czapski, letter to Natalia Lebedeva in *Zeszyty Literackie*, 1995, no. 50, 124.

442 *It wasn't the case*...Karpiński, *Portrait de Czapski*, 73.

442 *The subject is very interesting*...Unpublished transcript of conversations between Andrzej Wajda and Andrzej Wolski.

443 *I wish to say a few words*...Andrzej Wajda, film screenplay for *Katyn*, 36.

443 *He was above all*...Karpiński, *Portrait de Czapski*, 161.

444 *as if there was no break*...Józef Czapski, diary entry, May 1, 1973, in *L'art et la vie*, 231.

444 *On meurt seul*...Józef Czapski diary, Muzeum Narodowe w Krakowie inventory, #2179.

444 *Wednesday*...Józef Czapski, diary entry, May 16, 1979, in *L'art et la vie*, 238.

445 *It's as if you told me*...Benjamin Ivry, "Searching for Pain and Painting for Pleasure," *The European* (September 7–9, 1990).

445 *Here we are*...Emil Cioran, unpublished letter to Józef Czapski.

445 *How did I meet you?*...Mavis Gallant, unpublished diary excerpt, 1993.

Selected Bibliography

Abarinov, Vladimir. *The Murderers of Katyn*. New York: Hippocrene Books, Inc., 1993.

Aeschlimann, Richard. *Czapski: Moments partagés*. Lausanne: Éditions L'Âge d'Homme, 2010.

Akhmatova, Anna. *The Complete Poems of Anna Akhmatova*. Two vols. Translated by Judith Hemschemeyer. Boston: The Zephyr Press, 1989.

Amiel, Henri-Frédéric. *Journal Intime*. Translated by Mrs. Humphry Ward. New York: Brentano's, 1928.

Anders, Władysław. *An Army in Exile*. London: Macmillan & Co., Ltd, 1949.

Anderson, Nancy K. *Anna Akhmatova: The Word That Causes Death's Defeat*. New Haven, CT: Yale University Press, 2004.

Applebaum, Anne. *Gulag: A History*. New York: Doubleday Anchor, 2004.

———. *Iron Curtain: The Crushing of Eastern Europe, 1944–1956*. New York: Doubleday, 2012.

Baumann, Felix A., and Poul Erik Tojner. *Cézanne and Giacometti: Paths of Doubt*. Berlin: Hatje Cantz, 2008.

Benjamin, Walter. *Illuminations*. Translated by Harry Zohn. New York: Schocken Books, 1968.

Berberova, Nina. *The Italics Are Mine*. New York: Knopf, 1991.

Besançon, Alain. *The Forbidden Image: An Intellectual History of Iconoclasm*. Translated by Jane Marie Todd. Chicago: The University of Chicago Press, 2000.

Boleslavski, Richard. *Lances Down*. Garden City, NY: Garden City Publishing Company, 1952.

Botsford, Keith. *Józef Czapski: A Life in Translation*. Lewes, England: The Cahier Series, 2009.

Brodsky, Joseph. *Less Than One: Selected Essays*. New York: Farrar, Straus and Giroux, 1986.

———. *A Part of Speech*. New York: Noonday Press, 1980.

Bromke, Adam. *Poland's Politics: Idealism vs. Realism*. Cambridge, MA: Harvard University Press, 1967.

Butler, Susan, ed. *My Dear Mr. Stalin: The Complete Correspondence of Franklin D. Roosevelt and Joseph V. Stalin*. New Haven, CT: Yale University Press, 2005.

Camus, Albert, and André Malraux. *Correspondance (1941–1959)*. Edited by Sophie Doudet. Paris: Gallimard, 2016.

Cataluccio, Francesco M. *Je m'en vais voir la-bas si c'est mieux*. Lausanne: Les Éditions Noir sur Blanc, 2014.

Chiaromonte, Nicola. *The Worm of Consciousness and Other Essays*. New York: Harcourt Brace Jovanovich, 1976.

Ciechanowski, Jan. *Defeat in Victory*. New York: Doubleday & Company, 1947.

————. *The Warsaw Uprising of 1944*. Cambridge, MA: Cambridge University Press, 1974.

Cienciala, Anna M., Natalia S. Lebedeva, and Wojciech Materski, eds. *Katyn: A Crime Without Punishment*. New Haven, CT: Yale University Press, 2007.

Cohen-Solal, Annie. *Sartre: A Life*. New York: Pantheon, 1988.

Coleman, Peter. *The Liberal Conspiracy: The Congress for Cultural Freedom and the Struggle for the Mind of Postwar Europe*. New York: The Free Press, 1989.

Colin, Jean. *Jean Colin d'Amiens*. Paris: Librairie de Marignan, 1961.

————. *Journal de Jean Colin d'Amiens*. Paris: Éditions du Seuil, 1968.

Conquest, Robert. *Reflections on a Ravaged Century*. New York: W. W. Norton & Co., 2000.

Czapska, Maria. *A travers la tourmente*. Lausanne: L'Âge d'Homme, 1980.

————. *Une famille d'Europe centrale*. Paris: Plon, 1972.

Czapski, Józef. *Czytając*. Kraków: Znak, 2015.

————. *Inhuman Land: Searching for the Truth in Soviet Russia, 1941–1942*. Translated by Antonia Lloyd-Jones. New York : New York Review Books Classics, 2018.

————. *L'art et la vie*. Edited by Wojciech Karpiński. Lausanne: Éditions L'Âge d'Homme, 2002.

————. *L'Oeil: Essais sur la peinture*. Lausanne: Éditions L'Âge d'Homme, 1982.

————. *Lost Time: Lectures on Proust in a Soviet Prison Camp*. Translated by Eric Karpeles. New York: New York Review Books Classics, 2018.

————. *Patrząc*. Kraków: Znak, 2016.

————. *Proust contre la déchéance*. Lausanne: Les Éditions Noir sur Blanc, 2011.

————. *Recit du Voyage par le comte Joseph Czapski dans le but de rechercher le capitaine Bronisław de Romer*. Kraków: Czartoryski Library.

————. "The Russian Man; Before and After the Revolution," unpublished lecture, Harvard University, March 24, 1950.

————. *Souvenirs de Starobielsk*. Montricher, Switzerland: Les Éditions Noir sur Blanc, 1987.

————. *Terre Inhumaine*. Lausanne: Éditions L'Âge d'Homme, 1991.

————. *Tumulte et spectres*. Montricher, Switzerland: Les Éditions Noir sur Blanc, 1991.

————. "What Happened in Katyn." Newport, RI: U.S. Naval War College, Department of Intelligence, 1950.

————. *Wyrwane strony*. Edited by Piotr Kłoczowski and Joanna Pollakówna. Lausanne: Les Éditions Noir sur Blanc, 1993.

————. *Wyrwane strony*. Warsaw: Zeszyty Literackie, 2010.

Czapski, Józef, and Zbigniew Herbert. *Korespondencja*. Warsaw: Zeszyty Literackie, 2017.

Czapski, Józef, and Ludwik Hering. *Listy 1939–1982*. Gdańsk: Terytoria Ksiazki, 2015.

Davies, Norman. *Heart of Europe: A Short History of Poland*. New York: Oxford University Press, 1984.

————. *Rising '44: The Battle for Warsaw*. London: Macmillan, 2003.

————. *White Eagle, Red Star*. New York: St. Martin's Press, 1972.

Davison, Peter. *George Orwell: A Life in Letters*. London: Liveright, 2013.

Doran, Michael. *Conversations with Cézanne*. Berkeley: University of California Press, 2001.

Erlich, Victor. *Child of a Turbulent Century*. Chicago: Northwestern University Press, 2006.

Etkind, Alexander, et al. *Remembering Katyn*. Cambridge, UK: Polity Press, 2012.

Eubank, Keith. *Summit at Tehran*. New York: William Morrow & Company, 1985.

Evain, Christine, and Christine Bertail. *Mavis Gallant on Her Work*. Paris: Éditions Publibook, 2009.

Falkowska, Janina. *Andrzej Wajda: History, Politics, and Nostalgia in Polish Cinema*. New York: Berghahn Books, 2007.

FitzGibbon, Louis. *Katyn: A Crime Without Parallel*. London: Tom Stacey Ltd, 1971.

———. *Katyn: A Triumph of Evil*. Dublin: Anna Livia Books, 1975.

Fleming, Thomas. *The New Dealers' War*. New York: Basic Books, 2001.

Florensky, Paweł. *Iconostasis*. Crestwood, NY: St. Vladimir's Seminary Press, 1996.

Franaszek, Andrzej. *Miłosz: A Biography*. Translated by Aleksandra and Michael Parker. Cambridge, MA: The Belknap Press of Harvard University Press, 2017.

Freud, Sigmund. *The Interpretation of Dreams*. Translated by James Strachey. New York: Avon Books, 1971.

Gagnebin-Werner, Murielle. *Czapski: La main et l'espace*. Lausanne: Éditions L'Âge d'Homme, 1974.

Garrard, John, and Carol Garrard, eds. *World War 2 and the Soviet People*. New York: St. Martin's Press, 1993.

Garton-Ash, Timothy. *The Polish Revolution: Solidarity, 1980–82*. New York: Scribner, 1984.

———. *The Uses of Adversity: Essays on the Fate of Central Europe*. New York: Random House, 1989.

Gellhorn, Martha. *The Face of War*. London: Rupert Hart-Davis, 1959.

Gombrowicz, Witold. *Diary*. Translated by Lillian Vallee. New Haven, CT: Yale University Press: 2012.

Gross, Jan Tomasz. *Fear: Anti-Semitism in Poland After Auschwitz*. New York: Random House, 2006.

———. *Golden Harvest*. New York: Oxford University Press, 2012.

———. *Neighbors*. Princeton: Princeton University Press, 2001.

Gross, Jan Tomasz, and Irena Grudzińska-Gross. *War Through Children's Eyes: The Soviet Occupation of Poland and the Deportation, 1939–1941*. Stanford, CA: Hoover Institution Press, 1981.

Grudzińska-Gross, Irena. *The Scar of Revolution: Custine, Tocqueville, and the Romantic Imagination*. Berkeley: University of California Press, 1991.

Guillier, Vincent. *Jean Colin d'Amiens ou le jeune homme et la mort*. Amiens, France: Encrage Édition, 2015.

Halévy, Daniel. *Degas parle*. Paris: Éditions de Fallois, 1995.

Harper, John Lamberton. *American Visions of Europe*. Cambridge, MA: Cambridge University Press, 1994.

Haskell, Barbara. *Milton Avery*. New York: Harper & Row, 1982.

Haven, Cynthia, ed. *Czesław Miłosz: Conversations*. Jackson, MS: University Press of Mississippi, 2006.

———. *An Invisible Rope: Portraits of Czesław Miłosz*. Athens, OH: Ohio University Press, 2011.

Heaney, Seamus. *The Government of the Tongue: Selected Prose*. New York: Farrar, Straus and Giroux, 1989.

Herbert, Zbigniew. *The Collected Poems: 1956–1998*. Translated by Alissa Valles. New York: HarperCollins, 2007.

———. *The Collected Prose: 1948–1998*. Translated by Alissa Valles et al. New York: HarperCollins, 2010.

Herling, Gustaw. *The Noonday Cemetery*. Translated by Bill Johnston. New York: New Directions, 2003.

———. *Volcano and Miracle*. Translated by Ronald Strom. New York: Viking Penguin, 1996.

———. *A World Apart*. Translated by Joseph Marek. New York: Roy Publishers, 1950.

Héronnière, Edith de la. *Promenade parmi les tons voisins*. L'Hay-les-Roses, France: Éditions Isolato, 2007.

Hippius, Zinaida. *Between Paris and St. Petersburg: Selected Diaries of Zinaida Hippius*. Translated by Temira Pachmusa. Urbana, IL: University of Illinois Press, 1975.

Hirsch, Edward. *Responsive Reading*. Ann Arbor, MI: University of Michigan Press, 1999.

Hochschild, Adam. *The Unquiet Ghost: Russians Remember Stalin*. New York: Viking, 1994.

Irving, David. *Accident: The Death of General Sikorski*. London: William Kimber, 1967.

Jeleński, Konstanty A. *Cahier Gombrowicz*. Paris: Éditions L'Herne, Série Slave. 1971.

———. *Chwile oderwane*. Gdańsk: Słowo/Obraz Terytoria, 2010.

———. *Listy z Korsyki*. Warsaw: Zeszyty Literackie, 2001.

Judt, Tony. *Past Imperfect: French Intellectuals, 1944–1956*. Berkeley: University of California Press, 1992.

———. *Postwar: A History of Europe Since 1945*. New York: Penguin Press, 2005.

Judt, Tony, with Timothy Snyder. *Thinking the Twentieth Century*. New York: Penguin Press, 2012.

Karpiński, Wojciech. *Ces livres de grand chemin*. Montricher, Switzerland: Les Éditions Noir sur Blanc, 1992.

———. *Portrait de Czapski*. Lausanne: Éditions L'Âge d'Homme, 2003.

Kessler, Harry. *Berlin in Lights*. Translated by Charles Kessler. New York: Grove Press, 1999.

———. *Journey to the Abyss: The Diaries of Count Harry Kessler, 1880–1918*. Translated by Laird M. Easton. New York: Alfred A. Knopf, 2011.

Kitowska-Łysiak, Malgorzata, and Magdalena Ujma. *Czapski i Krytycy*. Lublin, Poland: Wydawnictwo Uniwersytetu, 1996.

Kłoczowski, Piotr, ed. *Józef Czapski: Autour de la collection Aeschlimann*. Warsaw: Zachęta Narodowa Galeria Sztuki/Galerie Plexus, 2007.

———. *Józef Czapski: Świat w moich oczach*. Zabki, Poland: Apostolicum, 2001.

Kochanski, Halik. *The Eagle Unbowed: Poland and the Poles in the Second World War*. Cambridge, MA: Harvard University Press, 2012.

Koskodan, Kenneth. *No Greater Ally*. Oxford: Osprey Publishing, 2009.

Kot, Stanisław. *Conversations with the Kremlin and Dispatches from Russia*. Translated by H. C. Stevens. London: Oxford University Press, 1963.

Kotkin, Stephen. *Stalin: Paradoxes of Power*. New York: Penguin Press, 2014.

Kott, Jan, ed. *Four Decades of Polish Essays*. Evanston, IL: Northwestern University Press, 1990.

Kowalski, E. D. *Joseph Czapski: Un destin polonais*. Lausanne: Les Éditions Noir sur Blanc, 1997.

Lane, Arthur Bliss. *I Saw Poland Betrayed*. New York: Bobbs Merrill Company, 1948.

Lauck, John H. *Katyn Killings: In the Record*. Clifton, NJ: Kingston Press, 1988.

Lechoń, Jan. *Dziennik*. Warsaw: PIW, 1992.

Lukowski, Jerzy, and Hubert Zawadzki. *A Concise History of Poland*. Cambridge, England: Cambridge University Press, 2001.

Lynn, Katalin Kádár, ed. *The Inauguration of Organized Political Warfare: Cold War Organizations*. Saint Helena, CA: Helena History Press, 2013.

Mackiewicz, Joseph. *The Crime of Katyn: Facts and Documents.* London: Polish Cultural Foundation, 1965.

———. *The Katyn Wood Murders.* London: Hollis & Carter, 1951.

Małkiewicz, Adam, ed. *Józef Czapski: Wnętrye człowiek i miejsce.* Kraków: Muzeum Narodowe w Krakówie, 1996.

Malraux, André. *Les voix du silence.* Paris: NRF, 1951.

Mandelstam, Nadezhda. *Hope Against Hope.* Translated by Max Hayward. New York: Modern Library, 1999.

Maresch, Eugenia. *Katyn, 1940.* Stroud, Gloucestershire: Spellmount, 2010.

McCarthy, Mary. *Between Friends: The Correspondence of Hannah Arendt and Mary McCarthy.* New York: Harcourt Brace & Company, 1995.

Merleau-Ponty, Maurice. *The Merleau-Ponty Reader.* Edited by Ted Toadvine and Leonard Lawlor. Evanston, IL: Northwestern University Press, 2007.

Michnik, Adam. *In Search of Lost Meaning.* Translated by Roman S. Czarny. Berkeley: University of California Press, 2011.

———. *Letters from Freedom.* Translated by Jane Cave. Berkeley: University of California Press, 1998.

———. *Letters from Prison.* Translated by Maya Latyński. Berkeley: University of California Press, 1985.

———. *Polskie pytania.* Paris: Zeszyty Literackie, 1987.

Mickiewicz, Adam. *1798–1855: Selected Poems.* Edited by Clark Mills. New York: Noonday Press, 1956.

Miłosz, Czesław. *The Captive Mind.* Translated by Jane Zielonko. New York: Random House, 1981.

———. *The Collected Poems.* New York: Ecco Press, 1988.

———. *The History of Polish Literature.* Second edition. Berkeley: University of California Press, 1983.

———. *The Land of Ulro.* Translated by Louis Iribarne. New York: Farrar, Straus and Giroux, 1984.

———. *Miłosz's ABC's.* Translated by Madeline G. Levine. New York: Farrar, Straus and Giroux, 2001.

———. *Native Realm: A Search for Self-Definition.* Translated by Catherine S. Leach. Berkeley: University of California Press, 1981.

———. *New and Collected Poems: 1931–2001.* New York: Ecco Press, 2001.

———. *Postwar Polish Poetry.* Third edition. Berkeley: University of California Press, 1983.

———. *To Begin Where I Am: Selected Essays.* Translated by Bogdana Carpenter and Madeline G. Levine. New York: Farrar, Straus and Giroux, 2001.

———. *Unattainable Earth.* Translated by Czesław Miłosz and Robert Hass. New York: Ecco Press, 1986.

———. *The Witness of Poetry.* Cambridge, MA: Harvard University Press, 1983.

———. *A Year of the Hunter.* Translated by Madeline G. Levine. New York: Farrar, Straus and Giroux, 1994.

Młynarski, Bronisław. *The 79th Survivor.* Translated by Casimir Zdziechowski. London: Bachman & Turner, 1976.

Muhlstein, Anka. *A Taste for Freedom: The Life of Astolphe de Custine.* New York: Helen Marx Books, 1999.

473

Musée Jenisch. *Joseph Czapski Retrospective.* Essays by Jean-Louis Kuffer, Michel de Ghelderode, Jeanne Hersch, Wojciech Karpiński. Vevey, Switzerland: Éditions Plexus, 1990.

Muzeum Narodowe w Krakówie. *Gry Barwne: Komitet Paryski 1923–1939.* Museum catalogue, text by Stefania Krzysztofowicz-Kozakowska, 1996.

Naimark, Norman, M. *Stalin's Genocides.* Princeton: Princeton University Press, 2010.

Nalkowska, Zofia. *Medallions.* Translated by Dian Kuprel. Evanston, IL: Northwestern University Press, 2000.

Nicolson, Harold. *Diaries and Letters 1939–1945.* London: Collins, 1967.

Norwid, Cyprian Kamil. *Poems.* Translated by Adam Czerniawski. Warsaw: Wydawnictwo Literackie, 1986.

———. *Vade-Mecum.* Montricher, Switzerland: Les Éditions Noir sur Blanc, 2004.

Olechnowicz, Emilia, ed. *Józef Czapski: Wybrane strony 1942–1991.* Two vols. Warsaw: Instytut Dokumentacji i Studiów nad Literaturą Polską, 2010.

O'Malley, Owen. *Katyn: Despatches of Sir Owen O'Malley to the British Government.* London: Polish Cultural Foundation, 1972.

———. *The Phantom Caravan.* London: John Murray, 1954.

Orr, John, and Elżbieta Ostrowska. *The Cinema of Andrzej Wajda.* London: Wallflower Press, 2003.

Paul, Allen. *Katyn: Stalin's Massacre and the Triumph of Truth.* DeKalb, IL: Northern Illinois University Press, 2010.

Pétrement, Simone. *Simone Weil: A Life.* New York: Pantheon, 1976.

Pierre-Quint, Léon. *Marcel Proust: sa vie, son oeuvre.* Paris: Éditions du Sagittaire, 1925.

Poland. Committee of Enquiry into the Question of Polish Prisoners of War from the 1939 Campaign Missing in the U.S.S.R. *Facts and Documents Concerning Polish Prisoners of War Captured by the U.S.S.R. During the 1939 Campaign.* Typescript, "For Private Circulation Only." London, 1946.

Pollakówna, Joanna. *Czapski.* Warsaw: Wydawnictwo Krupski i S-ka, 1993.

Proust, Marcel. *À la recherche du temps perdu.* Four vols. Paris: Gallimard, 1987.

———. *The Collected Poems.* Edited by Harold Augenbraum. New York: Penguin Books, 2013.

———. *Remembrance of Things Past.* Translated by C. K. Scott Moncrieff and Terence Kilmartin. Three vols. New York: Random House, 1981.

Raczyński, Edward. *In Allied London: The Wartime Diaries of the Polish Ambassador.* London: Weidenfeld & Nicolson, 1962.

Rayfield, Donald. *Stalin and His Hangmen.* New York: Random House, 2004.

Reeder, Roberta. *Anna Akhmatova.* New York: St. Martin's Press, 1994.

Rossino, Alexander B. *Hitler Strikes Poland: Blitzkrieg, Ideology, and Atrocity.* Lawrence, KS: University Press of Kansas, 2003.

Rothko, Mark. *Writings on Art.* Edited by Miguel López-Remiro. New Haven, CT: Yale University Press, 2006.

Rozanov, Vasily. *La face sombre du Christ.* Paris: Gallimard, 1964.

Różewicz, Tadeusz. *Sobbing Superpower: Selected Poems.* Translated by Joanna Trzeciak. New York: W. W. Norton & Co., 2011.

———. *They Came to See a Poet.* Translated by Adam Czerniawski. London: Anvil Press, 2004.

Saillot, Frédéric. *Joseph Czapski, Peintre.* Unpublished manuscript.

Sanford, George. *Katyn and the Soviet Massacre of 1940*. London: Routledge, 2005.

Sartre, Jean-Paul. *"What Is Literature?" and Other Essays*. Cambridge, MA: Harvard University Press, 1988.

Schapiro, Meyer. *Modern Art, 19th and 20th Centuries: Selected Papers*. New York: George Braziller, 1978.

Sebag-Montefiore, Simon. *Stalin: The Court of the Red Tsar.* New York: Knopf, 2004.

Shirer, William. *The Rise and Fall of the Third Reich: A History of Nazi Germany*. New York: Simon and Schuster, 1960.

Shore, Marci. *The Taste of Ashes*. New York: Crown Publishers, 2013.

Silberstein, Jil. *Lumières de Joseph Czapski*. Montricher, Switzerland: Les Éditions Noir sur Blanc, 2003.

Silvera, Alain. *Daniel Halévy and His Times*. Ithaca, NY: Cornell University Press, 1966.

Slowes, Salomon W. *The Road to Katyn*. Translated by Naftali Breenwood. Oxford: Blackwell Publishers, 1992.

Snyder, Timothy. *Bloodlands: Europe Between Hitler and Stalin*. New York: Basic Books, 2010.

———. *The Red Prince: The Secret Lives of a Habsburg Archduke*. New York: Basic Books, 2008.

———. *Sketches from a Secret War: A Polish Artist's Mission to Liberate Soviet Ukraine*. New Haven, CT: Yale University Press, 2005.

Stempowski, Jerzy. *Essais pour Cassandre*. Paris: Noël Blandin, 1991.

———. *Notes pour une ombre*. Montricher, Switzerland: Les Éditions Noir sur Blanc, 2004.

———. *Od Berdyczowa do Rzymu*. Paris: Instytut Literacki, 1971.

Swianiewicz, Stanisław. *In the Shadow of Katyn: Stalin's Terror*. Pender Island, Canada: Borealis Publishing, 2002.

Sword, Keith. *Deportation and Exile: Poles in the Soviet Union 1939–48*. London: St. Martin's Press, 1994.

Tyrmand, Leopold, ed. *Explorations in Freedom: Prose, Narrative, and Poetry from* Kultura. New York: The Free Press, 1970.

———. *Kultura Essays*. New York: The Free Press, 1970.

U.S. House, Committee on House Administration. *The Katyn Forest Massacre: Hearings Before the Select Committee to Conduct an Investigation of the Facts, Evidence and Circumstances of the Katyn Forest Massacre, Eighty-Second Congress, First and Second Sessions, on Investigation of the Murder of Thousands of Polish Officers in the Katyn Forest near Smolensk, Russia (H. Rpt. 2505)*. Washington, D.C.: U.S. Government Printing Office, 1988. (Reprint)

Valéry, Paul. *Degas Danse Dessin*. Paris: Gallimard, 1936.

———. *Mauvaises pensées et autres* in *Œuvres*, vol. II, Paris: Gallimard-Bibliothèque de la Pléiade, 1960.

Venclova, Tomas. *Aleksander Wat: Life and Art of an Iconoclast*. New Haven, CT: Yale University Press, 1996.

Wajda, Andrzej. *Katyn*. Warsaw: Prószyński i S-ka, 2008.

Wat, Aleksander. *My Century*. Translated by Richard Lourie. New York: New York Review Books, 2003

———. *With the Skin*. Translated by Czesław Miłosz and Leonard Nathan. New York: Ecco Press, 1989.

Weidlé, Wladimir. *Les Abeilles d'Aristée*. Paris: Gallimard, 1954.

Weil, Simone. *Gravity and Grace*. Translated by Emma Craufurd. London: Routledge and Kegan Paul, 1952.

———. *Waiting for God*. Translated by Emma Craufurd. New York: Putnam, 1951.

Wells, David. *Anna Akhmatova, Her Poetry*. Oxford: Berg, 1996.

Werner, Eric. *Portrait d'Eric*. Vevey, Switzerland: Xenia, 2010.

Wittlin, Thaddeus. *Time Stopped at 6:30*. New York: Bobbs-Merrill Company, 1965.

Woźniakowski, Jacek. *Pisma Wybrane*. Volume VI. Kraków: Universitas, 2011.

Zagajewski, Adam. *Another Beauty*. Translated by Clare Cavanagh. New York: Farrar, Straus and Giroux, 1998.

———. *Canvas*. Translated by Renata Gorczynski, Benjamin Ivry, C. K. Williams. New York: Farrar, Straus and Giroux, 1991.

———. *A Defense of Ardor*. Translated by Clare Cavanagh. New York: Farrar, Straus and Giroux, 2004.

———. *Two Cities*. Translated by Lillian Vallee. New York: Farrar, Straus and Giroux, 1995.

———. *Without End: New and Selected Poems*. Translated by Clare Cavanagh, Renata Gorczynski, Benjamin Ivry, C. K. Williams. New York: Farrar, Straus and Giroux, 2002.

Zagajewski, Adam, ed. *Polish Writers on Writing*. San Antonio, TX: Trinity University Press, 2007.

Zaloga, Steven, and Victor Madej. *The Polish Campaign 1939*. New York: Hippocrene Books, 1985.

Zamoyski, Adam. *The Forgotten Few: The Polish Air Force in the Second World War*. London: John Murray, 1995.

———. *The Polish Way*. London: John Murray, 1987.

———. *Warsaw 1920: Lenin's Failed Conquest of Europe*. New York: HarperCollins, 2008.

Zaslavsky, Victor. *Class Cleansing: The Massacre at Katyn*. Translated by Kizer Walker. New York: Telos Press, 2008.

Zawodny, J. K. *Death in the Forest: The Story of the Katyn Forest Massacre*. Notre Dame, IN: University of Notre Dame Press, 1962.

Illustration Credits

The photographs of Józef Czapski, his family, and his friends are from an archive established in Warsaw by Janusz Przewłocki and continued by his son Grzegorz. Weronika Orkisz has generously granted permission to publish the black-and-white photographs and drawings, as well as the pages from Czapski's diaries from the archive of the Princes Czartoryski Library of the National Museum in Kraków. For independent images, every attempt has been made to identify the photographers for permission. The black-and-white photographs have been reproduced courtesy of the individuals and institutions below.

Misia Godebska by Pierre Bonnard, 1902 (detail), courtesy of Arnoldo Mondadori / Bridgeman Images.
Anna Akhmatova. Photo by Lydia Chukovskaya.
Jerzy Giedroyc, Zofia and Zygmunt Hertz. Photo courtesy of the Instytut Literacki.
Catherine Djurklou. Photo courtesy of Nils and Lilie Djurklou.
Ludwik Hering. Photo by Irena Jarosińska / Ośrodek KARTA.
Zbigniew Herbert. Photo by M. Langda / PAP / CAF.
Adam Zagajewski. Photo by Renata von Mangoldt.
Czesław Miłosz. Photo courtesy of Czesław Miłosz Papers. General Collection, Beinecke Rare Book and Manuscript Library, Yale University.
Jean Colin. Photo from Czapski's diary.
Konstanty Jeleński. Photo courtesy of Richard Overstreet.
Simone Weil. Photo courtesy of the Estate of Simone Weil.
Jeanne Hersch. Photo courtesy of akg-images / ullstein bild-Gertrude Fehr.
Adam Michnik. Photo by Andrzej Friszke.
Daniel Halévy. Photo by Karoly Forgacs, courtesy of ullstein bild / Getty Images.
Czapski in his bedroom/studio with Maria Paczowska. Photo by Bohdan Paczowski.
Czapski's hands. Photo by Krzysztof Gierałtowski.

Paintings by Józef Czapski have been reproduced courtesy of the individuals and institutions below, with the permission of Weronika Orkisz.

Young Man Before de Staël, 1981, oil on canvas, 25.5 x 18 inches. Wojciech Karpiński, Paris. Photo by Marianne Rosenstiehl.
In the Park, 1933, oil on canvas, 39 x 29 inches. National Museum in Warsaw. Photo by Piotr Ligier.
In the Mirror, 1937, oil on canvas, 36 x 25 inches. National Museum in Warsaw. Photo by Piotr Ligier.

À La Tour d'Argent, 1948, colored pencil on paper, 12 x 6 inches. National Museum in Warsaw. Photo by Piotr Ligier.

Self-portrait, 1948, colored pencil on paper. National Museum in Kraków. Photo by Jacek Świderski.

The Butcher Shop, 1955, oil on canvas, 31 x 39 inches. National Museum in Warsaw. Photo by Piotr Ligier.

The Beggar, 1953, oil on canvas, 41 x 21 inches. National Museum in Poznań.

Zbigniew Herbert, 1958, oil on canvas, 35 x 22 inches. The Zbigniew Herbert Foundation, Warsaw. Photo by Piotr Ligier.

Self-portrait with Lightbulb, 1958, oil on canvas, 31 x 24 inches. Michael Popiel de Boisgelin, Kurozwęki. Photo by Piotr Ligier.

Neon and Sink, 1959, oil on canvas, 31 x 39 inches. Richard and Barbara Aeschlimann, Chexbres. Photo by Alain Herzog.

Man at Exhibition, 1959, oil on canvas, 35 x 46 inches. National Museum in Warsaw. Photo by Piotr Ligier.

Visiting the Patient (Maria Dąbrowska), 1964, oil on canvas, 29 x 39 inches. National Museum in Warsaw. Photo by Piotr Ligier.

Stairwell, 1964, oil on canvas, 39 x 31 inches. Richard and Barbara Aeschlimann, Chexbres. Photo by Alain Herzog.

Baggage Trolleys in the Station, 1965, oil on canvas, 35 x 46 inches. Richard and Barbara Aeschlimann, Chexbres. Photo by Alain Herzog.

Femme Forte, 1965, oil on canvas, 21 x 29 inches. Jan Woźniakowski, Warsaw. Photo by Piotr Ligier.

The Young Philosopher (Eric Werner), 1971, oil on canvas, 46 x 24 inches. Private collection. Photo by Slobodan Despot.

Self-portrait, 1974, oil on canvas, 40 x 22 inches. Dimitrijević family. Photo by Oriol Tarridas.

Exhibition, 1977, oil on canvas, 20 x 25.5 inches. Muzeum Okręgowe im. Leona Wyczółkowskiego, Bydgoszcz.

Thomas and Claudia Thun, 1982, oil on canvas, 31 x 25.5 inches. Private collection. Photo by Haydar Koyupinar.

Poland (Białołęka), 1982, oil on canvas, 39 x 31 inches. National Museum in Kraków. Photo by Jacek Świderski.

Yellow Cloud, 1982, oil on canvas, 25.5 x 18 inches. Richard and Barbara Aeschlimann, Chexbres. Photo by Alain Herzog.

At the Eye Doctor, 1982, oil on canvas, 28 x 24 inches. Richard and Barbara Aeschlimann, Chexbres. Photo by Alain Herzog.

Sunrise, 1984, oil on canvas, 20 x 25.5 inches. Richard and Barbara Aeschlimann, Chexbres. Photo by Alain Herzog.

Blue Cloth, 1985, oil on canvas, 25.5 x 20 inches. Richard and Barbara Aeschlimann, Chexbres. Photo by Alain Herzog.

A page from a 1966 diary of Józef Czapski. National Museum in Kraków. Photo by Jacek Świderski.

A page from a 1970 diary of Józef Czapski. National Museum in Kraków. Photo by Jacek Świderski.

Woman in Front of a Train, 1971, oil on canvas, 39 x 29 inches. Private collection, Lausanne. Photo by Alain Herzog.

Index

Eric Karpeles is a painter who writes about the intersection of visual and literary aesthetics. His book *Paintings in Proust: A Visual Companion to* In Search of Lost Time has appeared in many languages. Translator of *Proust's Overcoat* and Józef Czapski's *Lost Time: Lectures on Proust in a Soviet Prison Camp*, he is a fellow of the Czesław Miłosz Institute at Claremont McKenna College.